Making Their Mark

Edited by Mark Godfrey
and Katy Siegel

Making
Their Mark

Art by Women
in the Shah Garg
Collection

Gregory R. Miller & Co.

To Manju and Ratin Shah
for believing that any woman
can reach for the stars

Contents

Artists on Artists

Plates

Texts by Allie Biswas, Hannah Johnston, and Lauren O'Neill-Butler

Preface

NOTE TO THE READER

Dimensions of works are given in both inches (or feet and inches, when at least one dimension exceeds 100 inches) and centimeters (to the tenth place); height precedes width, followed by depth, where applicable. Captions for full-page details appear on p. 432. The plates, beginning on p. 142, are arranged by artists' birth years rather than dates of specific works. Life dates are provided for artists and other figures discussed in the texts when they might prove illuminating and especially when other clues to periodization are absent; however, life dates are omitted when their inclusion would impair a text's readability or when a figure is exceedingly well known.

Komal Shah and Gaurav Garg began collecting contemporary art in earnest around 2014, after being struck by the ambition and beauty of several abstract paintings by women that were presented in that year's Whitney Biennial. For some time after, they focused their collection on a group of painters working in New York and Los Angeles, fascinated both by the singular qualities of their work and by the ways they pushed one another forward. Shah forged strong friendships with many of these artists; listening to them speak about older artists they admired, she started to collect an earlier generation of painters, whose work had emerged in the late 1960s. This decision to add historical works was the first of many moves Shah has made to expand the Shah Garg Collection from its core concern with contemporary abstract painting. Over the intervening years, she has grown interested in the connections between painting and textile-based work, such as weaving and quilting; in multiple approaches to sculpture; and in the ways so many artists dissolve the binary of abstraction versus figuration.

While the collection's formal and conceptual emphases have evolved, the couple's commitment to the work of women artists has remained an essential driving force. Initially surprised by the gender inequities that remain in the study, presentation, and acquisition of works of art, Shah has resolved to illuminate the depth and breadth of women's contributions to the history of visual culture, from the modern era to the current moment. Collecting has led organically to active advocacy, especially in support of those artists who are still unacknowledged, or underacknowledged, in the prevailing narratives. As Shah has come to know many artists personally, she and Garg have supported their exhibitions and their publications, created a series of public artists' talks, and helped museums to acquire their works.

The publication of *Making Their Mark* is another important step in Shah's efforts to amplify the voices and visions of a broad spectrum of women artists and to capture through new scholarship and dialogues their bold, innovative, and often risk-taking work. The volume presents paintings, sculptures, and works on paper by more than 135 artists in the Shah Garg Collection. Largely hailing from North America and Europe, the artists come from diverse communities, and their works often engage with the multidimensional experiences that shape their practices.

Making Their Mark comprises two wide-ranging essays, one written by each of us, as well as contributions by six guest writers exploring different topics related to the collection. The book also includes an interview with Shah; reflections by fifteen artists on artists in the collection who have inspired them; and short scholarly texts about each of the artists featured in the book. This liberal range of content offers readers a wide range of perspectives, and it is our hope that *Making Their Mark* will spark future exhibitions and publications.

A note about language: artists, authors, and everyone involved in this book have first-person authority over the words and names associated with them. All choices, including more general editorial decisions, follow from that principle—hence, our refusal to police or define "woman" biologically, as modeled by Associate Justice of the Supreme Court Ketanji Brown Jackson in her recent confirmation hearing, when she affirmed her own self-identification as a woman rather than asserting any universal definition. Language preferences are individual; they are also historical and ever-changing, and this volume represents a further moment in that history.

Indeed, language is just one facet of a big-picture history that also encompasses art and social change. Over the past several years, some museums have committed to acquiring art by women in reparative proportion as well as to mounting monographic and group shows of women artists. The most recent Venice Biennale, in 2022, focused almost exclusively on the work of women artists, and such recently published books as *Great ~~Women~~ Artists* (edited by Rebecca Morrill), Jennifer Higgie's *The Mirror and the Palette*, and Katy Hessel's *The Story of Art without Men* are part of the effort, begun in the 1970s, to question an art history centered on male artists. The ever-expanding Shah Garg Collection, and the varied activities that have resulted from its creation, contribute to this growing momentum.

And yet, even as we celebrate women artists, "women" as a large and diverse social category have, like other oppressed groups, experienced escalating attacks on their/our bodily autonomy and civil rights. The Shah Garg Collection, and *Making Their Mark*, emerged and grew during this apparently paradoxical period, sparked by the ambition to play a role in the communal endeavor of creating new, more inclusive and accurate histories. In light of the long and violent history of inequality and the uncertain future of even recently gained progress, the ambition to rewrite history in service of the present is more vital than ever.

—Mark Godfrey and Katy Siegel

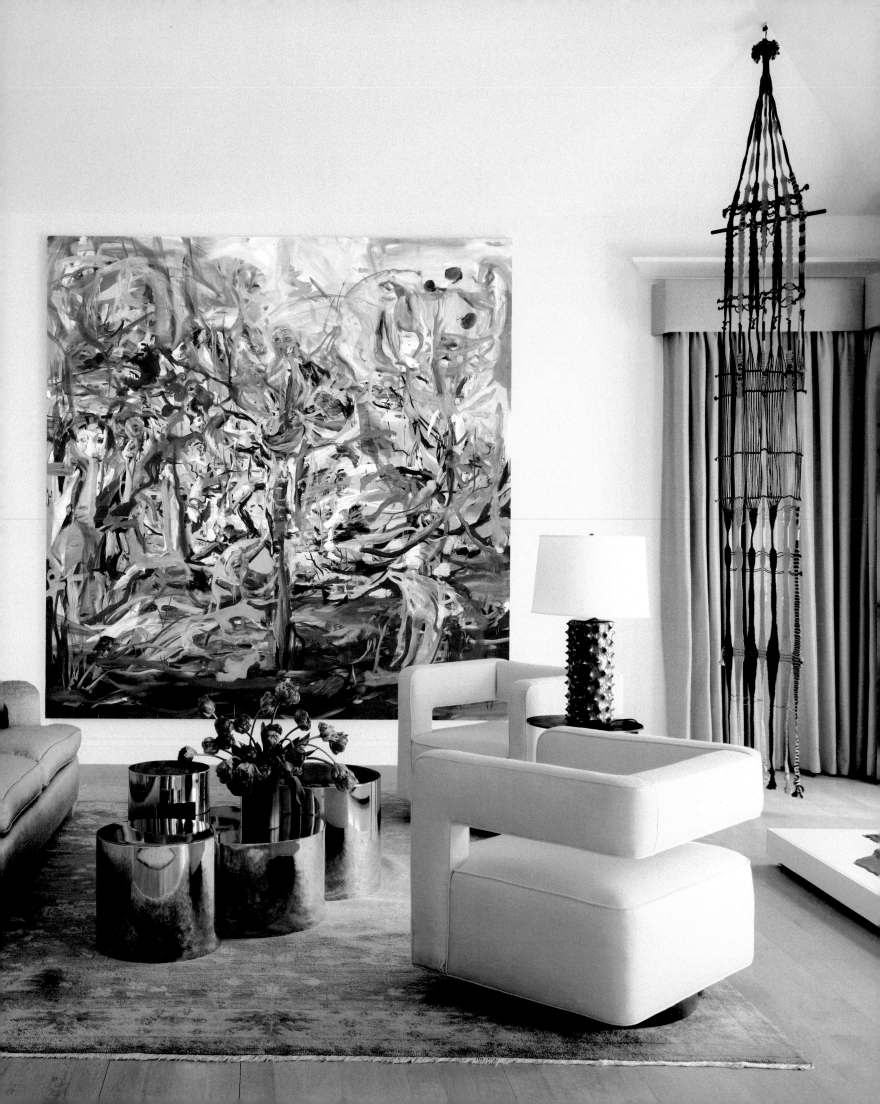

Komal Shah in Conversation with Mark Godfrey and Katy Siegel

Mark Godfrey To start, Komal, can you please share with us your experiences with art while you were growing up?

Komal Shah My early years were rich with art and visual culture. I grew up in Ahmedabad, which has long been considered the textile capital of India. My father was a textile trader, and I grew up surrounded by exquisite fabrics at home. My parents taught me to feel for texture, assess pattern, and look for color harmony. We also had painting lessons that included the study of Western art. And we frequently visited monuments and Jain temples in India and admired them for their beauty and grandeur. But I didn't get to visit many museums before I came to the U.S. My husband, Gaurav [Garg], also grew up in Ahmedabad, but like me, he wasn't exposed to museums growing up.

Katy Siegel Do you think some of your early aesthetic experiences, even if they weren't strictly tied to an idea of fine art in the contemporary sense, shaped your taste and interest in art?

KoS Yes. The works of art in the Shah Garg Collection are expressive, bold, visually harmonious in color, and grounded in abstraction. I think that my innate sense of color and composition, which I consider critical to great painting, stems from my background in textiles and from constructing garments for my dolls as a child.

MG Let's skip forward in time a bit and talk about your move to the Bay Area.

KoS I came to the U.S. over thirty years ago to study computer science at Stanford. I had fallen in love with coding and what I could create with it at fifteen years of age, and I started teaching coding at a nearby institute. When it was time to pursue grad school, my parents were very keen on Stanford, which was an unfulfilled personal dream of my father's. I loved being in the Bay Area, and the possibilities seemed endless. I felt energized and emboldened. Six

months after I arrived at Stanford, I called up my parents to say that I had found my home.

MG And what about the art world? Did you start visiting museums soon after you moved?

KoS I remember discovering the Cantor [Center for Visual Arts] in my first year [at Stanford] by sheer chance. Eventually, in those long days of engineering school, it became a place of refuge and respite from nonstop coding. Although I did not understand what I was looking at, the Cantor became a place to lift my spirits and transport me to a different place. Unfortunately, the demands of a seventy-hour work week and my focus on a high-tech career left little room for art immersion.

Right after Gaurav and I got married, in 1999, we visited New York. Gaurav had a great appreciation for Abstract Expressionism, and we spent a lot of time looking at works by Rothko, Kandinsky, and de Kooning at MoMA [The Museum of Modern Art, New York]. We also visited galleries and were enthralled, but the idea of collecting had not quite entered our consciousness. However, that was the beginning of a shared language of appreciation between Gaurav and me, one of abstraction and expressive mark making, which has lasted decades. We continue to make it a point to visit art institutions together as much as possible.

KaS How did you make the transition to collecting, or to thinking about a collection?

KoS In 2008, I decided to shift my focus to my family. My children needed support, and I could not do justice to them while meeting the professional standard I had set for myself in the tech world. So, I stepped back from my career. Soon after, the Asian Art Museum in San Francisco invited me to join its board, as an advocate for the Indian community and Indian arts. During my tenure at the Asian, I realized that I had fully embraced the Bay Area and the U.S. as home, and I intuitively connected with a language of art that was more global and reflective of this adopted home. That's when I

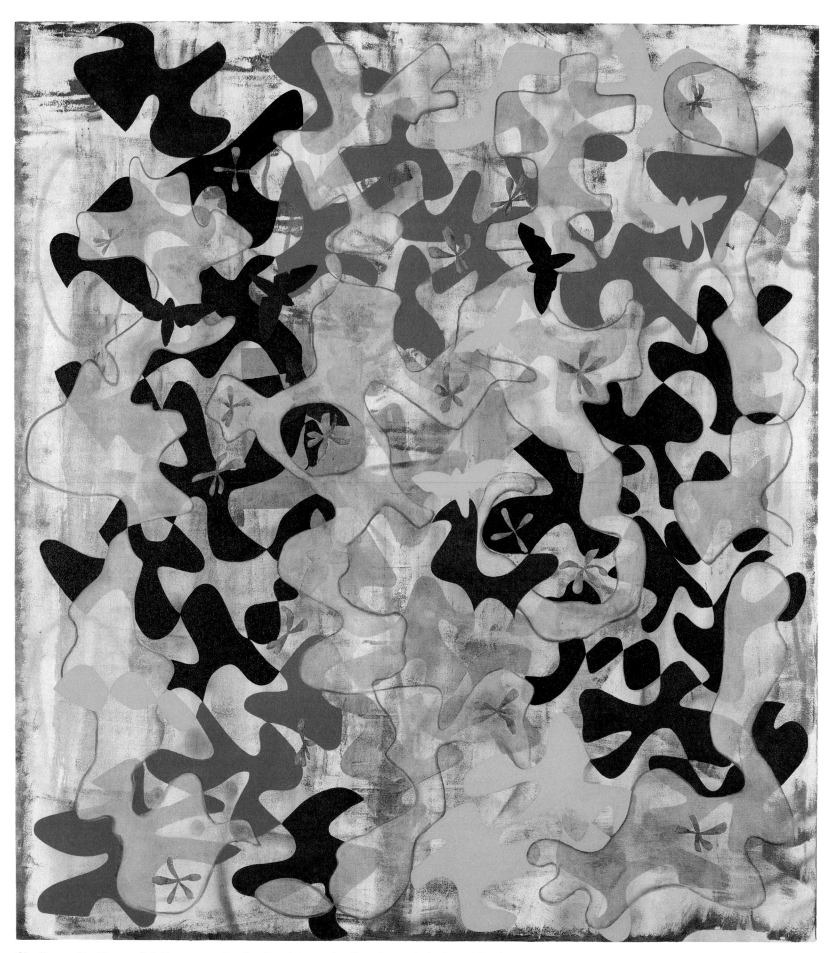

Charline von Heyl (born 1960). *Nunez*, 2017. Acrylic, oil, and charcoal on linen, 82 × 74 in. (208.3 × 188 cm). Shah Garg Collection

knew I had to expand my involvement with art. I started to dabble in 2011, acquiring a few works that I liked, but had not developed a clear point of view then.

In 2014, I was invited on a trip to New York with supporters of Tate Modern. That's when I met Mark [Godfrey]. We spent about three days looking at art, especially at the Whitney Biennial. Listening to Mark opened my eyes to a new world that I was immediately drawn to. I remember standing in front of works by Jacqueline Humphries and Laura Owens at the Whitney and saying to myself, "I really need to own this work." There was this incredible gut reaction. That was the big moment: the switch flipped. That's when the collector in me was born.

MG What was the first work you acquired?

KoS My first acquisition, in 2011, was a work on paper titled *It Rained so she Rained* [pl. 73], by Rina Banerjee. I was on a trip to New York with several Indian friends and mentors, and we went to an auction of South Asian modern and contemporary art at Christie's. I fell in love with the haunting beauty of the lone figure poetically catching her tears in an upside-down umbrella. I had deliberately not registered for the auction, because I did not trust my collecting ability. I had a friend bid on my behalf. I still adore the work to this day. Looking back, I think that Rina's transnational art practice—she was born in India and considers herself a New Yorker—spoke to me most, among all the Indian modernist works that were in the auction.

MG The curator Michelle Grabner, who herself is an artist from Chicago, brought together major works by women artists for the Whitney Biennial in 2014. Did you feel an immediate political commitment to collecting works by women?

KoS No. At that moment, I acquired works based on their visual appeal and my connection with the underlying ethos. I didn't even know the artists were women initially. I didn't focus on their names in that way.

KaS At what point, then, did you feel a particular drive to collect works by women, as a mission for your collection?

KoS Initially, my eye and heart were drawn to new and creative approaches to abstraction, without a real focus on gender. Subsequently, as I started attending gallery openings for exhibitions of work by Charline von Heyl and Jacqueline Humphries, I started to get to know the artists personally. I also began building relationships with other women artists—Amy Sillman, Laura Owens, Rachel Harrison, Mary Heilmann, Mary Weatherford, Cecily Brown, Dana Schutz—because they were a fierce constellation of friends supporting each other and showing up at openings as a gesture of respect.

As I started having conversations with these women, I was impressed by their enormous talent and grit in the face of stacked odds. As someone who had inhabited the business world for so long, I realized that the pricing of works by women artists was skewed unfavorably, compared to their male counterparts, especially given that pricing often signals an assumption of quality. There was also a perception bias against women artists among collectors and critics.

Celebrations of women were confined to a group of loyalists, as opposed to the glorification of male artists by a much broader audience. Women also had to struggle with the work-family balance, like women in other lines of work, and with significant time away from the studio and the loss in production that entails—a reality many male artists do not face.

KaS Can you speak about how your process evolved as you came to these realizations?

KoS In my philanthropic life, I had already focused on supporting women's issues. Sensing these disparities in the art world, I desired to support women artists. Fellow collectors would often inquire about the focus and purpose of our collection, which helped crystallize my thinking. If I was going to spend my resources, both time and financial, on collecting art, the collection had to tell a story that would make a difference to the art world. It would strive to bring balance, and parity based on gender, to the art world. As ambitious as that sounds, it is a belief and mission that has only grown stronger over the last decade.

MG How do you acquire works, given the broader mission?

KoS It's important to say that I fell in love with the work of Charline, Amy, Laura, and Jacqueline at first sight, and that instant reaction to a work is still critical to me. I have to connect to the object. As my knowledge has grown, I also find myself asking the next level of questions: What is the narrative of this work? What is the underlying sociopolitical context? What is the significance of this work to me or to a broader dialogue? Who or what influenced its making?

Thus, the foremost criterion for a work to enter the collection is that it be outstanding on its own merits. We are so lucky today to be surrounded by supremely brilliant artists who happen to be women. So, while this book shines a light on more than 130 artists currently in our collection, there are so many more impressive women artists, locally and globally, and we will absolutely continue to expand the narrative in the future. My wish list never stops growing.

MG I'll play devil's advocate: Right now, Simone Leigh is representing the U.S. at the Venice Biennale, where Jadé Fadojutimi, Charline von Heyl, Jacqueline Humphries, Allison Katz, Amy Sillman, Rosemarie Trockel, Andra Ursuţa, Portia Zvavahera, and Merikokeb Berhanu, all in your collection, are also presenting new works. Julie Mehretu recently had a retrospective that went from LACMA [Los Angeles County Museum of Art] to the Whitney. Laura Owens had one that went from the Whitney to Dallas to MOCA [The Museum of Contemporary Art, Los Angeles]. Katy [Siegel] and Sarah Roberts's major survey of Joan Mitchell took place in the last year, in Baltimore. I could continue. Many artists in the collection now occupy positions of great power in galleries, art schools. So, is there still a need for advocacy for women artists in this context, as opposed to in 2014?

KoS There are several great things happening right now. Two years ago, 2020, was the centennial of the ratification of the Nineteenth Amendment in the U.S. Many museums announced focuses on work by women that year. What I'm most worried about is that these are fleeting moments in

which institutions can capitalize on an anniversary in a performative manner, and then avoid doing the actual work of long-term, sustainable action to fix the inequities that have been perpetuated for so long. It is a triumph that Simone is the first Black woman to represent the U.S. in the national pavilion at the Venice Biennale and that she won the Golden Lion for best artist [in the international exhibition at the Arsenale]. It is a triumph that Joan Mitchell is finally having a successful transatlantic show thirty years after her passing and is now recognized as central to the canon. However, these wins come after decades of hard work and uphill battles.

Historically, there have been many blips and waves of seeming success in gender parity, especially in the '70s. But only too often, the world shrinks back into old habits and patterns. Case in point: basic rights for women are in jeopardy yet again, after so many decades of progress. Those blips of success have to become the normal state of affairs.

I want to help bring about systemic changes that last beyond our lifetimes. I believe that influencing the hearts and minds of young men and women is of utmost importance. Women artists are strong and equally capable to their male counterparts. Museums' and private collections' embrace of women artists should not be just a dashboard metric but truly ingrained into the acquisition strategy.

KaS Your collection is also focused, in particular, on abstraction. Why abstraction?

KoS Gaurav and I are intuitively drawn to it. Abstraction, as opposed to figuration, offers multiple entry points that lead me to further contemplate the image. Abstraction slows you down by inviting you to linger over the possible nuances of the work, to bring your own personal reflections into the meanings you derive from it. As a product of global displacement, I love that abstraction blurs geographical boundaries and unites us. It is universal and personal, all at the same time.

KaS I think it's really interesting the way you have spoken about figuration previously, especially as it relates to a woman's experience of the body. I wonder if you could talk a little bit about that.

KoS A lot has been written about shifting power to the woman's gaze. But women have also been abstracting the representation of the body and conceptually expanding the idea of a body. I find it tremendously empowering when artists extend the body to something larger and universal, as, for example, in Joan Semmel's painting *Horizons* [pl. 18]. Is the woman's body itself a visual metaphor for the landscape or the horizon? The lush, expressionistic gestures in the painting, the melding of body with the universe, make it a bridge between abstraction and figuration.

Simone Leigh's *Stick* [pl. 81] embraces the Black woman's body with a sense of pride and beauty by combining it with architecture in a way that speaks to Black women's life journeys. The blue patina ascribes to the figure a divinity that is typically bestowed upon Indian gods such as Vishnu and Krishna.

I want to share an anecdote that relates to this subject: Roberta Smith, the *New York Times* critic, was giving a talk about Elizabeth Murray at Stanford [in February 2019].

Simone Leigh's *Stick* (pl. 81) in the garden of the Shah Garg residence, 2022

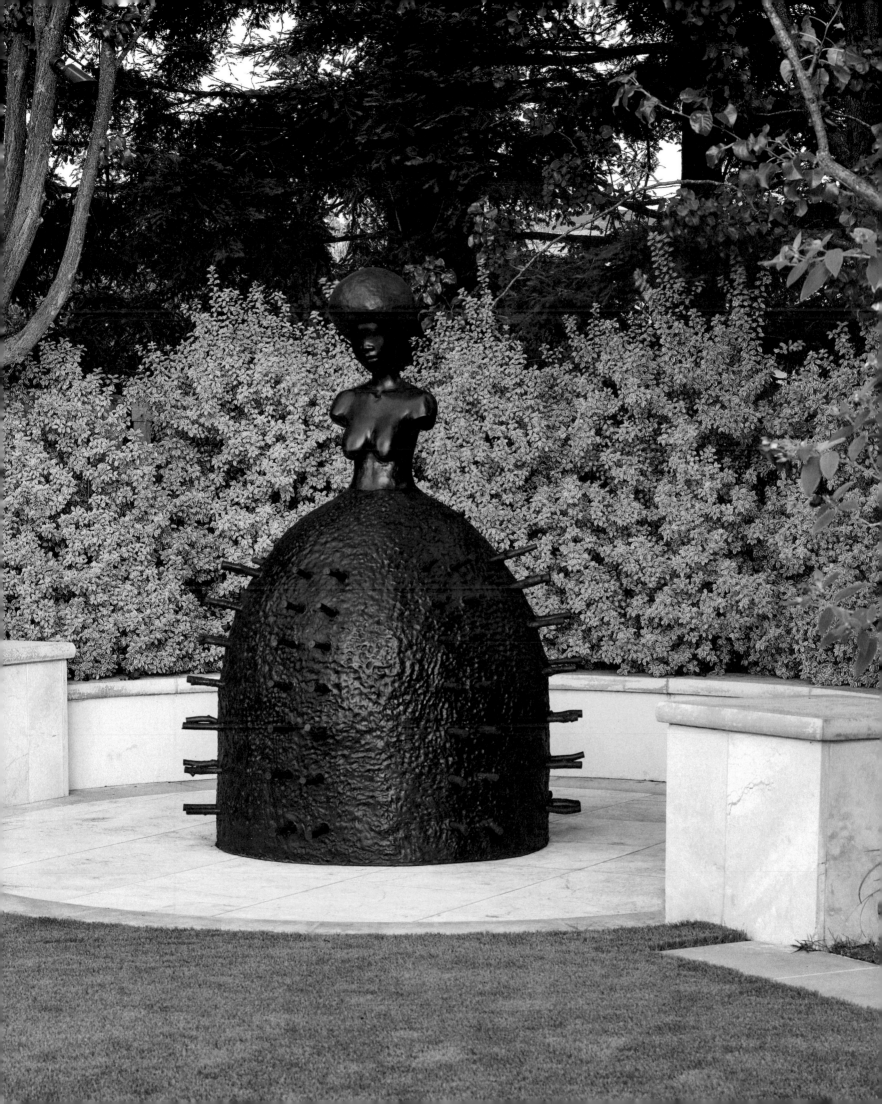

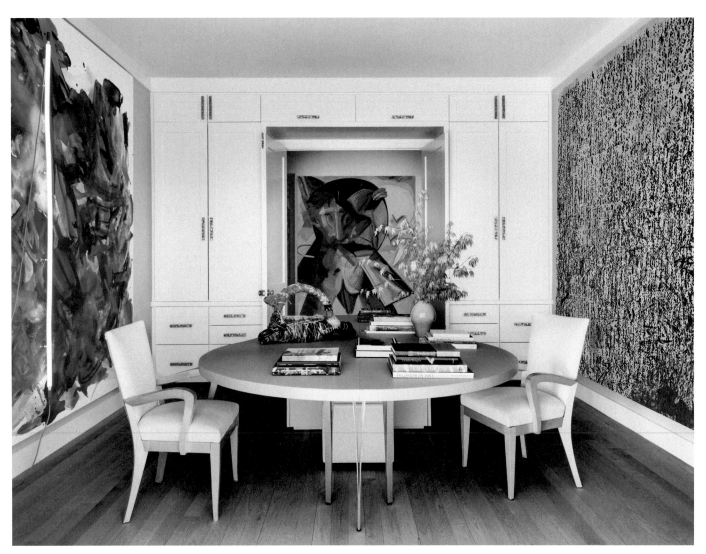

Works by Mary Weatherford (pl. 75), Judith Scott (on table; pl. 48), Dana Schutz (pl. 100), and Jacqueline Humphries (pl. 67) in the office of the Shah Garg residence, 2022

The first slide of her presentation was a work by Murray that happens to be in our collection, titled *Joanne in the Canyon* [pl. 34]. I invited Roberta to see the work, and she spent about three hours the next day looking at our collection. For about an hour of that time, she just stood in front of that Murray painting.

It turns out that *Joanne in the Canyon* is an abstract portrait of Murray's friend JoAnne Akalaitis [born 1937], an acclaimed theater director. As Roberta was talking, I started seeing [JoAnne's] arms with musical notes, her favorite clogs, and the canyons in Utah where she and Murray had walked together. That conversation challenged me to think about what abstraction really is. Does it mean the absence of representation, of any references at all, or is it something that's rich with all these references? To me, it is much more a continuum than a hard line.

MG Another way in which the collection has developed is in its expansion of medium, to sculpture. Can you speak to your engagement with the work of women sculptors?

KoS I met Rachel Harrison at an opening for Laura Owens. I had looked at her sculpture before as part of my engagement with Tate. I was drawn to this particular work, *Fendi* [pl. 78], because of its painterliness—its saturated palette of teal and magenta—and its references to de Kooning. Beyond the physical beauty, I loved the sly commentary in the work on the contemporary culture of consumerism and brand fetishism, which places certain items and brands on a pedestal. Many sculptors, like Rachel, Carol Bove, Barbara Chase-Riboud, Phyllida Barlow, and Lynda Benglis, are masters at communicating in three-dimensional space the same formal concerns often explored in painting: line and color. Carol Bove draws in space with massive twelve-inch, sixteen-inch, steel tubes that she folds in on themselves, slumped like clay in a fist—but she's actually manipulating her material with heavy machinery. These sensual forms require a mastery of materials and a real muscularity to create that I find thrilling and empowering. Like [Richard] Serra and [John] Chamberlain, women are at the forefront of making strong, powerful works.

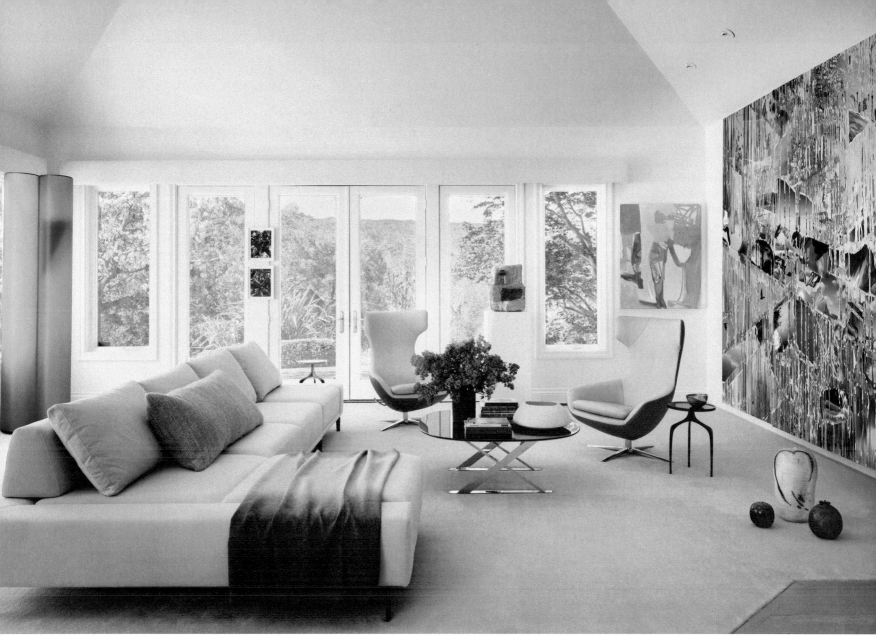

Works by Helen Pashgian (pl. 20), Tunji Adeniyi-Jones (born 1992), Rachel Harrison (pl. 78), Amy Sillman (fig. 4 on p. 77; see also pl. 64), Sarah Sze (pl. 87), and Toshiko Takaezu (on floor; pl. 7) in the family room of the Shah Garg residence, 2022

KaS Yes—it's absolutely not a metaphor to say that Carol Bove's sculpture is muscular. That can also be said of works by Barbara Chase-Riboud and Simone Leigh. These are enormous, ambitious, and just physically challenging works to make.

KoS I absolutely respect the raw power and ambition. Barbara Chase-Riboud's political and monumental art has been such a huge influence on younger artists working today. She was a trailblazer in paying homage to the past while experimenting with new material.

KaS Barbara takes us across that line from sculpture into craft. You've also expanded into media not traditionally seen as "high art," and people playing the edge of that divide, like Barbara, Sheila Hicks, Lenore Tawney, Trude Guermonprez, Joyce J. Scott, Qunnie Pettway, Toshiko Takaezu. How did you begin this direction of exploration, and what dimension does that add to the collection?

KoS The 2019 exhibition *With Pleasure: Pattern and Decoration in American Art, 1972–1985*, curated by Anna Katz at MOCA LA, was an eye-opener for me. Before seeing the show, I had assumed it would be all women. But seeing the rich diversity among the artists, including several men, I started reflecting on the folly of stereotyping art by gender. The show also led me to rethink the criteria for a work to be perceived as legitimate. Why is craft, often considered women's work, not part of the canon? As I investigated further, I realized that the high priests of art criticism were men, and their bias against craft prevented it from getting its due.

In many instances, women have had to work on a more intimate scale, balancing family life and work and engaging with the materials to which they have ready access. Craft was central to many women's artistic practices. After a lot of discussion, especially with you, Katy, I had this moment of clarity and gave myself permission to collect works without worrying about the projected gender of the work—that is something I had subconsciously internalized. I felt a freedom to start acquiring works I now regard as tremendously important.

After acquiring the Lenore Tawney weaving *Inquisition* from '61 [pl. 2], I sat next to it for several months, trying to figure out how she did it. It makes me want to add more to my collection. Another important artist, Sheila Hicks, has been working with textiles for more than sixty years, and she was often classified as decorative rather than as an art maker. A prime example is her works resembling prayer rugs—we have one, circa 1970s [pl. 19], still as immaculate and fresh as if it were made yesterday. These were a result of her global travels and exposure to Islam in North Africa. She was making these hangings, and larger ones, on commission for design firms, because they weren't considered "high art" then. That blows my mind. If you spend even thirty seconds glancing at these pieces, you can see her mastery and creativity. We need to reevaluate the canon, and I firmly believe that textiles and craft practices should be on equal footing to painting, sculpture, and other forms.

KaS You referenced looking at Lenore Tawney from 1961 and Sheila Hicks from the '70s. Have you begun to turn toward the historical?

KoS In the early years of collecting, I would always notice Mary Heilmann at openings—in her role as a mother figure, checking out the collectors and looking out for many of the younger artists. I learned that many, including Rachel Harrison and Laura Owens, were very influenced by her work. So, I started learning about Mary. It struck me that while some of the younger artists were gaining visibility, their predecessors still were not getting that exposure.

It became exciting to start mapping these networks. Traversing the paths of influence in history has been very gratifying and has helped to build layers and stories in the collection. I also started learning a lot more about the A.I.R. Gallery and its founders. The '70s were such a huge

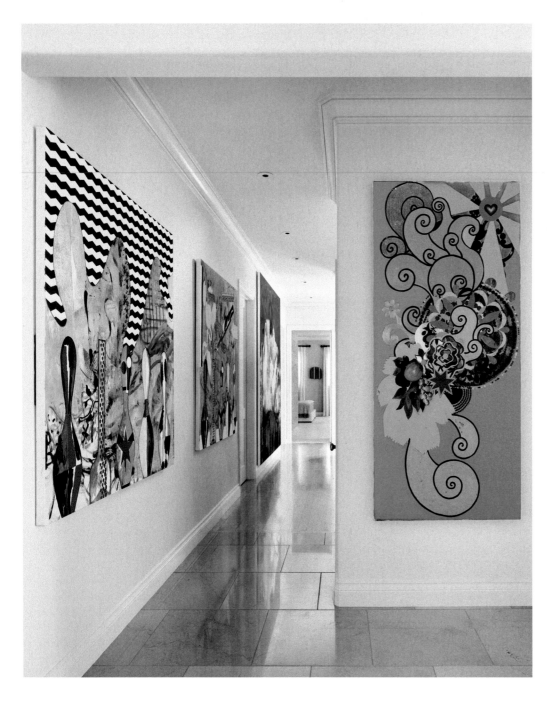

Works by Charline von Heyl (pl. 71), Lorna Simpson (pl. 70), and Beatriz Milhazes (pl. 68) in a hallway of the Shah Garg residence, 2022

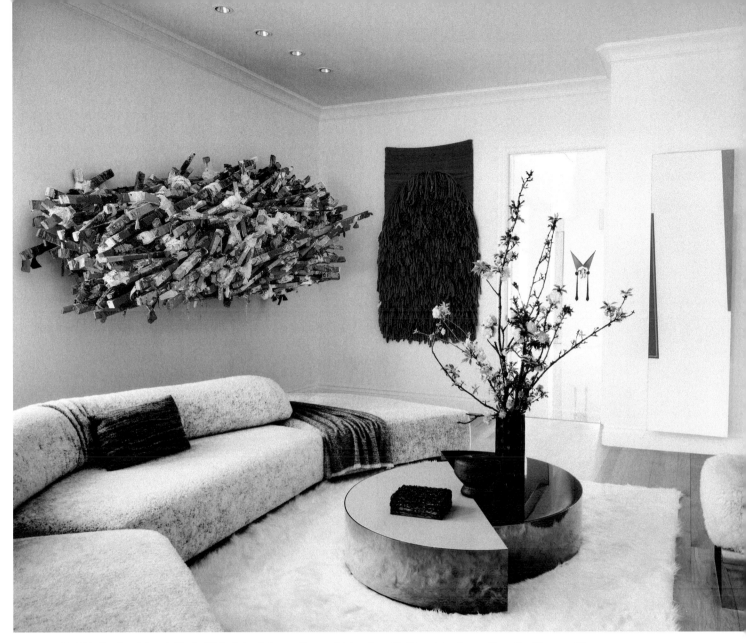

Works by Phyllida Barlow (pl. 49), Sheila Hicks (pl. 19), Senga Nengudi (pl. 44), and Jo Baer (pl. 12) seen from the library of the Shah Garg residence, 2022

moment in the rise of feminism and its intersection with the art world. The earliest work in the collection is a drip painting by Janet Sobel from 1946, and then we have artists from every decade, starting in 1960.

I feel an urgency to collect work by historical artists because they really deserve the spotlight after persevering for such a long time. And a few artists, such as Louise Fishman and Helène Aylon, have passed away in the last two years, so I know that we don't have forever to duly recognize them.

MG In the 1960s, major lesbian artists did not make their sexuality a public aspect of how they talked about their work. In the 1970s, they began to, but in ways that weren't necessarily very obvious. Right now, if you look at someone like Christina Quarles, it's very much an aspect of the work. Do you think about those strands within your collection?

KoS I strongly believe in the freedom to express gender and sexual identity as people deem appropriate. When I heard stories from Louise Fishman about how it was so difficult to

be accepted by the art world because she was publicly out, it upset me a great deal. As time has progressed, many queer women artists are feeling more comfortable weaving their own selves with the work. Having said that, on an intellectual level, works that question identity based on sexual orientation, race, and geography resonate with me as being so pertinent to the times we live in.

KaS You're not necessarily setting out to collect work by queer artists or Black artists or Indigenous artists, but your collection is naturally embracing and growing in diversity. You are closely involved with many institutions—SFMOMA [San Francisco Museum of Modern Art], Hammer Museum, Studio Museum [in Harlem], and Stanford Arts [Advisory Council]. What do you think of the support for diversity in U.S. civic institutions today?

KoS If you've seen the 2019 *artnet* report, only 11 percent of museum acquisitions between 2008 and 2018 were of works by women artists.[1] I was stunned when I read that.

While diversity metrics and quotas may seem trivial, they are crucial to establishing balance in museum collections that have been so severely lopsided. To the many who feel that buying work solely based on gender compromises quality, I would say, Look carefully, and with an open mind. The assumption that women's work should only be bought for equity is so fraught with bias, because it suggests that the work by women itself is substandard. Nothing could be further from the truth. There are many incredible women artists who are easily at par with the top male artists, if we only allow ourselves to get past our historical bias.

In 2019, the *Economist* published an article, "Portrait by a Lady: Why Women's Art Sells at a Discount," discussing a paper by four economists that revealed how the discount had "nothing to do with talent or thematic choices. It is solely because the artists are female."[2] The authors of the study relied on 1.9 million transactions between 1976 and 2018 across forty-nine countries and found an average discount of 42 percent. They also performed a blind study with computer-generated images, randomly ascribing them male and female names. It is perhaps not too shocking to learn that images with male names were assigned higher value.[3]

We must overcome this societal bias to create a level playing field for all artists regardless of gender. Civic institutions need to lead the charge in truly reflecting and respecting 51 percent of the world's population.

MG When you are asked to represent your collection publicly, you're obviously making a curatorial decision about what to put forward. Recently, interviews published with you have foregrounded works by Jaune Quick-to-See Smith. I wonder what it means to advocate for an artist in that way, and also about your engagement with art by Indigenous artists in general.

KoS You brought Kay WalkingStick's *Red Painting/Red Person* [pl. 22] to my attention, and I discovered work by several other Indigenous women artists, including Jaune Quick-to-See Smith and Marie Watt, through Katy. I admit, I was blown away by Jaune and her multilayered paintings, laden with sociopolitical commentary and her deep knowledge of art history. Her somewhat lighthearted but very satirical riffs on [Jasper] Johns and [Robert] Rauschenberg, combined with her mastery of painting, made me want to spread the word on how good, and overlooked, an artist she is. Marie Watt invites the community to join her for "sewing circles" at which they help her create fabric sculptures and installations that often allude to spaces and displacement in a way that invites empathy and understanding. This social engagement is crucial to her artistic practice.

KaS It is interesting that the collection reflects connections between artists like Jaune Quick-to-See Smith and Marie Watt. But there are also relationships across categories of identity and practice. Jaune has collaborated with Harmony Hammond; Howardena Pindell, Kay WalkingStick, Emma Amos, and Zarina were all in dialogue, and in exhibitions together; other artists in the collection admire each other's work but may have never met in person. There are many different constellations represented in the collection.

KoS The art world has never been siloed. Artists have traversed countries and continents to experience other cultures and learn techniques. That many artists like Zarina, Howardena Pindell, Mary Grigoriadis, and others came together via A.I.R. and other small institutions in the '70s despite different ethnic backgrounds is not surprising. What is surprising is how we try to put boundaries around art, even though there has always been a great exchange of ideas across the world over centuries.

As a personal example, many important artists, including Robert Rauschenberg, Roy Lichtenstein, Frank Stella, Lynda Benglis, and Amy Sillman, have done residencies in my hometown, Ahmedabad. Did you know that Rauschenberg's famous *Jammer* series, made in the mid-'70s, was directly influenced by the rich textiles of Ahmedabad and his experiences there?[4] And Amy's work of the late '90s reflects Indian miniature paintings.

KaS You've also put a lot of thought and weight behind some very young artists in the last few years. What gives you confidence about an artist, when you buy their work in the early stage of their career?

KoS Visiting young artists in their studios, looking at their work, and learning from them are absolutely some of the most energizing aspects of collecting. Studio visits help me understand where the artist has come from, who their influences are, and where they are going. I look for passion and big ideas, as well as authenticity and vulnerability. I confess that I am excited that today, many young women artists can boldly articulate their practice, and bring their personal narrative into their practice, with fluency and self-confidence.

As an example, in the summer of 2018, I visited a young artist in London named Jadé Fadojutimi, who at that point was two years out of the Slade [School of Fine Art]. Her parents had emigrated from Nigeria; she is first-generation British, and completely devoted to abstraction. There was so much strength in her paintings—they were tightly composed, with a color palette that accentuated that balance. I started talking to her about her influences, and it turns out they were some of the artists I most admire: Charline, Laura, and Amy. When I asked if she had considered referencing her Black identity in her work, she very simply said that as a native Brit, and thanks to her parents, she felt free to pursue abstraction in her work. I was impressed with her quiet confidence and authenticity. I knew then that she would be an artist to watch.

That same year, I also visited the artist Firelei Báez, who was busy painting a monumental work, *For Améthyste and Athénaïre . . .* [pl. 111], to be displayed in the MoMA window for a year. That painting portraying the exiled royal princesses of Haiti as symbols of endurance, grace, and strength—and representing the new Haiti—left me speechless with awe. Firelei's masterful painting and her articulation of the actual and imagined history of Haiti made an indelible impression on me. Báez, an artist of color, clearly also feels completely free to choose to make such references in her work. Women can choose. Any artist can choose.

KaS Is there a sense that abstraction or modern painting is still the "big table," in some ways? Finding out that modernism is global, that there are both multiple dimensions of and multiple sources for those modernisms—does that feel important to you?

KoS Absolutely. You think about the Gee's Bend quilters, who made quilts for decades in many patterns and styles, using the material at their disposal [pls. 21, 45]. In general, quilting has been a tradition for so many centuries, born initially out of practical and decorative concerns, but now it has many other interesting associations. I don't think abstraction has ever had one particular source, and certainly, Abstract Expressionism is not the mother of all abstraction.

KaS I think that's important to say: Joan Mitchell and Lenore Tawney are older artists, but the collection doesn't frame either as an origin point. You have works by artists who point to American quilting, or art in West Africa, as a source for their practice—Faith Ringgold often refers to the Tibetan *thangka* cloths she saw in a museum long ago. Abstraction has many, many roots.

KoS So true. It is not a seventy-year-old invention. It has been around for centuries, on a global level.

KaS That feels very current and important as an argument for how to think historically in the present moment.

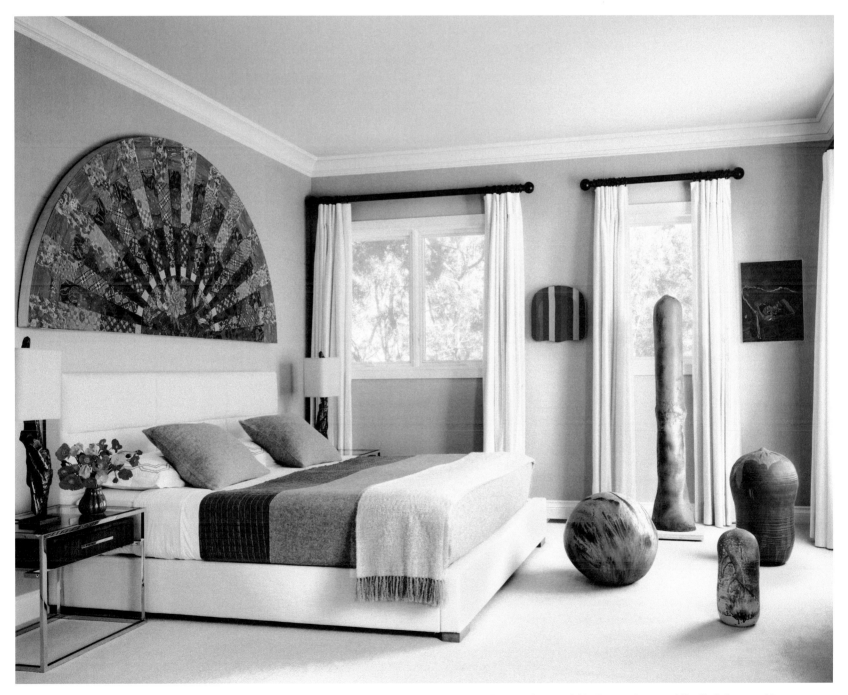

Works by Miriam Schapiro (pl. 9), Sherrie Levine (pl. 54), Toshiko Takaezu (on floor; pl. 7), and Danielle McKinney (born 1981) in the guest room of the Shah Garg residence, 2022

MG One thing about this book is that it allocates pretty much the same space to an artist with a current retrospective and a very high auction price as it does to an artist who hardly has a collecting audience. Why is this approach important to you?

KoS I feel that my mission is to shine light equally on great artists whether they have been seen and celebrated or are still underrecognized. So, as a guiding principle of this book, you, Katy, and I decided to celebrate all the artists on a level playing field. I also acknowledge that despite my best efforts, there are so many artists still to meet and shine a light on, across the world. I have only scratched the surface in my journey of discovery and support. That is the beauty of a living and growing collection.

This conversation, which took place in December 2021 in Atherton, California, has been edited for clarity and condensed.

1. Julia Halperin and Charlotte Burns, "Women's Place in the Art World: Museums Claim They're Paying More Attention to Female Artists. That's an Illusion," *artnet news*, September 19, 2019, https://news.artnet.com/womens-place-in-the-art-world/womens-place-art-world-museums-1654714.
2. "Portrait by a Lady: Why Art by Women Sells at a Discount," *Economist*, May 18, 2019, 78–79.
3. Renée Adams, Roman Kräussl, Marco Navone, and Patrick Verwijmeren, "Is Gender in the Eye of the Beholder? Identifying Cultural Attitudes with Art Auction Prices" (working paper, CFS Working Paper Series 595, Center for Financial Studies, Goethe-Universität, Frankfurt am Main, 2018), https://nbn-resolving.de/urn:nbn:de:hebis:30:3-469276.
4. Elizabeth Gollnick, "Unions: Robert Rauschenberg in Ahmedabad," in *post: Notes on Art in a Global Context*, Contemporary and Modern Art Perspectives (C-MAP), The Museum of Modern Art, New York (website), September 5, 2017, https://post.moma.org/unions-robert-rauschenberg-in-ahmedabad/.

Firelei Báez (born 1981). *temporally palimpsestive (just adjacent to air)*, 2019. Acrylic and oil on printed canvas, 7 ft. 6 in. × 9 ft. 6½ in. (228.6 × 290.8 cm). Shah Garg Collection

Some Women

Katy Siegel

1. Some women artists question and are questioned about what it means to be a woman and an artist.

Faith Ringgold, at the end of the 1970s, recalled that during that decade women had begun asking and being asked a lot of questions: "Is there a Women's Art? Is there a Women's Culture? Is there a Feminist Art? And, special for me, Is there a Black Woman's Culture? Is there a Black Woman's Art? Is there a Feminist Black Art? Are you a Woman Artist? Are you a Black Woman Artist?"[1] Ringgold identified as a Black woman artist and a feminist, but she also understood that the threat of being relegated to second- (or third-) class status made it difficult for some women artists to answer "yes." Even when women were doing the asking, the questions were freighted with social pressure and rarely offered a multiple-choice response, much less an essay option. As answers, "yes" and "no" can feel equally confining. In this essay, I want to linger in the possibility that the answer could be more contingent and nuanced: some women, some of the time.

The key word itself is challenging; as the philosopher Denise Riley writes, the "excessively described and attributed being of 'women' is saddled with "an extraordinary weight of characterisation."[2] The way the world sees gender, and women in particular, is prescriptive, drawn broadly and cartoonishly. But while "woman" is a heavy label, it is not a stable one, according to Riley: "To put it schematically: 'women' is histori-cally, discursively constructed, and always relatively to other categories which can themselves change."[3] Even feminism has often failed to account for difference and material experience: as the late critic bell hooks explained, "The concept 'Woman' effaces the difference between women in specific sociohistor-ical contexts, between women defined precisely as historical subjects rather than as a psychic subject (or non-subject)."[4] At the current moment, with social definitions of gender in flux, it is worth remembering that "woman" has never meant the same thing for different women, and that those meanings have changed constantly throughout history.[5]

The instability of the collective extends to the individual, who does not necessarily feel the same way about her gender identity over her lifetime; may not experience it as consistently primary; and may also be inconsistently named "woman" by the world. Riley again: "While it's impossible to thoroughly be a woman, it's also impossible never to be one."[6] An interview between two artists in the Shah Garg Collection[7] touches on this:

Dana Schutz: I never really thought of myself as a girl painter until recently.

Amy Sillman: What brought this on?

Schutz: I started to realize that other people would bring it up. I don't know if I want or don't want that category for myself because the public conversation about it is sort of inadequate. The idea of female angst is a private conversation with myself in the studio, different from the public one.

Sillman: Some of the ambiguous gender things that your paintings call to mind are really cool. You don't know if the characters are women, men, fiction, por-trait, sculpture, painter, rock stars, castaways, cartoon characters or *Déjeuner sur l'herbe*. There are a lot of things that the viewer doesn't really know about your paintings just by looking at them. They seem to show a world that may or may not exist and if that's the case, then the openness of not really nailing it down means that you are also not nailing down any identification process. And I think that is feminist.[8]

Rather than the familiar choice between essential biological being and social construction, we might consider "woman" as a quality that flickers with changing contexts—a quality that does not require us to identify consistently with a single group, to share our thoughts in public, or to feel that being a woman is the sole or even the most important part of our identity.

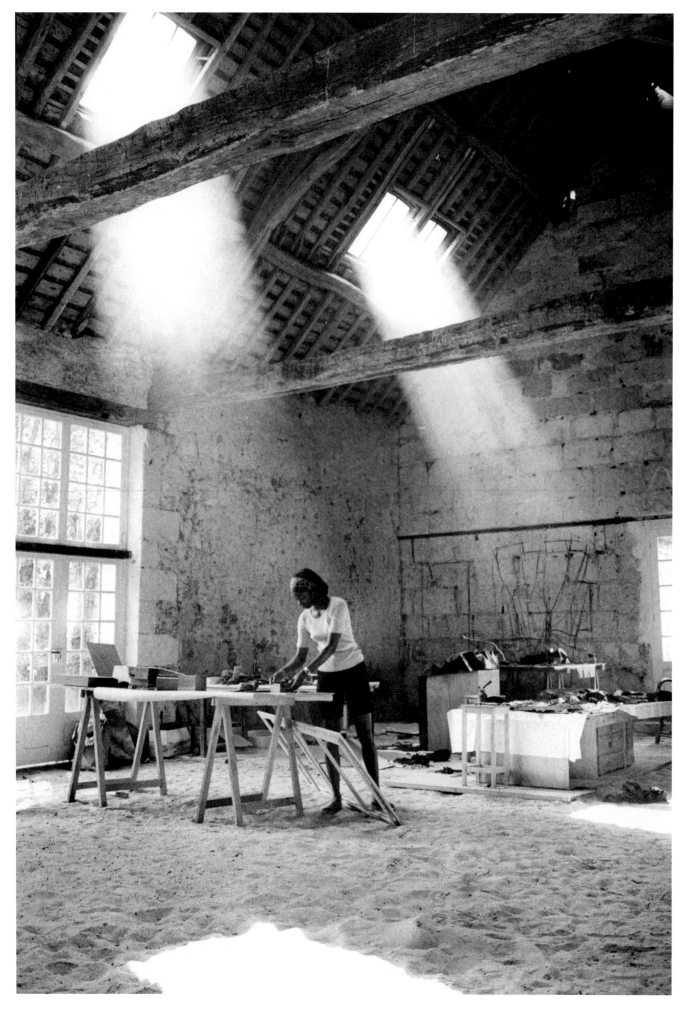

Fig. 1 Barbara Chase-Riboud working in her studio, La Chenillère, in Pontlevoy, France, 1969. Photo: Marc Riboud

OPPOSITE Fig. 2 Joan Mitchell painting in her studio at 60 Saint Mark's Place, New York City, 1957. Photo: Joan Mitchell and Rudy Burckhardt

2. Some women artists want to retrieve the women left out of mainstream history.

Sitting in the museum's archives in front of folders of materials and notebooks listing the artists and artworks in the collection of the Museum of Modern Art, Elizabeth Murray saw "hundreds of things about male artists that I had never even heard of, but with the women, there might just be one letter.... It was heartbreaking. As a woman, you just weren't interesting to pursue."[9] Murray's visit, to plan an exhibition of work by women at the museum, took place in the mid-1990s, not so long ago; even today, women are often confronted with histories that do not account for us. And some women—lesbians and queer women, Black women, Indigenous women, women of color—are even less present than others. Despite the current art-world interest in women and marginalized people, recognition has been a slow process; powerful financial and cultural, even personal, investments in the status quo underwrite objections to canon correction and historical revision as defenses of supposedly objective facts. The act of rewriting has its own rich history, one that is by turns feminist, womanist, activist; here, my concern is with the ways artists themselves engage with history. As Barbara Chase-Riboud (fig. 1) has said, equally describing her sculptural practice and her historical fiction, "Basically my dialogue is with established but untruthful mainstream history."[10]

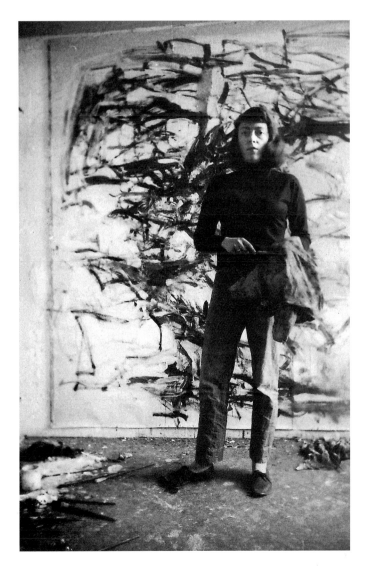

The problem of how a woman might project herself into the grand tradition of modern art has often involved gender bending. In 1956, Joan Mitchell's lover Jean-Paul Riopelle played with edgy affection on the slippage between the artistic master and the amorous mistress, applauding Mitchell's paintings as the work of a "maître au feminin" (fig. 2).[11] In the French, even "the feminine" takes masculine form, modifying—or failing to modify—"master." The absurd impossibility of a female master meant that there were no words for what Mitchell was. Firelei Báez (fig. 12) recalls becoming aware of the gendered passivity of Romance languages while growing up, which conflicted with the presence of powerful women in the folktales circulating in her community.[12] English is equally prescriptive, from the hideous "lady painter" of Mitchell's moment to the lingering disparity today between the familiar, near-ubiquitous sound of "women artists" and the awkwardness and rarity of the parallel phrase, "men artists."

Mitchell was questioned incessantly about being a woman artist. By the 1970s, amid the political ferment of feminism, womanism, and activism, women had also begun asking their own questions. In 1971, Ringgold and other artists, curators, scholars, teachers, and critics demanded, "Are museums relevant to women?"[13] Or they pointed, as the art historian Linda Nochlin famously did, to the absurdity of the questions aggressively put to women: "Why have there been no great women artists?"[14] Pulling apart the old chestnut in the eponymous essay, published in the January 1971 issue of *ARTnews*, Nochlin also belied it in a historical exhibition she curated, *Women Artists, 1550–1950*; the show was a sensation as it traveled to Austin, Pittsburgh, Los Angeles, and Brooklyn in 1976–77, seen by many thousands, referenced and reviewed and debated. In her ecstatic review, the artist Miriam Schapiro highlighted a passage in the catalogue's preface enumerating the works that were too "wormy"—in poor physical condition—to be part of the exhibition, speculating about the lack of care directed to, and value placed on, art by women.[15] While who is written into history is, to a certain extent, contingent, history is also written by force and highly regulated, and that contingency is not evenly distributed. Báez reminds us that history is never neutral, and neither are its blind spots: "There's always been a concerted effort of women and people of color to have affirmative spaces of love and regeneration. History actively tries to erase these gestures but that doesn't mean that they're really gone."[16] Her gorgeous paintings celebrate those spaces and gestures, and also the palimpsests of historical erasure.

Taking women into account cannot be reduced to an exercise in racking up "contributions" to mainstream history, although much remains to be done in that respect as well; Rosemarie Castoro, Virginia Jaramillo, and Mary Lovelace O'Neal belong at the center of conversations about experimental abstract painting, for instance. Many women artists have engaged with art history in its dominant form: a narrow, stylistic story of one movement's pushing aside the previous one, through Abstract Expressionism, Pop, Minimalism, and so on. But often, rejected by and/or rejecting its tenets, they have made art that moves outward, broadening and complicating the shape of history. As the critic Lucy Lippard wrote in 1980, "In endlessly different ways, the best women artists have resisted the treadmill to progress by simply disregarding a history that was not theirs."[17]

3. Some women artists make their own history to create their own possibility.

There are, of course, very different ways to define progress. In 1986, Emma Amos, Vivian Browne, and Julia Hotton curated the exhibition *Progressions: A Cultural Legacy* at the Clocktower in New York.[18] The catalogue traced the history of Black women artists starting in the nineteenth century, documenting their significance for American culture and for broad art histories as well as their shaping of a Black aesthetic. The three curators researched historical figures such as Edmonia Lewis (1844–1907) and Augusta Savage (1892–1962) for the catalogue, while works by contemporary artists, including Browne and Amos as well as Faith Ringgold, Howardena Pindell, and others, formed the checklist for the actual exhibition. The essay actively connected the past to the present: "Their courage, tenacity and passionate commitment to art and freedom helped pave the way for their contemporary offspring. . . . Knowing about the lives and works of these creative pioneers provides today's black woman artist with spiritual linkages to the past that are crucial to the building of a productive future."[19] Similarly, *Women of Sweetgrass, Cedar and Sage*, curated in 1985 by Jaune Quick-to-See Smith and Harmony Hammond, was dedicated to the legacy of the printmaker and painter Helen Hardin (1943–1984), whose departures from the expectations of both her community (Santa Clara Pueblo, in present-day New Mexico) and the commercial art market Smith saw as a significant precedent for herself and other Native women artists.[20]

Revisionist historical exhibitions and texts have always existed in relation to thinking about contemporary women's art.[21] Counter to the modernist fetish of originality, many artists want to know that they are *not* the first, *not* alone—for them, a truthful history creates a precedent for enacting that "productive future" in the present moment.[22] In 1973, Betye Saar curated *Black Mirror*, an exhibition of work by five Black women: Gloria Bohanon, Suzanne Jackson, Marie Johnson, Samella S. Lewis, and Saar herself. The artist-curator wrote, "We are searching for a past that has been long denied us, emerging from a period of a white program society, and now attempting to form our own mirror image."[23] That trope of the mirror recurred in *Sister Chapel*, a special project for P.S.1 in Queens, New York, in 1978, which invited artists to paint an image of a woman role model in an architectural setting. Centered in the ceiling above walls bearing depictions of figures such as the Italian Renaissance painter Artemisia Gentileschi (by May Stevens) and the twentieth-century Mexican artist Frida Kahlo (by Shirley Gorelick) was a mirror whose reflective surface placed each viewer within the "Hall of Fame . . . History of women revered by women artists."[24]

Linda Nochlin's 1971 essay and 1976–77 exhibition both featured the artist Rosa Bonheur (1822–1899), with whom Joan Mitchell (who adopted the nickname Rosa, or Rose, in the 1970s) felt an explicit kinship around questions of ambition and painterly scale as well as the personal refusal to conform: Bonheur's masculine clothing and women partners made her a genuine *maître au feminin*.[25] Harmony Hammond (fig. 3) also acknowledged Bonheur as a forerunner as she began to document and theorize art by lesbians through her editorial work at the feminist journal *Heresies* and in her own writing.[26] Similarly, the cover of the *Progressions* catalogue

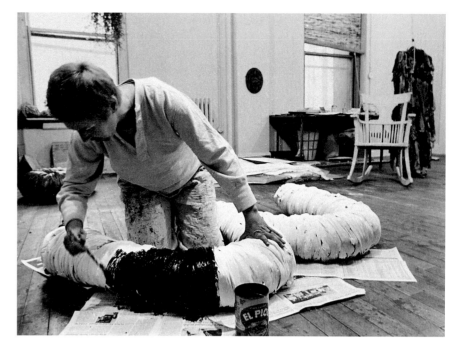

Fig. 3 Harmony Hammond working on one of her wrapped sculptures in her studio at 129 West 22nd Street, Chelsea, New York, October 17, 1977. Harmony Hammond Papers, Getty Research Institute, Los Angeles (2016.M.3)

featured a 1931 carved wood sculpture by Nancy Elizabeth Prophet (1890–1960) titled *Congolaise* (which the authors speculated may have been a self-portrait). More recently, Simone Leigh found an entry in Prophet's Paris diary that resonated with her as a record of self-discovery and conviction in the face of difficulty: "I remember how sure I was that it was going to be a living thing, a master stroke, how my arms felt as I swung them up to put on a piece of clay."[27]

Contemporary artists continue to point to women artists from the past as precedent: Aliza Nisenbaum has a drawing for an unrealized mural by María Izquierdo (1902–1955) as her Zoom background; Tschabalala Self speaks of Ringgold's importance (see pp. 134–35) and supported the realization of her 2022 retrospective at the New Museum, New York.[28] One mark of genuine social change is that today, men artists, including those who contributed to this volume, have also begun to cite women artists as touchstone figures. Another might be that when a young artist such as Jadé Fadojutimi recently discussed artists whose use of color inspired her, she included a litany of women—Joan Mitchell, Lee Krasner, Amy Sillman, Laura Owens—without calling any attention to their gender.[29]

4. Some women artists rethink what abstraction can be.

Amy Sillman, who was taught by third- and fourth-generation Abstract Expressionist painters as an undergraduate at New York's School of Visual Arts, recalls, "It was shocking to me to understand over the years how male Ab-Ex is supposed to be. It's a real erasure and makes invisible the efforts and achievements of a generation of women who worked within the terms of gestural painting. It's an art history problem, not a painting problem."[30] By now there have been many texts and exhibitions, both monographic

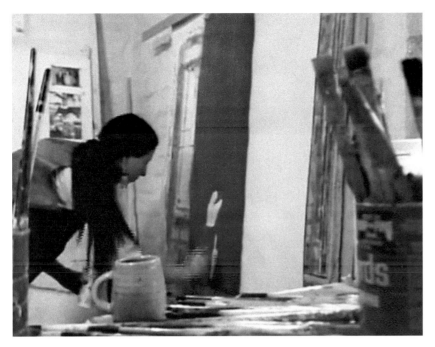

Fig. 4 Jaune Quick-to-See Smith at work on a drawing from *Red Lake Series* in her Albuquerque studio, ca. 1981

and group, arguing for the excellence of abstract art made by women, including Joan Mitchell, Alma Thomas, Anne Truitt, and Eva Hesse. Because abstraction has been framed as the "big table" of modernist art, the pinnacle of individual artistic creativity, it has been a priority for revisionist scholars to make room for women at that table.

But there is another facet to the art-history problem: since the 1950s, the dominant American and European account, in which painting moved in relentless pursuit of pure paint on a rectilinear canvas, without illusion or reference, worked to discipline abstraction and those who could make it. (Might not those two acts of exclusion be connected?) In the early 1970s, some women artists and critics advanced the idea of a "feminine sensibility" as a way to characterize an intrinsically "female" art, visibly marked by its use of pastel colors and/or centering of curvilinear forms (a style teased, more recently, by Carrie Moyer in her candy-colored paintings). Others criticized that whole conceit for its apparent agreement with the dominant formalist aesthetic as well as with a stereotypical White femininity, expressed in pastel colors.[31] Other attempts at expanding abstraction included those of the Pattern and Decoration artists, such as Miriam Schapiro and Mary Grigoriadis, who were largely but not solely women; many of these artists looked to techniques traditionally practiced by women and to non-Western cultural forms.[32] For Jaune Quick-to-See Smith (fig. 4), abstract art is historically related to women's artistic activities, including beading, weaving, quilting, and embroidery: "Abstraction is another area that belongs distinctly to Native American women artists."[33] More recently, Tau Lewis has explained her shift from descriptive portraiture to abstract art by reference to "what feels closest to me or what feels most human," crediting Black women who "did it first when you're talking about abstraction and talking about Gee's Bend."[34] These artists demand not just admission to the mainstream story of abstraction but an expansive

redefinition of the term itself, with implications for modernist ideals like history, originality, and autonomy.

For some women, an expanded abstraction is the art best able to reflect an expanded self, unbounded by existing categories. For Julie Mehretu, abstraction is "a strategy of resistance against flattening."[35] She sees abstraction as "a refusal of description, of language, of containment, a breakdown of national identity, not being reduced to the body, the skin, a place, a language—rather, a trajectory for a more complex and discursive project."[36] As such, abstraction allows her to hold together multiple, even apparently incommensurable, ideas, feelings, experiences: to be a woman, queer, Black, African, U.S. citizen, all at once, without the obligation to explain what each might mean. Charline von Heyl also intends her painting to work against language-based categorical thinking, including the very idea of a fundamental difference between abstraction and representation: "If I hear the explanation that I'm hovering between abstraction and representation one more time I'm going to go on a killing spree. . . . It is terribly difficult to write about painting, especially abstract painting. It's a slippery entity that's hard to catch with words because in its essence it doesn't want to be described."[37] Mehretu and von Heyl both make complex paintings that layer and blur colors, materials, and ways of making a mark (including the photograph and the print) as well as admitting references to the world outside the studio. For some women artists—besides von Heyl and Mehretu, we might name Emma Amos and Ellen Gallagher—figuration and abstraction can coexist.

5. Some women artists embrace skills and materials rejected by art history.

Painting and sculpture—and particularly abstract painting—have dominated the history of modern art, while other narratives have often been absent. Who gets to figure in history strongly influences what kind of making is socially valued. In the West, not only are sewing, weaving, quilting, and beading related to craft, and thus of lower status than the fine arts, but they have also been given little value as "women's work," practiced largely by women.[38] Elaine Reichek has said, "I picked the medium of embroidery for a lot of reasons: because it's associated with women; because a medium that's been left out of art history offers a way to tell stories that have been left out of art history."[39] Reichek's embroidered portrait of Georges Seurat's mother sewing (pl. 47) contrasts needlework and modern painting, ordinary women and famous artists. (The fact that the artist considers the work a self-portrait shows her negotiating her own position on both sides of the binaries.)

Even as the teaching, making, and marketing of highly skilled craft work became increasingly professionalized in the postwar era, ceramics, weaving, and similar practices and practitioners were still relegated to a sphere apart from that of fine art, with their own schools, galleries, and magazines. Craftspeople were never seen as equal, in historical significance, originality, or intellectual importance, to modernist artists.[40] On the positive side, craft institutions were spaces where women artists could bypass the gatekeepers of fine-art fields such as painting and sculpture. Olga de Amaral, Françoise Grossen, Kay Sekimachi, Toshiko Takaezu,

and Lenore Tawney all found recognition within craft circles, where it was easier for artists who were not White men to succeed.[41] As a young woman, Takaezu (fig. 5) felt a gendered pressure inherent in sculpture—something that also put off Mary Heilmann—while ceramics felt more open, lighter.[42] (It is worth noting that Takaezu, coming from ceramics, had a harder time winning recognition for her gestural paintings than Heilmann, coming from painting, did for her ceramics.) Still more broadly, Amaral said of her time at the design- and craft-oriented Cranbrook Academy of Art, "I never thought I was making Art. I was just loving what I was doing."[43] And for some artists, almost the reverse was true, and the typical aesthetics and techniques of craft felt confining: Tawney insisted that she looked instead to sculpture and painting to inform her textile practice.[44]

The association with women's work could seem "less than," even oppressive. Louise Fishman recalls rejecting enforced "girl" activities in her youth: "I spent my life avoiding sewing and anything else that had to do with 'women's tasks.'"[45] She overcame her distaste, however, and rethought the question in the early 1970s, shifting from hard-edge abstract painting to cutting up, dyeing, and sewing canvas: "I thought, Okay I'm going to embrace this shit. I hate it, but I'm going to figure out what it is. I'm going to figure out what it is in me that has such trouble with this."[46] The experimental use of unstretched canvas in the 1970s by Fishman and Harmony Hammond, as well as Sam Gilliam, Al Loving, and Alan Shields, and in the 1980s by Howardena Pindell and Pacita Abad, turned out to be a significant intersection of craft with modernist painting.[47]

Attention to craft processes complicates the register of historical actors, who may have graduated from a traditional art school; spent time at an institution that encompassed craft and design as well as fine art, such as Cranbrook, Creative Growth Art Center, Haystack Mountain School of Crafts, or Pond Farm; learned their skills through personal connections; or benefited from some combination of these modes of knowledge acquisition. There is a value placed on those lineages: as Magdalene Odundo says, "I think a lot of ceramicists, a lot of potters, do tend to make references to past work. We work very close to the history of who we are."[48] Many of these artists draw on traditions from all over the world. Odundo attends to Nok terracottas from West Africa as well as Greek and Egyptian objects.[49] Tawney and Sheila Hicks both look to historical Latin American textiles; Amaral is the rare artist from South America recognized for working with those traditions.[50] Even artists who attended formal art schools have ended up appreciating the everyday lessons taught by their mothers, as Hicks acknowledges: "I learned, from my grandmothers and from my mother, to sew, to embroider, to knit, to crochet, to cut patterns, to drape."[51] Marie Watt's art embodies a critical awareness of the history of women's work: while sewing bees, historically, were a way to inculcate the habits of White femininity, Watt's sewing circles work to reconfigure that tradition as a celebration of conversations among Native women.[52] Billie Zangewa was deeply impressed by the skills and also the life-sustaining conviviality of her mother's sewing circle: "Even as a child, I was able to understand the soft power and subversiveness of sewing, and that there is a reason why women have been doing it for generations."[53] Zangewa's embroidered-silk scenes focus on women's everyday lives, with her own experience as a mother often at center.

6. Some women artists put their mothers into history.

There are few people modern society values less than those who care for children and work in homes. When women artists recognize their mothers, therefore, it is often a kind of "history from below"—recognizing figures not usually seen as history's protagonists.[54] As the quilt maker Louisiana P. Bendolph said about an exhibition devoted to her mother-in-law, Mary Lee Bendolph, "To see our history and our past up on the walls, and realizing that Mama had left a legacy. . . . It was so beautiful."[55] Toyin Ojih Odutola explains her use of the surnames of both of her parents, Nelene Ojih and Jamiu Ade Odutola: "I wanted my mother and her heritage to be included in the narrative of my work. . . . To see our name on the wall."[56]

Sometimes, artists remember and hold an image of a mother confronted with the impossibility of realizing her own ambition: women's attempts at self-realization have historically been met with extreme social violence, along with the less obvious repressions of twentieth-century sexism.[57] Joan Mitchell's mother, Marion Strobel, was a poet who became an editor of *Poetry* magazine, but her daughter viewed hers as a cautionary tale about a talent stunted by the demands of domestic and social life.[58] Mitchell came from a wealthy family; Louise Fishman, a "working class Jewish dyke," recalled that while her mother, Gertrude Fisher-Fishman, and aunt, Razel Kapustin, both managed to become painters, their attempts at leading the artist's life were met with refusal,

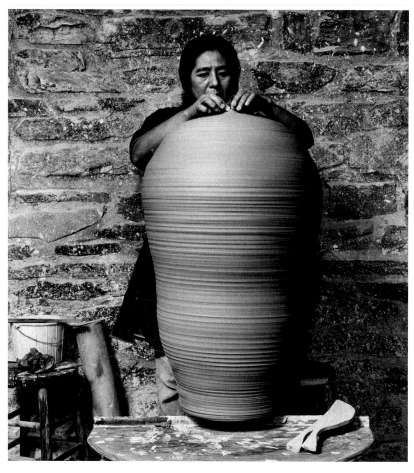

Fig. 5 Toshiko Takaezu making a large "closed form" at Penland School of Craft, Penland, North Carolina, 1974. Toshiko Takaezu Papers, Archives of American Art, Smithsonian Institution, Washington, DC

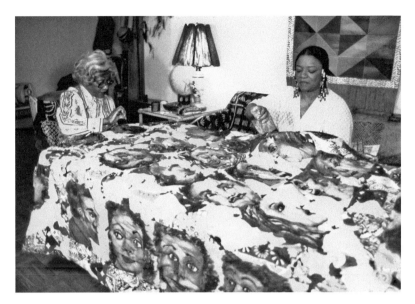

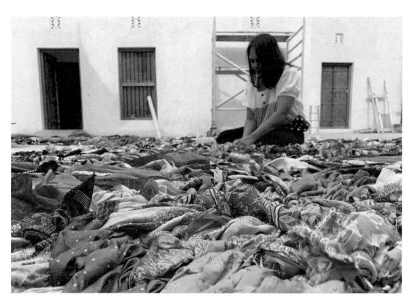

Fig. 6 Faith Ringgold and her mother, Willi Posey, working on the *Echoes of Harlem* quilt, Harlem, New York, 1980

Fig. 7 Suchitra Mattai working on the installation *Imperfect Isometry* at Bait Obaid Al Shamsi, Sharjah Art Foundation, Sharjah, United Arab Emirates, 2019

frustration, and failure.[59] She would dedicate several paintings to them, including *Angry Gertrude* and *Angry Razel* of 1973;[60] forty years later, Fishman helped to organize *Generations*, an exhibition featuring works by all three artists at the Woodmere Art Museum, Philadelphia.

Joyce J. Scott and Faith Ringgold trace matrilineal family connections through quilts and other forms of making that reach back to the work of enslaved relatives (the relationship between Joyce J. Scott and her mother, Elizabeth Talford Scott, is illuminated in this volume; see pp. 130–31). Like many other artists, including Sheila Hicks and Pacita Abad, Ringgold was taught to sew by her mother. Willi Posey sewed professionally as a fashion designer, and Ringgold framed her accomplishments without qualification: "My mother was always an artist."[61] The two collaborated on several projects, including Ringgold's first quilt, 1980's *Echoes of Harlem* (fig. 6).[62] Kay Sekimachi's mother, Wakuri Sekimachi, and a grandmother were both weavers, and the artist recalls her mother's material assistance as well as her judgment: "[My mother] was often my best critic, and gave me real support. She held warps for me every time I put a new warp on the loom."[63] It is striking to see daughters placing their mothers in the culturally elite roles of artist and critic.

Like Ringgold, many women artists save and repurpose materials belonging to their mothers. Tschabalala Self has incorporated fabric gathered by her mother, Glenda M. Self, a seamstress, into her own paintings: "Working this way feels like honoring her."[64] For her textile collages, Suchitra Mattai (fig. 7) amasses saris from family members and other women in her community: "I really see myself as collaborating with these materials and these makers of the past. Whether it's someone who designed the print on the sari or someone who made the needlepoint it's . . . about using the aura and inspiration found in those objects to tell a story that is more deeply personal."[65] The process can be explicitly social as well as familial: Dawn Williams Boyd's mother, Dr. Narvie Hills Puls, brought back textiles from several trips to Africa as part of her project to build an Afrocentric teaching museum in Atlanta, and Boyd used some examples in her work *Africa*

Rising (pl. 60).[66] Lorna Simpson's painting *Ice 11* (pl. 70) and related works integrate photos from magazines collected by her mother, Eleanor Simpson, and maternal grandmother, Madeline Wagner; the source images from *Ebony* and *Jet* form an archive that entangles Simpson's family life with broader accounts of the United States.[67]

The materials these artists choose embody the interweaving of biography, small-*h* history, and capital-*H* History. Some women talk about their mothers because they are *asked* about them—the kind of probing, biographical questions women, and not men, often face in interviews. But some women choose to talk about their mothers because they matter: taking them seriously means changing the shape of history, who writes it, and who are its actors. Barbara Chase-Riboud, whose novels make protagonists out of oppressed and erased Black women, including Sarah Baartman and Sally Hemings (as well as Hemings's daughter, Harriet), also conducted a decades-long correspondence with her mother, Vivian Mae Chase, that is itself a historical document, as well as a record of her own development.[68] Tomashi Jackson based her master's thesis on extensive interviews with her mother, Aver Burroughs, on the subject of women's labor.[69] As she wrote, "I am made of songs and memories. I am the product of people who have labored and people who have sung to me."[70] Jackson's art honors historical and contemporary working-class women of color.

7. Some women artists want to make art from a woman's point of view.

To state the obvious: the dominant culture—high and low—sees women as objects, whether celebrated or denigrated. We want to be active subjects, makers—making decisions, making history, making worlds, making art.

Artists of Maria Lassnig's and Joan Mitchell's generation inherited the critical framework of midcentury phenomenology, and both Lassnig and Mitchell, in their work, emphasized a type of embodied experience that fused looking and feeling

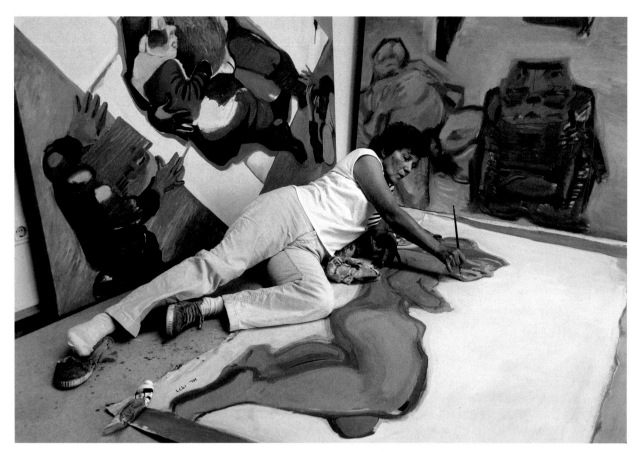

Fig. 8 Maria Lassnig at work in her Vienna studio, 1983. Photo: Kurt-Michael Westermann

Fig. 9 Senga Nengudi setting up for a performance of *R.S.V.P. X* in her Los Angeles studio, 1976. Senga Nengudi Papers, Amistad Research Center, New Orleans

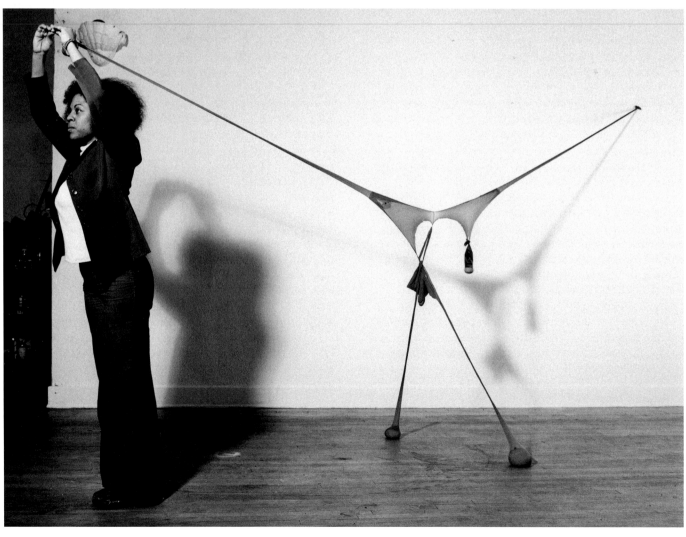

as a way of apprehending the world and blurring the boundary between interior and exterior.[71] Mitchell's foundational act as an artist was to take in a view, especially a landscape, and then to fuse her emotional and physical sensations with the object of that view: "It's all squashed together."[72] Lassnig (fig. 8) similarly painted not what her body looked like but how it felt under particular conditions: her butt spread on a couch, her arm bending.[73] She called her work *Körpergefühlsmalerei* (body awareness painting): "I searched for a reality that was more fully in my possession than the exterior world, and I found it waiting for me in the body house in which I dwell, the realest and clearest reality."[74]

Some of this melding of touch and vision was continued by artists of the next generation, with underpinnings in different histories and practices. The dramatic stretch and sag of Senga Nengudi's soft sculptures speak to her performance work, her own changing physicality, and her historical and political observations (fig. 9).[75] In the catalogue for the 1980 exhibition *Dialectics of Isolation*, which she co-curated for the women's cooperative gallery A.I.R., Nengudi wrote, "I am concerned with the way life experiences pull and tug on the human body and psyche. And the body's ability to cope with it. Nylon mesh serves my needs in reflecting this elasticity."[76] Jaune Quick-to-See Smith has described the Native woman artist's way of seeing as looking imbricated with touching. In 1985, she distinguished her attitude of "oneness with the land" from that of the so-called land artists of the previous decade, claiming closeness—an "inner view"—rather than mastery and distance.[77]

Feminism brought gendered subjectivity into focus in the late 1970s and 1980s, criticizing the cultural demand that we see the world through men's eyes. As Judy Chicago recalled of her early life, "I did struggle with my essential identity: was I subject or object? . . . I encountered increasingly after adolescence and early womanhood, expectations from me and from society, that I be object, that I exist to fulfill men's needs, rather than be subject and fulfill my own needs."[78] This subject/object dilemma runs across all realms of visual culture: women who want to enjoy mainstream movies or museums have been forced to do so through a kind of masquerade, seeing as if they were men.[79] In the 1990s, the filmmaker Barbara Hammer and the critic bell hooks expanded the critique of the male gaze in their texts about the failure of film (and also much feminist theory) to construct authentic representations of, as well as active subject positions for, lesbians and Black women.[80]

The question of subject and object is perhaps most evident and urgent in the act of depicting a woman's body. In the late 1970s, Joan Semmel said, "If you look at the history of art, the kinds of images of women that are projected to us are . . . not in any way as a mover, a person who comes from herself in any sense."[81] While some feminists of the time decided to flip the binary and render men as sexual objects, or create heroic images of women, Semmel (fig. 10) sought to render a truer image and—even more—the *feel* of being a woman. Her paintings refuse not only the male gaze but also the vantage of the mirror, in which you see yourself at a distance, from the outside: "When you look at yourself, you're not looking at the whole body, you see it in fragments. I was interested in how you experience the body rather than an image of an ideal."[82] The bodies in her paintings do not have heads—the heads are doing the looking—and the painter's

Fig. 10 Joan Semmel working on a painting in her *Erotic Series* in her studio in SoHo, New York, ca. 1973

perspective bends and spreads the bellies and limbs out to the horizon.

This merging of seeing and being clearly spurred Lassnig early on; her shift from abstraction to representation belonged to a quest to grasp both at once, to unite subject and object, interior and exterior. As she described it, her paintings "proceeded first from a limited field of vision; what a child also sees first; its own arms and legs as a real picture."[83] That entanglement of subject and object never left Lassnig, and *Die grüne Malerin* (The Green Paintress; pl. 5) is a tour-de-force image of the artist twisting in on herself in an act of self-creation. The fragmentation induced by seeing/being resonates strikingly with Christina Quarles: "I often say that my paintings are portraits of living within a body. . . . Oftentimes that sense of living within your body doesn't at all line up with what it is to look onto your body or to look onto another body. One of the devices I've used is to emphasise the hands and the feet. I think a lot about how we are able to see our own hands and feet as the outermost extensions of ourselves."[84] Learning not to look at ourselves as objects can be a radical act.

8. Some women artists change what representation can be.

Representation, taken to its extreme, is all objectification, all social convention, privileging generality over direct experience and material reality.[85] We could even turn the label around and call it "abstraction," in the usual use of the term. But, in fact, both representation and abstraction have the potential to be specific and concrete. Representation becomes conventional more obviously, because we associate it with legibility, which easily slips into objectification—the reduction of a person to a function or an attribute. Objectification in racist, sexist popular culture, in pornography, in the history of art, has charged and complicated the practice of representation for women, for Black artists, for people of color, for queer artists. This is part of abstract art's enduring appeal: its unlabeled material reality resists reduction to categories and reflexive, assigned meanings.

Abstraction is one response to the charged history of representation; it can intersect with others, including critique and reinvention. Ellen Gallagher (fig. 11) explains that she largely eschews traditional representation because of its formation inside patriarchal and colonial histories—histories that Mary Lovelace O'Neal took on from her perspective when working in Morocco.[86] Those same traditions prevented even a great artist like Henri Matisse from accessing the truth of a woman, according to Theresa Chromati; she believes that women share an "unspoken language that we understand between each other," and her own paintings' layered surfaces reflect layers of meaning.[87] Shahzia Sikander takes on these charged narratives explicitly in her refractions of art histories of the West and the global South, effacing boundaries of time, nation, race, and religion.[88] Lynette Yiadom-Boakye, who paints figures (and has had a significant influence on younger figurative artists), speaks about the care required in representation. In imagining her subjects, she chooses their gender before beginning to paint, conscious of the very different histories of representing men and women, and the imperative to find compositions that acknowledge the traps (for example, she paints reclining men more often than reclining women). Her figures of women can be sensual, but there is a particular kind of beauty, of availability, that the artist rejects for its proximity to stereotypes of Black women.[89]

Yiadom-Boakye insists on the fact that her portraits are not images of real women. They are fabricated, like every painting: "The abstraction is always there. . . . The process of painting is building something out of colors and marks. Often the figure doesn't arrive until the end, until I've put in all this history, groundwork, and mapping."[90] As Toyin Ojih Odutola puts it, "The subjects . . . are really the marks themselves. There is no representation happening in these portraits."[91] She and Yiadom-Boakye bring the openness of abstraction to a figurative practice. It can be difficult to get people to see that openness; particularly when race and gender intersect, social convention prompts viewers to try and fit even complex, nuanced images into generalizations. Jordan Casteel notes that social "messaging" about Black people often obscures not only the people she paints but her own role as an artist, as an active, making subject: the critical failure to attend to "style, technique, and composition," she observes, means that "intent is often left out of the conversation."[92]

Casteel seeks "a representation that feels genuine" through "a kind of proximity. This practice is not a voyeuristic thing for me."[93] In order to depict people as dimensional subjects, she paints them in their personal spaces, as with the Rutgers University–Newark student portrayed in *Cansuela* (see p. 92), whom we see in her own bedroom, looking directly at the artist/viewer in a "reciprocal relationship."[94] Gisela McDaniel, a Pacific Island artist, paints Indigenous women who also gaze directly out at us and, in accompanying audio clips, narrate their own experiences. She seeks to undo Paul Gauguin's objectifying images of Pacific Island girls and women: "His relationships with his

Fig. 11 Ellen Gallagher engraving a copper plate with a tattoo machine for the portfolio *DeLuxe* (2004–5) in New York City

Fig. 12 Firelei Báez standing before the painting *Untitled (United States Marine Hospital)* in her studio, Bronx, New York, 2020

sitters were often problematic and as someone who's had similar experiences to the sitters, I want to share those stories, the stories that were erased and that Gauguin assisted in erasing."[95]

The relationship between the person portrayed and the artist is central as well to Aliza Nisenbaum: "What I'm most engaged with is the process of my work; meeting new people, seeing if we can be open to each other . . . to think of new paradigms in art that seem to be emerging more and more, a politics of care."[96] The artist spends time hanging out with members of social groups—museum workers, salsa dancers, other artists—and paints individual and group portraits of them, at work and at home. The people in her paintings never feel formally posed; in *Sin Salsa no hay Paraíso* (pl. 102), a couple hold hands, relaxing on a couch, as if they have done this a million times and are comfortable with the artist as well as each other. This making visible is both social and artistic: "One man I painted in Brixton suddenly started to weep and said: 'I'm going to go down in history because of this painting.' That was so nice."[97] As Nisenbaum says, "To pay attention to someone can be a political act."[98]

9. Some women artists are still asking questions.

In some ways, the questions have changed: as the need to justify the mere fact of being both an artist and a woman fades, there is room for genuine inquiry. Some women artists question the categorical ways we think and talk: Ellen Gallagher asks, "If visual art can be recuperated neatly

within language then what does that mean about it as an experience?"[99] Like Shahzia Sikander, they question the dominant culture: "Who's veiled anyway?"[100] Like Tschabalala Self, they question how people see them: "What do my physicality and my identity signify to others? What's the potentiality of that identity?"[101] Like Christina Quarles, they answer a question with a question: "Sometimes someone asks, 'Is it always two women in your paintings?' and I'll reply: 'Well, is it always two, and is it always women?'"[102] Like Gisela McDaniel, they question with kindness: "So much of my process is conversation. It's asking: 'What parts of your body are you comfortable with me painting? What do you want me to celebrate?'"[103] And they also ask intimate and powerful questions of themselves, with answers so apparently obvious that they should be rhetorical, and yet we need them. Firelei Báez: "Everything that's inscribed onto that figure [the *ciguapa*] becomes the antithesis of ideal femininity. And then as a kid I'd think, 'There's so much freedom in that, why would I not want to be that? Why would I not want to be untraceable and fearless?'"[104]

Why would I not?

I thank Gabriella Shypula for her expert help with research and for her insights when discussing this essay with me.

1. Faith Ringgold, "The Politics of Culture: Black, White, Male, Female," *Women Artists News* 6, no. 2–3 (Summer 1980): 20.
2. Denise Riley, "Does a Sex Have a History?," in *"Am I That Name?": Feminism and the Category of "Women" in History* (Minneapolis: University of Minnesota Press, 1988), 16. The feeling of a social label/ identity as a weight unshouldered by White men is also expressed by the artist Firelei Báez: "The question is: How to remove weight, to move

toward lightness?" Firelei Báez, "In Conversation with Firelei Báez: On the Wondrous Exhibit *Bloodlines* and Her Exploration of Black Womanhood," interview by Jasmin Hernandez, *Whitehot Magazine of Contemporary Art*, March 2016, https://whitehotmagazine.com /articles/bloodlines-her-exploration-black-womanhood/3357.

3. Riley, "Does a Sex Have a History?," 1–2.

4. bell hooks, "The Oppositional Gaze," in *Black Looks: Race and Representation* (Boston: South End, 1992), 124.

5. The trans philosopher Talia Mae Bettcher asserts that trans people have "first-person authority" over their gender identities; see Talia Mae Bettcher, "Trans Identities and First-Person Authority," in *"You've Changed": Sex Reassignment and Personal Identity*, ed. Laurie J. Shrage (New York: Oxford University Press, 2009), 98–120.

6. Denise Riley, "Bodies, Identities, Feminisms," in *"Am I That Name?,"* 114.

7. Nearly all artists mentioned in this essay are also in the collection and represented on pp. 142–413 by works and short texts.

8. Dana Schutz and Amy Sillman, joint interview, *North Drive Press*, no. 1 (2004): n.p.

9. Elizabeth Murray, "Interview with Elizabeth Murray," by Robert Storr, in *Elizabeth Murray*, exh. cat. (New York: The Museum of Modern Art, 2005), 193.

10. Barbara Chase-Riboud, "On Her Own Terms: An Interview with Barbara Chase-Riboud," by Suzette A. Spencer, *Callaloo* 32, no. 3 (Summer 2009): 755.

11. Jean-Paul Riopelle to Joan Mitchell, December 13, 1956, Joan Mitchell Papers (JMFA001), Joan Mitchell Foundation Archives, New York.

12. Báez, "In Conversation with Báez," by Hernandez.

13. See *Feminist Art Journal* 1, no. 1 (April 1972), including Patricia Mainardi, "Open Hearing at Brooklyn Museum," 6, 26–27; Ann Sutherland Harris and Cindy Nemser, "Are Museums Relevant to Women?," 7, 18, 27; and Kay Brown, "'Where We At' Black Women Artists," 25.

14. Linda Nochlin, "Why Have There Been No Great Women Artists?," *ARTnews* 69, no. 9 (January 1971): 22–39, 67–71. Nochlin echoed a question asked by Shulamith Firestone the previous year: "But what about the women who have contributed directly to culture? There aren't many." Shulamith Firestone, "(Male) Culture," in *The Dialectic of Sex: The Case for Feminist Revolution* (1970; repr., New York: Bantam, 1971), 158. In the intervening years, as Nochlin's essay became the subject of widespread discussion, scholars, artists, and critics have adapted the question to specify intersections of gender and race; see, for example, Michele Wallace, "'Why Are There No Great Black Artists?': The Problem of Visuality in African-American Culture," in *Black Popular Culture*, ed. Gina Dent (Seattle: Bay Press, 1993), 333–46, and Karen Higa, "What Is an Asian American Woman Artist?," in *Art/Women/ California: 1950–2000: Parallels and Intersections*, ed. Diana Fuller and Daniela Savioni (Berkeley: University of California Press, 2002), 81–94.

15. Miriam Schapiro, "At Long Last: An Historical View of Art Made by Women," *woman art* 1, no. 3 (Winter/Spring 1977): 5.

16. Firelei Báez, interview by Hồng-Ân Trương, *Brooklyn Rail*, November 2018, https://brooklynrail.org/2018/11/art/firelei-bez-with-hng-n-trng.

17. Lucy Lippard, "Sweeping Exchanges: The Contributions of Feminism to the Art of the 1970s," *Art Journal* 40, no. 1–2 (Fall/Winter 1980): 363.

18. The Clocktower, located at 108 Leonard Street in Lower Manhattan, was a precursor and companion space to P.S.1 in Long Island City, Queens.

19. Emma Amos, Vivian Browne, and Julia Hotton, *Progressions: A Cultural Legacy*, exh. cat. (New York: Clocktower, 1986), n.p.

20. Harmony Hammond and Jaune Quick-to-See Smith, "Introduction," in *Women of Sweetgrass, Cedar and Sage*, ed. Harmony Hammond and Jaune Quick-to-See Smith, exh. cat. (New York: Gallery of the American Indian Community House, 1985), n.p.

21. Many shows and collectives were organized in the early 1970s by Black women artists, including Faith Ringgold, Betye Saar, and Suzanne Jackson, at the very same moment Linda Nochlin and Judy Chicago were most active. Benita Roth and other scholars have carefully reoriented feminist historiography to acknowledge that even though women of color may not have signed on to a feminism seen as White, women of color who were politically active around race, class, and gender belong equally to that early moment and should not be understood as offering a belated corrective to White feminism. See Benita Roth, "The Making of the Vanguard Center: Black Feminist Emergence in the 1960s and 1970s," in *Still Lifting, Still Climbing: Contemporary African American Women's Activism*, ed. Kimberly Springer (New York: New York University Press, 1999), 70–90.

22. Miriam Schapiro: "My own heritage as a woman painter was denied to me and I imagined that I was the first woman artist." Quoted in Patricia Mainardi, "Feminine Sensibility: An Analysis," *Feminist Art Journal* 1, no. 2 (Fall 1972): 9.

23. Betye Saar, "Black Mirror," *Womanspace* 1, no. 2 (April–May 1973): 22.

24. Ilise Greenstein described the installation as a "Hall of Fame for women in the Arts . . . Science. Sports. Humanities"; see Ilise Greenstein, "Women in the Arts Proposal for BiCentennial [*sic*]," September 30, 1974, handwritten manuscript (photocopy), Elsa M. Goldsmith Papers, private coll., quoted in Andrew Hottle, "From Genesis to Revelation: The Origins, Development, and Realization of *The Sister Chapel*," in *The Art of the Sister Chapel: Exemplary Women, Visionary Creators, and Feminist Collaboration* (Burlington, VT: Ashgate, 2014), 13, 50n50.

25. Katy Siegel, "Green," in *Joan Mitchell*, ed. Sarah Roberts and Katy Siegel, exh. cat. (San Francisco: San Francisco Museum of Modern Art; New Haven, CT: Yale University Press, 2021), 213–15. Mitchell's attitude toward being named as a "woman artist" changed considerably in the 1970s, in the context of feminism and her relationships with younger women artists.

26. In 1977, Harmony Hammond wrote to the lesbian art historian Arlene Raven asking her to share slides of works by both contemporary and historical lesbian artists, including Bonheur. She asked Raven, "Are there any other women we definitely know about as lesbians besides [Romaine] Brooks, Bonheur, [Emily] Carr? . . . What about Artemesia [*sic*] she must have been. And why do you say Cassatt? I am not arguing but just so hungry for information, or speculation based on specifics. Tell, tell tell me." Harmony Hammond to Arlene Raven, November 19, 1977, typescript, Harmony Hammond Archive (approximately 1960– 2000; 2016.M.3), Getty Research Institute, Los Angeles. A year later, however, Hammond was cautious about embracing Bonheur as an ideal historical precedent because Bonheur did not extend to other women, as a general good, the freedom she herself enjoyed; see Harmony Hammond and Betsy Damon, "Lesbian Artists," in *Our Right to Love: A Lesbian Resource Book*, ed. Rita Mae Brown (Englewood Cliffs, NJ: Prentice Hall, 1978), 261.

27. Nancy Elizabeth Prophet, "Diary: Paris, France" (1922), 4, Brown Archival and Manuscript Collections Online, Brown Digital Repository, Brown University Library, Providence, RI, https://repository.library .brown.edu/studio/item/bdr:786295/, quoted in Sharifa Rhodes-Pitts, "Simone Leigh: For Her Own Pleasure and Edification," *The Hugo Boss Prize* (New York: Guggenheim Museum Publications), 2018, n.p.

28. See Anne Ellegood, "Tschabalala Self: Community and Culture," *Juxtapoz*, no. 210 (Summer 2019): 115, and Faith Ringgold, interview by Tschabalala Self and Dorian Bergen, *Brooklyn Rail*, April 2022, https:// brooklynrail.org/2022/04/art/Faith-Ringgold-with-Tschabalala-Self.

29. See Jennifer Higgie, "From Life—Thoughts on the Paintings of Jadé Fadojutimi," in *Jadé Fadojutimi: Jesture*, exh. cat. (London: Pippy Houldsworth Gallery, 2020), 9.

30. Amy Sillman, "'I'm Working with and against Painting'—An Interview with Amy Sillman," by Imelda Barnard, *Apollo*, September 26, 2018, https://www.apollo-magazine.com/amy-sillman-interview-camden -arts-centre/.

31. Patricia Mainardi criticized the notion of a "feminine sensibility" for aligning with formalist abstraction; see Janet Sawyer and Patricia Mainardi, "A Feminine Sensibility?—Two Views," *Feminist Art Journal* 1, no. 1 (April 1972): 4, 25. Michele Wallace criticized White feminist artists for cultural bias and racism, in that their clichéd associations of pastels and light colors with femininity excluded Black women. See Michele Wallace, "Daring to Do the Unpopular," *Ms.* 1, no. 7 (September 1973): 24–27. See also statements by Howardena Pindell and Faith Ringgold in Mainardi, "Feminine Sensibility: An Analysis," 9, 22.

32. On non-Western women's craft as a source of abstraction, see Harmony Hammond, "Feminist Abstract Art—A Political Viewpoint," *Heresies* 1, no. 1 (January 1977): 66–70. For a complex unfolding of one cross-cultural aspect of Pattern and Decoration, see Sarah-Neel Smith, "A Meeting of Two Minds: Oleg Grabar and Amy Goldin on the Met's Islamic Art Galleries, 1975," in *With Pleasure: Pattern and Decoration in American Art, 1972–1985*, ed. Anna Katz, exh. cat. (Los Angeles: Museum of Contemporary Art; New Haven, CT: Yale University Press, 2019), 138–47.

33. Jaune Quick-to-See Smith, "Women of Sweetgrass, Cedar and Sage," in Hammond and Smith, *Women of Sweetgrass, Cedar and Sage.*

34. Tau Lewis, "Art in the Spotlight: Tau Lewis," interview by Erin Christovale, Art Gallery of Toronto, April 9, 2021, YouTube video, 57:32, https://youtu.be/zbAnp_1MMho?t=2754.

35. Julie Mehretu, presentation at "Black/Queer/Abstract: A Convening on the Occasion of *Julie Mehretu*," Whitney Museum of American Art, New York, July 28, 2021, YouTube video, 1:30:49, https://youtu.be/lGeFJ-g81o9g?t=2419. Images of Joan Mitchell's *Ladybug* (1957; The Museum of Modern Art, New York) and Alma Thomas's *Blast Off* (1970; National Air and Space Museum, Smithsonian Institution, Washington, DC) are shown as Mehretu makes this statement.

36. Mehretu, presentation at "Black/Queer/Abstract."

37. Charline von Heyl, interview by Shirley Kaneda, *BOMB*, no. 113 (Fall 2010): 85.

38. Elissa Auther asserts that the devaluing of "women's work"/craft in the art world directly relates to the devaluing of "women artists" in the art-world hierarchy. See Elissa Auther, "The Feminist Politicization of the Art/Craft Divide," in *String, Felt, Thread: The Hierarchy of Art and Craft in American Art* (Minneapolis: University of Minnesota Press, 2009), 98.

39. Elaine Reichek, "Projects 67: Elaine Reichek; An Interview with Beth Handler," *MoMA* (members' magazine) 2, no. 3 (March–April 1999): 32.

40. See Glenn Adamson, *Thinking through Craft* (Oxford: Berg, 2007); Auther, *String, Felt, Thread*; and Julia Bryan-Wilson, *Fray: Art and Textile Politics* (Chicago: University of Chicago Press, 2017).

41. Krystal Reiko Hauser writes, "By just choosing craft, the three Nisei artists were carefully negotiating their ethnic and gender identities, and their participation in the art and craft markets"; see Krystal Reiko Hauser, "Crafted Abstraction: Reexamining Abstract Expressionism," in "Crafted Abstraction: Three Nisei Artists and the American Studio Craft Movement; Ruth Asawa, Kay Sekimachi, and Toshiko Takaezu" (PhD diss., University of California, Irvine, 2011), 179.

42. "Toshiko Takaezu: Interview/January 22, 1970, Clinton, N.J., Unedited/Uncorrected," typed transcript, 15, Toshiko Takaezu Foundation Archives, Flemington, NJ. Mary Heilmann, "Cherchez la femme Peintre!," *Parkett*, no. 37 (September 1993): 138.

43. Olga de Amaral, quoted in Charles Talley, "Olga de Amaral," *Craft Horizon* 48, no. 2 (May 1988): 39.

44. Lenore Tawney, interview by Paul Cummings, Archives of American Art, Smithsonian Institution, Washington, DC (website), June 23, 1971, https://www.aaa.si.edu/collections/interviews/oral-history-interview-lenore-tawney-12309.

45. Louise Fishman, "Zero at the Bone: Louise Fishman Speaks with Carrie Moyer," *Art Journal* 71, no. 4 (Winter 2012): 40.

46. Ibid.

47. See Katy Siegel, ed., *High Times, Hard Times: New York Painting, 1967–1975*, exh. cat. (New York: Independent Curators International; D.A.P., 2006); Auther, "Feminist Politicization of the Art/Craft Divide," 160–62; and Lynne Cooke, *Outliers and American Vanguard Art* (Chicago: University of Chicago Press, 2018).

48. Magdalene Odundo, "'I'm Looking at History and the Human Need to Make Things'—An Interview with Magdalene Odundo," *Apollo*, January 28, 2019, https://www.apollo-magazine.com/magdalene-odundo-interview/.

49. Ibid.

50. Glenn Adamson, "Fabric of Impulse: Fiber Artist Olga de Amaral Melds Artistic Spontaneity with Slow Craft," *Art in America* 109, no. 6 (November–December 2021), https://www.artnews.com/art-in-america/features/olga-de-amaral-artistic-spontaneity-slow-craft-cranbrook-lisson-1234612003/.

51. Sheila Hicks, interview by Monique Lévi-Strauss, Archives of American Art, Smithsonian Institution, Washington, DC (website), February 3–March 11, 2004, https://www.aaa.si.edu/collections/interviews/oral-history-interview-sheila-hicks-11947.

52. Watt notes that her emphasis on collaboration is an Indigenous mode of working; see "Practice + Process: MODA Curates 2021 Edition," interview by Erin Gallagher, Miriam and Ira D. Wallach Art Gallery, Columbia University, New York (website), April 12, 2021, video, 22:34, https://wallach.columbia.edu/practice-and-process-marie-watt.

53. Billie Zangewa, "Billie Zangewa: Soldier of Love," interview by Jareh Das, *Ocula Magazine*, April 24, 2020, https://ocula.com/magazine/conversations/billie-zangewa/.

54. For most of its existence, the discipline of history has largely focused on the role of "great men" and large, impersonal forces. In the mid-twentieth century, some historians, such as C. L. R. James and E. P. Thompson—and, more recently, Saidiya Hartman—have brought attention to marginalized people in order to recover missing voices, acting out of the belief that it is such everyday actors who shape historical change.

55. Louisiana P. Bendolph, quoted in Dana Friis-Hansen, "Beyond Gee's Bend: The Future of Art," in *Mary Lee Bendolph, Gee's Bend Quilts, and Beyond*, ed. Paul Arnett and Eugene W. Metcalf, exh. cat. (Atlanta: Tinwood; Austin, TX: Austin Museum of Art, 2006), 55.

56. Toyin Ojih Odutola, interview by Kimberly Drew, *Lindsay*, no. 4 (2019): 41.

57. As Alice Walker famously asked, "What did it mean for a black woman to be an artist in our grandmothers' time? In our great-grandmothers' day? It is a question with an answer cruel enough to stop the blood." Alice Walker, "In Search of Our Mothers' Garden," in *In Search of Our Mothers' Garden: Womanist Prose* (1974; repr., New York: Harcourt Brace Jovanovich, 1983), 233.

58. Eleanor Munro, "Joan Mitchell," in *Originals: American Women Artists* (1979; repr., Boston: Da Capo, 2000), 241.

59. Harmony Hammond quotes Fishman's words from the verso of an unstretched canvas in a seven-panel reversible painting about her mother; see Hammond, "Feminist Abstract Art," 68. This work seems to be no longer extant; a drawing on the subject is reproduced in Jill H. Casid, "Queer Expressivity; or, the Art of How to Do It with Louise Fishman," in *A Question of Emphasis: Louise Fishman Drawing*, ed. Amy L. Powell, exh. cat. (Champaign-Urbana, IL: Krannert Art Museum, 2021), 46–47. In a collection of conversations on specific subjects with ten lesbian artists recorded and transcribed by Fishman, an unidentified artist (most likely Fishman), in the "Mothers" section, describes a mother and an aunt who were artists but failed to offer "a real alternative . . . because of their terrible and unfulfilled struggle to make art." The aunt studied painting for thirty years and ultimately killed herself. See Louise Fishman, ed., "The Tapes," *Heresies* 1, no. 3 (Fall 1977): 17.

60. *Angry Gertrude* is in the collection of the National Portrait Gallery, Smithsonian Institution, Washington, DC.

61. Faith Ringgold, "Reminiscences: Faith Ringgold," *Heresies* 1, no. 4 (Winter 1977–78): 84.

62. According to the artist's daughter Michele Wallace, Ringgold's *Dah* series of abstract works were also made in honor of Posey; see "On Faith: Matrilineal Art Histories," New Museum, New York, March 12, 2022, Vimeo video, 1:09:16, https://vimeo.com/691489816.

63. Kay Sekimachi, "The Weaver's Weaver: Explorations in Multiple Layers and Three-Dimensional Fiber Art; Kay Sekimachi," interview by Harriet Nathan, Fiber Arts Oral History Series, University of California, Berkeley, 1996, quoted in Krystal Reiko Hauser, "Crafting Modernism: Reconsidering the Role of Postwar Art Education in the United States," in "Crafted Abstraction," 127, 128n202.

64. Tschabalala Self, "Artist Tschabalala Self Sewing in Her Studio," interview by M. H. Miller, *T: The New York Times Style Magazine*, April 21, 2022, https://www.nytimes.com/2022/04/21/t-magazine/tschabalala-self.html.

65. Suchitra Mattai, "In Conversation: Suchitra Mattai and Rebecca Hart," Unit London (website), exh. (*Monster*) on view January 11–February 12, 2022, accessed May 17, 2022, https://unitlondon.com/blog/287/.

66. Dawn Williams Boyd, unpublished artist's statement, courtesy of Fort Gansevoort, New York.

67. See "In Conversation: Lorna Simpson and Thelma Golden," Hauser & Wirth, London, March 1, 2018, YouTube video, 1:05:43, https://www.youtube.com/watch?v=toqOQYmal2o&t=1078.

68. Barbara Chase-Riboud, *I Always Knew: A Memoir* (Princeton, NJ: Princeton University Press, 2022).

69. Tomashi Jackson, "The Seen, the Unseen, and the Aesthetics of Infrastructure" (MS thesis, Massachusetts Institute of Technology, Department of Architecture, 2012).

70. Ibid., 6.

71. Katy Siegel, "Par Avion," in Roberts and Siegel, *Mitchell*, 40–47.

72. Joan Mitchell, quoted in Siegel, "Par Avion," 45.

73. Maria Lassnig, "1970, Body-awareness-painting," in *Maria Lassnig: The Pen Is the Sister of the Brush; Diaries 1943–1997*, ed. Hans Ulrich Obrist, trans. Howard Fine with Catherine Schelbert (Göttingen, Germany: Steidl; Zurich: Hauser & Wirth, 2009), 66.

74. Ibid.

75. See John Perreault, "The Whitney Counterweight: Stretching It," *SoHo Weekly News* 4, no. 25 (March 24, 1977): 22–27, and John P. Bowles, "Side by Side: Friendship as Critical Practice in the Performance Art of Senga Nengudi and Maren Hassinger," *Callaloo* 39, no. 2 (Spring 2016): 408.

76. Senga Nengudi, quoted in *Dialectics of Isolation: An Exhibition of Third World Women Artists of the United States*, ed. Kazuko, Ana Mendieta, and Zarina, exh. cat. (New York: A.I.R. Gallery, 1980), n.p. See also Leslie King-Hammond, "Introduction: Art as a Verb; Theme and Content," in *Art as a Verb: The Evolving Continuum; Installations, Performances and Videos by 13 African-American Artists*, ed. Leslie King-Hammond and Lowery Stokes Sims, exh. cat. (Baltimore: Maryland Institute College of Art, 1988), n.p. The exhibition addressed Black artists who dealt with bodily experiences in history.

77. Smith, "Women of Sweetgrass."

78. Judy Chicago, "Woman as Artist," *Everywoman* 2, no. 7 (May 7, 1971): 24–25.

79. See Laura Mulvey, "Visual Pleasure and Narrative Cinema," *Screen* 16, no. 3 (Autumn 1975): 6–18.

80. Barbara Hammer, "The Politics of Abstraction," in *Queer Looks: Perspectives on Lesbian and Gay Film and Video*, ed. Martha Gever, Pratibha Parmar, and John Greyson (New York: Routledge, 1993), 70–75. hooks, "Oppositional Gaze," 115–31.

81. Joan Semmel, interview by Ellen Lubell, *woman art* 2, no. 2 (Winter 1977–78): 17.

82. Joan Semmel, interview by Laila Pedro, *Brooklyn Rail*, November 2016, https://brooklynrail.org/2016/11/art/joan-semmel-with -laila-pedro.

83. Maria Lassnig, "1980," in *Lassnig: The Pen Is the Sister*, 75.

84. Christina Quarles, "Intimacy, Unknowing and Discovery: David J. Getsy in Conversation with Christina Quarles," in *Christina Quarles*, ed. Andrew Bonacina, exh. cat. (Wakefield, UK: Hepworth Wakefield, 2019), 34.

85. Betye Saar's *Black Mirror* text highlights representation's inherent objectification, opening with a list of stereotypes embodied by names/ labels: "The black woman has been labeled mammy, Aunt Jamima [*sic*], Sapphire, and baby." Saar, "Black Mirror," 22.

86. See Adrienne Edwards, "Vectors and Veneers: The Thickness of Blackness," in *Ellen Gallagher: Accidental Records*, by Adrienne Edwards and Philip Hoare, exh. cat. (Zurich: Hauser & Wirth, 2017), 31–40.

87. Theresa Chromati, "Notes of a Painter," in *A Modern Influence: Henri Matisse, Etta Cone, and Baltimore*, ed. Katherine Rothkopf and Leslie Cozzi, exh. cat. (Baltimore: The Baltimore Museum of Art, 2021), 129, 230.

88. See "Julie Mehretu and Shahzia Sikander in Conversation, Moderated by Gayatri Gopinath," The Morgan Library and Museum, New York, July 19, 2021, YouTube video, 1:22:24, https://www.youtube .com/watch?v=Z2JimBm_mXg&t=102s.

89. Lynette Yiadom-Boakye, interview by Naomi Beckwith, in *Lynette Yiadom-Boakye*, by Naomi Beckwith, Donatien Grau, and Jennifer Higgie, exh. cat. (Munich: Prestel, 2014), 114–15.

90. Lynette Yiadom-Boakye, "Artist × Artist: Lynette Yiadom-Boakye and Jennifer Packer," interview by Elizabeth Gwinn, *Studio: The Studio Museum in Harlem Magazine*, Winter/Spring 2014, 53.

91. Toyin Ojih Odutola, "Toyin Ojih Odutola's 'Of Context and Without' at Jack Shainman," interview by Emory Lopiccolo, *Whitewall*, January 26, 2016, https://whitewall.art/art/toyin-ojih-odutolas-of-context-and -without-at-jack-shainman.

92. Jordan Casteel, "Reciprocating Gaze: Jordan Casteel Interviewed by Cassie Packard," *BOMB*, April 29, 2020, https://bombmagazine.org /articles/reciprocating-gaze-jordan-casteel-interviewed/. Conversely, racialized narratives can sometimes exaggerate the presence of the artist, obscuring the actual artwork, as Toyin Ojih Odutola notes in "There Is No Story That Is Not True: An Interview with Toyin Ojih Odutola," by Osman Can Yerebakan, *Paris Review*, September 27, 2018, https:// www.theparisreview.org/blog/2018/09/27/there-is-no-story-that -is-not-true-an-interview-with-toyin-ojih-odutola/.

93. Jordan Casteel, "Jordan Casteel: 'My Perspective Is One Full of Empathy and Love,'" interview by Allie Biswas, *Studio International*, October 21, 2015, https://www.studiointernational.com/index.php /jordan-casteel-interview-brothers-black-man-in-our-times. Jordan Casteel, "Many Are Called," interview by Massimiliano Gioni, in *Jordan Casteel: Within Reach*, ed. Massimiliano Gioni, exh. cat. (New York: New Museum, 2020), 25.

94. While Casteel points to her father, Charles Casteel, and his sisters as one source for her vision of being an artist, she also mentions the social justice work of her mother, Lauren Young Casteel, as a model of building equitable relationships; see Casteel, "Many Are Called," 17–18.

95. Gisela McDaniel, "Gisela McDaniel: 'Gauguin's Paintings of Pacific Islanders Felt Like Theft to Me,'" interview by Ravi Ghosh, *Elephant*, February 18, 2022, https://elephant.art/gisela-mcdaniel-gauguins -paintings-of-pacific-islanders-felt-like-theft-to-me-18022022/.

96. Aliza Nisenbaum, interview by Yasi Alipour, *Brooklyn Rail*, September 2019, https://brooklynrail.org/2019/09/art/Aliza -Nisenbaum-with-Yasi-Alipour.

97. Nisenbaum, "Nisenbaum—Interview," by Rix.

98. Aliza Nisenbaum, quoted in Dodie Kazanjian, "Personal Histories," *Vogue*, February 2017, 143.

99. Ellen Gallagher, "This Theatre Where You Are Not There: A Conversation with Ellen Gallagher," interview by Thyrza Nichols Goodeve, in *Ellen Gallagher*, exh. cat. (Birmingham, UK: Ikon Gallery, 1998), 22.

100. Shahzia Sikander, "Shahzia Sikander: Gods, Griffins, and Cowboy Boots," interview by Zarui Basmadjian, James Carroll, Pauli Evanson, Navid Islam, Heber Sanchez, and Blanca Valdivia, Red Studio (teen-focused website), The Museum of Modern Art, New York, accessed May 17, 2022, https://www.moma.org/interactives/redstudio /interviews/shahzia/transcript/.

101. Tschabalala Self, "A Space to Dance: An Interview with Tschabalala Self," by Ashton Cooper, *Pelican Bomb*, March 14, 2016, http://pelicanbomb.com/art-review/2016/a-space-to-dance-an -interview-with-tschabalala-self.

102. Quarles, "Intimacy, Unknowing and Discovery," 34.

103. McDaniel, "McDaniel: 'Gauguin's Paintings.'"

104. Firelei Báez, "Firelei Báez on Generosity and Freedom in Art," interview by Angie Cruz, *Aster(ix)*, July 6, 2017, https://asterixjournal .com/firelei-baez/.

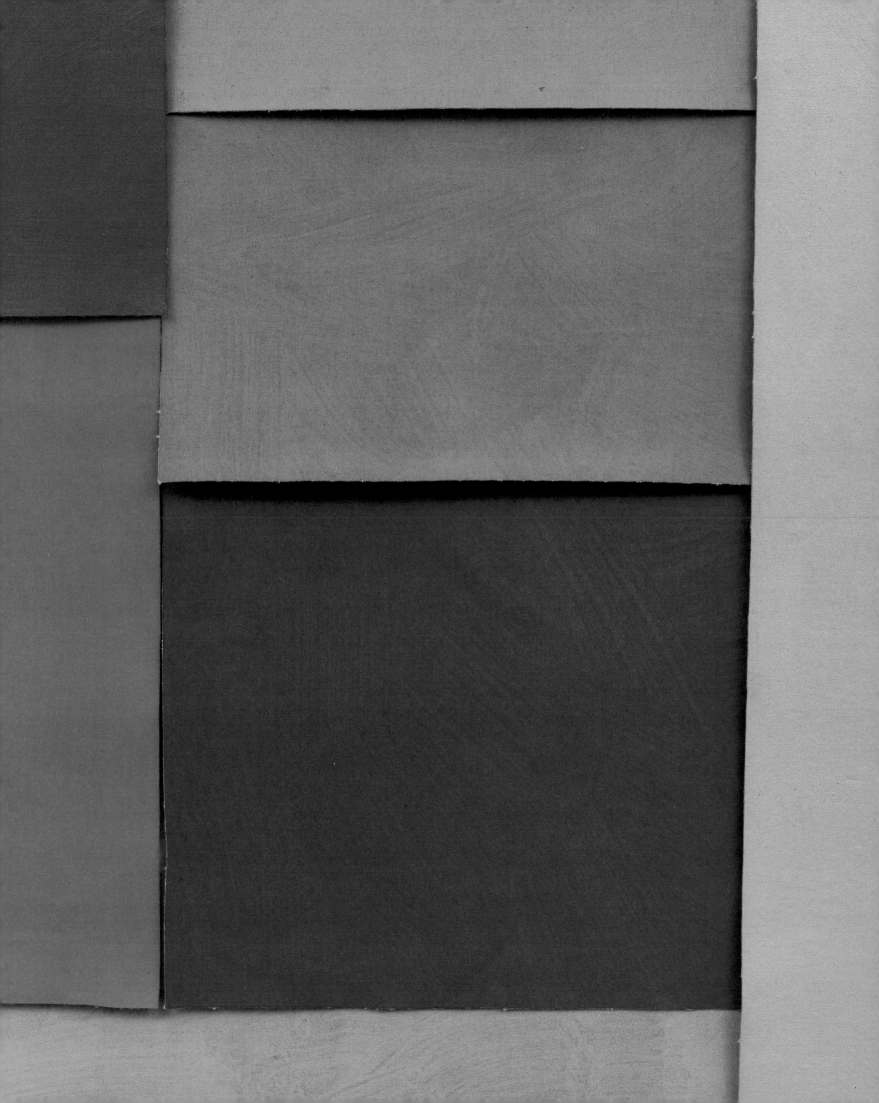

Alive and Kicking: Abstraction in the 1970s

Mark Godfrey

She was a painter in the 1970s, when painting was said to be dead.

—Lynn Zelevansky on Mary Obering

I think the talk of the death of painting had to do with a certain male sensibility. They were making paintings without stories. They were dealing with formalism, abstraction, minimalism, whereas women were questioning all those ways of working.

—Joan Snyder

Abstract painting is the focus of the Shah Garg Collection, even if it now includes works of art which are neither paintings nor abstractions. And the collection really gets going with art made around the end of the 1960s and the early 1970s, even if some works were made earlier. What is curious about the confluence of that particular historical moment with the collection's focus on abstract painting is that in many narratives of art history, the end of the 1960s was precisely when abstract painting reached a point of exhaustion. Many even felt it had reached an end point. Hence, Lynn Zelevansky's comment above about the late geometric abstractionist Mary Obering.[1]

Partly this was because Clement Greenberg's discourse of "modernist painting" had become stale. The influential critic had concentrated on the quality of flatness, as a function of medium specificity, in his assessment of abstract painting, and younger critics associated with him described a disembodied viewing experience in great detail, using the idea of "opticality." Greenberg and his allies may have provided compelling ways to think about *some* abstract art— artists such as Jules Olitski reduced their compositions to huge fields of color—but these ideas seemed to reach a kind of terminus and were not useful to a new generation of painters. At the very same time, and in a not unrelated way, younger artists, who had often trained in the painting departments of art schools, grew tired of the Greenbergian discourse around abstraction. They took to new modes of art making—land art, performance, video, architectural and institutional interventions. By the mid-1970s, many curators,

when tasked with exhibiting emerging artists, were privileging these new forms. In the shows they organized, they left abstract painting behind.

There are some historians of feminist art who accept the account just laid out at face value, arguing that the rise of overtly feminist practices in the 1970s took place against a background of painting's exhaustion and the turn to new media by young artists. Those making such a case have various examples at their disposal. They could cite Carolee Schneemann, who forsook her assemblages and AbEx canvases when conceiving performances such as *Interior Scroll* (1975). They might point to the way Hannah Wilke shifted from her pastel abstract canvases of the mid-1960s to the labial forms of her ceramic and latex sculptures of the early 1970s. They could mention Judy Chicago's turn away from brightly colored geometric paintings and sculptures toward projects such as *Womanhouse*, in 1972. They might even know about Barbara Kruger's fabric-and-canvas assemblages of the early 1970s and remind us that she abandoned abstraction when she began combining photography and text toward the end of the decade. All these examples could be the basis of an argument that in this pivotal decade, women needed to leave abstract painting behind to make the work that felt necessary for the historical moment.

The works gathered in the Shah Garg Collection tell a different story, one that shows how women used and abused abstract painting in different radical ways, rather than simply consigning it to oblivion. Indeed, the collection gives proof of the versatility of abstract painting and its usefulness to generations of artists who have wanted to think anew about art making. Perhaps precisely because of its privileged status in the art discourse, abstract painting could be pulled apart and reconfigured by artists wishing to contest privileged positions in one way or another. The implicit argument for abstract art made by the Shah Garg Collection has been stated before—for instance, in "Feminist Abstract Art— A Political Viewpoint," Harmony Hammond's 1977 essay in the feminist magazine *Heresies*, and in two essays published exactly thirty years later, Helen Molesworth's "Painting with Ambivalence," in the catalogue for Cornelia Butler's

exhibition *WACK!*, and Anna C. Chave's "Outlaws: Women, Abstraction, and Painting in New York, 1967–1975," in Katy Siegel's *High Times, Hard Times* catalogue—but it has never been so clearly substantiated in a private collection.[2]

Harmony Hammond, in another text for *High Times, Hard Times*, remembered that in the 1970s, "Painters interrogated the components of traditional painting—support, ground, and pigment, shape, pictorial space, as well as placement in relationship to architecture and viewer.... Feminism brought a gendered content to this way of working."[3] Following Hammond's lead, in this essay I will concentrate on how various artists questioned in their work the preordained material components of abstract painting: that it had to be made on a flat, thin, continuous, rectangular canvas support hung parallel to the wall; that it consisted primarily of oil or acrylic paint on canvas; and that the paint must be applied with a brush or poured from a can or other container. By exploring and undoing these three conventions, artists were able to ask new questions through their abstract painting practices. And, as Hammond implies, sometimes these questions were bound up in their identities as women, and women who were Black or White or Native American or Jewish or lesbian or straight, while sometimes they had nothing at all to do with the artists' positions or lived experience.[4]

Before coming to some examples, I want to note a couple of qualifications to the story here. The first is that my examples will be almost exclusively by American artists, as the Shah Garg Collection currently concentrates largely on American art. It should be acknowledged that these three conventions of abstract painting were being undone in other ways by artists such as Carla Accardi in Italy, Lygia Clark in Brazil, Mary Martin in the United Kingdom, Behjat Sadr in Iran, Niki de Saint Phalle in France, Zilia Sánchez in Cuba, and Tsuruko Yamazaki in Japan. The second qualification is that the Shah Garg Collection includes, alongside the artists I will focus on, who, in different ways, took apart these material- and process-based conventions, others who dismantled another major assumption about abstract painting—namely, its separation from figuration. There is a parallel story to be told about artists who kept painting on stretched, rectangular canvases with brushes but allowed bodily forms and abstract passages to merge into one another. This story would include Maria Lassnig, Joan Semmel, Mary Lovelace O'Neal, Sue Williams, Amy Sillman, and Ellen Gallagher, through to Christina Quarles, Ilana Savdie, and others.

Disruptions and Continuations

Eva Hesse's *Hang Up* of 1966 (fig. 1) is probably the most emphatic example of how an artist could reference the conventions of abstract painting while moving away from *all* of them, and how she could thereby define a new and original set of interests. Hesse wrapped an empty, rectangular wood frame with cloth that she painted in gradations of gray. In lieu of a broad, curving brushstroke on a painted canvas, a long cord, also gradated in color, pushes out in a giant sweep, touches the floor, and zooms back again to the top left corner of the frame. This cord, invading the room and reaching into the space where viewers stand, prevents them from remaining passive in front of the artwork and perhaps unsettles their composure—exposing their hangups. *Hang Up* was followed by many floor-bound or suspended works that were seen much more as sculptures than as new kinds of paintings, but Hesse continued to address painting: *Contingent* (1968),[5] for instance, with its sheets of cheesecloth hung 90 degrees from the wall rather than parallel to it, has been read as a kind of reinterpretation of Mark Rothko's floating rectangles. Other artists who exhibited frequently in the 1960s took apart the materials and conventions of abstract painting in different ways. Lee Bontecou created elaborate reliefs from strips of canvas laid over steel armatures that extend in cone-like volumes from the wall, surrounding empty volumes that read like gaping voids (fig. 2). Lee Lozano punctured her canvases with holes, too, or hung four separate canvases on the same wall, each with an arc painted on it, as if parts of a broken circle (fig. 3). All these precursors were known to the artists whose work is now in the Shah Garg Collection.

Jo Baer's work of the 1960s appeared to accept the conventions of abstract painting that I have outlined: she became known for very spare paintings that were all on square canvases, stretched over thin wood bars and hung parallel to the wall; that usually featured a wide band of black and a narrower band of a color, like two interior frames; and that were painted just on the front face, with brushes. Living in New York, Baer was surrounded by Donald Judd, Robert Morris, and other artists who claimed that painting was necessarily illusionistic and had to be abandoned for an artist to address real space. Baer set herself the challenge of sticking to painting while refuting the charge of illusionism. One way to do this was to begin to paint around the sides of the canvas-covered stretcher so that a viewer had to confront the real volume of the painted object to make sense of the composition that covered three of its five visible surfaces. This inquiry led to her boldest works, the "radiator" paintings, so nicknamed because with their oblong shapes, hung close to the floor, they resemble wall heaters. In the series, Baer thickened the stretchers so that they protruded some four inches from the wall. Then, she plotted out compositions that took up space both on the face of the canvas and on the left and right sides, and sometimes on the top edge as well. The Shah Garg Collection includes *V. Speculum* of 1970 (pl. 12), a vertical example, which appeared on the cover of *Artforum* shortly after it was made. Baer was pushing painting as far as it could go into the world of Minimalist sculpture but insisting that the work was *painting*, and that to apprehend it, one had to treat it as such, comparing the painted tones of a continuous form that lapped over from a face to an edge.[6]

Mary Corse, at this time, also began to think about the relation of a painting to the viewer's space and to create works that are animated by one's passage from side to side in front of them. Whereas Baer thickened the painting so that its edges and top could come into play, Corse disregarded the material conventions of abstraction by replacing paint with tiny glass spheres suspended in an acrylic medium. In works such as *Untitled (White Grid, Horizontal Strokes)* of 1969 (pl. 52), she created a grid structure on the canvas, then brushed the beads on in directions that ignored that structure. From a fixed position, one might see the grid as the painting's primary composition, but with a slight movement, the brushwork becomes more apparent than the grid.

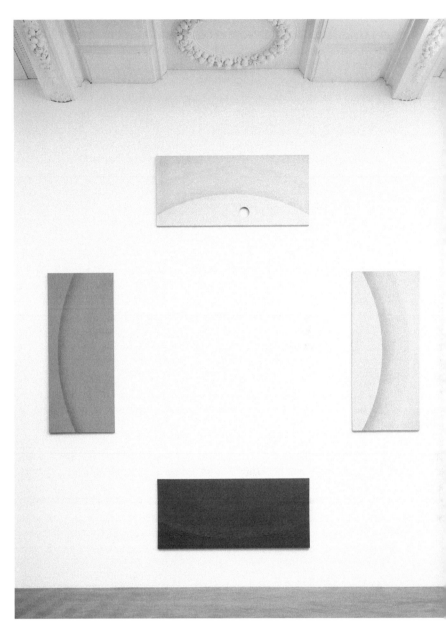

TOP LEFT Fig. 1 Eva Hesse (1936–1970). *Hang Up*, 1966. Acrylic on cloth over wood, acrylic on cord over steel tube, overall 72 × 84 × 78 in. (182.9 × 213.4 × 198.1 cm). The Art Institute of Chicago, Through prior gifts of Arthur Keating and Mr. and Mrs. Edward Morris (1988.130)

BOTTOM LEFT Fig. 2 Lee Bontecou (1931–2022). *Untitled*, 1961. Welded steel, canvas, fabric, rawhide, copper wire, and soot, 6 ft. 8¼ in. × 7 ft. 5 in. × 2 ft. 10¾ in. (203.6 × 226 × 88 cm). The Museum of Modern Art, New York, Kay Sage Tanguy Fund (398.1963). Installation view, *Collection 1940s–1970s* ("Everyday Encounters" gallery), The Museum of Modern Art, New York, November 2020

ABOVE Fig. 3 Lee Lozano (1930–1999). *No Title*, 1969. Oil on canvas (4 parts), each 42 × 96 in. (106.7 × 243.9 cm). Private collection. Installation view, *Lee Lozano: No Title, 1969*, Hauser & Wirth, London, March 30–May 5, 2007

Fig. 4 Helène Aylon (1931–2020). *Slowly Drawing*, 1973. Linseed oil on paper, mounted on high-density fiberboard, 57 × 45½ in. (144.8 × 115.6 cm). Shah Garg Collection

Fig. 5 Joan Snyder standing before *Symphony* (1970) in her studio, New York, 1971. Photo: Larry Fink

Corse understood that the painting is one node of a triangular network that also includes the static electrical-lighting system above and the viewer in front of the work. Only the viewer can move, and light hitting and reflecting off the microbeads creates the impression that the entire surface is luminescent, turning on and off as one walks by precisely because of one's movement.

Pours and Strokes

Hélène Aylon, Lynda Benglis, Rosemarie Castoro, and Barbara Kasten all took different paths from Jo Baer and Mary Corse and from each other in their explorations of processes and materials. Benglis, in 1969, began pouring liquid latex onto the floor, calling the resulting works "fallen paintings"; the Shah Garg Collection includes *Baby Planet* of 1969 (pl. 39). Benglis's pours were thought to reinterpret Jackson Pollock's drip paintings of the late 1940s and to extend the implications of the stained canvases Helen Frankenthaler had been making since 1953. In Benglis's work—as in Frankenthaler's—ideas of flow that some critics connected to femininity and women's bodies replaced an emphasis on arm gestures. Benglis also took aim at Postminimalist sculpture, including the so-called scatter pieces that had brought renown to Carl Andre, Robert Morris, and Richard Serra. In place of their industrial gray and black materials, Benglis used Day-Glo colors to introduce sensuousness, pleasure, and visual drama into her work.

With her staged advertisements in *Artforum*, Benglis became an icon in the early 1970s; Hélène Aylon and Barbara Kasten were much less well known, but they were similarly engaged with the idea of fluidity in abstract painting and how it could open up new ways of working. Aylon chose slick supports such as sheets of aluminum and plexiglass, spraying waves of acrylic over their surfaces to produce shimmering fields. Using language reminiscent of some contemporaneous interpretations of the paintings of Mark Rothko, who died in 1970, the year she made *First Coral* (pl. 15), Aylon connected her processes with her perspective as an observant Jewish woman. In creating these "changeable"

and "elusive" surfaces, she was "in my religious mode looking for an invisible presence, a mystical female presence."[7] In her next series, represented in the Shah Garg Collection by 1973's *Slowly Drawing* (fig. 4), she spread linseed oil onto paper backed with Masonite to observe the changes that would occur in the visual appearance of the work over time. Rather than seeking a fixed image, as so many abstract artists had done before her, she "wanted the paintings to actually change like the earth changes."[8]

Barbara Kasten, having started out as a weaver and fiber artist, began a series of works in 1974 that she called *Photogenic Paintings*. Borrowing the fiberglass window screening she had been using to mold her woven sculptures, she created new, flat cyanotypes in a multistep process. First, she prepared a light-sensitive emulsion and painted it onto a sheet of BFK Rives rag paper, which she had chosen for its velvety surface. Once the paper was dry, she placed the screen over the paper. Because of its undulating surface, some parts touched the paper, and others rose slightly above it. She then exposed the ensemble to sunlight. During development, the parts of the paper not covered directly by the screen turned a deep blue; where the screen rose over the paper, the blue was reduced in intensity. She then exposed the paper a second time after painting it with Van Dyke chemicals, creating brown tones, and also painted and poured colored inks onto some areas of the paper. Kasten had been thinking about László Moholy-Nagy's work at the Bauhaus and was interested in "merging the essence of painting and photography."[9] In *Photogenic Painting Untitled 76/7* (pl. 23), she engaged American painting as well: the two rectangular forms call to mind the soft-edged shapes in many Rothkos, while the varying colors, from deep blue to greenish white to purple, evoke the layers of liquid paint in Frankenthaler's canvases. Kasten managed to make a photograph without a camera, and a painting without paint or canvas.

Benglis, Aylon, and Kasten each reimagined the pour, which had been one of the primary mark-making processes employed by abstract artists since the 1950s; a more traditional method of delivering paint to the canvas surface was, of course, the brushstroke. Much of the discourse around Abstract Expressionism had revolved around arm movements and gestures—the full-arm sweeps deployed by Willem de Kooning, for instance. American artists found different ways to challenge the rhetoric around the stroke, famous examples being the nongestural stripes Frank Stella laid on his *Black Paintings* with a house painter's brush in 1958–60 and the parodic swaths of Roy Lichtenstein's 1965–66 *Brushstroke* series. The work of Joan Snyder and Rosemarie Castoro can be considered in this context. In her "stroke paintings" of 1969, Snyder anatomized the language of Abstract Expression like a surgeon. Separating individual strokes across the canvas, she conducted both a celebration and an analysis of gestural painting (fig. 5). As Marcia Tucker wrote in *Artforum* in 1971, the paintings "not only involve the dissection, vivisection, and dissolution of each stroke but also its examination from every point of view."[10] The effect of this dissection was to make impossible the kind of viewing aficionados of AbEx had enjoyed: "Because no one image takes precedence over another, and because there are so many images in a single canvas, there is no *gestalt*, no holistic aspect to these paintings."

Fig. 6 Rosemarie Castoro standing before her installation *But But But...* (1972) in her New York studio, in a Polaroid photograph made with a self-timer, 1972–73

For some artists, there is a desire to amalgamate the multiplicity of one's experience into a single image, to comprehend and give it order. Snyder presents the multiplicity as it is experienced."[11]

For her part, Rosemarie Castoro decided to isolate and monumentalize brushstrokes in a series of works begun in 1972. She created a mixture of marble dust, gesso, and modeling paste and used a mop or non-artist's brush to spread it over sheets of Masonite; once the panels had dried, she cut them into the shapes of giant strokes with a jigsaw. Finally, she rubbed graphite over the surface to create modulations of light and shade. *Gentless (Brushstroke)* (pl. 28), from the first series of these works, hangs on the wall, as tall as many AbEx paintings—a kind of sculpture of a brushstroke. "Castoro's wall-sized brushstrokes, ironically dripping with pseudo impasto, and freestanding paintings executed with a broom [sic] instead of a brush, are both a witty reaction to stained color painting as well as quite substantial statements in themselves," wrote Barbara Rose in 1972.[12] Castoro was not just repeating Stella's and Lichtenstein's critique of gestural painting. She saw each of her giant stroke-sculptures as a different character, sometimes performing with the works as if they were active presences in the studio (fig. 6).

Referential Processes

If we think for a moment just about the artists discussed thus far—Baer, Corse, Benglis, Aylon, Kasten, Snyder, Castoro—we already have a powerful sense of how the traditional processes and material conventions of abstract painting could be reinvented. But how did these artists understand their formal inventions and disruptions in relation to their identities as women from different kinds of cultural communities? Baer and Corse were not interested in connecting gender to material experimentation: they regarded their procedures in purely formal terms and held in mind a general viewer whose gender did not impact that

viewer's approach to art. The other artists took somewhat different positions. They conceived their work in dialogue with a language they understood to have been invented and perpetuated largely by men. Benglis's use of Day-Glo colors and emphasis on fluidity were strategies for feminizing the conventions of painting and Postminimalist sculpture; Castoro's work was an attempt to inflate and animate brushstrokes so that they could no longer signify as they had done in AbEx paintings made primarily by men. Aylon was interested in what it meant to make art not just as a woman but as a Jewish woman, brought up in a traditional religious community. Snyder's "stroke paintings" materialized ideas of "multiplicity," and in the early 1970s, this could be seen as analogous to the multiplicity of her own identity: a painter, a woman, a new mother, a recently out lesbian. Such ideas became more explicit in the art of Louise Fishman, Harmony Hammond, Howardena Pindell, and Kay WalkingStick, all working around the same time; all, in different ways, conceived their processes, material experimentations, and disruptions in relation to their intersectional identities and to different histories and traditions they wished to emphasize as their own.

Louise Fishman's *Victory Garden of the Amazon Queen* of 1972 (pl. 31) crosses the traditions of formalist abstraction with what Debra Singer has called "techniques and materials traditionally associated with women's work, craft traditions, the handmade, and the domestic realm."[13] This was an important work for the artist, chosen to be exhibited in the 1973 Whitney Biennial. To reach this landmark moment, Fishman had first abandoned the more conventional stretched canvases with geometric grids she had been painting in the late 1960s. She also set aside a group of works from 1971 incorporating rubber or small fragments of canvas together with grommets and lengths of string and twine. If the former paintings felt too close to Mondrian and Ellsworth Kelly, the stitched works of 1971 may have felt too indebted to the language of Eva Hesse. By 1972, Fishman had turned back to painting, but with work that was decidedly different from her 1960s grids. *Victory Garden* comprises four small, unstretched, squarish canvases hung in a row, each divided in a loose grid into four smaller squares. In the repetitive structures within each square and in the whole four-part work, Fishman nodded to Minimalist art, but she exchanged its industrial character for something far more bodily, far more queer: each square has a slightly different shape, due to quirky frays of the canvases and slightly different stretches and curves. Each canvas has a distinct inner composition, because Fishman painted wiggly, messy squares rather than straight ones. She also exchanged the bright colors of so much Minimalist art for earthy greens and browns. She talked about remembering the "victory gardens" grown by Americans of her parents' generation during World War II, but with this palette, she was also evidently thinking of "Amazon queens" and mythical connections between women and nature.

Earlier on, I referred to artists such as Hannah Wilke who left behind abstract painting to make work that used materials, forms, and processes traditionally gendered as "female." In Harmony Hammond's case, the story is reversed, somewhat. In the early 1970s, Hammond showed a group of sculptures titled *Floorpieces* that she had made from fabric waste, braided together and painted with acrylics in

concentric circles. She later considered these her "most radical works referencing women's traditional arts,"[14] but her next body of work, the "weave paintings," is in some ways more nuanced and intriguing. For these compositions, the artist moved away from actual weaving or braiding and instead coated canvases in one layer of paint, then another that had been thickened with a wax medium. As she scored the thick top layer with the wrong end of the brush, she exposed the delicate colors beneath. In *Letting the Weather Get In* of 1977 (pl. 50), the top layer is dark green, and the underlayer is turquoise and light green. The score patterns, crucially, resemble herringbone and braid patterns. As Carter Ratcliff noted in a contemporary review, "It's important to note that Hammond's new works are not the results of weaving processes; they are not woven objects. They *refer* to weaving, they exhibit *traces* of it."[15] For Ratcliff, Hammond's move from actual woven art to paintings that referred to weaving allowed her to open up a dialogue with the convention of Abstract Expressionist "allover" painting. Hammond insisted that actual weaving traditions were every much as significant as the practice of dripping or spreading paint across a surface. Another way she spoke back to earlier conventions was by using rounded canvases rather than rectangular ones: the oval form of *Letting the Weather Get In* calls to mind the curves of the body more than any straight-edged canvas could. Although it was not stated at the time, Hammond's shapes and surfaces were later seen as an attempt to queer abstraction, queering being posited as an operation rather than a characteristic.[16]

Howardena Pindell's earliest mature paintings were made by spraying paint through a hole-punched stencil to create fields of multicolored dots. One such work was included in the 1971 exhibition *Contemporary Black Artists in America* at the Whitney Museum of American Art. By the time she made *Untitled #21* of 1978 (pl. 46), Pindell's approach to process and materials had become much more complex. Instead of stretching rectangular lengths of canvas over wood bars, she cut up canvas into small squares, which she then sewed together into a tight grid (fig. 7). The process calls to mind various quilting traditions, and Pindell's encounters with two exhibitions earlier in the decade—

Fig. 7 Howardena Pindell (born 1943). Detail of reverse of *Untitled #21* (pl. 46), 1978. Acrylic, gouache, watercolor, dye, paper, talcum powder, glitter, and sequins on sewn canvas, overall 6 ft. 11 in. × 9 ft. 5 in. (210.8 × 287 cm). Shah Garg Collection

Abstract Design in American Quilts at the Whitney in 1971, and *African Textiles and Decorative Arts* at the Museum of Modern Art in 1972—led to her decision to hang the finished works directly on the wall, without a stretcher. The artist's most important move, however, had to do with her surfaces. She had always saved the punched circles from her stencils, and she began to stick them onto her canvases, embedding them in layers of paint. Sometimes, she also scattered glitter onto the wet paint. In an interview with Kellie Jones conducted more than thirty years later, Pindell indicated what these surfaces meant to her:

> Afro-American artists are very often involved in the extended surface. . . . We get involved in crossover surfaces into sculpture-painting, painting-sculpture. . . . When a sculpture is done it possibly has additional aggregates on it to empower it. . . . A very rich surface empowers the piece. I find that often Afro-American art has this aspect.[17]

In the early 1970s, Pindell had been told by the director of the Studio Museum in Harlem that she was not making "black art" because she had chosen abstraction over "didactic images."[18] But rather than shift in that direction, she thickened her surfaces, and by 1978, she evidently sensed that her experimentation with "sculpture-painting" had given her work an "Afro-American" character. She appears to have associated her paintings embedded with matter with "power objects": figures used in African rituals whose power grows as nails or other objects are embedded in them.

One further aspect of Pindell's practice should be mentioned, something that has been lost to time: she often sprayed paintings such as the one in the Shah Garg Collection with perfume before they were exhibited. Pindell's use of perfume has gained little attention. An easy interpretation is to say that she used a "feminine" aroma to complement the pastel colors and glittered sparkle of the paintings. A more complex account would note that by giving her work a scent, Pindell was deprivileging the optical and insisting on the haptic and the olfactory. This, in itself, was a feminist move, because the Greenbergian emphasis on the optical was often connected to patriarchal attitudes; therefore, to stress that other senses were important to the experience of art necessarily meant questioning those attitudes. (In recent years, the artist Anicka Yi has contended that using smell in artworks is a feminist move.[19])

Kay WalkingStick's paintings of the early 1970s—such as *April Contemplating May*, in the Whitney's collection—were Pop-influenced canvases in which she depicted naked bodies as flat blocks of bright color against equally high-pitched polychrome grounds. By the mid-1970s, she had begun to make abstract paintings, and her colors, materials, processes, shapes, and titles all point to her increasing consciousness of what it meant to be "the Indian painter," as she recently described herself: "In my own mind I was trying to see myself in that way."[20] In *Red Painting/Red Person* of 1976 (pl. 22), a terracotta-red border encloses a band of unprimed canvas covered with yellow ink, streaked with black drips. This square serves as a frame for the large square dominating the work, again terracotta red. Within this square are four large arcs joined by straight vertical lines, or extended semicircles on end—three facing one way,

one the other. To create them, the artist, who had mixed her paint with saponified wax to make it particularly thick and malleable, built up layers of color around the shapes, leaving the surface within much thinner and lighter. The forms came from WalkingStick's general alertness to the ones she saw and remembered in her daily life. For instance, when talking about the work, she has recalled seeing huge, draped nets suspended under bridges in New York City to catch debris as construction workers labored to repair them.[21] But by the time WalkingStick made *Red Painting/Red Person*, she had also begun a series of more than thirty small abstract paintings dedicated to Chief Joseph, the Nez Percé leader whose resistance and dignity made him an iconic figure in Native American history (fig. 8). In those works, the arcs were understood to evoke arrowless bows or, indeed, shields. The title *Red Painting/Red Person* elegantly brings together modernist language (*Red Painting* was a title used by both Philip Guston and Ad Reinhardt) and the language of racial classification, slurs, and resilient self-identification; thus, the title plays an active role in the experience of anyone who reads it while viewing the work. The title does not resolve anything about the painting or fix any "meaning"; instead, it provokes questions. To what extent might one view this canvas as a purely formal exercise in shape, texture, and surface? To what extent is it legitimate to read it through the lens of Native American identity and to understand the arcs as bows and shields, or to see the color as significant? (WalkingStick did not comment on it at the time but has recently said, "I find it's very earthy." It is "the color of the earth in Oklahoma . . . sacred earth.")[22]

The last work of the 1970s I want to discuss is Miriam Schapiro's *Double Rose* of 1978 (pl. 9), because it—like Hesse's *Hang Up*—is such an emphatic statement of purpose. The large canvas, stretched over a semicircular support, is divided into twenty-four equal sections that spread from a red semicircle at the bottom center to the edge like the spokes of a wheel: there are twelve darker spokes and twelve lighter ones. Each of these twenty-four sections is divided, in turn, into equal-length bands. This is a meticulously plotted structure, but each of the carefully measured sections is covered with bright patterns, sometimes on strips of fabric, sometimes painted by the artist. The two roses of the title can be found on the red semicircle of fabric at the bottom. Schapiro called works like this "femmages," a word that articulated her combination of collage, crafts, and decorative patterns traditionally devalued as feminine pursuits and pleasures. The fan shape of *Double Rose* is another gesture toward an object historically associated with women. (Her *Blue Burst Fan* and *Barcelona Fan*, both of 1979, make this reference even more explicit.)[23] Yet, as much as the "femmages" celebrated "women's" crafts and patterns, they also engaged with, and reworked, conventions of modernist abstraction. Frank Stella's *Basra Gate III* of 1969,[24] for instance, has the same proportions and same basic composition as *Double Rose*. Schapiro must have known the Stella, for she herself was painting hard-edge abstract canvases at the time, and Stella was the most celebrated hard-edge painter in the country then. Some early critics, such as Norma Broude, made a case for Schapiro's "femmages" as a feminist form of painting that was at once allied with and critical of the modernist mainstream.[25] Others felt that Schapiro's work was too naïvely celebratory of "women's

Fig. 8 Kay WalkingStick (born 1935). *Chief Joseph Series* (nos. 5, 14, 22, 28), 1975–77. Acrylic and saponified wax on canvas, each 20 × 15 in. (50.8 × 38.1 cm). National Museum of the American Indian, Smithsonian Institution, Washington, DC (26/5366)

work," or that she was not addressing craft on its own terms but keeping it subservient to a dominant, male-defined tradition. Elissa Auther, who has recently mapped out the debates around Schapiro's work, makes a convincing case that the artist raised important questions about modernism's repressions (for instance, the decorative tendencies in modernist abstraction not sufficiently acknowledged by critics such as Greenberg). At the same time, just as WalkingStick invoked the issue of what it meant to see her work as a "red painting" or as something connected to a "red person," Schapiro "questions the way we conceive of *both* high art (painting) and everyday experience (in the form of women's creative labor in the home), querying the different aesthetics, materials, processes, and tastes we bring to these spheres."[26]

Ten Years Later

I have been mapping different ways in which women artists worked with materials, shapes, supports, and processes, generally moving away from the convention of brushing oil or acrylic paint onto a flat, rectangular canvas so as to be able to stress new concerns while maintaining a disruptive yet productive dialogue with modernist abstraction. The pursuits of the 1970s led to several new directions in contemporary painting, but before getting to the more recent works in the Shah Garg Collection, I would like to compare two works made roughly a decade after the period I've been concentrating on, because even though the two artists occupied somewhat different camps in the New York art world, they make an interesting pair, as both decided to paint on curved or angled wood, and both brought a kind of humor to their work.

The first is Sherrie Levine's *Chair Seat: 6* of 1986 (pl. 54), one of a small series of related works. Instead of using canvas as a support, the artist bought a simple wood chair, removed the legs, and painted bands of red, orange,

and green onto the seat. The curved contours of the seat are extremely regular and machine-cut, but the painted stripes themselves have a handmade character—they aren't totally straight or crisp, and there are tiny, unpainted gaps between the bands. The wood grain is also visible beneath the paint. "I enjoy painting because of its physicality," Levine said in 1987. "The surface becomes a record of the artist's bodily relationship to the painting."[27] Yet, when she exhibited this work, most viewers would not have known Levine as a painter at all but as an appropriation artist who rephotographed the work of other artists to address and unsettle ideas often upheld by male critics of art made by men, such as "originality" and "genius." (Although she had been included in Douglas Crimp's 1977 exhibition *Pictures*, at Artists Space, the term "Pictures Generation" had not yet taken hold in 1986.) Levine had by this time photographed works by Walker Evans, Piet Mondrian, and Egon Schiele, but in *Chair Seat*, she was not directly copying a particular historical work: "What [my abstract paintings] appropriate are concerns of other artists rather than a specific image. This confuses the notion of originality even more, which I find amusing."[28] The "amusing" character of *this* work also resides in Levine's choice to paint on a seat; it is not just any readymade object but, like the stool in Duchamp's *Bicycle Wheel* of 1913,[29] one usually in contact with someone's bottom. This means that when standing before *Chair Seat*, instead of getting lost in the act of looking, one also becomes aware of one's own ass, and even imagines what it would mean to sit on the painting! Much has been written about the implications of Jackson Pollock's painting on a horizontal surface, and on the connection between Robert Rauschenberg's arrangements of silkscreens and the tables used by photo editors to lay out text and pictures prior to publication. Extending this conversation of how horizontality unsettles verticality, Levine introduced a subversive, feminist wit.

Elizabeth Murray's *Joanne in the Canyon* (fig. 9) was made shortly afterward, in 1990–91, and also has a curved wood support. While artists before her had thickened the painted object (Baer), curved it (Hammond), or removed the wood backing entirely (Pindell, Fishman), Murray created a wildly irregular surface with no fewer than fourteen beveled pieces of wood, to which she stapled canvas and which she then fastened together into a continuous whole, interlocking, overlapping, sticking out at sharp corners, and sometimes parting into a kind of crater, perhaps reminiscent of the holes in Lee Bontecou's reliefs but also calling to mind the dramatic landscapes of Utah and the American Southwest, where Murray often traveled. The central painted form, colored orange like its sandstone terrain, can be read as a collection of bulbous shapes but also as Murray's friend JoAnne Akalaitis (born 1937), hiking through the canyon in her green shoes, under a red sun, with a New York City skyscraper way behind her as she explores a new landscape. Rather than wrestling with all the problems of canonical modernist abstraction, Murray fearlessly fused narrative and formalism, abstraction and figuration, graffiti and AbEx drips, biomorphic curves and Cubist planes, birthing a fierce new form with humor and abandon. "Murray rejected the track of painterly purity," Kellie Jones has written. "*This* was her feminist statement."[30]

Forty Years Later

Far from being "exhausted" or "dead," abstract painting is endlessly malleable, continually being reinvented by artists who, while confronting its histories and material conventions, find new ways to express their attitudes to their world. Of the same generation as the artists discussed already, Suzanne Jackson and Dona Nelson have been making and exhibiting work since the late 1960s and mid-1970s, respectively, but in the last few years, in a way that is connected to the material explorations I have charted, they have made the radical move to shift painting off the wall into open space—as seen in Jackson's *Cut/Slip for Flowers* (fig. 10) and Nelson's *Crow's Quarters* (pl. 55). Jackson suspends irregular sheets of dried acrylic paint with wires; Nelson places a stretched canvas, worked on both sides, into a metal assembly that holds it up in the middle of a room. Jackson explains this move with language that emphasizes her interest in organic structures. She expresses an ecological sensibility: her methods gather and recycle waste. And she keeps her paintings in tune with the surrounding environment.

> Since the late '90s, my paintings reflect my breaking away from the structure of stretched canvas or paper. I enjoy "ragged edges," using torn shapes and found materials. I don't predetermine or think about making organic painted shapes. . . . I use all sorts of studio construction leftovers. Sometimes I reuse the paintbrush water so the paint doesn't go down the drain, or I'll include paint residue or elements of studio detritus in the layering process. The temperature or humidity where the pure medium paint dries—or requires over-painting—allows the works to be suspended in space as sculpted paintings.[31]

Nelson explains her own turn to two-sided paintings as a response to painting's history and current predicament. "Since Frank Stella's Black Paintings," she writes, "the objecthood of abstract painting has been highlighted. His stripes and wide stretchers got rid of painterly illusion. My two-sided paintings emphasize objecthood even more!"[32] What interests me most is another of Nelson's points: that her works are a response to the inadequate ways paintings are consumed today—as scrollable shimmers on screens, as easily consumable images.

> My two-sided paintings cannot be photographed as you would experience them in an exhibition, walking around them. . . . The backs of the paintings, which are inseparable, but often very different from the fronts of the paintings, determine that my two-sided paintings will keep producing themselves in time and space and resist both photographic reproduction and the production of meaning.[33]

While neither artist's work can be reduced to aspects of identity, it is interesting to consider how much Jackson's concept of "sculpted paintings" echoes Howardena Pindell's idea of "sculpture-painting, painting-sculpture"—a tendency Pindell feels is particularly African American. Meanwhile, as much as Nelson's decision to make two-sided works is intended as an affront to the world of Instagram fodder, her insistence on difference, and her resistance to the "production of meaning," may also be read as a queer strategy, comparable to those of Fishman and Hammond (with whom Nelson showed in 1978's *A Lesbian Show* at 112 Workshop, or 112 Greene Street, the precursor to White Columns). The painting is neither one side nor the other, nor simply the combination of the two: it is an object that refuses to be categorized.

There are plenty of works in the Shah Garg Collection by younger artists that could be spotlighted to show how the conventions of abstraction continue to be undone: Jacqueline Humphries's *[///]* (pl. 67), which began with her making a stencil based on a blown-up photograph of the canvas weave; Ruth Root's *Untitled 10* (pl. 83), made up of panels of sprayed paint and patterned fabrics; Rachel Harrison's *Fendi* (pl. 78), a painted sculpture shaped almost like a seat, serving as a platform for a bottle of perfume (an intriguing update of Pindell's perfumed works and Levine's *Chair Seat*); and Firelei Báez's *temporally palimpsestive (just adjacent to air)* (see pp. 24–25), painted over a print of an architectural plan. But I want to end with a work that feels exemplary because it looks backward and forward at once and connects to several of the works already discussed.

In 2012, Laura Owens began a new series of abstract works which started with her thinking about gesture (fig. 11). "Is it even possible for a woman artist to be the one who marks?," she asked.[34] Instead of replicating the highly personalized male gestures of midcentury American painting, Owens populated her canvases with "oversize impastoed gesture marks . . . made up of large paint strokes and then given drop shadows. They are overdetermined but also undeniably physical."[35] The paint strokes themselves fill bulbous areas derived from computer drawing programs. Once the outlines were transferred onto canvas, studio assistants filled in the areas with whipped-up strokes of Flashe paint. Owens's separated and inflated gestures recall Joan Snyder and Rosemarie Castoro, but her confrontation with gestural painting is distinctive, because by creating marks that involve different moments in time and more than one person, she disrupts ideas of immediacy and individuality. Owens even compared her new gestures to the "female orgasm," which "can't be located in time"—an intriguing and brilliant update of thinking about mark making in painting.[36]

Around this time, Owens was also embracing digital image editing and silkscreening to a greater degree, and by 2016—the date of *Untitled*, in the Shah Garg Collection (pl. 89)—she was exploring the connections between pixelated images and the grids in embroidered fabrics, having recently rediscovered her grandmother Eileen Owens's needlepoint work. For several paintings, she scanned the needlepoint designs to create silkscreens. In *Untitled*, which—significantly—is on a ground of pink-dyed linen, she

Fig. 10 Suzanne Jackson (born 1944). *Cut/Slip for Flowers*, 2020. Acrylic paint and D rings, 75 × 47 × 3 in. (190.5 × 119.4 × 7.6 cm). Shah Garg Collection

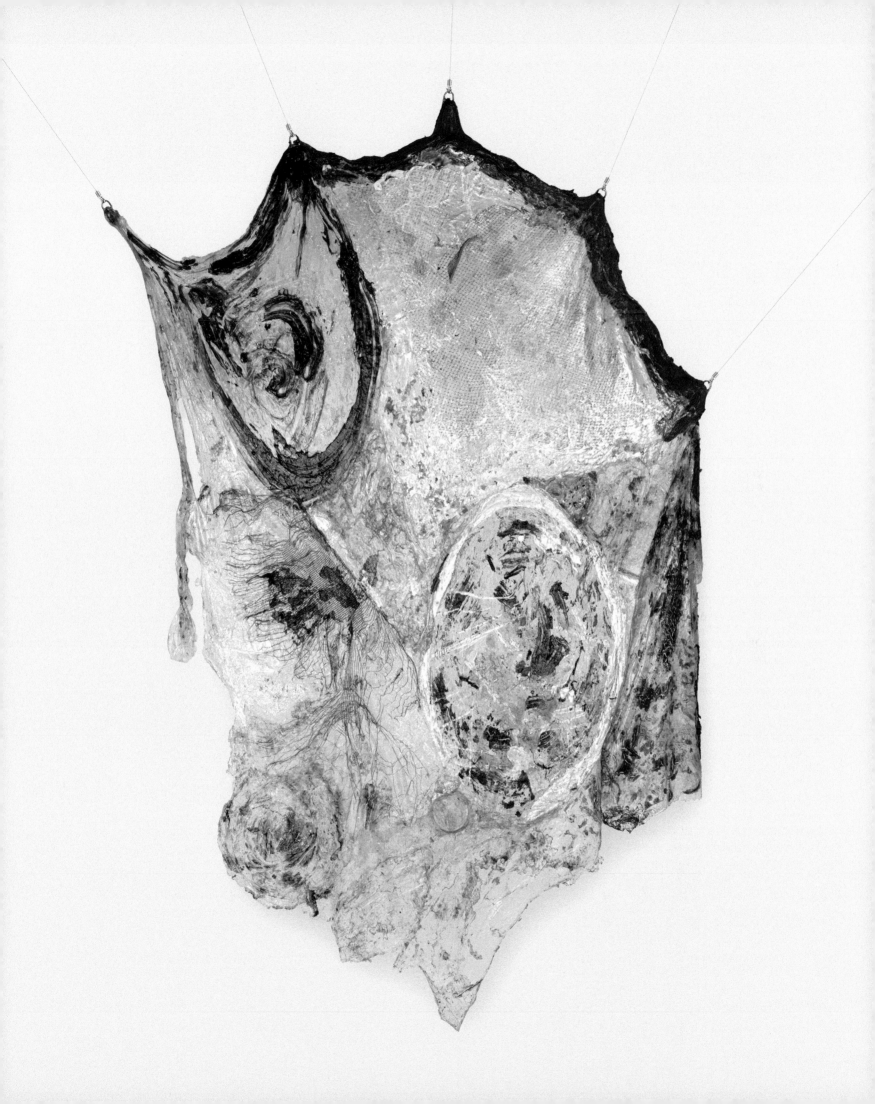

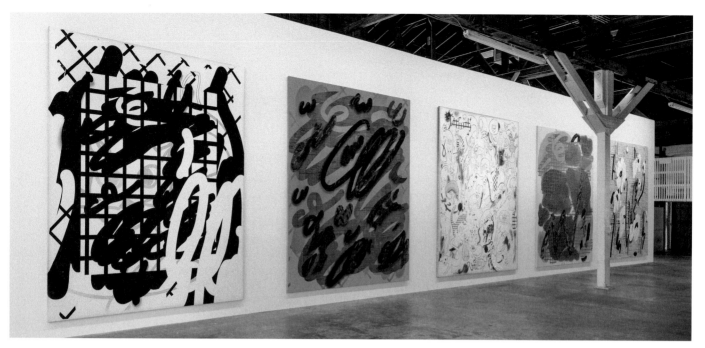

Fig. 11 Installation view of Laura Owens's exhibition *12 Paintings*, 356 South Mission Road, Los Angeles, January 20–July 7, 2013

printed from the silkscreens, juxtaposing those passages with fields of silkscreened, colored pixels. (Sometimes, but not here, she has also directly embroidered onto her paintings.) Artists before Owens—such as Hammond, Pindell, and Schapiro—found ways to refer to previously devalued "women's work," whether by copying the appearance of a woven pattern, stitching canvas squares together, or collaging patterned fabrics. In addition to recognizing these figures, Owens acknowledged her grandmother's hobby and her own digital processes in the same moment, as if to indicate that each is an equally serious practice, and each equally useful in making a new kind of abstract painting. At the center left of the canvas is a real bicycle wheel, painted blue and attached to the painting in such a way that it is free to revolve (fig. 12): Owens has updated Levine's engagement with Marcel Duchamp. It is significant that the wheel is from a kid's bike, decorated with painted-on "stickers." Owens has previously incorporated her own children's drawings and writings into her paintings, and although this wheel belonged to neither of them, it calls to mind a front yard where your kids' old bikes lie around long after they've outgrown them. In one surface, Owens connects grandmothers and children, readymades and needlepoint, Harmony Hammond and Sherrie Levine, the modernist grid and the low-res, pixelated image. With all these things spinning around like the wheel, abstract painting has never seemed so alive.

Fig. 12 Laura Owens (born 1970). Detail of *Untitled* (pl. 89), 2016. Vinyl paint, screen-printing ink, and bicycle wheel on dyed linen, overall 9 × 7 ft. (274.3 × 213.4 cm). Shah Garg Collection

Epigraphs: Lynn Zelevansky, "Foreword," in *Mary Obering*, by Lynn Zelevansky and Matthew Levy, exh. cat. (Los Angeles: Inventory Press; Kayne Griffin; New York: Bortolami, 2022), 11. Joan Snyder, interview by Phong Bui, *Brooklyn Rail*, September 2008, https://brooklynrail.org/2008/09/art/joan-snyder-in-conversation-with-phong-bui.

1. Most of the artists mentioned in this essay are in the Shah Garg Collection and represented on pp. 142–413 by works and short texts.
2. Harmony Hammond, "Feminist Abstract Art—A Political Viewpoint," *Heresies* 1, no. 1 (January 1977): 66–70. Helen Molesworth, "Painting with Ambivalence," in *WACK! Art and the Feminist Revolution*, ed. Cornelia Butler, exh. cat. (The Museum of Contemporary Art, Los Angeles; Cambridge, MA: MIT Press, 2007), 428–39. Anna C. Chave, "Outlaws: Women, Abstraction, and Painting in New York, 1967–1975," in *High Times, Hard Times: New York Painting, 1967–1975*, ed. Katy Siegel (New York: Independent Curators International, 2007), 121.
3. Harmony Hammond, artist's statement, in Siegel, *High Times, Hard Times*, 121.
4. It should be noted that some male abstract artists in the 1970s approached painting in ways related to those discussed in this essay, turning to stitching or quilting for various reasons. Notable among these artists were Al Loving (1935–2005) and Alan Shields (1944–2005).
5. National Gallery of Australia, Canberra.
6. For more on Baer's paintings, see my essay "Programmatics, Poetics, Painting: On Jo Baer," in *Robert Lehman Lectures on Contemporary Art, No. 5*, ed. Lynne Cooke and Stephen Hoban (New York: Dia Art Foundation, 2014), 75–104.
7. Helène Aylon, interview by Monika Fabijanska, *Brooklyn Rail*, March 2019, https://brooklynrail.org/2019/03/criticspage/Helne-Aylon-with-Monika-Fabijanska.
8. Ibid.
9. Barbara Kasten, email message to the author, May 2022.
10. Marcia Tucker, "The Anatomy of a Stroke: Recent Paintings by Joan Snyder," *Artforum* 9, no. 9 (May 1971), https://www.artforum.com/print/197105/the-anatomy-of-a-stroke-recent-paintings-by-joan-snyder-37523.
11. Ibid.
12. Barbara Rose, "Art: The Big Squeeze," *New York*, February 28, 1972, quoted in Tanya Barson, "Rosemarie Castoro 1964–79: An Obstacle Course for a Dancer?," in *Rosemarie Castoro: Focus at Infinity*, ed. Tanya Barson and Melissa Feldman, exh. cat. (Barcelona: Museu d'Art Contemporani [MACBA], 2018), 32. While Rose mentions a broom, the artist typically used a mop or a non-artist's brush to create the texture. Castoro's estate is in possession of a typed document by the artist titled "The Technique of Flat Strokes" and dated February 5, 1972, in which a handwritten annotation (itself dated February 18) replaces "broom brush" with "mop." Irene Del Principe, Press Officer, Thaddaeus Ropac, email message to Gina Broze, November 2, 2022.
13. Debra Singer, "Going Rogue," in *Louise Fishman* (New York: Karma, 2020), 13.
14. Harmony Hammond, quoted in Amy Smith-Stewart, "Material Outlaw," in *Harmony Hammond: Material Witness/Five Decades of Art*, ed. Amy Smith-Stewart, exh. cat. (Ridgefield, CT: The Aldrich Contemporary Art Museum; New York: Gregory R. Miller, 2019), 11.
15. Carter Ratcliff, "Harmony Hammond," *Arts Magazine*, March 1976, 7.
16. This is an argument made by Julia Bryan-Wilson, mainly in reference to earlier bodies of work; see Julia Bryan-Wilson, "Queerly Made: Harmony Hammond's *Floorpieces*," *Journal of Modern Craft* 2, no. 1 (March 2009): 59–79.

17. Howardena Pindell, interview by Kellie Jones, in Kellie Jones, *EyeMinded: Living and Writing Contemporary Art* (Durham, NC: Duke University Press, 2011), 231.
18. Ibid.
19. "Eyesight and vision are associated with knowledge, discovery, power and the masculine. Smell is shrouded in mystery, subjectivity, because it's related to long-term memory. There are things about smell that are objective; they're just really difficult to talk about. And anything difficult is put into a mysterious box, and therefore feminine." Anicka Yi, "Anicka Yi on the Power of Smell, Bacteria, and Feminism," interview by Karen Rosenberg, *e-flux Conversations*, March 13, 2015, https://conversations.e-flux.com/t/anicka-yi-on-the-power-of-smell-bacteria-and-feminism/1191.
20. Kay WalkingStick, telephone conversation with the author, March 2022.
21. Ibid.
22. Ibid.
23. Jewish Museum, New York, and The Metropolitan Museum of Art, New York, respectively.
24. Museum Folkwang, Essen, Germany.
25. Norma Broude, "Miriam Schapiro and 'Femmage,'" in *Feminism and Art History: Questioning the Litany*, ed. Norma Broude and Mary D. Garrard, quoted in Elissa Auther, "Miriam Schapiro and the Politics of the Decorative," in *With Pleasure: Pattern and Decoration in American Art 1972–1985*, ed. Anna Katz, exh. cat. (Los Angeles: The Museum of Contemporary Art; New Haven, CT: Yale University Press, 2019), 76.
26. Auther, "Schapiro and the Politics of the Decorative," 81.
27. Sherrie Levine, quoted in Lilly Wei, "Talking Abstract: Part Two," *Art in America* 75, no. 12 (December 1987): 114.
28. Ibid.
29. Original no longer extant.
30. Kellie Jones, "Assured Calamity: Elizabeth Murray's 1980s," in *Elizabeth Murray: Painting in the '80s*, by Kellie Jones and Bob Holman, exh. cat. (New York: Pace, 2017), 14.
31. Suzanne Jackson, interview by Barbara McCullough, *BOMB*, no. 157 (Fall 2021), https://bombmagazine.org/articles/suzanne-jackson/.
32. Dona Nelson, "Two-Sided Paintings," in *Dona Nelson: Stand Alone Paintings*, ed. Ian Berry and Molly Channon, exh. cat. (Saratoga Springs, NY: The Frances Young Tang Teaching Museum and Art Gallery, Skidmore College, 2020), 141.
33. Ibid.
34. Laura Owens, "Optical Drive: Sarah Lehrer-Graiwer Talks with Laura Owens," *Artforum* 51, no. 7 (March 2013): 231–39.
35. Ibid.
36. "Isn't it interesting that a male orgasm has a DNA imprint that will replicate itself over and over again, reinforcing itself the way language or naming might, but the female orgasm has no use, no mark, no locatability. It can't even be located in time. I want to think about how that can be the model for a new gesture" (ibid., 236). See also my essay "Laura Owens: Emphatic Abstraction," in *Laura Owens*, by Walead Beshty et al. (New York: Skira Rizzoli, 2015), 89–100.

Women Curating Women, 1915–2022

Daniel Belasco

Inspirational and divisive, the all-women exhibition has been one of the most important, though still underappreciated, institutional practices in modern art since its emergence in mid-nineteenth-century Europe in response to the needs of a growing number of professional women artists. All-women exhibitions index women's artistic agency, recording changes in aesthetics, gender discourse, and social activity during the long period when very few women were able to gain recognition from male-dominated institutions. Yet these projects have existed almost entirely outside the primary narratives of art history, because they were rarely viewed as avant-garde or at all influential until the onset of the feminist art movement in the 1970s. Most were organized by the artists themselves, usually in the form of salons or annual exhibitions by members of women artists' groups to combat discrimination, advocate for their work, and boost professional prospects. Sometimes, commercial galleries hosted all-women exhibitions of contemporary art. Less frequently, museums devoted gallery space to exhibitions of art by women. Whatever the context, these presentations invariably elicited objections to their gender segregation, which critics have generally considered antithetical to the universalist values of modern art. Indeed, many women artists have declined to participate out of concern that being associated with an exhibition of "women's art"—analogous, in some quarters, with dilettantism, craft, and domesticity—would diminish their standing in the male-dominated art world, with its self-validating criteria of greatness and genius. "Let's get the hell out of here," Joan Mitchell said to Elaine de Kooning at a party when an unidentified man asked for their opinion as "women artists."[1] Nevertheless, many thousands of women artists have presented their work and otherwise benefited from the public exposure and communal relationships achieved through all-women exhibitions.

The present essay focuses on exhibitions organized in the United States by women artists—not curators, dealers, or membership groups—to extend their aesthetic priorities into the political realm. In this vein, such shows can be aligned with the "political timing specific" interventions staged by the Cuban performance artist Tania Bruguera (born 1968). As the art historian Claire Bishop has explained, Bruguera's works are "not commissioned or invited but self-initiated; they stem from urgency, frustration, and daring."[2] Especially since the 1970s, women artists have rejected or ignored internal and external doubts and taken the risk of organizing exhibitions for themselves and their peers that illuminate intersectional discrimination, question gender binaries, and build new communities. Many of the artists in the Shah Garg Collection have participated in or been impacted by such transformative projects, which have helped to destabilize social constructions of race as well as gender.

The history of all-women exhibitions as political extensions of women's artistic practices in the United States began over a century ago, in the convergence of first-wave feminist activism, visual culture, and the art market. In an early example, six artists organized *Works of Art by Women Painters and Sculptors for the Woman Suffrage Campaign* at the Macbeth Gallery in New York to raise funds several weeks before a state referendum in 1915 (fig. 1). Although some of the more than ninety artists had previously contributed illustrations, banners, or signs to the movement's journals and demonstrations, this was the first specifically timed mass mobilization of fine art by women in response to a major suffrage vote. "Hereto we have thought we would do the most for the cause by staying in our studios and doing our work as well as we could," one participant explained of the reprioritization of the political valence of studio art.[3] Despite its generic title and the largely apolitical artwork on view, the exhibition served as a notable early effort by artists to intertwine the issues of women's rights and artistic freedom in the form of an all-women exhibition.

Following women's social and economic advances of the 1930s and early 1940s, the Cold War era's resurgent conservatism and antifeminist backlash motivated a handful of artists to bolster their positions in contemporary art by pointing to women's accomplishments in earlier art history. Dorothy Woodhead Brown (1899–1973), an artist and art professor at UCLA, began to exhibit her collection of paintings, prints, and drawings by women from Angelica

Fig. 1 Announcement for *Works of Art by Women Painters and Sculptors for the Woman Suffrage Campaign*, Macbeth Gallery, New York, 1915. Macbeth Gallery Records, Archives of American Art, Smithsonian Institution, Washington, DC

Fig. 2 Announcement for the exhibition *Women in Art*, Contemporary Arts Association of Houston, 1953. Contemporary Arts Museum of Houston Records, Woodson Research Center, Rice University, Houston

Kauffmann to Grandma Moses in venues such as the Stanford Art Gallery to support her claim that, in contemporary art, "women are enjoying a new era of creative emancipation."[4] In Texas in 1953, the artist (and high-school art teacher) Norma Henderson (1911/12–2000) curated the craft-oriented *Women in Art* at the Contemporary Arts Association of Houston, precursor of the Contemporary Arts Museum Houston (fig. 2). She enlisted fifty-seven artists (such as the jeweler Margaret de Patta and the fiber artist Mariska Karasz) whose creative responses to the atomic age, she posited, fell into an ancient continuum: "Woman has found new work for her sensitive hands interpreting her environment with new materials, new ideas, and old skills," reads the brochure text.[5] Both Brown and Henderson employed the all-women art show as an apolitical vehicle to educate the public about women's achievements, but, in affirming essentialist stereotypes and avoiding critical discourses, these prematurely celebratory narratives of the success of women artists in the United States failed to address continuing institutional gender and race discrimination.

It was not until the late 1960s and the rise of radical second-wave feminism, with its consciousness-raising groups and direct political action, that disillusioned artists embraced the all-women exhibition as a tool to publicly challenge the secondary status of women in the art world after nearly a decade of New Left activism. From 1969 to 1971, Women Artists in Revolution (W.A.R.), a collective of artists including Faith Ringgold (born 1930) and Nancy Spero (1926–2009), sent letters to museums in New York demanding that they implement "some form of a woman's exhibition" and enact other changes to begin to compensate for massive

historical underrepresentation.[6] One of the letters, submitted to the Museum of Modern Art (MoMA) in December 1969, called for a survey of women artists since 1850 and a show specifically of Black women artists as well as a retrospective of the work of Georgia O'Keeffe, then in her early eighties. Curating bold all-women exhibitions, often with satirical titles such as *Unmanly Art*,[7] became a key element of the radical feminist program to shatter the myth of "feminine fragility" (as the critic Margaret Breuning once phrased it)[8] and recast women artists as professionals no longer embarrassed by their gender.

Black women were not content to wait for MoMA or anyone else to get around to this reconciliation, however. In Los Angeles, the artist Suzanne Jackson (born 1944) organized the groundbreaking *Sapphire Show*, which opened on July 4, 1970, at Gallery 32, her alternative space in Westlake (fig. 4). "For a long time people couldn't figure out where my work was coming from, where to put me," Jackson recalled.[9] Her creation of a context for her expressive figurative paintings, along with the pigmented-water-filled vinyl sculptures of Senga Nengudi (then still known as Sue Irons), Yvonne Cole Meo's symbolic/iconographic paintings, and Gloria Bohanon's mystical ones, established a space of resistance against both the racial insensitivities of most feminist organizations and sexism within the Black Arts Movement. (Jackson's artwork has metamorphosed over the decades; see fig. 3, p. 53, pl. 51.) A year after *Sapphire*, in New York, Kay Brown (1932–2012), Dindga McCannon (born 1947), and Faith Ringgold organized *Where We At*, an exhibition of fourteen Black women artists, in a Greenwich Village gallery. These two shows produced a new sense of collectivity, prompting

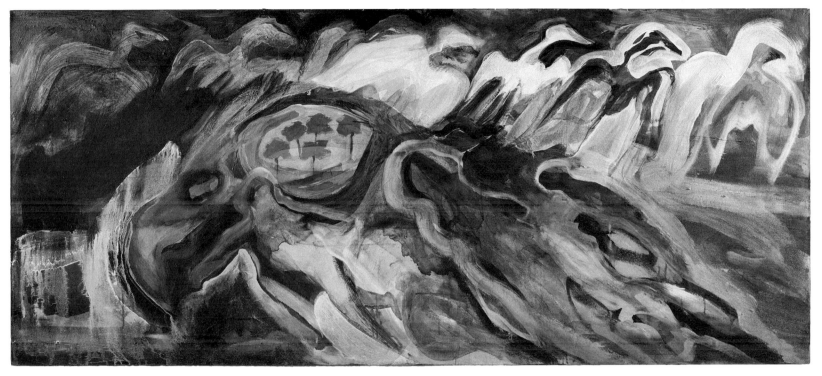

Fig. 3 Suzanne Jackson (born 1944). *Migration*, 1998. Acrylic on canvas, 36⅛ × 84¼ in. (91.8 × 214 cm). Shah Garg Collection

Fig. 4 Announcement for *Sapphire Show*, Gallery 32, Los Angeles, 1970. Ankrum Gallery Records, Archives of American Art, Smithsonian Institution, Washington, DC

subsequent exhibitions and contributing to the establishment of gender and racial difference as productive curatorial frameworks in American art. *Where We At* evolved into a long-lived, official collective of the same name, whose members met to discuss their work, provided childcare to support each other's productivity, and served hearty food at their exhibitions. These shows are frequently cited as the first exhibitions in the United States devoted exclusively to the work of professional Black women artists. However, Black women had been organizing exhibitions of art, craft, and photography for decades through local women's organizations, such as the Priscilla Art Club, established in Dallas in 1911, and in global settings such as the World's Columbian Exposition of 1893, in Chicago, which included an exhibition of creative work by Black women from New York organized by the educator Joan Imogen Howard.[10] Jackson, Ringgold, and others built on the legacy of these shows, often couching their urgent and transformative assertions of identity in freely expressive wit.

In the decade kicked off by the *Sapphire Show* and *Where We At*, the all-women exhibition became a force for change in the United States and internationally. New feminist organizations and groups, often structured as nonhierarchical collectives, supported artists' efforts to curate such exhibitions, which enabled intergenerational mentorship and raised political self-awareness. At Douglass College, the women's college of Rutgers University in New Brunswick, New Jersey, the painter and Douglass alumna Joan Snyder (born 1940), frustrated with entrenched discrimination in the art department, initiated the Women Artists Series, a multiyear program of one-woman exhibitions, to facilitate

contacts between students and established artists. "Women are emerging from history because history needs them to show the way to peace and the way to another kind of strength and reflection," she wrote.[11] In the first season, 1971–72, solo presentations of Mary Heilmann and Pat Steir, among others, at the Mabel Smith Douglass Library posited an enlightened future through a celebration of women's artistic innovations in abstraction and mark making, distinct from male-dominated paradigms. In Los Angeles in 1972, Judy Chicago (born 1939), Miriam Schapiro (1923–2015), and students in the Feminist Art Program of the California Institute of the Arts (CalArts) created *Womanhouse*, a collection of installations primarily concerned with embodying and subverting forms of gender discrimination. Also in 1972, twenty artists, among them Mary Grigoriadis (born 1942), Harmony Hammond (born 1944), and Howardena Pindell (born 1943), founded A.I.R., the first women's cooperative gallery in New York since the short-lived, apolitical Gallery 15 opened in Midtown in 1958.[12] These exhibitions and their sponsoring organizations aimed to revalue modern art by identifying and dismantling gender bias in the hierarchies of medium, technique, and content.

All-women exhibitions, by the end of the 1970s, had become an important mechanism for exposing homophobia, racism, and classism within feminist communal spaces. Hammond extended her art practice to curate exhibitions that surfaced hidden and subaltern identities. In 1978, she organized *A Lesbian Show*, showing Louise Fishman, Amy Sillman, and others at the alternative space 112 Workshop (also known as 112 Greene Street) in perhaps the first public exhibition of its kind. In a statement published in the same year, she wrote, "I refuse to be quiet; I want lesbian artists to be visible."[13] In that text, casting an eye backward, Hammond also sought to recuperate the legacies of artists such as the French painter Rosa Bonheur (1822–1899) and the American expatriate Romaine Brooks (1874–1970), who had never easily fit into the normative heterosexuality of earlier all-women exhibitions. The subversive centering of sexual orientation also opened the door, in later years, for

younger queer and nonbinary artists to organize more inclusive exhibitions that reflected the spectrums of sex and gender and deconstructed the male/female and man/woman dualities.

The following decade witnessed a new urgency on the part of overlooked women artists of color to assert a diversity of voices and presences. In 1980, Ana Mendieta (1948–1985), Kazuko Miyamoto (born 1942), and Zarina (1937–2020) organized *Dialectics of Isolation: An Exhibition of Third World Women Artists of the United States* at A.I.R., confronting the cooperative's persistent Eurocentrism. Pindell, the only Black founding member, presented the twelve-minute video *Free, White and 21*, a blistering first-person take on formalist aesthetics and American racism, in which she appears in whiteface. A few years later, in 1985, Jaune Quick-to-See Smith (born 1940) sought to rectify the near invisibility of contemporary Indigenous women artists by curating, with Hammond, *Women of Sweetgrass, Cedar and Sage*, a landmark exhibition of thirty artists at New York's Gallery of the American Indian Community House. With an emphasis on abstract and symbolic imagery, the exhibition responded to a shared history of oppression with an optimistic message. "There is a need to beautify life—rather than dwell on the difficulties," Smith explained in a catalogue text.[14] *Women of Sweetgrass* included, among examples of traditional crafts and exuberant takes on the same traditional media, Kay WalkingStick's allusive abstractions rendered in a blend of acrylic paint and saponified wax. For many women artists from underrepresented communities, organizing collective exhibitions that explored intersectional identities achieved tangible social and aesthetic aims.

A new wave of activism in response to the antifeminist backlash of the early 1990s brought together the Women's Action Coalition (WAC) and public protests against rape, the anti-abortion movement, and right-wing attacks on the National Endowment for the Arts. In 1994, at the New Museum, New York, the curator Marcia Tucker recognized the potential of this combative, punk-oriented aesthetic and organized *Bad Girls*, an exhibition of mostly women

artists that welcomed fellow-traveling queer men under the feminist tent. The often contentious works reveled in personal liberation, flaunting art-world taboos about good taste, decorum, and sexual content. Equally if not more assertive, the shaming tactics prosecuted by the Guerrilla Girls, aimed at increasing representation of women artists in museum collections and galleries, finally began to influence curatorial departments in the age of multiculturalism. Another pivotal exhibition occurred in 1995 when the painter Elizabeth Murray (1940–2007), invited by the Museum of Modern Art to curate an "Artist's Choice" exhibition, capitalized on the opportunity to celebrate women in modern art, selecting often overlooked works in the museum's collection by Jennifer Bartlett, Barbara Chase-Riboud, Helen Frankenthaler, Joan Mitchell, and many more (fig. 5). Though privately concerned about "ghettoizing" women, Murray followed her gut and assembled the first matrilineage of modern art within its most august temple. "I still don't know if it's the right thing to do. But I still just went ahead and did it anyway," she wrote in her journal.[15]

Murray's *Modern Women*, opening a quarter century after W.A.R.'s letter-writing campaign, anticipated major museums' emerging agenda to incorporate the category of "women artists" into their programming. Since then, nearly every major international museum has mounted some sort of all-women exhibition, from historical studies to collection surveys, often organized by curators with professional training in feminist art history. Projects such as *WACK! Art and the Feminist Revolution* (The Museum of Contemporary Art, Los Angeles, 2007), *We Wanted a Revolution: Black Radical Women, 1965–85* (Brooklyn Museum, 2017), and *Women in Abstraction* (Musée National d'Art Moderne–Centre Pompidou, Paris, 2021) have reintroduced the essential work of hundreds of women artists to the public and expanded the collective understanding of their interactions with politics, identity, and aesthetics. Yet, while museums now devote unprecedented resources to the excavation and presentation of global histories of women artists, individual artists and small collectives continue to call attention to the evolving terms of gender and art. Exhibitions such as *Brand New Heavies* (fig. 6), curated by Mickalene Thomas and Racquel Chevremont (collectively known as Deux Femmes Noires; both born 1971) at Brooklyn's Pioneer Works in 2021 and featuring monumental installations by three women artists of color—Abigail DeVille, Xaviera Simmons, and Rosa-Johan Uddoh—create necessary spaces of strength and solidarity. After a century and more of women artists' curating exhibitions to assert control over their work, a wholesale revaluation of art and its historiography has affirmed the avant-garde status of the all-women exhibition, which is now both a potent concept for commercial gallery shows and an emerging field of academic study.[16]

1. Elaine de Kooning with Rosalyn Drexler, "Dialogue," in *Art and Sexual Politics: Women's Liberation, Women Artists, and Art History*, ed. Thomas B. Hess and Elizabeth C. Baker (New York: Macmillan, 1973), 56.
2. Claire Bishop, "Rise to the Occasion," *Artforum* 57, no. 9 (May 2019): 198–204.
3. Mariea Caudill Dennison, "Babies for Suffrage," *Woman's Art Journal* 24, no. 2 (Autumn 2003–Winter 2004): 24.
4. "Talented Artist Turns Professor," *Independent* (Los Angeles), May 8, 1958: A7.
5. "Foreword to Catalogue," in *Women in Art*, exh. cat. (Houston: Contemporary Arts Association of Houston, 1953), n.p.
6. Women Artists in Revolution, "Mz PLAN/NYC MUSEUMS 1970–1971," in *A Documentary HerStory of Women Artists in Revolution* (New York: W.A.R., 1971), 32. See also Carmen Hermo, "Collective Artist Actions in New York," in *We Wanted a Revolution: Black Radical Women, 1965–85; A Sourcebook*, ed. Catherine Morris and Rujeko Hockley (Brooklyn, NY: Brooklyn Museum, 2017), 116.
7. June Blum, *Unmanly Art*, exh. cat. (Stony Brook, NY: Suffolk Museum, 1972).
8. Ellen Wiley Todd, *The "New Woman" Revised: Painting and Gender Politics on Fourteenth Street* (Berkeley: University of California Press, 1993), 62.
9. Suzanne Jackson, interview by Karen Anne Mason, August 12–16, 1992, Center for Oral History Research, UCLA Library (website), https://oralhistory.library.ucla.edu/catalog/21198-zz0008zszs.
10. *World's Columbian Exposition, 1893: Official Catalogue of Exhibits*, pt. 14, *Woman's Building* (Chicago: W. B. Conkey, 1893), 66–67.
11. Joan Snyder, "8 Women Artists: A Series of Exhibits at the Library," undated memorandum, Mary H. Dana Women Artists Series Records, Special Collections and University Archives, Rutgers University Libraries, New Brunswick, NJ.
12. Jeanette Feldman, "Texas Letters—and the Story of the First Women's Co-op," *Women Artists News* 4, no. 8 (February 1979): 10.
13. Harmony Hammond, "Lesbian Artists," in *Wrappings: Essays on Feminism, Art, and the Martial Arts* (New York: TSL Press, 1984), 40.
14. Jaune Quick-to-See Smith, "Women of Sweetgrass, Cedar and Sage," *Women's Studies Quarterly* 15, no. 1–2 (Spring/Summer 1987): 35.
15. Jason Andrew, "25 Yrs Ago: Elizabeth Murray Curates 'Modern Women' at MoMA," Estate of Elizabeth Murray (website), June 15, 2020, https://elizabethmurrayart.org/archive/2020/6/15/25-yrs-ago-em-curates-artists-choice-at-moma.
16. See Catherine Dossin and Hanna Alkema, "Women Artists Shows/Salons/Societies: Towards a Global History of All-Women Exhibitions," *ArtI@s Bulletin* 8, no. 1 (2019), https://docs.lib.purdue.edu/cgi/viewcontent.cgi?article=1224&context=artlas. Recent homages to all-women exhibitions of the past include *31 Women* (2017) at Breese Little, London; *You've Come a Long Way, Baby: The Sapphire Show* (2021) at Ortuzar Projects, New York; and *52 Artists: A Feminist Milestone* (2022–23) at the Aldrich Contemporary Art Museum, Ridgefield, CT.

Fig. 6 Installation view, *Brand New Heavies*, Pioneer Works, Brooklyn, April 2–June 20, 2021

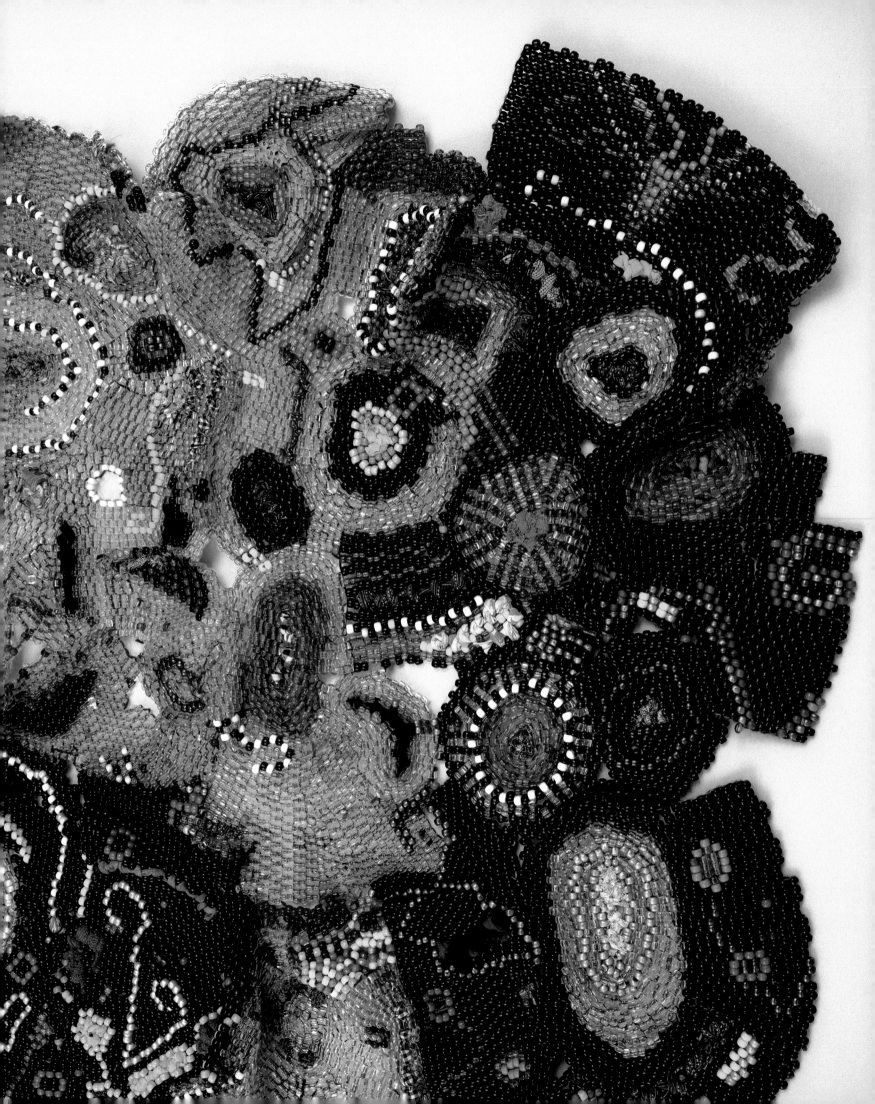

Craft in the Abstract

Glenn Adamson

A few years ago, the Swedish visionary artist Hilma af Klint (1862–1944) resurfaced from obscurity. She was hailed as an overlooked progenitor for her radiant, diagrammatic paintings, which predate the conventionally established inception of abstract art by several years.[1] Around the same time, the yarn-wrapped sculptures of Judith Scott (1943–2005) were the subject of a posthumous touring exhibition.[2] The American artist had had Down syndrome, which rendered her largely uncommunicative. In light of this, the institutional recognition of her work—work that she had generated completely independent from any precedent—applied "critical pressure," as the scholar Tobin Siebers had put it some time earlier, "on intention as a standard for identifying artists."[3]

Such rearrangements of the art-historical canon are certainly welcome, destabilizing, as they do, the settled, patriarchal account of modernism's origins and the misleadingly narrow account of its linear forward development. Yet they also raise provocative questions. If we accept Scott's work as a viable contribution to the annals of abstraction—and the sheer formal power of her work demands that we must—then the presumption that abstraction's value is inherently programmatic, or manifesto-driven, is untenable. And if we are also to backshift the advent of abstraction by a few years on the basis of one exceptional case, why not go still further back—much, much further? If Scott's sculptures and af Klint's paintings are great abstract artworks, what about certain anonymous Tantric Hindu paintings, such as those made in Rajasthan and elsewhere in South Asia since at least the seventeenth century (fig. 1)?[4] Or the cosmological sand paintings of the Navajo?[5] Or the dense, polychromatic patterns that Aboriginal Australians have been making for thousands of years?[6]

For that matter, what about crafts? Textiles, in particular, have always been a context for complex abstraction. The discipline's vocabulary has developed in a way that might be described as "medium-specific," through intelligent manipulation of the woven matrix or the more adventitious juxtapositions of patchwork. Similar dynamics occur in other crafts, such as ceramics, whose formal lexicon has evolved through the technical possibilities of hand-building or wheel-throwing and through various methods of glazing and firing.

Makers, alive to the creative potential of these disciplines, have long been ahead of art historians on this score. Consider Lenore Tawney (1907–2007; fig. 2), for example, who was deeply influenced by ancient American gauze textiles in which warp threads, laterally manipulated into diagonals and twists, break up the regular grid. In her "woven forms," she enlarged this idea to a grand scale, creating

Fig. 1 *Untitled*, 2009. Made in Sanganer, Rajasthan, India. Paint on salvaged paper, 12⅛ × 8¾ in. (30.8 × 22.2 cm). From *Tantra Song: Tantric Painting from Rajasthan*, ed. Franck André Jamme (Los Angeles: Siglio, 2011)

Fig. 2 Lenore Tawney seated in her studio at 27 Coenties Slip, New York, 1958. Photo: David Attie

openwork hangings with a propulsive vertical rhythm and a sinuous silhouette, which somewhat evoke the human figure.

Many other fiber artists took up the implicit challenge of Tawney's work, among them Trude Guermonprez, Sheila Hicks, Françoise Grossen, and Kay Sekimachi, all of whom developed new ways to open up the discipline to sculptural three-dimensionality. Guermonprez (1910–1976) trained in Europe—not exactly at the Bauhaus, but in its orbit—and succeeded Anni Albers as a weaving instructor at Black Mountain College in North Carolina; after the experimental school's closure, she moved to California. There, as a way to assert sculptural qualities in space, she developed the relatively straightforward approach of placing multiple woven planes in intersection. Working in parallel to Guermonprez was the supremely individualistic Sheila Hicks (born 1934), who embarked on an adventurous few years in Mexico in 1959, keenly observing vernacular textile practices and incorporating them into her own work. *Taxco* (fig. 3), made in the 1970s, looks back to this formative period, taking its title from a town in the state of Guerrero where the artist had lived. It also projects forward, presaging the increasing

Fig. 3 Sheila Hicks (born 1934). Detail of *Taxco* (pl. 19), ca. 1970s. Wool, cotton, and metallic thread, overall 78 × 45 × 6 in. (198.1 × 114.3 × 15.2 cm). Shah Garg Collection

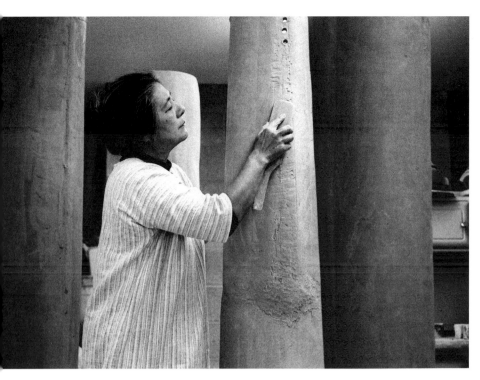

Fig. 4 Toshiko Takaezu paddling one of her ceramic "trees" in her studio in Quakertown, NJ, 1984. Photo: Walter Chandoha

freedom—spatial, sculptural, and spiritual—of her present-day works, in which she employs off-loom techniques to achieve polychromy at architectural scale.

Sekimachi (born 1926) and Grossen (born 1943), for their part, have brought diametrically opposed aesthetics to the discipline: Sekimachi creates extraordinarily complex, diaphanous structures by integrating multiple woven surfaces, while Grossen is predisposed to the thick, ropy, and muscular, employing oversized knotting and asymmetry to visceral effect. Though abstract, both artists' works have the feeling of bodies in space. *Contact III* (pl. 43), one of Grossen's most important works, resembles Baroque passementerie at a grand scale, but it also patently demonstrates how the artist managed to repossess the technique of seriality from Minimalism. Grossen's oeuvre is a reminder that it is in crafts (and textiles in particular) that rhythmic repetition has been exploited to greatest effect.

To the extent that Lenore Tawney had a counterpart in the world of ceramics, it was Toshiko Takaezu (1922–2011; fig. 4). Though almost a generation apart in age, the two women were extremely close (they even lived together for a time in the late 1970s) and often showed their work in tandem. It was an inspired juxtaposition, Tawney's lightly constructed, ethereal weavings floating amid Takaezu's massively built objects. Despite the sense of opposition, the two women shared a great deal in their artistic approaches. Takaezu, too, was inspired by historical precedents—in her case, East Asian pots and calligraphy—and found ways to transform those idioms to make them relevant to contemporary art. Most obviously, this involved sheathing her ceramics in glorious veils and supervening splashes of glaze, in implicit dialogue with Abstract Expressionism. She also activated her work in another, subtler way, by introducing loose rattles of fired clay inside her closed forms, making them into kinetic, sounding sculptures.

Just recently, some of these figures—all of whom, it will be noticed, are women—have been getting their just and belated attention from museums.[7] So, too, have other leading protagonists of modernism, such as Sophie Taeuber-Arp (1889–1943) and Sonia Delaunay (1885–1979), who shuttled back and forth between abstract paintings and textiles (as well as other media, including jewelry).[8] All this activity marks a decisive break with the orthodox art-historical attitude to craft, which relegates it by fiat to a marginal position. Indeed, the related concept of "decoration" was often construed as a zone of potential failure, a state into which a serious artwork might inadvertently, and irretrievably, collapse.[9]

This dismissive attitude toward craft was vigorously contested by feminist artists in the 1970s, particularly those associated with the Pattern and Decoration (P&D) movement, who advocated a thorough reappraisal of historical material culture and borrowed from it extensively in their own work. Yet, while P&D did gain some critical traction, it was soon all but written out of art history. As the curator Lynne Cooke has commented, this was due partly to a reckoning with the movement's essentialist and Orientalizing tendencies; partly to a rejection of its preference for surface-oriented sensuousness over conceptual seriousness; and, "not least," to "the art world's entrenched sexism [which] fostered the occasion for its denizens to belittle and sideline a movement renowned for the dominant role played by women in its genesis and trajectory."[10] Only recently has this history been confronted, aided by the art world's long-delayed imperative toward gender and ethnic inclusivity.[11] Works in the Shah Garg Collection by Dawn Williams Boyd, Vibha Galhotra, Ruth Root, and the late Elizabeth Talford Scott (pls. 60, 105, 83, 4) show the sheer range of expression afforded by crafted abstraction. Although these artists may be more or less explicit in their citations, all have taken inspiration from vernacular traditions, which are themselves being broadly reevaluated for their contributions to art history.

A bellwether moment for this new outlook—in the United States, at any rate—was the exhibition *The Quilts of Gee's Bend*, which, from its outset in 2002, astounded many observers by drawing huge crowds on its national tour, especially at New York's Whitney Museum of American Art. (This shouldn't have been too much of a surprise, as a hastily organized exhibition of Amish quilts at the Whitney in 1971 had broken attendance records in its own day; the fact that craft registers deeply with the public is a lesson that museums apparently must relearn each generation.)[12] The general tendency, in responses to the Gee's Bend show, was to compare quilts by women such as Mary Lee Bendolph (born 1935) and Qunnie Pettway (1943–2010) to more familiar abstractions in the Euro-American canon. Thus, Michael Kimmelman, in the *New York Times*, wrote of the quilts as "some of the most miraculous works of modern art America has produced. Imagine Matisse and Klee (if you think I'm wildly exaggerating, see the show) arising not from rarefied Europe, but from the caramel soil of the rural South."[13] The geographic isolation of the community was nearly always stressed in such accounts—as if it somehow guaranteed the purity of the work made there, protecting the natural genius of the community.

A great deal was stripped away in this narrative of immaculate conception. The broader historical context

of Southern quilts, involving White as well as Black makers, tended to get short shrift in the show's popular reception. So did the political context of the civil rights movement, especially as manifested in the Freedom Quilting Bee, a cooperative based in southeastern Alabama that had strong links to Gee's Bend via activist-artisans such as Lucy Mingo (born 1931), who participated in protests in the state capital, Montgomery.[14] Most important, what was lost in presenting Gee's Bend quilts as a singular, inspiring phenomenon was the fact—as the art historian Anna C. Chave has argued— that they are, in fact, crafted, made for practical purposes, even out of necessity. "The arduous, perennial labor of assembling their families' covers was done above all out of abject need on top of the backbreaking labor of farming and running households," Chave wrote. "Refuting their status as handcrafted objects of utility and assimilating them to—or colonizing them for—art world purposes and discourses, critics deprive the quiltmakers of their rightful status as specialists in their own cultural form."[15]

This is a powerful challenge to the well-meaning but obtuse habit of supposedly "elevating" craft by folding it into conventional art history. The respect paid to objects and their makers is welcome, but it often comes at the cost of deracination, a willful forgetting of the specific expertise, and broader economic and social conditions, that make craft possible (and necessary) in the first place. And feminists of the 1970s well understood this. Begun in 1974, Faith Ringgold's *Window of the Wedding* series (pl. 14), her first entirely abstract works, were based on Tibetan *thangka*s she had seen at the Rijksmuseum in Amsterdam. The painted canvases were conceived as backdrops for imagined "ideal weddings" for her own daughters (who remained unaware of the project), "a kind of hanging prayer rug . . . giving them magic protection, and above all, happiness."[16] She extended this familial gesture by incorporating textile work executed, at her request, by her own mother into the *Window*s, a literal materialization of the artist's indebtedness to her forebears; a further such materialization is the pattern of tessellating triangles painted onto the unstretched canvases, inspired by cloths made by the Kuba people of central Africa (present-day Democratic Republic of the Congo). The pattern also recalls then current hard-edge abstract paintings as well as African American quilts. Ringgold thus gave equal time to modernist innovation (including her own) and the aesthetic knowledge accumulated by past generations.[17]

A few years later, Ringgold recounted this ancestral lineage in detail: her great-grandmother Betsy Bingham had been taught to sew by her own mother, Susie Shannon (who had been born enslaved), using bleached flour sacks as quilt linings; her grandmother Ida made clothing; and her own mother, Willi Posey, also took up that trade, designing and making garments and even staging fashion shows. "My mother was always an artist," Ringgold wrote, "but she thinks of herself as a business woman."[18] This personal history appeared in a special 1978 issue of the journal *Heresies* devoted to women's traditional arts, pointedly subtitled "The Politics of Aesthetics." Throughout, the issue's editors emphasized the pragmatic constraints that impinge on craft as well as on aesthetic achievement. "The boundaries women have worked within and challenged were familiar to us," they wrote in their introduction. "Traditionally, women's working

spaces have been defined by their tent, hut or home, their psychological spaces by the rhythm of domestic demands."[19] In a contribution devoted to the Navajo community of Canyon de Chelly, in Arizona, the historian Madeleine Burnside noted, "[The weaver's] efforts are not to achieve but to continue. . . . At times weaving is not a pleasant task but a wasteland of drudgery, an end to which is not promised."[20]

Chave's observations about the lives of quilters in Gee's Bend, and the insights of the Heresies Collective, usefully focus attention on a dynamic that is easily overlooked in the laudable imperative to canonize figures such as af Klint and, for that matter, Tawney, Takaezu, and Hicks. All of these women managed to achieve an exceptional degree of personal and artistic freedom, but even they faced considerable constraint. This condition is implicit in af Klint's decision to keep her work largely out of public view during her own lifetime and in the limited support Tawney and Takaezu enjoyed over the course of their careers: they showed mainly in museums and galleries specializing in craft or in small, regional institutions. (Tawney had the advantage of an independent income, while Takaezu supported herself by teaching and selling functional pottery.) Even in the case of Hicks, who was relatively successful in commanding institutional attention in Europe, it is arguably only now that she is being given platforms commensurate with her artistic stature.

Of course, craft is not only about freedom; it is also defined by its limits. Tools and materials afford only certain possibilities, supplying a kind of creative friction to the maker; it is when these inherent restrictions are accepted, deeply understood, and tested to the utmost that craft becomes truly empowering (and let's remember that the word itself is derived from a Germanic root meaning "strength" or "power"[21]). Kathy Butterly (born 1963) exemplifies this principle in her ceramics. Although she positively luxuriates in clay's sensuous attributes, that sense of abandon is hard-won, emerging from an intensely rigorous process. She begins every object from an identical shape—a simple bowl, slip cast—then builds up an intricate carapace of ornament and glazes through multiple firings. In her most recent body of work, she places her amorphous porcelain vessels atop slab-built plinths of glazed red earthenware. Viewers may not be consciously aware of the material contrast, but at some level, they feel it.

Closely related to such probings of formal constraints and possibilities is craft's indexing of social position. Craft speaks richly of class, gender, and ethnicity, reflecting the reality of those identity formations even as it pushes against the prejudices that attend them. This was the core argument of the British art historian Rozsika Parker's influential book *The Subversive Stitch*: "The art of embroidery has been the means of educating women into the feminine ideal . . . but it has also provided a weapon of resistance to the constraints of femininity."[22] Emma Amos's *Star* (pl. 24), half weaving and half painting, depicts just this kind of situation: a figure, partly dissolving into the mesh of weaving and threadwork, also leaps unbounded into pictorial space. Amos (1937–2020), who was so personally invested in craft that she hosted a how-to program on Boston public television called *Show of Hands*, once spoke of her imagery as follows:

Fig. 5 Simone Leigh (born 1967). *Brick House* (detail), 2019. Bronze, overall height 16 ft. 4 in. (498 cm). Installation view, *Simone Leigh: Brick House*, High Line, New York, June 5, 2019–May 2021

> I became especially concerned with the issues of freedom of expression in figurative imagery, particularly the symbolic use of dark bodies. Researching the impact of race, I found that white male artists are free to incorporate any image. . . . Much of this work continues to be seen as groundbreaking in its expression of the will to cross boundaries. When African-American artists cross boundaries, we are often stopped at the border.[23]

Amos here was addressing not abstraction, but figuration—and in terms that strikingly anticipate the proliferation of this idiom among Black artists today. Yet the broader point she was making, that "freedom of expression" is a presumed prerogative only for White men, is equally pertinent to crafted abstraction, which has so often been the expressive means for everyone else. Given this history of inequity, the tremendous burden of the past is felt in such forms of abstraction—but so, too, is the possibility of that burden's being shifted.

Such a sense of displacement is palpable in the towering sculptures of Barbara Chase-Riboud (born 1939), which she has been making since the 1960s. Magnificently multivalent, they allude simultaneously to Baroque sculpture, African American garments and hairstyles, and African dance masks. They incorporate both bronze and fiber (usually wool or silk)—which is to say, they juxtapose conventional "fine" and "decorative" art materials, free of hierarchy. "This is the magic part," she has said, "when the bronze becomes silk solidifying into the material that supports the weight of the metal despite the fact that you know this cannot be so."[24] Similar transmutations of culturally encoded materials occur in the oeuvres of Joyce J. Scott (born 1948) and Marie

Watt (born 1967). Working in a medium—beading—that is typically identified with amateur or traditional practice, Scott primarily uses the peyote stitch, familiar from Native American beadwork, which does not require a loom and can therefore be used to build free-form shapes. Watt, who is partly of Seneca Nation ancestry, employs many materials but is particularly invested in reclaiming domestic textiles; in *Companion Species (A Distant Song)* (pl. 84), she stitches together satin blanket edgings to create an expansive abstract landscape, redolent of the broad American horizon and its competing mythologies.[25]

As the present volume was being organized, Simone Leigh (born 1967) was preparing to represent the United States at the 59th Venice Biennale. Her example serves as a fitting culmination to this essay—although, like Emma Amos, she engages with abstraction primarily in conjunction with figuration. Like her closely related, monumental public sculpture *Brick House* (fig. 5), which graced the High Line in New York City in 2019–21, *Stick* (pl. 81) is a marvel of resolution that flows from many currents of content. In a much-discussed social media post in 2019, Leigh enumerated some of these sources, including the Négritude movement, the works of David Drake (also known as Dave the Potter; ca. 1801–1870s), Saidiya Hartman's concept of "critical fabulation," Dogon statuary, and the life of the Congolese activist Pauline Opango Lumumba, whose bare-breasted protest of her husband's assassination, in 1961, seems a possible allusion in the conception of *Stick*. Leigh concluded her commentary by observing that if you are unaware of her many interconnected references, "then you lack the knowledge to recognize the radical gestures in my work. And that is why, instead of mentioning these things, I have politely said black women are my primary audience."[26] This framing of her intentions should not, I think, be taken as a gesture of exclusion—after all, Leigh's work does deliver abundantly to a less informed viewer, both emotionally and aesthetically—but rather as an insistence on one's awareness of the forcible occlusion of these histories, and the possibilities that derive from reclaiming them.

It is telling that Leigh, who trained in ceramics early in her career, has consistently included the medium's techniques and typologies in her sophisticated intellectual repertoire. Here, we see another side of craft's relation to abstraction, in which both are conceived not as static categories but as interlocking cultural processes. This synthetic impulse is also magisterially realized in the ceramics of Magdalene Odundo (born 1950), which, for all their apparent simplicity, contain a multitude of cultural sources—referring to ancient Greek, West African, Native American, and other pottery traditions—while simultaneously evoking the poised forms of a self-respecting human being. Crucially, such feats of synthesis open up the possibility of rethinking abstraction itself. Once upon a time, it was thought that abstraction's destiny lay in some final, liberating gesture; then, it seemed to be confined to a series of moves and countermoves in a hermetic, self-referential, and circumscribed discourse. Take craft from the margins and place it in the center of the story, though, and that narrow account opens up to a breathtaking vista, in which all cultures, all people, have played a part. Who, having glimpsed that broad view, if only for a moment, would want to see it any other way?

Fig. 6 Olga de Amaral (born 1932). Detail of *Alquimia Plata 6(B)* (pl. 17), 1995. Gesso, acrylic, silver leaf, and gold leaf on linen, overall 45 × 71 in. (114.3 × 180.3 cm). Shah Garg Collection

1. Tracey R. Bashkoff, *Hilma af Klint: Paintings for the Future*, exh. cat. (New York: Guggenheim Museum Publications, 2018). The Guggenheim show was preceded by an exhibition at the Serpentine Gallery, London, in 2016. Interest in af Klint was soon echoed by attention to another early abstractionist, Agnes Pelton (1881–1961). See Gilbert Vicario, ed., *Agnes Pelton: Desert Transcendentalist*, exh. cat. (Munich: Hirmer, 2019).
2. Catherine Morris and Matthew Higgs, eds., *Judith Scott: Bound and Unbound*, exh. cat. (Brooklyn, NY: Brooklyn Museum; New York: DelMonico Books/Prestel, 2014). The exhibition was shown at the Brooklyn Museum and the Aspen Art Museum in 2014–16.
3. Tobin Siebers, "Disability Aesthetics," *Journal for Cultural and Religious Theory* 7, no. 2 (Spring/Summer 2006): 69.
4. See Franck André Jamme et al., *Tantra Song: Tantric Painting from Rajasthan*, trans. Michael Tweed (Los Angeles: Siglio, 2011).
5. See Don Lago, *Where the Sky Touched the Earth: The Cosmological Landscapes of the Southwest* (Reno: University of Nevada Press, 2017).
6. See Wally Caruana, *Aboriginal Art*, 2nd ed. (London: Thames and Hudson, 2013).
7. Jenelle Porter, ed., *Fiber: Sculpture, 1960–Present*, exh. cat. (New York: DelMonico Books/Prestel; Boston: Institute of Contemporary Art, 2014); Karen Patterson, ed., *Lenore Tawney: Mirror of the Universe*, exh. cat. (Sheboygan, WI: John Michael Kohler Arts Center; Chicago: University of Chicago Press, 2019). Also relevant here are recent exhibitions of Olga de Amaral (born 1932; fig. 6) at the Museum of Fine Arts, Houston, and Cranbrook Art Museum, Bloomfield Hills, MI, and of Anni Albers (1899–1994) and Magdalena Abakanowicz (1930–2017) at Tate Modern, London. Hicks has been the subject of several recent exhibitions, including at the Nasher Sculpture Center, Dallas. Takaezu's work has been presented in relation to Abstract Expressionist painting at the Yale University Art Gallery, New Haven, CT; Museum of Fine Arts, Boston; and Crystal Bridges Museum of American Art, Bentonville, AR. At the time of this writing, a Takaezu retrospective is in preparation at the Noguchi Museum, Queens, NY.
8. See Marta Ruiz del Árbol et al., *Sonia Delaunay: Art, Design, Fashion*, exh. cat. (Madrid: Fundación Colección Thyssen-Bornemisza, 2017), and Anne Umland, ed., *Sophie Taeuber-Arp: Living Abstraction*, exh. cat. (New York: The Museum of Modern Art, 2021).
9. Elissa Auther, "The Decorative, Abstraction, and the Hierarchy of Art and Craft in the Criticism of Clement Greenberg," *Oxford Art Journal* 27, no. 3 (January 2004): 339–64.
10. Lynne Cooke, "Pattern Recognition," *Artforum* 60, no. 2 (October 2021), 132, 135.
11. See Anna Katz, ed., *With Pleasure: Pattern and Decoration in American Art, 1972–1985*, exh. cat. (Los Angeles: The Museum of Contemporary Art; New Haven, CT: Yale University Press, 2019), and Esther Boehle and Manuela Ammer, eds., *Pattern and Decoration: Ornament as Promise*, exh. cat. (Cologne: Walther König, 2018).
12. See Janneken Smucker, *Amish Quilts: Crafting an American Icon* (Baltimore: Johns Hopkins University Press, 2013), 77–79.
13. Michael Kimmelman, "Jazzy Geometry, Cool Quilters," *New York Times*, November 29, 2002, https://www.nytimes.com/2002/11/29/arts/art-review-jazzy-geometry-cool-quilters.html.
14. Lucy Mingo, artist's statement, in John Beardsley et al., *Gee's Bend: The Women and Their Quilts*, exh. cat. (Atlanta: Tinwood; Houston: Museum of Fine Arts, 2002), 281. See also Nancy Callahan, *The Freedom Quilting Bee: Folk Art and the Civil Rights Movement* (Tuscaloosa: University of Alabama Press, 1987).
15. Anna C. Chave, "Dis/Cover/ing the Quilts of Gee's Bend, Alabama," *Journal of Modern Craft* 1, no. 2 (July 2008): 225, 242.
16. Faith Ringgold, *We Flew over the Bridge: The Memoirs of Faith Ringgold* (Boston: Bulfinch, 1995), 203.
17. See Massimiliano Gioni and Gary Carrion-Murayari, eds., *Faith Ringgold: American People*, exh. cat. (New York: New Museum; Phaidon, 2022).
18. Faith Ringgold, "Reminiscences: Faith Ringgold," *Heresies* 1, no. 4 (Winter 1977–78): 84. After the first issue, published in January 1977, each issue of *Heresies* had an individual title, printed on the cover, that expressed its theme. The fourth issue was titled "Women's Traditional Arts—The Politics of Aesthetics."
19. "From the Editorial Group," *Heresies* 1, no. 4 (Winter 1977–78): 2. The editors included several of the key P&D artists, among them Valerie Jaudon, Joyce Kozloff, Melissa Meyer, and Miriam Schapiro.
20. Madeleine Burnside, "Weaving," *Heresies* 1, no. 4 (Winter 1977–78): 27.
21. See Alexander Langlands, *Cræft: An Inquiry into the Origins and True Meaning of Traditional Crafts* (New York: W. W. Norton, 2018).
22. Rozsika Parker, *The Subversive Stitch: Embroidery and the Making of the Feminine*, rev. ed. (London: Bloomsbury Visual Arts, 2010), vi. Parker was active in British feminism in the 1970s, contributing to the journal *Spare Rib* in its early years. For a recent extension of Parker's influential work into the study of masculinity, see Joseph McBrinn, *Queering the Subversive Stitch* (London: Bloomsbury Visual Arts, 2021).
23. Emma Amos, artist's statement, 1994, quoted in *Emma Amos: Falling Figures*, digital exh. cat. (New York: Ryan Lee Gallery, 2020), exh. on view September 10–November 7, 2020, accessed June 7, 2022, https://issuu.com/rlgallery/docs/falling_figures_catalogue?fr=sOGQ3NzMzMTgyMA.
24. Barbara Chase-Riboud, "On Her Own Terms: An Interview with Barbara Chase-Riboud," by Suzette A. Spencer, *Callaloo* 32, no. 3 (Summer 2009): 747.
25. See Glenn Adamson, "Native Song: Marie Watt's Communal Incantations in Fabric," *Art in America*, November 3, 2021, https://www.artnews.com/art-in-america/features/marie-watts-native-american-fabric-sculpture-1234608583/.
26. For a discussion of Leigh's post, see Seph Rodney, "Probing the Proper Grounds for Criticism in the Wake of the 2019 Whitney Biennial," *Hyperallergic*, June 7, 2019, https://hyperallergic.com/503513/probing-the-proper-grounds-for-criticism-in-the-wake-of-the-2019-whitney-biennial/. For Saidiya Hartman on critical fabulation, see her "Venus in Two Acts," *Small Axe* 12, no. 2 (June 2008): 1–14.

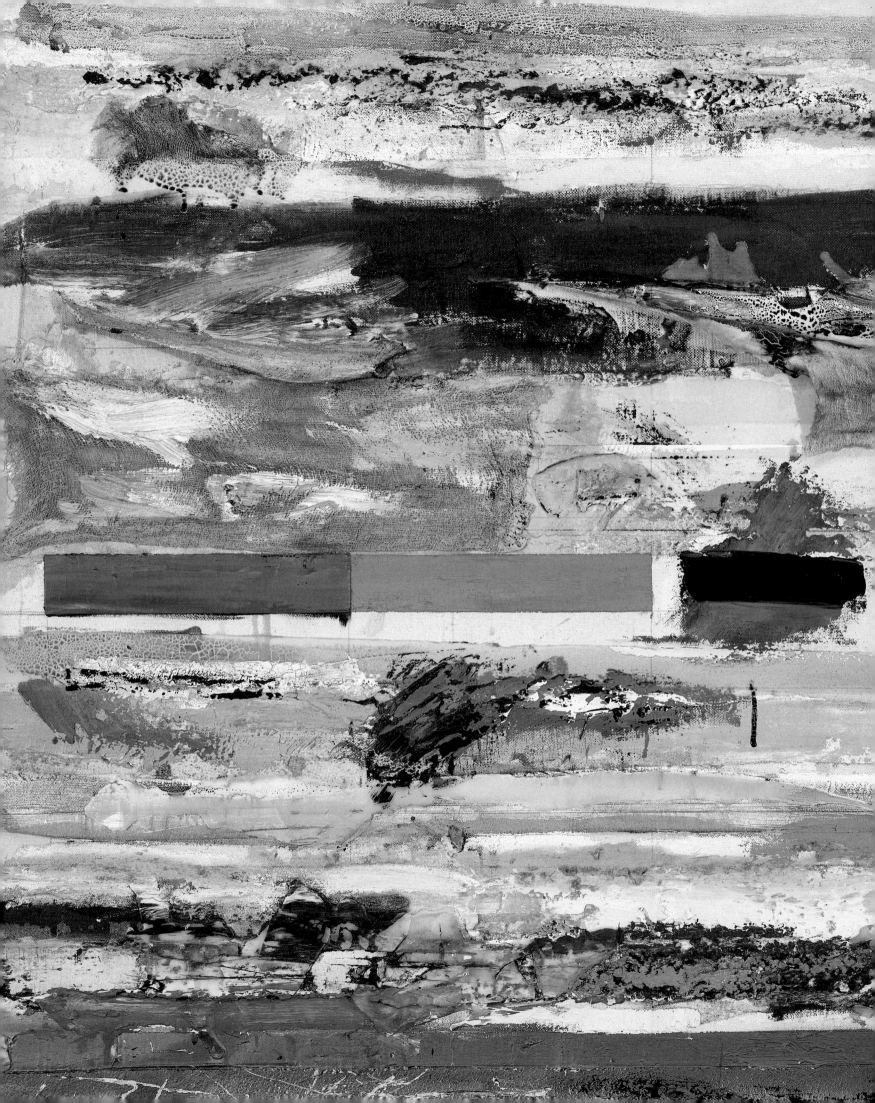

Queer Possibilities: Lesbian Feminist Abstract Painting in the 1970s and After

David J. Getsy

Abstract art has queer potential. By turning away from the representation of the recognizable world, artists can invest in forms and formal relations to conjure and present less restricted versions of how things might be—and be together. Since its emergence in modernism, abstraction has proved a useful place for some artists to register their lack of fit with expectations of sex, gender, family, and society that are based on a narrow, binary account of how people relate to one another.

In the 1970s, abstract painting, in particular, became an arena in which certain lesbian feminist artists confronted tradition and formulated other ways of seeing.[1] In the wake of the Stonewall Uprising in 1969, a more concerted and increasingly public movement emerged to speak to queer, lesbian, and/or gay experience. These developments were underwritten by the feminist movement and the profound impact it had on American art through the launching of countertraditions, new institutions, and a more activist mode of artistic practice. Lesbian and other nonheterosexual cisgender women were active participants, and a distinctly lesbian feminist art came into focus in these years.[2] On the one hand, photography and figuration took center stage (mirroring developments in feminist art as a whole). Artists such as Joan E. Biron (known as JEB), Tee Corinne, Honey Lee Cottrell, Diana Davies, Donna Gottschalk, and E. K. Waller sought new visual vocabularies for lesbian communities, often developing innovative modes of address and exhibition tactics to circumvent the sexism and homophobia they encountered in art institutions. Others turned to abstraction. The groundbreaking filmmaker Barbara Hammer (1939–2019), for instance, blended representation and abstraction in important experimental films that forged a different account of temporality, the body, and affective relations.[3] It was the medium of painting, however, that became pivotal in these debates. Abstract painters tackled the historical weight of art's traditions from an explicitly feminist and lesbian stance. Artists such as Lula Mae Blockton (born 1947), Mildred Thompson (1936–2003), and the three from the Shah Garg Collection who are the focus of this essay—Louise Fishman, Harmony Hammond,

and Joan Snyder—all drew on abstraction to visualize aspects of queer experience and community. Whereas the dominant art-historical narratives of the 1970s have tended to privilege dematerialized artistic practices such as conceptual and performance art, abstract painting proved particularly dynamic for lesbian feminist artists in the 1970s.

Painting—especially in its gestural, expressive, and animated forms, which emphasize the medium's capacity to be infused with action and performance—derives from and incites bodily engagements. As such, it was generative for feminist and lesbian artistic priorities that centered the meaningfulness of the body and its specificities. Abstract painting, furthermore, left behind the traditions of the figure (and the objectified female form that was their mainstay), instead creating a zone in which bodily analogies and empathies could be wrought through form and materiality. Examining works from the Shah Garg Collection, this essay discusses the ways in which artists rendered aspects of their queer experience and tendered different accounts of the body, community, eroticism, and relations from within the language of abstract painting. There is no unified or singular account of queer abstraction (or, indeed, of lesbian feminist abstraction).[4] More productive, rather, is to think of it as a shared questioning of how bodies, eroticisms, kinships, and potentials can be visualized without foreclosing any of the many ways that people can come together.

In queer versions of abstraction, there is often a concerted refusal of the recognizable and the categorizable. Instead, in the viewing of such works, allusion and analogy must be centered. Historically, one way in which lesbian, gay, and other forms of queer art have been limited, controlled, and compartmentalized is by demanding that they clearly and unequivocally produce visible evidence. Most often, some sort of eroticized or sexualized body or coupling has been expected, and anything that does not fulfill that limited iconographic requirement is doubted. This pattern of expectation reproduces the silencing and erasure faced by many queer people, as the only queer content that is valued is that which can be clearly seen—and, as a consequence, surveilled. But queer life involves much more than

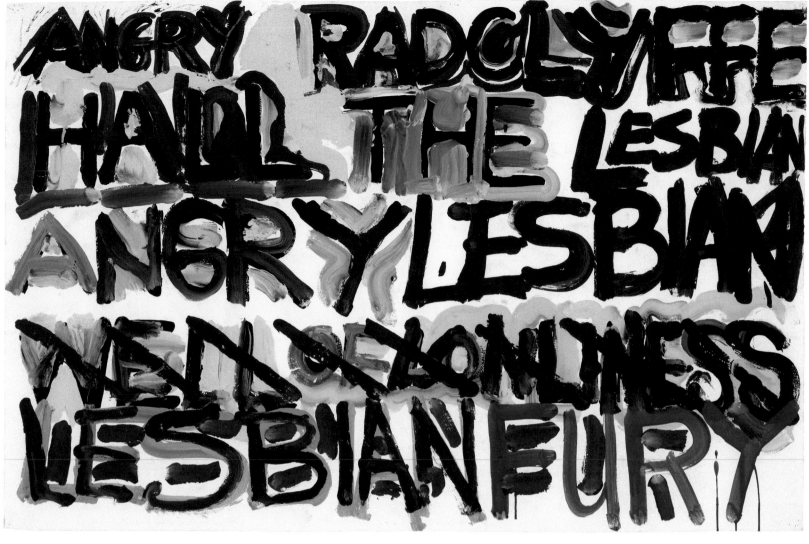

Fig. 1 Louise Fishman (1939–2021). *Angry Radclyffe Hall*, 1973. Acrylic on paper, 24 × 40 in. (61 × 101.6 cm). Louise Fishman Estate, New York

sex or eroticism (however defining those might be). Relations, domesticity, familial expectations, parenthood, others' misrecognitions, transformational genders, kinship, and aging are also components of queer lives. Because abstraction abjures the figure and emphasizes formal relations, it has proved useful in addressing relationality more broadly. Abstract paintings of queer experience (such as the ones discussed in this essay) do not repay any search for symbols or images; instead, they play out new ways of relating—to structures, to others, and to oneself—through forms, materials, and processes.

It is also important to remember that most artists working from minoritarian or marginalized positions will reject simplistic or reductive categorizations of those positions. Lesbian and gay artists, for instance, regularly claim that they do not make "lesbian paintings" or "gay sculptures." The reason for this is neither denial nor temerity. Rather, such rejections come from the understanding that their work is doing much more than that. These artists do not spurn the idea that their art relates to their identities but do recognize that others tend to limit their work to that category. The fight over the shorthand used to describe artists arises from a recognition of the limitations of labels and of their circulation as currency. But these same artists will

often speak of the importance of their individual experiences and political commitments, which help give shape to their work. For instance, in 1977, Louise Fishman (1939–2021) wrote, "I've been a lesbian and I've been a painter for a long time. I have little respect for rhetoric, politics that squeeze the life's blood out of artists, or theories of lesbian sensibility or lesbian imagery formulated out of daydreams."[5] This refusal of categorization, however, does not mean that Fishman's personal and political perspective did not inform her work, and she rigorously and repeatedly sought ways to register her own experience and position in her paintings. Her famous *Angry Women* series of 1973—which couples the defiant word "angry" with the names of important female-identified artists and writers (fig. 1)—is a case in point.[6] Her other works, too, do not simply represent lesbian content or subject matter; rather, they activate questions about finding possibility outside of heteronormative expectations.

Fishman's 1972 *Victory Garden of the Amazon Queen* (pl. 31) is one example. The painting came after the artist's previous turn to a reductive, more minimalistic style. The remnants of this minimalism can be seen in the underlying grid structure: each of the four linen surfaces is broken into four square containers holding schematic but energetic diagonal strokes, some of which coalesce into a form

resembling a flower. *Victory Garden* sets the modernist grid in tension with the brisk lines that both constitute it and transgress its internal boundaries. Fishman combatted the grid's structure of regularity and consistency through the superimposition of dynamic strokes that outline and define the square form as a layered set of gestural tracings along the four right angles. This grid is not a preexisting and presumed regularity; it has been hard-won through a campaign of emphatically painted lines. Each of the boxes is utterly unique while still being part of a chain of sameness; they are all squares and something more than squares. In this endeavor, Fishman was in dialogue with other artists who explored a dynamic relationship between sameness and particularity within the modernist grid, such as Agnes Martin (1912–2004) and Eva Hesse (1936–1970). Fishman, however, pushed her grid further through the layered, vigorous lines— some thick, some thin—that make up the painting's lattice.[7]

One might be tempted to view each square in *Victory Garden* simply as a frame, within which is set a picture. Indeed, Fishman seems to have flirted with that pictorial possibility. Across the sixteen squares, a few contain tree- or flower-like forms, and some include horizontal lines that establish something like perspective. Elsewhere, however, the drawn tracks of paint extend across squares and even across the divided canvases, as with the pinkish diagonal line that jumps the gap between the second and third canvases in the lower register. Most of the squares seem flat and emblematic, and the V shapes that occupy certain of them stand bluntly before us, creating a kind of absurd endgame of pictorial illusion, flatness, and signification. (Here, Fishman was in conversation with the very different treatment of the presentness of the graphic letter by artists such as Jasper Johns and Robert Indiana.) Others dissolve into opaque abstract fields filling the right-angled squares with allover compositions and diffuse gestures. (Think Helen Frankenthaler.)

Across Fishman's sixteen conjugations of a gestural grammar of square, diagonal, horizontal, and vertical, there is a profound examination of the pictorial possibilities of painting. *Victory Garden* levels the core techniques used to create images, illusions, surfaces, and depths. Pictures, emblems, gestures, and fields populate this grid, which is both foursquare and fulsome. The deep play with formal structures and with painting's possibilities in Fishman's work should be seen allegorically. The concerted unpacking of the grid structure and the contingency of the lines that compose it can be seen as a negotiation of the given versus the made: that is, the grid—that supposedly universal, objective, rational, and endlessly extensible modernist ideal— presents its sameness and regularity as the backdrop for uniqueness, interpretation, and potential. Each similar frame becomes not just a different picture but a different *kind* of picture—from glyph to landscape. With this lesson in the theory of painting, Fishman offered a demonstration of how to make difference from sameness.

The title of the work, *Victory Garden of the Amazon Queen*, reminds us that this questioning of difference and sameness is closely tied to feminism and to the potential of women's community and power. It conjures a utopian vision not just of the leader of the mythical Amazons but also of her preparedness and capacity for self-defense. Popularized during the wars of the twentieth century, victory gardens were planted (often by women) to increase self-reliance, boost morale, and contribute to war efforts. With her title, Fishman seems to have been implying that providing for one's own needs is a contribution to a greater effort. Through her reference to the stereotypical Amazon warrior, the artist invoked an all-women collective as the context for variation, possibility, and growth, and her painting can be taken as an illustration of how to cultivate those qualities from the stony ground of the modernist grid.

Like much predominantly abstract painting, Fishman's *Victory Garden* makes its claims through formal, processual, and material means. There is no blatant queer iconography in such a work; instead, abstraction becomes a place to evoke and imagine new ways a given form (such as the square) can be put into relation, appropriated, and transformed. A few years after making the painting, Fishman wrote:

> I want to caution against the dangers of purposefully and consciously setting out to make lesbian or feminist imagery or any other imagery which does not emerge honestly from the rigors of work. The chief danger as I see it lies in losing direct touch with the art, risking an involvement with a potentially superficial concern. This is not to say that the question of feminist or lesbian imagery is not a legitimate concern but rather to caution against its forced use.[8]

Fishman's statement provides a road map for understanding the ways in which abstract painting in the 1970s could register queer experience while refusing the spectacle and objectification that the direct representation of lesbian sexuality or eroticism might have incited. As with Hammond and Snyder, Fishman's larger aim was to capture modes of living and relating in greater complexity—evoked but not literally depicted. The art historian Jill H. Casid recently made a compelling and expansive case for Fishman's painting as a paradigm of queer expressivity:

> Fishman's working of the work of art offers us a way to grapple with the potentials of excessive expressivity as a queer, feminist creative praxis that draws on and with what is in excess of the regulated subject, both the abjected aspects of what is consigned to the merely "personal" and "emotional" of experience and also the immanent of the as yet—including what we might yet become.[9]

Forms and their relations are the terrain of abstraction, and abstraction becomes a vehicle for visualizing new variations and possibilities for them.

Modified grids, rectilinear planes, and right angles also provide a counterpoint in the works of Joan Snyder (born 1940), who often takes painting as an opportunity to compare related, yet distinct, aspects. This is the case with *Untitled* (pl. 36), made in a pivotal year in the artist's development. In the early 1970s, Snyder had developed a critical engagement with the terms of painting, resulting in her "stroke paintings" (fig. 2). These works took the stroke of paint as the basic unit of both painting and image making. The stroke simultaneously defines and covers, creating layers and depths that are both material and metaphorical. Snyder's works of these years often juxtapose grids (regular

or irregular) with declensions of isolated, colored strokes—each unique and separated while nevertheless connected to the others through their shared terms, shape, and orientation. The paint stroke's trace is inherently bodily, as it involves the redistribution of a malleable substance over a period of time (however short) by an animating body. In these years, Snyder was engaged with the expressionist discourse that saw painting as action and event, but she brought to that discourse a new determination about the painted mark not just as an effect of the artist's intention but as irreducibly material in and of itself. By juxtaposing the seemingly direct stroke of paint against tenuously drawn lines or grids, Snyder extended a new analytic to the expressionist gesture that both addressed its conventionality and put it in dialogue with its supposed opposite—the geometric.

Despite the success of the "stroke paintings," Snyder turned away from them in 1974, the year of *Untitled*. In new works, she explored color blocks and fields, replacing the grid with patchworks of rectangles that operated as both skin-like surfaces and interlocking panels. In her history of lesbian art in the United States, published in 2000, Harmony Hammond wrote that "Snyder is very conscious of using paint as a kind of skin, so that every gesture done with, on, or to the paint becomes a reference to the gendered body. In her use of collaged materials and of paint as an embodied material, Snyder is able to suggest narratives of gender and sexuality."[10] Throughout her work, Snyder often relied upon tensions between the painted mark and the painted surface, allowing for the staging of comparisons between them. As the art historian Jenni Sorkin has noted, "Through squares, diptychs, triptychs, and series of panels, Snyder's flexible sectioning is utilized as a strategy of differentiation, a way to separate and draw distinct boundaries between spatial areas and webs of ideas."[11] In *Untitled*, the comparative approach of the artist's earlier works comes into full force. The left side of the bisected canvas presents a series of horizonal strokes and washes, some of which bleed into the next. The underlying structure of horizontal bands becomes the scaffolding for boundaries that appear both porous and transgressed. One can see this structure and its breakdown in comparison to the more tightly controlled right side of the painting, with its clearly delineated blocks of color. The painting presents two options for seeing the same color relations: one liquid and intermingling, the other defined in a poised tessellation of monochrome rectangles and squares. Neither half is bounded or pure. An archipelago of defined horizontal rectangles extends into the left side of the painting, and two brown lines move into and across the right side's verticals. *Untitled* calls for a process of back-and-forth looking in which each side is perceived through the retinal burn and memory of the other. Despite its division, the work offers a synergy between its two sides' handling and composition.

The year of *Untitled* was one of transition for Snyder. For much of the first part of the year, she had stopped painting while recovering from Lyme disease; in the second part, she began to explore the new direction of these paintings that paired strokes with filled-in grids. This was also the year she began to make more explicitly feminist paintings incorporating words and language. In this context, *Untitled*'s dialectic of two different, yet related, sides can be understood allegorically. The brazen and the controlled coexist here, seen as reflections of each other.

Only later did Snyder come out publicly as a lesbian, but her paintings of the 1970s were—as she has remarked on numerous occasions—deeply informed by her feminism, frustrations, and abandonment of heteronormative expectations. In 1973, she said, "The painting always had to do with my life."[12] In the second half of 1974 and early 1975, in particular, she created works that struggled with acceptance of queer difference and with personal relationships. Her major work made the same year as *Untitled—Vanishing Theatre/The Cut* (1974)—derived from the dissolution of an entangled long-term relationship. The writer Hayden Herrera has noted that the painting "speaks clearly of conflicts of female sexuality."[13] Soon after, Snyder's 1975 *Heart On* also addressed her coming to terms with her sexuality.[14] *Untitled* sits alongside these two paintings chronicling the artist's realization and affirmation of her queer desire and future. Its bipartite comparison can be understood in light of the gradual fragmentation of long-held relations and emerging conflicts (both personal and interpersonal) between differing points of view. Snyder's works of this period speak to such crossroads and their divergences in perspective, presenting two related aspects of the same forms—one held together, the other dripping down—in which echoes of the one can be discerned in the other.

In contrast to the more gestural handling of oil paint deployed by Fishman and Snyder, *Letting the Weather Get In* (pl. 50), by Harmony Hammond (born 1944), might appear at first as a near monochrome, seamless and geometric. This distanced view is deceptive, however, as the shaped canvas came about from an intense bodily process. Up close, the dark surface reveals itself as a meticulously worked grid of warp and weft, created through the very thickness of the paint itself.

At various times in her career, Hammond has produced textile-wrapped armatures, floor-bound knotted tondos, and densely layered monochrome paintings punctured by grommets. Uniting all these works are two shared themes: first, the work of art is the outcome of a repeated and determined manual process (such as wrapping, knotting, weaving, or layering); second, a contest is staged in the work between the surface and the depths it struggles to contain. Hammond has long employed abstraction as a means to evoke openness and possibility, which are achieved through the manipulation of materials and the divergent forms that can be made from them. In an essay on the wrapped sculptures the artist started making in 1977 (the same year as *Letting the Weather Get In*), the art historian Margo Hobbs offers a compelling analysis of Hammond's abstraction and working process as analogues for lesbian experience:

> Two principles informed Hammond's production of her fabric constructions. She believed that there was a quality of lesbianness that consisted of more than sexual desire for women, but influenced her entire sense of herself in the world. And she thought that this quality expressed itself materially in her art-making practice, not just the final form but the process by which she shaped her sculpture.[15]

Indeed, the artist's materially rich abstractions offer a twofold evocation of the body: they result from bodily engagement, and they present their insides and outsides as an

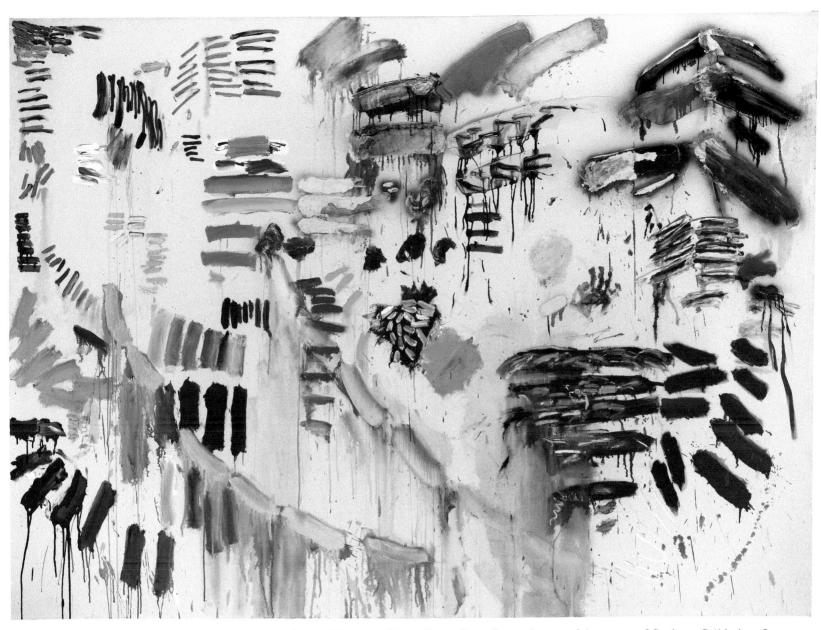

Fig. 2 Joan Snyder (born 1940). *Dark Strokes Hope*, 1971. Oil, acrylic, acrylic medium, and spray paint on canvas, 6 ft. 7 in. × 9 ft. ½ in. (200.6 × 275.7 cm). Tate, Lent by the Tate Americas Foundation, courtesy of Tate Americas Foundation and Komal Shah 2020. On long-term loan

analogy to her (and her viewers') sense of their own embodiment. We all know that we are more than we appear, yet we do not always apply that knowledge to others. Hammond's works are concerted acts of making that remind us that more lies within: not only do the base layers and armatures determine the outer layers that subsume and hold them, but they also make themselves evident through and upon the upper surface.

Letting the Weather Get In is one of a series of abstract "weave paintings" Hammond made from 1974 to 1977, after creating her floor-hugging textile tondos. Part of her return to easel painting at the time, these works sought to transpose some of the manual techniques of her textile works to the medium of oil paint on canvas. This wedding of painting and textile processes was an attempt to tackle the historical weight and authority of oil painting and to challenge its association with male dominance. In the artist's words:

This non-figurative feminist content in painting was radical at the time. I was very clear about what I was

doing. By referencing weave patterns found in textiles and basketry, I was able to take the feminist project of creating a historical narrative of women's creativity back into the painting field, merging traditional and fine arts in the skin of paint.[16]

In *Letting the Weather Get In*, the fusion of textile processes and painting techniques is achieved at the level of surface. Hammond deliberately slowed the viscosity of her oil paint by blending it with a wax medium, giving the painted surface a literal depth and thickness. Rather than merely representing a pattern or weave, Hammond cut into the paint's layers to create a topography of orthogonal patterns that support each other in place, much as they would in a textile. The consequence is an active tension between order and variation. As the artist says about these works, "The resulting surface was irregular, lumpy and bumpy, emphasizing the painting surface as skin and indirectly the body. For me, the painting skin, that edge where art and life literally meet, always relates to the body as site."[17] Whereas traditional

paintings offer the surface as a window to be looked through into illusionistic distances, Hammond's practice demands acknowledgment that paintings—like bodies—have integuments and insides.

It is significant that Hammond undertook these formal and material procedures within the realm of abstraction, as they led to a more capacious account of the body as, itself, material potential. Avoiding the depiction of the figure allowed her to evoke more directly the experience of living in a body. Hammond was among those feminist artists—including Fishman and Snyder—who declined to represent the human form because of the traditional objectification of images of women in art history. (There were other feminist artists, by contrast, who complicated the same histories of the figure by confronting the heterosexual male gaze and its presumptions.) Her priority was to explore bodies as sources of meaning, connection, and resistance. She turned to abstraction for the ways in which its formal relations and material processes could speak to interpersonal relations and embodiment. The artist later remarked:

> Abstraction offers the possibility of erotic art that bypasses the problematics of figuration. Instead of focusing on the figure with its fixed contour and impermeable surface of skin, abstraction opens up time and space, allowing us (other women/lesbians) to feel/respond sexually "in the body" (versus "to the figure") to what we see.[18]

The horizontal lozenge shape of *Letting the Weather Get In* relates to other works in which the artist sought an alternative to the verticality of the figure while still evoking a biomorphic roundness. As the art historian Tirza True Latimer has noted, the rounded lozenge is also, for Hammond, a repudiation of the modernist grid:

> Exhibited in an architectural space defined by right angles, the lozenge shaped work rejects interpretation as a part of a larger grid system. Curved edges reformulate the way the eye/body moves through space. While paintings in square formats suggest the possibility of infinite grid-like repetition, the lozenge disrupts this logic and unmasks the complicity of "white cube" gallery architecture and other high-art display conventions.[19]

Hammond also used the lozenge, or quasi-oval, form to imply sexuality, engaging with contemporaneous feminist conversations around vaginal imagery.[20] Suggesting but not representing such imagery allowed her to circumvent the voyeuristic objectification of the body while nevertheless addressing its experience. For instance, in the same year, she made *Conch* (fig. 3), which consists of two ovular forms wrapped in painted cloth and suggestively stacked one on top of the other. (This was the work Hammond chose to have reproduced in the history-making 1977 "Lesbian Art and Artists" issue of the feminist journal *Heresies*.)[21]

The horizontality of *Letting the Weather Get In* imparts a sense of depth and horizonal endlessness, while its rounded edges nevertheless squeeze, or hug, that space inward. As one nears the painting physically, what first appeared as a singular, dark monochrome comes into focus

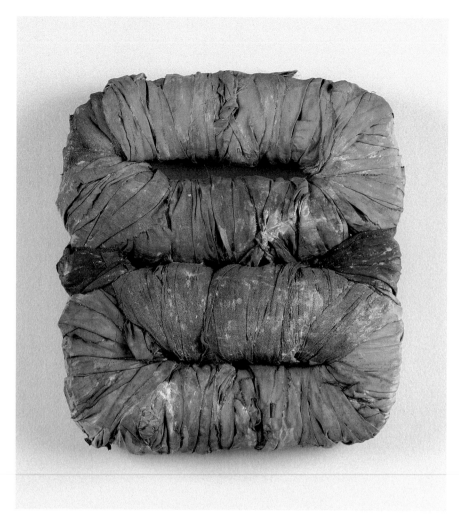

Fig. 3 Harmony Hammond (born 1944). *Conch*, 1977. Acrylic on fabric, 14 × 12 in. (35.6 × 30.5 cm). Collection of Rosemary McNamara, New York

as a variegated field punctuated by pockets of depth, revealing other hues in submerged layers. The title of the work suggests an open relation between inside and outside, and it calls to mind the opening of windows and doors to increase the flow of air and elements across a threshold. Hammond explains the title in this way:

> I've always been interested in layers, or more specifically, underlayers—what's behind or underneath being revealed or asserting itself. The title *Letting the Weather Get In* refers to the revealed underlayers of color as well as the notion of the outside world (people/places/politics) affecting one's life/art. This visual strategy of underlayers of pigment having agency to assert themselves on the painting's surface remains engaged in my most recent thickly painted near-monochrome paintings.[22]

As with the other paintings discussed thus far, *Letting the Weather Get In* evades being seen singly, and it evokes queer experience by performing the queer insistence on being more than what one appears to others. Not only do Hammond's paintings dissemble as monochromes, but they also demand attention to *all* that might not be apparent at first glance. There are multiple ways to encounter such a painting, and one could easily treat this artist's material and formal

strategies solely as reflections on modernism, or craft, or landscape, or flatness. However, Hammond (like Fishman and Snyder) has insisted that her strategies are more than that. As she said of some of her later paintings, "In their refusal to be any one thing at the same time they are themselves, the paintings can be seen to occupy some sort of fugitive or queer space and in doing so, remain oppositional."[23]

Working in the ferment of 1970s feminism, Fishman, Snyder, and Hammond each discovered that abstraction's forms and materials offered possibilities to expand expectations and confront limitations. All three were forthright about their feminist commitments, and Fishman and Hammond were two of the most visible and catalytic lesbian painters and community organizers of these years. The experience of living outside the framework of compulsory heterosexuality took energy, bravery, and commitment. As Hammond recalled about finding artists for her epochal 1978 exhibition *A Lesbian Show* at 112 Workshop, also known as 112 Greene Street, "[It] was a radical and risky gesture not to be underestimated. . . . As one's personal life was made public, artists risked everything from family and community disapproval to job discrimination to artistic stereotyping."[24] In making work that declared lesbian experience to be foundational, these artists demanded that familiar forms (like the monochrome or the grid) be seen differently: received rules had to be modified or broken; presumed patterns of behavior had to be remade. These experiences were transposed back to their work, in which they, too, navigated expectations, categorizations, and conventions—and sought egress from them. The predominance of the grid (as a foil) and gesture (as embodied) stood in for the larger set of limitations that needed to be shrugged off or forged anew.

The careers of Fishman, Snyder, and Hammond extended far beyond the 1970s, and each deepened her sophisticated engagement with the histories and possibilities of painting in the subsequent decades, providing bedrock for ongoing conversations in and around abstraction. The foundations they established inspired younger artists also to consider gestural abstractions and modified geometries as urgent sites of identification and visualization. Amy Sillman (born 1955) was just starting out as a painter in the 1970s and was immersed in this context. A member of the collective that put together the Fall 1977 *Heresies* issue, Sillman remarked at the time, "In my personal life the power of the combination lesbian/feminist/artist is tremendous. By personal life I mean the life I lead in my studio, where I take measurements of myself and begin to invent hypotheses and possibilities based on these measurements."[25] Her comment helps to illuminate the ways in which queer experiences could become a resource for artistic priorities, and Sillman later played a central role in debates about the queer possibilities of painting. Works such as her 2005 *Untitled (Little Threesome)* (fig. 4) result from a layering of recursive revisions of the same painted field—so much so that they demand an almost archaeological appraisal of their imbricated layers. In much of Sillman's work, abstraction vies with schematic figuration to suggest body parts or limbs, but without fully coming into focus. Each canvas is an archive of fittings and coverings— of findings and losings—that accumulate on and as the surface. Sillman's paintings call for an understanding of their temporality and the ways that elements (be they material or formal) have been compacted into the painting. She once

stated, "Abstract painting is a process of being in the world, of thinking, and not just a design. . . . Abstraction is a form of compression."[26] Sillman's layerings are a gestural action that is distinct from—but related to—the ways Fishman, Snyder, and Hammond used painterly or process-based gestures to confront the grid and the monochrome. Her layerings can be understood as records of attempted relations, some of which resolve and others that get buried. This, too, is a way of thinking about how the practice of painting can evoke both personal and interpersonal experience.

Similarly, Christina Quarles (born 1985) engages in processes of revision in her work. She often draws with paint on raw canvas, leaving some of the latter visible in the end. As a figure comes into focus, the artist will photograph the in-process form and manipulate it digitally before incorporating that visual and perspectival experimentation into the forms and fields she paints on canvas. As with Sillman's compressions, Quarles's paintings are records of modification and adaptation, but she focuses on the figure as a site of openness and relation in which inside and outside fold into each other. She has commented:

I often say that my paintings are portraits of living within a body, rather than portraits of looking onto a body. A lot of the things that interest me about gender, race and sexuality are things that I want to convey through the sense of living in a racialized body, a gendered body, or a queer body. Oftentimes that sense of living within your body doesn't at all line up with what it is to look onto your body or to look onto another body.[27]

Fig. 4 Amy Sillman (born 1955). *Untitled (Little Threesome)*, 2005. Oil on canvas, 45 × 36 in. (114.3 × 91.4 cm). Shah Garg Collection

Quarles's *Meet in tha Middle* (pl. 119; detail opposite) is a figural composition in which doubling and sameness are interwoven with difference. Figures and their shadows occupy the same spaces, and viewers might see one, two, or even three figures depending on how they count the various limbs and parts. Through the fragmentation, layering, and mirroring of the body, the artist has attempted to visualize the experience of embodiment and touch. Quarles's work may seem to be more directly concerned with queer sexuality than the other, less figurative paintings by Fishman, Snyder, Hammond, and Sillman, but they all have the shared goal of moving beyond the image of the body as an object for others' visual consumption. By contrast, they seek to evoke the complexity of bodies and persons that are more than they appear to others. In Quarles's confounding fusions of limbs and torsos, patterns of sameness allow for a queer potential to arise; their doublings (and triplings) exceed any binary preconception of how bodies must interact.

All the works discussed herein refuse a simple designation as lesbian and/or queer and/or feminist, but they are infused with the personal and political ramifications of these terms and the new possibilities that might be envisioned from them. Sillman perhaps summarized it best:

> To me, the word queer means difference. Queer represents the state of being different, not binary, not strictly one thing or another thing, and not either, but both, or some of each, or some of more than two, or something like that. That kind of open-endedness is useful to me both personally and aesthetically, and it's no accident that in my politics and my erotics and my art, the personal is linked with the aesthetic, and desire intertwines with form and with content and with process.[28]

Paintings made from queer experience need not make themselves immediately and readily visible as such, and painters such as Fishman, Snyder, Hammond, Sillman, Quarles, and others, such as Carrie Moyer (see pl. 69), have all used degrees of abstraction to evoke more open-ended recourses for relating, desiring, aligning, and being in the world. They refuse to offer a consumable image of a queer life. Instead, they use painting's processes and histories as tools to visualize queer possibilities.

1. In this, they built upon the precedent of earlier artists who subverted expectations of gender and sexuality, such as Nancy Grossman (born 1940), Agnes Martin (1912–2004), Louise Nevelson (1899–1988), Betty Parsons (1900–1982), Sonja Sekula (1918–1963), and Lenore Tawney (1907–2007). See Ann Eden Gibson, *Abstract Expressionism: Other Politics* (New Haven, CT: Yale University Press, 1997), 127–31; Ann Gibson, "Lesbian Identification and the Politics of Representation in Betty Parsons's Gallery," *Journal of Homosexuality* 27, no. 1–2 (1994): 245–70; Judith E. Stein and Helène Aylon, "The Parsons Effect," *Art in America*, November 2013, 132–39; Elizabeth Buhe, "Painting Opacity," in *Betty Parsons: Heated Sky*, ed. Alejandro Jassan and Alexandra Seneca, exh. cat. (New York: Alexander Gray Associates, 2020), 11–18; Jonathan D. Katz, "Agnes Martin and the Sexuality of Abstraction," in *Agnes Martin*, ed. Lynne Cooke, Karen Kelly, and Barbara Schröder, exh. cat. (New Haven, CT: Yale University Press, 2011), 170–97; Julia Bryan-Wilson, "Keeping House with Louise Nevelson," *Oxford Art Journal* 40, no. 1 (2017): 109–31; and David J. Getsy, "Second Skins: The Unbound Genders of Nancy Grossman's Sculpture," in *Abstract Bodies: Sixties Sculpture in the Expanded Field of Gender* (New Haven, CT: Yale University Press, 2015), 147–207.

2. For an overview, see Harmony Hammond, *Lesbian Art in America: A Contemporary History* (New York: Rizzoli, 2000).

3. See Barbara Hammer, "The Politics of Abstraction," in *Queer Looks: Perspectives on Lesbian and Gay Film and Video*, ed. Martha Gever, Pratibha Parmar, and John Greyson (New York: Routledge, 1993), 70–75.

4. For more on the potentials that queer artists have seen in abstraction, see David J. Getsy, "Ten Queer Theses on Abstraction," in *Queer Abstraction*, ed. Jared Ledesma, exh. cat. (Des Moines, IA: Des Moines Art Center, 2019), 65–75.

5. Louise Fishman, editor's statement, in "From the Lesbian Issue Collective," *Heresies* 1, no. 3 (Fall 1977): 4.

6. See Sarah Whitworth, "Angry Louise Fishman (Serious)," *Amazon Quarterly* 1, no. 4, and 2, no. 1 (October 1973): 57–59, and Catherine Lord, "Their Memory Is Playing Tricks on Her: Notes toward a Calligraphy of Rage," in *WACK! Art and the Feminist Revolution*, ed. Cornelia Butler, exh. cat. (Los Angeles: The Museum of Contemporary Art; Cambridge, MA: MIT Press, 2007), 440–57.

7. For more on the role of the grid in Fishman's practice, see Amy L. Powell, "Louise Fishman Drawing," in *A Question of Emphasis: Louise Fishman Drawing*, ed. Amy L. Powell, exh. cat. (Urbana-Champaign, IL: Krannert Art Museum, 2021), 19–29.

8. Louise Fishman, "How I Do It: Cautionary Advice from a Lesbian Painter," *Heresies* 1, no. 3 (Fall 1977): 75.

9. Jill H. Casid, "Queer Expressivity; or, the Art of How to Do It with Louise Fishman," in Powell, *Question of Emphasis*, 50.

10. Hammond, *Lesbian Art in America*, 37.

11. Jenni Sorkin, "Joan Snyder: The Geography of the Surface," in *Joan Snyder*, by Hayden Herrera, Norman L. Kleeblatt, and Jenni Sorkin, exh. cat. (New York: Jewish Museum; Harry N. Abrams, 2005), 69.

12. Joan Snyder, quoted in Hayden Herrera, "Joan Snyder: Speaking with Paint," in Herrera, Kleeblatt, and Sorkin, *Snyder*, 41.

13. Ibid., 40.

14. The Metropolitan Museum of Art, New York. See Hammond, *Lesbian Art in America*, 37.

15. Margo Hobbs [Thompson], "'Lesbians Are Not Women': Feminine and Lesbian Sensibilities in Harmony Hammond's Late-1970s Sculpture," *Journal of Lesbian Studies* 12, no. 4 (2008): 435–54.

16. Harmony Hammond, email message to the author, November 24, 2021.

17. Ibid.

18. Harmony Hammond, "A Space of Infinite and Pleasurable Possibilities: Lesbian Self-Representation in Visual Art," in *New Feminist Criticism: Art, Identity, Action*, ed. Joanna Frueh, Cassandra L. Langer, and Arlene Raven (New York: Harper Collins/Icon, 1994), 122.

19. Tirza True Latimer, "Harmony Hammond: Becoming/Unbecoming Monochrome," in *Harmony Hammond: Becoming/Unbecoming Monochrome*, ed. Tirza True Latimer (Denver: RedLine Art Space, 2014), 19–21.

20. See Hobbs, "'Lesbians Are Not Women,'" for a fuller discussion.

21. On the issue and its contentions, see Tara Burk, "In Pursuit of the Unspeakable: *Heresies*' 'Lesbian Art and Artists' Issue, 1977," *Women's Studies Quarterly* 41, no. 3–4 (Fall/Winter 2013): 63–78.

22. Hammond, email message to the author, November 24, 2021.

23. Harmony Hammond, "A Manifesto (Personal) of Monochrome (Sort of)," reprinted in Latimer, *Hammond: Becoming/Unbecoming Monochrome*, 4.

24. Harmony Hammond, "A Lesbian Show," in *In a Different Light: Visual Culture, Sexual Identity, Queer Practice*, ed. Nayland Blake, Lawrence Rinder, and Amy Scholder (San Francisco: City Lights Books, 1995), 46.

25. Amy Sillman, artist's statement, *Heresies* 1, no. 3 (Fall 1977): 48.

26. Amy Sillman, "Artist Talk: Amy Sillman" (lecture), The Art Institute of Chicago, October 30, 2017. See also Amy Sillman, *Faux Pas: Selected Writings and Drawings* (Paris: After 8, 2020).

27. Christina Quarles, "Intimacy, Unknowing, and Discovery: David Getsy in Conversation with Christina Quarles," in *Christina Quarles*, ed. Andrew Bonacina, exh. cat. (Wakefield, UK: Hepworth Wakefield, 2019), 34.

28. Amy Sillman and Gregg Bordowitz, *Between Artists* (New York: A.R.T. Press, 2007), 40.

Women and Painting: Rejections of Rejections

Kirsty Bell

I. Opportunities Missed

"I was shocked when I found out that you lived here for twelve years," wrote Amy Sillman in a letter to Maria Lassnig, realizing that they had lived in New York at the same time but their paths had never crossed.[1] Not only did Sillman miss Lassnig in New York, but they never met in person at all: the letter was written three years after the Austrian artist's death. Sillman, born in 1955, had moved from Chicago to New York in the mid-1970s and enrolled at the School of Visual Arts. In 1968, when Lassnig (1919–2014) moved to New York (on the advice of the American artist Nancy Spero, whom she had met in Paris), she was already almost fifty. The United States was the "country of strong women,"[2] Lassnig believed, and she spent the next twelve years living there, even taking a course in animation at SVA, where Sillman was studying painting. During these years, a collective spirit was emerging among women artists, fostered in the anything-goes atmosphere of a still affordable New York. They formed groups for mutual support and exchange of ideas beyond the usual institutions of the art world, to which they were not always granted access. Lassnig herself was a founding member of Women/Artist/Filmmakers, Inc., a cooperative set up in 1974 by Carolee Schneemann (1939–2019), Susan Brockman (1937–2001), and several others.

"Like you, in the '70s I hung out with a lot of women and experimental filmmakers," wrote Sillman to Lassnig. "But I am sorry to say that in the '70s I didn't even know your work, though we were in so many of the same rooms and streets." It would take another decade for women artists to begin hitting the mainstream, but even then, wrote Sillman, "eccentric figuration and wonky animation were sidelined and angst was being replaced with something hard-edged or cool."[3] Lassnig's uncompromising figurative works, which she called "body awareness paintings" (fig. 1), were out of step with the main thrust of New York's art world at the time.[4] The hybrid bodies she painted in jarring shades, their anatomies contorted by sensation and emotion, were confrontational images that often included her own naked, eventually aging, physique.

In the 1970s, women artists in both Europe and the U.S. struggled for visibility in galleries, museums, and academies. Faced with the two-pronged problem of access to male-dominated art scenes and disputes over painting's relevance, women on both sides of the Atlantic became driving forces in rethinking the medium from the inside out. Since then, across several generations, they have led a concerted examination and deconstruction of the overloaded medium, reconstituting it in a self-aware and sophisticated manner. The failed meeting between Sillman and Lassnig is particularly poignant given Sillman's own brand of "eccentric figuration and wonky animation," with its real-time tussle between lifelike elements (a truncated limb, an architectural extract) and an urge toward abstraction and dissolution of color and form. "It struck me that so much about female artists before the '80s is simply unknown, left out," wrote Sillman, getting to the root of the difficulty for her generation and the previous ones: the dearth of women role models.[5]

Fast-forward fifty years, and Sillman is among the most respected painters of the moment, one of many women redefining the status of the medium. These developments have been influenced by movements of individuals across the Atlantic, traveling from Europe to the U.S., as Lassnig did, or in the opposite direction. For Lassnig, the years spent living in New York offered a crucial escape from the stultifying, provincial atmosphere of her home in Austria. She had begun her education in Vienna at the Akademie der Bildenden Künste Wien in 1940, when the Nazis were in power. Nothing beyond landscapes or portraits of peasants in dark colors was sanctioned, while the wartime backdrop was one of almost inconceivable everyday brutality. Lassnig's move first to Paris and then to New York was a rejection of the limitations she experienced in Austria and a search for freedom and affirmation, which she discovered in the collaborative feminist circles of which she became a part. Lassnig returned to Vienna in 1980 when she was offered a position at the Hochschule für Angewandte Kunst, which she took up, thus becoming the first woman professor of painting in the German-speaking countries. It was another five years before she had her first retrospective, at the age of sixty-five, at Vienna's Museum Moderner Kunst/Museum des 20. Jahrhunderts. In the meantime, Sillman herself has become a regular visitor to Germany, as a professor of painting at Frankfurt's prestigious Städelschule since 2015.

Fig. 1 Maria Lassnig (1919–2014). *Dreifaches Selbstporträt/New Self* (Triple Self-Portrait/New Self), 1972. Oil on canvas, 68⅛ × 90½ in. (173 × 230 cm). Maria Lassnig Foundation, Vienna

II. Points of Intersection

Times have changed since the 1970s, when Amy Sillman was in school, not least because many more of the professors students encounter today are likely to be women themselves. "If you attended art school in New York in those days," writes Sillman about her time as an undergraduate, "your teacher would most likely be one of those former AbEx party members who had gotten himself a teaching gig. I didn't like him," she says of her own teacher, "and he warned me in return that I would certainly fail as an artist, but he was the only painter I knew."[6]

The few women painters who did carve out a career in the 1960s and 1970s were not only determined characters but, perhaps by necessity, notoriously spiky ones. Mary Heilmann, born in 1940, moved to New York in 1968 after studying ceramics in Berkeley. Her decision to paint was an "antagonistic move," as she recently put it.[7] "Coming to New York was like going to war, a religious vocation, as if you were fighting in the crusades."[8] A combative attitude was "the style for women artists, because you were the enemy or the underdog. I was prejudiced against the women, too, because I wanted to be with all the guys. Just me and Eva Hesse and two or three others.... It wasn't about seducing them, it was being at war with them or competitive with them."[9] Heilmann took Abstract

Expressionist and Minimalist tropes and played them out irreverently, adopting an embodied, felt approach to abstraction. She called her work "ironic painting that was often hard to look at."[10] Along with her contemporaries Howardena Pindell (born 1943) and Joan Snyder (born 1940), she was making paintings whose abstraction was full of coded meaning and emotional expression that did not resolve neatly.[11]

"No thinking beyond AbEx was allowed," writes Laura Owens (born 1970) about her own undergraduate years at Rhode Island School of Design in the early 1990s. "It's hard to synopsize the stereotypical 'boys' club' that held sway then."[12] Almost twenty years had passed since Sillman's college experience, but not much seemed to have changed. "One teacher had insisted all the women in his class paint representationally from still lifes or models. Only men could paint abstractly. I was the only woman painting abstractly. We got in many arguments."[13] It was only thanks to classes with visiting professors such as the historian Deborah Kerr that Owens was exposed to a wider range of thinkers and writers, including John Berger, bell hooks, Griselda Pollock, and Jacqueline Rose, who provided a counterweight to the narrow, stifling idea of painting that prevailed among the RISD painting faculty.

Owens moved to Los Angeles to pursue an MFA at California Institute of the Arts (CalArts), but there, in the

theory-driven, conceptually oriented graduate program, painting as a practice was generally scorned. Happily for Owens, Heilmann, who had been teaching at SVA in New York since 1977, arrived as a visiting tutor in 1994 and had an enduring influence on her. Owens herself became part of a loose West Coast confederation, including Rebecca Morris, Monique Prieto, Frances Stark, and Mary Weatherford, that was rethinking painting's parameters. "They came to painting after decades of hostility between pro- and anti-painting forces," wrote Amy Sillman in a 2018 review of Owens's work, "and the energy among these figures can be seen as partially a rejection of a rejection."[14]

Owens embraced a hard-won lightness—an attitude she says she learned from Heilmann—that emphasized "being serious about not being serious."[15] Her subsequent boundary-defying work, in its playful questioning of the conventions of painting, both inside and outside the frame, is evidence of this. It takes on site-specificity and architectural context, sometimes extends to embroidery or handmade books, and can even become mechanized with, say, the addition of clock hands to a painted surface, or prompts for visitors to link to a website with audio clips, which allow the paintings themselves to speak. These "speaking" paintings do not explain themselves, however, but rather ask questions of the viewer: "When you look at these objects, do you think they are looking at you?"[16] The point of making paintings, Owens's fluid and diverse oeuvre seems to imply, is to ask fundamental questions about the nature of image making itself. "I try to start over with each project or painting and try to teach myself the way to make that project," she says. The question ends up being, "Where is the painting?"[17] Is it on the canvas or in the room? Is it a book, a wallpaper, a cartoon, or an illustration? Where does it begin and where does it end?

Owens's interrogative practice developed as much through her peer group as through her formal education, if not more so. The prevailing attitude in her circle was that if you did not fit into the mainstream way of thinking, you should make up your own structures into which you *would* fit. Like the second-wave feminists of the 1970s, Owens and her peers took the situation into their own hands, forming groups of like-minded artists, staging exhibitions, devising support systems, and protesting inequities. Most important of all was to make work, be visible, and establish a voice of your own. While studying in Los Angeles, Owens was exposed to contemporary abstract painting from Europe by her occasional teacher David Reed (born 1946), who showed his students slides he had made on his travels. In 1996, she traveled to Berlin, sharing an artist's residency with her friend Sharon Lockhart (born 1964) and meeting fellow artists such as the Cologne-based Charline von Heyl. There was a certain back-and-forth between the U.S. and Germany at the time thanks to residencies and exhibition opportunities in German galleries and *Kunstvereine*, on the one hand, and teaching gigs in the U.S., on the other.[18] Through Lockhart, who was already represented by a German gallery, several of the Rhineland's most influential thinkers and writers visited Los Angeles to teach at CalArts or Pasadena's ArtCenter College of Design. "Everyone looked up to Diedrich [Diederichsen], Jutta [Koether] and [Martin] Prinzhorn," says Owens about that time. "They had a more complex, expanded way of thinking about art."[19]

III. Occupied Territory

Jutta Koether, born in 1958, studied at the Universität zu Köln in the late 1970s and early 1980s against the backdrop of German Neo-Expressionism; by the mid-1980s, she was writing cultural criticism for Cologne's *Spex* magazine (fig. 2). At the same time, she was making her own works, primarily paintings, that were informed by the anarchism of punk culture. "I tried to find operations to pull painting into a problematized terrain where it could perform a change on its own terms, where it could develop into something that was not merely rehashed or pastiched but actively dealt with its own fucked-up history," she has said.[20] Her understanding of painting has always been intersectional, straddling the realms of music, performance, and literature. She sees it as "a platform, a potential, an island, a lifeboat, a discipline to negotiate life . . . a performance. An attempt at something impossible, a reinvention of painting through painting."[21]

Koether visited New York in 1987 and ended up moving there in 1991—a change of context that she calls a "strategic distancing from the ground where I came from."[22] This act of distancing also reinforced her predilection for painting: "I kept asking, Why must feminist art practice perform 'otherness' in an 'other' medium? Why not in painting? Painting stayed on my mind and eventually led me to the US, where I turned toward other interests and other models, shifting from Beuys to Warhol in the very late 1970s, early '80s. At some point in the '80s, with the arrival of my first red paintings, I realized, *My mind is painted*."[23]

The Rhineland art scene in the 1980s and early 1990s was a hothouse for artists of all persuasions, among them Charline von Heyl, Monika Baer, and Michaela Eichwald. Eichwald (born 1967) studied philosophy and art history rather than studio art, wrote poetry and other texts, and made videos and performances, espousing the punk-feminist attitudes of Cologne as well as the scene's anti-production mind-set. It was almost two decades before she began painting, and when she did, her overladen works performed all the tropes of "bad painting," dabbling along the fringes of fragility and disgust. Although the German art world did not have to contend with the AbEx problem that monopolized discourse in the U.S., it was still heavily male-dominated. Baer (born 1964), who studied at the Kunstakademie Düsseldorf from 1985 to 1992, has spoken of the "pervasive chauvinism"

Fig. 2 Covers of *Spex* magazine, August and September 1984

of the time.[24] Gerhard Richter was a professor in Düsseldorf from 1971 to 1993 and cast a long shadow; the other main players in the 1980s were Jörg Immendorff, Martin Kippenberger, Albert Oehlen, and Sigmar Polke. Influential women professors such as Christa Näher (in Frankfurt) and Rosemarie Trockel (in Düsseldorf; fig. 3) were conspicuous as "lone fighters, as exceptions,"[25] in Baer's words, and thus were themselves evidence of the art scene's misogyny.

Painting was "occupied territory," Baer has also said, while the emergence of conceptual art "put painting in a difficult spot," a problem it was crucial for practitioners of the medium to be aware of.[26] Baer's solution was to conceive the canvas as an overtly theatrical arena and to access the practice of painting through that device. This was literally the case in early works depicting an actual stage proscenium populated by puppet protagonists (fig. 4), but the idea remained metaphorically active in later works she describes as being "composed of fragments, parts, and then, after the picture is done, the constellation is taken apart again."[27] There is a vital restlessness to Baer's works; the relation of motif to surface is a source of constant ambivalence, articulating doubt in painting through the very act of painting. There is an inside and an outside to each work, and the painter, akin to a theater director, gets to decide what does—and doesn't—appear on each canvas.

Von Heyl (born 1960), like Baer, Eichwald, and Koether, emerged from the Rhineland art milieu. She began her studies at the Hochschule für Bildende Künste Hamburg from 1982 to 1984, continued at the Kunstakademie Düsseldorf, and subsequently worked as a studio assistant for Immendorff. "It was a heavily male, very jokey, and ironic stance toward painting. Anarchistic and also quite arrogant," she has said of that time.[28] However, as she saw it, the potential for painting to articulate the complexity of ideological or political stances was accepted in Germany, as it was not in the U.S.,

Fig. 3 Rosemarie Trockel (born 1952). *Untitled*, 1985. Wool on canvas in plexiglass frame, 25¾ × 25⅞ in. (65.4 × 65.5 cm). Private collection, Berlin

where conceptual work held sway. "I started out as a painter in an environment where painting was something very powerful and I never actually lost that feeling," she says. "I never doubted painting."[29] She brought this painting-positive attitude with her when she moved to New York in 1996, as Koether had done a few years earlier.

In von Heyl's works, gestures are knowingly referential, and the slippery correspondences they suggest—not only

Fig. 4 Monika Baer (born 1964). *Untitled*, 1997. Oil on canvas, 4 ft. 9 in. × 9 ft. 6¼ in. (145 × 290 cm). Private collection, Belgium

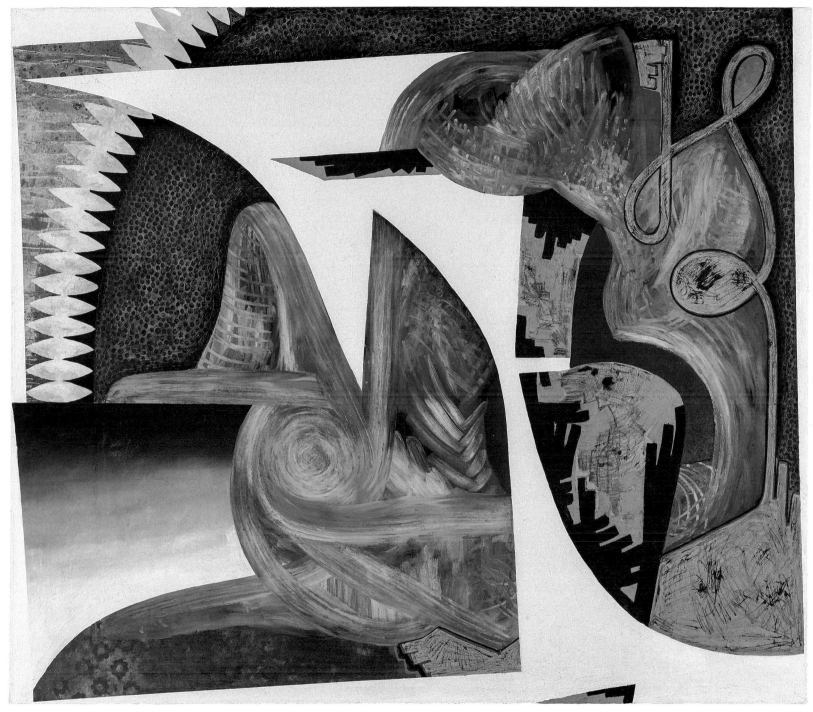

Fig. 5 Charline von Heyl (born 1960). *Untitled (7/92, III)*, 1992. Oil on linen, 65 × 77 in. (165.1 × 195.6 cm). Shah Garg Collection

to painterly forebears but also to literature, philosophy, objects, and design—elaborate explicitly through paint itself the ways in which meaning is multivalent and signs do not always denote one thing. Her paintings employ different speeds of imagery, subject matter, and technique, from loose, gestural areas to graphic patterns marked in black, or scribbles that approximate handwriting but cannot be deciphered (fig. 5). Although her works synthesize many diverse elements, she resists the overt display of skill for its own sake: "Virtuosity is kind of self-serving, a dead end, it is rarely enough to hold a painting," she has said—whereas

"doubt and indecision open up space. . . . They make all those dichotomies and paradoxical moves possible, which create interesting tensions in the paintings."[30] Paradox is a key word in von Heyl's vocabulary, but while in previous generations paradox was often expressed through the externalized antagonism that was necessary for a woman artist even to gain entry to the art scene, followed by attempts to achieve a contrasting levity on canvas, von Heyl embraces complexity within the works themselves. They aim for "a place where thoughts and feelings meet, where looking feels like thinking."[31]

IV. Synthesizing Fields

From 2003 to 2007, Charline von Heyl taught in the mentorship program in the graduate art program at New York's Columbia University, where Amy Sillman also mentored. Allison Katz, born in Canada in 1980, received her MFA from Columbia in 2008 and studied with both of them. The references Katz brings into her work, like those in von Heyl's, remain slippery. She adopts styles from advertising, illustration, art history, and cartoons in her ostensibly figurative works, embracing the medium's uncanny ability to synthesize—to bring things of diverse registers together. She sees painting as a compressing activity, whereby meaning can be opened out like a zip file and extrapolated. At times, a motif recurs and begins to form a trope within her oeuvre: cabbages; a snowy winter scene; a gaping mouth, whose red lips and exposed teeth form a kind of frame or parapet around the painting's ostensible subject. The rooster is one such motif, first appearing in 2011 and leading to an intermittent series of "cock paintings," as Katz calls them, which range across various painterly styles and modes of depiction (see pl. 110). Unlike the singular subject, such a motif "takes on a life of its own," which, for Katz, is not about repetition but, rather, "attention, defiance."[32]

"It's a balancing act between belief and doubt, never falling for either entirely," says Katz. "The work then inherits the energy of persuasion, of a continually renewing dialogue, maybe an argument, or perhaps a seduction."[33] There is a tension in her paintings that has to do with presence and memory, and how our perception develops in real time as a combination of the two. The artist likens this to a "combining of tenses, of going back and forth within the same work," and refers to Maria Lassnig's "body awareness painting [which] pushes this further, trying to capture the bodily experience: portraying not how the body looks, but how it *feels* to be inside one."[34] As this example shows, each new painter builds on what came before, on an ever thicker and richer trove of works, ideas, and experiences to be embraced or rejected. By this point in the history of painting after modernism, no single movement takes up the whole field, as Abstract Expressionism did in the post–World War II United States. The rubrics of abstraction versus figuration are also no longer useful. Rather, the painted canvas is an expansive and porous medium—an arena in which to perform, and one in which doubt is a generative factor.

The artists loosely gathered in this essay are nodes in a broader discourse, but the clear connections among them are evidence of the vital network of influence established by the generations that span Maria Lassnig (fig. 6) and Allison Katz. The canon is in an ongoing state of realignment to accommodate women painters from earlier periods, as well as artists previously marginalized on account of gender, race, or class. It is no surprise that fragment and paradox play such a decisive role in many of their works. The field of painting may have been occupied, de facto and ideologically, but, as Monika Baer says, it is "open to takeovers, to capture," and thus is ripe for reconfiguring.[35] It has reemerged as one of the most exciting and relevant areas of artistic debate, thought, and invention while remaining, in Baer's words, "an exceptionally paradoxical practice."[36]

1. Amy Sillman, "Dear Maria Lassnig" [2017], in *Faux Pas: Selected Writings and Drawings* (Paris: After 8, 2020), 213.
2. Maria Lassnig, quoted in Andrea K. Scott, "Art Online: Maria Lassnig," *New Yorker*, July 20, 2020, 6.
3. Sillman, "Dear Maria," 217.
4. For "body awareness paintings" (*Körpergefühlsmalerei*), see, among others, Anna Fricke, "Stillstand ist der Tod," in *Body Check: Martin Kippenberger, Maria Lassnig*, ed. Veit Loers, exh. cat. (Cologne: Snoeck, 2018), 123.
5. Sillman, "Dear Maria," 217.
6. Sillman, "AbEx and Disco Balls: In Defense of Abstract Expressionism II" [2011], in *Faux Pas*, 117–18.
7. Mary Heilmann, quoted in Ben Luke, "Mary Heilmann: My Work Follows 'No Linear Time; It's All a Chunk,'" *Art Newspaper*, February 5, 2021, https://www.theartnewspaper.com/2021/02/05/mary-heilmann-my-work-follows-no-linear-time-its-all-a-chunk.
8. Mary Heilmann, interview by Ross Bleckner, *BOMB*, no. 67 (Spring 1999), https://bombmagazine.org/articles/mary-heilmann/.
9. Heilmann, quoted in Luke, "Heilmann."
10. Mary Heilmann, quoted in "Art House: Revisiting 'The All Night Movie,'" *Ursula*, January 30, 2021, https://www.hauserwirth.com/ursula/31377-the-all-night-movie-mary-heilmann/.
11. See Helen Molesworth, "Painting with Ambivalence," in *WACK! Art and the Feminist Revolution*, ed. Cornelia Butler, exh. cat. (Los Angeles: The Museum of Contemporary Art; Cambridge, MA: MIT Press, 2007), 438.
12. Laura Owens, quoted in Scott Rothkopf, *Laura Owens* (New York: Whitney Museum of American Art, 2017), 37.
13. Ibid.
14. Sillman, "Laura Owens" [2018], *Faux Pas*, 228.
15. Owens, quoted in Rothkopf, *Owens*, 162.
16. Audio text accompanying paintings in the exhibition *Laura Owens*, Sadie Coles HQ, London, October 5–December 17, 2016.
17. "Laura Owens: The Materiality of Abstraction," Getty Conservation Institute, Los Angeles, March 5, 2020, YouTube video, 13:29, https://www.youtube.com/watch?v=sNpjpS52CE8.
18. *Kunstvereine* are small-scale exhibiting institutions, organized as artists' associations and found in many German towns and cities.
19. Owens, quoted in Rothkopf, *Owens*, 61. Diedrich Diederichsen, born in 1957, is a German author, music journalist, and cultural critic. He was editor in chief of *Spex* from 1985 to 1990 and lived in Cologne. Martin Prinzhorn, also born in 1957, is an Austrian linguist and art critic whose writing has been published in the Cologne-based art magazine *Texte zur Kunst* and elsewhere.
20. Jutta Koether, "A Conversation with Jutta Koether," by Benjamin H. D. Buchloh, *October*, no. 157 (Summer 2016): 15.
21. Ibid., 20.
22. Ibid., 17.
23. Ibid.
24. Monika Baer and Daniel Herleth, "Eye Bait," in *PS:*, ed. Dominic Eichler and Brigitte Oetker, Jahresring 61 (Berlin: Sternberg, 2014), 212.
25. Ibid., 213.
26. Ibid., 212.
27. Ibid., 213.
28. Charline von Heyl, interview by Shirley Kaneda, *BOMB*, no. 213 (Fall 2010), https://bombmagazine.org/articles/charline-von-heyl/.
29. Ibid.
30. Charline von Heyl, "The Eye Is Always a Game: A Conversation with Charline von Heyl," by Evelyn C. Hankins, in *Charline von Heyl: Snake Eyes*, ed. Dirk Luckow, exh. cat. (London: Koenig, 2018), 68.
31. Ibid., 61.
32. Allison Katz, "Confessions of a MASK: A Conversation with Camilla Wills," in *Allison Katz*, ed. Clément Dirié, exh. cat. (Geneva: JRP, 2020), 172.
33. Ibid., 170.
34. Ibid., 173.
35. Baer and Herleth, "Eye Bait," 213.
36. Ibid., 217.

Fig. 6 Maria Lassnig (1919–2014). *WOMAN WORLD!*, ca. 1970s. Graphite on paper, 23⅞ × 17⅞ in. (60.6 × 45.4 cm). Shah Garg Collection

WOMAN-WORLD !

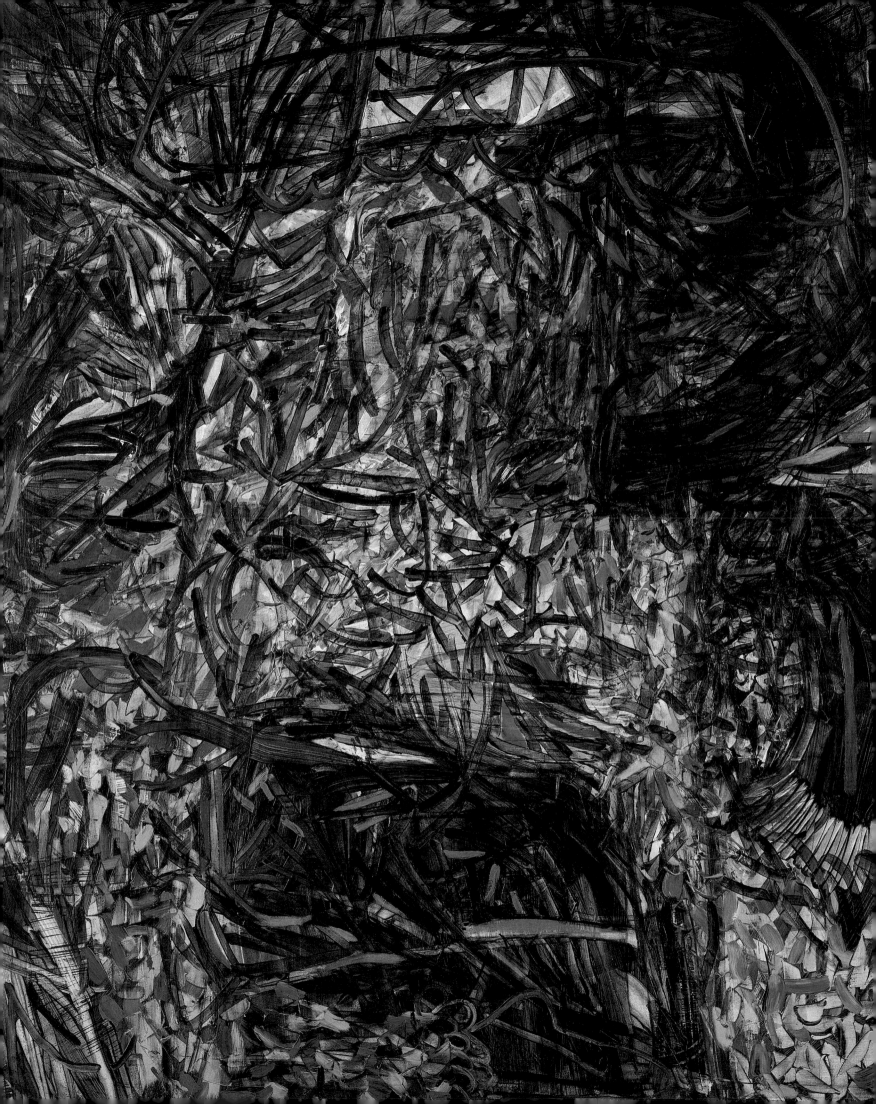

How to Make a World: Black Women Artists Now

Jessica Bell Brown

The past decade has seen a number of women artists receive their due visibility and recognition in the contemporary art world. Even in the last five years, the art world has widened, and as a result, its denizens have directed more attention toward women and other artists of the global majority who have long been unfairly situated at its margins. This essay explores a group of significant Black women artists whose work is held in the Shah Garg Collection and who engage in processes of world building and conceptual frameworks of interiority: the late Emma Amos, whose vanguard, craft-informed approach to painting garnered much-deserved appreciation in the final years of her life, and the younger artists Firelei Báez, Jordan Casteel, Jadé Fadojutimi, Lauren Halsey, and Simone Leigh. These artists sometimes move between figuration and abstraction and flirt with illegibility and opacity in their works. Arguably, they are rewriting the language with which we understand art history. They reject the centrality of male dominance and recenter the nodal points of meaning making on their own terms. They are an intergenerational cohort of women whose divergent aesthetic, social, and cultural interests, taken together, represent seismic shifts and expansive possibilities for how contemporary art today can both grapple with history and map unique networks of community.

New Directions in Abstract Art

Adjusting the Moon (The right to non-imperative clarities): Waning of 2019, by the Dominican-born painter Firelei Báez (born 1981), is a trompe-l'oeil niche, arched in shape and commanding in presence. Originally installed as part of a diptych in *Utopian Imagination*, a 2019 exhibition at the Ford Foundation in New York, and two years later at Toronto's Art Gallery of Ontario in the show *Fragments of Epic Memory*, with a simulated arcade separating the two paintings (fig. 1), the work features the *ciguapa*, a mythical trickster figure hailing from Dominican folklore, which frequently appears in Báez's work. Abstract passages of warm sienna, magenta, and yellow radiate from the figure, whose body is partially silhouetted with flora and fauna. Báez imposes a condition of illegibility on the viewer with the beams of light that burst and cascade from the head and torso. The artist is playing on the charged tropical landscapes of the global South as a metaphor for Glissantian opacity[1]—hedging against a reduction of knowledge and of ways of being, forged through colonialism, that demands a totalizing transparency. The ever-evasive *ciguapa* exists in a liminal space between gender, race, and class, between the human and the supernatural. By juxtaposing the *ciguapa* and its surround, the artist alludes to the propagation of European architectural forms through colonialism, creating a not-too-distant echo of the diasporic dispersal of Black bodies within and across the Atlantic. Báez also questions the beholder's share in the concretization of narratives of coloniality and power through spectatorship and witnessing. At the same time, the *ciguapa*'s ability to redirect the gaze is a method of speaking back to systems and structures of power—one that refuses, in Édouard Glissant's words, to "contrive to reduce things to the Transparent" through "the process of 'understanding' people and ideas from the perspective of Western thought."[2] Glissant argues that "it is impossible to reduce anyone, no matter who, to a truth he would not have generated on his own. That is, within the opacity of his time and place. . . . Widespread consent to specific opacities is the most straightforward equivalent of nonbarbarism."[3]

In *temporally palimpsestive (just adjacent to air)*, also of 2019 (see pp. 24–25), Báez's *ciguapa* has transformed completely into an abstraction. This implosion of the image through a superimposition of painterly gesture is a visual and conceptual strategy to which the artist also alludes in the work's title. In many of her paintings, Báez employs the trope of the palimpsest, a literary term that refers to traces of an erasure evident on a manuscript bearing new text. Archival maps, eighteenth-century board games, and literary documents are the foundational images of canvases that become a stage on which the *ciguapas* act. In this work, however, Báez has eliminated the figure altogether, offering abstraction as a vehicle for exploring various politicizing and dehumanizing forces and their entanglement with complex colonial histories of resource extraction, enslavement, and imperialism. With abstraction,

Fig. 1 Firelei Báez (born 1981). Far left: *Adjusting the Moon (The right to non-imperative clarities): Waxing*, 2019–20. Oil and acrylic on panel, 9 ft. 6 in. × 6 ft. 6 in. (289.6 × 198.1 cm). Private collection, New York. Far right: *Adjusting the Moon (The right to non-imperative clarities): Waning*, 2019–20. Oil and acrylic on panel, 9 ft. 6 in. × 6 ft. 6 in. (289.6 × 198.1 cm). Shah Garg Collection. Installation view, *Fragments of Epic Memory*, Art Gallery of Ontario, Toronto, September 1, 2021–February 21, 2022

Báez constructs a metaphorical veil for uninterrupted refusal, allowing the complexities of diasporic subjectivities across time and space to remain uncontained and to permutate strategies of illegibility.

Whereas Báez engages abstraction as part of a process of building nearly impenetrable worlds from the fragments and vestiges found in diasporic histories, the British Nigerian artist Jadé Fadojutimi (born 1993) takes abstraction in a direction more aligned with the tradition of the Abstract Expressionists, who reckoned with the modern world through a new visual language beyond the symbolic registers of form. Her improvisational works frequently turn away from certainty into the space of rigorous contemplation. Often likened to stained glass, her vast fields of marks and colors span emotional states, from somber to transcendent. They become prisms, or even mirrors. Indeed, the artist thinks of her paintings as portals to an interior world of her own making: "When I'm in my space, I'm in my own world, and I let myself be. There aren't so many moments available to just be."[4] That sense of deep and uninterrupted reflection becomes a groundswell of abstraction as Fadojutimi builds up her surfaces with passages of transparency and bold, graphic lines.

In her 2017 essay "My Window," Fadojutimi muses about the role of the window in her practice and contextualizes the personal investigations of self and identity that play out as she works, always making decisions in the moment. For her, the window metaphor serves as a kind of visual confrontation with one's sense of being and the accumulation of traumas, memories, and experiences that shape how we see, imagine, and remake ourselves in the world every day: "The life I adhere to is the life of the window."[5] *Inside My Shell* of 2018 (pl. 133), a painting made shortly after the artist completed her master's degree at London's Royal College of Art, appears as a dark thicket of converging brushstrokes in competing gauges of thickness and boldness. Light emanates from the center, as if suggesting a place or point of visibility beyond the surface. A haunting shroud, or possibly a broken seashell, outlined in orange, hangs or floats at the top of the painting:

> My empty shell is powerless and coloured envy, a fear of being left behind. I wish to be filled until I overspill. Only then will I be whole. If I am rejected, dispelled by the window's overpowering presence, I will still not look away because in realizing my inner void, I have comfort in a new place of belonging. I no longer desire to see what is beyond all of this; I only wish to be in tune with the window itself.[6]

One could posit that it is only through Fadojutimi's unlocking of various states of mind and accumulations of experience that the power of her work is revealed. Her process of

applying and removing paint, moving across the canvas in meditation, is reflected in the many layers, material and psychological, that are present in her work. She conjures the role that doubt plays in how we come to see and understand our realities: the notion of a window as a device for greater illumination is one that she shatters, and perhaps, by breaking out of concentric shells of inner life, a transformation is possible.

New Origins of the Universe

The works of Emma Amos and Jordan Casteel, American artists born half a century apart, are tethered not primarily to art history but to gestures of the everyday, whether through a commitment to the undersung techniques of weaving or sewing or through an investigation of the artists' personal connections to those nearest to them. Over a career of six decades, Amos (1937–2020) brilliantly hinged together traditions of Black artistic practice to pursue the complexities of subjectivity through the materiality of painting as much as through its content. The only woman in the elite artists' collective Spiral, established in New York in 1963 by prominent Black artists such as Romare Bearden and Norman Lewis, Amos grew into her maturity as an artist after leaving the group and expanding her material investigations beyond oil on canvas and ink on paper. In her groundbreaking paintings and textile assemblages, she also tackled questions of an artist's inner life, as a mother, an ambitious image maker, and a radical feminist.

Star of 1982 (pl. 24) evinces Amos's longtime interest in weaving and textile design, which she taught at the Newark School of Fine and Industrial Arts, in New Jersey, starting in 1970.[7] Previously, she had studied weaving at Antioch College under Robert Metcalf (1902–1978), and concurrently with teaching, she worked with the textile designer Dorothy Liebes (1899–1972). She also taught weaving at Threadbare Unlimited, a yarn shop and craft school in Manhattan's Greenwich Village owned by her friend Sandy Lowe. Amos sourced West and East African textiles to be incorporated into her paintings and collage constructions (fig. 2), along with textiles that she wove herself by hand. In *Star*, the composition features a faceless figure quickly descending through the negative space of a striped pattern running counter to the body; shifts between black and vibrantly colored thread create an effect of dizziness and downward velocity. Amos never shied away from claiming craft as a locus of artistic innovation and creativity, especially within the context of wider debates around women's rights and Black women's exclusion from feminist discourse. By embracing craft, she called into question the perceived limitations of "women's work," domestic expertise, and decorative art. Instead, viewed through the lens of materiality and the important shifts in art making Amos refined over the course of her career, her oeuvre generously reflects the histories of communal exchange across generations of weavers, designers, and artists forged outside the mainstream art world.

Since her residency at the Studio Museum in Harlem in 2015–16, Jordan Casteel (born 1989) has become embedded in the lives of her subjects across different swaths of community in New York City and beyond. This mode of seeking connection is faithful to how many artists, over centuries, have depicted or engaged with those in their most proximate circles. However, Casteel's community stretches beyond normative class structures and certainly beyond the elite sphere of the art world: the subjects of her vivid portraits include street vendors, restaurateurs, art students, friends, and family members. Drawing on the legacies of socially engaged portraitists such as Alice Neel (1900–1984) and Raphael Soyer (1899–1987), Casteel's large-scale figurative paintings center the ordinary lives of the people she knows; their attendant environments, living rooms, bedrooms, and places of work and leisure are vital to how viewers encounter the works. In a recent interview, the artist noted, "I've found a kinship with many of the people I paint. It's less about them individually than it is about aspects of them that I see in myself. I want people to see me, and they often don't. Painting becomes a tool to get people to see the multiplicity of our selves: our sadness, our joy, our love, our loss, our moments of stillness, the moments that don't get heard."[8]

Casteel's canvases, at just above human scale, become landing fields for the shared emotional connection and synergy between herself and her chosen subjects. They are meant to be immersive, affording grandeur to those whose ancestors may not typically appear in museums or in the heralded, aristocratic spaces of visual representation. *Cansuela* (fig. 3), a portrait of a former student of the artist's in her bedroom, is rife with visual contradiction. Paintings produced by Cansuela during her and Casteel's semester together at Rutgers University–Newark hang proudly on the wall behind her. Although her embodied presence seems mature and womanly, her shy personality is quite evident; she clutches a plush panda bear, presumably to seek comfort from her nervousness. Casteel's bright palette exudes a tender fondness and optimism toward her subject, who is momentarily disconnected from the weight of the world outside.

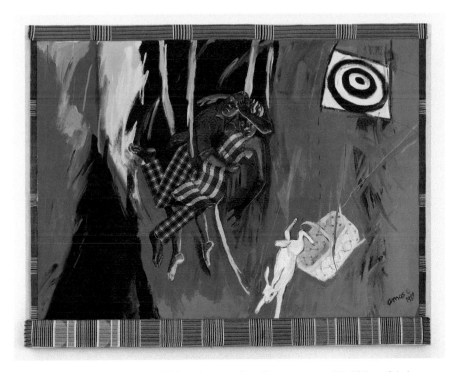

Fig. 2 Emma Amos (1937–2020). *Targets*, 1992. Acrylic on canvas, with African fabric borders on linen, 57 × 73½ in. (144.8 × 186.7 cm). Collection of LaToya Ruby Frazier

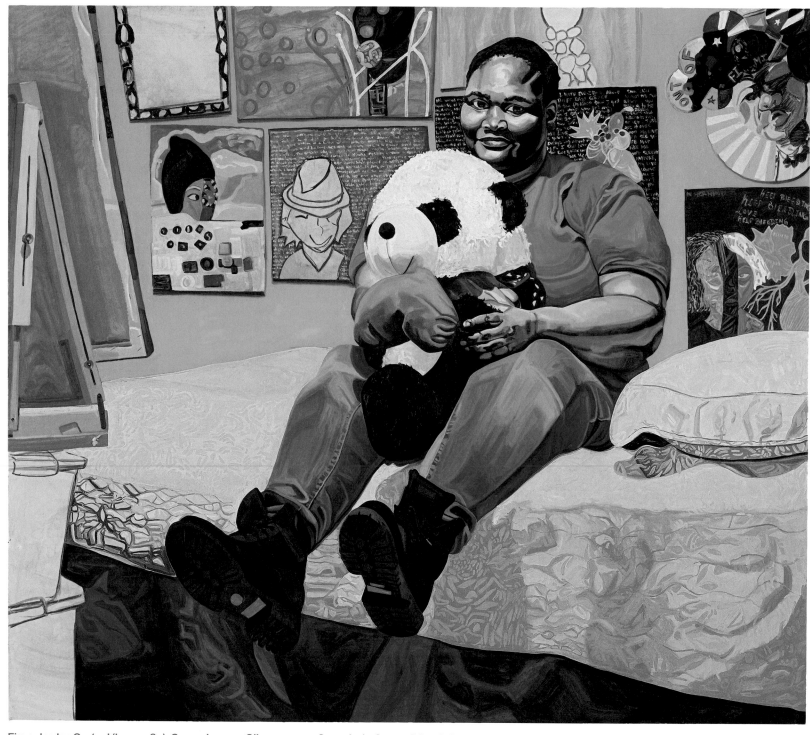

Fig. 3 Jordan Casteel (born 1989). *Cansuela*, 2019. Oil on canvas, 78 × 90 in. (198.1 × 228.6 cm). Shah Garg Collection

Where Past, Present, and Future Collide

Lauren Halsey (born 1987) similarly works from within the confines of her community, as in her 2020 sculpture *Untitled* (see p. 111). Carving into gypsum panels, a form of plaster technology related to that used by the ancient Egyptians, the artist culled words and motifs from the vibrant signage and visual culture of South Central Los Angeles, yoking references to antiquity to the verisimilitude of contemporary life. Nearly eight feet tall, this and other towering works by

Halsey (fig. 4) posit formal and informal architectures generated by the small businesses and underground economies of LA, which she references through a hyperlocal vantage point. She also embeds within her objects and installations affirming messages of the possibilities of a new Black futurity, making an intentional connection to the African continent as a source of social, spatial, and creative liberation. Emblems such as "Black 'N Beautiful" and "Black Pride Brown Pride" meet a small row of pyramids and references to George Floyd, Elijah McClain, and Breonna Taylor, all Black Americans who

and folk traditions of Black diasporic visual culture. Her works center Black women's subjectivity and are multilayered in their references to ways of being and modes of making that extend beyond an early twentieth-century view of Western art history. Past, present, and future collide in her recent bronze *Stick* (pl. 81), which appeared in the 2019 Whitney Biennial and catapulted the artist into the mainstream on the heels of her High Line presentation of the same year, *Brick House* (see fig. 5 on p. 67). Cast in bronze and resplendent in a deep cobalt blue, *Stick* features a seemingly impervious form; armless and eyeless, the figure still exudes power and asserts its presence. We as viewers are kept at bay, not meant to penetrate the interiority that Leigh affords her subject. The sumptuous curves of the skirt are met with thin cylinders modeled after the torons—bundles of rodier palm wood—found on the surface of certain mudbrick African mosques, such as the Great Mosque of Djenné in Burkina Faso.[9] The jutting cylinders read as a measure of distancing and protection and, at the same time, as a rightful celebration of African architectural innovation in history. By choosing to work in bronze and clay and synthesizing forms and references across time, Leigh embeds a collective sensibility in her work, from its historical mapping to its formation and making. She refuses to invisibilize the many hands and minds that have brought her work to life, rather choosing to encircle ways of being that are inherently womanist and historically inclusive.

Preceded and heralded by Amos, the several artists discussed in this essay—Báez, Fadojutimi, Casteel, Halsey, and Leigh—provide refreshing and unique models for engaging with histories and collectivity in contemporary art. Together, they establish a primacy for relational Black and diasporic subjectivities while transforming the paradigm of what it means to be an artist working today.

1. See Édouard Glissant, "For Opacity," in *Poetics of Relation*, trans. Betsy Wing (Ann Arbor: University of Michigan Press, 1997), 189–94.
2. Ibid., 189.
3. Ibid., 194.
4. Jadé Fadojutimi, "Jadé Fadojutimi: When I Change, the Work Changes," interview by Tessa Moldan, *Ocula Magazine*, November 24, 2001, https://ocula.com/magazine/conversations/jade-fadojutimi -ica-miami/.
5. Jadé Fadojutimi, "My Window" (unpublished), November 2017, courtesy of Pippy Houldsworth Gallery, London.
6. Ibid.
7. For excellent discussions of Amos's early training and weaving practice, see Thalia Gouma-Peterson's essay "Reclaiming Presence: The Art and Politics of Color in Emma Amos's Work," in *Emma Amos: Paintings and Prints, 1982–92*, ed. Thalia Gouma-Peterson, exh. cat. (Wooster, OH: College of Wooster Art Museum, 1993), as well as Lisa Farrington's "Emma Amos: Art as Legacy," *Woman's Art Journal* 28, no. 1 (Spring/Summer 2007): 3–11.
8. Jordan Casteel, "Artist Jordan Casteel Thinking in Her Studio," interview by Sandra E. Garcia, *T: The New York Times Style Magazine*, April 21, 2022, https://www.nytimes.com/2022/04/21/t-magazine /jordan-casteel.html.
9. See the discussion of *Stick* by Allie Biswas on p. 303 for an alternative explanation of these cylinders.

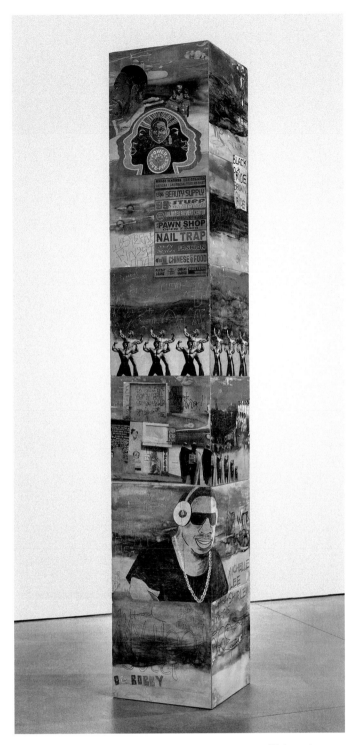

Fig. 4 Lauren Halsey (born 1987). *WE IN HERE*, 2022. Watercolor ink, colored pencil, and collage on hand-carved gypsum, 11 ft. 8¾ in. × 1 ft. 11½ in. × 1 ft. 11½ in. (357.5 × 59.7 × 59.7 cm). Private collection

died at the hands of police in 2019 and 2020. With the racial reckoning of those years not far from view, Halsey holds space for joy and collective care amid the oppressive forces that shape everyday existence; at the same time, she ties the vibrancy and self-reliance of her community to an equally rich and triumphant Pan-African coalition of the past.

Like Halsey and Báez, Simone Leigh (born 1967), in her ceramic busts and monumental bronze sculptures, draws on an amalgamation of imagery gleaned from the African diaspora and the lesser-known histories, architectures,

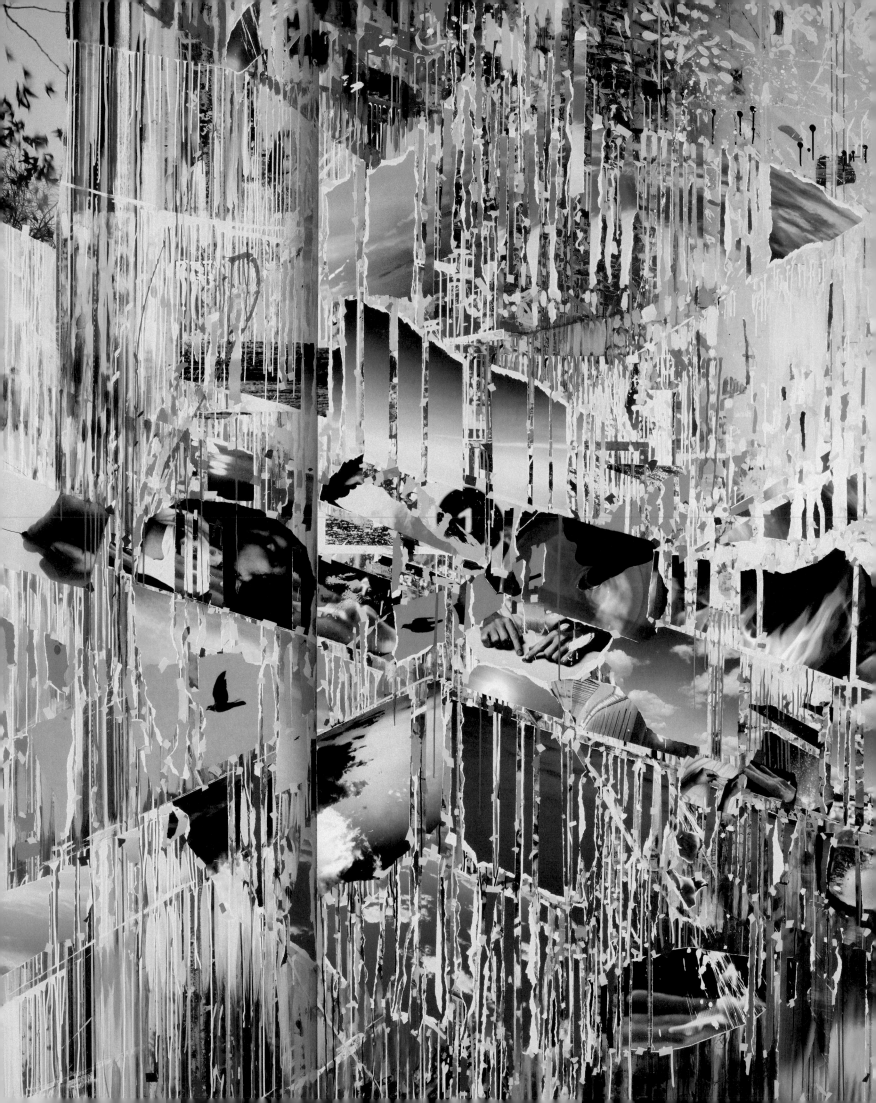

The Computational Logic of Contemporary Painting

Gloria Sutton

Despite their distinct practices, three artists in the Shah Garg Collection, Tomashi Jackson, Christina Quarles, and Ilana Savdie, can be considered in tandem for their propensity to treat painting and computational media as inherently social forms rather than discrete disciplines. Works by these artists reveal that computational media, like painting itself, are not a stable phenomenon but rather a cultural process informed by the material conditions under which those media are produced and circulated. In their compositions examined herein, the artists make clear how contemporary painting not only represents, but *renders*—forms and transmits, or hands down—a worldview structured by the visual regime of the graphical systems we use every day, including scrolling, zooming, and scaling. Whether captured by digital cameras or scanners, generated with 3D-modeling software, or simply displayed on the pixelated grid of a monitor, these works remind us that most of the images we encounter are subject to computational operations that treat images as objects to be manipulated, compressed, and stored.[1]

Jackson, Quarles, and Savdie often combine the material logic of the sensible world with the informatic logic of computational systems. Consequently, the works under discussion are not reducible to the established art-historical vocabularies of modernist abstract painting, nor are they simply the result of newer image technologies that, through a kind of technological determinism, necessarily produce different aesthetic outcomes or special effects. Jackson's, Quarles's, and Savdie's specific use of computational terms and processes in their analogue works are contextualized here within a historical trajectory established by certain women artists born half a generation earlier, including Laura Owens, Sarah Sze, and Haegue Yang, whose paintings and sculptures, also represented in the Shah Garg Collection, have long demanded that we pay attention to critical issues of scale and scalability within a network culture predicated on the leveling of images for optimal compatibility across multiple platforms.

Since the 1990s, scale—the physically palpable sense of ratio or commensurability of an image to its source or subject—has become so amorphous that any measurable relation to a contextual frame is rarely noted and is rendered irrelevant. In the era of open-ended variations manifested either online or offline, scale is often treated as a formatting issue. Owens, Sze, and Yang have asked us to consider exponentially larger quantities of data and a broader range of inputs, gliding back and forth between the astronomical and the nano and pointing to what can be thought of as a type of twenty-first-century scalar humanism. This is a conceptual and political orientation of how we picture ourselves in a world that has continued to shift away from the sense of industrial uniformity or universality that undergirded twentieth-century modernism toward the decidedly personal and contingent sense of alterity that shapes subjectivity in the current networked digital age. In contrast, the works by Jackson, Quarles, and Savdie discussed here demonstrate the ways a viewer's perception is shaped by scalar contiguity: how we rely on gradations in size, color, and form to order our knowledge of the world, and how we comprehend the scalar forces we do not know firsthand by incrementally comparing them to the ones we do.

Close reading of these works in the Shah Garg Collection offers a procedural logic to help us comprehend the wide-scale purchase digital computing has established on all forms of contemporary art, implicitly telling us more about the long digital age than digital artworks themselves can do. The three younger artists named above were born in the 1980s, at the moment when digital computing scaled down from the institutionally operated mainframe to the relative portability of the personal desktop, forming the enduring graphical metaphor for the ways we store, file, and arrange information and images. The artists' coming of age in the early 2000s was marked by the spread of network culture and the rise of ubiquitous computing, which tethered life to an operating system rather than to a single device. The result is that Jackson, Quarles, and Savdie wield digital tools and painterly techniques in equal measure, less as a commentary on the state of painting or the inevitability of digital mediation than as a given input—among many—of contemporary lived experience. Simply put, their paintings draw direct connections between the variability of the

computational media we use and the mutability of the identities we inhabit.

The application of such computational terms to these works of art is not intended to refute or reject the formal vocabularies of painterly abstraction (itself a diffuse and diverse category) that thrived in tandem with the rise of digital computing during the postwar era. Instead, the concepts are presented here as a material argument about the ways contemporary art history can be iterated upon, not simply repeated. We can consider the works of Jackson, Quarles, and Savdie through the viewing habits shaped by network culture and its sense of variability rather than in the grip of the mass audience of television or film, which influenced painting's earlier adoption of media technology (seriality, appropriation). To frame their work in the computational parlance of iteration, compression, and compositing as opposed to the modernist tropes of repetition, abstraction, and the grid is to argue that these artists are engaging in the computational process of iteration itself—building on or learning from a previous application or output not in an effort to replicate it but to insist on an enactment of difference from that previous model or moment. Seen thusly, their works gesture toward what the late performance scholar José Esteban Muñoz termed a "queer futurity," a utopian sphere of potentiality, a type of visuality that would require us all "to squint, to strain our vision and force it to see otherwise, beyond the limited vista of the here and now."[2] Indeed, the attempt to read these decidedly abstract, painterly works within a computational framework makes a critical space within art history for practices yet to come.

Between Computability and Uncomputability

Fundamentally, digital computation is about identifying limits—finding the threshold of what is computable, processible, and thus recognizable. Paradoxically, the notion of the computable hinges on the "uncomputable"—a term the media scholar Alexander R. Galloway ascribes to acts of exclusion or limitation. Historically, digital computation "has relied on discrete symbols—relied on them being discrete and remaining that way," suggests Galloway, who also emphasizes that "when symbols start to dissolve, they pose a threat to computability. When a symbol cannot be fixed, it becomes more difficult to calculate."[3] Yet, thanks to the rise of 3D modeling and artificial intelligence found in common software applications that are endemic to everyday life (video games, voice assistance, facial recognition), indeterminacy and contingent data have become more valuable in refining the accuracy of these applications than predictable, determinative information is. As Galloway argues, "Today the computable is closely intertwined with the uncomputable."[4]

The threshold between computability and uncomputability is an area that the painter Christina Quarles (born 1985) prodigiously mines. Compositionally, she uses the physical limitations of the canvas to create what she has described as "self-imposed frames within a frame."[5] Elsewhere, she enumerates the process: "I start with the figures. But I don't have a plan or a sketch book. I lay down broad strokes then take a lot of time not painting, just looking and trying to build figures out of what is an abstract starting point. Then I photograph the work, bring that photo into a computer and play

around with the compositional elements (like the bodies) in Photoshop."[6] Quarles's digital manipulations, which often give her vibrant, pattern-filled compositions a 3D quality, bring about an interlacing of textures and bodies in various states of transformation. In *Meet in tha Middle* of 2018 (pl. 119), for example, braided torsos are enmeshed with unfurling limbs, hair, and digits, all balanced precariously atop a fleshy foundation of ample thighs and buttocks anchored in the lower right corner. Thanks to a venetian blind that takes up much of the background, the blue light of an external world radiates into the painting at staggered intervals. Line-drawn articulated details—an index finger is both an anatomical act of flexing a phalange and a pointed provocation, glandular forms coalesce into a supple breast—convey the artist's insistence on the intimacy of gestural mark making within a digitally composed framework. "That's a way for me to still incorporate drawing and experimentation in this play between intention and actuality," says Quarles, further noting that

> it changes the gesture into being not this grand physical gesture but this more minute, figure gesture of a mouse trackpad. It allows me to create these digital moves that I bring back into the canvas through stenciling, which allows for a gesture that's really not tied to my physical body—so it's a way of mixing up the gesture that gets put into the work. I think the figure, for me, is a helpful tool because I know it so well that I can play with the limits and the stretching of legibility just because I'm so familiar with how it's actually supposed to look.[7]

Quarles's sense how a figure gets computed is seen in the dense meshwork of *Meet in tha Middle.* Figures are outputted in intense profile, in a careful intermingling of shapes that become characteristics or features—peaks and arches morph into noses and lips, undulating lines of mascara-like, cakey black strokes form loose streaks of hair, which then stream into lush washes of mauve and umber skin tones that bleed from one body to another. The artist's compositional moves reflect the specificity of computational vision: objects can and will be viewable from all sides and angles regardless of how a work might be situated. In particular, *Meet in tha Middle*'s digital point of view prompts the recognition that bodies are read from multiple vantage points and appear against a shifting contextual background. Quarles describes this process in reference to her own experience, offering a type of bodily knowledge that is endemic to many:

> We know ourselves as this fragmented jumble of limbs and this kind of code switching that happens. . . . It's about overlapping that with what it is to be in a racialized body as somebody who's multiracial and who is half Black but is also half white and is legibly seen as white by white people. . . . The basis of the work is trying to get at what it is to be in a racialized body, to be in a gendered body, to be in a queer body, really to be in any body and the confusing place that that actually is with knowing yourself.[8]

Importantly, *Meet in tha Middle* underscores the mutability of identitarian formations, specifically "the experience of living within a racialised body, or living within a queer body" rather than what it is to look at a racialised or

queer body"[9]—helping us see how figures, bodies, and individuals comport themselves at any given moment, how they shrink or take up space, become seen or erased, pointing to what is computable or uncomputable and what lies between.

Compression

Analyzing the computational effects on all forms of visual art has become increasingly critical since the year 2006 ushered in the ubiquity of image search. This was a moment when the efficiency of the Web further eroded the frameworks of scale. In contrast, the artist Tomashi Jackson (born 1980) uses seemingly anachronistic techniques of silkscreen printing and photographic image transfer to produce vivid works that demonstrate the persistence of scale—a measure of size as well as saturation (color scale)—and that explore the unstable ways scale and color are manifested in the digital realm as well as in contemporary life.

Both chemical photographic processes and printmaking typically rely on a one-to-one scale relationship between the matrix (the surface that is printed) and the image that is produced. As Jackson has explained, "They're wet/dry concerns. . . . They are processes that are not up for any sort of conceptual or artistic debate. They are facts about how machinery and materials work and how images are made."[10] Jackson's hand-rendered inscriptions of the variegated American vernacular terrain, along with its social infrastructure (educational systems, housing conditions), voting processes, and means of public dissemination (news, music, film, texts), might seem intentionally cumbersome in an era of digital image making and instantaneous photo sharing. However, her works undertake an incisive consideration of image technology itself, exposing it to be cyclical rather than linear. The artist recounts her undergraduate experience: "2006 was the year after the copy camera was retired in the Cooper Union print shop so I never got to learn to use that machine. So, the way that I learned about making a halftone dot or halftone line was entirely through Photoshop."[11] She goes on to make the salient point that "historically we go from etching to lithography to photography to tintypes to daguerreotypes, to the moving image and to digital imagery. It was really fascinating to me that, in turning a solid image into a halftone line, a digital image can be returned to the origin point of printmaking, the line."[12] In *Girls Time (Heartbreak Hotel)* of 2020 (fig. 1), Jackson demonstrates how individual lines—produced through the transfer of photos and prints onto a shared surface—can underscore select information while also, when combined with other lines, forming crosshatches that obscure or obfuscate certain details. Like much of the artist's recent work, *Girls Time* rests on an architecturally scaled wood armature (a motif that recalls both a painting stretcher and a refined shipping pallet) that refuses to lie flat against the wall. Its 3D form casts a distinct shadow on the floor below and allows the viewer to see the work in extreme frontality, like a bus-shelter billboard or a storefront awning. Simultaneously, when viewed from the side, the work offers a literal cross section of the way information is collected, stacked, and unevenly disseminated.

Specifically, for *Girls Time*, Jackson sourced archival images that record the act of voting as a civic right, from the

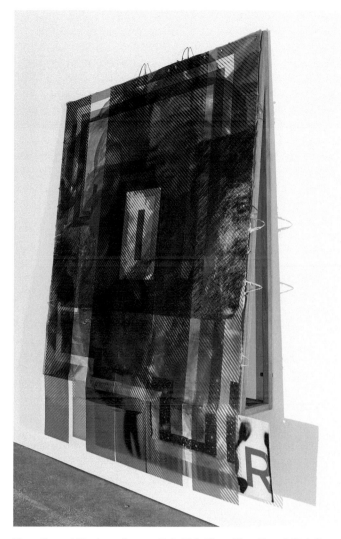

Fig. 1 Tomashi Jackson (born 1980). *Girls Time (Heartbreak Hotel)* (pl. 109), 2020. Archival flatbed print on PVC marine vinyl, with acrylic paint, paper bags, Pentelic marble dust, Greek canvas, fabric from Walmart, and American linen, mounted on handcrafted pine awning structure with brass hooks and grommets, 8 ft. 11 in. × 6 ft. 9 in. × 1 ft. (271.8 × 205.7 × 30.5 cm). Shah Garg Collection

legacy of ancient Greece to the Voting Rights Act of 1965. She also located images that corroborate the discriminatory ways this democratic idea has actually been incarnated for Black Americans, from gerrymandering to more violent forms of voter suppression. *Girls Time* points to an accretive imaging process, which—like social change itself—develops over time rather than occurring instantaneously. The painting was built up by Jackson's deft reprocessing, screening, printing, and scaling of images, along with the incorporation of found and sourced materials (paper bags, marble dust, textiles from Greece, the United States, and, specifically, Walmart), which have all been compressed—like a digital file in which information sometimes drops out or erodes the more it is circulated. Twine loops attached at the edges of the support seem to stabilize the layers of paper, canvas, and linen while conveying the sense that those layers have been bundled, not unlike a stack of newspapers. Five strips of clear vinyl machine-printed with halftone cyan lines hang from hooks mounted at the top of the armature, their weight supported by brass grommets. The vinyl's semitransparency allows streaks of fuchsia and shots of yellow to bleed through

the blue lines, resulting in a type of screen image: a tricolor printing process rendered in 3D. The vinyl strips themselves read as spatialized vertical lines that run through the length of the work, at once highlighting and obscuring information at different intervals. Gaps, wrinkles, and folds in the layered images point to the ways representation functions (and malfunctions) not only in painterly terms but also in the body politic—in the variable, unreliable right to count as citizens. Jackson makes the case that the ability to count, to be counted, is susceptible to the same mechanisms of distortion and erasure to which images are often subjected when they are compressed, stored, or transferred over time. *Girls Time*'s compression of decades of information eschews a singular focus on image refinement; instead, it operates through a logic of digital compression that generatively builds on the deletion or dropping out of information in equal measure with additive techniques such as assemblage and collage.

Compositing

The idea of a digital technique's operating as a type of aesthetic intelligence can also be seen in *The Enablers (an adaptation)* (pl. 122; detail opposite), a work of 2021 by Ilana Savdie (born 1986), in which four separate panels have been fitted together to form a single work. More than just a formal means of scaling up to a larger overall image size, the act of compositing here becomes a powerful metaphor for the ways identity pushes and pulls against the corporeal—not that the work is about Savdie's body or any particular identity, but rather that it conveys the fact that biographical identity is made up of multiple composite parts. Identity is never a stable whole; it is a more fractious construction, which turns on notions of multiplicity, heterogeneity, precarity, and, for many, a sense of marginality.

Compositing is a cornerstone of Adobe's ubiquitous Photoshop software, and the artist indeed uses Photoshop in the sketching process, less as a means of perfecting an image than of experimenting. She typically begins each painting with "a drawing that comes entirely from memory and then I start looking to other sources. It's pretty human figurative. . . . Then it becomes about connecting and moving ink across the page. I translate that into a digital sketch where I bring in color and I play with collage."[13] Distinct from the analogue process of collage, however, Photoshop is typically deployed to blur the demarcation lines between the individual units that are being conjoined in order to produce a visually unified whole: the software is designed to digitally erase any sign of a break between the sections, or at least to make them less noticeable to the viewer. While Savdie's acid-green fields, violent washes, and twisting, highly pigmented forms may visually push the eye to the outer edges of each of the four canvases, the margins remain highly visible, preventing the image from becoming a seamless whole.

At the same time, the artist eschews layering or building up an image from overlapping parts: the biomorphic forms and undulating lines remain contiguous, crossing the edge from one panel to the next. Both the composited canvases themselves and the abstract patterning on their surfaces insist on the margins as a space of potential rather than something to be erased or ignored. This is what marks the work's shift away from earlier paradigms of abstraction, in which seemingly innocuous biomorphic forms actually sublimated identitarian readings. Instead, Savdie's *Enablers* instantiates the notion that if one's identity does not adhere to codes or conventions of fixity or stability, then the margins are a place of plenitude. Or, in her own account, "I am interested in the carnage that happens in those liminal spaces where the folkloric and the biological can cohere to propel power for those of us deemed impure, inconvenient, and culturally complicated."[14] *The Enablers* places value on the indeterminate and fractious instead of participating in the drive for universality—or uniformity—of modernist abstraction.

Countering Network Effects

Paradoxically, while the adoption of digital tools within painting may suggest a more pluralistic aesthetic sensibility, the digital age has actually ushered in an extreme conformity. For instance, rather than a civic arena, the public is now defined by the habits of online commerce and social media. If Web 1.0's utopian dream was of a decentralized network that would lead to a decentralization of power, ushering in a type of digital subjectivity unmoored from the strictures of class, race, gender, and ableism, today's reality is quite the opposite. Rather than fostering fluidity, network effects staunchly reinforce hierarchies and stereotypes. Digital instruments built on the promise of radical agency and open access surveil, track, target, and troll in equal measure. The media scholar Moya Bailey astutely identified this phenomenon in 2008 when she coined the term "misogynoir" to describe the racist misogyny that Black women experience, particularly in the United States, via the tools of digital culture, including social media and image search functionality—a stark reminder not only that digital technology is never neutral but that it expedites and reinscribes bias and discrimination, both increasing and normalizing their spread.[15] Jackson, Quarles, and Savdie render complex images that break up the dichotomies of good/bad, White/Black, us/them, analogue/digital. Moreover, these artists help us think about the conditions of mediation as being defined not by the specific aspect ratios or formats of photography or video but by the scalar dynamics inherent to digital production—and point to the relative speed of digital circulation.

Within the Shah Garg Collection, the scalar dynamics of mediation can be linked to the distinct conceptual trajectories and critical vocabularies of the three other artists mentioned at the outset, Laura Owens, Sarah Sze, and Haegue Yang, who came to the fore during the 1990s and continue to make deep impressions in the field of contemporary art. Each of them, in her own indelible way, has interfaced with the more fragmented, provisional, and particularized audiences shaped by the rise of the Internet, which was a sonic (dial-up modem) and physical (IP protocol) materialization before it was strictly seen as a visual one. Rather than adopting televisual forms and techniques (seriality, appropriation), Owens, Sze, and Yang have always taken a multisensory approach to art making. Painting, in their deft handling, is shaped by acts of filtering, aggregation, and iteration. Their works in the Shah Garg Collection brilliantly convey the complex, embodied ways pictorial representation is *rendered* through

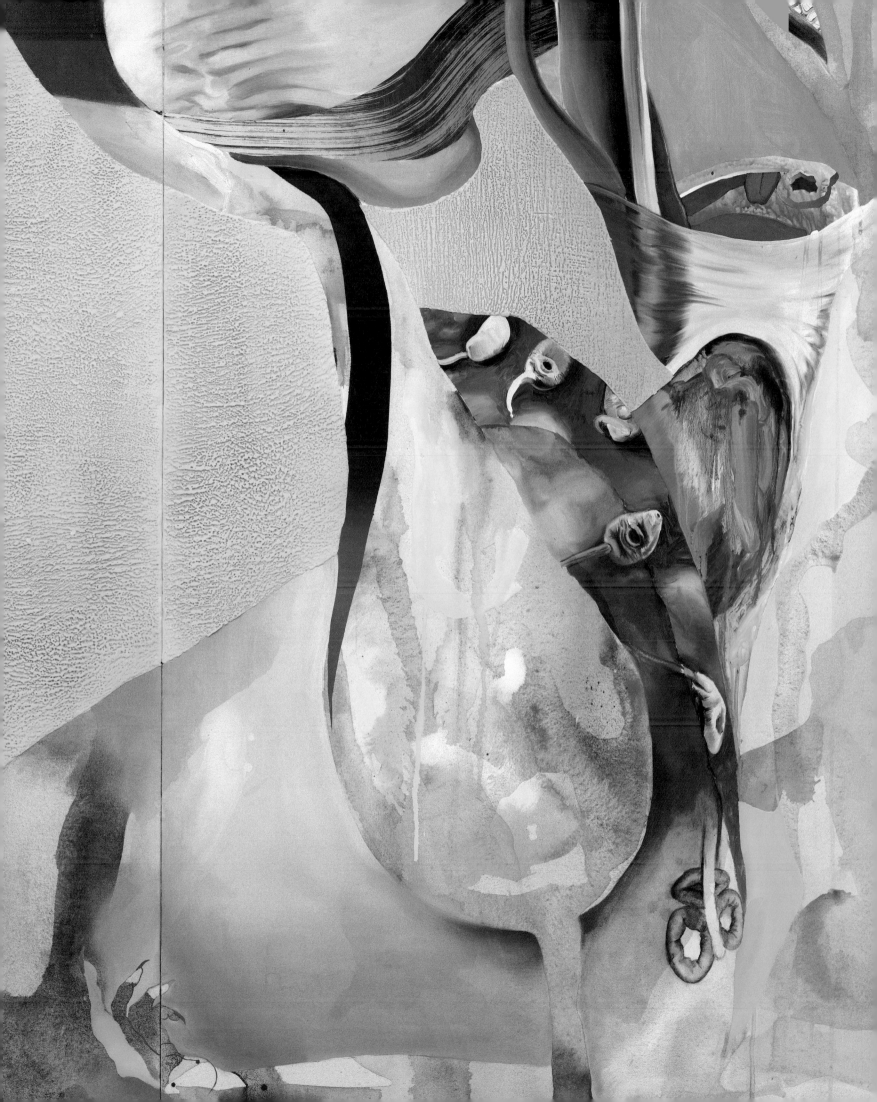

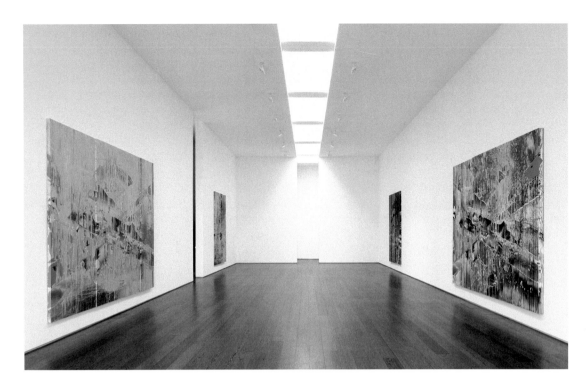

Fig. 2 Installation view, *Sarah Sze*, Victoria Miro, London, October 12– November 6, 2021, showing *Crisscross Apparition* (2021; Marciano Art Collection) and *Crisscross* (pl. 87) in the foreground

computational logic rather than simply *captured* by cameras or lenses (photographic, filmic, video, or even human-less variants, such as satellites, drones, scanners). Above all, in their work and their personhood, Owens, Sze, and Yang insist that visual art is produced and operates within the circulatory networks of public life.

Scalar Differentiation

In her meticulous practice, Sarah Sze (born 1969) has long underscored the ways codes and coordinates create shapes, including the curve of a line; textures, such as that of paint; and, most emphatically, yet still undertheorized, a sense of scalar differentiation. While often conflated with size, scale in Sze's work is conditioned by degrees of amplitude, force, and duration—a set of external relations, as well as internal ones, that all have various scalar forces acting upon them—and thus retains its multiplicity. Looking at *Crisscross* of 2021 (pl. 87), an image composed of a set of smaller images cut through with incised and painted lines, should disabuse any viewer of the idea that digital code is limited to the screen or the projected image. Created with the specific parameters of its gallery presentation in mind, the dynamic, architecturally scaled work makes clear that code controls the physical world through architecture, the built environment, and form itself. Specifically, scale in *Crisscross* operates on a dynamic spectrum, as a set of relationships and circuits that come through as recursive motifs: hands manipulating materials, birds in states of flight, flames in various degrees of combustion, and an array of cloud formations that appear in intersecting tracks across the almost twelve-foot-wide canvas.

Moreover, physically encountering *Crisscross* in its original installation enacted this sense of scalar differentiation in a way that parallels the habits of online viewing (fig. 2). One of a pair of canvases—one in what Sze called "its original state," the other "a step away from that state"—*Crisscross*

was initially mounted facing its pendant so that the viewer was "caught between these two images . . . in that in-between space" and had to toggle between the two works in order to "rectify these two images."[16] Sze describes the experience as part of a longer investigation into the very process of iteration itself:

> I was really thinking about how any work of art is just a generation in many, many steps of an artist's work. So, I really think of an artist's body of work as one work, and at each stage you're just seeing a little window into a set of decisions, and that set of decisions titrates, it changes, it evolves, and it's really that evolution and that space in between, those decisions that you make in between a work, that create the next work, that creates the next work after, that I really wanted to highlight by painting these paintings in pairs, where you could see very closely that they were the same painting in two different stages.[17]

In this way, the concept of iteration—endemic to computational software—pushes against the deeply ingrained modernist trope of original versus copy, in which the hierarchy of value continues to elevate notions of singularity and uniqueness. In Sze's work, scalar difference operates as a hermeneutic, marking a sense of difference that does not turn on derivation while at the same time making new connections between our senses of mediation and subjectivity. Instead of reinforcing a regime of vision or opticality, *Crisscross* speaks to specifically twenty-first-century scalar encounters—from nanotechnologies (in everything from chemical sunscreen to natural silk fibers) to big data (as used in GPS and search functionality). These simultaneously ever-smaller and ever-larger forms of radical alterity shape contemporary lived experience, which Sze's extraordinary body of work has keenly manifested through sculptures, installations, and paintings—*Crisscross* being just one recent example.

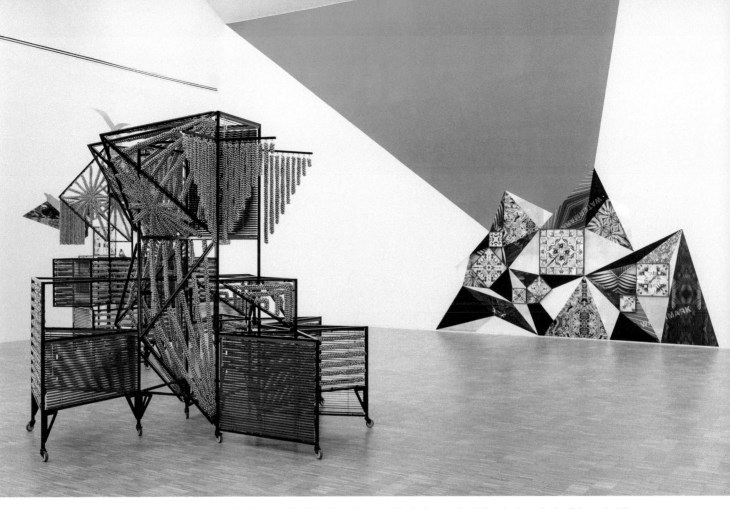

Fig. 3 Installation view, *Haegue Yang: Tightrope Walking and Its Wordless Shadow* (Furla Series #02), Fondazione Furla, Triennale Milano, September 7–November 4, 2018, showing *Sonic Dress Vehicle—Bulky Birdy* (2018) and *Voltaic Montane—Trustworthy #359* (2018)

Expansion and Compression

Historically, the scalar computational terms "expansion" and "compression" have been deployed in a reciprocal manner in relation to concepts such as minimalism and abstraction, codes and shorthand, redundancy and ornamentation, and any number of other qualities and techniques that either delete or proliferate aesthetic material, particularly around issues of resolution, definition, and fidelity. Thus, compression and expansion are paradigms well suited to the work of contemporary art history writ large, despite the fact that the two terms are usually limited to discussions of digital culture. An exception is the work of Haegue Yang (born 1971), which has explicitly probed the mutual affinities between processes of expansion and compression in a range of materials evocative of industrial fabrication, craft, and performance. While some of Yang's bodies of work engage directly with themes of folding and unfolding or doubling and halving, her *Dress Vehicles* (fig. 3) and *Series of Vulnerable Arrangements* use electric fans, casters, scent emitters, and the artist's signature venetian blinds, among other materials, to generate and mobilize structures that offer a "range of sensorial experiences" and explore an "expanded notion of movement"[18]—one that extends even to social and political movements, partly by activating a salient dialectic of transparency and opacity.

An early foray into thinking about these issues is fore-grounded in Yang's *Trustworthy* series, begun in 2010, in which she generates tessellated collages from graph paper, origami paper, and cut and torn security envelopes (procured from galleries, museums, and her personal network) that often move from the frame to the wall in symmetrical or asymmetrical patterns and play on gradations of form and color. These works turn business envelopes—analogue vehicles for corporations' dissemination of private information—inside out, deploying idiosyncratic tactics of aggregation and disaggregation. The artist asks us to consider how acts of information circulation sync up with other models of dispersion, including movements of people in the form of migration, colonialism, and tourism. Moreover, she incorporates references pertinent to digital-age security, such as passwords and encryption, and explores how they meet up with more intimate notions of secrecy and privacy. The 2016 mural *Masked Eyes—Trustworthy #277* (pl. 93) operates within the decidedly networked conditions of the twenty-first century rather than the systems thinking of the 1960s.[19] The pervasiveness of networks in contemporary life, according to the media scholar Wendy Hui Kyong Chun, has become "a defining concept of our epoch," allowing those networks "to trace and spatialize unvisualizable interactions as flows: from global capital to environmental risks, from predation to affects."[20]

Against Dispersion

Laura Owens (born 1970) handily dispenses with digital culture's propensity for naturalizing the arbitrariness and randomness of images. Unwilling to leave decision making

Fig. 4 Laura Owens (born 1970). *Untitled*, 2015. Glazed porcelain, diameter 1½ to 3 in. (3.8 to 7.6 cm). Selections from an open edition of unique, hand-glazed ceramic sculptures depicting various emojis. Shah Garg Collection

to the algorithm or any sense of formula, her works decry the rise of universalization and homogenization in network culture, in which images (from paintings to selfies) seem equally at home on the screen—be it a monitor or a smartphone—as they do installed in a museum or other physical space. These seemingly dueling characteristics—arbitrariness and algorithmic predetermination—in much contemporary Euro-American painting have led critics to use the moniker "Painting 2.0" to denote "painting after conceptualism," which they describe as being primarily concerned with issues of "de-skilling" and "anti-authorship."[21] However, Owens's distinct painterly language is defined by a formal adroitness, awareness of period specificity, and commitment to rigorous experimentation with installation. Her works draw historical and social connections between patterns of information (algorithmic or handmade, art-historical or familial) and their respective modes of dissemination (websites, computer networks, books, prints, workshops, exhibitions, communities of people) and expose those connections as ultimately material and immanently communal.

Owens's porcelain emojis of 2015 (each about the size and weight of a golf ball) convey the efficient expressiveness of literal digital icons through an economic application of colored glazes and spare indentations (fig. 4). Three years later, these 3D emojis reverted to 2D computer-graphical imagery when they circulated as a series of iMessage stickers downloadable from Apple's App Store.[22] Specular highlights that conveyed the sheen of porcelain and flat, gray ovals

that mimicked the objects' shadows in real life not only differentiated the icons from Apple's default versions but are signature gestures often used by the artist in her own canvases. The recursive relationship between digital forms and analogue objects is further displayed in *Untitled* of 2016 (pl. 89). In the nine-foot-tall canvas, undulating bands of cross-stitch Xs blur into pixelated lines, referencing a range of visual paradigms, from early bitmapped video games to homespun embroidery. Owens demonstrates the reliance of both craft and computation on comparable patterns of grids, arrays, and codes. In fact, to create the work, Owens scanned a swatch of her grandmother's embroidery—reminiscent of a type of needlework, the sampler, in use since the 1400s as a tool for knowledge production, to teach young women the alphabet and other practical and ideological matters—and manipulated it digitally before screen-printing portions of it onto the canvas with the aid of a lattice-shaped stencil. Not simply painterly trompe l'oeil, Owens's techniques make a material argument about the weight and forbearance of history, about how it is taught and passed down through mechanisms of repetition and iteration. In *Untitled*, the artist interrupts this lesson with an actual spinnable bicycle wheel adorned with hand-painted hearts, which evokes both the Duchampian readymade and a bored student doodling during history class. The work is a tour de force of her insistence on referencing both the context and the formats of her subjects. Lens-based imagery remains flat on the surface; textiles are built up through strands that iterate lengthwise and

widthwise; the warp and weft of string act as sets and arrays of computational formulae. Owens's individual paintings are not unlike units, each an iteration with a series—a process that is at the core of digital computation itself.

Since the late 1990s, much has been written about the ways Owens has reprogrammed the code for painting's operations within contemporary art. However, what has gone unremarked upon is her steady, and no less powerful, pursuit of an understanding of what can be described as an "epistemology of search." This is a reference to the art historian David Joselit's concept that meaning can be derived from purposefully aligning so-called variable content, revealing not only the end results but the processes that lead to them. He and other scholars have primarily acknowledged Owens's male peers, most notably Seth Price, for their explorations of this concept.[23] In particular, Price's 2002 treatise *Dispersion* is often cited for explicating how an artwork's meaning is not determined by a singular context but may take the form of a version, a platform, or a unique materialization of a file or computer code that gets redistributed within an economy of the digital. Yet, as Owens makes evident in *Untitled*, code is not limited to the digital but informs the photographic, the printed, and the woven. Because code is not a thing in and of itself, the question is not what painting under computation can or cannot do, but the one Owens poses in her contribution to Price's 2018 exhibition catalogue: not to foreground "recent technological developments in photography and printing" but rather to critically ask "what could you do with it."[24]

Ultimately, the inherently digital conditions displayed in the works of Quarles, Jackson, and Savdie meet up with those in Sze, Yang, and Owens to help us see the ramifications of computability, compression, compositing, and iteration not simply as visual metaphors but as reflections of the ways all media operate under the pressure of computation. Importantly, these selected works in the Shah Garg Collection reveal the mutual embeddedness of computation and identity in the artists' attempts to make the lived experiences that shape both not just *visible* but *recognizable* as cultural constructions—a responsibility that remains pressing and critical in the long digital age.

1. For a technical and cultural history of computer graphics and how they became one of the principal technologies determining how we encounter and comprehend the material world, see Jacob Gaboury, *Image Objects: An Archaeology of Computer Graphics* (Cambridge, MA: MIT Press, 2021).
2. José Esteban Muñoz, *Cruising Utopia: The Then and There of Queer Futurity* (New York: New York University Press, 2009), 22.
3. Alexander Galloway, *Uncomputable: Play and Politics in the Long Digital Age* (Brooklyn, NY: Verso, 2021), 3.
4. Ibid., 4.
5. Christina Quarles, "Christina Quarles: Reading the Body; In Conversation with Perwana Nazif," *Ocula Magazine*, April 14, 2021, https://ocula.com/magazine/conversations/christina-quarles/.
6. Christina Quarles, quoted in Christopher Borrelli, "How to See the Christina Quarles Show at the MCA? Go with the Rising Star Artist, and Forget Your Glasses," *Chicago Tribune*, June 2, 2021, https://www.chicagotribune.com/entertainment/museums/ct-ent-christina-quarles-mca-chicago-20210602-xb4jeduo4reypkuxg0727nibqm-story.html.
7. Christina Quarles, "Christina Quarles on the Intricacies of Figuration and Selfhood: 'We Know Ourselves as This Fragmented Jumble of Limbs,'" interview by Claire Selvin, *ARTnews*, April 15, 2021, https://www.artnews.com/art-news/artists/christina-quarles-artist-interview-1234589606/.
8. Ibid.
9. Quarles, "Quarles: Reading the Body."
10. Tomashi Jackson, interview by Maddie Klett, *Brooklyn Rail*, October 2021, https://brooklynrail.org/2021/10/art/Tomashi-Jackson-with-Maddie-Klett.
11. Ibid.
12. Ibid.
13. Ilana Savdie, "Boundless, Abundant Color: A Conversation with Ilana Savdie," by María Elena Ortiz, in *Ilana Savdie* (Los Angeles: Kohn Gallery, 2022), 87.
14. Ilana Savdie, artist's statement, in Kathy Battista, Roxane Gay, et al., *This Is America*, exh. cat. (Berlin: DISTANZ, 2021), 76.
15. See Moya Bailey, *Misogynoir Transformed: Black Women's Digital Resistance* (New York: New York University Press, 2021).
16. "Sarah Sze," film by Eva Herzog, posted on Victoria Miro, London, website, for the exhibition *Sarah Sze*, October 12–November 6, 2021, https://online.victoria-miro.com/sarah-sze-london-2021/. The work paired with *Crisscross* was *Crisscross Apparition* (2021; Marciano Art Collection).
17. Ibid.
18. Both are titles of sculpture/installation series by Yang. See Patricia Falgueres, "A Dance Lesson at the Aubette, 2013," in *Haegue Yang: Anthology 2006–2018; Tightrope Walking and Its Wordless Shadow*, ed. Bruna Roccasalva, exh. cat. (Milan: Skira, 2019), 248–63.
19. Ibid.
20. Chun makes this case in her book *Updating to Remain the Same: Habitual New Media* (Cambridge, MA: MIT Press, 2016), 3.
21. See, for example, the Berlin-based critic Isabelle Graw's anthology of essays opining on the status of contemporary painting as an arbiter of social value after MoMA's exhibition *The Forever Now: Contemporary Painting in an Atemporal World* (2014–15) and *Painting 2.0: Expression in the Information Age* at Museum Brandhorst, Munich, and mumok, Vienna (2015–16): Isabelle Graw, *The Love of Painting: Genealogy of a Success Medium*, ed. Niamh Dunphy, trans. Brían Hanrahan and Gerrit Jackson (Berlin: Sternberg, 2018).
22. The stickers were issued in conjunction with the midcareer survey *Laura Owens*, on view at the Whitney Museum of American Art, New York, from November 17, 2017, to February 26, 2018, and are no longer available through the App Store.
23. David Joselit, "What to Do with Pictures," *October*, no. 138 (Fall 2011): 81–94. These male artists include, in addition to Price (born 1973), Wade Guyton (born 1972) and Josh Smith (born 1976), who have dominated the discourse on computation and contemporary art in a manner that remains unchecked and problematic.
24. Laura Owens, "Absent Third Term," interview by Rachel Kushner, in *Seth Price: Social Synthetic*, ed. Beatrix Ruf and Achim Hochdörfer, exh. cat. (Amsterdam: Stedelijk Museum; Cologne: Walther König, 2018), 341.

Artists on Artists

To pour the heart out
Kevin Beasley on Lynda Benglis

In the prone position a person breathes better. Intake. If one is on a ventilator, the flow of oxygen reaches the lungs uninhibited, unlike the supine position, where the lungs compress against the heart. To lie prone is to rest on your stomach, facing downward, and if on a concrete floor—cold-pressed against it. We can take shape on the ground, depending on how much of our body's surface makes contact. Furthermore, the swells in our back and knots in our shoulders can come from the bottom of our feet. Proper soles separate our feet from the floor. This feeling stretches throughout our muscles. The length of us, entirely. Networked. Our skin is ubiquitous. Covered in organs—the seven layers of skin vary in weight and purpose, yet there are three main layers of tissue: The epidermis, made of five layers, is the most protective layer, against bacteria, germs, rain, and sun. The dermis grows hair, creates oils, and holds our nerves, while the hypodermis provides fatty cushioning around our muscles and bones. Seven layers of survival. Thick skin or not, it is what registers our pain, a searing of our mind and body. It is what we press upon to release the lactic acid in our muscles. The pressure.

It's the force of gravity. The reaching for the center of the planet. The resistance of flow—its viscous character acts on instinct, plays upon plays, movements within brawn—it spreads. A soupy force of nature, where everything rises to the top. Even the ill take stage. A proscenium of street antics, toxic conflict, and metabolic burn. In need of a cleanse in these damn streets. Manufactured empathy, or some-thing.

To pour out the heart—spent and defiled as it crawls across the floor, we watch it level. It never does, though—there is always an edge. The heart stops at some point, it doesn't pump forever—a lifetime of blood can fill a million barrels. But there are billions of notes, trillions of organized assets floating in fluid. It eventually hardens, and if it is invested in anything but itself, it will take on that shape. Otherwise it holds its autonomy like a once-living organism. Frozen in a state of travel, flowing toward the lowest point in the room.

Lynda Benglis's *Baby Planet* (below right) is akin to the fatty tissue stretching along the hard surface. The work carries itself in the room. What is to be said that has not

Kevin Beasley (born 1985). *Untitled (street family)*, 2014. Polyurethane foam, polyurethane resin, jeans, T-shirts, carpet, and altered muumuu, 7 × 59 × 41 in. (17.8 × 150 × 104.1 cm). Rennie Collection, Vancouver

already been stated about a process and an object that reinvents both itself and how it was made? An artist so deeply of her time, so sensitive to what was prescient *then* that her moves transcend even those not conceived yet. Some would say "ahead of her time," but this does not pay her insistence on the *now* its due. An insistence on what is urgent rather than latent. *Baby Planet* is an exercise of unmaking by virtue of each layer's stretching over, around, and through while adhering to its previous manifestation. It is evidence of the layers of processing it takes to understand the tendencies of the body. The epidermis completely replaces itself every thirty days, and I imagine this pigmented latex gives us proximity to a microscopic evolution, frozen in time. The hours, the days to set. The floppiness of the weight gives mass to every forearm that tries to lift it. It rubs. Its sensual surface radiates not because of its color but because of its core. The surface is all we see, but the thickness and girth give hue. Thicker than most latex. Yet flat. Its mystery gives erotic curiosity to what has been laid bare before us. More than fifty years ago. And we come back to it continuously because it arouses our desire to connect with one another. To get a peek at its saturated viridian-ochre glaze. To hook up with the strange. To seduce our material fetishes. *Artforum* **is** glossy.

Splurge. The pouring out is so essential here. Benglis pours out so much for us, and its generosity is also sharp-edged. It gives purpose and weight to seemingly hapless materials. Desirous gestures. Left without an appetite because there is a constant satiation. A wetting of the lips that occurs at the right moment—at the right time and right where we want it.

Parallel. I wish to consider a "body politic." That even amid all the sensual materials and spillage in the work, Benglis is a director of sentiment and urges her audience to consider their own reflection and impact as a body in space. The rippling consequences of such existence. She takes control of her body, and, in turn, our humanness or lack thereof glows and wanes in its illness and health. Her works expose our worst tendencies, in the form of patriarchal vestiges to which we still hold on, while also setting us on a generative path through much-needed promiscuous experimentation and formal exploration. Deeply connected to ancient Greek art and philosophy, thanks in part to her familial roots in Kastellórizo, the world Benglis crafts in even the most minimalist ways—not to be confused with Minimalism—is an homage and also a challenge to tradition and the canonized center of serial practices. Ain't nothin' quite like another in her oeuvre. Yet it is paramount to understand this with a lens of tactility and acute perception—this is to be her world now, poured on the floor—spilling off the walls.

Lynda Benglis (born 1941). *Baby Planet* (pl. 39), 1969. Pigmented latex, 1½ in. × 9 ft. 2 in. × 2 ft. (3.8 × 279.4 × 61 cm). Shah Garg Collection

Aria Dean on Julie Mehretu

I often find myself jealous of painters for the day-to-day, moment-to-moment engagement their kind of work calls for. A naïve comparison, to say the least, given that painting long ago expanded its field to include a variety of mediated, machinic, and digital processes. And just as well—it's my own fault that I'm a sculptor whose hand never once touches her objects. But to put a finer point on it, I'm jealous of the possibility offered the painter to, if she chooses, stand in front of a canvas and thrash paint across it at will.

Julie Mehretu is known for her deft and complex negotiations of abstraction. While many painters linger in broad strokes, leaning on color blocking and sparse mark making to communicate a world beyond the figure, Mehretu has always woven intricate compositions that balance control and chaos; her line work is obviously so human but, at the same time, somehow feels like a pen-plotter machine run amok.

Mehretu takes this underlying tension between organic and mechanical mouthfeel to a new level in her recent paintings, including *Among the Multitude VI*, in the Shah Garg Collection (pl. 88). This body of work incorporates degraded digital photographs as underpaintings, transferred onto canvas by mechanical means. The artist culls these images from the Internet, where they circulate as part of the massive, undulating body of vernacular and official media produced from major political moments for circulation online and in traditional news sources.

Mehretu's process brings to mind Hito Steyerl's concept of the "poor image"—now over a decade old, amazingly. For Steyerl, images were increasingly being circulated in low-resolution formats throughout massive digital-social networks, their value transforming from auratic, quality- and scarcity-oriented schemas toward accessibility, "cult value," and pleasure. Today, all images are poor, but this poverty is readily converted to wealth. Steyerl calls poor images the "wretched of the screen," and just like Frantz Fanon's wretched of the earth, they are readily

Aria Dean (born 1993). *Eraser (plastic phenomena)*, 2021. Cryogenically engraved crepe rubber and aluminum (3 parts), each 36¼ × 13¼ × ⅞ in. (92.1 × 33.7 × 2.2 cm), overall 36¼ × 41¾ × ⅞ in. (92.1 × 106 × 2.2 cm). Private collection

Julie Mehretu (born 1970). *Mind-Wind Fusion Drawings #1*, 2019–20. Ink and acrylic on paper, 26⅛ × 40 in. (66.4 × 101.6 cm). Shah Garg Collection

extracted from. Today, images are sheer information—impossible to *read*, made to *scan*—thanks to the excess of semiotic activity surrounding them. When the image becomes sheer information, it also becomes a material: data, fuel, currency, etc.

So, Mehretu's *Among the Multitude VI* is an exercise in some kind of digital materialism. The artist extracts images from circulation and, holding them in place however momentarily, accelerates their degradation. This process taps into what Erika Balsom calls the "Janus-faced" nature of the poor image; such images (all images?) belong equally to the people and to circulation, but they can just as easily be repurposed, made site-specific, and brought under the control of an individual. This is a gesture that bears some relation to appropriation-art practices of the 1980s and '90s but departs meaningfully from them, concerning itself, again, with images as actual material rather than as a series of signs and their framing.

The result, in Mehretu's case, is a satisfying relocation of the social and political content of the work to the back-

ground, literally. These paintings are tethered to contemporary conditions and events without symbolizing or reflecting them back to us. The quietude of painterly contemplation gives way to Baudrillard's "screen and network . . . a non-reflecting surface, an immanent surface where operations unfold" (*The Ecstasy of Communication*, 1987).

It is on such a surface that Mehretu then makes her signature marks. In some ways, despite having expanded the field of painting to the point of apparent total inclusion, we might still be uncertain about our beliefs around the intimacy of rendering—still deciding if it feels or means something different to render mechanically or digitally. But atop this confusion, or discourse, really, Mehretu's operations unfold—the same gestural language we've come to know so well. However, here, vibrating with the energies of our collective turmoil, and aftershocks of unprecedented circulatory speed, such marks appear even bolder and more urgent.

Documenting the Black Imagination
Charles Gaines on Lauren Halsey

Lauren Halsey's *Untitled* of 2020 (opposite) is a hand-carved bas-relief sculpture consisting of eight two-by-two-foot segments of gypsum board, forming a grid four segments high and two segments wide. The images carved into it are a montage of posters, signs, and tags based on those found on the brick wall of My Liquor Bank, a small commercial establishment in the Leimert Park neighborhood of South Central Los Angeles. Familiar names such as those of George Floyd (1973–2020), Breonna Taylor (1993–2020), and Elijah McClain (1996–2019), all victims of police violence, and references to popular Black celebrities such as the singer Adina Howard (born 1973) are inscribed alongside announcements such as "We Buy Houses." The bas-relief technique transforms the original posters and tags into a unifying, colorless display of shadows, light, and textures.

What is noteworthy is the sense that this work is a snapshot of a moment in the life of a community, a documentation of an instant in time mapped out by the arbitrary relationship between signs and tags that come from a diversity of contributors. As such, it expresses how the community uses the wall: like a visual town hall that is available to anyone who has something to say, or a data warehouse of claims and announcements coming from multiple sources and serving multiple intentions. The work maps time in the same way montage does, as a collection of different events, persons, and utterances all existing in the synchronic present. Words and signs are arbitrarily cut off by the work's edges or by the obtrusive incisions performed by the grid of segments. This is a conceptual puzzle, the very definition of montage, simultaneously totalizing and fragmented, with contents that are disparate but bound together by community.

The hierarchies that control the Western worldview—particularly that of White people, because of their dominant position in the social order—are the product of the

Charles Gaines (born 1944). *Numbers and Trees: Central Park Series II: Tree #9, Malik*, 2016. Black-and-white photograph, acrylic on plexiglass, 8 ft. × 10 ft. 6½ in. × 5¾ in. (243.8 × 321.3 × 14.6 cm). Shah Garg Collection

Lauren Halsey (born 1987). *Untitled*, 2020. Hand-carved gypsum board, mounted on wood, 95 × 47¾ × 3 in. (241.3 × 121.3 × 7.6 cm). Shah Garg Collection

Enlightenment theory of progress. This idea, that the world is getting better, and that this progress can be understood and assisted by reason, has long carried consequences that privileged Whites and victimized Blacks. It turns out that the world can only get better on the backs of some of its people. To oppressed communities of color, the social space is not linear but is instead a synchronic puzzle, more montage-like than perspectival. Difference, the space between things, is not a smooth segue from one point to another; it is a fissure, a gap, a terrain of uncertainties, where movement from one point to another is a leap rather than a gradual transition. Solutions to problems must negotiate the indeterminate nature of this gap. And the montage is the model that organizes that space.

The cultural theorist Fred Moten advances the idea that Black aesthetic practice (and, to my mind, Black social and intellectual practice) operates in the space between oppositions. He writes, "Montage renders inoperable any simple opposition of totality to singularity. It makes you linger in the cut between them, a generative space that fills and erases itself. That space is, is the site of, *ensemble*: the improvisation *of* singularity and totality and *through* their opposition. For now that space will manifest itself somewhere between the first lines of tragedy and the last lines of elegy."[1] Note that Moten speaks of "ensemble" instead of montage, but the two terms are closely related. To speak of the ensemble as a site of "improvisation of singularity and totality" is to describe the negotiation of the collective differences of the montage. Moten also discusses the writings of Saidiya Hartman and her exploration of the "massive discourse of the cut, of rememberment and redress, that we always hear in narratives where blackness marks simultaneously both the performance of the object and the performance of humanity."[2] "Cut," "rememberment," and "redress" describe Halsey's project well.

In addition to montage, *Untitled* is also an attempt at monument making. For the artist, the work is part of a larger ambition to create a monument to the material culture of this neighborhood, which she says is "being lost to gentrification." As she remarked to me in a text, "I was thinking about neighborhood preservation and wanting to contribute to an archive that was about material culture, multiple black histories, aesthetics, sociopolitical records. All of the work has an architectural desire, so I started thinking about adapting or remixing forms that I sort of like, permanent records and built structures. [I] landed on the hieroglyph and started remixing the function of the hieroglyph relief as a permanent record in structural form."[3] Halsey's interest is not to create a montage just as a compositional or stylistic device; *Untitled* is a metonymic display of objects, not a poetic or metaphorical expression. Her interest is in *monumenting* the wall, including its signs and tags, and in so doing to monument the culture, community, and circumstances that produced it.

The artist's use of gypsum—a reference to limestone, and thus to Egyptian art and architecture—reveals her deeper intention to monument the material culture of the Black community. As well as being a stand-alone sculpture, *Untitled* is intended to be architectural. As explained in the Austrian art historian Alois Riegl's 1903 essay "The Modern Cult of Monuments," an architect involved in conserving a building has the task of preserving those material parts that are authentic and restoring those that are damaged or missing,[4] thus bringing together the old and the new. Riegl's interest was in the historical accuracy of objects, which came out of his lifelong project to map the relationship between cultural development and stylistic history as it applies to works of art. In earlier texts, he established that style as a driving force in art, or *Kunstwollen* (roughly translatable as "will to art"), has its own autonomy and history separate from representation and mimesis.[5] The compelling problem for him was how the history of style, an autonomous language, was related to cultural history.

Riegl is relevant to our consideration of Halsey's work because of the importance he placed on the monument (the art-historical document) in his ideas on art, particularly with respect to the relationship between the language of art (style) and culture. He did not see art as a pure reflection of culture, nor did he see it as independent of it. In many ways, Halsey is addressing Riegl's question. The idea of the monument shows how stylistic and cultural (otherwise called "discursive") interests combine. With *Untitled*, Halsey proposes that the montage is the perfect form for this integration. Because of the manner in which it organizes time, it is a poststructuralist model of a way of life. This makes it a forming principle, the genetic footprint of a community identity that is altogether different from that of the mainstream White community.

1. Fred Moten, *In The Break: The Aesthetics of the Black Radical Tradition* (Minneapolis: University of Minnesota Press, 2003), 89.
2. Ibid., 1–2.
3. Lauren Halsey, text message to the author, March 5, 2022.
4. See Carolyn Ahmer, "Riegl's 'Modern Cult of Monuments' as a Theory Underpinning Practical Conservation and Restoration Work," *Journal of Architectural Conservation* 26, no. 2 (March 2020): 150–65.
5. See Alois Riegl, *Problems of Style: Foundations for a History of Ornament*, trans. Evelyn Kain (Princeton, NJ: Princeton University Press, 1992); originally published in 1893 as *Stilgrafen: Grundlegungen zu einer Geschichte der Ornamentik*.

Lyle Ashton Harris on Lorna Simpson

Growing up in the Bronx, I lived in a world infused with rich historical and familial imagery. My grandfather was an avid amateur photographer, and a few blocks from my house, in my grandparents' living room, scores of photos picturing their three daughters' families—many grandchildren, sisters and brothers, nieces and nephews—were enshrined along with their own wedding portrait (shot in 1932 by James Van Der Zee) as the centerpiece. As an adolescent, I was particularly drawn, among my grandfather's hundreds of books, to a paperback edition of *The Sweet Flypaper of Life*, a collaboration between the artist Roy DeCarava and the writer Langston Hughes first published in 1955, which merged photographic images and text and which my grandfather gifted to me in his later years, before he passed.

My mother and my South African stepfather both understood well the power of photography in its portrayal of postcolonial resistance movements throughout the African continent and beyond. I found their copy of *House of Bondage*, Ernest Cole's 1967 photographic record of apartheid in South Africa, and immersed myself in its documentary images as well as in the searing photographs published in *Sechaba*, the official journal of the African National Congress, which documented the killing of hundreds of schoolchildren in the Soweto Uprising of 1976.

This early exposure to vernacular and documentary photography served as a prelude to my undergraduate years in the mid-1980s at Wesleyan University, where Professor Ellen "Puffin" D'Oench introduced me to the greatest hits of modernist photography. But my curious young eyes sensed that something very new was on the horizon when I encountered a black-and-white photograph by Lorna Simpson printed on the announcement for a 1988 exhibition curated by Kellie Jones at the Jamaica Arts Center in Queens, New York. It appeared to be an image of the back of a Black woman's head, but the figure portrayed could have been a man or a woman . . . or was it the artist herself?

Suggestive of a rigorous intelligence and a distilled conceptual practice, that enigmatic figure embodied a refusal to offer its countenance for judgment. And it spoke to me very directly, beckoning me to continue my own intuitive photographic transgressions. As I was poised to enter graduate school on the heels of my honors thesis at Wesleyan (for which I produced my *Americas* and *White Face* series), Lorna's engagement with themes of gender, race, and sexuality left me feeling emboldened, as if my spirit guide had conjured an unforeseen complex of redemptive possibilities. Although some time would pass before I actually encountered the artist herself in the flesh, the excitement that Lorna's work elicited brought me no small comfort as I embarked upon my own creative path, seeking to embrace the transformative potential of personal and social trauma by bearing witness through art.

Given my queer brashness, it's understandable that my mother initially had some misgivings about my decision to leave my family in New York for graduate school at California Institute of the Arts in Los Angeles at the height of the AIDS pandemic. I recently unearthed a couple of snapshots taken during that period, when Lorna and I found ourselves in each other's company at an annual conference of the Society for Photographic Education. In one of the shots, Lorna (sporting a ponytail, a teal-blue sweater, and Levi's) beams a big smile at the camera; in another, she looks in the direction of Pat Ward Williams (sitting out of frame). We're pictured among other artists, photographers, students, and educators in a nondescript hotel room, everyone sprawled around the bed, some holding beer bottles while others look through stacks of Ektachrome slides in plastic sleeves on a portable light box, with stacks of Polaroid SX-70 prints piled on an adjacent night table. This candid scene epitomizes those intimate moments in the early 1990s when young aspiring photographers communed in a spirit of camaraderie. Even so, Lorna brought a special aura to the proceedings, drawing everyone's interest by virtue of her unique sensibility and distinctive Black photographic practice, cool yet conceptual, equally informed by the Pictures Generation and the legacy of the Kamoinge Workshop's collective social practice.

My Ektachrome Archive records another shared moment with Lorna around that time, at the "Black Popular Culture" conference presented in 1991 by the Studio Museum in Harlem and the Dia Foundation. It pictures a youthful Lorna together with Thelma Golden (who would become the director and chief curator of the Studio Museum in 2005) and my brother, the filmmaker Thomas Allen Harris, all of whom had converged to imbibe the rich nectar of inspiration and intersectionality delivered by a host of contemporary Black critical thinkers, including Angela Davis, Stuart Hall, bell hooks, Marlon Riggs, and Cornel West. Lorna's subsequent groundbreaking engagements with twentieth-century African American media imagery and texts, which placed the Black woman center stage as the subject of desire, were emblematic of her radical studio-based practice, which continues to infuse the archive with new aesthetic meanings while seeking to problematize representation.

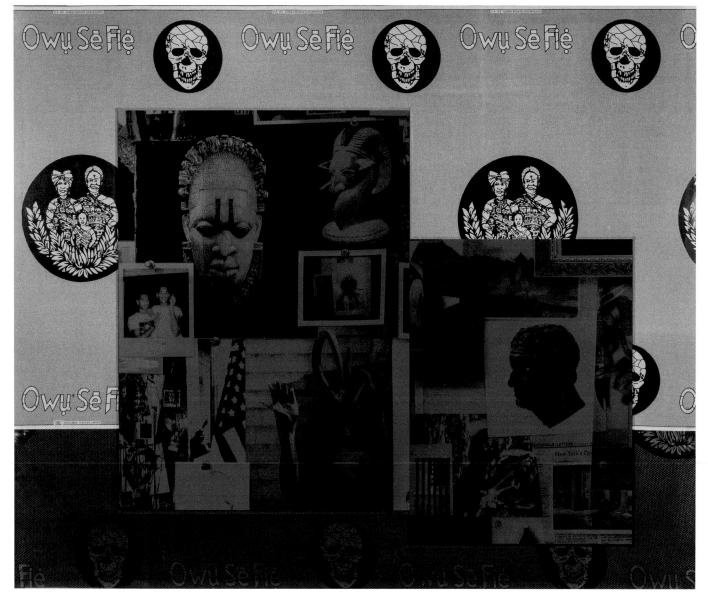

Lyle Ashton Harris (born 1965). *Ombre à l'Ombre*, 2019. Ghanaian cloth, dye sublimation prints, and ephemera, 62½ × 75½ in. (158.7 × 191.7 cm). The Museum of Modern Art, New York, Acquired through the generosity of Agnes Gund, and David Dechman and Michel Mercure (544.2022)

Begun in 2017, Lorna's *Ice* series harks back to the 56th Venice Biennale in 2015, *All the World's Futures*, wherein the late Okwui Enwezor presciently curated a selection of the artist's painterly explorations, which at that time were considered an unusual formal departure for her. I recall my first shock of delight in Venice that year upon fortuitously encountering her monumental compositions. These works, whose gestures and mark making can be seen as resonant with Black abstraction's growing critical mass, served— especially for those of us weaned on photographic practices—to invigorate and expand our material and formal vocabularies in singular ways. I remain in awe of Lorna's relentless commitment to experimentation ("just messing around") through her multidisciplinary practice and of her boundless courage to plunge deeply into the fertile repository that is the Black archive.

In this time of recurrent struggle against atavistic White supremacy, as well as the need to ensure that there will be a livable Earth upon which we can all coexist in harmony and flourish, the layered indigos found in works such as *Ice 11* (pl. 70), amid which uneasily sits a foreboding glacial protrusion, evince an enduring spirit of fearless hope, a gathering vision heartened by the promise of other possibilities that whisper not only of human survival but of creative style and grace and beauty, emerging from the depths of uncertainty.

SHE SAW HIM DISAPPEAR BY THE RIVER, THEY ASKED HER TO TELL WHAT HAPPENED, ONLY TO DISCOUNT HER MEMORY.

Lorna Simpson (born 1960). *Waterbearer*, 1986. Silver gelatin print with vinyl lettering, overall 59 × 82 × 2¼ in. (149.9 × 208.3 × 5.7 cm), framed print 41¾ × 79¼ × 2¼ in. (106 × 201.3 × 5.7 cm), lettering 14 × 82 in. (35.6 × 208.3 cm)

Jacqueline Humphries on Rosemarie Trockel

Chamade (pl. 59) and its pendant at the 59th Venice Biennale in 2022, *The Same Different* (below), each consist of two monochromatic knitted structures hung on the wall like paintings. In each case, the smaller structure is a "study" for the larger one and is identically stitched, as if it were a fabric sample. Rosemarie Trockel has called similar works *Strickbilder* (knitting pictures), but they defy easy categorization. First presented in 1984, some of the *Strickbilder* were fabricated by computerized knitting machines, and some, like *Chamade* and *The Same Different*, were knit by hand. *Study for Chamade* and *Study for The Same Different* could have been knit by someone sitting in a rocking chair, but the scaled-up versions would have thoroughly overwhelmed their maker's body. One can picture the knitter getting lost in heavy folds of expanding purple or yellow flatness as the spherical opacity of the ball of wool played out narratively into its textual unwinding. *Chamade* and *The Same Different* are taut and concise and, despite their surface irregularities, seem emblematic of the series as a whole. I sometimes think of these works as flat sculptures

of painting, which iconicize and deflate the pretensions of painting, undoing our security in its definition.

Famously, Trockel inverts the hierarchy of art over craft, but her work is irreducible to any particular transvaluation: it prompts a rethinking of the differences between the handmade, the accidental, and the mechanical. What motives and techniques do we attribute to the artist? Does "mechanical production" imply the freedom of chance-based automatism or the reification of pre-programmed automation? Does "handmade" connote femininity, softness, authenticity—or craftiness, irony, subversion?

A chamade is defined as a "drum or trumpet signal for a parley with the enemy." Perhaps, Trockel's work is a kind of parley, armistice, or truce between warring parties. She invites us to think through abrasive extremes, but then disarms us by exposing the interstitial linkages that draw them together. Hard-edged concepts become metaphorical in a way that prompts indefinite associations. It's as if the artist were throwing a soft blanket over conceptual dialectics—softening the blows by blurring the boundaries. The verbal

Rosemarie Trockel (born 1952). *The Same Different* and *Study for The Same Different*, 2013. Wool on canvas with wood, 9 ft. 8½ in. × 9 ft. 8½ in. × 2¾ in. (296 × 296 × 7 cm), 39⅜ × 39⅜ × 2¾ in. (100 × 100 × 7 cm). Private collection. Installation view, *The Milk of Dreams*, Venice Biennale, April 23–November 27, 2022

Jacqueline Humphries (born 1960). *Untitled*, 2022. Oil on linen, 8 ft. 4 in. × 9 ft. 3 in. (254 × 281.9 cm). Courtesy of the artist and Greene Naftali, New York

and visual games Trockel plays cannot be instantaneously captured but involve an elongated deferral of thinking and seeing. What seems to be the back, front, support, or surface is continuously displaced, creating a capacious and mobile plane that encompasses its own contradictions.

Chamade and *The Same Different* play with several fictions of backwardness: they are composed of a "reverse stockinette" stitch, which connotes the back side of a knitted surface; the stretchers are made visible, placed in front of the knitted field, as if they were a frame; and the very use of knitting foregrounds the over/under process that determines what faces the viewer and what is tucked away.

In 2015, I made a series of works incorporating a magnified canvas grain pattern, making visible the usually obscured woven quality of the canvas. Like *Chamade* and *The Same Different*, these works play with backwardness and make the support the subject, creating the impression

that you are looking at the painting through the back of the canvas, out toward the space where the viewer normally resides. In Trockel's latest *Strickbilder*, the hard, skeletal structure of the visible stretcher pierces the soft, transparent imaginary of the picture plane. The frame's intrusion is like a Brechtian alienation effect that has been softened so that any potential didactic takeaways get lost in ambiguity. Trockel's conceits play with the fictions of reversal without the strong-armed certainty of conceptual revolution.

I like to joke that I keep making the "last" painting because the idea of the end of painting has a deathless allure. Trockel also seems fascinated by this tug-of-war between iteration and conclusion. Her work reconfigures how painterly gestures and conceptual notions are registered by making slash, drip, stitch, and reversal into icons, with no authentic origin or final end point. In the face of her deflating iconicizations, even the tightest knits are subject to unraveling.

7 Vignettes for 5 Paintings
Allison Katz on Charline von Heyl

The depths

One day, a plumber came to my studio building to work on something in the communal kitchen. I heard him knocking and banging, and once he'd gone, I went in to make a cup of tea. Nothing looked different, but on the wall beside the sink he had scrawled,

<div align="center">

C H
V

</div>

Hmmm, I wondered. Was this where he planned to move the pipes? Then I laughed out loud. He had unwittingly tagged Charline von Heyl, giving rise to a new alias,

<div align="center">

Cold von Hot

</div>

Or maybe even better,

<div align="center">

Charline versus Heyl

</div>

In this act of preparing a room for construction, the plumber gave me the key to CvH's painting: generative contradiction. Paradox, or the true absurd. When seemingly opposing forces balance each other out. Belief versus Doubt. No one better than a plumber to do it: the person who fits and repairs the pipes. Our comfort—water, sanitation, heat—must be confronted. Go deeper—"to plumb"—which we use to measure how deep something is, to understand or discover all there is to know. Even the dictionary cannot resist, with this exemplary phrasing: "Now that she had begun, she wanted to plumb her own childhood further." Journey down, drop the *b*: she comes back up with something that is very good and worth having ("plum"). Anyhow, as an adverb: exactly. She hit me *plumb* on the nose. Lead-pipe painting.

Motherlode

The surfer shows his wounds to the reporter. It is a long list of lacerations, ruptures, parts that have been torn and burnt by sand, salt, and sun. The body wears the score of this quest to ride and fuse with the unnameable; the act itself simply cannot be described. When the surfer goes under in search of the elemental, the skin becomes the visible index of what happened. What just happened? We point to the wound to induce the immaterial. A painting like *Vel* (opposite), with its visceral marks of battle, has been somewhere, and returns to prove that this somewhere is elsewhere. There are, in fact, some places we will never see, but which we can only access by looking.

Pinhead, or Get your ducks in a row

The stupid idea, the only one worth having.

Bowling

It's no small feat to be struck dumb by a painting, and CvH's paintings perform this feat regularly. Suddenly, swiftly, language appears to leave the room. Yet actually it has only flooded back into the body, getting recharged by

Allison Katz (born 1981). *Noli Me Tangere!*, 2021. Oil and acrylic on canvas, with grains of rice, 78¾ × 86⅝ in. (200 × 220 cm). Rachofsky Collection, Dallas

not-knowing, rinsing the grease from the valves. Hold on. Artistic purification and renewal are suspicious states. They are best when sabotaged by contamination and destructiveness. In combination, they let us into the full spectrum of being. Ambiguity is a condition that needs to be practiced, so we don't become too graphic, hard-edged, or taped off. Stay mixed, impure and opaque; but also have passages of clarity, transparency, habit (repetition). Notice the pattern that swirls without clear boundaries in and out of consciousness. Get fat and thin, oily and watery, front and back (and back to front). A ray of light comes through the dirty window, streaked with millennia-old handprints. There are no states of being that cannot be translated by her marks.

Back to those bowling pins, all lined up, in *Plato's Pharmacy* and *Dunesday* (pl. 71). Standard tenpins, to be precise, as opposed to duckpins, which are squatter and knocked out with a much smaller ball. CvH loves a duck![1] Fuck a duck. Pins: how now like a woman. That shape—something about having hips. And legs. All lined up at the bottom of the canvas, ready to get knocked down. Is this a brutal joke?

Why does the figurative always figure in, no matter how nonobjective we stake our claim? CvH stated that painted eyes that return the viewer's gaze will automatically soak up the focus, and nothing else in the frame stands a chance for our attention. In reaction to this, her work deliberately

Charline von Heyl (born 1960). *Vel*, 2020. Acrylic and oil on linen, 90 × 82 in. (228.6 × 208.3 cm). Shah Garg Collection

A blazing saddle of a sunflower gets cut off midsentence, lopped off like the ear of *that* genius mid-impasto painting *that* flower. Sunflowers can never again be painted without a knowing wink. Which looks like . . . ? Painting back in the white ground. Letting the ground come up to swallow you, that's what, the perfect escape for any embarrassing situation, thank you very much. (What could be more embarrassing than painting?)

Eating into the ground, by painting it back in, CvH keeps tabs on our lust for sense making. We don't even know we seek rejection, and that's the point. Self-help book after book tries to teach the contemporary viewer how to keep it together. CvH's paintings might offer an alternative: how to go to pieces while falling apart. Who needs subjectivity to be one thing? Least of all you. Her paintings plumb taste formation, and this beckoning toward self-reflexivity is perhaps their biggest gift to the viewer. Where do all our visual ideas come from? Not us. Cues, memories, encounters, and remixes are the stuff of images that cannot assemble neatly. We are formed by the inanimate and give it life. Painting is a dry run for living.

CvH once told me to *question your own taste*, that it's the only way to evolve as an artist. Belief and doubt, in a balance as tautly stretched as a blank canvas, which, incidentally, before it is painted, can be played like a drum.

Hearing things
Her paintings now inspire music.[3] The eye fertilizes the ear, and in reverse. The ear, so rarely considered as material substance in visual culture (except in one sensational episode) becomes a source for painterly dispersion, funneling between the veils. *My end is my beginning*, goes Machaut's fourteenth-century rondeau, conveying something rhythmic and circular from the pit.

Painting that becomes pure intensity, "nothing but the translation of energy itself, a force."[4]

Intrigue is a form of visual intelligence. Clues are often audible. Is it a coincidence that CvH enjoys mystery novels? The presence of the painter surprises her, and is not always welcome. Alien skills, however, always are. Why something gets made is equal to how. Fate likes to clean the brushes.

1. See, for example, *Interventionist Demonstration (Why-A-Duck?)* (2013; The Art Institute of Chicago) and *Orange Duck* (2014; Walker Art Center, Minneapolis). *Why Not?*, a 2015 solo exhibition at Corbett vs. Dempsey, Chicago, comprised nine smallish paintings incorporating von Heyl's duck motif; see "Charline von Heyl Why Not?," Corbett vs. Dempsey (website), exh. on view April 30–June 6, 2015, accessed May 31, 2022, https://corbettvsdempsey.com/exhibitions/charline-von-heyl-why-not/.
2. *Untitled (1/1992, II)* (1992; private coll.), for example, includes false eyelashes in the list of media; *Untitled (11/89)* (1989; private coll.) shows a bent, fleshy arm but not its hand or shoulder; etc.
3. The Primavera Project sees a diverse group of composers creating musical commissions based on von Heyl's reinterpretation of Botticelli's *Primavera*; see Primavera Project (website), accessed May 31, 2022, https://www.theprimaveraproject.com/.
4. George Baker, "Paul Thek: Notes from the Underground," in *Paul Thek: Diver; A Retrospective*, ed. Elisabeth Sussman and Lynn Zelevansky, exh. cat. (New York: Whitney Museum of American Art; Pittsburgh: Carnegie Museum of Art, 2010).

blocks one-direction; presents allover eyes, eyes that multiply, brush marks that look back instead. No single pair.

CvH was always painting the figure, without a body. In her works of the 1990s, she especially anticipated the current affairs of dis-figuration; she took on Picasso's game of parts and Nochlin's "body in pieces."[2] Showing skin excites the eye as much as it redeems the tool—oil paint being invented for that very task—and so one could argue (contra Greenberg) that the endgame wasn't ever flatness, but flesh. A bit of skin quickens the rest of what is in play as we dance against the urge to self-insert.

Strike
Bowling lingo is something of a CvH lexicon: strike, spare, frame, foul, double, turkey, gutter.

The pins are, in fact, attractive, they are knockouts. They knock themselves out. What happens to your eyes with that kind of punch? You see stars. Like the cartoon wings of concussed bliss, all that swirls returns to settle down at some point. Dust. (*Nunez*; see p. 14.)

Do you C what I C?
The abyss streaks across the canvas in *Untitled (7/92, III)* (see p. 85). The great chasm of the "unpainted" (the undead) breaks the frame and dismantles the hegemony of composition.

Visible Teeth
Helen Marten on Laura Owens

The bicycle wheel is an elemental conundrum: a circular border with linear spokes radiating from a central point into overlapping wedges of space. When it spins, the wheel brings with it a special sense of spatial delirium: rational and irrational problems of image, speed, and legibility slivered into continually subdividing territories. Atop an undulating swell of differently sized pixels, squares, nets, and fences, the wheel is itself built into an index of transformative gestures and behaves in its most operational sense, dialing up the intensity of pixelation (see pl. 89). Perhaps its centrifugal speed dictates, with an air of Duchampian comedy, just how wide, baggy, minute, inflated, or saturated any single square of color and its separating marks might be. The implication of the wheel—a painterly tactic riddled with exponential linguistic corruptions—is one of chance and animation.

Paint, too, has a strangely uncomfortable relationship to external geologic reasoning: it is elastic in some instances, sticky, slippery, scratchable, parched, granular, cracked. Its essence is unruly, not like a flippant teenage obstinacy, but more an ancient set of productive problems: sometimes paint flows and pours, and at other times it must be cajoled and forced unwillingly into application. It is perfectly logical to imagine that oil paint will move nowhere when mixed with water. Nylon-based paint, however—more chemically unhinged and often put to work in screen printing—is possessed of all the elastic springiness and potential energy of a rubber ball. This paint is wild and flexible, deployed in a kind of seasonally fluctuating manner: toward the crisp authority of visually solid lines, planes, or washes; the stumbling legibility of skittering dots and fuzzy dashes; for soft-feathered spray shadows; for bright pastiches of underlying junk that emphasize the unseen structures of Cubism, with overlapping forms, negative space, collages, and cutouts. Like rain in a courtyard that comes down at different speeds, each micro block of color is a fractional part of a bigger collective phenomenon.

Fuzzy logic is an approach to computing and analytics that describes degrees of truth rather than the conventional binaries of true or false. So, too, in paintings by Laura Owens, there are foils and false abstractions: daubs, drips, rasters, patchwork, smears, scratches, viscosity, gloop, liquidity, tears, and pixels. But the causality of paint on canvas is made treacherous by instances of deliberate digital plotting. The screen-printed vector in painting is expedient—its line is authoritative and clean—but it is caught in a strange state of contingency, too. Visual direction is continually tangled between the two- and three-dimensional. It is possible to read flatness in both a hard-outlined graphic and in something material and lumpy that unthinkingly reverts back into planar space because we are habitual creatures of the screen. It is impossible not to think about technology's impulse to sanitize the bristling bloodiness of painting, to subject every moment of viewing and digesting information to a malaise of optical impatience. This treachery of time-scale is particular to the process of screen printing and is determined by the order in which visual information is delivered: how image, materiality, exposure, size, flatness,

alignment, and imperfection all signify at different speeds. Common visual intuition is not what it seems: Which layers come first? How does a yellow transparent ink appear on top of white versus cantaloupe orange? How can color with the thickness of cake mix sit on the same level as the insouciant shine of reflective gesso? If you make a printing screen with dispersion dots to connote the perfect evanescence of smoke, will its sensual arabesque quality be fully conveyed? As a process, screen printing is impossibly full of allegory and shorthand. Any solid vector color needs its own screen, so the necessity of determining a hierarchy is implicit from

Helen Marten (born 1985). *The Earth good and the stars good (wettings)*, 2021. Nylon-based ink on fabric, aluminum, ash frame, medium-density fiberboard, fabric, cast pewter, steel, cereal boxes, wood balls, ribbon, dry transfers, *sepili*, masonry, pistachio shells, sanded train tickets, string, steel wire, cast Jesmonite, toothbrush, marble, button, and stainless-steel rod, overall dimensions variable, frame of painting 10 ft. 2⅛ in. × 8 ft. 2⅜ in. × 3⅜ in. (310.2 × 249.9 × 8.6 cm), plinth 50 × 23⅝ × 26⅛ in. (128.8 × 60 × 66.5 cm). Collection of Jill & Peter Kraus

Laura Owens (born 1970). *Untitled*, 2016. Vinyl paint, screen-printing ink, and yarn on dyed linen, 9 × 7 ft. (275.4 × 213.4 cm). Tate, Purchased with assistance from the Tate Americas Foundation, courtesy of the North American Acquisitions Committee, and with funds provided by Alireza Abrishamchi and Komal Shah 2017

and collapse in exponential sequences of compression and spillage. There are windows which open onto schematic cutaways of many domestic scenes: trees, cats, skies, curtains. Marks are schematized but enormously generous. The optical effect is dizzying—paint as literal rhizome—shooting stems, reflections, and tiles out onto the topmost surface of the painting. The pictorial depth of field and contextual size relationships are masterfully corrupted—impossible, even. This is not paint applied to the silent vacuum of plastic or metal, but performing a more audible kind of visibility: a smooth surface assumes heterogeneity, but here, all around are the rub and vibration of multiple grains, of fabric's tooth, an open-weave scramble!

With grain or ragged edges there is implicit information, there is muddling—imagine the dirt caught in the seams, the dust gathering on the tops of those trellised edges. The grid is a motif of mapping and order, but in Laura Owens's paintings, rhythms of structure and visual turbulence are constantly moving. There is something of a Vuillardian or Bonnardesque obsession with interlocking pockets of light and color, with plaid, with checked tessellations of paint, with the strange density of a curve that breaks over shadow. Cross-stitch presents a mirage of information: from the front, it is pictorially rigorous, deploying many neatly focused Xs of color, but the reverse side is often a sea of knotted and trailing chaos. Embroidery of any kind is a decidedly analogue practice, slow and humble in its self-effacing chasteness. Although cross-stitch shares a similar image-generating logic with the JPEG, it is not possessed of the same rough crudeness of degradation, and cross-stitch feels majestic because its economy is deliberate and carefully plotted. Pixels are a visual illustration of the empirical problem of focus: how far can we go to describe what we cannot clearly see? Even the word is a condensed linguistic portmanteau— picture and element rammed together like an atomic coupling gone awry.

But where painting dissolves, is transient and sometimes fleeting, the pixel, like the cartoon, exposes itself dumbly to receive animation. It is objectified and, at times, empty or silent. It can be both artificial and resistant to movement, yet also active or infected. In painted form (or photographically reproduced), pixels represent an image like holding your breath, where the impulse to inhale and the choice to continue without oxygen are unspecified and incomparable variables. Imagine a rolling sea, a volcanic eruption, or children jumping rope described in paint via a mosaic of little squares. Up close, visual promiscuity is no more articulate than a dumb bitmap grid, but with distance, a shimmering landscape emerges. This deliberate dragging of the gaze through multiple levels of image clarity is an act of painterly subterfuge, a deploying of color-as-camouflage. Even the real, organic forms seen at micro scale are composed of many hard, angular surfaces: look at a snowflake under an electron microscope, and any initial impression of ephemerality is reversed by the vision of many hundreds of gorgeously interlocking, Brutalist forms. There is great pleasure in this distortion, in forcing nano scale to the fore like a permanently magnified façade or prophylactic against the inevitable moment when information is emptied out and exhausted.

the beginning. Screens can be used exhaustively; they must be repetitively cleaned, dried, and taken care of; the emanating smell of inks, cleaning fluid, thinners, and catalysts is positively hallucinatory. Screens can be wiped and re-exposed in the swiftest of moments. As a process, screen printing is both autotelic and possessed of multiple invisibly implied conceptual laminations. The labor involved is vast, but spookily eliminated from the final impression of totality which emerges.

In Laura Owens's visual index, there are grids, checkers, graph lines, weaves, and skeuomorphs of all of these. Fragmented sections of embroidered samplers swell from raggedy sets of blocks, themselves screen-printed via mesh onto canvases with visibly pronounced and geometrically legible fabric grain. Tautological squares of all kinds— apertures, color fills, panels, exits, quantifiers—breathe

Laura Owens on Mary Heilmann

I met Mary three decades ago in graduate school, which had moved temporarily just north of Valencia to Lockheed Martin; the defense contractor had donated an unused portion of its office buildings to CalArts after earthquake damage forced the campus to close. Heilmann's talk was held in one of many empty, disused conference rooms, and no more than a handful came to see her on her West Coast tour. She gave a lecture with no words, just a boombox and two slide projectors. Double projectors and music, the clicking and whirring of the slides, as loud as the songs about love and loss, and equal to the visiting artist's silence.

Her painting's titles—another chance to say more—have the flavor of memories, places held in mind while painting. *San Francisco (Day)* and *San Francisco (Night)* (pl. 33), like

the projectors, are a diptych side by side, and they persuasively represent a temporality. Like repainting an older painting from memory—not the original subject, still life or person, but a *painting*—the same painting is here twice, perhaps. San Francisco cascades gently, easily.

Many of Heilmann's canvases cut away to glowing layers below the surface, like images of the past. Less dense and more colorful, they shine like tiny lightbulbs through the thicker, heavier top layer of paint. These luminous spaces are cared for, rectangles left—not perfect or cut, but hand-carved—made by painting around, occluding most of those now-distant first brushstrokes.

Born in San Francisco, Heilmann cascades gently, easily to a painting. I don't know why (I have a few guesses), but

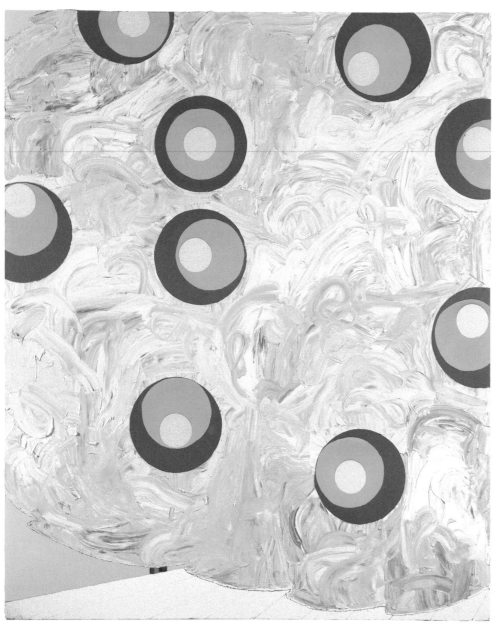

Laura Owens (born 1970). *Untitled*, 1994. Oil on canvas, 72 × 60 in. (182.9 × 152.4 cm). Orange County Museum of Art, Costa Mesa, CA, Gift of Peter Norton (1999.028.033)

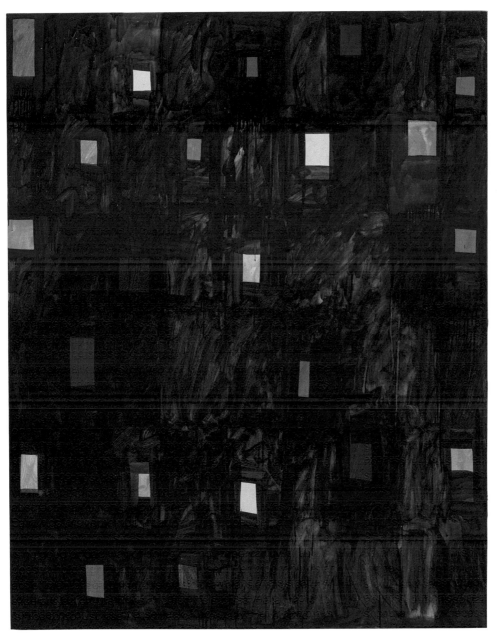

Mary Heilmann (born 1940). *Neo Noir*, 1998. Oil on canvas, 75⅛ × 60¼ in. (190.8 × 153 cm).
Private collection

gesture in Western painting adds the weight of a signature to the hand: authenticity, biography, and seemingly bold confidence or, if its inverse, lack. Knowingly, Heilmann plays with our predisposed cultural tendency to see more in an abstract mark than simply paint hitting the canvas. With her paintings, we remember that paint just does certain things when you splatter, splash, blob, pull, or brush it on; that there is no good or bad way of doing it; and, importantly, that it doesn't hold signification inside of itself. Her biography is an act of mental conjuring, the music that plays alongside the slide projector, the titles and her life stories. Here, painting is free to do just itself. And this can feel a bit naked and vulnerable, but so much better.

What we learn from each other we feel compelled to express, but said directly it can only emerge in some cursory, shorthand way, necessarily truncated. Sometimes a painting acts like another painting. Some act like mirrors, others like windows. Looking at paintings is a big part of how Heilmann paints: she paints, and then she looks for a very long time. She taught me how to enjoy looking at my own painting while I am making it. I wish I could express how not easy it is to sit in the middle of an unfinished painting and look at it, very slowly and carefully. It sounds and looks a lot like doing nothing, but it is so hard.

Christina Quarles on Joan Semmel

In Joan Semmel's work, I feel seen in how I see myself. Her paintings provide respite from the insistence that our bodies be confined to the vertical. When I look at one of Semmel's paintings, I am looking down onto my own body; I am looking up at the body of my lover; I am looking across the body of my close friend in repose. Her work leaves space for the body to exist as landscape, to relish the potential of flesh as horizontal, and, in so doing, provides companionship with which to look out from an otherwise isolated vantage point.

I once remarked to my wife that I know her face better than I will ever know my own face. I can see her face in real time, I can see how it shifts, the movements she unwittingly makes, the expressions that never appear when a camera or mirror is present. As for my own face, I barely know it at all. I spend my day with a mere memory of what my face looked like the last time I saw it, which was most likely as a flattened and reversed image that appeared in my bathroom mirror. I have only ever seen my face in the second dimension, mediated by the glass of a mirror or a phone, or captured in photos and videos, made distant in scale and time.

I spend my day looking at faces, the one part of my own body I can never truly see. And all the while, as I look upon your face, which sits atop a complete and cohesive body,

I am within my own unruly body, which I experience as a compilation of varied parts: an outstretched arm that branches into five dexterous fingers, a back that aches on its right side, two feet that are cold with toes that tingle, three downward mounds in my periphery that I have come to know as my breasts and my stomach.

I move through the world always looking down at my assemblage of parts and forward at bodies that appear (however deceptively) as whole. How alienating to experience every other person as effortlessly cohesive while living in a body that I perceive in disjointed fragmentation. How lonely to be a social being who looks out from a perspective that simultaneously places the other in frontal verticality and oneself in perspectival horizontality.

In Semmel's paintings, I find solace in my first-person perspective. Her work provides an externalized representation of an internalized event, creating the potential for a collective reflection on an otherwise isolating experience. As social beings, we yearn to be understood, to be seen. And yet our being understood is continually undermined by the limitations of legibility. Legibility teeters on a razor's edge, with illegible vagueness and illegible ambiguity on either side. When we lack information about something, it is vague.

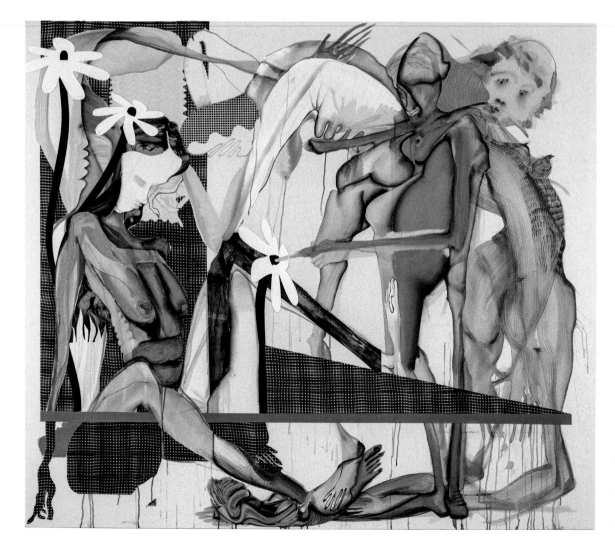

Christina Quarles (born 1985). *Push'm Lil' Daisies, Make'm Come Up*, 2020. Acrylic on canvas, 72 × 80 in. (182.9 × 203.2 cm). Rennie Collection, Vancouver

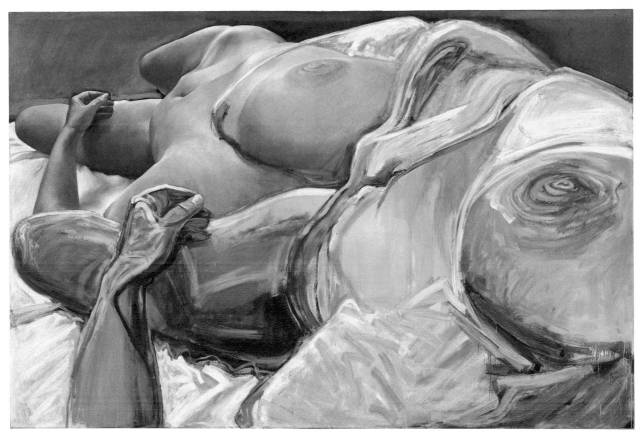

Joan Semmel (born 1932). *Self Made*, 1980. Oil on canvas, 6 × 10 ft. (198.1 × 304.8 cm). The Museum of Contemporary Art, Los Angeles, Gift of David and Maria Wilkinson (2017.37)

As information accumulates, the vague comes into focus and eventually becomes legible. However, as information accumulates, the risk for contradictory information increases, and an excess of simultaneous contradictory information will cause legibility to break down into a state of ambiguity.

I have spent a lifetime accumulating contradictory information about myself. I know myself in every imaginable context. I have seen myself change form to fill the empty spaces in a situation. I contort to fit. I am daughter to my mother and mother to my daughter. I am student to my teachers and teacher to my students. I am, simultaneously, boss, coworker, and subordinate. I am the Blackest person in the room. I am the Whitest person in the room. I hear my voice rise an octave when speaking to customer service, I hear my voice in giddy gulps as I gossip with a close friend, I hear my voice strain through practiced smiles, eager to please a stranger.

I know just how much I change in front of you, and you, and you, and you. But I only know you as you exist in relation to me. To me, your context is completely stable. You are always my mother, always my daughter, always my mentor, always my student. How enviable is your singularity, your legibility! Of course, this is a mere illusion caused by my being your constant. To you, I am also always one thing, always legible. But, because I know you in part, I experience you as whole. And because I know myself wholly, I experience myself to be a collection of parts.

To assert ambiguity is not paradoxical, but it does present us with a paradox: that the whole, its entirety, will always appear fragmented, and that a fragment, in isolation, will appear, however falsely, as whole. The beauty of intimacy is that it *is* an assertion of ambiguity. When speaking of intimacy, I am not referring exclusively to that which occurs between lovers (though this is one form of intimacy). There is a myriad of ways in which intimacy manifests. An expansive view of intimacy includes any moment in which we can exist wholly fragmented, in which ambiguity is asserted. Intimacy provides a knowledge of self and of another that permeates the flattened, vertical simulacrum of a body. Intimacy allows an existence in the round. Intimacy transcends the boundaries of legibility so we can be seen as truly whole, in all our fragmentation and contradiction.

Intimacy is found in love, in friendship, in family, but it is just as present in sickness, in violence, and in death. True intimacy can be liberating, but it is a surrender that is not fully sustainable. This is why humanity has continued to gravitate toward art. Art is a medium with which to explore the depths of intimacy. Art provides an image that is simultaneously singular and fractal. I have turned to art, as both maker and viewer, to help satiate my need for representation, which is expansive rather than confining; to see my multitudes reflected before me, to be reminded that the incongruous can have beauty and substance. I return to Joan Semmel's paintings to process how I inhabit my body. Semmel reminds me that this perspective of self is uniquely my own *and* one that is held by every other being on Earth. In Semmel's paintings I find camaraderie, and the loneliness within my body subsides as confinement gives way to exploration. Semmel, by depicting the downward, upward, and sideways perspectives of the body in paint, tilts the portrait into landscape, giving each of us permission to wander and wonder from the vantage point of self.

Jaune Quick-to-See Smith and Kay WalkingStick in Conversation

Jaune Quick-to-See Smith At the present time, here in New Mexico, I'm living on the unceded land of the nineteen Pueblo tribes, as well as Navajo and Apache peoples, who have lived here since time immemorial. I thank them for the privilege of residing on their land. I myself am a citizen of the Confederate Salish and Kootenai Nation. Kay, when you were a kid, did you know that you wanted to be an artist?

Kay WalkingStick Oh, yes. Didn't you?

JQS I did, but not everybody does. Some people say they don't know until they're twenty-five or thirty.

KW No, I was raised in a family of artists, and we all made art—some more professionally than others—but we all made art. I was drawing and making things all my life. There's nothing else I ever wanted to do. This is it.

JQS How old were you when you realized that being an artist was the thing you wanted to do professionally?

KW As soon as I realized that there were professions, that people did things with their lives—I was an infant, practically. I was given paper and pencil in church to make drawings of things during long sermons, and it was always what I did. From the beginning, Jaune.

JQS Where did you grow up?

KW Syracuse, New York, in Onondaga County. In fact, we lived right near the Onondaga Reservation.

JQS Did you have any friends from there?

KW No. When I was in high school, there were girls I knew, but I wasn't close to any of them. I wasn't actually close to anybody—I was a very solitary kid.

JQS A lot of artists are, that's true. Do you remember anything from your childhood, an epiphany or any experience?

KW I was the baby of five: I had two older brothers, two sisters, and then myself. I was born during the Depression, so I have this long memory, a lot of history. My uncle Howard used to take us for drives around Syracuse, and we'd go to the Onondaga Valley, which is very beautiful. I can remember thinking that I wanted to paint it . . . although I had no paint or brushes! I knew that one day I would be an artist.

JQS When you went to Beaver College [now Arcadia University, in Glenside, PA], did you experiment? Did you take ceramics and sculpture?

KW It was not offered. Beaver was a small women's school, with a nice painting program, and I fell in love with painting.

JQS Was it oil painting at that time?

KW Yes, I was trained in oil. I waited ten years before I went to graduate school. By then, I had a husband and two kids, so I lived at home. At Pratt [Institute, in Brooklyn], I started working in acrylic, experimentally, just to find out about it. Around the same time, I started working with ideas that had to do with my heritage. Then, I found a wax that you could mix with acrylic, and the paint became more organic-looking. You melt the beeswax and add water and an emulsifier, and the result is called "saponified wax." *Sapone* means "soap" in Italian, so it's made the way soap is made. It looks like mayonnaise when it's done—very beautiful and smells of honey. Wonderful.

JQS Why did you move from oil to acrylic?

KW To do what I wanted to do, which was to put something down and have it dry quickly so I could work back on it without it mixing. Acrylic was the ideal medium. No one else was using [this blend of acrylic and wax]—it was something that, basically, I made up—and it suited me perfectly.

JQS When did you start going into New York to see the museums?

KW As soon as I moved there—1960. I remember going into the Metropolitan Museum of Art pregnant, walking around with this huge belly.

JQS What did you see?

KW The objects that most impressed me on my first visit were the Cycladic sculptures. And all my favorite painters, like the Lorenzetti brothers and Giotto, with his lovely abstraction of forms. That early period was about people and things and a spirituality that was very moving to me. Still is.

JQS Those are figurative paintings. How did they impact your work?

KW Our daily lives trace the arc of the things we see, the people we love, and all these things influence our life and our art somehow. The wonderful colors of that period have influenced my work over the years.

JQS How did that painting influence the heavily textured surface that you created?

KW I don't think it did. You bring your own personality to things. I love the feel of paint—the tactility of that surface is very inviting. It's a tactility that's visual as well as actual: you sense the tactility when you see it.

JQS I got a late start compared to you because of economics. It was 1976 when I first started coming to New York, and the artists I was most drawn to were women. Martha Diamond and Susan Rothenberg and Jennifer Bartlett were all making oversized paintings, and they were all using thick, thick oil paint. I would go into the gallery and just swoon—it was like

Jaune Quick-to-See Smith (born 1940). *In the Future Map*, 2021. Acrylic, paper, and fabric on canvas, 72 × 47¾ in. (182.9 × 121.3 cm). Shah Garg Collection

In 1976, you did a painting called *Red Painting/Red Person* [pl. 22]. Can you talk about that? Because it is really abstract.

KW I had just gotten out of graduate school at Pratt. I was doing a series of works that had to do with my heritage. I did the *Chief Joseph* paintings (see fig. 8 on p. 50), one about the Cherokee John Ridge, a number of pieces about prominent Native leaders. I had made other works that had to do directly with my heritage, and this painting was toward the end. You'll notice it doesn't have thick paint—none of the pieces from this period do—just some wax to give it a natural look rather than a slick, plastic, acrylic look. It has a ground of poured ink. I wanted everybody to understand how it's made, or the process, so you can see on the edges how it's constructed. Very '70s thinking.

The arcs are remaindered—I painted the part of it I wanted painted and left the rest. It's painted with a knife, and there are lines scraped out with a screwdriver. It is a very reduced painting. It's simply four arcs on a square format, almost square—it isn't exact—with a border. The border comes forward spatially because of its color but physically recedes because it's behind the red. I liked the idea that there's a little confusion about where things are spatially. With all that, it's still very flat. I wanted to reduce the elements of the painting, the formal elements, but I didn't want to take away that voice that a painting can have. I wanted it to speak to people.

JQS When you started one of these paintings, did you know where it was going to end up before it finished?

KW I had a general idea, but paintings talk to you. They tell you what step to take next. There's something haphazard about a lot of Abstract Expressionism that just doesn't do it for me. I was drawn to Minimalism, and my goal was to speak through it. I didn't want it to be cold and Minimalist. I wanted it to be hot. I wanted to speak through it with energy.

JQS Aren't those two things opposites of one another?

KW You bet. That's what interested me—that I could take this idea of reduction and still give it a heat that would speak of all things, of anger and lust and love.

JQS I'm curious: when you go out on-site to collect information for your [more recent] landscapes, are you photographing, are you drawing, are you painting? What is the departure from your abstract paintings of the '70s?

KW If you look at them, there's landscape suggested in a lot of those abstract works of the '70s. The NMAI [National Museum of the American Indian, Washington, DC] owns an abstraction called *Homage to Chief Joseph* [or *Chief Joseph #1*; 1975], in which the central portion of poured paint absolutely reads as landscape. I think there's a suggestion of landscape in the earlier works as well. I started doing some landscapes in 1970; for example, I did a Hudson River series. I was painting the river then, but hard-edged. You could say that it's an abstraction of the river, but it's still the river. I've done landscape on and off right along, even in those years I was doing abstraction. The Heard [Museum, Phoenix] has the last abstraction I did, which is called *Cardinal*

an elixir, because of the heat, and the paintings off-gassing, with linseed oil coming out. That is one of my favorite memories of being in New York, seeing those women's paintings. Joan Mitchell, too—they were all doing this heavy, thick oil paint.

KW That notion of thick paint was in the air—I just took it a few steps more. My painting was thicker than everybody else's!

JQS Today, all the kids are raised on computer screens, and they see the world differently than we do. I know from teaching that students' work is very flat, not tactile, and very illustrative, because that's what they see. I yearn for the smell of oil paint.

Points [1985]. Then, I went out to La Jolla and then to Durango—I got out of the city and started doing diptychs with both landscape and abstraction. I didn't want to do abstractions of the landscape. I wanted them to be different but to work together symbiotically.

JQS Who are the artists who influenced that? Were there any you were close to?

KW No, there was no one. That's unfortunate, because it always helps to have other people doing the same thing. I got a lot of hostile remarks from people in New York. My work was not accepted—once I started really being interested in combining landscape with abstraction, I left my gallery, because I knew that she [Bertha Urdang] wouldn't want to show it and wouldn't know what to say about it if she did. I started showing with Howard Scott at M13 in SoHo.

JQS I remember Bernice Steinbaum was uptown, up on 75th or 76th, in a walkup. [The abstract painter] Paul Brach, Miriam Schapiro's husband, and I had just started [showing] with Bernice. We both had been with other galleries in the '70s. Then, we saw that galleries were coming to SoHo. Midtown featured more mature artists, and [SoHo] was the happening place. We kept talking and talking to Bernice until she finally went down to SoHo and began investigating. I remember going to SoHo to see shows and spending a full day going up and down the stairs, and up and down the elevators, to see all the hot artists in New York at that time. It was a really exciting time for painting. Did you feel that? Did you enjoy it?

KW I sure did, yes.

JQS All the new, younger artists who were coming in from Italy and Germany . . . painting was everywhere, tons of painting, Julian Schnabel and David Salle and Susan Rothenberg and Martha Diamond, Katherine Porter, Jennifer Bartlett, and more. The place was just full of hot painting, and because SoHo was a place you could get around easily, you could see a lot of shows in a day. Painting isn't painting anymore. Unless you go see [the recent exhibitions of] Joan Mitchell or Philip Guston.

KW Guston was always a good painter. His abstractions were wonderful.

JQS Yes. Of course, I prefer the figures, because I like the storytelling that he does. The stories about his life, Jewish life, escaping and going to Canada and then coming to this country full of sadness and terror. I was really attracted to his paintings, his figurative paintings, for that reason, and the tormented relationship he had with his wife [Musa McKim], too—*Night Studio* [1988; written by their daughter, Musa Mayer] is a book about the two of them. I've always loved artists' biographies—do you read them?

KW Yes, I've always liked Manet, especially, and reading about him was lovely because it made me feel like I really knew him.

JQS Was that what drew you to Europe, then, besides having gone to the Met?

KW Well, also pure curiosity—so much of our visual culture comes from Europe. And I was sent there because I taught at Cornell, which has a Rome program. I went for three separate semesters, usually for five months at a time, and that had a tremendous influence on my painting. I returned to using brushes, for instance—I hadn't used brushes for years. I introduced figures again after not having done figures for twenty-five years. I also introduced gold leaf. I just loved Italy.

JQS How does that mesh with your Native heritage?

KW There is a great deal more in my paintings than my Indian heritage. One's entire personhood is represented in the art, and I am who I am—a biracial woman. I'm a Cherokee, I was raised in a White culture, and both are in everything I do, whether it's landscape or figures or abstraction. It is always there because I'm there.

JQS Yes. Kay, do you recall when we met?

KW You came to New York to do a Grey Canyon Group show.

JQS Grey Canyon—I founded it here in Albuquerque. It was a co-op. Larry Emerson [Navajo Diné artist, scholar, and activist; 1947–2017] named it Grey Canyon for the concrete buildings and streets of the city.

KW Right. He was in this show. I went to the opening, I got all dressed up in my wonderful red leather tunic, but there was no art on the walls because it hadn't arrived yet. Do you remember that brouhaha?

JQS Yes, I remember. It was caught in a snowstorm in Chicago. I had them get a slide projector out, and I gave a slide talk and showed all the art that would be coming.

KW That's the first time we met: 1980-something, maybe.

JQS I remember that you told me you were part of the feminist community. When did you feel that you were part of the New York feminists, and did you work with *Heresies* magazine, with Harmony Hammond and Lucy Lippard?

KW I knew them, and I went to the WIA [Women in the Arts] meetings, and I showed with them a bit, but I didn't live in New York, so I wasn't part of it, because I wasn't active. Eventually, I was asked to be on the magazine's staff, but by then I had moved to Cornell. I just went to meetings, basically. I saw myself as a feminist—I still do.

JQS Did you ever feel there were racist tactics among the sisterhood? Faith Ringgold has talked to me about that.

KW Well, it was a middle-class White girls' association, largely, at that time. Also, I know that there were Indian women who didn't want the trappings of a feminist movement because they felt that there were feminine roles and masculine roles that they were fulfilling.

JQS Do you recall when I invited you to be in the exhibition *Women of Sweetgrass, Cedar and Sage* in 1985?

Kay WalkingStick (born 1935). *The San Francisco Peaks Seen from Point Imperiale*, 2021. Oil on wood panel, 31¾ × 95¼ in. (80.6 × 241.9 cm). Private collection

KW Of course I remember *Sweetgrass*, but there was another show before that, at the Southern Plains Indian Museum in Anadarko, Oklahoma [*Conceptual Art: Four Native American Women Artists*, June 29–July 31, 1980]. Do you remember?

JQS Right, yes.

KW That was the first invitation you gave me.

JQS Then, we had *Confluences of Tradition and Change* [1982] with George Longfish at the University of California, Davis. [Longfish was a Seneca-Tuscarora artist and the director of the Carl N. Gorman Museum at UC-Davis from 1974 to 1996.]

KW Right. That was exciting—I went to the opening and met a number of the artists. A memorable event.

JQS Then, the Heard Biennial—I had gone over to the museum to consult with them; they invited me to do that. They were just going to do one exhibition on painting, and I suggested that they do something like the Whitney Biennial and do it every other year to teach the board and their viewers about contemporary Native art, because everything they had in the museum was traditional. We had a tiny little brochure—that was all the money they gave us. For the second one, in 1985, I wanted to do established artists, and so you were in that second one. We did one after the other of these exhibitions that had never been done before. We were bringing people together. Were any of those really memorable for you?

KW The most memorable show was at the Heard: *Shared Visions: Native American Painters and Sculptors in the Twentieth Century*, in 1991. Margaret Archuleta and Rennard Strickland curated the show, and that catalogue is still used. There was a conference, and Elder West [Southern Cheyenne

artist and professor Richard West Sr.; 1912–1996] spoke—it was an impressively wonderful experience. Pablita Velarde [Tewa artist; 1918–2006] was there, and I was so impressed I couldn't speak to her!

JQS Would you say that the work you're doing right now is a culmination of your years of experience? When you go to the Grand Canyon or, now, Niagara Falls, do you feel a sense of bringing forth work that you haven't seen in the past?

KW I have done what I set out to do. I set out to become the best painter I could be, and yes, these are really strong paintings, there's no doubt about that, but some of the earlier works are, too. I think the work I am doing now is a natural progression from the earlier work.

The other thing I really wanted to do when I came to New York as a very, very young woman was to bring Native art into the mainstream. I thought it was shameful that Native painters weren't shown in all the museums, just like White artists. I feel that I have been part of bringing Native art to the mainstream, along with yourself and many others. Because of the activity of a lot of people, I think that has been accomplished, and it's amazing.

JQS Would you say that at this point in time the museums have opened up, and your work is being acquired? Is it a change in galleries? Is it a change related to Black Lives Matter? Standing Rock? Do you think that's had an impact on your life?

KW It's a slow political growth, stimulated by all of these occurrences. Just as the women's movement affected me in 1972, and the taking over of Alcatraz before that [in 1969–71], these things affect our lives. Recently, people have finally realized that they have to start buying women's art as well as men's art, and they must also start showing and buying Indigenous people's art. It's been a very long trail, and it still isn't fully accomplished, but there is major improvement.

Joyce J. Scott on Elizabeth Talford Scott
As Told to Cecilia Wichmann

Thank God my mom told me lots of stories about her youth. She had thirteen siblings—two of them passed away. There were twelve children in a house, with a mom and a dad. Sharecroppers, picking cotton and crops. The kids went to school around picking. I think the younger siblings had a better chance of going to school, because they could read and write better than my mom. Her father, Samuel Caldwell Sr., worked for the railroad, which meant he wasn't home all the time. She said that all the kids would see him walking toward their home, just a pinpoint getting larger and larger, burdened with bags and shoes. They'd jump on him, going through his pockets to get peppermints and shoes that fit them. The last person had to wear the last pair of shoes, whether they fit or not.

My mother's side of the family were craftsmen. One of her grandfather's jobs was as a blacksmith, and her father's, too. They had special songs they would sing, because when you hit the metal there's a sound that tells you it's ripe, it's ready. It's not just the look. They knew what that pitch was. When they wanted to quilt, they lowered a quilting frame they had hoisted to the ceiling, or, as they say in South Carolina, "heist." The women would get around it, including my mother's father. From the way she talked about him, I'm sure he was a rascal, talking great trash around there with the women, but also quilting himself. The kids were underneath, doing their own quilting samples and sending the needles up if they dropped through. Now, how much more phantasmagorical can you get? I know that's what informed my mother's sense of humor, and me, the most wonderful Joyce J. Scott, who can't stop talking trash all the time.

My mom was a rascal, very smart. Someone drenched in justice. She'd give you opportunities to do the right thing. When I say she didn't read or write very well, that meant she had to experiment. So, she did. She was a very, very kind and giving person, and she really wanted a child. She wanted

someone she could love and be loved by unconditionally. That was our relationship. My father was there, too, he just didn't get the art thing. Both of my parents were people of their time. They saw what the future held for me, but they were very lodged in their time—because of having had to leave the South, and because of how imperious and never-ending racism was for them, overtly.

I don't remember a time when I wasn't an artist. I learned stitching very easily and very young. I always knew that we were up to something. There was no tattered or torn anything in the house that didn't have stitching on it, that my mother hadn't glued together artfully, that she hadn't thrown something on. I remember our hallway was floral greens and reds, and she said, "I want the banister and the steps painted bright red." I knew something was up.

Then I went to Maryland Institute College of Art, and suddenly I'm doing all the things she taught me. In the field of art education, you had to learn everything—clay, stitching, weaving, drawing, printmaking—because you're going to be teaching all these things. But I thought, "Hey, wait a second, this is what I learned at home." Then I went away for graduate school in Mexico, and when I came home, we bought this house. That really started her ability to have her own studio. We had a lot of space, and she had a garden. Everyone knew her garden. And as she became more and more known as a quilt artist, people would bring her fabric and ties and things. Her lovingness made it easy for us to work together. I'd sit stitching with her, and we'd sing spirituals, thread needles for the next day.

My mom made up this system—I haven't seen anything like it—where she'd cut a strip and sequentially tie knots next to each other that looked like a row of beads. That rascal! Then, she would sew them down. That was a sculptural addition to her quilts. She'd also add beads, rocks, pebbles, you name it. I'd take her out to dinner or the movies, and then,

Joyce J. Scott (born 1948). *Mother's Hand* (front and back), 1997. Beads, thread, and wire, 6¼ × 4½ in. (15.9 × 11.4 cm). Collection of the artist, Baltimore

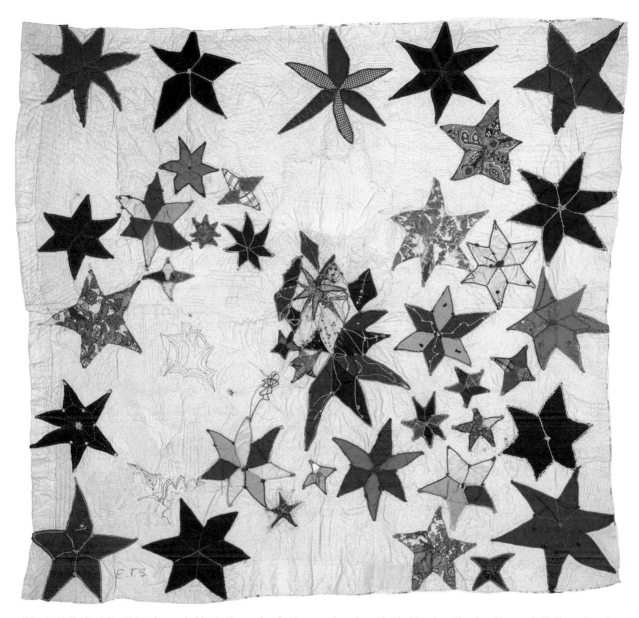

Elizabeth Talford Scott (1916–2011). *Plantation*, 1980. Cotton, wool, and synthetic-blend appliqué, cotton and silk thread, and metal needle on cotton, with cotton lining, 68½ × 74½ in. (174 × 189.2 cm). The Baltimore Museum of Art, Collectors Circle Fund for Art by African Americans, Baltimore Appliqué Society Fund, and purchased as the gift of the Joshua Johnson Council, and Mr. and Mrs. Irvin Greif, Jr., Lutherville, Maryland (BMA 2012.226)

on the way home, I was the one who had to schlep the rocks she found. She would paint the rocks with fingernail polish, or I would give her some indelible pencils, and she'd use those. My mother talked about how sacred quilts were—what the stitching meant, what the colors meant. Her work was allegorical. There'd be ones about butterflies, or snakes, about things that bit her or about things she would bite. Stars meant a lot to her.

Quilting is writing for preliterate people. My mom wrote music with her quilts. There's rhythm. There's symmetry. There's the way she put shapes together, grouped squares or rocks like a chorus. She was very lyrical with her work. And because she didn't have to answer to anyone, that was it. She might put a couple of log-cabin shapes in a quilt, and before you knew it, they were gone: "You're supposed to follow that. But I don't have to do that."

Putting together the pieces of *Harriet's Quilt* [pl. 56], I didn't map it out at all. It's encoded, but it's the kind of code that happens when someone knows how to work with

materials. Something that came from your mom a hundred years ago, and you know this is the proper place to use it. Where, "That little twist there is something she taught me, and then we had cinnamon." Where, "Oh, wait—I know this knot was made out of that sweater she had. I'm going to put that in." I thought of this piece as "Harriet's quilt," but of course I've always said that another persona for my mother could have been Harriet Tubman.

My artwork is very intuitive. I got that from my mom. Following the muse, improvisational. But here's the thing about that, what I prize in my mother and what I prize about myself, and can say without hubris, as a way of explaining my practice: My mother was a consummate quilter. She could quilt with her eyes closed. She could quilt in her sleep. I am a consummate beader. To be that intrinsic with your work, to have that kind of considered and mature flow, comes from not only being in love with but attacking the artwork. Being a friend to it, an enemy, hanging with it, trying to get away from it, being drawn back to it. That's what my mom had.

Kay Sekimachi on Trude Guermonprez
As Told to Jenelle Porter

I first heard Trude Guermonprez lecture about weaving at the Pond Farm artists' colony in Guerneville, California, in 1951. I didn't know much about weaving then, but I had bought a loom in 1949 with my last $150. I was taking basic instructional classes at the Berkeley Adult School and was involved in several local weaving guilds. But Trude explained weaving in ways that were unlike any other teacher. She had studied with the Bauhuas-trained weaver Benita Koch-Otte [1892–1976], and then she taught at Black Mountain College. Trude taught us to get to know the loom, to be "one with the loom," in ways that evolved from backstrap weaving. She opened my mind. In the other classes I'd been taking, we just copied patterns out of a book.

I studied with Trude during summer sessions at California College of Arts and Crafts in 1954 and 1955. She taught with this big, cross-sectioned board to illustrate basic weaves, and that's how I learned about weaving drafts. We made drawings on graph paper. The foundations of my work began in her classes.

In the late 1950s or early 1960s, I wove a small sample: a quadruple weave on an eight-harness loom. When I took

the sample off the loom, I played with the four layers. I realized that if I could find the right material, the weaving itself could open up, and stay open, to become three-dimensional. Around that time, a friend of mine sent me some nylon monofilament from her mother's workplace, DuPont. Since I'd received a lot of this material, I put a warp on the loom right away. I made another quadruple-weave sample, and when I took it off the loom and pulled the layers apart, it stayed open. I'd found the material I needed to make a three-dimensional weave. I made the first woven sculpture in about 1963.

Not only did monofilament have the right stiffness to hold a three-dimensional shape, it was transparent. The layers were see-through, and I was drawn to transparency. But the nylon material was hard to work with. It's slippery and wiry, totally unlike wool or cotton. It had to be handled so carefully. You could easily lose a cross. I tied it in many different places before taking it off the warping board, just to be sure I didn't lose the warp. I was trying to weave four layers, so I had four shuttles that I had to tie. I made a little box to hold the shuttles on either side of the loom. I had to

Kay Sekimachi (born 1926). *Pale Moon*, 1959. Linen, cotton, and rayon, 13½ × 18 in. (34.3 × 45.7 cm). Collection of the artist

be so careful not to cross the weft threads, because there was really no way to correct that except to start over. I could weave about one inch per hour.

The first monofilament objects I made are dated 1965. I worked on one weaving at a time, experimenting over the course of about six or seven years to make two dozen or so works. Some I made with clear monofilament, and for some I dyed the material black before putting it on the loom. Some include plastic rings for structure, to keep the weave open, or glass beads at the bottom. As far as I knew at that time, no one else was weaving with monofilament. Because I loved thinking in three dimensions and I loved transparency, monofilament was ideal for me. I wanted my weavings to be shaped objects rather than flat wall hangings.

I recognize now that my monofilament weavings were quite unique for that era. At the time, though, I was just enjoying working away in my garage studio on Milvia Street in Berkeley. Trude came to visit one day, and when she saw what I was working on, she said, "I knew you were doing something exciting." Trude considered the loom a machine for creativity. She taught us that the loom was a tool that we could control, and the importance of understanding our materials.

Trude became my mentor. She was so disciplined. And I loved everything she made. She was a wonderful weaver. She mostly made wall hangings that emphasized texture, the warp, and she even used stenciled warps. In fact, Trude made her "space hangings" around the same time I began my monofilaments. Dimensional weaves must have been in the air. Even though I love black, white, and natural colors for my work, I admired Trude's use of color in those space hangings, those bright pinks and yellows (see pl. 3). She used just two colors for those double-weave space hangings, one color per layer, and then she twisted them and used brass rods to make them three-dimensional. Trude always emphasized working within limitations. I learned this from her, and it's what I've always done with my own work.

Trude Guermonprez (1910–2007). *Calico Cat*, 1953. Cotton, wool, and rayon, 18⅞ × 24⅝ in. (47.9 × 62.5 cm). Collection of Kay Sekimachi

Tschabalala Self on Faith Ringgold

Faith is an apt name for a woman and a visionary such as Ms. Ringgold, whose trajectory as an artist restores faith in so many who have grown jaded by the cynicism and turbulence of the art world, especially the turbulence most often inflicted on the perceived other. Faith Ringgold, as an activist and an artist, has spent her career fighting for people who are marginalized in the mainstream art community and within broader Western society. As an outspoken feminist and advocate for Black liberation, Ringgold has long maintained resolve in her own voice and abilities, believing—rightly so—that her work could and would change the minds of multitudes, creating new perspectives for the culture at large regarding what an artist should and could be.

There are few artists who, through the simultaneous use of craft and figuration, have achieved the specificity that Ringgold has through her story quilts. The mere gesture of reclaiming the quilt as a painting substrate was revolutionary, for Ringgold literally had to do away with a rigid framework. The success of these works truly lies in their materiality: the materials themselves speak to conceptual and political concerns in the artist's ongoing practice. The materiality of the works alludes to the complications of

Black life, the poetics of collage, and the power of bringing together, through one common seam, things that are conventionally perceived to be unalike.

The strength of Ringgold's visual language allows her to move seamlessly from figuration to abstraction and from two dimensions to three. The *Window of the Wedding* series of the mid-1970s grew from a doll project depicting imagined relationships between the artist's daughters and their ideal suitors. Thus, through abstraction, two works in the Shah Garg Collection, *Window of the Wedding #3: Woman* and *Window of the Wedding #4: Man* (pl. 14), are aspirational in conception, speaking to the desire to depict a perfect Black love—not necessarily romantic, but a deep love that is familial and pure. The flexibility of Ringgold's formal gestures has never been clearer. Above all, Ringgold's work elevates the conversation around Black life by having constant conversations about all aspects of Black desire, including the desire for the quotidian—something I believe our work shares.

Ringgold and I are both from Harlem, which perhaps accounts for the overlap in our worldviews. Harlem circa 1990, when I was born, was still a predominantly Black,

Tschabalala Self (born 1990). *Sprewell*, 2020. Fabric, painted canvas, silk, jeans, painted newsprint, paper, stamp, thread, photo transfer, and acrylic on canvas, 7 × 6 ft. (213.5 × 183 cm). Solomon R. Guggenheim Museum, New York, Gift; Galerie Eva Presenhuber, Zurich; and the Artist, 2021

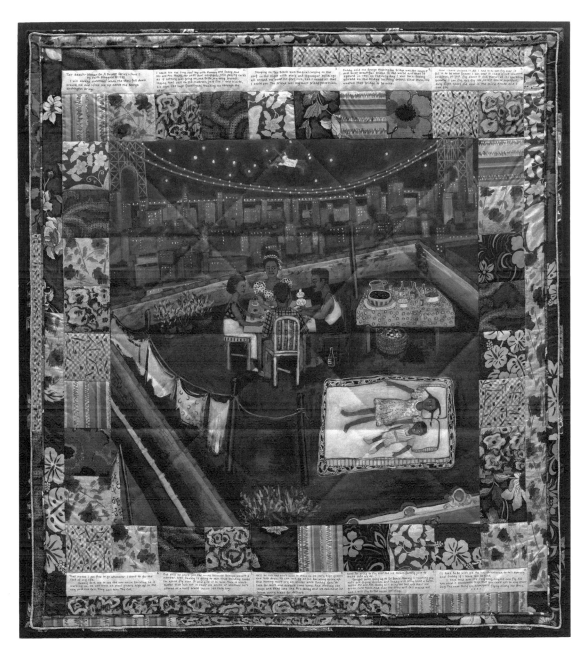

Faith Ringgold (born 1930). *Woman on a Bridge #1 of 5: Tar Beach*, 1988. Acrylic, canvas, printed fabric, ink, and thread, 74⅝ × 68½ in. (189.5 × 174 cm). Solomon R. Guggenheim Museum, New York, Gift, Mr. and Mrs. Gus and Judith Leiber, 1988 (88.3620)

working-class neighborhood. Vibrant and dense, Harlem was, and remains, in many ways, a small inner city within a huge metropolis's smallest and most affluent borough. This dizzying combination makes Harlem a very dynamic and sometimes combustible community. From this cauldron, many things have arisen—notably, many interesting and talented people, one of whom is Ms. Faith Ringgold. Ringgold's work has always been a part of my life, even before I knew who she was. When I was a child, my mother purchased for me her 1991 children's book, *Tar Beach*. There, I was transported into another world, one nearly identical to my own but, at the same time, entirely different.

The tenements and skyline drawn so joyfully in *Tar Beach* mirrored the Harlem I knew and loved; the difference lay in the fantastical. The magic that existed in *Tar Beach*, despite its implausibility, was familiar because Harlem, like most

Black spaces, is imbued with magic—some of it dark, but magic all the same. The fantastical element, while foreign to me as a child, intrigued me and appealed to my youthful sensibilities, for don't all children hope to float, fly, and soar like Cassie Louise Lightfoot in the book and on the quilt that inspired it, *Woman on a Bridge #1 of 5: Tar Beach* (above)? Yet, encountering Ringgold's work again as an adult, and having lived in the United States for the entirety of my life, I now find the surreal elements of *Tar Beach* more realistic—because Black life in America is so often absurdist. The challenges imposed on our communities and the pure miracle of the resilience we exercise every day would be unbelievable if they were not a lived experience. Faith Ringgold's works and legacy truly speak to this joy and pain, and to the duality and patchwork of contemporary Black life.

Mary Weatherford on Joan Mitchell

I'm in the South of France right now. The light is different than Venice, where it bounces off the lagoon—here, it bounces off the Mediterranean. It's the light and the air, and the lightness of the air, and the color on the water, and the shadows and little flowers, pine trees and pittosporum and tiny daisies. Then, sunset. Not the ball of sun over water like California, but a magical turn of water *and* sky to pink. Then the water changes from dusty pink to that magical mirror quality the ocean gets in the evening when it turns lavender. No wonder painters gravitated to this place. It's living in a van Gogh. Pale lavender irises grow to my waist,

red tulips and every kind of flora—flowers, of course, but you're in the South, so palm trees and succulents, too—and the wild diversity of color against the white rocks.

Joan Mitchell's early work has lots of dark colors—it's urban, very New York. What's astounding about her evolution is that she gives up tonal contrast for chroma. She can paint a yellow next to a blue, and if you snapped a black-and-white photograph of the two marks, they'd be the same gray. To the naked eye they are vibrating against each other at a tense frequency. It's not about value—it's about the color itself. That's why a black-and-white reproduction of a

Joan Mitchell doesn't do much. An earlier Joan Mitchell, yes, but not a later one. Curiously, a lot of younger artists are working in that high-chroma vein right now, like Mimi Lauter. Sam Gilliam worked that way. Essentially, Mitchell is working with Bonnard colors and drawing them out into great dramas of movement.

For me, the pastels are especially important—they are so simple and so good that it's hard to understand. Many of the marks are just at the surface, they're coming straight out of the stick of pastel. It's not mixed color. Again, Mitchell understands which color will make another vibrate. I have painted

paintings with the Joan Mitchell pastel books open, trying to figure out, "How do *I* do this color move?" How do you get to Carnegie Hall? Practice, practice, practice. You can read what you want about color. You can be fancy and say "color theory." Success is knowing the color wheel by instinct. When I paint, I have a dial in my head—I know the opposite of a color without much thinking, the way a musician knows how to build a major chord or a minor chord. I know what's opposite a given color on the color wheel. If I move to the right or left of that, it will make something interesting happen. I can move exactly opposite, or I can move a tick to one side or the

Mary Weatherford (born 1963). *Light Falling Like a Broken Chain; Paradise*, 2021. Vinyl paint on linen, 11 ft. 1 in. × 24 ft. (337.8 × 731.5 cm). Shah Garg Collection

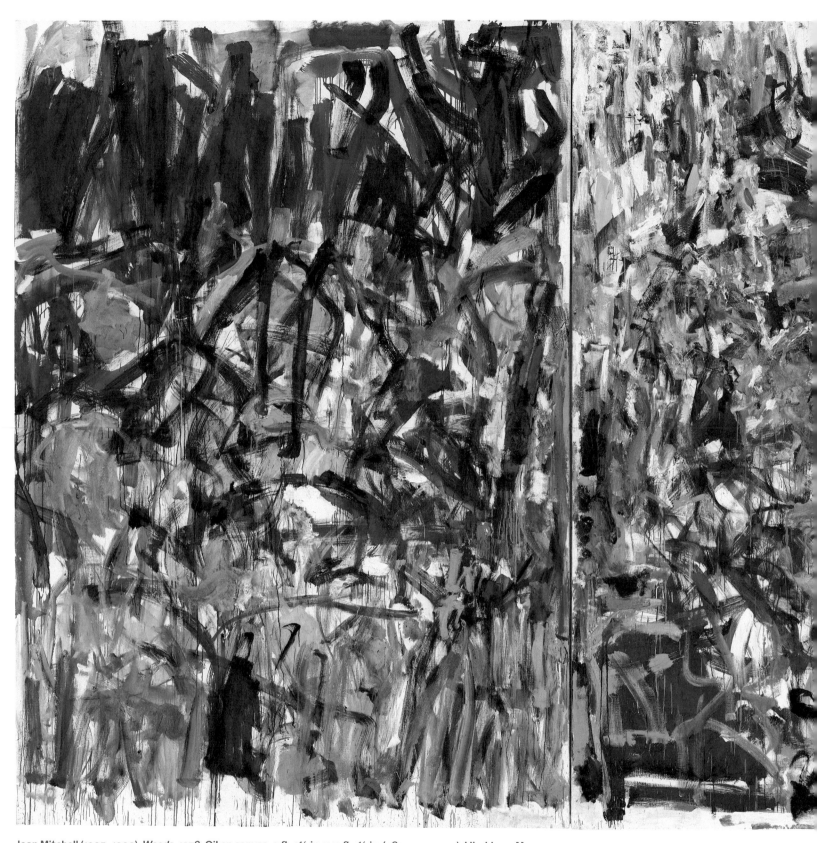

Joan Mitchell (1925–1992). *Weeds*, 1976. Oil on canvas, 9 ft. 2½ in. × 13 ft. 1½ in. (280.7 × 400 cm). Hirshhorn Museum and Sculpture Garden, Washington, DC, Gift of Joseph H. Hirshhorn, 1977 (77.29)

other of opposite. That's how I'm getting things to happen. As I paint, I say to myself, as I'm making the color choices, "Am I staying within one-quarter of the color wheel? Am I opening the color wheel up? Am I going to the opposite side?" It's always in steps, pushing one color to relate to the other—I try not to go for tonal contrast until the end.

Mitchell loves to make a yellow painting, which is hard to do. When you succeed, it's a showstopper. Yellow, yellow, yellow, yellow, lavender. Mitchell is pure color—she uses form as a vehicle for color. If we talk about *Untitled* (pl. 10), the yellow could be nickel yellow. Then, she's got this gold-orange, and she's staying in the warm range, but then she goes green, but then she's got her lavender, because lavender is the opposite of yellow. In this case, it's a light lavender—it has some white in it, it's not the same value as the yellow. One weird thing about this painting is that she has these scribbles in the middle that are a reddish violet, but then also some phthalo green, and those two darker spots in the middle. That makes the painting. Absent that center passage, the painting would be flat and fall apart. She uses unexpected colors! And she goes over a lot of areas with white to push that area back in space.

Weeds (left) is one that impresses me color-wise. Orange to blue: she's going total opposites. A lot of times I'll make a painting and think, "That looks too much like a sports team." Here, it doesn't read that way. She muffles it with light lavenders, and a little bit of yellow. It's stupendous. That looks like fun to me. A long, difficult puzzle—and really, really satisfying when the puzzle starts coming together.

I also think about Mitchell's scale, and the panoramic view in those beautiful paintings that bring to mind Monet's *Water Lilies*. I've started making much larger works, like *Light Falling Like a Broken Chain; Paradise* (previous spread). Painting that was harder than I thought it would be, simply because it was enormous. It took eleven hours. I don't make sketches; I make a catalogue of experiences—swimming, flowers on water, a bird swooping down. *Light Falling* is a gigantic narrative painting, everything that happened over the course of three weeks in Kauai. I've read that Mitchell also worked from remembered experience.

Like Mitchell, I like the physicality of painting. I think I was in my head so much as a kid that I've grown into the person who wants to be out of her head and in her body. A therapist once commented, "Oh, you sure do like the somatic experience." Temperature, water, air and light, the taste of things, the physical world, are everything. That may be common to painters. Musicians can fall in love with how one note or chord changes to another. In his song "Hallelujah," Leonard Cohen explains how to craft a song to elicit an emotion: "It goes like this, the fourth, the fifth, the minor fall, the major lift."

That's exactly what Mitchell does to play emotions: sap green to nickel yellow. Hallelujah.

Plates

Texts by Allie Biswas, Hannah Johnston,
and Lauren O'Neill-Butler

Janet Sobel

Near Ekaterinoslav, Russia (now Dnipro, Ukraine), 1894–1968 Plainfield, New Jersey

Born Jennie Lechovsky in a shtetl in southwestern imperial Russia, Janet Sobel was a mother and a grandmother when she took up painting in 1939, at the age of forty-five. Her family had immigrated to the United States in 1908 after her father was killed in a Russian pogrom. The artist changed her name to Janet on arrival and married Max Sobel, settling in Brighton Beach, Brooklyn, where the couple raised five children. But in 1939, despite a total absence of artistic training, she felt compelled to create. Using materials belonging to her nineteen-year-old son, Sol, who attended the Art Students League of New York, Sobel painted on anything she could find, including envelopes, paper scraps, and shells scavenged from the beach.

Recognizing his mother's ability, Sol shared her paintings with influential art-world figures, including the Surrealists Max Ernst and André Breton, the philosopher John Dewey, and the dealer Sidney Janis, who would become a key supporter of her work. Sol also wrote to Marc Chagall, who invited the family to visit his studio. In 1944, Sobel made her debut in a one-woman show at New York's Puma Gallery and in Janis's prominent traveling exhibition *Abstract and Surrealist Painting in America*. Through Ernst, she was also introduced to Peggy Guggenheim, who included her in the group show *The Women* at her Midtown gallery, Art of This Century, in 1945 and gave her a solo exhibition in the following year.

Sobel's authentic naïveté as a painter—"I paint what I feel within me," she explained in 1946—was readily subsumed within the Surrealists' ideology.[1] However, her background and self-taught status set her apart from her more intellectual peers, and she worked at home without reference to other artists. Her earliest paintings were folkloric, incorporating motifs drawn from her memories of childhood. Peasants in regional costumes, Jewish families, and armed soldiers are outlined in black and surrounded by brightly colored floral patterns evocative of Ukrainian folk art. Soon, however, her work became less figurative and more exploratory. She experimented with enamel paint, often mixed with sand—as can be seen in the granulated surface of *Untitled*—and adapted glass pipettes from her husband's costume jewelry business to drip and blow paint in new ways. Sometimes, she used a vacuum cleaner to move paint around. The result was a body of allover abstract compositions characterized by looping lines of dripped and splattered paint. Sobel worked with frenetic spontaneity across her career. "It is not easy to paint," she once said. "It is very strenuous. But it's something you've got to do if you have the urge."[2]

In 1958, the critic Clement Greenberg revealed that Jackson Pollock (1912–1956) had seen Sobel's work in the early 1940s, relating that the pioneering Abstract Expressionist had admired "one or two curious paintings" at Guggenheim's gallery by "a 'primitive' painter."[3] In his description of a work similar to *Untitled*, consisting of "schematic little drawings of faces almost lost in a dense tracery of thin black lines lying over and under a mottled field of . . . color," Greenberg acknowledged that Sobel's innovative allover compositions had "made an impression" on Pollock.[4] The critic's diminutive, gendered language reflected contemporaneous press coverage, which focused on Sobel's persona as grandmother and housewife before that of artist.

Just as Sobel was establishing herself in New York's avant-garde, she fell into obscurity almost as swiftly as she had risen to fame. The family moved to Plainfield, New Jersey, in 1946 to be closer to her husband's business, and Sobel's inability to drive left her isolated. She also developed an allergy to paint, which forced her to work instead with the less fluid media of crayon and pencil. In the late 1960s, after she had been creating for two decades without recognition, the curator William Rubin reaffirmed Sobel's pivotal role in the development of drip-painted abstraction in the pages of *Artforum* and acquired her masterpiece *Milky Way* (1945) for the Museum of Modern Art's collection.[5] At the time of this writing, it hangs on one of the museum's illustrious walls. HJ

1. Janet Sobel, interview by Bill Leonard, "This Is New York," WCBS Radio, December 16, 1946, transcript, Gary Snyder Fine Art archives, quoted in Sandra Zalman, "Janet Sobel: Primitive Modern and the Origins of Abstract Expressionism," *Women's Art Journal* 36, no. 2 (Fall/Winter 2015): 24.
2. Janet Sobel, quoted in Maya Blackstone, "Overlooked No More: Janet Sobel, Whose Art Influenced Jackson Pollock," *New York Times*, July 30, 2021, https://www.nytimes.com /2021/07/30/obituaries/janet-sobel-overlooked.html.
3. Clement Greenberg, "American-Type Painting" [1955; revised 1958], in *Art and Culture* (Boston: Beacon, 1961), 218, quoted in Zalman, "Sobel: Primitive Modern," 20.
4. Ibid.
5. Rubin's article "Jackson Pollock and the Modern Tradition" included a discussion of Pollock's encounter with Sobel's work at Art of This Century and was published in *Artforum* in April 1967.

1. *Untitled*, ca. 1946
Matte paint, enamel paint, and sand on wood panel
21¾ × 15¼ in. (55.2 × 38.7 cm)

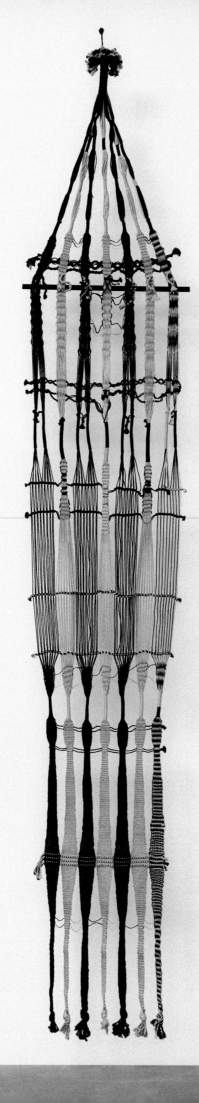

Lenore Tawney

Lorain, Ohio, 1907–2007 New York City

Lenore Tawney was a renowned pioneer of fiber art, whose revolutionary approach to weaving helped to determine the course of the movement in the 1960s. Over a five-decade career, which began when she was in her forties and ended with her death at the age of one hundred, she produced weavings, sculptural installations, and boxlike assemblages alongside works on paper, including drawings and postcard collages.

Born in Ohio, Tawney moved in her twenties to Chicago, where she worked as a proofreader for a legal publisher and attended evening classes at the School of the Art Institute of Chicago. Following the untimely death of her husband in 1943, she moved to Urbana, where she studied art therapy at the University of Illinois. Three years later, she returned to Chicago and enrolled at the New Bauhaus (later known as the Institute of Design and now part of the Illinois Institute of Technology). There, she studied drawing with László Moholy-Nagy, sculpture with Alexander Archipenko, watercolor with Emerson Woelffer, and weaving with Marli Ehrman (1904–1982).

While she initially concentrated on sculpture, Tawney turned her efforts to weaving in 1954 after completing a tapestry workshop with the Finnish weaver Martta Taipale (1893–1966) at Penland School of Craft in North Carolina. By 1957, she had decided to dedicate herself more fully to her practice. In search of "a barer life, closer to reality, without all the things that clutter and fill our lives," she left Chicago and moved to a loft on Coenties Slip, a tiny street near the seaport in Lower Manhattan.[1] Among her neighbors were Jasper Johns, Ellsworth Kelly, Robert Indiana, and Agnes Martin, who would remain a lifelong friend.

With space to experiment as never before— "the idea of weaving in volume floated up to consciousness this morning," she wrote in her journal in 1958—Tawney's work expanded.[2] She spent three months studying Peruvian textiles and gauze-weaving techniques with the German fiber artist Lili Blumenau (1912–1976) in the autumn of 1961 and worked industriously for her first New York solo exhibition, which opened at the Staten Island Museum that November. Around this time, her aesthetic changed. She cleared her studio of old yarn and ordered a weighty, custom-made linen variety in just two colors, black and natural, with the ambition of "weav[ing] forms that would go *up*."[3] As she explained in an interview in 1979, her existing setup was not amenable to such experimentation: "You can't weave forms like those on a conventional loom. I had to invent a new kind of reed—the device that holds the warp thread apart. I designed it. And I had it made. And then I set to work."[4]

With the use of this new reed, Tawney began to weave in three dimensions for the first time. The device gave her better control to shape as she worked, allowing her to produce objects that were taller than she had imagined possible. The artist intended these works to be hung in space as sculptural objects, refuting the flat, rectangular nature of traditional textiles. She also surpassed the medium's conventions by leaving large areas of material transparent and unworked. Inspired by the Peruvian textiles she had studied—as well as by the knotted- or woven-rope fenders on tugboats she could see from her loft on Coenties Slip— Tawney began incorporating knots and braids into her works. The results were, in her words, "expanding, contracting, aspiring forms."[5] Agnes Martin (1912–2004), who wrote the accompanying text for her Staten Island Museum exhibition, also helped to name some of the forty works on view.[6] While seemingly not exhibited there, *Inquisition*— its title as characteristically evocative as those of Tawney's other "woven forms"—was created around the same time, by the same techniques.

Like Martin, Tawney maintained an interest in Eastern philosophy throughout her life and likened her artistic process to a form of meditation. Speaking of her spirituality and the role of her studio as a space for quiet reflection, she once said, "You first have to be in touch with yourself inside very deeply in order to do something. . . . I want to be under the leaf, to be quiet until I find my true self."[7]

HJ

1. Lenore Tawney, quoted in Shira Wolfe, "Lost (and Found) Artist Series: Lenore Tawney," *Artland Magazine*, accessed December 2, 2021, https://magazine.artland.com/lost-and -found-artist-series-lenore-tawney/.
2. Lenore Tawney, quoted in press release for *Lenore Tawney: Part Two*, Alison Jacques Gallery, London (website), exh. on view November 18, 2021–January 8, 2022, accessed December 2, 2021, https://alisonjacques.com/exhibitions /lenore-tawney-part-ii#text.
3. Lenore Tawney, quoted in Eleanor Munro, *Originals: American Women Artists* (New York: Simon and Schuster, 1979), 329.
4. Ibid., 330.
5. Lenore Tawney, quoted in press release for *Lenore Tawney: Part One*, Alison Jacques Gallery, London (website), exh. on view October 12–November 6, 2021, accessed December 2, 2021, https://alisonjacques.com/exhibitions /lenore-tawney-part-i#text.
6. Anne Coxon, catalogue entry for Lenore Tawney, *The Queen* (1962), Tate (website), March 2016, accessed August 28, 2022, https://www.tate.org.uk/art/artworks /tawney-the-queen-l03874.
7. Tawney, quoted in Wolfe, "Lost (and Found) Artist Series: Tawney."

2. *Inquisition*, 1961
Linen
11 ft. 11 in. × 2 ft. 3 in.
(363.2 × 68.6 cm)

Trude Guermonprez

Danzig, Germany (now Gdańsk, Poland), 1910–1976 San Francisco

Trude Guermonprez (née Jalowetz) studied painting for a year in Cologne at the Kölner Werkschulen before enrolling at the Staatlich-Städtische Kunstgewerbeschule Burg Giebichenstein in Halle an der Saale, near Leipzig, in 1931. It was there that she developed an interest in weaving. The largely Bauhaus-trained faculty included the textile designer Benita Koch-Otte (1892–1976), whose lessons on abstraction, form, and process were deeply influential. The ceramist Marguerite Wildenhain (1896–1985) was another important instructor.

In 1933, with the advent of National Socialism, Guermonprez accepted a fellowship to study weaving in Sweden and Finland. She subsequently moved to the Netherlands and, in 1934, began working for the prestigious Dutch textile firm Het Paapje. Over the next decade, Guermonprez continued to cultivate her understanding of technical weave structures and patterns, securing freelance commissions for rugs, upholstery fabrics, and other custom textiles. During this period, in 1939, the artist's parents, the musicologist Heinrich Jalowetz (1882–1946) and Johanna Groag Jalowetz (1885–1966), a teacher of voice and bookbinding, took up positions at Black Mountain College in North Carolina. In 1947, following the deaths of her father and her first husband, Guermonprez joined her mother there, and she led the weaving program, at Anni Albers's request, until it was dissolved in 1949. Then, she began teaching at Pond Farm in Guerneville, California, at the invitation of Wildenhain, who had helped to found that school and artists' colony. Around this time, the artist began to explore new directions in her weaving. Writing in her journal decades later, she reflected, "At that time pictorial weaving had been done mostly in the Gobelin technique, where the weft thread carried the color and formed the image. My thought then was this: Painters used woven canvas as the base for their brushwork; why then should not I, as a weaver, enter the process at an earlier phase. I would paint on the warp and see how subsequently the perpendicular interlacing of the weft would alter color and texture."[1]

As a teacher, Guermonprez emphasized the importance of handcrafting skills and prioritized technical finesse prior to engaging in creative expression. "My thinking within weaving is very much influenced by Bauhaus training," she said.[2] She nonetheless encouraged her students to be responsive to their surroundings and held classes on the beach so that they could record and incorporate into their work the structures and textures of rocks, shells, and driftwood. "She impressed upon us the importance of being flexible and not starting with preconceived ideas," one of her students, the noted fiber artist Kay Sekimachi (see pl. 11), later remembered.[3] Guermonprez's next academic position was her most long-standing: she taught at San Francisco's California College of Arts and Crafts (now California College of the Arts) from 1954 to 1976, serving as chair of her department for the last seventeen years of her tenure.

The early 1960s marked another significant shift in the artist's practice. Having devoted her previous production largely to private commissions, Guermonprez began to pursue an experimental style of weaving that disregarded functionality and, above all, had all the attributes of sculpture. Between 1961 and 1965, she made a series of large-scale works she called "space hangings"—some of the earliest three-dimensional weavings created in the United States. The example in the Shah Garg Collection consists of a single reverse-double-weave panel that connects along a central axis so that it maintains a crossed form when opened and suspended. Abandoning traditional tapestry weaving, Guermonprez devised several novel techniques: she left warps unwoven, resulting in a gauzy, transparent surface that appeared to shift in the light, and used pattern weaves to enhance the quality of movement. Guermonprez's innovations emerged in conjunction with the burgeoning fiber art movement, which was recognized with the 1963 exhibition *Woven Forms*, held at New York's Museum of Contemporary Crafts (now Museum of Arts and Design).

After the "space hanging" series, Guermonprez never again experimented with three-dimensional weaving, but the "textile graphics" and "word hangings" she made from 1970 on—such as *Our Mountains* (1971), a landscape in which her second husband's and her own profiles form rocky peaks, and *Mandy's Motto: The Wind Don't Blow One Way All the Time* (1975), which quotes her housekeeper—continued to reconsider the possibilities of weaving as an expressive form. AB

1. Trude Guermonprez, quoted in Hazel V. Bray, *The Tapestries of Trude Guermonprez*, exh. cat. (Oakland, CA: Oakland Museum, 1982), 6.
2. Trude Guermonprez, quoted in Bobbye Tigerman, "Fusing Old and New: Émigré Designers in California," in *California Design, 1930–1965: Living in a Modern Way*, ed. Wendy Kaplan, exh. cat. (Los Angeles: Los Angeles County Museum of Art; Cambridge, MA: MIT Press, 2011), 96–98.
3. Kay Sekimachi Stocksdale, "Trude Remembered," in Bray, *Tapestries of Guermonprez*, 22.

3. *Untitled (Space Hanging)*, ca. 1965
Silk (double weave) and brass
80 × 32 × 32 in. (203.2 × 81.3 × 81.3 cm)

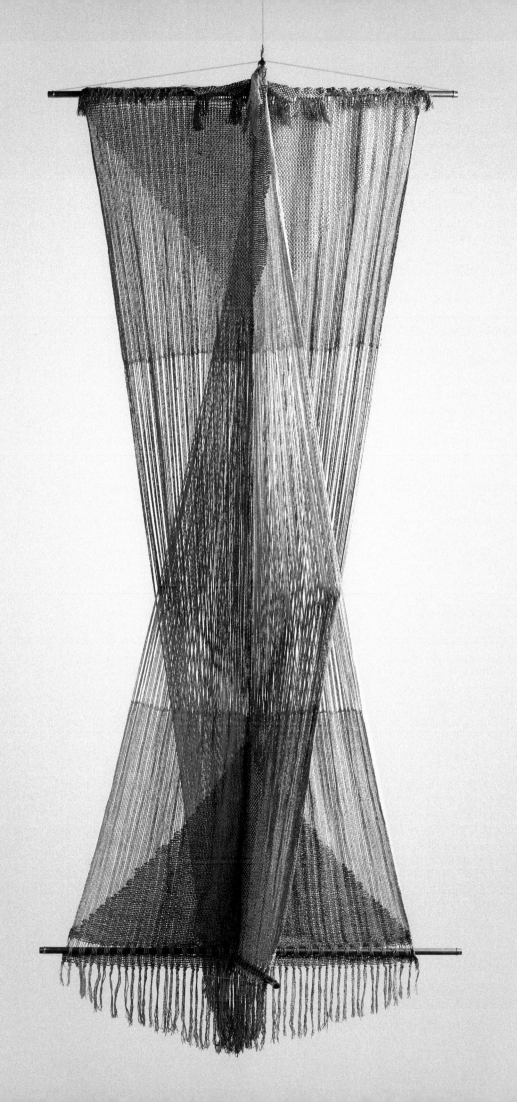

Elizabeth Talford Scott

Enoree, near Chester, South Carolina, 1916–2011 Baltimore

Elizabeth Talford Scott was an American fiber artist known for her quilts and mixed-media compositions. The sixth of fourteen children, she was born at Blackstock Plantation near Chester, South Carolina, where her family lived as sharecroppers and her grandparents had previously been enslaved. Obliged to prioritize paid employment and caregiving for many years, the artist was most prolific in later life.

Scott was raised by a family of craftspeople who practiced a multitude of techniques, including needlework, knitting, basketry, pottery, and metalwork. Learned out of necessity, these skills, passed down through generations, facilitated the creation of essential utilitarian objects from repurposed materials. For many Black communities in the rural South at this time, quilting—another of these essential techniques—was a way of life. As well as providing warmth in uninsulated homes, quilts functioned as a means of creative expression and, by integrating fabric that had belonged to specific individuals, of commemoration, storytelling, and history keeping. Scott's father—a railroad worker who collected fabric scraps as he traveled for work—and her mother both quilted, and Scott had been trained in needlework by the age of nine. "My mom learned to quilt from her family . . . many, many generations," the artist's daughter, Joyce J. Scott (see pl. 56), has recalled. "It was a way to recycle fabrics. It was cheaper to make a quilt than to buy a blanket."[1]

In search of brighter economic prospects and, she hoped, less racial prejudice, Scott moved to Baltimore in 1940 as part of the Great Migration. Working long hours as a domestic servant and nanny while caring for her own daughter, who was born in 1948, the artist was forced to forgo her quilting practice. It was only in the 1970s, after her daughter was grown and with her retirement stretching out before her, that she returned to her métier. In the years that followed, Scott developed a unique and innovative style that elaborated on the traditional strip-piecing approach she had learned from her family. Gradually moving away from the rectangle, she began to create asymmetrical forms—quilted mixed-media *objects*, as opposed to conventional quilts.

Beginning with a patchwork base, Scott used a vast array of techniques to embellish her compositions. Areas of embroidery, appliqué, and knotting sat alongside found objects, including buttons, shells, pieces of glass, and pebbles, which she affixed to the surface. Joyce J. Scott has referred to her mother's side of the family as "a polyglot of craft people," emphasizing their rich history of expertise.[2] While the techniques in question had traditionally been practiced separately, however, Elizabeth Talford Scott purposefully combined and layered them: "She just spread those mediums out into her quilt work. She was beading and adding knots, and crochet. She combined things that would have typically been separate techniques."[3] Drawing upon the rural environment in which she had grown up, the artist frequently incorporated flora and fauna, such as flowers and insects, into her iconography. Other references are more metaphysical, evoking family histories, cultural rituals, and beliefs. *Save the Babies* is part of a series of works made in the loosely defined shape of a shield. For the artist, this shape, thought to be capable of protection and healing, was representative of the works' spiritual and talismanic qualities.

One of the most profound influences on Scott in her later and most experimental years was her daughter, who had begun her own career as an artist by the late 1970s. A jewelry maker and sculptor—trained as a child in quilting and needlework by her mother—Joyce J. Scott offered her mother wider access to beads, sequins, and brightly patterned fabric. Intertwined in a mutually beneficial dialogue, the pair continued to exchange creative ideas until the elder artist's death. Recalling her mother's innovative and determined character, Joyce J. Scott has said, "She had an improvisational spirit and rascally ways, which gladly came through in everything."[4]

HJ

1. Joyce J. Scott, quoted in *Reality, Times Two: Joyce J. Scott and Elizabeth Talford Scott*, exh. cat. (Baltimore: Goya Contemporary Gallery, 2019), n.p.
2. Joyce J. Scott, quoted in "'She Had an Improvisational Spirit and Rascally Ways': See the Sculptural Quilts of Pioneering American Textile Artist Elizabeth Talford Scott," *Artnet Gallery Network* (sponsored content), *Artnet News*, December 10, 2020, https://news.artnet.com/partner-content/elizabeth-talford-scott-goya-contemporary.
3. Ibid.
4. Ibid.

4. *Save the Babies*, 1992
Cotton and synthetic fabric, embroidery thread, metallic embroidery thread, beads, shells, sequins, buttons, and cotton on polyester canvas backing
83½ × 59 × 3½ in. (212.1 × 149.9 × 8.9 cm)

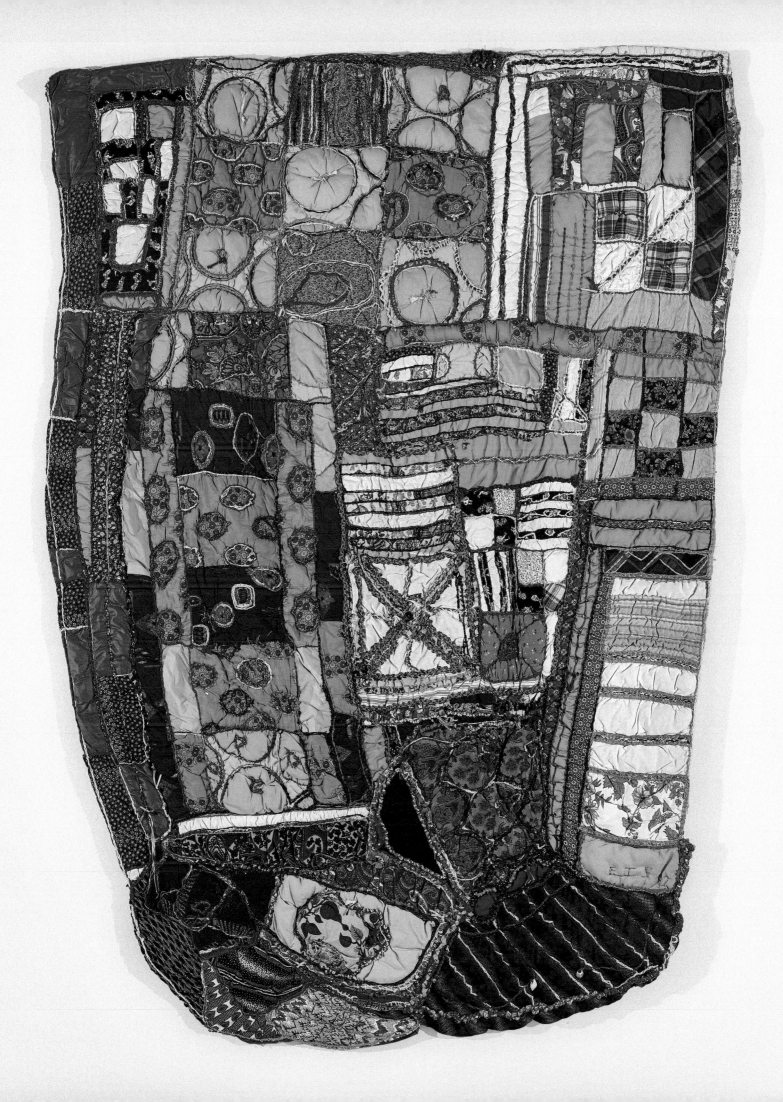

Maria Lassnig

Kappel am Krappfeld, Austria, 1919–2014 Vienna

Since the 1990s, and specifically after its inclusion in the 1993–94 multigenerational group show *Der zerbrochene Spiegel* (The Broken Mirror), curated by Kasper König and Hans-Ulrich Obrist, Maria Lassnig's work has been under renewed critical consideration for its bold and profoundly psychological approach to postmodern figuration. At the time of that exhibition, Lassnig was in her mid-seventies and still making work—which she continued to do, with humor and insight, into her nineties. The artist knew she had been overlooked, but it never stopped her. Lassnig was born in a small town in mountainous southern Austria in 1919, in the wake of World War I. Her parents were unmarried and her mother worked, so she lived with grandparents until 1925, when her mother and new stepfather relocated to Klagenfurt, the state capital. There, she attended a convent school and, after passing her examinations, worked briefly as a schoolteacher before moving to Vienna in 1940 to accept a placement at the Akademie der Bildenden Künste Wien. For the next five years, against the backdrop of the Nazi regime, bombings, and cultural restrictions, she studied painting in a city that was isolated from the advances in modernism taking place in the United States and elsewhere in Europe.

Around 1947, Lassnig embarked on a program of self-study that would define much of her later work, beginning with a series of drawings she called *introspektiv Erlebnisse* (introspective experiences).[1] Next came the sustained production of *Körpergefühlsmalerei* (literally, "body awareness paintings"—again, her own idiosyncratic terminology), depictions of the parts of her anatomy that she felt as she worked. The canvases, in particular, contrasted fruity hues such as bright green, pink, and blue with biomorphic shapes and lines based on her most important subject: herself. This tendency to turn inward to propel outward became something of a signature, although her art could never be so neatly pinned down. After a few visits to Paris, Lassnig took up residence in the City of Light from 1960 to 1968. This was a time of tremendous growth for the artist, in which she began to fully release herself from aesthetic constraints and developed a sense of freedom that became synonymous with her name. She then left Paris for a twelve-year stay in New York, where she flourished creatively and cofounded Women/Artist/Filmmakers, Inc.,

in 1974, along with other feminists such as Carolee Schneemann (1939–2019) and Martha Edelheit (born 1931). The drawing *WOMAN WORLD!*, in the Shah Garg Collection (see fig. 6 on p. 87), speaks to her feminist ideals of the time. Still, her work did not receive recognition—she "passed through NYC like a shadow," the painter Amy Sillman has written.[2]

In 1980, Lassnig returned to Vienna to teach at the Hochschule für Angewandte Kunst, becoming the first woman professor of painting in a German-speaking country. *Die grüne Malerin* (The Green Paintress) is indicative of her ongoing *Körpergefühlsmalerei* project: the occupational self-portrait sings with expressive strokes. Hans Werner Poschauko, Lassnig's assistant at the time of her death in 2014, has described her singular method and the meanings she assigned to colors: "She related the colors she used to emotions—love, hate, loneliness, depression. She was very precise about this. The forehead would get a thought color, the nose a smell color, the pain would get its own color and so on."[3]

While it took decades for Lassnig to finally receive her due, the wit, intimacy, and rigor of her output have clearly influenced later generations of artists—an international cohort including Jana Euler, Hayv Kahraman, Tala Madani, Ebecho Muslimova, and Dana Schutz (see pl. 100), to name a few, who have likewise underscored the bodily, thus performative, nature of their medium.[4] A painting is more than a mere object in their hands. It becomes an extension of a complex embodiment, of a physical and mental structure made up of sensations that are constantly changing. LOB

1. "Passages: Maria Lassnig," interview by Hans Ulrich Obrist (conducted November 11, 2012), trans. Christina Lehnert, *Artforum* 53, no. 2 (October 2014), https://www.artforum.com/print/201408/maria-lassnig-48223.
2. Amy Sillman, "Dear Maria Lassnig," in *Maria Lassnig: The Future Is Invented with Fragments from the Past* (Cologne: Walther König, 2017), 26.
3. Hans Werner Poschauko, quoted in Gesine Borcherdt, "Maria Lassnig: To Be Many Kinds," *Ursula*, no. 4, September 8, 2019, https://www.hauserwirth.com/stories/25670-maria-lassnig-many-kinds.
4. See Lauren O'Neill-Butler, "Discard the Style!," in *Maria Lassnig: The Paris Years, 1960–68* (New York: Petzel Gallery, 2021), 17–23.

5. *Die grüne Malerin* (The Green Paintress), 2000
Oil on canvas
49 × 39½ in. (124.6 × 100.2 cm)
Promised Gift to San Francisco Museum of Modern Art

Anne Truitt

Baltimore 1921–2004 Washington, DC

The beginning of the 1960s coincided with a major transition in Anne Truitt's practice, which informed the paintings and sculptures she would make over the next forty years. Starting then, the American artist developed a body of work consisting of monochromatic geometric constructions—specifically, freestanding wood columns—to which she applied multiple layers of tonally varied paint. The smooth surfaces of these sculptures are characterized by subtle variations of the same hue; Truitt sanded repeatedly between layers of paint, a technique that helped her to establish color as the primary focus of her work. "What I want is color in three dimensions," she explained, "color set free, to a point where, theoretically, the support should dissolve into pure color."[1]

After abandoning a career in clinical psychology in 1945 ("I had made a mistake," she reflected in a 1987 interview with the *Washington Post*), Truitt studied sculpture in 1949 with Alexander Giampietro (1912–2010) at the Institute of Contemporary Arts in Washington, DC, followed by a short stint at the Dallas Museum of Fine Arts' Museum School. During this period, she explored various processes and materials, including clay, cast cement, and welded steel. These experiments culminated in life-sized figurative sculptures constructed from chicken wire, cloth, and metal pipes, which she continued to produce over the next decade. The artist once described these works as "sort of bestial . . . very ugly and primitive. They had nothing to do with art in a way; they had to do with self-expression."[2] Soon, she would find herself navigating the same dichotomy in her abstract compositions.

It was a 1961 exhibition at New York's Solomon R. Guggenheim Museum, *American Abstract Expressionists and Imagists*, that prompted the profound shift in Truitt's thinking and led her to abstraction. Her encounter with works by Nassos Daphnis, Barnett Newman, and Ad Reinhardt proved revelatory: "I began to see how I could make exactly what I wanted to make in a new way."[3] Newman, in particular, had an immense impact. In her 1982 memoir, *Daybook: The Journal of an Artist*, Truitt describes seeing his landmark painting *Onement VI* (1953) in the show: "My whole self lifted into it. . . . Even running in a field had not given me the same airy beatitude."[4] While the sculptures she made between 1961 and 1962 still related directly to real-life sources (picket fences, tombstones), her compositions swiftly became less referential. The artist's habitual experiences nevertheless remained a vital framework for her work. She described her

first solo exhibition, held at André Emmerich Gallery, New York, in 1963, as "a strange distillation of a person's life," adding, "I've never understood people who made art out of art."[5] Truitt's pursuit of depth and dimensionality distinguished her practice from the Minimalist art that prevailed in the 1960s, with which she denied any association.

Working intuitively, Truitt sought to convey her innermost feelings through nonobjective, allusive forms. "My idea was not to get rid of life but to keep it and to see what it is," she said. "But the only way I seem to be able to see what anything is, is to make it in another form, in the form in which it appears in my head."[6] Approaching color as a metaphorical tool, she realized that "though color and structure retained individuality, they could join forces rather as independent melodies can combine into a harmonic whole. And that when I combined them in a particular way, they had a particular content—particular to me, that is, a meaning that was important to me."[7]

Although known primarily as a sculptor, Truitt also made paintings—works that were scarcely displayed during her lifetime. *Rock Cry* encapsulates her preoccupation with accentuating the verticality of the canvas, resulting in a form that mirrors the totemic quality of her sculptures. As with her three-dimensional works, Truitt's paintings often juxtapose several hues, augmenting the interplay between color and form and embodying the artist's long-standing objective to achieve "maximum meaning in the simplest possible form."[8]

AB

1. Anne Truitt, quoted in catalogue entry for *Triad* (1977), Whitney Museum of American Art, New York (website), accessed July 27, 2022, https://whitney.org/collection/works/27757.
2. Anne Truitt, "Grand Allusion," interview by James Meyer, *Artforum* 40, no. 9 (May 2002), https://www.artforum.com/print/200205/grand-allusion-2756.
3. Ibid.
4. Anne Truitt, *Daybook: The Journal of an Artist* (London: Simon and Schuster, 2013), 155, quoted in Charles Joseph Parsons, "The Line of Dichotomy: Standpoints and Meaning in Anne Truitt's Art" (BA thesis, College of William and Mary, 2021), 8.
5. Truitt, "Grand Allusion."
6. Ibid.
7. Ibid.
8. Anne Truitt, quoted in Victoria Dawson, "Anne Truitt and the Color of Truth," *Washington Post*, March 14, 1987, https://www.washingtonpost.com/archive/lifestyle/1987/03/14/anne-truitt-and-the-color-of-truth/feodfb81-4bcf-48e5-8bbd-7533b3b3e1cb/.

6. *Rock Cry*, 1989
Acrylic on canvas
82½ × 36½ in. (209.6 × 92.7 cm)

Toshiko Takaezu

Pepeʻekeo, Hawaiʻi, 1922–2011 Honolulu

Toshiko Takaezu was a leading American ceramist, an esteemed teacher of the medium for decades, and one of the key figures in the midcentury transformation of ceramics from craft to fine art. The artist's parents had immigrated to Hawaiʻi from Okinawa, Japan, and she was the middle child of eleven. She first studied art at the University of Hawaiʻi at Mānoa and, in 1951, enrolled at the Cranbrook Academy of Art in Bloomfield Hills, Michigan, to train with the Finnish ceramist Maija Grotell (1899–1973). She eventually became Grotell's primary assistant. Her teacher was, in Takaezu's view, an "unusual and rare human being who felt it was important for students to become individuals. It was through her criticism that I began to discover who I was."[1]

While still in Hawaiʻi, Takaezu made traditional vessels, but in the 1950s, while studying with Grotell, she embraced the idea that ceramics could be exhibited as artworks rather than simply used as functional objects. She also developed a broader view of what it means to be an artist. "You are not an artist simply because you paint or sculpt or make pots that cannot be used," she told *Ceramics Monthly* in 1975. "An artist is a poet in his or her own medium. And when an artist produces a good piece, that work has mystery, an unsaid quality; it is alive."[2] During an eight-month-long trip to Japan with her family in 1955–56, Takaezu spent time in a Zen monastery and studied with some of the country's most eminent traditional potters.

Takaezu's signature form was a rounded, bottle-like shape with an opening resembling a nipple at the top, which allowed gasses to escape during firing. She is also known for the diverse methods of glazing she employed, from brushing and dripping to pouring and dipping. In her stoneware and porcelain works, some which are small enough to fit in the palm of a hand, Takaezu used her clay "canvas" to blend the expressive bravura of Abstract Expressionism with the peaceful, contemplative quality found in traditional Japanese pottery. She also emphasized forms suggestive of the natural world, such as acorns, melons, and tree trunks.

Among Takaezu's best-known bodies of work are the thick orbs she called "moons"; her vertical "closed forms"; and the tall, thin ceramic "trees" inspired by scorched trunks she discovered along Devastation Trail in Hawaiʻi Volcanoes National Park, on the Big Island (these resemble the "closed forms" but tend to be taller and narrower, although the "closed forms" also grew sharply in height in the late 1990s). At times, Takaezu exhibited the "moons" in woven hammocks, an allusion to her method of drying her pots in nets. She also cast bronze bells and wove rugs. In a 2003 interview, the artist acknowledged that, to her, the most exciting aspects of her practice were still the "unknown intangible things that happen," and, moreover, that those surprises made her want to see if she could make the work again—if she might, in turn, "get the perfect piece."[3]

LOB

1. Toshiko Takaezu, *The Art of Toshiko Takaezu: In the Language of Silence*, ed. Peter Held (New York: Toshiko Takaezu Book Foundation; Chapel Hill: University of North Carolina Press, 2010), 14.
2. "Toshiko Takaezu: A Thrown Form," *Ceramics Monthly* 23, no. 9 (November 1975): 32.
3. Toshiko Takaezu, interview by Gerald Williams, Archives of American Art, Smithsonian Institution, Washington, DC (website), June 16, 2003, https://www.aaa.si.edu/collections/interviews/oral-history-interview-toshiko-takaezu-12097.

7. CLOCKWISE FROM FAR LEFT

Closed Form, ca. 1980s
Glazed porcelain
18 × 8 × 7 in. (45.7 × 20.3 × 17.8 cm)

Untitled Closed Form, ca. 1979
Glazed stoneware
30 × 15 × 15 in. (76.2 × 38.1 × 38.1 cm)

Tree, ca. 1980
Glazed stoneware
66 × 13 × 13 in. (167.6 × 33 × 33 cm)

Anagama Hearts, 1992
Anagama-fired and glazed porcelain
16 × 9 × 9 in. (40.6 × 22.9 × 22.9 cm)

Untitled Moon, ca. 1990
Glazed stoneware
20 × 21 × 21 in. (50.8 × 53.3 × 53.3 cm)

Closed Form, ca. 1960
Glazed stoneware
8 × 6½ × 5 in. (20.3 × 16.5 × 12.7 cm)

Closed Form with Rattle, ca. 1998
Glazed porcelain
5 × 5¼ × 5¼ in. (12.7 × 13.3 × 13.3 cm)

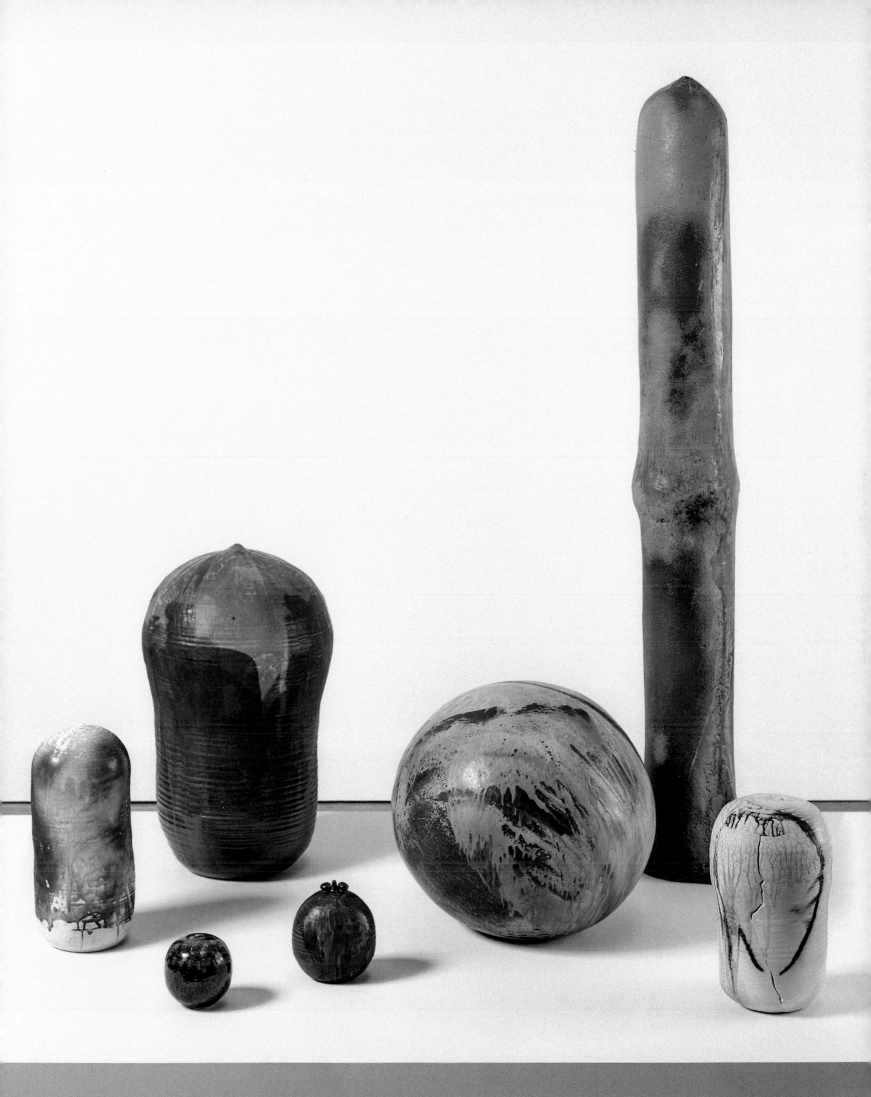

Yvonne Cole Meo

Seattle 1923–2016 Pasadena, California

Both a practicing artist and an art historian, Yvonne Cole Meo held multiple advanced degrees, including an MA and an MFA from California State University, Los Angeles (completed in 1960 and 1988, respectively), and a PhD from Cincinnati's Union Institute and University (1977). Her dissertation was titled "A Survey on Traditional Arts of West Africa and Contemporary Black American Art: A Study of Symbolic Parallels and Cultural Transfer." She also contributed a journal article, "Ritual as Art: The Work of Houston Conwill," to *Black Art: An International Quarterly* in 1979. (Conwill [1947–2016] was a sculptor, performance artist, and conceptualist whose work, like Cole Meo's, fused emotions and politics while reminding us of our humanity.) She taught art for nearly half a century: she was the first woman instructor at Andrew Jackson Boys' School in East Los Angeles and at Fisk University in Nashville.[1] During the 1960s in LA, she was encouraged by the legendary artist and educator Charles White (1918–1979) to show her work in the city's galleries. According to her biography in a 1995 anthology devoted to Black women artists, White "told her she was fifty years ahead of her time. [Cole] Meo followed his advice and exhibited in galleries but continued her teaching."[2]

Cole Meo was featured in the first-ever exhibition devoted solely to Black women artists in the United States, a 1970 survey titled *Sapphire Show*, held at Suzanne Jackson's Gallery 32. The show included six artists: Jackson herself (see pl. 51), Cole Meo, Eileen Abdulrashid (then Nelson), Gloria Bohanon (see pl. 27), Senga Nengudi (then Sue Irons; see pl. 44), and Betye Saar. Organized by the participating artists and opening on July 4, the six-day exhibition was a reaction to a show of work by Black artists sponsored by the Carnation evaporated-milk company at its Los Angeles headquarters earlier that year, which had included only one woman. The Gallery 32 exhibition took its title from the bossy, know-it-all character Sapphire Stevens of the radio and TV series *Amos 'n' Andy* (played by Ernestine Wade in both formats), turning a sexist stereotype into a badge of feminist pride. Later in the same month, Cole Meo had a solo exhibition at the gallery. Her artist's statement for that show began: "My sculptural painting and textural ideagrams [*sic*] are unequivocal statements on Today's happenings. They are documentary commentations on life, itself." It concluded: "My aim, as an artist, is to portray the indescribably beautiful as well as the most frightening aspects of man's plight in hopes that he will save himself and assure the next generation a future."[3]

Status Quo depicts a series of clenched fists holding fake dollar bills (marked "NON NEGOTIABLE"), along with two more open hands, against solid-colored backgrounds. Painted-over plastic tokens frame painted stars and stripes that evoke the American flag, but in shades of green and white. The composition may have been included in the artist's solo exhibition at Le Dilettante, a gallery/boutique/restaurant in Los Angeles. The show was reviewed in the November 1965 issue of *Artforum* by Molly Barnes, who commented that Cole Meo "calls herself a 'chemical painter,' as she works exclusively with her 'secret' mixtures of plastics, melted vinyl, and occasional bits of collage."[4] Barnes also noted that Cole Meo's focus was on the "luminosity of color and creating a sculptural surface tension," which is clear in *Status Quo,* although the work primarily offers a biting political commentary on what it takes to successfully "make it" as a Black person in the art world (or perhaps in American society at large). Another piece included in Cole Meo's Le Dilettante exhibition, *Tunnel of Status Symbols*, "shows us a gruesome wreck on the Hollywood Freeway," Barnes noted, adding, "Mrs. Meo uses real nails for the freeway fence posts, to drive the point home."[5] LOB

1. Nancy Odessky Acord, "Yvonne Cole Meo," in *Gumbo Ya Ya: Anthology of Contemporary African-American Women Artists*, ed. Lesley King-Hammond (New York: Midmarch Arts, 1995), 168.
2. Ibid.
3. Yvonne Cole Meo, quoted in announcement for *Yvonne Cole Meo*, Gallery 32, Los Angeles, July 1970, archive of Suzanne Jackson, Savannah, GA.
4. Molly Barnes, "Yvonne Cole Meo at Le Dilettante," *Artforum* 4, no. 3 (November 1965): 34.
5. Ibid.

8. *Status Quo*, ca. 1965
Mixed media on medium-density fiberboard, in original found frame
Overall 37 × 43 × 3 in. (94 × 109.2 × 7.6 cm)

Miriam Schapiro

Toronto 1923–2015 Hampton Bays, New York

Productive as a painter, sculptor, printmaker, and educator over a six-decade career, Miriam Schapiro was a foundational figure in feminist art practice. Of Russian Jewish extraction, she grew up in Brooklyn (her father, Theodore Schapiro, who had trained as an artist, worked as an industrial designer and served as the director of the Socialist Party's Rand School of Social Science). After receiving a BA and two master's degrees from the University of Iowa, Schapiro moved back to New York City. She began her career as an Abstract Expressionist in the male-dominated New York School and, in 1958, was the first woman to have a solo exhibition at the prestigious André Emmerich Gallery.

A dramatic shift coincided with Schapiro's move westward in 1967, when she took up a teaching position at the University of California, San Diego. Inspired by the coastal landscape, modern architecture, and dazzling light, she began producing hard-edge paintings; presciently, she collaborated with computer programmers at UCSD to develop a system through which she could digitally manipulate geometric drawings. In the late 1960s, Schapiro introduced the stylized vaginal forms—or "central core imagery," as she termed them—that characterize her earliest overtly feminist works. The artist joined the faculty of the California Institute of the Arts (CalArts) in Los Angeles in 1970. Following an encounter at Fresno State College, Schapiro and Judy Chicago (see pl. 30) decided to move the latter's Feminist Art Program, created to diversify artistic practice with new forms of expression based on women's experience, from Fresno to CalArts. The culmination of the program in 1972 was the landmark exhibition *Womanhouse*, a collaborative installation in a dilapidated LA mansion.

Profoundly influenced by the women's movement throughout the 1970s, Schapiro began to incorporate collage into her work. Borrowing decorative conventions from traditional processes such as appliqué, sewing, and quilting, she produced a body of assemblages that combine acrylic paint with scraps of fabric and ribbon as well as examples of handicraft produced by anonymous women, such as handkerchiefs and lace doilies. Schapiro used the term "femmage"—a portmanteau of "female" and "collage" invented by the artist and another abstract painter, Melissa Meyer (born 1947)—to describe centuries-old craft techniques practiced by women that often depended on the ingenious reuse and reassembly of various materials.[1] Seeking to counter the historical dismissal of these practices as inferior and instead validate a multigenerational history

of women's creativity, Schapiro remarked in 1977, "I wanted to explore and express a part of my life which I had always dismissed—my homemaking, my nesting. I wanted to validate the traditional activities of women, to connect myself to the unknown women artists who made quilts, who had done the invisible 'women's work' of civilization."[2]

Schapiro's interest in using decorative materials to question the hierarchy of "high" and "low" art was shared by a like-minded group of artists, and in the mid-1970s, she was among the founders of the Pattern and Decoration movement (P&D, as it was known). Defined by intricate patterning, a vibrant palette, and an investment in both Western and non-Western decorative arts, P&D represented a response to the dominant doctrines of Minimalism and conceptualism—a move "towards an art of opulence," as Schapiro described it.[3] The deliberately ambitious scale of much of the work—a direct undermining of the supposedly trivial nature of the decorative—was as important as its focus on visual pleasure.

Deeply committed to feminism, Schapiro lectured on art and politics throughout the 1970s and 1980s. Alongside her "femmages," which took the form of cabinets, hearts, houses, aprons, and so on, two important motifs of japonaiserie—the kimono and the fan—recur in her work of this period. A monumental, semicircular canvas in the shape of an open fan, *Double Rose* is intricately and colorfully patterned. While fans are typically associated with women across cultures and time periods and connote a certain flirtatious frivolousness, Schapiro transformed the shape into a feminist icon. Elevating it as a "heroic form," she considered it "an appropriate symbol for all my feeling and experiences about the women's movement."[4] HJ

1. For the first use of the term, see Melissa Meyer and Miriam Schapiro, "Waste Not, Want Not: An Inquiry into What Women Saved and Assembled; Femmage," *Heresies* 1, no. 4 (Winter 1977–78): 66–69.
2. Miriam Schapiro, quoted in Tracey R. Bashkoff, *Miriam Schapiro: The Politics of the Decorative*, ed. Christina M. Strassfield, exh. cat. (East Hampton, NY: Guild Hall Museum, 1992), 6.
3. Miriam Schapiro, quoted in Elissa Auther, "Miriam Schapiro and the Politics of the Decorative," in *With Pleasure: Pattern and Decoration in American Art, 1972–1985*, ed. Anna Katz, exh. cat. (Los Angeles: The Museum of Contemporary Art; New Haven, CT: Yale University Press, 2019), 81.
4. Miriam Schapiro, interview by Ruth A. Appelhof, in *Miriam Schapiro: A Retrospective, 1953–1980*, ed. Thalia Gouma-Peterson (Wooster, OH: College of Wooster, 1980), 46, quoted in Bashkoff, *Schapiro: Politics of the Decorative*, 10.

9. *Double Rose*, 1978
Acrylic and fabric on canvas
47¾ × 96 in. (121.3 × 243.8 cm)

Joan Mitchell

Chicago 1925–1992 Neuilly-sur-Seine, France

Joan Mitchell is widely recognized as one of the preeminent abstract painters of the postwar period. Trained at the School of the Art Institute of Chicago, she rose to fame in the early 1950s as a key member of the younger generation of Abstract Expressionists.

Following her graduation in 1947, Mitchell was awarded a travel fellowship, which took her to France for a year. In 1949, she moved to Manhattan, where she became an active member of the New York School of painters and poets. The work of Willem de Kooning was instrumental, and she later recounted having been overwhelmed by that of Franz Kline, which left her feeling "out of my mind."[1] In May 1951, Mitchell's work was included in the landmark *Ninth Street Exhibition of Paintings and Sculpture*. Organized by the Artists' Club (also known as the "8th Street Club" or simply "the Club")—the New York School's meeting place and center of debate since 1949—the show heralded the public arrival of the Abstract Expressionist movement. Mitchell would later become one of the Club's very few women members. Despite this circle of supporters, Mitchell began dividing her time between Paris and New York in 1955, before moving permanently to France in 1959. In 1968, she settled in Vétheuil, a village near Claude Monet's former estate in Giverny, where she remained until her death.

Throughout the 1950s, Mitchell developed her characteristic style: rhythmic, gestural lines and layers of color applied to large canvases with turpentine-thinned paint. Speaking in 1986 of her approach, Mitchell said, "Abstract is not a style, I simply want to make a surface work."[2] Though seemingly unrestrained, the artist's process was, in fact, quite structured. She worked methodically, assessing paintings from a distance between brushstrokes—climbing down from a ladder if she was using one, as she did for her larger canvases. While Kline and de Kooning were major influences, the foundations of her technique had been laid during her time at the Art Institute of Chicago, where she reveled in the paintings of Vincent van

Gogh, Henri Matisse, Paul Cézanne, and Vasily Kandinsky. From them, she gleaned a distinctive approach to color and light that remained with her throughout her career.

Mitchell derived great joy from her gardens at Vétheuil, and her arrival there in the late 1960s coincided with the emergence of sunflowers in her work. As she remarked, "Sunflowers are something I feel very intensely. They look so wonderful when young, and they are so very moving when they are dying. I don't like fields of sunflowers. I like them alone, or, of course, painted by van Gogh."[3] She returned to the motif, in the form of explosions of yellow and orange paint, periodically throughout her life. *Untitled*—one of her final diptychs—contains pared-down versions of the same sunflower form.

In her later years, Mitchell painted with renewed intensity, continuing to work on a grandiose scale in spite of illness. First exhibited at New York's Robert Miller Gallery in 1993, *Untitled* is representative of the steely determination of her concluding efforts, combining two monumental, swirling balls of golden yellow with strokes of green, red, black, and blue that surge among them. The artist applied each mark with her signature confidence, while drips of excess paint stand as a testament to the unrelenting ambition and physicality of her painting process. Seeming to synthesize a lifetime of artistic influences and technical mastery, *Untitled* foregrounds the artist's priorities at the end of her life. As she had said in 1974, "My paintings aren't about art issues, they're about a feeling."[4]

HJ

1. Joan Mitchell, interview by Linda Nochlin, Archives of American Art, Washington, DC (website), April 6, 1986, https://www.aaa.si.edu/collections/interviews/oral-history-interview-joan-mitchell-12183.
2. Joan Mitchell, interview by Yves Michaud, in *Joan Mitchell: New Paintings*, exh. cat. (New York: Xavier Fourcade Gallery, 1986), n.p.
3. Ibid.
4. Joan Mitchell, quoted in Marcia Tucker, *Joan Mitchell*, exh. cat. (New York: Whitney Museum of American Art, 1974), 6.

10. *Untitled*, 1992
Oil on canvas
9 ft. 2¼ in. × 11 ft. 10 in. (280 × 360.1 cm)

Kay Sekimachi

Born San Francisco 1926

The Berkeley, California–based American fiber artist Kay Sekimachi is perhaps best known for her otherworldly woven hangings in nylon monofilament, which she began creating on a twelve-harness loom in the 1960s. Sekimachi was born in San Francisco to first-generation Japanese Americans and, from 1942 to 1944, was interned with her family at Tanforan Assembly Center in the Bay Area and then at Topaz War Relocation Center in Utah. From 1946 to 1949, she attended California College of Arts and Crafts, or CCAC (now California College of the Arts), where she studied painting, design, and silkscreening. In the summer of 1954, Sekimachi returned to CCAC to study with the German-born American textile artist, designer, and educator Trude Guermonprez (see pl. 3). Guermonprez challenged Sekimachi to expand her repertoire, which led to her mastering more complex techniques, including double-weave. In 1956, Sekimachi attended Haystack Mountain School of Crafts in Liberty, Maine, where she studied with the American textile designer Jack Lenor Larsen (1927–2020).[1] A staunch champion of her work, Larsen commissioned Sekimachi to design a fabric for his production company.

Sekimachi first received samples of nylon monofilament in 1956 from a fellow artist whose mother worked for the DuPont chemical company. Typically used as fishing line, monofilament is a firm, synthetic fiber that holds a wider variety of shapes more successfully than natural, spun strands, and Sekimachi found it perfectly suited to her pursuit of organic abstraction. Made of clear monofilament but effectively milky white, the works in the *Amiyose* series, which takes its title from the Japanese word for "multilayered," were formed from multiple woven layers curled into flowing columns. To create them, the artist wove monofilament into flat sheets, which she unfurled off the loom and twisted into spontaneous volumes, producing what she calls the work's "inner core."[2] Next, she added woven strips that spiral around the central spine; finally, she threaded a single piece of monofilament through the work to create a vertical axis. Later, the artist noted the "excitement" she had felt when she "was able to open up the multi-layered cloth by hanging it from the ceiling and have the weaving exposed because of the stiffness and translucency of the monofilament."[3]

Sekimachi's complex, three-dimensional nylon hangings were featured in several of the major exhibitions of the fiber art movement, including *Wall Hangings*, curated by Mildred Constantine and Jack Lenor Larsen for the Museum of Modern Art, New York, in 1969; *Deliberate Entanglements*, presented at the UCLA Art Galleries in 1971; and the 1975 and 1983 editions of the Biennale Internationale de la Tapisserie, held in Lausanne, Switzerland. In the landmark book *Beyond Craft: The Art Fabric*, Constantine and Larsen wrote of her work, "Kay Sekimachi is very much the product of California's Nisei subculture and the intellectual-creative climate of the Bay Area. Like [Ed] Rossbach, Guermonprez, and [Ruth] Asawa, she has developed her own style, without precedent and without successors. Her persistent research in a single technique and her faithfulness to one wiry material bring her closest to San Francisco pioneer Ruth Asawa. With her, too, she shares the use of an organic symmetry and soil-resisting monofilament."[4]

In 2014–15, San Diego's Mingei International Museum presented Sekimachi's work, along with that of her late husband, the self-taught woodturner Bob Stocksdale (1913–2003), in the exhibition *In the Realm of Nature*. There, Sekimachi showed several examples of a recent series of "leaf bowl" sculptures. To make these ethereal objects, she obtained actual leaves from bigleaf maples that had already been processed down to the veins, then used those "skeletons" in conjunction with kōzo paper (Japanese mulberry paper) to form bowls. These pieces were preceded by the simpler paper bowls she started making in the early 1990s to expand her sculpting technique without using a loom. Sekimachi often employed Stocksdale's bowls as forms for her paper sculptures; she preferred Japanese paper for its variety of textures and inclusions, but sometimes she would wrap the pieces in thread for additional visual interest. Wonderfully, she also used hornets' nests to make her bowls. From the natural to the human-made, from low to high tech, the artist certainly moved beyond a "single technique" and "faithfulness to one wiry material." Indeed, Sekimachi's art has never been just one thing. LOB

1. The school relocated to Deer Isle, Maine, in 1961.
2. Sarah Parrish, "Kay Sekimachi," in *Fiber: Sculpture, 1960–Present*, ed. Jenelle Porter, exh. cat. (Munich: DelMonico Books/Prestel; Boston: Institute of Contemporary Art, 2014), 224.
3. Kay Sekimachi, quoted in Yoshiko Wada, "Contemplative Geometry: Kay Sekimachi's Poetic Expressions in the Essential Language of Line, Surface, and Dimensional Form," in *Kay Sekimachi*, by Yoshiko Wada, Signe Mayfield, and Kenneth R. Trapp, Portfolio Collection 20, ed. Matthew Koumis (Brighton, UK: Telos Art Publishing, 2003), 20.
4. Mildred Constantine and Jack Lenor Larsen, *Beyond Craft: The Art Fabric* (New York: Van Nostrand Reinhold, 1972), 258.

11. *Amiyose*, 1965
Nylon monofilament
66 × 12 × 12 in. (167.6 × 30.5 × 30.5 cm)

Jo Baer

Born Seattle 1929

Jo Baer counts among the foremost proponents of Minimalism working in New York in the 1960s and early 1970s and is one of the few painters who participated in the movement. Ever since that time, she has remained steadfastly committed to her medium. When the sculptor Robert Morris launched an attack on what he termed the "antique" art of painting in *Artforum* in the summer of 1967, Baer responded in quick-witted defense in the next issue. Referring both to Morris and to Donald Judd—who had articulated similar thoughts in his 1965 essay "Specific Objects"[1]—her letter blasted, "An 'inescapable' delusion moves the above critics. It is objectionable."[2] Working with geometric forms and a radically flattened picture plane, Baer promoted a progressive redefinition of painting, fueled by an interest in perceptual science. Drawing on her study of behavioral psychology at New York's New School for Social Research, the artist wrote at length about different theories of light and color, including those of the Austrian physicist and philosopher Ernst Mach (1838–1916). Speaking of the fundamental importance of light in her work, Baer has said, "A mechanical line is dead. A hand-painted line is kept alive by light. Light jumps off every wiggle, every slight irregularity."[3]

While her work of the mid-1960s confined itself to the face of the canvas, by 1969 Baer had turned her attention to the edges: "I was interested in seeing what happens when you go around a corner. . . . Things change quite radically in all kinds of ways when you go around a corner."[4] In 1970, she began producing her "radiator" paintings, so called on account of their proportions and the way they are installed, just above the floor. Four inches deep, the canvases are painted on both their fronts and their sides. Likely exhibited at Galerie Rolf Ricke in Cologne as part of Baer's solo exhibition there in 1970, *V. Speculum* is the first vertical painting in the series.

Seen from the front, *V. Speculum* features two truncated triangles against a cream background: one, colored gray, extends downward, and a second, black and trimmed with green, extends upward. As the viewer might expect from the artist's interest in perceptual science, however, the painting is full of trickery. By positioning the shapes at the edges of the canvas, the artist has encouraged viewers to peer to the side. When they do so, the painted flank comes into view, transforming what had been visible as a triangle, face on, into a rectangle. Shadows caused by the depth of the stretcher are cast onto the adjacent wall and mimicked by

paint. Real shadows and painted "shadows" conflate, while seemingly vertical lines are revealed, on closer inspection, to be subtly curved. Colors alter slightly when the painting is viewed from different angles, making it hard to distinguish whether it is a change in the lighting conditions or in the shade of paint that is at play. Baer describes her work of the period as having been engaged with the "dialectic of the object versus sleight-of-hand. . . . There can be," she insists, "no mark within a painting's format which does not deceive."[5]

In 1970, Baer began titling many of her paintings with botanical Latin names. An avid collector of orchids, she joined both the American Orchid Society and the Greater New York Orchid Society, contributed articles to their bulletins, and cultivated prizewinning plants. The title of each of the "radiator" paintings includes a Latin word alongside the letter H or V, denoting its horizontal or vertical orientation. Incorporating the Latin word for "mirror," the title *V. Speculum* suggests the mirroring of shapes on the painting's edges.

Soon after her landmark midcareer exhibition at the Whitney Museum of American Art in 1975, Baer left New York for rural Ireland. Striving for "more meaning" and "more content," she denounced what she deemed to be the increasingly decorative nature of abstraction and began working in a style she referred to as "radical figuration."[6] Combining depictions of bodies and body parts, animals, and objects, these works often draw upon imagery from ancient civilizations and archetypal symbols of the feminine. Speaking of the shift in her work, she has said, "The world had changed and the work needed to change too."[7] HJ

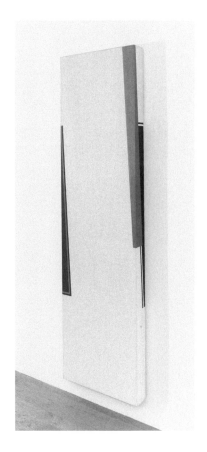

1. "Specific Objects" was first published in *Arts Yearbook*, no. 8 (1965). *Arts Yearbook* was an annual publication of *Arts Magazine*; each issue had an individual title, and the 1965 title was "Contemporary Sculpture."
2. Jo Baer, letter to the editor, *Artforum* 6, no. 1 (September 1967): 6.
3. Jo Baer, "Jo Baer Interviewed by Mark Godfrey, 2004," in *Jo Baer: Broadsides and Belles Lettres; Selected Writings and Interviews, 1965–2010*, ed. Roel Arkesteijn (Amsterdam: Roma, 2010), 28.
4. Ibid., 35.
5. Jo Baer, quoted in *The Tate Gallery 1980–82: Illustrated Catalogue of Acquisitions* (London: Tate Gallery, 1984), republished in catalogue entry for *Stations of the Spectrum (Primary)* (1967–69), Tate (website), accessed September 9, 2021, https://www.tate.org.uk/art/artworks/baer-stations-of-the-spectrum-primary-t03110.
6. Baer, "Baer Interviewed by Godfrey," 34.
7. Ibid.

12. *V. Speculum*, 1970
Oil on canvas
80 × 22 × 4 in. (203.2 × 55.9 × 10.2 cm)

Deborah Remington

Haddonfield, New Jersey, 1930–2010 Moorestown, New Jersey

Dorset was first shown at Bykert Gallery in New York in 1972. The exhibition of new works by the American artist Deborah Remington marked her third solo show with the gallery, after her debut presentation there in 1966—notable also for being her first one-person exhibition in New York. Her fourth, and final, show at the prestigious venue was held in 1974, prior to its closure the following year. Remington's affiliation with Bykert, which was known for promoting a lauded group of emerging artists, including Brice Marden and Dorothea Rockburne, corresponded with a major transition in her practice that is epitomized by *Dorset*.

Prior to her relocation to New York from San Francisco in 1965, Remington had produced a body of work that comprised, in the artist's own words, "more or less abstract expressionist paintings."[1] These gestural compositions emerged in the early 1950s while she was a student at the California School of Fine Arts (later San Francisco Art Institute), where she was taught by the influential abstract painter Clyfford Still (1904–1980) as well as David Park (1911–1960) and Elmer Bischoff (1916–1991), adherents of the Bay Area Figuration movement. (In 1954, Remington cofounded Six Gallery, haunt of the Beat poets and site of Allen Ginsberg's first recitation of "Howl.") By the beginning of the next decade, the artist had started to refine her visual language, reducing her forms and limiting her color palette. She attained success with the resulting paintings, receiving three solo shows at San Francisco's Dilexi Gallery between 1962 and 1965 as well as an exhibition at the San Francisco Museum of Art (now SFMOMA) in 1964.

After she moved to New York, Remington's hard-edge abstraction became fully fledged. Her paintings emphasized the relationship between figure and ground through central graphic forms reminiscent of mirrors, automobile parts, or blank screens, which appeared to float in space. She positioned these tonally varied shapes at the center of her paintings, and around them seemed to glow an infinite void. The artist's sleek, futuristic aesthetic favored illusion, so although "the work at times seems to refer to something in reality," Remington explained, "the reference is denied."[2] Underlining her interest in producing a nonobjective image, the artist once said of these enigmatic works, "While I do not completely understand the sources of this imagery, my work contains elements, which by simultaneously attracting and repelling one another, create a tense balance which has emotional and spiritual meaning for me."[3]

Dorset is at the apex of the crystalline images Remington had made by this point, whose qualities she would continue to develop throughout the 1970s, before again adopting a more gestural mode. A crisp oval forms the centerpiece of the composition, around which irregular shapes are rendered in what had by now become the artist's signature hues: black, blue, and red. This stripped-down tonal range alludes to the artist's training in calligraphy, which she had pursued for nearly three years while traveling in Japan and Southeast Asia in the 1950s. A formative experience, studying this art form also taught her how to envisage the principal image within a painting or drawing: for Remington, the fact that each character in the Japanese writing system was "one tiny little picture" conveyed the possibilities of an isolated image.[4]

The extreme flatness of the picture plane—another hallmark of Remington's work—is indicative of her continued efforts to eradicate any evidence of her own hand. The artist was determined to generate the smoothest possible surface. Working on *Dorset* over the course of almost a year, she applied thin glazes of oil paint in two or more stages, with prolonged periods of drying time in between. Months later, Remington varnished the surface. The fine outlines seen throughout the composition were achieved through hand-drawn lines that she covered in tape during the painting process to reach the level of precision that she desired.

Although the artist maintained that her paintings made no reference to real life, her radical approach of applying principles of realism within a carefully modulated abstract framework resulted in works in which the virtual and physical worlds, the organic and the machinelike, appear to overlap.

AB

1. Deborah Remington, quoted in Rachel Churner, "Deborah Remington: Five Decades," exh. brochure, Bortolami Gallery, New York (website), exh. on view May 1–June 12, 2021, accessed August 15, 2022, https://bortolamigallery.com /wp-content/uploads/2021/04/Churner_Remington _essay.pdf.
2. Deborah Remington, "Artist Statement," Deborah Remington Charitable Trust for the Visual Arts, New York (website), accessed August 15, 2022, https://deborah remington.com/artist-works/.
3. Deborah Remington, artist's statement, in *Art '65: Lesser Known and Unknown Painters; Young American Sculpture— East to West*, exh. cat. (New York: Star Press, 1965), n.p., quoted in Lilly Wei, "Drawing It Out," in *Deborah Remington: A Life in Drawing*, by John Mendelsohn and Lilly Wei (New York: Deborah Remington Charitable Trust for the Visual Arts, 2016), 23.
4. Deborah Remington, interview by Paul Cummings, Archives of American Art, Smithsonian Institution, Washington, DC, May 29–July 19, 1973, quoted in John Mendelsohn, "Deborah Remington: A Life in Drawing," in Mendelsohn and Wei, *Remington: A Life in Drawing*, 17.

13. *Dorset*, 1972
Oil on canvas
91 × 87 in. (231.1 × 221 cm)

Faith Ringgold

Born New York City 1930

As an artist, activist, teacher, and award-winning children's book author, Faith Ringgold has explored gender and racial inequality in a career spanning over five decades. She is best known for her story quilts, which combine narratives drawn from her own experiences as an African American woman with politics and social history to "tell my story, or, more to the point, my side of the story."[1]

Born in Harlem in 1930, Ringgold was raised amid the creative stimuli of the Harlem Renaissance. The artists Aaron Douglas, Romare Bearden, and Jacob Lawrence all lived near the family home, as did the pianist Duke Ellington. While her asthma often kept her out of school, she was encouraged in her creativity by her mother, who taught her to sew, and her father, who purchased her first easel. In 1950, when Ringgold's ambitions to study art at the City College of New York were thwarted on account of her gender, she enrolled in the college's School of Education instead. Thus circumventing prejudice, she graduated with undergraduate and graduate degrees in visual art in 1955 and 1959, respectively. Her lively Harlem neighborhood provided an essential counterpoint to the school's narrowly Eurocentric curriculum: "I had all these African American artists living around me—I didn't have to go anywhere to study them, I just had to open my eyes and recognise who they were."[2]

Ringgold's first major body of work was the *American People* series (1963–67), a group of politically charged oil paintings highlighting the stark racial tensions and inequalities that characterized American society during the civil rights era. Executed in a graphic style, they were, the artist has explained, illustrations of "what it was like living in America at the time."[3] By 1970, Ringgold had become actively involved in a number of feminist groups. Accompanied by her daughters Michele and Barbara Wallace, she organized protests outside New York museums in demand of gender and racial equality, designed political posters, and co-organized *People's Flag Show* at Judson Memorial Church in Greenwich Village, for which she was arrested on charges of desecrating the U.S. flag.

In 1972, Ringgold encountered a gallery of fifteenth-century Tibetan and Nepalese *thangka* paintings while visiting the Rijksmuseum in Amsterdam. Offering a solution to her ongoing difficulties with storing and transporting large canvases, the *thangka* format was lightweight and—designed to be rolled up when not displayed—infinitely mobile. Later that year, Ringgold made her first two sets of *thangkas*, the *Feminist* and *Slave Rape* series, both of which incorporated elaborate cloth frames made by her mother, the fashion designer Willi Posey (1903–1981). Ringgold's third set of *thangkas*—a group of twenty made in 1974—was the *Window of the Wedding* series, to which these two works belong.

Featuring borders fabricated by Posey, the paintings are characterized by vivid abstract patterning inspired by Kuba textiles. Originating in what is now the Democratic Republic of the Congo, these fabrics were introduced to the United States via Christian missionaries in the early twentieth century. With titles that refer to "small talk," "patience and responsibility," and "family"—alongside "man" and "woman," seen here—the works in the series imagine the foundational components of a marriage. They were also used as backdrops for soft sculptures depicting couples that Ringgold made around the same time.

In 1980—faced with resistance in her efforts to publish an autobiography—Ringgold started to contemplate other ways to tell her and her family's story. "I thought," she recalled, "how can I get published and get my words out there? The way to do it is to write it on my art. Nobody can stop me from doing that."[4] Again working in collaboration with her mother, she developed her iconic story quilts, which combine textual accounts of childhood memories and stories of Black life—physically inscribed onto the surface with a felt-tip marker—with images rendered in acrylic paint and traditional pieced-fabric borders (see p. 135 for an example, *Tar Beach*). While some of the quilts celebrate Harlem's joyous buzz, the fabrication technique also links each one to a deeply personal history of racial terror: that of Ringgold's maternal grandmother and great-grandmother, who were both born into slavery in Jacksonville, Florida, and who quilted for plantation owners.　　　HJ

1. Faith Ringgold, *We Flew over the Bridge: The Memoirs of Faith Ringgold* (Durham, NC: Duke University Press, 2005), ix.
2. Faith Ringgold, interview by Hans Ulrich Obrist, in *Faith Ringgold: "Raise Your Voice. Unite. Tell Your Story,"* ed. Melissa Blanchflower and Natalia Grabowska, exh. cat. (London: Serpentine Gallery; Koenig, 2019), 32.
3. Ibid.
4. Ibid., 38.

14.

Window of the Wedding #3: Woman, 1974
Acrylic on canvas, with pieced-fabric border
83 × 39 in. (210.9 × 99 cm)

Window of the Wedding #4: Man, 1974
Acrylic on canvas, with pieced-fabric border
83⅝ × 36½ in. (212.4 × 92.7 cm)

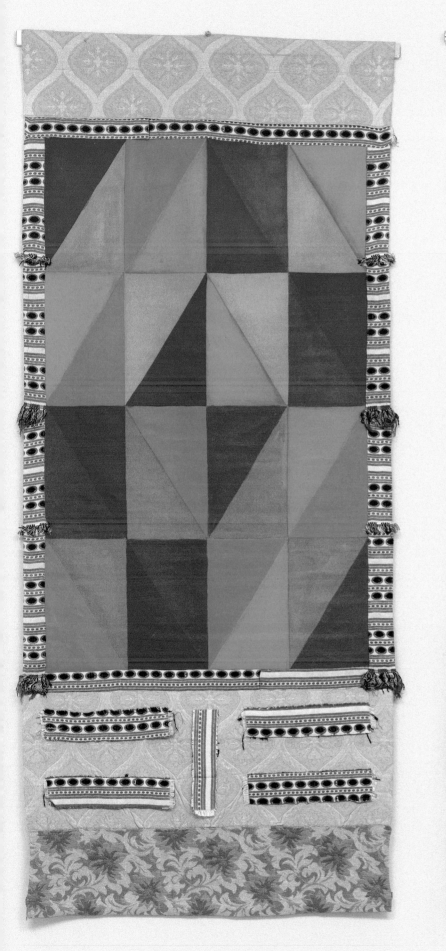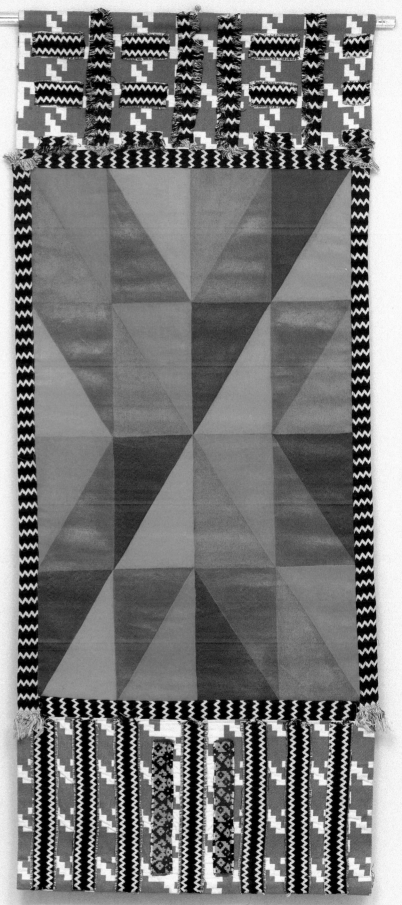

Helène Aylon

Brooklyn, New York, 1931–2020 New York City

Helène Greenfield was brought up in the ultra-Orthodox Jewish community of Borough Park, Brooklyn. At eighteen years old, she married a rabbi, but he died in 1961, leaving her a widow with two young children at the age of thirty. Two years later, she adopted the surname Aylon, a Hebraized version of her first name. The artist is renowned as a pioneer of process-based abstraction and, throughout her career, was guided by her acute feminist consciousness.

Aylon's artistic career began in 1958, when she secretly enrolled at Brooklyn College and took classes with the abstract artist Ad Reinhardt (1913–1967). Reinhardt, who would become an important friend and mentor to Aylon, facilitated for her an eye-opening studio visit with Mark Rothko. Pushed by Reinhardt to "go beyond traditional painting," she began a body of process-driven abstract paintings in the late 1960s, grouped under the title *Elusive Silver* (1969–73).[1] *First Coral* is part of this body of work.

First shown at New York's Max Hutchinson Gallery in 1970, works in the *Elusive Silver* series were produced by spray-painting layers of acrylic onto a piece of plexiglass backed by an aluminum sheet. Thanks to this technique and despite its vast size, *First Coral* has an ethereal quality, evocative of clouds of smoke. The appearance of the surface changes as the viewer moves: areas of shadow are transformed into glimmers of light as the shine of the aluminum backing peeps through gaps in the paint. Speaking later of the series, Aylon said, "I was still in my religious mode looking for an invisible presence, a mystical female presence. Silver paintings were changeable but they were elusive—they only change with the position of the viewer."[2]

When the artist left New York for the San Francisco Bay area in 1973, she began to explore notions of flux in different ways. As well as earning an MFA from San Francisco State University, she enrolled in women's studies classes at Antioch College/West, where reading feminist philosophers and writers such as Susan Griffin revolutionized her outlook. It was in this same year that she began using linseed oil in her practice, producing a series entitled *Paintings That Change in Time* (1973–76), to which another work in the Shah Garg Collection, *Slowly Drawing* (see fig. 4 on p. 46), belongs. This body of work was first shown in 1975 in two concurrent exhibitions, held at Betty Parsons Gallery and Susan Caldwell Gallery in New York.

To produce the paintings, Aylon layered brown paper over a nonporous Masonite base. She then poured linseed oil onto the paper in quantities varying from a trickle to a large puddle. As the title of the series suggests, changes *do* occur in the works over time. As the oil seeps naturally into the paper over a period of months and years, the surface becomes darker, shapes move, and marks and lines appear. Commenting on her intentions, Aylon said, "I wanted the paintings to actually change like the earth changes, like we change, like everything does change."[3] While her material expertise gave her an indication of how the patterns might unfold, the results were largely determined by chance. Each work assumed a life of its own, in a process that is continual and unending. Understood by the artist herself as deeply indebted to her social principles—the series was "about process rather than completion, which I think of as feminist"—*Paintings That Change in Time* bears witness to an uncontrollable process of change, reflecting Aylon's increasing concern for the environment.[4] By the 1980s, the artist had abandoned her studio practice to focus on antinuclear activism. HJ

1. Helène Aylon, *Whatever Is Contained Must Be Released: My Jewish Orthodox Girlhood, My Life as a Feminist Artist* (New York: Feminist Press at the City University of New York, 2012), 49.
2. Helène Aylon, interview by Monika Fabijanska, *Brooklyn Rail*, March 2019, https://brooklynrail.org/2019/03/criticspage/Helne-Aylon-with-Monika-Fabijanska.
3. Ibid.
4. Aylon, *Whatever Is Contained*, 68.

15. *First Coral*, 1970
Acrylic and plexiglass on aluminum
48¼ × 96¼ in. (122.6 × 244.5 cm)

Freedom Quilting Bee

Active Alberta, Alabama, 1966–2012

The Freedom Quilting Bee was a quilting cooperative based in the community of Alberta, Alabama, thirty miles from Selma, in Wilcox County. The collective, born during the civil rights movement, is recognized for having prompted a nationwide quilting revival. It belongs to a long history of alternative, communal economic work performed by Black Americans. In recent years, the Bee has often been confused with the Gee's Bend quilters' collective, from the nearby community of Boykin (formerly Gee's Bend; see pls. 21, 45).[1] Some participants in the Freedom Quilting Bee belonged to both groups, and many of the quilters were born in and around Gee's Bend and Rehoboth, a town on the way from Gee's Bend to Alberta (moreover, the names of the towns are often used interchangeably).

The members of the Bee began selling their quilts at the suggestion of Father Francis X. Walter, an Alabama-born Episcopal priest who had returned to the area as part of the Selma Inter-religious Project, a coalition of ten religious denominations serving as a spiritual presence after the protest marches from Selma to Montgomery in 1965. Walter noticed Op art–like themes in the patterns on the quilts and believed that local quilters could benefit from forming a coalition and selling their wares in New York and elsewhere.

The Bee quilts were typically stitched from scraps of cloth according to patterns—such as "Roman Cross," "Pine Burr," and "Chestnut Bud"—that were reflective of the history of Black quilting in the area. Quilters usually learned the craft from a mother or grandmother. After the Bee's first auction in a photography studio off Central Park West in 1966, the quilts gained critical acclaim and popularity, prompting the artists to organize the official quilting cooperative. The group counted sixty members from across the so-called Black Belt, with a nucleus in Alberta, the home of Estelle Witherspoon (1916–1998), a skilled founding member and politically savvy community leader.

Additional auctions in New York stirred more momentum, and the quilts were sold for ten to one hundred dollars and upward. The famed decorator Dorothy "Sister" Parrish purchased quilts from the cooperative for her clients' homes, and Diana Vreeland, editor of *Vogue*, promoted the "patchwork look" in the influential fashion magazine, showing specific examples attributed to the Bee. Department stores, including Bloomingdale's and Saks Fifth Avenue, bought quilts for resale, and the *New York Times* covered the cooperative.[2] The "Coat of Many Colors," or "Joseph's Coat," pattern was named for the biblical story of Joseph and was popular with New York patrons of the Freedom Quilting Bee.[3]

In the 1970s, the collective decided to limit the number of patterns it produced to meet market requirements. The quilters no longer crafted bespoke, one-of-a-kind showpieces, and this change drew some criticism. But members were committed to raising the economic standards in their families and communities. In its busiest period, the collective produced five thousand corduroy pillow shams a month for Sears, Roebuck.[4] The group also produced its own interpretation of the traditional African dashiki, a popular garment at the time, especially with advocates of Black liberation. Such items, which were sold in large numbers to clients across the United States—from Washington, DC, to Berkeley, California—further showcase the sophistication and creativity of the Freedom Quilting Bee.

Membership in the Bee dwindled in the 1990s. Then, in September 2004, Hurricane Ivan damaged the Bee's workplace since 1969, the Martin Luther King Jr. Memorial Sewing Center, causing the handful of remaining quilters to convene in the living room of the Bee's then manager. In 2012, a year after the last original board member died, the Bee officially closed. In June 2021, the Freedom Quilting Bee Legacy, a nonprofit in Alberta, Alabama, received a $250,000 grant from the Souls Grown Deep Foundation and Community Partnership to build a museum honoring the legacy of the historical quilting collective.[5] LOB

1. Nancy Callahan, "Freedom Quilting Bee," in *Encyclopedia of Alabama*, August 8, 2008, updated September 9, 2020, http://www.encyclopediaofalabama.org/article/h-1628. Rehoboth is another small community associated with Gee's Bend and Alberta and with the quilting traditions of central Alabama.
2. Rita Reif, "The Freedom Quilting Bee: A Cooperative Step Out of Poverty," *New York Times*, July 9, 1968, https://www.nytimes.com/1968/07/09/archives/the-freedom-quilting-bee-a-cooperative-step-out-of-poverty.html.
3. Nancy Callahan, *The Freedom Quilting Bee: Folk Art and the Civil Rights Movement* (Tuscaloosa: University of Alabama Press, 1987), 116.
4. "History," Freedom Quilting Bee Legacy (website), accessed July 25, 2022, https://freedomquilting.com/history.
5. "Souls Funds Freedom Quilting Bee Legacy Efforts to Renovate Historic Building in Alberta, AL," press release, Souls Grown Deep Foundation, Atlanta (website), June 16, 2021, https://www.soulsgrowndeep.org/souls-grown-deep-funds-freedom-quilting-bee-legacy-efforts-renovate-historic-building-alberta-al.

16. Quilt in "Joseph's Coat" Variation,
ca. late 1960s
Cotton
8 ft. 11 in. × 6 ft. 1½ in. (271.8 × 186.7 cm)

Piecers: Lucy Mingo (born 1931),
Nell Hall Williams (1933–2021)

Quilters: Ella Mae Irby (1923–2001),
Doll James (born 1941), Sam Square (1945–1997)

Olga de Amaral

Born Bogotá, Colombia, 1932

Emerging during the height of the fiber art movement in the mid-1960s, Olga de Amaral developed a facility for off-loom constructions. She began her training in architectural drafting before enrolling in a textiles course at Cranbrook Academy of Art, the center for modernist design outside Detroit, in 1954. Under the leadership of the Finnish designer Marianne Strengell (1909–1998), Cranbrook's program focused on the production of textiles for architecture and industry. Amaral continued to work in this vein on her return home to Colombia in 1955, setting up with her husband and fellow Cranbrook graduate, the sculptor Jim Amaral (born 1933), a studio that fabricated upholstery fabrics, rugs, and clothing.

Encouraged by the fiber artist Lillian Elliott (1930–1994), also a Cranbrook alumna, during a trip to San Francisco in 1964, Amaral stepped away from commercial activity and began to create unique tapestries, experimenting with traditional and custom-made looms as well as with freehand techniques of wrapping and braiding. By the following year, she had developed an innovative body of *entrelazados* (interlaced forms), wall hangings with a split warp and interlocking, vertical, plain-weave bands, that gained her acceptance into exhibition circles. One such piece was displayed in the seminal 1969 exhibition *Wall Hangings* alongside works by twenty-seven international peers—all but four women—at the Museum of Modern Art, New York.[1]

By the time of her 1970 solo exhibition at New York's Museum of Contemporary Crafts (now Museum of Arts and Design), Amaral was plaiting prewoven strips and lengths of cord to produce what she termed *muros tejidos* (woven walls). As she explained, her technique generated texture and volume: "Weaving linen and cotton together creates the perfect surface: a clay-like cloth that is the basis of the strips that are, in turn, the cornerstone of my work. I have always thought about them as a way of making the thin, elemental thread much larger and more visible."[2] Amaral also produced works of this kind with other natural fibers, including wool and horsehair, as well as with sheets of plastic. As the scale of her work increased, her constructions moved away from the wall to be suspended from the ceiling or staged as interventions in the Colombian landscape.

The geometric quality of Amaral's early work ensured her importance as a key figure in the development of Latin American abstraction. The local context also had a profound impact on her practice, however, and her muted palette of the 1960s and 1970s evokes both the organic dyes used in vernacular art-making traditions and the "landscape of deep, dark-green vegetation" that surrounded her.[3] Indeed, Amaral considers the woven strips and other elements that make up her tapestries to be "words" with which she creates "landscapes of surfaces, textures, emotions, memories, meanings, and connections."[4]

In the early 1980s, Amaral began her *Alquimia* (Alchemy) series, to which *Alquimia Plata 6(B)*—a wall hanging constructed of more than one thousand individual rectangular tiles, woven from linen and arranged into vertical columns—belongs. To make the work, the artist secured each tile into place before applying gesso to smooth the surfaces, then topped that with acrylic paint and gold and silver leaf. The geometric configuration suggests an allusion to the tiled roofs of her hometown of Bogotá. While the value and sacred nature of gold in a number of pre-Columbian cultures is also a reference point, the artist attributes her adoption of the material to the British ceramist Lucie Rie (1902–1995), in whose studio she saw a broken vase being mended with gold according to the Japanese art of *kintsugi*. Amaral has insisted that she always remained centered on the formal challenge of "how I could turn textile into golden surfaces of light."[5]

In recent works—such as her *Brumas* (Mists) and *Nudos* (Knots) series—Amaral has adopted an increasingly experimental material approach as well as a dramatically intensified palette of reds, pinks, and blues. At times, she paints directly onto individual fibers with gesso and acrylic in order to "change the physical, three-dimensional traits of fiber itself" through the addition of color and weight.[6] Captivated by the perspectival possibilities of weaving—and the role of the moving viewer in co-creating them—she continues to produce sculptural objects that push the boundaries of traditional textile making. HJ

1. Mildred Constantine and Jack Lenor Larsen, *Wall Hangings*, exh. cat. (New York: The Museum of Modern Art, 1969), n.p. A scan of the full catalogue is linked from MoMA's website: https://www.moma.org/calendar/exhibitions/1800.
2. Olga de Amaral, "The House of My Imagination," in *Olga de Amaral: The Mantle of Memory*, by Matthew Drutt, Edward Lucie-Smith, Juan Carlos Moyano-Ortiz, et al., exh. cat. (Paris: Somogy Éditions d'Art, 2013), 208.
3. Ibid., 207.
4. Ibid., 208.
5. Ibid.
6. Ibid., 218.

17. *Alquimia Plata 6(B)*, 1995
Gesso, acrylic, silver leaf, and gold leaf on linen
45 × 71 in. (114.3 × 180.3 cm)

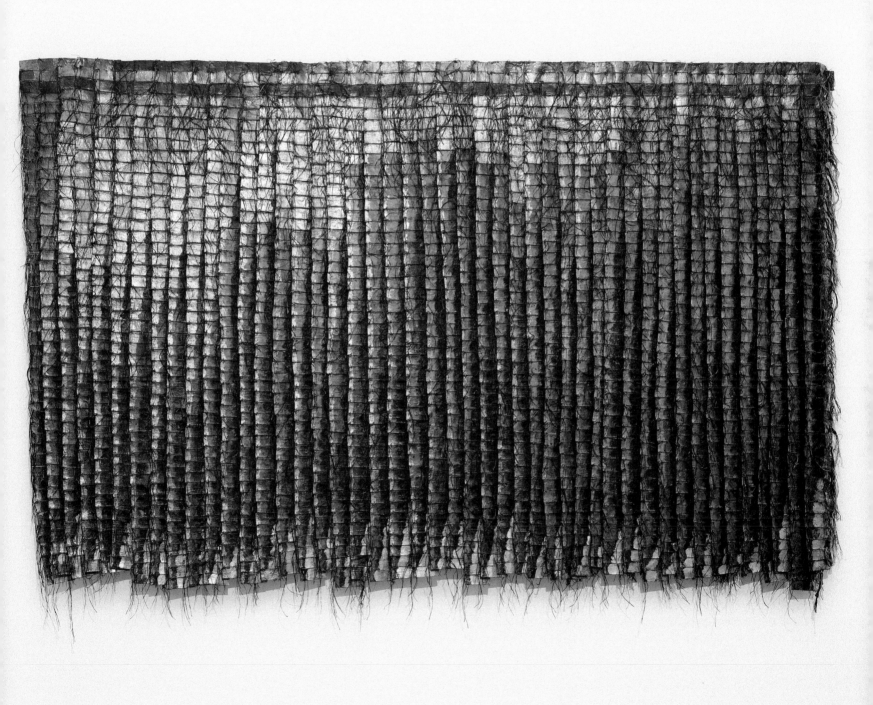

Joan Semmel

Born New York City 1932

Following her training at the Cooper Union for the Advancement of Science and Art in Manhattan and the Pratt Institute in Brooklyn, Joan Semmel began her career as an Abstract Expressionist in Spain, where she moved in 1963 with her then husband. On her return to New York in 1970, however, the burgeoning women's movement engendered a radical shift in her practice. As she later recalled, "My whole life changed. Feminism brought me back to the figure."[1] A staunch advocate of women's rights, Semmel began to attend meetings held by Women in the Arts (WIA) and the Ad Hoc Women Artist's Committee. It was through such organizations that she joined other artists who had also begun to picture women's bodies in their work, including Judy Chicago (see pl. 30), Miriam Schapiro (see pl. 9), Nancy Spero, and Louise Bourgeois. "Charged," as she has termed it, by her "then-emerging consciousness as a feminist," Semmel set about searching for "a plastic means with which to express personal and social concerns."[2]

Semmel's *Sex Paintings* and *Erotic Series* of the early 1970s were the artist's attempt to assert women's agency in response to the proliferation of sexist pornography. Reclaiming the nude for her own agenda and refusing both the romanticization and the taboos of sex in popular culture, she portrayed couples engaged in sexual activity as equal partners. In the mid-1970s, the artist turned to her own nude body as subject matter, alongside Hannah Wilke, Carolee Schneemann, and other artists who had likewise adopted this strategy as a way to subvert the male gaze. For these self-portraits, Semmel worked from collages of photocopied photographs she had taken of herself, using the camera "as a tool to locate and structure the image."[3] By holding the apparatus close to her face and looking down on her torso, she pictured herself in a reclining position. The resulting images—cropped at the neck and radically foreshortened, with flattened breasts—function as intimate representations of her own body as experienced by herself. Rather than mere self-representation, they

are an ideological exercise in liberating the nude from objectification. As the artist has recently explained, "I wanted the body to be seen as a woman experiences herself, rather than through the reflection of the mirror or male eyes."[4]

While Semmel's earlier canvases depicting sexual partners had been executed in vivid colors, the use of her own body in her work brought about a more naturalistic palette. Painted simultaneously in both styles, however, *Horizons* forms part of a series titled *Echoing Images*, which, in the artist's words, sought to "resolve the tension between abstraction and figuration."[5] In an exploration of the broad possibilities of representation, the same composition is repeated twice. At the bottom of the canvas, fine brushstrokes and sensitive shading depict details such as the texture of skin and minuscule hairs on the arm of the realistically depicted figure. The same nude—with knee crossed and heel held over the opposite thigh with a hand—is magnified and repeated at the top of the composition with intensely colored, gestural brushstrokes. Enlarged and closely cropped within the frame, the contours of the form begin to resemble the gradations of a landscape viewed from above. Speaking of the dynamic interplay between these realistic and expressionistic modes, Semmel describes the double figures as "almost like internal and external views of the self that combine a perceptual image with the ambition and striving of the emotive ego."[6]

HJ

1. Joan Semmel, quoted in *Exposures: Women and Their Art*, by Betty Ann Brown and Arlene Raven (Pasadena, CA: NewSage, 1989), 22.
2. Joan Semmel, quoted in Joan Marter, "Joan Semmel's Nudes: The Erotic Self and the Masquerade," *Woman's Art Journal* 16, no. 2 (Fall 1995/Winter 1996): 24.
3. Joan Semmel, "A Necessary Elaboration," in *Joan Semmel: Across Five Decades*, exh. cat. (New York: Alexander Gray Associates, 2015), 5.
4. Ibid., 5–6.
5. Ibid., 6.
6. Ibid.

18. *Horizons*, 1981
Oil on canvas
6 ft. 6 in. × 10 ft. (198.1 × 304.8 cm)

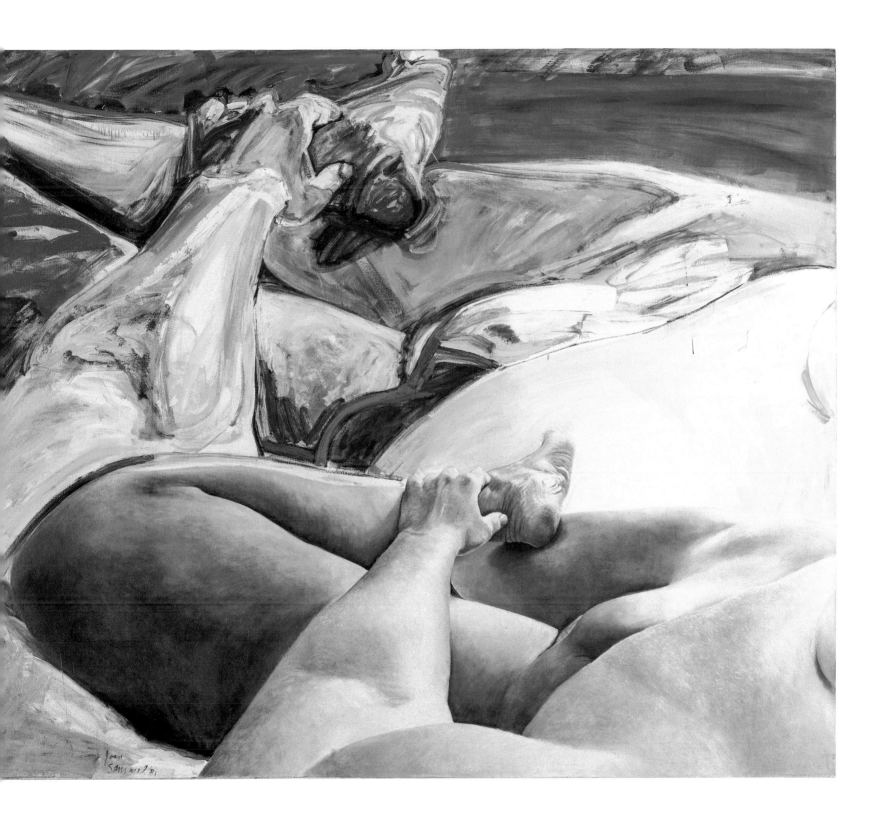

Sheila Hicks

Born Hastings, Nebraska, 1934

Describing herself as "thread conscious" from an early age, Sheila Hicks is one of the world's foremost artists working with textiles.[1] Her innovative approach to materials placed her at the center of the burgeoning fiber art movement in the 1960s and 1970s, and she has never surrendered that spot, as evinced in 2017 by her simultaneous installations at the 57th Venice Biennale and on New York's High Line. Inspired by international travel throughout her career, she has lived in Paris since 1964.

During her time as a student at Yale University, from 1954 to 1959, Hicks studied with Josef Albers (1888–1976), whose lessons on color theory had a lasting impact. She also attended classes on the art of Latin America led by the art historian George Kubler. Fascinated by the pre-Columbian textiles he showed, Hicks attempted to re-create them on a backstrap loom she improvised from canvas stretchers. She recalls, "Kubler was flashing slides of incredible weavings up on the screen and what caught my interest was their colour, design and shape. I began teaching myself how to weave."[2] When Albers saw her interest, he introduced her to his wife, Anni Albers (1899–1994), former head of the Bauhaus weaving workshop in Dessau, Germany. Speaking of both artists, Hicks has said, "If Josef had awakened me to the world of colour and ways of using colour . . . , [Anni] helped me to think about structure."[3] In 1957, Hicks received a Fulbright fellowship to paint in Chile. She took the opportunity to travel around South America, methodically photographing as she went. While she persevered at painting, she later recalled that her love of textiles "slowly overtook every other enthusiasm."[4] After completing her MFA in 1959, she moved to rural Mexico, where she set up a weaving studio in Taxco el Viejo, Guerrero, and forged relationships with local craftspeople.

Having begun many decades ago on her backstrap loom, Hicks has continued to work in that format. Simultaneously, she has undertaken commissions—including designs for Knoll, the prestigious textile firm, and large-scale wall hangings for companies and organizations ranging from the Ford Foundation to Fuji—which have, in turn, expanded the scale of her museum installations.

While the smaller weavings formed the basis of her practice—"I found my voice and my footing in my small work," she maintains—commissions have enabled her to experiment with new techniques.[5] They also offer up excess material for her studio endeavors. In reference to the two sides of her production, Hicks has said, "I could create on an intimate scale after stretching my design vision during the day. . . . The big workshops and abundant material stocks opened my mind. I felt quite free. There was an osmotic cross fertilization—large to small and small to large, continuously."[6]

The artist refers to her small works, such as *Taxco*, as "miniatures" or *minimes* (from the French for "very small"). Produced in the 1970s and titled after Hicks's hometown of the time, this example was fabricated from wool and cotton, materials readily available in Mexico, and dyed a deep, electric blue; tight wrappings of red thread in a few dozen places pulsate against the blue, illustrating the importance of color to the artist. An area of flat weave at the top contrasts with the mass of cascading, scissor-cut tassels below, arranged in a parabolic shape that evokes the arched forms Hicks had likely seen in Spanish colonial structures in Mexico as well as in Islamic architecture on her travels in North Africa. Irresistibly tactile, the work expresses the artist's fundamental philosophy: "Hands, eyes, brain: it's the magic triangulation."[7] HJ

1. Sheila Hicks, quoted in Susan C. Faxon, "Twined Thoughts," in *Sheila Hicks: 50 Years*, ed. Joan Simon and Susan C. Faxon, exh. cat. (Andover, MA: Addison Gallery of American Art, Phillips Academy; New Haven, CT: Yale University Press, 2010), 44.
2. Sheila Hicks, "Fibre Is My Alphabet," interview by Jennifer Higgie, *frieze*, no. 169 (March 2015), https://www.frieze.com/article/fibre-my-alphabet.
3. Sheila Hicks, "My Encounters with Anni Albers," *Tate Etc*, no. 44 (Autumn 2018), https://www.tate.org.uk/tate-etc/issue-44-autumn-2018/anni-albers-sheila-hicks.
4. Hicks, "Fibre Is My Alphabet."
5. Sheila Hicks, interview by Monique Lévi-Strauss, Archives of American Art, Smithsonian Institution, Washington, DC (website), February 3–March 11, 2004, https://www.aaa.si.edu/collections/interviews/oral-history-interview-sheila-hicks-11947.
6. Ibid.
7. Hicks, "Fibre Is My Alphabet."

19. *Taxco*, ca. 1970s
Wool, cotton, and metallic thread
78 × 45 × 6 in. (198.1 × 114.3 × 15.2 cm)

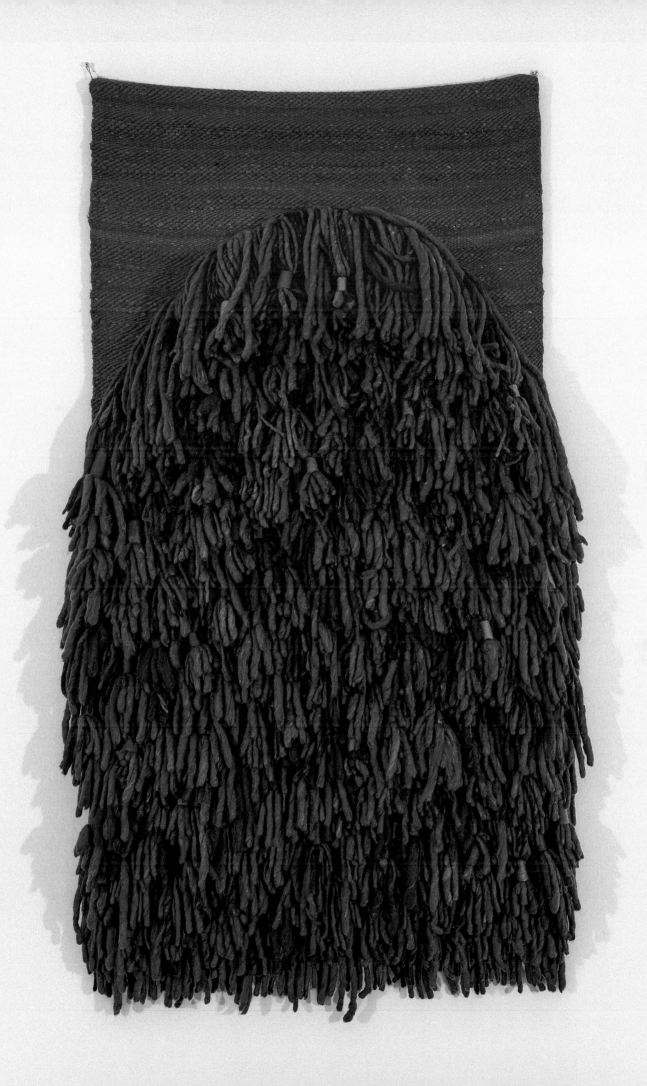

Helen Pashgian

Born Pasadena, California, 1934

Helen Pashgian is best known as a member of the Light and Space movement that emerged in Southern California in the 1960s. Over a five-decade career, she has challenged various theories of perception, producing sculptures that explore the possibilities of light as both medium and subject and creating immersive optical experiences that are unique to each viewer.

Captivated as a child by patterns of light in tide pools and trees, Pashgian began her education at Pomona College in Claremont, California, in 1952. There, she discovered the work of the seventeenth-century Dutch painter Johannes Vermeer—renowned for his treatment of light—in a course led by the art historian Seymour Slive. After studying at Columbia University and Boston University, Pashgian was offered a place in the art-history doctoral program at Harvard University in 1958. Deciding against a career in academia, she instead took a position teaching art and art history at a school in Newton, Massachusetts, which piqued her interest in the transparency of ceramic glazes. Returning to California in 1963 in search of sun and light, she began to experiment with industrial materials such as plastic, polyester resin, and fiberglass. Her interest in luminosity and geometric abstraction was shared by others, and she became associated with the artists who founded the Light and Space movement in the early 1960s, including Robert Irwin, John McCracken, and James Turrell.

To produce her earliest mature works, in the mid-1960s, Pashgian heated resin and poured it into a mold, having first placed solid pieces of acrylic inside. Once the material cooled, she meticulously sanded and polished it to form highly reflective spheres. Further technical experimentation came in 1971, when the artist began a two-year residency at the California Institute of Technology (Caltech) led by the artist Peter Alexander (1939–2020). Through this experience, she was introduced to a number of materials developed in California's aerospace industry that had recently, following World War II, become declassified. As she recalls, "Chemicals that had been used in bomb fabrications ended up in craft stores. The materials were poisonous and terrible, but very seductive."[1]

By the late 1960s, Pashgian had begun casting convex discs in epoxy and calling them "lenses" after the lens in the human eye, which adjusts in response to ambient light. Tapered to a sharp edge at the perimeter, these sculptures incorporate layers of carefully embedded color, designed to radiate evenly outward from the center of the work and "dissolve," as the artist describes it, "into nothing at the edge."[2] Pashgian controls the lighting conditions under which the works are shown with a timed rheostat, beginning with darkness and gradually increasing the light until the edge of the lens seems to fade into the space around it. As she explains, she is searching for "an object that becomes a non-object as we look at it"—an experience that challenges our assumptions about perception.[3] Color is fundamental to Pashgian's practice, and she chooses each hue carefully on the basis of its ability to reflect or refract light in a particular way. The deliberate use of near-invisible pedestals allows for a vision of "color floating in space."[4]

Most recently, Pashgian has produced large-scale freestanding columns, such as *Untitled (orange)*. These she makes by heating acrylic sheets at high temperatures before wrapping the softened material around wood molds to generate, in cross section, a double elliptical form. Each column also encapsulates an additional acrylic element—described by the artist as "nebulous and ghostly"—at its center.[5] The glowing columns invite close inspection and rely on the participation of viewers, whose experience of the light changes as they move. In the artist's words, "The double elliptical shape is continually mysterious because as you move around it whatever you see inside distorts, dissolves, and reappears."[6] Summarizing her fascination with the ephemerality of the optical experience, Pashgian has said, "I think of the columns as 'presences' in space—presences that do not reveal everything at once. . . . It touches on this mysterious part beyond which the eye cannot go but beyond which the eye struggles to go."[7] HJ

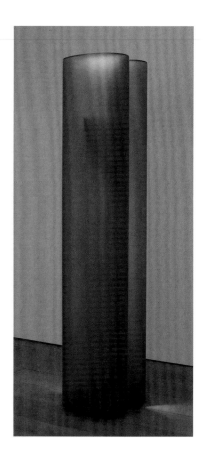

1. Helen Pashgian, "Helen Pashgian on Her Visionary Life in Color," interview by Canada Choate, *Artforum*, November 15, 2021, https://www.artforum.com/interviews/helen-pashgian-on-her-visionary-life-in-color-87180.
2. Helen Pashgian, interview by Michael Straus, *Brooklyn Rail*, February 2020, https://brooklynrail.org/2020/02/art/helen-pashgian-with-Michael-Straus.
3. Ibid.
4. Ibid.
5. Helen Pashgian, quoted in Carol S. Eliel, *Helen Pashgian*, exh. cat. (Los Angeles: Los Angeles County Museum of Art; Munich: DelMonico Books/Prestel, 2014), 18.
6. Pashgian, interview by Straus.
7. Pashgian, quoted in Eliel, *Pashgian*, 18.

20. *Untitled (orange)*, 2009
Heat-formed acrylic, with additional acrylic elements
91 × 18¾ × 22¼ in. (231.1 × 47.6 × 56.5 cm)

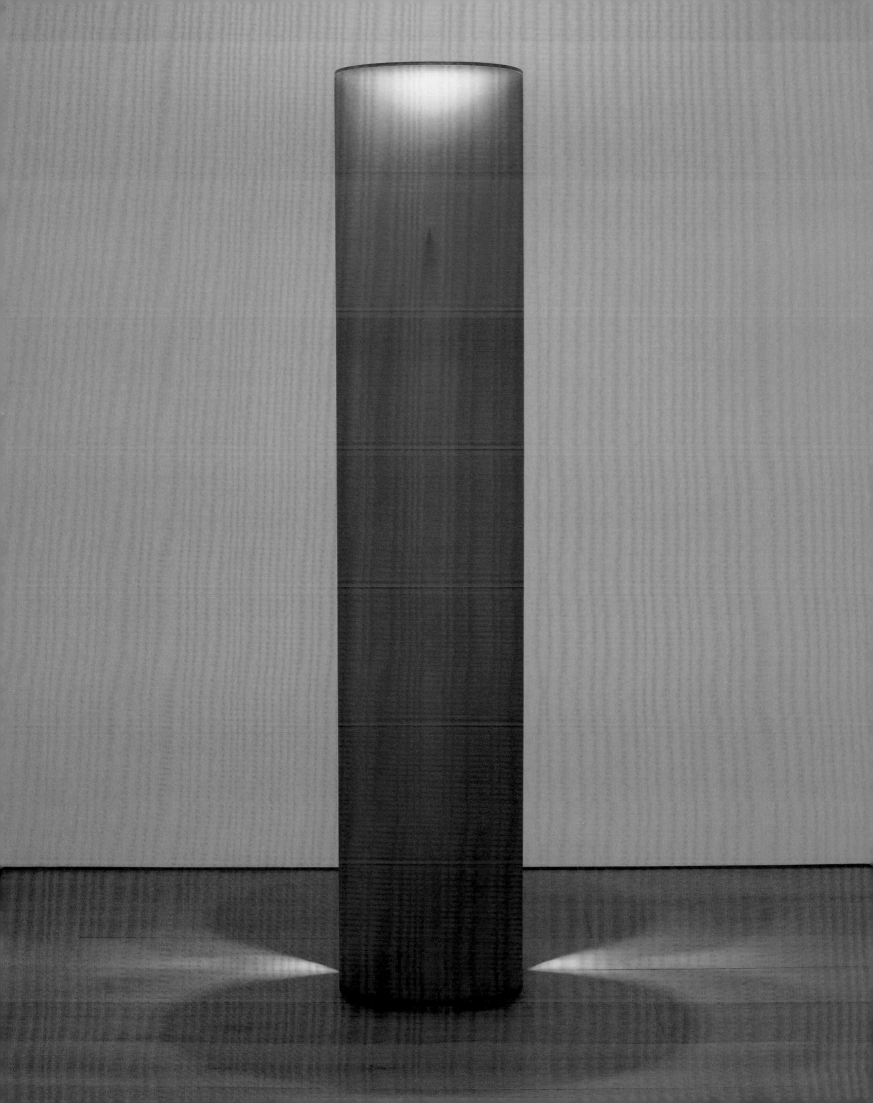

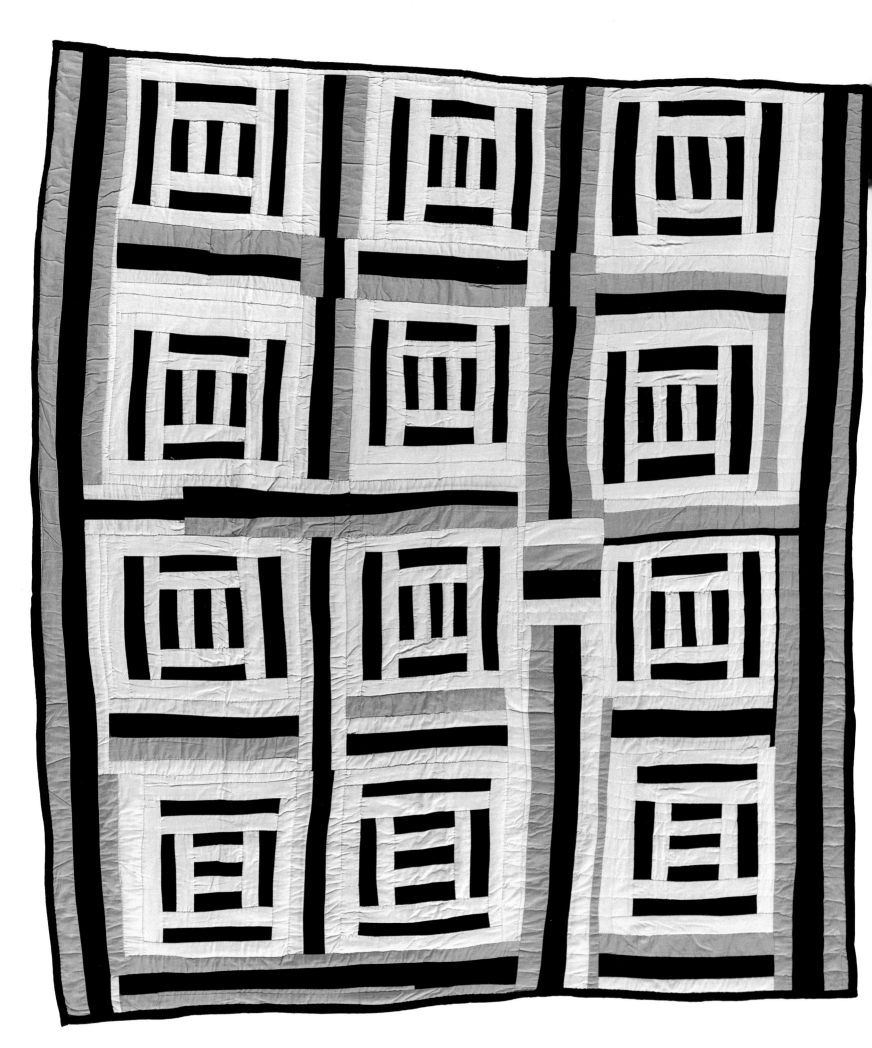

Mary Lee Bendolph

Born Gee's Bend (now Boykin), Alabama, 1935

Mary Lee Bendolph is a quilter from Gee's Bend, Alabama, a mostly African American community located in a bend of the Alabama River about sixty miles west of Montgomery. It is home to an intergenerational group of quilt-making women whose work is renowned for its highly original abstract language. In August 1999, the *Los Angeles Times* featured Bendolph in J. R. Moehringer's Pulitzer Prize–winning article "Crossing Over: Mary Lee's Vision," which recounted the community's efforts to reinstate the ferry service across the river—suspended in the 1960s to prevent residents from registering to vote. Hitherto unknown outside the local region, Bendolph's work was presented to an international public as part of the traveling exhibition *The Quilts of Gee's Bend*, originating at the Museum of Fine Arts, Houston, in 2002.

The rural community of Gee's Bend (now officially known as Boykin) is home to a few hundred people. Many of them—as the proliferation of the name "Pettway" suggests—are descended from enslaved people and, later, sharecroppers who lived on the cotton plantation owned by a man named Mark H. Pettway. Bendolph was born in Gee's Bend in 1935, the seventh of seventeen children. Following the collapse of cotton prices in the 1920s and 1930s, life was particularly hard. Bendolph's mother, Aolar Carson Mosely (1912–1999), taught her to sew, and she began quilting at the age of twelve. At this time, she and her fellow quilters did not consider themselves artists, nor did they conceive of their quilts as art objects. Instead, the textiles had a fundamentally utilitarian purpose: to provide warmth in uninsulated homes. While quilting was simply a way of life for the community's women, the intricate design work evinces their deeper investment in the projects: providing a change of pace from rural labor and child-rearing, quilt making offered a vital opportunity for creative self-expression.

Working with very limited means, Bendolph fabricated her early quilts primarily from remnants of sun-faded work clothes, feed sacks, and other discarded fabrics. Her first quilt incorporated a "raggly old shirt what the wagon had rolled over."[1] She produced the patterned tops of the quilts by tearing fabric into strips, then assembling, or "piecing," them together into geometric arrangements. While the style of each quilt maker is unique, the community's output is characterized by a shared abstract vocabulary. Beginning with the same geometric elements, quilters improvise to develop complex, often asymmetrical configurations of shape and color. A version of the "Housetop" pattern—based on concentric squares—is seen in the Shah Garg Collection example.

Although the appearance of Gee's Bend quilts has prompted comparisons with the formal language of modernist painting, the community has drawn almost exclusively on its own environment for its motifs. As Bendolph has said, "Most of my ideas come from looking at things. Quilts is in everything. Sometimes I see a big truck passing by. I look at the truck and say, I could make a quilt look like that. . . . As soon as I leave the house I get ideas."[2] By integrating fabric belonging to specific individuals, quilt making can also function as a process of commemoration. "Old clothes carry something with them," the artist has explained. "You can feel the presence of the person who used to wear them."[3] Pattern design is a largely solo activity, but quilt assembly has long been a shared labor. Traditionally, when quilting communally, women found respite from daily life in stitch, song, and prayer.

Having briefly participated in the Freedom Quilting Bee—a cooperative established in 1966 to support struggling communities and generate funds for civil rights efforts (see pl. 16)—Bendolph, beginning in the 1970s, supported her family as a factory seamstress. She resumed quilting in earnest in the late 1990s, buoyed by widespread appreciation of her work and with the time to experiment freely after her retirement. Despite her now vastly different access to materials, she has continued to work with aged fabric: "I can have any material I want now, but I still love to use the leftover and recycled-again cloth. . . . I see the value of leftover cloth."[4]

HJ

1. Mary Lee Bendolph, "Mama's Song," in *Gee's Bend: The Architecture of the Quilt*, ed. Paul Arnett, Joanne Cubbs, and Eugene W. Metcalf, exh. cat. (Atlanta: Tinwood, 2006), 176.
2. Ibid., 178.
3. Mary Lee Bendolph, quoted in Joanne Cubbs, "The Life and Art of Mary Lee Bendolph," in *Mary Lee Bendolph, Gee's Bend Quilts, and Beyond*, ed. Paul Arnett and Eugene W. Metcalf, exh. cat. (Atlanta: Tinwood; Austin, TX: Austin Museum of Art, 2006), 14.
4. Mary Lee Bendolph, quoted in Hannah W. Blunt, "Piece Together: The Quilts of Mary Lee Bendolph," in *Piece Together: The Quilts of Mary Lee Bendolph*, by Andrea Packard et al., exh. cat. (South Hadley, MA: Mount Holyoke College Art Museum, 2018), 31.

21. Quilt in "IEEE" Variation, 2009
Cotton
86 × 75 in. (218.4 × 215.9 cm)

Kay WalkingStick

Born Syracuse, New York, 1935

Narratives and motifs relating to Native American history and heritage are at the center of Kay WalkingStick's practice. Using paint as her primary medium, the artist explores the landscapes and iconography of the American West, renewing and recasting them as Native terrain and in the context of Native concerns. While her earliest works, a series of self-portraits made in the late 1960s, were informed by the feminist art she encountered upon moving to New York City, her Cherokee heritage became the focus of her output from the beginning of the next decade. Influenced by various incidents, including the occupation of Alcatraz Island, in San Francisco Bay, by Native American activists in 1969–71 and the death of her father, Simon Ralph Walkingstick Jr.,[1] around the same time, WalkingStick started to incorporate references to Native American history and historical personages into her compositions. "Art is a portrait of the artist, at least of the artist's thought processes, sense of self, sense of place in the world. If you see art as that, then my identity as an Indian is crucial," she has said.[2] The abstracted landscapes she produced after joining the graduate program at Brooklyn's Pratt Institute in 1973 soon evolved to include political and cultural perspectives.

WalkingStick's first major body of work made reference to the Nez Percé leader Chief Joseph (1840–1904), who had initially negotiated and then fought to avoid ceding his people's land to the United States government. An icon to both Native and non-Native communities, he had been especially revered by the artist's father. The *Chief Joseph Series* (1974–77; see fig. 8 on p. 50), which the artist has described as an elegy, consists of thirty-six panels, typically exhibited in a grid. Each panel is covered in a dense layer of acrylic paint and wax, into which WalkingStick carved four shapes of varying sizes—convex on one side, flat on the other—with a screwdriver, revealing the surface of the stained canvas underneath. In this instance, her painting process was a type of ritualistic act, and the works underline the importance of the artist's hand. "One of the constants in my artwork is the emphasis on touch, which is sometimes expressed through the material itself, and other times through the image that suggests the physical feel of a body or a place," WalkingStick has explained.[3]

Throughout the 1970s, the artist produced such visceral, built-up surfaces, resulting in compositions that were distinctly sculptural. "The paintings were made with a weighty substance so the supports had to be strong," she has remarked. "I constructed heavy-weight stretchers, often three inches deep, so that the paintings became very much like wall sculptures."[4] *Red Painting/Red Person*, painted at the same time WalkingStick was immersed in her *Chief Joseph Series*, features incised, abstract symbols identical to the ones seen on those panels. Although the curved shape echoes certain aspects of Native American iconography—a bow or a canoe, most explicitly—the artist has described the motif in geometric terms, as a segment of a circle, to encourage wider readings. In *Red Painting/Red Person*, four of these forms are arranged in a row across a burgundy-hued square, one facing in the opposite direction from the rest. This red field, and the matching outer border, contrast with the ink-streaked, yellowish inner border, creating the kind of duality that has occupied WalkingStick throughout her practice: "The idea of two parts working together in a dialogue has [also] remained interesting to me."[5]

The diptych format became integral to WalkingStick's production in the 1980s, enabling her to present a geometric abstraction alongside a naturalistic portrayal of a lake or mountain range. In the artist's most recent paintings, made in the last decade (see p. 129), monumental vistas the artist has seen in person, and first documented through drawing or photography, merge with Indian weaving designs and traditional Navajo patterns in WalkingStick's continuing quest to visually reclaim the land of the Indigenous peoples of the present-day United States. AB

1. The artist's father did not capitalize the letter *s* in his last name.
2. Kay WalkingStick, quoted in Margaret Archuleta, "On Being Cherokee," in *Kay WalkingStick: An American Artist*, ed. Kathleen Ash-Milby and David W. Penney, exh. cat. (Washington, DC: National Museum of the American Indian, 2015), 105.
3. Kay WalkingStick, "Artist Statement," artist's website, accessed August 1, 2022, http://www.kaywalkingstick.com/statement/index_new.htm.
4. Kay WalkingStick, "Paintings Always Led the Way: Materials and Process," in Ash-Milby and Penney, *WalkingStick: An American Artist*, 78.
5. Ibid.

22. *Red Painting/Red Person*, 1976
Acrylic, saponified wax, and ink on canvas
46 × 48 in. (116.8 × 121.9 cm)

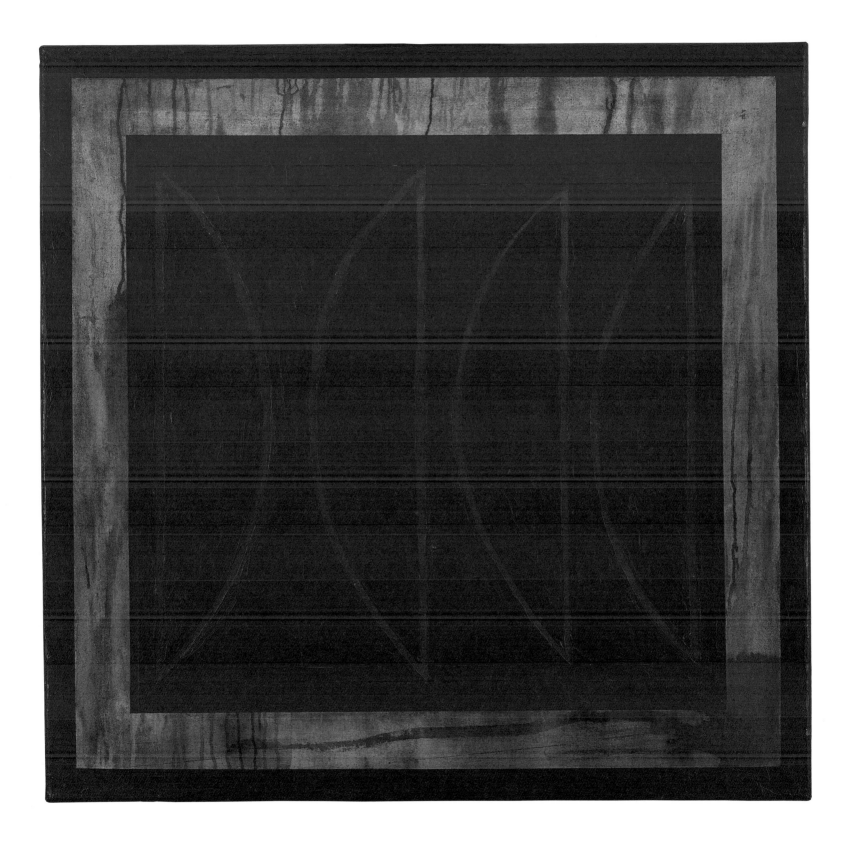

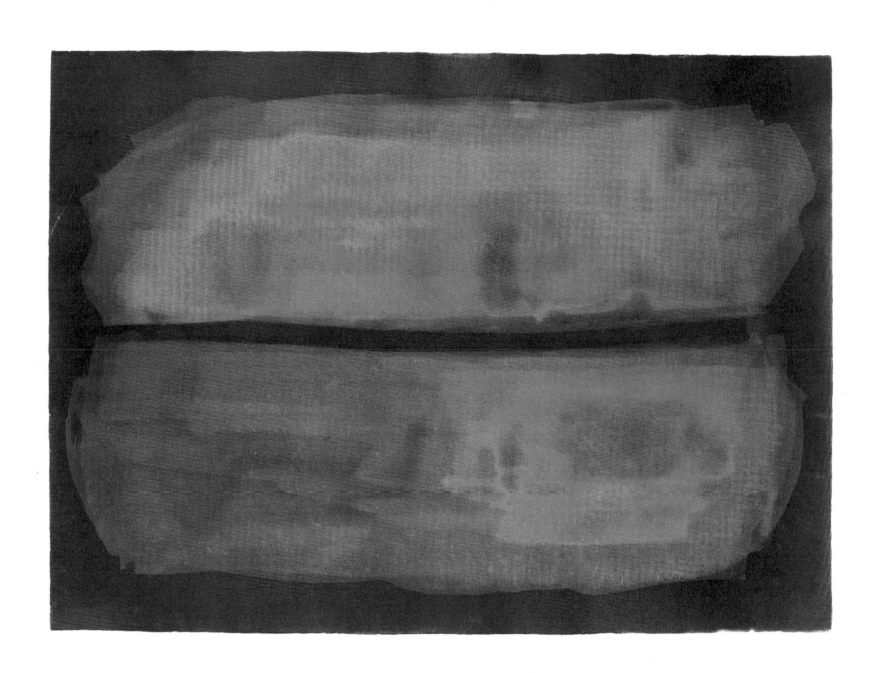

Barbara Kasten

Born Chicago 1936

Barbara Kasten is known for an unusual photographic practice that incorporates painterly, sculptural, and performative techniques. Trained as a painter at the University of Arizona, she initially worked in the fashion industry in San Francisco before moving to Germany in 1964. It was there, she recalls, that she encountered the emergent fiber art movement: "I decided when I saw a crafts show in Europe that the possibilities of texture and color achieved in fiber would be a good transition from my painting."[1] Returning home in 1967, she enrolled at California College of Arts and Crafts (now California College of the Arts), where she began her career working with fiber under the guidance of the Bauhaus-educated textile designer Trude Guermonprez (see pl. 3). Simultaneously, she enrolled in an introductory photography course taught by Leland Rice (born 1940)—her only formal training in the medium.

Following her graduation in 1970, Kasten moved to Los Angeles and taught as an adjunct professor at various schools in Southern California. Searching for a way to help her students extrapolate three-dimensional forms from flat surfaces, she started using fiberglass window screening as a demonstration tool. Its physical properties intrigued her, and she began creating abstract shapes from it, playing with the patterns of shadow and light they made against the wall. In 1974, these explorations led to the *Photogenic Painting* series—her first photographic (albeit cameraless) works, and the foundations of an experimental engagement with still life that has remained central to her practice ever since.

In each of these "paintings"—actually photograms—abstract patterns of varying degrees of translucency appear against a ground that is typically blue, though sometimes off-white or brownish. To create the images, Kasten brushed the chemical mixture required for the cyanotype process onto a sheet of paper and placed the fiberglass mesh over it. After exposure to light and a water rinse, the paper that had been exposed to light turned blue, while the areas that had been protected by the fiberglass material remained white. The textured weave of the fiberglass, as well as Kasten's movements of the material during exposure, resulted in rippled, abstract patterns reminiscent of woven cloth fibers. It was undoubtedly her material curiosity that led her to the technique; in Kasten's words, "The photogram, free from technical restraints and training, offered a direct way to merge a painterly technique with light-sensitive emulsions. . . . The result was ephemeral and surreal, even though the material itself was bland and meant for practical purposes."[2]

By the time she made *Photogenic Painting Untitled 76/7*, Kasten had begun to combine

cyanotype chemicals with washes of ink, silkscreen printing, and other photographic processes, such as Van Dyke, which creates the aforementioned brownish tint. Speaking of the process and her enduring interest in moiré—a graphic interference pattern that can be created by overlaying one material on another—Kasten has said, "The idea of using layers of screen to create this very interesting phenomenon and capturing it on a two-dimensional surface is what interested me. That was my eureka moment."[3] The title of this body of work riffs on the original name for the photogram assigned by its earliest proponent, William Henry Fox Talbot, in 1833: "photogenic drawing."

From the time of her graduate studies at CCAC, Bauhaus pedagogy has been central to Kasten's interdisciplinary approach. The photograms of László Moholy-Nagy (1895–1946), which she encountered firsthand in 1975, were of particular importance as "a means towards abstraction."[4] However, it was Kasten's engagement with the Light and Space movement in California during the 1970s, particularly the work of artists such as Robert Irwin and James Turrell, that ignited her ongoing preoccupation with the phenomena of light.

Since the 1980s, Kasten has focused largely on images that capture the meticulous sculptural installations that she assembles from props—often simple sheets of plexiglass—solely for the purpose of being photographed. These have varied widely, from the Constructivist-inspired compositions of the early 1980s to her more recent, minimalistic arrangements. While some of the resulting photographs have been in black and white, most have featured brighter colors than her works of the 1970s. For her early *Construct* series, for example, the artist used colored gels and either Polaroid equipment or the Cibachrome process to generate complex and elusive tableaux in jewel tones, primary colors, or surprisingly rich pastels. Addressing the enduring principles of her work, Kasten has described it as "an idea-based progression of abstraction. . . . It's the translation of light into something readable or experiential."[5] HJ

1. Barbara Kasten, quoted in Jenni Sorkin, "Tactile Beginnings," in *Barbara Kasten: Stages*, ed. Alex Klein, exh. cat. (Philadelphia: Institute of Contemporary Art, University of Pennsylvania; Zurich: JRP Ringier, 2015), 149.
2. Barbara Kasten, "Shape of Light: Through the Lens of Abstraction," *Tate Etc*, no. 43 (Summer 2018), https://www.tate.org.uk/tate-etc/issue-43-summer-2018/barbara-kasten-through-lens-abstraction.
3. Barbara Kasten, "In Conversation: Barbara Kasten and Liz Deschenes," in Klein, *Kasten: Stages*, 29.
4. Kasten, "Shape of Light."
5. Kasten, "In Conversation: Kasten and Deschenes," 34.

23. *Photogenic Painting Untitled 76/7*, 1976
Cyanotype, Van Dyke brown print, and ink
30 × 40 in. (76.2 × 101.6 cm)

Emma Amos

Atlanta 1937–2020 Bedford, New Hampshire

Emma Amos was a pioneering painter, printmaker, and weaver whose works explored questions of race, gender, power, and Black subjectivity. Over a six-decade career, she produced a diverse body of work, experimenting with printmaking techniques and integrating woven textiles into her figurative paintings. Her practice was characterized by a boldness of color that mirrored her personal convictions.

Born in segregated Atlanta, Amos was encouraged in her artistic pursuits by her parents from a young age. The family's friendships with some of the city's most important literary, cultural, and political figures—including W. E. B. Du Bois, Zora Neale Hurston, and Hale Woodruff—brought frequent visitors to the household, fostering in Amos a sense of the possibilities of creative freedom. At eleven, she was granted special permission to enroll in an undergraduate course in oil painting at Atlanta's Morris Brown College. She later studied at Antioch College in Yellow Springs, Ohio, and at the Central School of Art and Design (now Central Saint Martins) in London, where she specialized in etching and weaving.

In the early 1960s, Amos moved to New York, where she worked for the renowned textile designer Dorothy Liebes (1899–1972) and continued her printmaking practice under the guidance of Robert Blackburn (1920–2003) at the Printmaking Workshop in Chelsea. She entered New York University in 1964 and, through Woodruff (1900–1980), now her mentor, was invited to join Spiral, the Black artists' collective cofounded by Woodruff, Charles Alston, Norman Lewis, and Romare Bearden in 1963. She was the group's youngest member, and only woman. During this period, Amos painted vibrant abstractions influenced by Abstract Expressionism, Pop art, and color-field painting. Despite her affiliation with Spiral, she continued to feel impeded by her gender, age, and race. Profoundly affected by the civil rights movement, she turned away from abstraction and began producing figurative representations of Black subjects. As she later recalled, "I could not in good conscience paint just lovely colored pictures with brushy strokes without having some of the pain and angst of the things that I wanted to say about women, black women in particular."[1]

In the 1970s, Amos taught weaving and textile design and developed the public television program *Show of Hands* (1977–79), which celebrated master craftspeople in the Boston area. She also became actively involved in the feminist movement, contributing to the quarterly magazine *Heresies* in 1982–83 and donning a mask as one of the original members of the Guerrilla Girls in 1985. It was, however, her appointment as a professor in the Visual Arts Department at Rutgers University in 1980 that proved most consequential. Rejuvenated by this teaching position—which, crucially, provided her with a studio—she began to work with renewed vigor. Seeking depictions of empowerment and strength, she collated images of powerful Black bodies from sports magazines and used them to produce a group of pioneering figurative paintings in acrylic that incorporated her own brightly colored woven fabric. *Star* belongs to this body of work. While Amos had initially attempted to build her figures out of the fabric, she ultimately resolved to use it as a framing device. Here, a leaping body is silhouetted against the textile background, while trailing threads add a sense of depth and flow.

The notion of movement, and the body in motion, always remained integral to Amos's art. As she explained, "One of the most important elements in my work is movement. . . . When I make a painting, I am trying to use both the expressiveness of the paint flow and the movement of whatever it is I'm using, so that everything is in flux."[2] The dynamism of her earliest woven paintings led to the *Athletes and Animals* series (1983–85), which again celebrated the speed and prowess of Black athletes, and the later *Falling* series (1988–92), which depicted figures tumbling downward through abstracted spaces. This motif of the figure "in flux"—deeply informed by Amos's own social and political experiences of gender and race—populated her work until her death.　　　　　　HJ

1. Emma Amos, quoted in bell hooks, "Straighten Up and Fly Right: Making History Visible," in *Emma Amos: Paintings and Prints, 1982–92*, ed. Thalia Gouma-Peterson, exh. cat. (Wooster, OH: College of Wooster Art Museum, 1993), 21.
2. Ibid., 24.

24. *Star*, 1982
Acrylic, machine-made synthetic fabric, and handwoven synthetic fabric on canvas
76½ × 54⅛ in. (194.3 × 137.5 cm)

Mary Obering

Shreveport, Louisiana, 1937–2022 New York City

Over a fifty-year career, Mary Obering painted geometric abstractions that consistently explored the aesthetic possibilities of color and form. She is best known for her singular combination of traditional Renaissance materials—specifically, the egg tempera and gold leaf that dominated her work beginning in the mid-1970s—with Minimalism. But perhaps nothing is more revealing of the roots of her practice than a comment she made in a video shared recently by her gallery: "As a young child, I imagined the universe to be an infinite number of painted wooden blocks of different colors and various geometric shapes floating in deep blue."[1]

Obering's earliest training was scientific, and she received a BA in psychology in 1958 from Hollins College in Roanoke, Virginia, before briefly studying experimental psychology under Harvard University's renowned behaviorist B. F. Skinner. The experience was formative but had unforeseen results: "The scientific approach to life, and its impossibilities, led me to become an artist," she recalled.[2] She graduated from the University of Denver with an MFA in 1971, having studied sculpture and painting. That year, at the behest of Carl Andre, whom she had met at a gallery opening in Italy in 1970, Obering moved to New York. She became an active member of a flourishing artistic community, counting Marcia Hafif, Sol LeWitt, and Donald Judd as friends and neighbors. Even before her immersion in this context, however, Obering was firmly committed to a Minimalist ideology. "I think my art can stand or fall on its own," she had argued in her MFA thesis. "[Its] meaning or lack thereof (depending on the viewer) comes from the only place it can—the art object."[3]

Starting from modular, single-color fields of acrylic paint, Obering soon began to experiment with the three-dimensional possibilities of her medium. She started cutting loosely painted canvases into horizontal strips that she tacked, one on top of the other, to the top stretcher bar of an otherwise monochromatic painting. This method preserved the subtle gaps between the overlapping sections and the frayed irregularities of the fabric edges, imbuing the works with a unique sense of fluidity. These *Drop* paintings, as she titled them, led to her *Window Series*, which was selected by Andre to be shown at New York's newly formed Artists Space gallery in 1973. Part of that series, *Window Series #4* features seven sections of painted canvas whose arrangement against a warm tan background playfully conjures—as the title suggests—the Renaissance notion of a painting as a window onto the world.

While conceptualism dominated New York's art scene during the 1970s, Obering maintained her dedication to painting. In a deliberate search for more traditional methods, she began to paint on Masonite panels and produced her first work in the ancient technique of egg tempera in 1977. Her interest in the medium originated in her love of Early Renaissance painting, which she had first experienced when traveling around Italy as a teenager in the 1950s. As she recalls, "I was astounded by the Renaissance paintings. That experience was always in the back of my mind."[4] Obering's use of tempera prompted further exploration of Renaissance materials, and in the late 1970s, she was trained in the art of gilding by a professional gilder. From that time onward, gold leaf remained a near constant in her material repertoire.

During the early 1980s, Obering began to produce shaped canvases. Circular, crescent-shaped, and elongated zigzag supports conveyed her long-standing interest in scientific phenomena, from astronomy to particle physics. She also made work that emphasized physical aspects of her fabrication processes, using gilding clay, for example, as a material in its own right. In her later years, Obering moved into the realm of relief, painting the edges as well as the surfaces of increasingly deep panels. Works of the late 1990s and early 2000s incorporated multiple panels as well as thin veneers of stone sourced near her studio in Puglia, in southern Italy. Across media, she always remained true to her reduced visual vocabulary, continually exploring the permutations of recessive and projective visual space. HJ

1. Mary Obering, "In Focus: Mary Obering, *Archangel*," Bortolami Gallery, New York (website), accessed July 29, 2022, video, 2:21, https://bortolamigallery.com/in-focus/mary-obering-archangel/.
2. Mary Obering, quoted in Emily Gallagher, "Soho Stalwart Mary Obering Talks Art History," *Cultured*, December 11, 2017, https://www.culturedmag.com/article/2017/12/11/mary-obering.
3. Mary Obering, quoted in *Mary Obering* (Los Angeles: Inventory Press, 2022), 10.
4. Obering, quoted in Gallagher, "Soho Stalwart Obering."

25. *Window Series #4*, 1973
Acrylic on canvas
96 × 96 in. (243.8 × 243.8 cm)

Zarina

Aligarh, Uttar Pradesh, India, 1937–2020 London

The Indian-born American artist Zarina Hashmi (known professionally by her first name alone) is acclaimed for her lifelong exploration of the aesthetic and conceptual possibilities of paper as well as for her tactile sculptures in metal and wood. Articulated through her geometric forms and Minimalist language is a complex emotional record of her itinerant status, addressing themes of displacement, memory, and home.

Zarina graduated from Aligarh Muslim University with a degree in mathematics in 1958 before leaving the subcontinent to accompany her diplomat husband on his travels around the world. From 1963 to 1967, she studied intaglio with the celebrated English painter and printmaker Stanley William Hayter (1901–1988) at Atelier 17 in Paris, and in 1974, in Tokyo, she learned woodblock printing from Tōshi Yoshida (1911–1995). In the mid-1970s, after years of peripatetic existence and recently widowed, the artist moved to New York.

While the development of Zarina's practice owed a debt to the Minimalist art and geometric abstraction she encountered in New York in the 1970s, her work was nevertheless fundamentally embedded in her own experiences. The partition of India in 1947—which forced her family to relocate to Karachi, Pakistan, in the 1950s and resulted in the loss of her childhood home—was painful and remained with her for the rest of her life. Themes of house and home played an important part in Zarina's iconography, conveying her ongoing sense of deracination and exile. In 2006, she said, "Home is the centre of my universe; I make a home wherever I am."[1] Many of her prints and drawings incorporate the outline of a house, a floor plan, or a map, which the artist used to preserve the sites of her memories. In other works, geometric patterns evoke elements characteristic of the Mughal architecture of South Asia, such as the *jali*, or latticed stone screen.

Text was also central to Zarina's approach, and the inclusion of words in her native Urdu acts as a reminder of the geopolitical specificity of her personal identity. The partition of India not only dislodged both Muslim and Hindu families physically but also engendered cultural shifts, eclipsing the Urdu language in India, for example, in favor of Hindi. By incorporating Urdu text—some of it copied from letters written to the artist by her sister, Rani—into her works, Zarina defiantly resisted the decline of her mother tongue. As she explained, "The words are in my own language, recalling a time, a sensibility of thought and feeling."[2]

As a printmaker, Zarina considered paper her primary medium. In addition to mastering numerous printmaking techniques, including lithography, etching, woodcut, and silkscreen, she also produced works in which she cut, pierced, or otherwise punctured the material. In the late 1970s, she taught papermaking at the New York Feminist Art Institute, for which she researched the history, geography, and chemistry of paper. Around this time, she also extended her exploration of the material into three dimensions, pressing pulped paper into deep molds to create reliefs. Fundamentally, Zarina viewed paper as a substance with a life and character of its own. Likening it to skin, she once said, "It can be stained, pierced and moulded and it still has the capability of breathing and aging. It has a fragility and resilience that lasts through time."[3]

In later years, Zarina made works that explore the concept of *nūr*, or divine light, in Sufism. Moving beyond her customary earthy palette, she started using gold and pewter leaf, aluminum powder, and black sumi ink. She also created a number of sculptures based on *tasbīḥ*, sets of beads used in Muslim prayer. While a functional *tasbīḥ* need have only ninety-nine beads, or even thirty-three, Zarina chose to thread five hundred here. The gesture magnifies the object's presence even as it references a memorable *tasbīḥ* owned by her aunt when she was a child. The artist's repetitive act of stringing each wood disk onto the leather cord seems poignantly evocative of her reflective, enduring dedication to identity and home. HJ

1. Zarina, interview by Geeti Sen, in *Zarina: Paper Houses*, exh. cat. (New Delhi: Gallery Espace, 2007), 13.
2. Ibid.
3. Zarina, quoted in S. Kalidas, "Radiant Transits of Zarina Hashmi," *The Hindu*, February 5, 2011, updated October 8, 2016, https://www.thehindu.com/features/magazine /Radiant-transits-of-Zarina-Hashmi/article15130634.ece.

26. *Tasbih*, 2008
Maple wood stained with sumi ink (500 units), dusted with aluminum powder and strung with black leather cord (ed. 3/3)
Overall length 20 ft. 9 in. (632.5 cm), overall as installed
68½ × 9 × 3 in. (174 × 22.9 × 7.6 cm)

Gloria Bohanon

Atlanta 1939–2008 Los Angeles

By the end of the 1960s, Gloria Bohanon had established herself as an artist in Los Angeles. She moved to the city after completing a master's degree in art education at Detroit's Wayne State University in 1968. Although trained as an art instructor (her undergraduate degree was also in art education), she had developed a painting practice alongside her academic work. In 1970, she received her first solo exhibition at Brockman Gallery.

Founded in 1967 by the brothers Alonzo Davis and Dale B. Davis, the gallery, situated in Los Angeles's Leimert Park neighborhood, was the first prominent space in the United States to be run by and for Black artists. Both emerging and established figures exhibited there, including Romare Bearden, Elizabeth Catlett, David Hammons, John Outterbridge, and Noah Purifoy. In the same year the Davises opened their gallery, the painter and dancer Suzanne Jackson (see pl. 51) arrived in Los Angeles from San Francisco and, two years later, established an exhibition space in her painting studio in the Granada Buildings, between Lafayette and MacArthur Parks. Named Gallery 32, Jackson's initiative specifically sought to address Black women's lack of representation in the local art scene. In July 1970, the *Sapphire Show*, now considered the first survey of Black women artists in the entire country, opened at the gallery. Bohanon was included in the seminal presentation alongside Eileen Abdulrashid (then Nelson), Yvonne Cole Meo (see pl. 8), Senga Nengudi (then Sue Irons; see pl. 44), Betye Saar, and Jackson herself. While no photographs of the show exist, nor any written record of what was on view, Bohanon's works of this time (paintings, drawings, and collages) centered on bold, stand-alone forms and spiritual motifs. A painting on paper of about 1970 titled *Rio on My Mind (Corcovado, Quiet Nights of Quiet Stars)* depicts a mysterious orb reminiscent of a moon or an eye. Another painting made during this period, *Roots*, features the names of various African countries (including some outdated or soon-to-be-obsolete colonial designations) against a broad, riverine field of black, next to which a version of the ancient adinkra symbol of community service and struggle known as an *akoben*, based on a war horn, is silhouetted in red within a black circle.

In January 1972, Bohanon was included in *Eleven from California* at the Studio Museum in Harlem, the first major New York show devoted specifically to Black artists working on the West Coast. A month later, two of her enamel-on-board works (*Ball Game* and *Cradled Thoughts*) were displayed in a notable exhibition at the Los Angeles County Museum of Art, *Los Angeles 1972: A Panorama of Black Artists*. The exhibition was a victory on the part of the museum's Black Arts Council, founded in 1968, which was the driving force behind much of the institution's programming geared toward African American audiences and creators; Bohanon was one of the council's earliest members. Equality was at the forefront of Bohanon's work, specifically as a professor of painting, printmaking, and design at Los Angeles City College, where she taught for three decades, beginning in 1973. She notably organized Black Culture Week there in 1974, soon after assuming her role.

In her statement for *Black Artists on Art, Volume 2* (1971), a groundbreaking publication edited by Samella S. Lewis and Ruth G. Waddy, Bohanon spoke of her work's intention "to create a visual sense of touch, to feel with your eyes, to become involved, to create a love affair between the visual and the tactile, a unity, oneness."[1] The circular paintings Bohanon made at the beginning of the next decade, such as those in the Shah Garg Collection, highlight her search for sensuality through vibrant hues and the symbolic use of hands. AB

1. Gloria Bohanon, artist's statement, in *Black Artists on Art, Volume 2*, ed. Samella S. Lewis and Ruth G. Waddy (Los Angeles: Contemporary Crafts, 1971), 51.

27. CLOCKWISE FROM TOP

Love Notes II "Caught Up," ca. 1980
Acrylic and polyester cord on medium-density fiberboard
Diameter 17¾ in. (45.1 cm)

Love Notes II "I Love You This Much," ca. 1980
Acrylic on medium-density fiberboard
23½ × 39 in. (59.7 × 99 cm)

In My Aloneness, I Go Inside, ca. 1980
Acrylic, polyester cord, and paper on medium-density fiberboard
22¾ × 24 in. (57.8 × 61 cm)

Rosemarie Castoro

Brooklyn, New York, 1939–2015 New York City

A self-described "paintersculptor" who lived in the city all her life, Rosemarie Castoro emerged within the context of the Minimalist and conceptual art practices that dominated 1960s New York.[1] In 1959, she began her education in graphic design at Brooklyn's Pratt Institute. During her time there, she became involved with the New Dance Group (NDG), a thirty-year-old, politically minded dance studio, and trained simultaneously in dance and choreography. After graduation, however, she found few opportunities to choreograph, and while she had participated in pieces by the influential dancer and filmmaker Yvonne Rainer (born 1934), a career performing others' work did not interest her. Instead, she directed her energies toward painting, viewing it as a means to create independently without relying on others.

Castoro's earliest mature canvases, begun in 1964, were produced in the SoHo loft she shared with her then partner, the artist Carl Andre (born 1935). The works' allover design consisted of tesselating Y shapes painted in bold, contrasting colors. As her visual language developed, she began detaching the Y forms from each other and isolating them against bright, monochromatic grounds. Later, she broke them up into rectangular "bars" and superimposed them over each other.

At the end of the 1960s, Castoro's increasing use of systematic design principles led her toward conceptualism. Moving beyond the studio and into the city, she composed concrete poetry, recorded the duration of everyday actions with a stopwatch and typed up the results, and enacted street-based performances, including dribbling paint from a moving bicycle. In 1969, she used a line of shiny tape to divide the Paula Cooper Gallery in a conceptual practice she termed "cracking." Castoro also became involved in activism through the Art Workers Coalition, which often met in her studio on Spring Street. Despite her political consciousness, she did not align herself with the feminist movement, viewing its parameters as constrictive and segregating. Nonetheless, she acutely felt her experience of gender discrimination. Recalling the repercussions of an assumption by the gallerist Leo Castelli that her works must have been made by a man, she said, "I became hostile. It kept me working. I finally isolated myself, climbing the walls in my studio, snarling at whoever crossed my path."[2]

Castoro returned to painting in 1970 and began producing large-scale, freestanding panels whose textured surfaces she covered in graphite shading. By 1972, these panels had evolved into a body of wall-based reliefs, of which Gentless (Brushstroke) is one example. As the artist recalled, "The panels of graphite drawings grew, stood by themselves, and became room spaces" before "the corners turned and brushstrokes snapped away and landed smack on the existing brick walls of my studio."[3] To make the works in this Brushstroke series, Castoro applied a mixture of gesso, marble dust, and modeling paste to Masonite panels and used a mop or non-artist's brush to create a deep-grained texture. Once the coating had dried, she cut out brushstroke shapes with a jigsaw, preserving the delicately jagged edges, and rubbed graphite over the surfaces. The process was a messy and physical one, as she noted in her journal: "I am in dirt continually. . . . My studio is covered with graphite. . . . My ocean is made of graphite in front of which I tumble, chase, flop over."[4] The artist's formal training as a dancer had a profound, lifelong impact on her negotiation of space—"I want to carve space. I am carving space," she asserted in 1972—and Castoro used a self-timing Polaroid camera to record her body in motion in the studio in front of and inside her works (see fig. 6 on p. 48), crouching, posing acrobatically, or suspending herself from ropes attached to the ceiling.[5] While the earliest Brushstrokes were conceived as single, cursive strokes, they later expanded to form multipart installations, fabricated in the same bodily manner.

From the mid-1970s onward, Castoro focused on sculpture, producing objects in epoxy resin and welded metal, interventions in the landscape, and installations specifically conceived for the urban environment. Her introduction of subtly sexualized, organic forms countered the traditionally neutral approach of her peers, highlighting her unique subversion of the purity of the Minimalist idiom through its own formally reduced visual language. HJ

28. *Gentless (Brushstroke),* 1972
Gesso, marble dust, modeling paste, and graphite on high-density fiberboard
88 × 24¾ in. (223.5 × 61 cm)

1. Rosemarie Castoro, unpublished journal, August 1970–May 1971, quoted in Tanya Barson, "Rosemarie Castoro 1964–79: An Obstacle Course for a Dancer?," in *Rosemarie Castoro: Focus at Infinity*, by Tanya Barson, Melissa Feldman, Lucy R. Lippard, and Anna Lovatt, exh. cat. (Barcelona: Museu d'Art Contemporani de Barcelona, 2018), 23.
2. Rosemarie Castoro, "Artists Transgress All Boundaries," published as one of eight replies to Linda Nochlin's essay "Why Have There Been No Great Women Artists?" in *ARTnews*, January 1971, quoted in Barson, "Castoro 1964–79," 30.
3. Rosemarie Castoro, quoted in "Four Young Artists Living the Loft Life—Sylvia Stone, Rosemarie Castoro, Nancy Graves, Susan Crile," *Vogue*, August 1972, quoted in Barson, "Castoro 1964–79," 31.
4. Rosemarie Castoro, unpublished journal, quoted in "Rosemarie Castoro: Focus at Infinity," exh. brochure, Museu d'Art Contemporani de Barcelona (website), exh. on view November 9, 2017–April 15, 2018, accessed April 29, 2022, https://img.macba.cat/public/uploads/20171030/CASTORO_FOCUS_ENG.pdf.
5. Rosemarie Castoro, unpublished journal, June 1972–September 1973, quoted in Barson, "Castoro 1964–79," 21.

Barbara Chase-Riboud

Born Philadelphia 1939

Over a prodigious career spanning five decades, Barbara Chase-Riboud has used technical expertise and material experimentation to produce a unique, audacious body of abstract sculpture. She is also renowned as an author and a poet. Published in 1979, her much-debated first novel, *Sally Hemings*, which explores the relationship between Thomas Jefferson and his enslaved concubine, was a multi-translated international best seller.

Having begun her artistic training at the age of seven with classes at the Philadelphia Museum of Art, Chase-Riboud enrolled at Temple University's Tyler School of Art in 1952. Critical acclaim arrived early, and in 1955, following an exhibition of her prints at ACA Galleries in New York the year before, the Museum of Modern Art purchased her wood-cut *Reba* (ca. 1954). In 1956, the artist moved to the city, then won a fellowship from the John Hay Whitney Foundation to study at the American Academy in Rome. Returning to the United States in 1958, Chase-Riboud attended the Yale School of Architecture and Design (precursor of the Yale School of Art), becoming the first Black woman to graduate from there with an MFA. The artist has lived outside the U.S. since 1961 and has traveled extensively in Europe, Africa, and Asia.

While Chase-Riboud had always sculpted, her practice shifted in 1958 with her discovery of the traditional lost-wax casting technique. Working in an improvisational manner—without plans or preparatory drawings—she bent and joined paper-thin sheets of wax to create forms with "huge undercuts" that would have been impossible to produce in other materials.[1] At the foundry, these objects were fitted with conduits and covered with clay; the clay ensemble was then placed in an oven to melt the wax, and the cavity was filled with liquid metal. To retrieve the sculpture, the clay mold had to be broken. As a result of this fabrication process, each sculpture is unique and cannot be recast or reproduced. "The cast *is* the sculpture," Chase-Riboud explains. "There is no way that I can change it once it's passed through my subconscious."[2]

In 1967, living in Paris and wanting to conceal the bases of her sculptures in an effort to make them more abstract and less readable as objects on a plinth, Chase-Riboud turned to her friend and former Yale classmate Sheila Hicks (see pl. 19). Hicks taught Chase-Riboud a knotting technique, and she began to create "skirts" of wool and silk fibers that paradoxically appeared to support the much heavier metal sculptures above. Drawing on her understanding of the ways non-Western cultural objects often combine contrasting materials to symbolic and ritualistic effect, she created, in these hybrid sculptures, "a unity of opposites."[3] "When I finished those first skirts, I realized something extraordinary had happened," she says. "The fiber became the heavy, strong element, and the bronze became the liquid, flowing, moving material."[4]

Executed in this style, the sculptures for which Chase-Riboud is perhaps best known are those dedicated to the assassinated civil rights leader Malcolm X (1925–1965), which she produced from 1969 to 2016. Envisaged as funerary steles, the works are not intended to represent the deceased or his political struggle in any literal way. Instead, the artist made them "in memoriam" of a "historical icon whose life radiated far beyond the politics of the temporal."[5] After producing the first four *Malcolm X* works in 1969, Chase-Riboud did not return to the subject until 2003, when she created four more steles. She made five more in 2007–8, and the final seven in 2016. *Malcolm X #17* was first exhibited at Michael Rosenfeld Gallery, New York, in 2017. Cast at the Fonderia Artistica Mapelli outside Milan, it has a gold patina, which the artist chose to add reflectivity and illumination, rather than the black patina of most of the series. Describing the work's forms as "flowing, convoluted, mobile—like music," the artist acknowledges the influence of the Baroque, which has captivated her since her time in Rome.[6] Fundamentally, *Malcolm X #17* is an object that celebrates light, movement, and material union. "The silk material is motion," Chase-Riboud says. "Each strand is alive. The polished bronze is light, always reflecting the noble material and sublime materiality."[7] HJ

1. Barbara Chase-Riboud, "Memory Is Everything: Barbara Chase-Riboud in Conversation with Hans Ulrich Obrist," *Mousse*, October 4, 2017, https://www.moussemagazine.it /magazine/barbara-chase-riboud-hans-ulrich-obrist-2017/.
2. Barbara Chase-Riboud, "Taken to Its Extreme: The Malcolm X Steles; Barbara Chase-Riboud in Conversation with Carlos Basualdo," in *Barbara Chase-Riboud—Malcolm X: Complete*, exh. cat. (New York: Michael Rosenfeld Gallery, 2017), 14.
3. Ibid., 27.
4. Barbara Chase-Riboud, "Barbara Chase-Riboud Talks about Her 'Malcolm X' Series," interview by Grant Johnson, *Artforum*, October 24, 2017, https://www.artforum.com /interviews/barbara-chase-riboud-talks-about-her -malcolm-x-series-71850.
5. Chase-Riboud, "Taken to Its Extreme," 23.
6. Ibid., 11.
7. Ibid., 7.

29. *Malcolm X #17*, 2016
Bronze and silk
92 × 41 × 36 in. (233.9 × 104.1 × 91.4 cm)

Judy Chicago

Born Chicago 1939

A foundational figure in the first generation of feminist artists, Judy Chicago has worked as an artist, educator, and author for over fifty years, championing women's achievements in art and society and encouraging the full expression of women's experience. She employs painting, print-making, sculpture, and installation alongside traditional crafts such as pottery and needlework, often working collaboratively with other women. Throughout her career, Chicago has trained in unusual technical processes, including automotive painting and pyrotechnics, in pursuit of her artistic aims.

Born Judith Cohen into a liberal, politically active family on the North Side of Chicago, the artist moved in 1957 to Los Angeles, where she enrolled at UCLA. She began her career as part of the Finish Fetish group, which was associated with the influential Ferus Gallery and included Craig Kauffman (1932–2010) and Billy Al Bengston (1934–2022), among others. Inspired by the materials and industrial processes of the car industry, they created pristine, brightly colored objects that celebrated a Minimalist aesthetic as well as the popular and visual culture of California. After receiving her MFA in 1964, Chicago enrolled in an auto body class, where she learned the spray-painting technique. Recalling her enthusiasm for the approach, which she first used in her *Car Hood* series, she later said, "When I discovered spray paint—the idea of merging color and surface, I was hooked."[1] From the late 1960s, Chicago also created *Atmospheres*, ephemeral, landscape-based performances incorporating fireworks, flares, and colored smoke.

Dark Red, Blue, Green Domes (small) belongs to a group of sculptures comprising hemispheres, or "domes," that Chicago made during her Minimalist period, between 1968 and 1971. With its simple geometric forms, gradated hues, and slick, reflective finish, this example illustrates the influence of the Finish Fetish aesthetic. Speaking of the importance of her Los Angeles context, Chicago has said, "My formal language, my color language, my approach to art-making, I built it here."[2] And yet, despite its industrial origins, the work is also subtly feminine, its rounded forms reminiscent of two breasts and a pregnant belly. Alongside the "dome" sculptures, Chicago created a number of prismatic drawings in which she explored the permutations of color through a vocabulary of geometric shapes.

By the end of the decade—viewing art as "a symbol of systemic inequity," which mirrored the marginalization of women in everyday life—Chicago resolved to use her own practice to promote women and their accomplishments.[3] In 1970, in an act of liberation from the patriarchy, she legally adopted the surname "Chicago," after the city of her birth. She revealed the change first with an exhibition announcement in the October 1970 issue of *Artforum* and then, in the December issue, with a now-iconic advertisement showing herself dressed as a boxer. In the same year, she pioneered a studio program for women at Fresno State College (now California State University, Fresno). Designed to diversify artistic practice with new forms of expression based on women's experience (including collaboration and performance) and to research the contributions of women to the fields of visual art and literature, the Feminist Art Program soon moved to California Institute of the Arts (CalArts), where Chicago taught alongside her mentor, the artist Miriam Schapiro (see pl. 9).

From the 1970s onward, Chicago continued to develop a uniquely woman-oriented iconography. As she has explained, "After struggling for a decade in a male-dominated art community, I decided to take the risk of being who I was as an artist and as a woman. I attempted to reconcile my personal subject matter and style with a formalist visual language."[4] Chicago, who has written prolifically since meeting the writer Anaïs Nin in the early 1970s, began to combine visual imagery with text. Floral imagery emerged as a "symbol of femininity" and later evolved into vaginal forms.[5] Other bodies of work have addressed masculine power, the taboo of menstruation, the birthing experience, and the Holocaust. From 1974 to 1979, Chicago created the monumental installation *The Dinner Party*, which celebrates notable women in art and history through thirty-nine porcelain-and-textile place settings, predominantly featuring the vulva motif. On permanent display at the Brooklyn Museum, it remains a landmark of feminist art practice.　HJ

1. Judy Chicago, quoted in Carolina A. Miranda, "Judy Chicago Says, 'I Was Being Erased' from Southern California Art History," *Los Angeles Times*, September 6, 2019, https://www.latimes.com/entertainment-arts/story/2019-09-06/judy-chicago-beyond-the-dinner-party-feminist-art-jeffrey-deitch-los-angeles.
2. Ibid.
3. Judy Chicago, quoted in Gloria Steinem, "Feminist Art Icon Judy Chicago Isn't Done Fighting," *Interview*, December 11, 2017, https://www.interviewmagazine.com/art/feminist-art-icon-judy-chicago-isnt-done-fighting.
4. Judy Chicago, quoted in Viki D. Thompson Wylder, "Breakthrough Years: 1972–1975," in *Judy Chicago*, ed. Elizabeth A. Sackler, exh. cat. (New York: Watson-Guptill; Elizabeth A. Sackler Foundation, 2002), 28.
5. Judy Chicago, *Through the Flower: My Struggle as a Woman Artist* (New York: Penguin, 1975), 141.

30. *Dark Red, Blue, Green Domes (small)*, 1968
Acrylic spray lacquer on acrylic, with glass-and-plexiglass base
Overall including base 9⅜ × 15½ × 15½ in. (23.8 × 39.4 × 39.4 cm), each dome 1⅞ × 4⅞ × 4⅞ in. (4.8 × 12.4 × 12.4 cm)

Louise Fishman

Philadelphia 1939–2021 New York City

Born in Philadelphia, Louise Fishman grew up surrounded by art. Her mother, Gertrude Fisher-Fishman (1916–2013), had studied at the Barnes Foundation in Merion, Pennsylvania, and produced French modernist–inspired abstractions, while her aunt, Razel Kapustin (1908–1968), had trained alongside Jackson Pollock with the Mexican Social Realist David Alfaro Siqueiros. Fishman initially aspired to become a professional athlete but also immersed herself in her mother's library, where issues of *ARTnews* portrayed artists such as Willem de Kooning, Franz Kline, and Joan Mitchell at work in their studios. Fishman embarked on her education as a painter in 1956, studying at the Philadelphia College of Art (now University of the Arts), Pennsylvania Academy of the Fine Arts, and finally at Temple University's Tyler School of Art, from which she earned a BFA in 1963.

In 1965, after earning her MFA from the University of Illinois in Urbana-Champaign, Fishman moved to New York, where she spent a period producing hard-edge geometric abstractions. However, she quickly became involved with the emerging women's movement as well as the movement for lesbian and gay rights. She attended consciousness-raising (CR) sessions organized by radical feminist groups such as W.I.T.C.H. and the New York Feminist Art Institute and cofounded her own (unnamed)

CR group, which included Harmony Hammond (see pl. 50). Recalling the impact of her involvement in these activities, she later said, "I knew I was home! I felt like I was walking in my own shoes for the first time."[1] As she grappled with her double invisibility in the art world—as both a woman and a lesbian— she sought radical change in every element of her practice. Attempting to "figure out what part of me came from all the male stuff in my history and to eliminate it," she initially disregarded paint in favor of craft techniques, dyeing and cutting up canvas squares before sewing them back together.[2]

Fishman produced *Victory Garden of the Amazon Queen* in 1972 after returning to her original medium. Featuring variously obscured letter Vs against abstract backgrounds, its defiantly feminist title refers, as the artist once explained, "to the Victory Gardens my parents' generation grew during the war."[3] It was first exhibited at the Whitney Biennial in 1973, next to a wall-sized painting by Kenneth Noland.[4] Despite its intimate size, Fishman said, "My little painting really stood right up to that Noland; I was so pleased."[5] In 1973, the artist painted her seminal *Angry Women* series (see fig. 1 on p. 72), which combined abstract backgrounds with the names of friends and feminist icons and the word "angry" scrawled in visceral strokes. Speaking of the importance of language as a means of fulfilling

31. *Victory Garden of the Amazon Queen*, 1972
Acrylic on linen (4 parts)
Each 13¾ × 13 in. (34.9 × 33 cm)

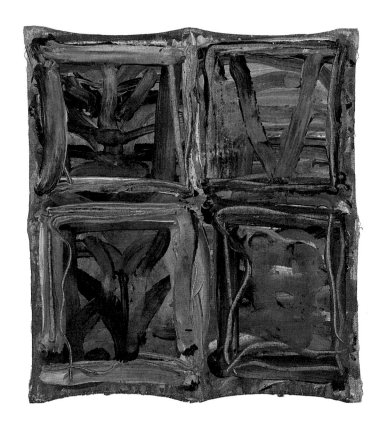
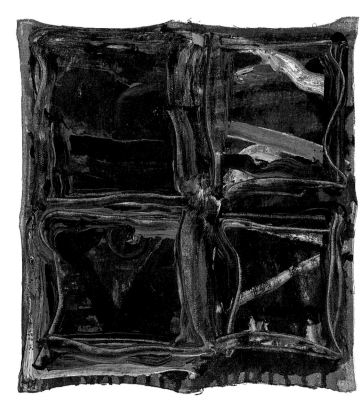

a feminist agenda during this period, Fishman explained, "Using words and bringing narrative into the titles were attempts to communicate in a way that I felt abstract painting was not communicating to the women who were my closest allies."[6]

Despite the fact that Abstract Expressionism had, by this time, been widely recast as a manifestation of masculine ego, Fishman remained committed to renegotiating its gestural language for her own experience, citing the "feeling of tremendous freedom" it gave her.[7] She applied her paint vigorously, using serrated trowels as well as brushes with a determined physicality that matched that of her predecessors. "I felt that abstract expressionist work was an appropriate language for me as a queer," she said. "It was a hidden language, on the radical fringe, a language appropriate to being separate."[8]

A shift in Fishman's practice occurred following a visit to the Auschwitz and Terezín concentration camps with a Holocaust-survivor friend in 1988. The result was her *Remembrance and Renewal* series, in which she mixed oil paint with beeswax and sediment from the Pond of Ashes at Auschwitz, said to contain the ashes of people who were murdered there. Further change came in the 1990s when she moved to New Mexico following a fire that devastated her New York studio. Executed in

an enduringly expressive style, her final paintings explore the natural world, particularly the element of water, calligraphically and through a meditative lens.

HJ

1. Louise Fishman, quoted in Helaine Posner, "Louise Fishman: The Energy in the Rectangle," in *Louise Fishman*, ed. Helaine Posner, exh. cat. (Purchase: Neuberger Museum of Art, Purchase College, State University of New York; Philadelphia: Institute of Contemporary Art, University of Pennsylvania; Munich: DelMonico Books/Prestel, 2016), 13.
2. Louise Fishman, quoted in Carrie Moyer, "A Restless Spirit," *Art in America* 100, no. 9 (October 2012): 130.
3. Louise Fishman, "Getting Small with Louise Fishman," interview by Ingrid Schaffner, in Posner, *Fishman*, 188.
4. The exhibition's curator, Marcia Tucker, placed *Victory Garden of the Amazon Queen* next to Kenneth Noland's *Sun Bouquet* (1972).
5. Louise Fishman, quoted in Alexxa Gotthardt, "On Louise Fishman's Hard-Won Task: Making Feminism and Abstract Expressionism Play Nice," *Artsy Editorial*, November 9, 2015, https://www.artsy.net/article/artsy-editorial-louise-fishman -on-making-abstract-painting-a-feminist-pursuit.
6. Fishman, "Getting Small," 188.
7. Louise Fishman, quoted in Nancy Princenthal, "Louise Fishman: Language Lessons," in Posner, *Fishman*, 53.
8. Fishman, quoted in Posner, "Fishman: The Energy in the Rectangle," 12.

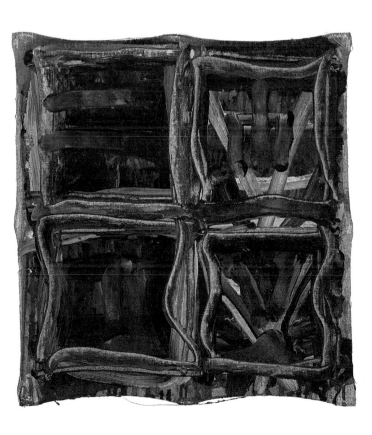 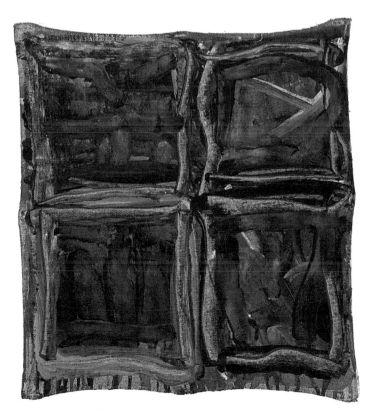

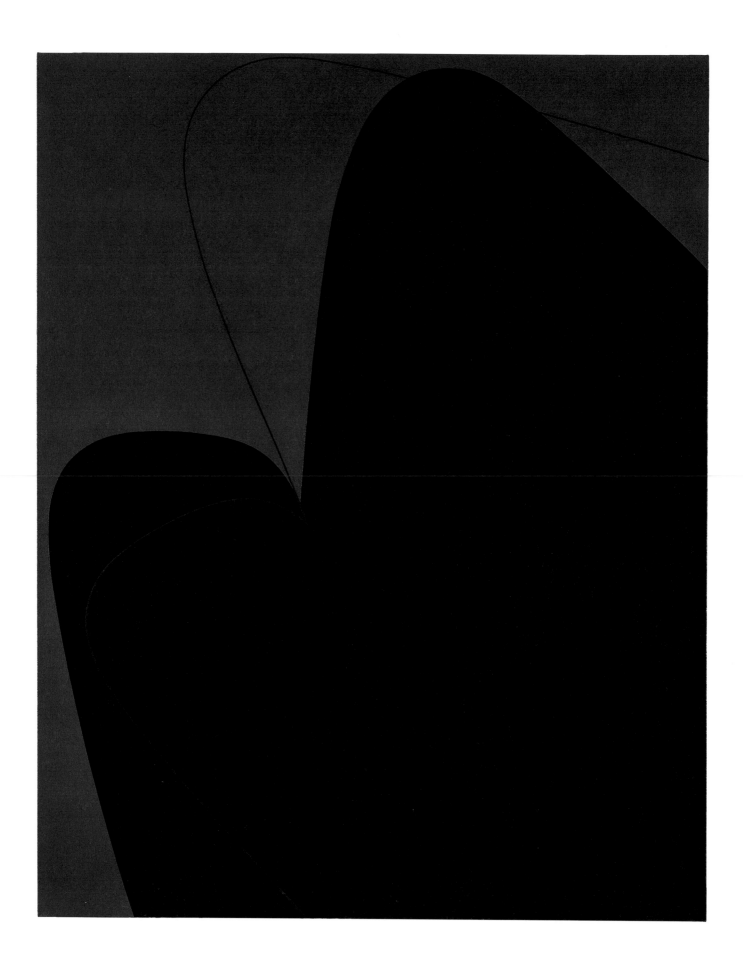

Virginia Jaramillo

Born El Paso 1939

Between 1969 and 1974, Virginia Jaramillo created a series known as the *Curvilinear Paintings*. In most of these large-scale works, a single curved line extends across a monochromatic field from one edge of the canvas to another. "Sometimes, it would take weeks just to get that line the way I wanted," the artist later commented. "It had to be right—it had to flow like a strand of hair."[1] *Infraction IV* is one of the earliest paintings in this body of work and is typical of the initial *Curvilinear* abstractions in its inclusion of large, rounded forms in what might be construed as the foreground. A painting titled *Genesis*, made the year before, is also purple, black, and red and has a similar structure, although the black portion is bisected into two separate, mound-like segments. As the artist developed the series, she would eventually deduct this compositional element, and the works became increasingly streamlined.

This period represented a major breakthrough for Jaramillo, who by then had been painting for nearly a decade. Following her graduation from the Otis Art Institute (now Otis College of Art and Design) in 1961, she continued to work in Los Angeles, her hometown since early childhood, where her paintings had already garnered attention: for three successive years, while she was still in art school, her work was accepted into the annual group exhibition at the Los Angeles County Museum of Art. Jaramillo's paintings of the early to mid-1960s featured areas of rough texture juxtaposed with a smoother black or umber surface. Reminiscent of sun-scorched terrain, these dark, gestural compositions were inspired by the expansive California landscape, in particular the ranch owned by her grandparents in Imperial Valley, which "really stayed with me. When I did those black paintings, I was trying to get to that—some kind of textural quality of earth."[2] The works can also be understood in relation to the racial tensions that led to the Watts Rebellion of 1965, which severely damaged Jaramillo's neighborhood in South Los Angeles.[3]

An enduring theme throughout Jaramillo's six-decade career, the sense of vastness explored in these early works led directly to the *Curvilinear Paintings*, which sought to emphasize negative space. The artist embarked on the series after a residency in Paris in 1965, which, as she recalls, "zipped open my brain."[4] Upon returning to the United States, she moved permanently to New York and set up a studio on SoHo's Spring Street; there, her work changed course. "That was the opening of my consciousness, aesthetically," the artist says.[5] Jaramillo's experiences in Europe solidified her interest in the Japanese concept of *ma* (literally, "gap" or "pause"), in which empty space is considered as important as occupied space. The artist generated the resulting paintings through an extensive process involving dozens of sketches of a single line on paper measuring eight by ten inches. She would then select one drawing to transpose onto canvas.

In 1971, the curator Peter Bradley selected two of the *Curvilinear* works for *The De Luxe Show* in Houston. This landmark exhibition, funded by the Menil Foundation, presented leading painters and sculptors who, like Jaramillo, were exploring new approaches to hard-edge abstraction, including Anthony Caro, Sam Gilliam, Kenneth Noland, and Jules Olitski. Jaramillo was the only woman on the roster. The following year, her painting *Green Dawn* (1970), which had been shown in Houston, also featured in the Whitney Museum of American Art's annual show (precursor to the Whitney Biennial). After the *Curvilinear* series, Jaramillo shifted to a new technique with her *Stained Paintings* (ca. 1975–79), which incorporated layers of translucent paint. Most recently, as part of her ongoing *Foundations* series, begun in the 1980s, the artist has investigated antiquity—specifically, prominent architectural sites that are now in ruins—recording mere traces of them in geometric fields of solid color.[6]

Infraction IV was shown in public for the first time in 2020 as part of the exhibition *Virginia Jaramillo: The Curvilinear Paintings, 1969–1974* at the Menil Collection in Houston. It was the first solo museum show of the artist's career. AB

1. Virginia Jaramillo, quoted in Maximilíano Durón, "Best Practices: Virginia Jaramillo's Abstractions Are Finally Coming into Focus," *ARTnews*, February 16, 2021, https://www.artnews.com/art-news/artists/virginia-jaramillo-artist-studio-visit-1234583813/.
2. Virginia Jaramillo, "No. 465: Virginia Jaramillo," *The Modern Art Notes Podcast*, October 1, 2020, audio, 58:55, https://manpodcast.com/portfolio/no-465-virginia-jaramillo/.
3. Christine Macel, "Virginia Jaramillo," in *Women in Abstraction* (London: Thames and Hudson, 2021), 270.
4. Jaramillo, "No. 465: Jaramillo."
5. Ted Loos, "A Painter Who Puts It All on the Line," *New York Times*, September 25, 2020, https://www.nytimes.com/2020/09/25/arts/design/virginia-jaramillo-menil-houston.html.
6. Matthew Jeffrey Abrams, "Painting at the Margins: Virginia Jaramillo's *Foundations*," in *Virginia Jaramillo: Foundations* (London: Hales Gallery, 2018).

32. *Infraction IV*, 1970
Acrylic on canvas
60 × 48 in. (152.4 × 121.9 cm)

Mary Heilmann

Born San Francisco 1940

Mary Heilmann is one of the most influential abstract painters of her generation. Her joyful, brightly colored canvases display a playful and spontaneous approach to color and form shaped by a childhood and young adulthood spent on California's beaches, listening to music and imbibing the 1960s counterculture. Heilmann's work is also deeply influenced by the philosophies of the Beat Generation, which she first discovered on reading *Howl*, Allen Ginsberg's 1956 volume of poems, as a teenager in San Francisco. The artist immediately wished to align herself with the Beat movement, which offered a new "sense of mission" to replace the Bible stories she had learned at Catholic school and the cowboy sagas she read in comics. "The Beats were my new cowboys, my new saints," she once said. "I wanted to be a beat chick with black stockings and heavy eyeliner."[1]

Heilmann originally studied literature at the University of California, Santa Barbara, before switching to poetry and ceramics at San Francisco State University and, later, the University of California, Berkeley. Moving to New York in 1968, she immersed herself in a vibrant avant-garde community, and through Richard Serra—a friend from San Francisco—she was introduced to other artists, including Carl Andre, Eva Hesse, Robert Smithson, and Keith Sonnier. Despite her best efforts in this environment, Heilmann was omitted from a number of key survey exhibitions of contemporary sculpture, including *Anti-Illusion: Procedures/Materials* at New York's Whitney Museum of American Art in 1969. It was this disappointment—despite her reservations about contemporary painting—that encouraged her to make the switch to a medium that she had sampled as a student but not fully embraced.

While her nonrepresentational canvases employ the vocabulary of geometric abstraction—their squares, rectangles, grids, and lines recalling the work of artists from Piet Mondrian to Ellsworth Kelly—a closer look reveals that the apparently casual simplicity of Heilmann's painted forms is deceptive. The grid is always slightly awry; freely drawn vertical and horizontal lines are not quite straight; and paint is applied with an uneven looseness that results in irregular and blurred margins. Layers, drips, and thin washes of paint all appear in her repertoire—a remnant, perhaps, of her experience with glazes as a ceramist.

Undercutting the seriousness of abstraction, Heilmann's seemingly nonchalant technique disguises a complex exploration of painterly space in keeping with the purposeful details of her works' fabrication, which gradually reveal themselves to a patient viewer. This approach reflects her admiration for Japanese and Chinese aesthetics in both two and three dimensions. She loves *wabi-sabi*, the pursuit of imperfection in ceramics and other media, and she is "obsessed with the space in Asian painting . . . how there can be several kinds of space at once. I play with this idea as I look, my eye and my mind flicking back and forth from one sense of space to another. This is the front. That's behind. No, that's the front and this is the background. . . . Gazing at a picture like this can amuse me for hours. It's like watching a movie."[2]

Representative of the artist's fascination with visual space, *San Francisco (Day)* and *San Francisco (Night)* suggest the same cityscape under different lighting conditions. The windowed façade of a building, colorfully lit from within, is implied by six small rectangles of vivid color that shine through a layered background: black overpainted with white, in the daytime view, and white overpainted with black, to represent night. Evoking the sensation of watching the world go by at different times of day—as, perhaps, from a bedroom window in a childhood home—these works demonstrate the way in which Heilmann's practice is inextricably linked to her own experience. As she has said, "Behind my choices of color, surface and scale, there is always a memory of a place or event."[3] HJ

1. Mary Heilmann, "The All-Night Movie" [1999], reprinted in *Mary Heilmann: Good Vibrations*, ed. Paula van den Bosch and Angelika Nollert, exh. cat. (Cologne: Walther König, 2012), 184–85.
2. Ibid., 179.
3. Mary Heilmann, quoted in Dominic van den Boogerd, "Eternal Sunshine," in van den Bosch and Nollert, *Heilmann: Good Vibrations*, 16.

33.

San Francisco (Day), 1990
Oil on canvas
54⅛ × 36¼ in. (137.5 × 92.1 cm)

San Francisco (Night), 1990
Oil on canvas
54⅛ × 36¼ in. (137.5 × 92.1 cm)

Elizabeth Murray

Chicago 1940–2007 Granville, New York

Celebrated for her elaborately three-dimensional, often brightly colored canvases, Elizabeth Murray belonged to a cohort of artists who emerged together in New York in the 1970s but against whose often process-oriented work her own stuck out like a lightning bolt or an exclamation point (both of which happen to have been literal motifs in her repertoire).[1] In 2005, two years before her untimely death, she became one of the few women to receive a retrospective at the Museum of Modern Art, New York, during her lifetime.

Inspired by comic strips and Walt Disney, Murray drew avidly throughout her childhood. In 1958, she enrolled at the School of the Art Institute of Chicago, hoping to become a commercial artist, but a work by Paul Cézanne in the museum's collection sparked different aspirations. Speaking of the encounter, she later said, "I was thrilled by his use of color, his application of paint, his emotion. . . . I wanted to be a painter. It was a kind of magical decision."[2] Setting her sights on New York—whose rich artistic culture she had discovered through *Artforum* magazine as a student—Murray moved to the city in 1967. In spite of the widespread contemporary critique of painting's value, she steadfastly continued to paint, producing works full of curvaceous geometric shapes and waves of lines that interrogated the strategies of Minimalism.

Perhaps the most significant breakthrough of Murray's career came in the late 1970s, when she translated her interest in the "objectness" of painting into the support itself. While she had been hanging some of her rectangular canvases diagonally since the mid-1970s, asymmetrical and irregular structures began to emerge from her studio at the end of the decade, influenced, to some extent, by the work of Ron Gorchov (1930–2020) and Frank Stella (born 1936). The artist tested ideas for these structures with reliefs made of unfired clay, then used templates to cut the necessary shapes out of plywood. These she beveled and sanded before stretching canvas over them to make uniquely shaped supports. In 1987, Murray said, "My paintings evolve in an organic way. . . . Certain kinds of shapes emerge, are changed, modified until I feel they are integrated and

resolved. I started painting on flat canvases, but gradually they became split, then fractured, then shaped. Now they are more and more three-dimensional."[3]

The evolution of Murray's canvases paralleled the evolution of her imagery, particularly her interest in biomorphic forms, such as those in the work of Jean Arp and Joan Miró. As these motifs began to materialize in her own work, their organic curves were reflected in the supports. Elements of popular culture and her daily life are also visible: In some paintings, fractured picture planes depict a Cubist iconography of tables, coffee cups, and shoes. In others, elongated figures and punctuation marks evoke the Chicago Imagists—who had been contemporaries of hers at the School of the Art Institute—as well as the urban graffiti artists of 1980s New York.

First exhibited at the Staatsgalerie Moderner Kunst, Munich, in spring 1991, *Joanne in the Canyon* is emblematic of Murray's work of the period. The surface is built up with multiple layers of oil paint in jarring colors, scraped across the surface with palette knives as well as brushes. An orange biomorphic form—with swirling protrusions suggestive of human limbs—extends over the visibly fragmented canvas. While the material object physically projects from the wall, compositional elements within it appear to recede, creating a sense of perspective. At the center is a vortex-like hole—the canyon, perhaps, of the painting's humorously rhyming title. As the artist summed up in 2005, more important than narrative in her work is "making the images move. To me," she continued, "it's bizarre, and funny, and sad at the same time, and total fantasy."[4]

HJ

1. On Murray's incongruity in her generation, see Carrie Moyer, "Carrie Moyer on Elizabeth Murray," *Painters on Paintings* (blog), September 25, 2014, https://painters onpaintings.com/carrie-moyer-on-elizabeth-murray/.
2. Elizabeth Murray, quoted in Robert Storr, *Elizabeth Murray*, exh. cat. (New York: The Museum of Modern Art, 2005), 26.
3. Elizabeth Murray, quoted in Barbara Rose, "Elizabeth Murray: The Shape of Things to Come," *Vogue*, July 1987, 225.
4. Murray, quoted in Storr, *Murray*, 189.

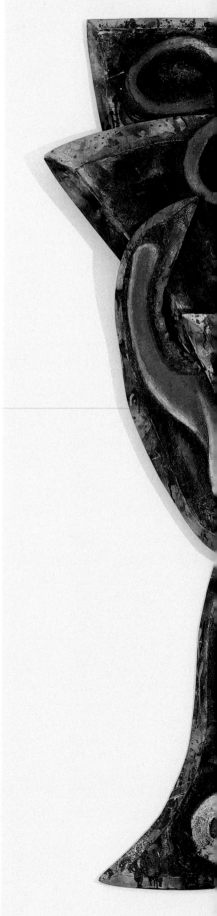

34. *Joanne in the Canyon*, 1990–91
Oil on canvas
78 × 84 × 6½ in. (198.1 × 213.4 × 16.5 cm)

Jaune Quick-to-See Smith

Born Saint Ignatius Mission, Confederated Salish and Kootenai Nation, Montana, 1940

In addition to her vocation as a painter, Jaune Quick-to-See Smith, a citizen of the Confederated Salish and Kootenai Nation, has worked as an influential curator, educator, and political activist for decades. Smith began her career in New Mexico in the mid-1970s. Like many artists of her generation, as well as those who have followed, she has a long-standing concern with the dispossession of Native lands. She has articulated her response to this ongoing controversy through the medium of landscape, which plays an enduring role in her practice. While her earliest works on paper convey the natural world in pastoral terms, her more recent output has focused on the connections between people and the land they inhabit and on the scars that that conflicted relationship leaves on both parties.

Petroglyph Park: Escarpment is part of a series of paintings that arose from deeply personal circumstances. Taking as its subject a location near the artist's home—an area known as the West Mesa escarpment, a few miles west of the Río Grande and the city of Albuquerque where more than twenty thousand ancient petroglyphs are carved into volcanic rock—it visualizes the struggle by the region's Indigenous people to protect the sacred site from a suburban housing development in the mid-1980s. Punctuated by stylized petroglyphs, the deep-blue river winds diagonally through the composition. The pictorial space is deliberately flattened, and the palette of warm, earthy tones— in addition to white and black, colors loaded with symbolic meaning for many Native American communities—conveys the beauty of the natural environment as well as its cultural significance. While the work's aesthetic evokes the appealing immediacy of 1980s graffiti culture, Smith remains focused on its political undertones. As she has explained, "My work has layered meanings. . . . I like to bring the viewer in with a seductive texture, a beautiful drawing, [and] then let them have one of the messages."[1]

In the 1990s, Smith began to work with the mixed media for which she is now best known. Combining source material from popular culture with art-historical references and Native American motifs, her canvases of this period incorporate fabric swatches, newspaper cutouts, photographs, maps, and comics, which she covers with drips of gesturally applied paint. Much of the source material references iconic personages, such as Chief Seattle, a nineteenth-century leader of the Suquamish and Duwamish peoples, who is best remembered for a political speech—available in many contested translations—he delivered in 1854 as he was forced to surrender his people's traditional lands to the United States government. The juxtaposition of text and landscape throughout Smith's oeuvre explores the complex histories of colonial exploitation as well as the reality of its enduring legacy for Indigenous communities. Elsewhere, the artist uses found objects, both authentic and inauthentic, to produce more complex assemblages. Baseball caps displaying racist caricatures, bumper stickers, beaded belts, artificial flowers, and toy headdresses appear alongside masterfully crafted parfleches. Through this conflation of opposing iconographies, Smith reflects upon her own complex identity and the uncertain sociopolitical status held by many Indigenous people today.

In her most recent works—such as *In the Future Map* (see p. 127)—the artist has moved beyond local and ethnic concerns to address the global environmental crisis. Part of the twelve-part series *Indigenizing the Colonized U.S. Map*, the painting features a map of the forty-eight contiguous states, rotated 90 degrees and embellished with paint and collaged elements. Newspaper clippings referencing global warming and Elon Musk's galactic ambitions sit alongside a reproduction of Eadweard Muybridge's stop-motion sequence of a buffalo in motion (covering most of North Dakota), poignantly evoking the historical fate of many Native Americans. For Smith, maps are political documents as much as topological ones—testaments to the tyranny of exploitation. Speaking of these recent paintings, she has remarked, "A map is not an empty form for me. . . . It's about real land— stolen land, polluted land."[2]

HJ

1. Jaune Quick-to-See Smith, quoted in Carolyn Kastner, *Jaune Quick-to-See Smith: An American Modernist* (Albuquerque: University of New Mexico Press, 2013), 40.
2. Jaune Quick-to-See Smith, "Jaune Quick-to-See Smith Maps New Meanings," interview by Joshua Hunt, *T: The New York Times Style Magazine*, December 2, 2021, https://www.nytimes.com/2021/12/02/t-magazine/jaune-quick-to-see-smith.html.

35. *Petroglyph Park: Escarpment*, 1987
Oil on canvas
72 × 60 in. (182.9 × 152.4 cm)

Joan Snyder

Born Highland Park, New Jersey, 1940

Joan Snyder gained critical acclaim in the early 1970s with her "stroke paintings," abstract canvases characterized by separate, mostly horizontal lines of differing colors and textures. Even before her first full-scale solo exhibition at New York's Paley and Lowe gallery in 1971, she was the subject of a major article in *Artforum* by Marcia Tucker, then a curator at the Whitney Museum of American Art, who lauded her as an essential counterpoint to the male-dominated fields of Minimalism and color-field painting. Over the past fifty years, Snyder has continued to innovate: her technical experimentation and use of unconventional materials have challenged the boundaries of abstract painting for both viewers and subsequent generations of artists.

Coinciding with the expansion of the women's movement, Snyder's swift critical acclaim inevitably brought with it the pressures of publicity. As an escape from city life, she bought a farm in Martins Creek, Pennsylvania, and moved there in 1973. The freedom of this new environment corresponded with a shift in her practice, allowing her feminist sensibilities to emerge in works that were about—in her own words—"trying to paint the internal, organic, anthropomorphic sense of being a woman."[1] Despite her evolving subject matter, Snyder's exploration of the *ways* paint can be applied to a canvas has remained a constant in her work. Lines, dabs, drips, smears, and stains coexist in complex compositions that seem to give each individual mark equal standing. Color is used sensitively to denote atmosphere and feeling—the artist has said, "different colors have different sounds and different meanings to me"—and despite her works' fluid appearance, her process is a methodical one.[2] As Snyder has explained, "I can be very spontaneous and very much in control at the same time. There's not a mark or drip [that] isn't meant to be there."[3]

First used to structure the "stroke paintings" in the form of an underlay drawn in pencil, the grid has remained an important compositional tool for the artist. Acting as "scaffolding," as Tucker termed it in *Artforum*—a framework upon which to layer color and form—the grid offers an entry point into a painting, allowing the viewer to make sense of each section in turn.[4] Speaking of the grid as both a regulating force and something to be challenged, Snyder has remarked, "Every grid that I've ever made has been different. I've rarely made the same grid twice. But it was a structure for me to either destroy on the way to making the painting or stay within like a musical staff, providing order."[5]

Like a number of Snyder's works of the same year, *Untitled* has a two-part composition. Separating the canvas into two distinct halves, a vertical border at the center divides loosely painted horizontal lines of varying colors and thicknesses, on the left, from a checkerboard of irregularly sized squares and rectangles filled in with relatively solid colors, on the right. Snyder used the grid in this way as a sectioning device to differentiate contrasting approaches to the application of paint within the same work. Providing a fundamental order and a kind of anchor, or resolution, to the instability of fluid brushwork elsewhere, these solid gridded sections—termed "resolves" by the artist—work to regulate ideas and explorations in paint.[6] HJ

1. Joan Snyder, interview by Phong Bui, *Brooklyn Rail*, September 2008, https://brooklynrail.org/2008/09/art/joan-snyder-in-conversation-with-phong-bui.
2. Joan Snyder, quoted in Hayden Herrera, "Joan Snyder: Speaking with Paint," in *Joan Snyder*, by Hayden Herrera, Norman L. Kleeblatt, and Jenni Sorkin, exh. cat. (New York: Jewish Museum; Harry N. Abrams, 2005), 31.
3. Ibid., 42.
4. Marcia Tucker, "The Anatomy of a Stroke: Recent Paintings by Joan Snyder," *Artforum* 9, no. 9 (May 1971): 43, https://www.artforum.com/print/197105/the-anatomy-of-a-stroke-recent-paintings-by-joan-snyder-37523.
5. Snyder, interview by Bui.
6. Snyder, quoted in Herrera, "Snyder: Speaking with Paint," 36.

36. *Untitled*, 1974
Oil, acrylic, wax, gauze, and tape on canvas
60 × 60 in. (152.4 × 152.4 cm)

Pat Steir

Born Newark, New Jersey, 1940

Raised in southern New Jersey, near Philadelphia, Pat Steir benefited greatly from that city's cultural institutions: paintings by Paul Cézanne, Henri Matisse, and Vincent van Gogh shaped her early artistic education, as did Marcel Duchamp's iconic *Large Glass* (1915–23; Philadelphia Museum of Art). She studied art and philosophy at Boston University before receiving her BFA in 1962 from Brooklyn's Pratt Institute, where her teachers included Adolph Gottlieb (1903–1974) and Philip Guston (1913–1980). In the early 1970s, after working in book publishing for several years, Steir taught at Parsons School of Design, Princeton University, and California Institute of the Arts (CalArts), where Amy Sillman (see pl. 64) was among her students. She was a cofounder of the quarterly feminist journal *Heresies* in 1976.

During her tenure at CalArts, Steir introduced the floral imagery that would become a defining characteristic of her earliest work. She painted a number of canvases depicting monochromatic silhouettes of roses crossed out with large Xs with a view to disrupting their iconographic status and symbolic meaning. She also used flowers as a motif through which to explore the art-historical canon. Painted between 1982 and 1984, the largest work in the monumental *Brueghel Series (A Vanitas of Style)* is a grid of sixty-four individual panels, each executed in the style of a different artist or school, which, from a distance, cohere into a magnified replica of a floral still life by Jan Brueghel the Elder (1568–1625).

Later in the 1980s, Steir began to experiment with poured paint, producing the "waterfall" paintings for which she is best known. To create them, she thinned paint with turpentine into different consistencies before pouring it down from a height onto unstretched canvases tacked to the studio wall. Over time, Steir built up layers of contrasting colors, resulting in compositions of a vivid chromatic intensity. An interest in Japanese woodcuts, Chinese ink painting, and Eastern philosophy influenced this body of work, as did Steir's contact with several new artist-mentors, including John Cage (1912–1992), whom she met in 1980, and Agnes Martin (1912–2004), whom she visited in New Mexico every year for three decades. Speaking of their impact, as well as that of Sol LeWitt (1928–2007), Steir recently said, "John talked to me about chance and Zen Buddhism, Sol about his

more conceptual approach. All three shared their philosophies about art with me."[1] While Martin's work took a different direction from Steir's, the younger painter noted that "it was how [Martin] thought about her work, how she approached it that I feel close to."[2]

Lessons from all three artists find expression in Steir's "waterfall" paintings. By pouring from above, she relinquishes control of the artistic process. Instead, gravity, chance, and the viscosity of the paint itself determine the work's outcome. Speaking in Veronica Gonzalez Peña's 2019 documentary *Pat Steir: Artist*, Steir explained, "My idea was not to touch the canvas, not to paint, but to pour the paint and let the paint itself make a picture. I set the limitations . . . the color, the size, the wind in the room, and how I put the paint on. And then everything outside of me controls how that paint falls. It's a joy to let the painting make itself. It takes away all kinds of responsibility."[3]

Over time, Steir's "waterfall" paintings evolved into a series the artist has referred to as "the Split."[4] She produces the works by the same pouring technique but layers the paint in broader swaths and bifurcates the canvases vertically at the center in a gesture reminiscent of Barnett Newman's "zips" of the late 1940s on. Drawing on dualistic principles central to Chinese and Japanese religion and philosophy, these works seem to represent two distinct sides of the same entity. *For Philadelphia Three*—first exhibited as part of the artist's 2014 solo presentation at Locks Gallery in Philadelphia—was created in this vein. The third in a trio of works named for the city, it seems to evoke the stonework of the Philadelphia Museum of Art itself in its solidity and its yellow and ochre tones. HJ

1. Pat Steir, "Pat Steir—Interview: 'I Want the Paint to Make the Painting, to Make a Picture of Itself—It's Process, Gravity and Chance,'" by Lilly Wei, *Studio International*, August 15, 2020, https://www.studiointernational.com/index.php /pat-steir-interview.
2. Ibid.
3. Pat Steir, quoted in Colm Tóibín, "The Flow of Chance: Pat Steir's 'Waterfall' Paintings," *New York Review of Books*, May 11, 2019, https://nybooks.com/daily/2019/05/11/the -flow-of-chance-pat-steirs-waterfall-paintings.
4. Pat Steir, "'The Paint Makes Its Own Image'—An Interview with Pat Steir," *Apollo*, January 22, 2019, https://www .apollo-magazine.com/the-paint-makes-its-own-image -an-interview-with-pat-steir/.

37. *For Philadelphia Three*, 2013
Oil on canvas
84 × 84 in. (213.4 × 213.4 cm)

Jennifer Bartlett

Long Beach, California, 1941–2022 Amagansett, New York

After graduating from Mills College in Oakland, California, with a BA in 1963 and receiving an MFA from the Yale School of Art and Architecture in 1965, Jennifer Bartlett established a studio in the SoHo neighborhood of downtown New York. Settling on Greene Street, where she would live for nearly fifteen years, the artist counted Nancy Graves, Alex Katz, Brice Marden, Elizabeth Murray (see pl. 34), Richard Serra, Joel Shapiro, and Jenny Snider among her neighbors and peers. The works Bartlett and her cohort were producing during this period embodied the conceptual and Minimalist practices that began to dominate the art scene in the United States, following the prevalence of Pop art.

While studying at Yale with the influential painters Josef Albers (1888–1976) and Jack Tworkov (1900–1982), Bartlett had experimented with compositions that contained multiple segments. When Robert Rauschenberg (1925–2008), a visiting critic at the school, compared one of Bartlett's works to Pablo Picasso's *Night Fishing at Antibes* (1939; The Museum of Modern Art, New York), she gained confidence and was inspired to pursue further structural experiments. In 1968, she started accentuating the modular component of her compositions with a new material: seeking a base for her paintings that could be worked on without any preparation, the artist had noticed the signs in New York's subway, which she likened to "hard paper." She obtained small steel plates and proceeded to cover them in white enamel, bake them, silkscreen grids onto them, and place them in geometric arrangements on a wall of her studio. Then, following the grids, she painted dots onto the plates in various colors and sizes that she had carefully determined in advance. Long before the onset of digitized images and their concomitant pixels, Bartlett recognized her dots as being analogous to brush marks, and her meticulous application of them evoked the aesthetics of pure mathematics.[1] These early plate paintings were featured in Bartlett's first solo show at the Reese Palley Gallery in 1972 and, in the same year, at the Whitney Museum of American Art's annual exhibition (precursor of the Whitney Biennial).

The ornamental, regimented dots that governed Bartlett's early works later evolved into more narrative and picturesque imagery. In *Rhapsody*, a sprawling installation realized in 1975–76 and now in MoMA's collection, the artist juxtaposed several painting styles. Comprising 987 steel plates, the work was envisaged as a conversation "in which people digress from one thing and maybe come back to the subject, then do the same with the next thing. That was how the images got developed."[2] Bartlett painted archetypal images of houses, mountains, and the ocean onto individual panels and also spread the same motifs out over several squares, interspersing them with panels bearing triangles and circles and others of pure color. While maintaining a formally rigorous framework through the system of the grid, *Rhapsody* was equally guided by intuition.

Bartlett's paintings of the late 1970s were central to the burgeoning New Image movement, which heralded a return to painting—specifically, to figuration. This moment was marked by the seminal exhibition *New Image Painting*, held at the Whitney in 1978, which featured Bartlett's work. A year later, the artist completed the first in a series of works devoted entirely to water. The ocean had been a long-standing reference for the California-bred artist, and her first paintings at Mills had explored the phenomena that exist beneath the water's surface. *At Sea* (1979), composed of 115 enameled steel plates overlaid with two oval canvases, is typically monumental in scale. Making reference to Gustave Courbet's wave paintings of the late 1860s and early 1870s and the sequential works of Claude Monet (stacks of grain, water lilies, Charing Cross bridge, and so on), the painting was succeeded by *Atlantic Ocean* and *Pacific Ocean* (both 1984) and, in the following year, by *Sea Wall*, which combined a huge triptych with more than a dozen sculptures on the floor in front of it. These three-dimensional objects, ranging from pastel-colored wooden boats to a pebble-encrusted chair in the shape of a seahorse, replicated the aquatic imagery of the painting. AB

1. Marie-Claire Groeninck and Sabrina Locks, *Jennifer Bartlett's Enameled Steel Plates* (Philadelphia: Locks Gallery, 2012), 5.
2. Jennifer Bartlett, interview by Phong Bui, *Brooklyn Rail*, July–August 2011, https://brooklynrail.org/2011/07/art/jennifer-bartlett-with-phong-bui.

38. *At Sea*, 1979
Vitreous enamel, silkscreen, and enamel paint on steel (115 parts), oil on canvas (2 parts)
Overall dimensions variable, each steel plate 12 × 12 in. (30.5 × 30.5 cm), left-hand canvas 18 × 36¼ in. (45.7 × 92.1 cm), right-hand canvas 18⅛ × 36⅛ in. (46 × 91.8 cm)

Lynda Benglis

Born Lake Charles, Louisiana, 1941

For more than fifty years, Lynda Benglis has been exploring shape and surface to produce works notable for their formal innovation and material specificity. Adopting a broad range of media, including wax, ceramic, metal, paper, glitter, plastic, and even water, she exploits the physical qualities of each substance and challenges our understanding of the ways in which it should behave and function.

Benglis began her career in the late 1960s with a series of encaustic paintings, created by brushing layers of heated beeswax and resin onto elongated wood supports. In attempting to manipulate the wax in this way, however, she determined that the form of a work should be dictated by the inherent qualities of the chosen material and that each idiosyncratic characteristic—strength, reflectivity, plasticity, and so on—should be celebrated. "I realized that the idea of directing matter logically was absurd," she said. "Matter could and would take, finally, its own form."[1] With this ambition already in mind, it was a visit to Sol LeWitt's studio in 1967—where she saw a work fabricated from latex by Eva Hesse (1936–1970)—that introduced her to the formal possibilities of an exciting new medium.[2]

Benglis is perhaps best known for the brightly colored works in poured latex—*Baby Planet*

included—that she began making in the late 1960s. Bridging the gap between painting and sculpture, these "fallen paintings," as the artist termed them, were produced by pouring gallons of pigmented liquid latex from large cans directly onto the floor to create organic shapes that are "boundless in form and continuous in imagery."[3] Exploiting the material's fluidity to develop layers of color, Benglis worked without premeditation or correction. Unable to alter the composition once the pouring had begun, she also remained mindful of the latex's evolving texture as it set into a hardened form, curiously at odds with the liquid that had preceded it. Benglis deliberately selected Day-Glo colors, aiming to generate what she described as a radiant "fluorescence" that would cause the works to "seem to 'bounce' from the floor surface."[4] *Baby Planet* is ethereal in more ways than one; its title—a reference to the July 1969 moon landing—evokes what the artist called "a kind of phenomenological, otherworldly viewing."[5]

Benglis's material explorations of the early 1970s coincided with the burgeoning women's movement in the United States and prolific debate about the role of gender in the art world. Nothing is perhaps more emblematic of the artist's wryly

39. *Baby Planet*, 1969
Pigmented latex
1½ in. × 9 ft. 2 in. × 2 ft.
(3.8 × 279.4 × 61 cm)

provocative understanding of this context than her notorious photographic self-portrait with dildo in the November 1974 issue of *Artforum*. The "baby" of the Shah Garg Collection work's title might be read, accordingly, as a tongue-in-cheek reference to a woman's infantilizing nickname, but *Baby Planet*, and all of Benglis's pours, are fundamentally concerned with a bodily, rather than gendered, encounter with the physical surface. As the artist has said, "In my work, I am involved with bodily response so that the viewer has the feeling of being one with the material and with that action, both visually and muscularly."[6]

While Benglis's engagement with materials and process aligns her with others working in a Postminimalist framework, contemporary critics immediately associated the fluidity of her poured latex with Jackson Pollock's drip technique. Indeed, she was pictured at work in the February 1970 issue of *Life* magazine in much the same way Pollock had been celebrated in the same publication in August 1949. Benglis did not reject the association,

but she did focus, when queried, on the painter's "new way of thinking" rather than his specific technique.[7] Her reworking of the legacy of Abstract Expressionism—which she curtly described in the mid-1970s as "a big, heroic . . . macho sexist game"— seems to both laud and parody Pollock's talismanic innovation.[8]

HJ

1. Lynda Benglis, quoted in Susan Richmond, *Lynda Benglis: Beyond Process* (London: I. B. Tauris, 2013), 18.
2. Ibid.
3. Ibid.
4. Lynda Benglis, quoted in *Rubber Developments* 24, no. 1 (1971), reproduced in *Lynda Benglis*, ed. Franck Gautherot, Caroline Hancock, and Seungduk Kim, exh. cat. (Dijon, France: Presses du Réel, 2009), 129.
5. Benglis, quoted in Richmond, *Benglis: Beyond Process*, 26.
6. Lynda Benglis, "Lynda Benglis and Seungduk Kim in Conversation: Liquid Metal," in Gautherot, Hancock, and Kim, *Benglis*, 170.
7. Benglis, quoted in Richmond, *Benglis: Beyond Process*, 24.
8. Benglis, quoted in Robert Pincus-Witten, "Lynda Benglis: The Frozen Gesture," *Artforum* 13, no. 3 (November 1974): 58, reproduced in Gautherot, Hancock, and Kim, *Benglis*, 52.

Lucia Laguna

Born Campos dos Goytacazes, Brazil, 1941

Jardim no. 56 belongs to a series of paintings by the Brazilian artist Lucia Laguna that document her garden, located adjacent to her home in São Francisco Xavier, a suburban neighborhood in the northern part of Rio de Janeiro. The artist's garden is a composite of growing plants, furniture, and objects she has accumulated in the forty years she has resided there. To date, this body of work, on which the artist first embarked in 2011, consists of nearly sixty compositions. While *Jardim no. 56* highlights animals and luscious greenery, other paintings in the series have depicted items collected by Laguna in the course of daily life, such as vases, padlocks, keys, and statues. The artist has referred to the garden as an archaeological site of her existence, specifically "a deposit of things that pass through my hands."[1]

The garden is one of three environments that Laguna records in her paintings. Another is the city of Rio, viewed and painted, like her garden, from the windows of her third-floor studio. This critical motif led to a major transition in the artist's practice: in a 2009 interview, she spoke of "trying to find a path. . . . I only found it when I looked out of the window and saw the sides of the buildings. I said: this is my subject. The place where I live is going to bring me a wealth of things about which I feel I am able to talk, as I live here. I am from the suburbs."[2] The studio itself is the third essential environment, and objects from her place of work, such as ladders, stools, and lamps, often appear in her compositions. As in *Jardim no. 56*, different spaces and scales are often interwoven; architectural details may be interspersed with flora, for instance. This accumulative approach reflects the density of the spaces the artist observes—particularly the concentrated cityscape of Rio, which encompasses train lines, favelas, highways, and hills—as well as her inclusive response to space. In Laguna's paintings, interior and exterior are treated in the same manner, with equal emphasis.

The artist's painting methods mirror this multifaceted richness. Gestural fragments are juxtaposed with precise, grid-like geometries constructed with the aid of masking tape, while sections of the canvas are often repainted numerous times, creating raised surfaces. "My painting is forged by the precariousness of the place," she has said. "It's not smooth, it's made with brush, spatula, bubbles, particles, dripping drops."[3] Since 2004, Laguna has collaborated with a small team of assistants, who often initiate the first stages of a composition prior to the artist's intervening and resuming the process.

Although she works intuitively, photographs are an important source for Laguna, as are the hundreds of art books she keeps in her studio. As a student at the Escola de Artes Visuais do Parque Lage (where she enrolled in 1995, in her mid-fifties, after a three-decade career as a high-school teacher of Latin and Portuguese), Laguna engaged with art practices from outside her homeland, which proved transformative. Mentored by the influential Scottish-born educator Charles Watson (born 1951), who had previously taught Beatriz Milhazes (see pl. 68) and Adriana Varejão, Laguna savored the trips her teacher organized to museums in Amsterdam, Barcelona, Madrid, and London as well as to major events such as the Venice Biennale and Documenta. Thanks to Watson, Laguna also visited the studios of other established artists, including Tony Cragg, Mark Francis, Cornelia Parker, and Sean Scully: "I think that this was fundamental to my education. The understanding of the processes used by contemporary artists. I started when I was 54 years old. I wanted to rush, I wanted to understand everything that had happened until then."[4]

Aside from these influences, Laguna's paintings can also be understood in relation to Brazilian modernism, specifically the Neo-Concrete movement that called for geometric art to be navigated through the lens of life, poetry, and politics. Informed by the teeming environments she inhabits, the artist conveys the magnitude of existence in her paintings. As she has explained, "This is what I want: that people don't know exactly what it is, but that it looks like ten different things."[5] AB

1. Lucia Laguna, quoted in Fabiana Lopes, "Lucia Laguna: Between Keeping and Letting Go," in *Lucia Laguna: Neighborhood*, ed. Isabella Rjeille (São Paulo: Museu de Arte de São Paulo Assis Chateaubriand, 2018), 40.
2. Lucia Laguna, "Paulo Herkenhoff Entrevista Lucia Laguna," interview by Paulo Herkenhoff, in *Prêmio SESI CNI Marcantonio Vilaça: Mostra itinerante, 2006–2008*, exh. cat. (Brasília: Serviço Social da Indústria, Departamento Nacional, 2009), n.p.
3. Lucia Laguna, quoted in Luiza Interlenghi, "Landscape, Garden, Studio: Almost Cinema," in *Lucia Laguna* (Cologne: Galerie Karsten Greve, 2018), 15.
4. Lucia Laguna, interview by Paulo Sérgio Duarte, Galeria de Arte Ipanema, Encounters with the Artists Series, organized by Centro Cultural Cândido Mendes, Rio de Janeiro, 2007, transcript courtesy of Fortes D'Aloia & Gabriel, São Paulo.
5. Lucia Laguna, quoted in "Foreword" (signed by the organization Itaú Cultural), in Rjeille, *Laguna: Neighborhood*, 13.

40. *Jardim no. 56*, 2021
Acrylic on canvas
82¾ × 55⅛ in. (210 × 140 cm)

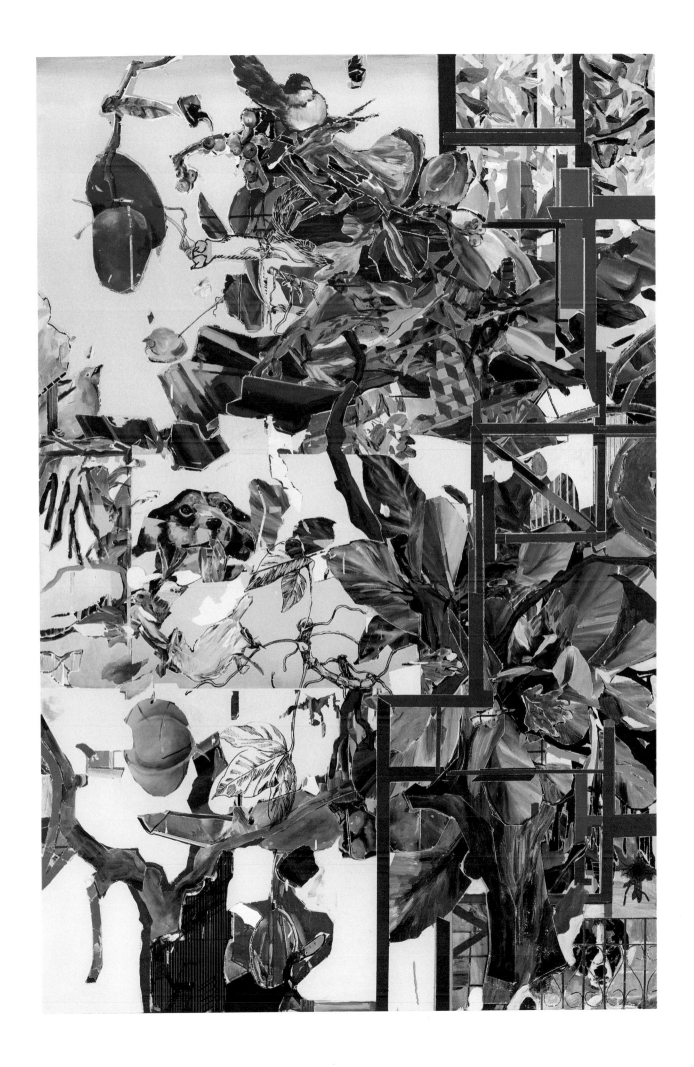

Mary Grigoriadis

Born Jersey City, New Jersey, 1942

Mary Grigoriadis was raised in New Jersey as a second-generation Corfiot American. The Greek Orthodox Church played a significant role in her family life, and sitting before the iconostasis during Mass, as she first did as a young child, enthralled her. This early exposure to images of saints, as well as the blue-and-gold patterned borders, left a deep impression. Grigoriadis's interest in art evolved throughout her youth. As a teenager, she spent hours at New York's Metropolitan Museum of Art, which she deeply cherished, and her encounters with the museum's vast collections became an exercise in "filing away images and trying to understand how paintings are made."[1] Grigoriadis went on to pursue her education in the city, at Barnard College, where she received a BA in 1963, and Columbia University, where she earned an MA in 1965. After that, she worked for Lawrence Alloway, chief curator of the Solomon R. Guggenheim Museum, an experience that proved revelatory. As the artist has explained, "There, I developed an understanding of contemporary art and an appreciation of what the commitment to making art entails."[2]

Grigoriadis established her painting practice during this period. By the late 1960s, she was creating white-on-white compositions on square canvases featuring patterns reminiscent of mandalas. *Untitled (White Painting 1)* of 1968–71, in the Shah Garg Collection (see p. 416), is one of the earliest examples of this body of work. While the paintings alluded to the Minimalist aesthetic that prevailed in the United States at the time, the decorative forms were suggestive of a new approach, especially in their compositional dominance and in Grigoriadis's accentuation of them through adept tonal variations.

The artist's subsequent travels abroad led to a further emphasis on pattern and ornament in her work while also introducing a vibrant palette that favored orange, yellow, and turquoise. Following trips to Russia, where she saw the onion domes of Moscow's Cathedral of Saint Basil the Blessed in 1970, and to Turkey, where she saw the mosaics of Istanbul's Hagia Sophia and Blue Mosque in 1971, Grigoriadis embarked on a series of oils on linen that she termed "secular icons." Retaining the square format of her previous works, symmetrical, precisely structured paintings such as *Cotton Stockings* allude to temple façades and sculptural reliefs—references to the artist's own heritage as well as to other ancient cultures, whether Assyrian, Persian, Byzantine, or Native American. Grigoriadis also cited in such works the handcrafted rugs and embroideries that had decorated her family home. The dense shapes that populate these canvases

(semicircles, stars, brickwork patterns, and so on) were generated through thickly applied layers of oil paint that left a glistening surface. Some of these works were exhibited in 1972 at A.I.R. (for "Artists in Residence") Gallery in New York's SoHo neighborhood. Grigoriadis was a founding member of this seminal space—the first women's cooperative gallery in the U.S.—and points to her involvement with A.I.R. in its nascent years as a turning point in her career. In 1973, her painting *Simple Pleasures* was included in the Whitney Biennial.

In 1975, the decorative tendencies being explored by Grigoriadis, along with a coterie of other young, New York–based artists, led to the birth of an official movement: Pattern and Decoration, or P&D. The exhibition *Pattern Painting*, mounted at P.S.1 Contemporary Art Center in Queens, New York, in 1977, examined this growing trend. While Grigoriadis did not directly associate with this self-identified group of artists, who formalized their work through a collective framework (members included Joyce Kozloff, Miriam Schapiro [see pl. 9], and Robert Zakanitch), her paintings were among the earliest to embody the movement's ethos. In response to the then-unchallenged preeminence of Western, male artists who expressed their rationalist ideals through the stark aesthetics of Minimalism and conceptualism, Grigoriadis's work was multicultural and hybrid, valuing ancestry and highlighting neglected art forms. Defiant, she evolved her practice in the face of contemptuous attitudes toward the decorative arts at large and toward non-Western cultures more specifically.[3]

From the 1980s onward, the artist abandoned strict symmetry and relied on a darker palette based in black and red. Although her works became increasingly concentrated, Grigoriadis, through impenetrably rich patterns, continued to conceive her paintings as "a paean to beauty, order, and opulence."[4]

AB

1. Mary Grigoriadis, "Mary Grigoriadis" (artist's statement), Anya and Andrew Shiva Gallery, City University of New York (website), exh. (*Transplants: Greek Diaspora Artists*) on view May 2–June 28, 2018, accessed August 1, 2022, https://shivagallery.org/mary-grigoriadis/.
2. Ibid.
3. Anna Katz, "Lessons in Promiscuity: Patterning and the New Decorativeness in Art of the 1970s and 1980s," in *With Pleasure: Pattern and Decoration in American Art, 1972–1985*, ed. Anna Katz, exh. cat. (Los Angeles: The Museum of Contemporary Art; New Haven, CT: Yale University Press, 2019), 46.
4. Mary Grigoriadis, quoted in Anna Katz, "Mary Grigoriadis," in Katz, *With Pleasure*, 290.

41. *Cotton Stockings*, 1973
Oil and foil paper on linen
66 × 66 in. (167.6 × 167.6 cm)

Mary Lovelace O'Neal

Born Jackson, Mississippi, 1942

Kurban, a Sweeter Day to Come belongs to a series of mixed-media paintings titled *Panthers in My Father's Palace*, created between 1984 and 1990. The works are characteristic of Mary Lovelace O'Neal's abstractions of the period, which combine bold, saturated colors and gestural forms with what the artist has described as "shifting planes." The series was conceived in 1984 during a residency O'Neal undertook as part of the Asilah Arts Festival, held in the eponymous port town on the northwest coast of Morocco. During her month there, the artist lived at the Raisuni (or Raissouni) Palace, erected by the famous outlaw Ahmad al-Raisuni in 1909, where she recalled a vivid childhood memory: attending rehearsals for an opera her father had staged at Arkansas State University, in Jonesboro, where he had been a professor of music.

Based on Italian folktales of the Nativity, Gian Carlo Menotti's 1951 one-act opera *Amahl and the Night Visitors* retells the story of the Magi from the point of view of a young resident of Bethlehem. "It didn't come back into my life until I was in Morocco and living in that palace," the artist recalls. "I had a bed by this window and I would look out at the ocean and the stars. The whole thing was magic. And it was then that all of those things started to be remembered. The mosaics and the quietness and shadows just opened my imagination."[1] The title of the series, as well as that of another painting in the group (*Running with Black Panthers and White Doves*; The Art Institute of Chicago), comes from a line in the opera sung by the Black king, Balthazar: "I live in a black marble palace with black panthers and white doves." *Kurban, a Sweeter Day to Come* is one of the later works in the series and was executed after the artist made another trip to Morocco, and Egypt, in 1989.

Alluding to what she has termed the "biblical presence of Africa" as well as to the subject of family and personal ancestry, the *Panthers in My Father's Palace* series underscores the role played by race in O'Neal's practice. "I grew up as a black woman in a segregated society, and my work always reflects that," she has explained.[2] As an undergraduate at Howard University in the 1960s, she was taught by the prominent African American

artists David C. Driskell (1931–2020), Loïs Mailou Jones (1905–1998), and James A. Porter (1905–1970) and became active in the civil rights movement, helping to form the university's Nonviolent Action Group (NAG). Through NAG and its Project Awareness programs, she met the writer James Baldwin, whom she considered a mentor. Moving to New York in 1968 to study at Columbia University, she continued to associate with Black Power activists.

Despite her political affiliations, O'Neal did not explicitly express her views in her art: "I couldn't paint black women jumping out of fields with guns."[3] Instead, she used abstraction as a device for exploring Black identity through color and form. In her "lampblack" paintings, begun in graduate school, she stained unprimed canvas with powdered black pigment, challenging widely held beliefs that abstraction could not relay the experiences of Black artists. Her teachers encouraged the approach, which seemed to be in keeping with the "quiet surfaces of Minimalism" that had come to dominate painting by the end of the 1960s.[4] However, in the artist's words, "The black pigment paintings were as black as they could be. They can also be seen as my response to my friends in the Black Arts Movement."[5] O'Neal later turned to a more physical, painterly style of mark making, as seen in the Shah Garg Collection work. Speaking in March 2020 on the occasion of her first solo exhibition in New York for some thirty years, at Mnuchin Gallery, the artist commented, "I'm reluctant to call myself an abstract expressionist or a minimalist. What I can do is paint and make things that are powerful. As for doctrinaire, I had to blow it up."[6] AB

1. Mary Lovelace O'Neal, interview by Melissa Messina, in *Mary Lovelace O'Neal: Chasing Down the Image*, ed. Sukanya Rajaratnam, exh. cat. (New York: Mnuchin Gallery, 2020), 88.
2. Mary Lovelace O'Neal, quoted in Wendy Moonan, "A Painter and Social Activist with an 'Unruly Nature,'" *New York Times*, March 1, 2020, https://www.nytimes.com/2020/03/01/arts/design/mary-lovelace-oneal-activist.html.
3. Ibid.
4. Mary Lovelace O'Neal, quoted in Lowery Stokes Sims, "Face Value, Media, and Meaning in the Work of Mary Lovelace O'Neal," in Rajaratnam, *O'Neal*, 7.
5. O'Neal, quoted in Moonan, "A Painter and Social Activist."
6. Ibid.

42. *Kurban, a Sweeter Day to Come*, from the series *Panthers in My Father's Palace*, ca. 1989–90
Mixed media on canvas
6 ft. 9 in. × 11 ft. 6 in. (205.7 × 350.5 cm)

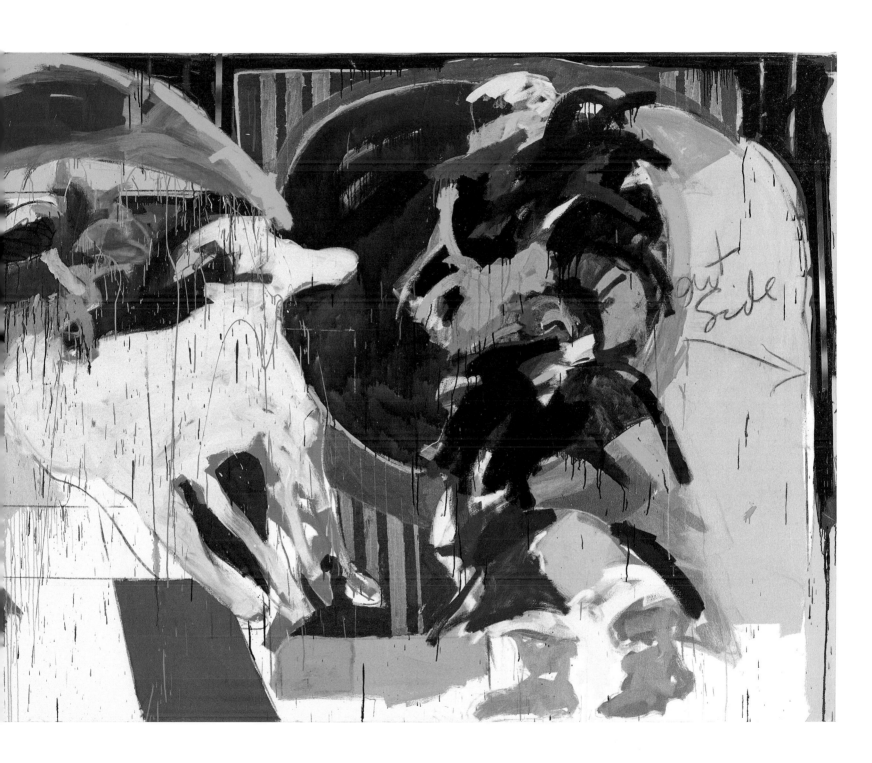

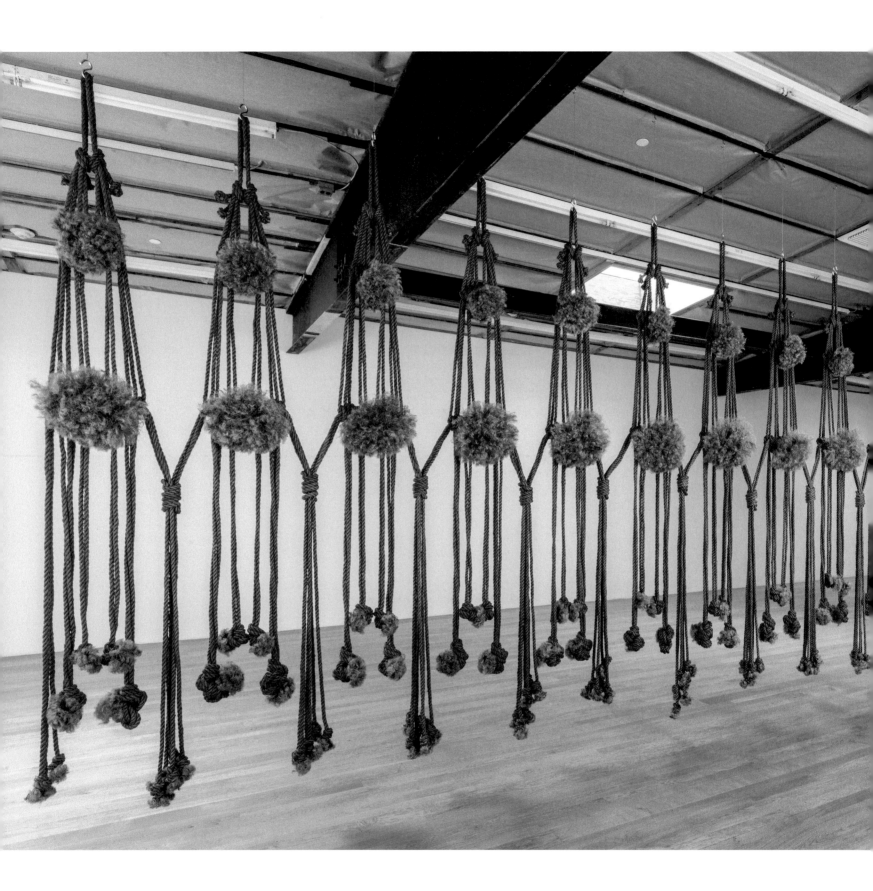

Françoise Grossen

Born Neuchâtel, Switzerland, 1943

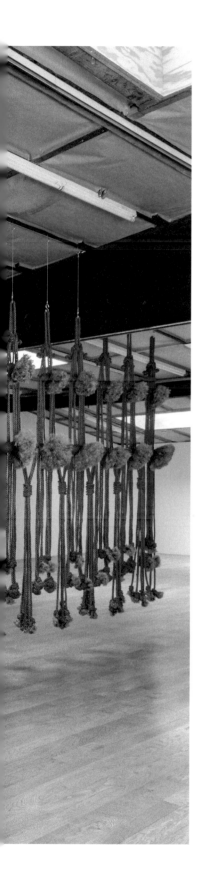

The Swiss-born artist Françoise Grossen has worked almost exclusively with rope for her entire career. Seeking to move beyond the parameters of conventional textiles, she is best known for the large-scale sculptures she has created in her signature freehand knotting and braiding techniques.

Grossen began studying architecture at the École Polytechnique in Lausanne in 1962. While there, she attended a textile class, which piqued her interest in the possibilities of fiber as a medium. After completing the program, she joined her parents, whose work had stationed them in Gabon, and spent six months traveling across West and North Africa. Both experiences contributed to her decision to abandon architecture and enroll as a textile design major at the Kunstgewerbeschule Basel in 1963. The following year, in Zurich, Grossen visited a small exhibition of the work of American fiber artists, including Sheila Hicks (see pl. 19), Lenore Tawney (see pl. 2), and Claire Zeisler (1903–1991). So revelatory was the encounter that she relocated to the United States after graduating in 1967 and began a master's course at UCLA, led by the textile artist Bernard Kester (1928–2018). She moved to New York in 1969.

While Grossen had trained on a loom, she quickly rejected the constraints of traditional textile practice. She later recalled, "I broke away from the tradition of weaving. I wanted to get rid of the frame. . . . With the loom you plan everything ahead of time. If you do knotting you can improvise so it's more fun."[1] Using such freehand techniques, Grossen produced complex and intuitive wall-based configurations. A milestone occurred in 1969, when the New York textile designer Jack Lenor Larsen (1927–2020)—for whom she had worked in her first job in the city—included her in the landmark exhibition *Wall Hangings*, presented at the Museum of Modern Art. Grossen's *Swan* (1967), fabricated from undyed sisal, was placed alongside works by the established fiber artists she so admired.

By the 1970s, Grossen's output was firmly three-dimensional. Summarizing her artistic development in the context of the philosophical ambitions shared by her peers, she has said, "First we broke with the rectangle, then we broke with the wall."[2] Her constructions were suspended from the ceiling and draped over pedestals, allowing them to be experienced from multiple viewpoints.

The artist also sprawled works across the floor, drawing on the influence of contemporary dance and its revaluation of the stage. A number of works during this period were designed in dialogue with architecture, having been commissioned for public settings such as offices and hotels. Other works engaged with the natural environment: *Inchworm II* (1978) was fabricated from plastic tubing and cork and floated across a pond at Reed College in Portland, Oregon. Evoking intertwined human forms, insect exoskeletons, and a wide array of Indigenous fiber objects, Grossen's work draws inspiration from both the natural and the man-made, and her early exposure to African craft techniques was undoubtedly foundational.

While the artist's adoption of rope was born out of an inability to procure woolen yarn during her time in Africa, she has remained committed to it. Speaking of her fabrication technique, she has explained, "My sculpture is cumulative: rope upon rope, braid after braid. . . . I build a volume and a surface rather than subtracting it from an existing hard mass as one would from stone or wood."[3] *Contact III* is a demonstration of the scale of Grossen's ambition, spanning a vast thirty feet. It was made from orange Manila rope—most commonly found in fishing nets and ships' lines—and was first shown in *Fiber Works: Americas and Japan*, held at the National Museum of Modern Art, Kyoto, in 1977. Grossen knotted the rope into seventeen sections to form a repeating pattern of vertical forms, each punctuated by several fuzzy pom-poms of deliberately frayed material. Reminiscent of body parts, these spheres—as the title suggests—evoke a line of interconnected figures, standing hand in hand.　HJ

1. Françoise Grossen, quoted in Payal Uttam, "Losing and Finding Françoise Grossen," *Prestige*, January 26, 2017, https://www.prestigeonline.com/hk/pursuits/losing-and -finding-francoise-grossen/.
2. Françoise Grossen, quoted in Martha Schwendener, "Review: Françoise Grossen, a Fabric Artist Inspired by Other Fields," *New York Times*, August 6, 2015, https://www .nytimes.com/2015/08/07/arts/design/review-francoise -grossen-a-fabric-artist-inspired-by-other-fields.html.
3. Françoise Grossen, "Braided Forms," artist's website, accessed May 6, 2022, http://www.francoisegrossen .com/forms.

43. *Contact III*, 1977
Manila rope (abaca) (17 parts)
Overall 9 ft. 9 in. × 30 ft. 8 in. × 1 ft. 2 in. (297.2 × 934.7 × 35.6 cm)

Senga Nengudi

Born Chicago 1943

Part of a vanguard generation of artists who emerged during the turbulent decade of the 1960s, Senga Nengudi (Sue Irons at birth) has been challenging the boundaries between sculpture and performance art for over five decades. Born in Chicago, she moved as a child with her mother to Los Angeles. In the aftermath of the Watts Rebellion of 1965, she volunteered as a teacher at the Watts Towers Arts Center. Aimed at adolescents and focusing on assemblage and free experimentation, the center's curriculum was an important influence on her own interest in the transformation of found materials. Today, Nengudi is best known for her sculptural installations that use everyday items and substances in innovative ways and that allude to the body as well as to social and cultural rituals.

Nengudi graduated from California State University, Los Angeles, in 1966, having studied fine arts and dance. She had also worked part-time at the Pasadena Art Museum (now Norton Simon Museum), where presentations by Claes Oldenburg and John Cage, among others, introduced her to the concept of happenings. The work of the avant-garde Gutai Art Association, which she discovered in a book on contemporary Japanese art, captivated her as well, and Nengudi resolved to begin her search for "a totally different point of view" by traveling abroad.[1] After spending a year at Waseda University in Tokyo, she returned to California State University to enroll in the graduate sculpture program.

In 1970, Nengudi presented her early *Water Compositions* of 1969–70 in an exhibition at Central 1015 Gallery in downtown LA. Radically different from the political work being produced by most African American artists at the time, these sculptures consisted of geometric forms made of clear vinyl, filled with colored water and sealed with a heat gun. Nengudi later said, "I like materials that are transformative. . . . I am particularly interested in this notion of shape-shifting."[2] Inviting the audience to touch the works, Nengudi intended their tactile pliability as a reference to the body. "They yielded to your touch," she recalled. "They produced a sensual experience."[3] The sculptures also demonstrated the impact of her encounter with the work of the Gutai artist Sadamasa Motonaga (1922–2011), who had likewise explored the transformational possibilities of water.

After completing graduate school and living briefly in New York, Nengudi returned to Los Angeles in 1974. Alongside David Hammons (born 1943) and Maren Hassinger (born 1947), she cofounded a loosely structured artists' cooperative called Studio Z, which engaged in spontaneous collaborative actions and experimented with discarded materials and spaces. An important change in Nengudi's work came after the birth of her first child in 1974. Inspired by her pregnancy and the elasticity of women's bodies, she began to experiment with used pantyhose. She suspended pairs from the ceiling, stretched them between walls, filled them with sand to allow gravity to exert its force, and pulled them tightly over objects. Round, heavy forms, such as those in *R.S.V.P. Untitled*, evoke breasts and testicles, while the nylon material itself—ubiquitous and universally understood—referenced women's bodies in a uniquely personal way. On the subject of her choice of material, Nengudi said at the time, "I am working with nylon mesh because it relates to the elasticity of the human body. From tender, tight beginnings to sagging end. . . . My works are abstracted reflections of used bodies."[4]

In March 1977, Nengudi exhibited her first pantyhose sculptures at Just Above Midtown, a gallery in Harlem, New York. Directly requesting that the audience engage with the work, the title of the exhibition—*R.S.V.P.*, or "please respond"—was later adopted as the title of the series. Two months later, Nengudi showed the works at Pearl C. Wood Gallery in Los Angeles, where Hassinger "activated" them with choreographed modern-dance performances. The impermanence of Nengudi's fragile objects, as well as her investment in the "experience" or "event," remain an important reference point for performance art as it developed during the 1970s.[5] As she later summarized, "My art is like a butterfly landing on one's knee. . . . The moment is fleeting—but remembered."[6] HJ

1. Senga Nengudi, "'I Believe Deeply That the Best Kind of Art Is Public': An Interview with Senga Nengudi," by Osei Bonsu, *frieze*, no. 198 (October 2018), https://www.frieze.com/article/i-believe-deeply-best-kind-art-public-interview-senga-nengudi.
2. Ibid.
3. Ibid.
4. Senga Nengudi, "Statement on Nylon Mesh Works" [1977], Senga Nengudi Papers, 1966–2017, Amistad Research Center, Tulane University, New Orleans, reproduced in *Senga Nengudi: Topologies*, ed. Stefanie Weber and Matthias Mühling, exh. cat. (Munich: Hirmer, 2019), 156.
5. Senga Nengudi, quoted in Stephanie Weber, "Dynamic Topologies," in Weber and Mühling, *Nengudi: Topologies*, 42.
6. Senga Nengudi, "Statement by the Artist" [1995], Thomas Erben Gallery archives, New York, reproduced in Weber and Mühling, *Nengudi: Topologies*, 242.

44. *R.S.V.P. Untitled*, 1978
Nylon mesh and sand
41 × 24 × 2⅛ in. (104.1 × 61 × 5.4 cm)

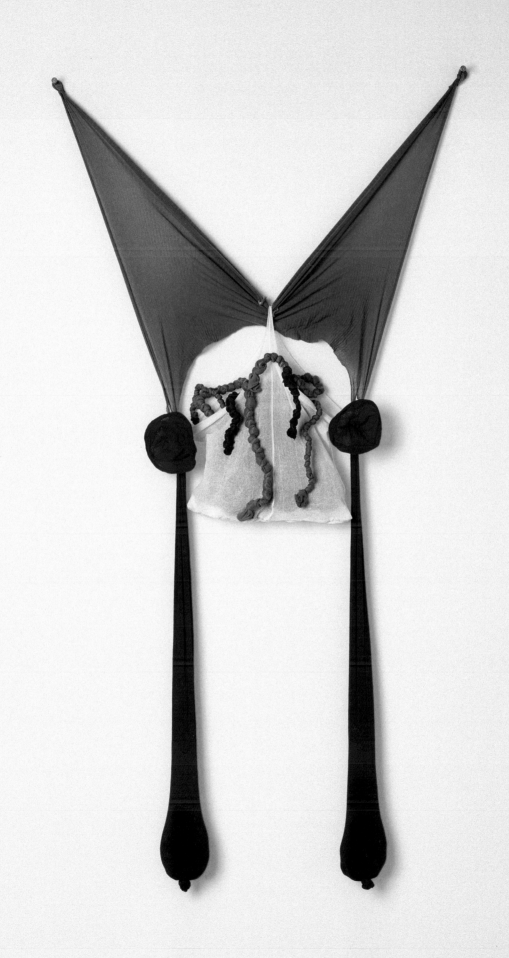

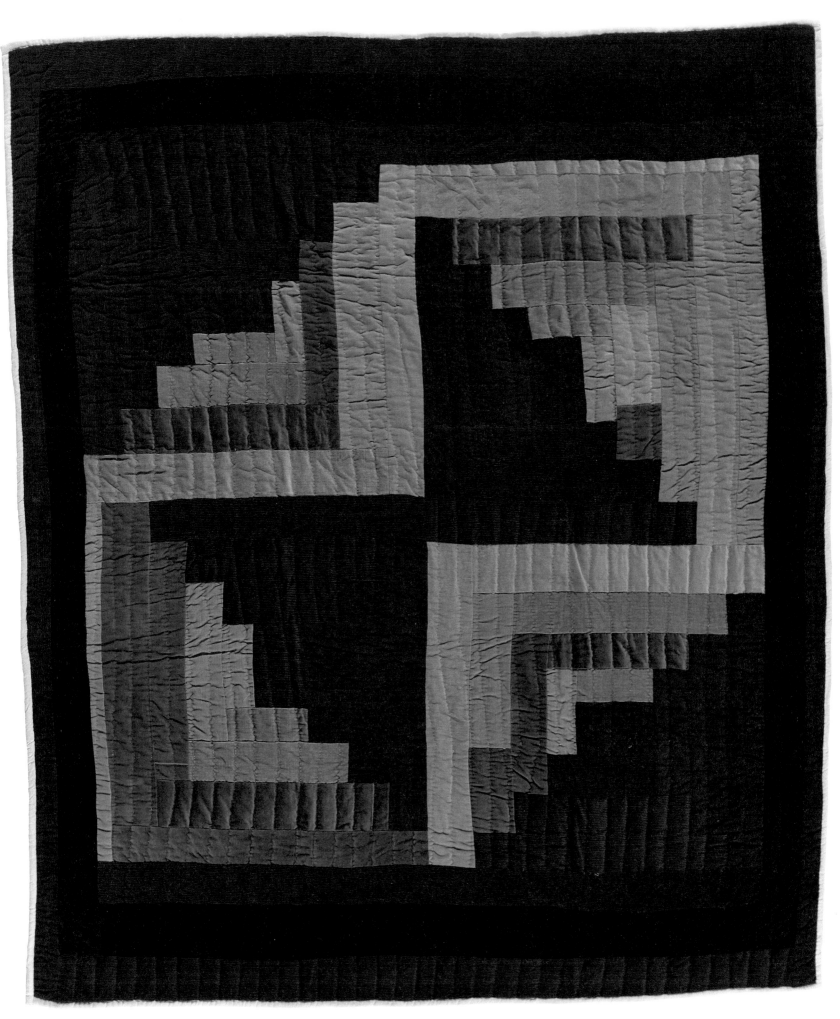

Qunnie Pettway

Gee's Bend (now Boykin), Alabama, 1943–2010 Boykin, Alabama

The American artist Qunnie Pettway was a member of the Freedom Quilting Bee (see also pl. 16), a group of women who lived and worked cooperatively in and around Alberta, Alabama—a secluded, mostly Black community in the center of the state—and who were active in the civil rights movement of the 1960s. Pettway was one of many members who hailed from Gee's Bend, about fifteen miles southeast of Alberta. Resembling an inland island, Gee's Bend (now officially known as Boykin) is surrounded on three sides by the Alabama River. Pettway could trace her ancestry back to Dinah Miller, the earliest identified quilt maker in the area and, according to local folklore and family history, one of the last enslaved people to arrive in the Bend. (Most residents of the Bend today are descended from enslaved people, and the surname "Pettway"—that of a former plantation owner—is common among the quilters. Joseph Gee, an earlier owner of the land, arrived from North Carolina in 1816 and initiated the growing of cotton there, with an entirely coerced labor force.)

Notoriously, in the 1960s, White locals made it difficult for Black people to navigate the river ferries, particularly during elections, in an attempt to deprive them of their right to vote. Initially formed to generate income for participants' families and to resist the oppression they faced, the Bee went on to facilitate the production of countless patchwork masterpieces. The quilting tradition in Alabama stretches as far back as the mid-nineteenth century, with the oldest extant examples dating to the 1920s. Invigorated by an expressive visual imagination that extends beyond the boundaries of the quilt genre, these methodically planned and executed textiles constitute a crucial chapter in the history of African American art and have drawn many comparisons to high-modernist abstraction.

A longtime member of the Bee, Pettway enjoyed bringing home scraps of fabric from the workplace and improvising new versions of traditional patterns. She had been surrounded by quilters her entire life and learned the classic patterns at the home of the American artist, civil rights activist, and longtime Bee manager Estelle Witherspoon (1916–1998), where upwards of twenty women would quilt together. As Pettway stated in 2002:

My mama, Candis Pettway, learned me how to quilt. We made "Housetops" and quilted them in rows. After, I got married in 1960, I started making pattern quilts. My sister learned me how to piece the "Wedding Ring." Then I learned to piece a "Chestnut Bud" at Mattie Ross house. Later on, I learned to piece the "Bear Paw," "Grandmama's Dream," "Grandmama's Choice" up to Mrs. Witherspoon's.[1]

Pettway's "Bricklayer" quilt in the Shah Garg Collection is made from the recycled legs of men's corduroy trousers. As the artist explained, "For myself, I like to piece a 'Crazy Z' quilt and strip quilts with the corduroy from the Freedom Quilting Bee. I made eight-point "Star" quilts for other people. When my health went to failing, I stick with simple quilts," adding, "I been to the doctor lately. I'm going blind in one eye." There is indeed much close work involved in making quilts—in both the piecing and the quilting processes—and one's eyesight is likely to suffer. After an intricate quilt top is pieced to completion, the quilt must be stuffed and stitched. Traditionally, the Bee's makers would spread the backing on the floor (or a second top as a backing, in the case of two-sided quilts), then lay the batting in place. Today, premade batting is available for purchase, but originally, raw cotton, or lint from the gin house, was gathered and the debris removed from it; then, enough was placed on the backing to cover it after the cotton had been pulled apart and beaten evenly. Finally, the two sides were sewn together, typically following the seams of the top. Today, the ageless quilting tradition continues in Alabama: Pettway's daughter, Loretta Pettway Bennett (born 1960), is a fifth-generation quilter from Gee's Bend and one of few who continue to make hand-stitched quilts in the renowned Gee's Bend style.[2]

LOB

1. Qunnie Pettway, artist's statement, in John Beardsley et al., *Gee's Bend: The Women and Their Quilts*, exh. cat. (Atlanta: Tinwood; Houston: Museum of Fine Arts, 2002), 330.
2. Mary Elizabeth Johnson Huff and Carole Ann King, *Alabama Quilts: Wilderness through World War II, 1682–1950* (Jackson: University Press of Mississippi, 2020), 138.

45. Quilt in "Bricklayer" Variation, 2010
Cotton
82¼ × 71 in. (208.9 × 180.3 cm)

Howardena Pindell

Born Philadelphia 1943

Howardena Pindell has rigorously explored surface, texture, and color over a consequential fifty-year career. Following her studies at Boston University and the Yale School of Art and Architecture, she became the first Black woman curator at the Museum of Modern Art, New York, securing a position in 1967 in the museum's Department of Drawings and Prints (later the Department of Prints and Illustrated Books). As a cofounder of A.I.R., the city's first women's cooperative art gallery, in 1972, she also was, and is, an ardent feminist, whose activism confronts discrimination in the art world and beyond.

Pindell is known for employing unconventional materials in her work, such as glitter, talcum powder, and even perfume. Perhaps most important to the trajectory of her practice, however, is the hole punch, which she started using around 1970, elevating the prosaic office tool from its customary function. By punching rows of holes into manila folders, lightweight metal sheets, and the like to make perforated templates, then spraying paint through them onto canvas in overlapping layers, she created abstract paintings whose dotted surfaces are reminiscent of nineteenth-century Pointillism. The hole punch, the artist explained in an interview, enabled her to pursue an interest in "very small points of color and light."[1]

Crucially for Pindell's later output, she saved the by-products of her hole-punching endeavors—thousands of tiny paper circles, known as chads—which, in 1973, began to make their way into the works themselves. After fixing canvas to the floor and spray-painting and squeegeeing acrylic paint through stencils, she applied confetti-like constellations of chads to the surface, where they adhered to the wet paint. *Untitled #21* was made five years after she devised this method and was first exhibited in her solo exhibition at the State University of New York, Stony Brook, in the fall of 1979. While from a distance the canvas appears uniformly painted, closer inspection reveals thousands of chads of varying sizes, which emerge from beneath layers of paint. Some of these were punched from colored sources and punctuate the overall whiteness as rainbow-colored flecks. Addressing the role of texture in her work (and that of other Black American artists), Pindell has said, "A very rich surface empowers the piece[s]."[2]

While Pindell's practice is rooted in material process, it is also indebted to her personal experience. In discussions about her recurrent use of the circle, the artist has often referred to a childhood memory of the indignity of racial segregation. When she and her father were traveling in southern Ohio or northern Kentucky in the 1950s, the pair visited a soda stand, where they were served root beer in mugs with red circles on the bottom, indicating that the vessels were reserved for people of color. Pindell explains, "I see that as the reason I have been obsessed with the circle, using it in a way that would be positive instead of negative."[3] The artist has linked her decision to paint on unstretched canvas to her interest in African textiles, which she encountered at MoMA in 1972–73 and on travels in West Africa shortly thereafter. She has said, "I find that my travel to Africa has influenced me in subtle ways, possibly because of my own ancestral family memories. . . . I loved the feeling of the flow of material."[4]

In 1979, Pindell left her position at MoMA, separated from her A.I.R. cohorts—lamenting their reluctance to integrate serious discussions of race into the feminist cause—and began teaching at SUNY Stony Brook (now known as Stony Brook University). She was also involved in a serious car accident that resulted in short-term memory loss. Since that time, her work has become more autobiographical, functioning to some degree as a mnemonic act of self-reclamation. HJ

1. Howardena Pindell, quoted in Terrie S. Rouse, *Howardena Pindell: Odyssey*, exh. cat. (New York: The Studio Museum in Harlem, 1986), 8.
2. Howardena Pindell, interview by Kellie Jones, in *EyeMinded: Living and Writing Contemporary Art*, by Kellie Jones (Durham, NC: Duke University Press, 2011), 231.
3. Howardena Pindell, quoted in Sarah Cowan, "Clearly Seen: A Chronology," in *Howardena Pindell: What Remains to Be Seen*, ed. Naomi Beckwith and Valerie Cassel Oliver, exh. cat. (Chicago: Museum of Contemporary Art Chicago; Munich: DelMonico Books/Prestel, 2018), 33.
4. Howardena Pindell, "Interview with Howardena Pindell by Kellie Jones (2011)," in Beckwith and Cassel Oliver, *Pindell: What Remains to Be Seen*, 210, excerpted from Pindell, interview by Jones, in Jones, *EyeMinded*.

46. *Untitled #21*, 1978
Acrylic, gouache, watercolor, dye, paper, talcum powder, glitter, and sequins on sewn canvas
6 ft. 11 in. × 9 ft. 5 in. (210.8 × 287 cm)

Elaine Reichek

Born Brooklyn, New York, 1943

At the beginning of the 1970s, Elaine Reichek began using thread as a medium. Trained as a painter first at Brooklyn College, where she studied with Harry Holtzman (1912–1987) and Ad Reinhardt (1913–1967), and then at the Yale School of Art and Architecture, from which she graduated in 1964, Reichek made large-scale, gestural works, formally related to Abstract Expressionism, as a student. The artist was one of just four women in her class and was taught solely by men. Upon graduating, she reconsidered her practice. "When I got out of Yale," Reichek explains, "I thought, I'm painting to please. This is not something I want to do."[1]

The artist was nonetheless committed to probing the possibilities of her chosen medium. She began to examine the qualities that constituted a painting, influenced by her earlier conversations with Reinhardt, who had been an important mentor. Embracing ideas related to Minimalism, Reichek created a group of paintings whose surfaces were punctured by sewn lines formatted as a grid. (*Untitled* of 1972, in the Shah Garg Collection, is an early example from this series.) In her subversion of the painted or drawn mark, Reichek became aware of the physicality of thread, which altered, quite literally, the two-dimensional plane. Viewing these works at Bertha Urdang Gallery in New York on the occasion of her first solo show in 1975, Reichek considered them afresh and had an epiphany: "Suddenly I thought, 'OMG, I'm sewing! What does that mean?' So I tried to work my way through the implications. I realized I was working with the classic modernist question of high versus low."[2] The artist went on to incorporate fabric into her practice in 1976, making works that layered swatches of organdy between layers of plexiglass to form geometric patterns. In 1979, she introduced knitted forms, and in 1982, she began juxtaposing those forms with photographs.

Needlework was a conceptual choice for Reichek, allowing her to establish a visual language that was separate from the tropes of high modernism. "What I do isn't about being a 'woman artist,'" she has said. "When I started out . . . we, my peers and I, hated everything that looked like art. Chuck Close purged brushes. Richard Serra was throwing lead. I was looking for a different medium to make marks with."[3] However, a critical, feminist perspective informed her later works, which include handmade embroidery samplers that explore the gendered associations encoded within certain materials. Traditionally, this type of embroidery, which flourished in the United States, England, and elsewhere in Europe in the eighteenth and nineteenth centuries, featured proverbs and homilies set within decorative motifs and were intended to instruct the girls who stitched them in both handicraft and moral rectitude. In Reichek's revisionist samplers, which formed the series *When This You See . . .* (1996–99), exhibited at New York's Museum of Modern Art in 1999, the artist replaced such aphorisms with quotations collected from art history, literature, and mythology. Although most of them referred to aspects of knitting, sewing, weaving, and so on, the artist's juxtapositions of image and text unraveled "associations that have been made with those activities, both consciously and unconsciously, through the ages. The effect is to examine these domestic practices for signs of social critique—for what they reveal about relations between the sexes, and also for what they reveal about art."[4]

Moreover, Reichek's use of the sampler format challenged art history itself, expanding the parameters of what can function and be respected as a work of art. To emphasize this point, the later compositions in the series depart from the conventional text/image format and appropriate works by other visual artists. *Sampler (Georges Seurat)* is based on the French painter's 1883 conté-crayon drawing *The Artist's Mother (Woman Sewing)*, in the collection of the Metropolitan Museum of Art. Comparisons have also been made to Johannes Vermeer's painting *The Lacemaker* (1669–70; Musée du Louvre, Paris). As Reichek notes, both artists "portrayed women engaged in domestic labor—wholly absorbed in a sphere of their own," and yet "the male artist is excluded from this occupation, even as his artistic activity parallels his subject's deep concentration."[5] While the original drawing served as a tribute to the artist's mother, for Reichek "it nevertheless reveals encoded gender norms that are deeply rooted in the history of art."[6] AB

1. Elaine Reichek, "Elaine Reichek Talks about Her Show at the Secession in Vienna," *Artforum*, April 10, 2018, video, 7:42, https://www.artforum.com/interviews/elaine-reichek -talks-about-her-show-at-the-secession-in-vienna-74945.
2. Elaine Reichek, quoted in Olivia Parkes, "The Artist Highlighting Sexism with Needle and Thread," *Vice*, February 13, 2016, https://www.vice.com/en/article/4xkzdj/the-artist -highlighting-sexism-in-the-art-world-with-needle-and -thread.
3. Elaine Reichek, quoted in Judith Thurman, "Stiches in Time," *New Yorker*, October 22, 2007, https://www.new yorker.com/magazine/2007/10/29/stitches-in-time.
4. Elaine Reichek, quoted in Beth Handler, "Projects 67: Elaine Reichek," exh. brochure, The Museum of Modern Art, New York (website), exh. on view February 4–March 30, 1999, accessed July 15, 2022, https://www.moma.org /documents/moma_catalogue_182_300199690.pdf.
5. Elaine Reichek, artist's statement, in "The Unreliable Narrator," exh. brochure (New York: ArtHelix Gallery, 2017).
6. Ibid.

47. *Sampler (Georges Seurat)*, 1998
Silk and cotton thread on linen,
in wood frame
Overall 13½ × 11¾ in. (34.3 × 29.8 cm)

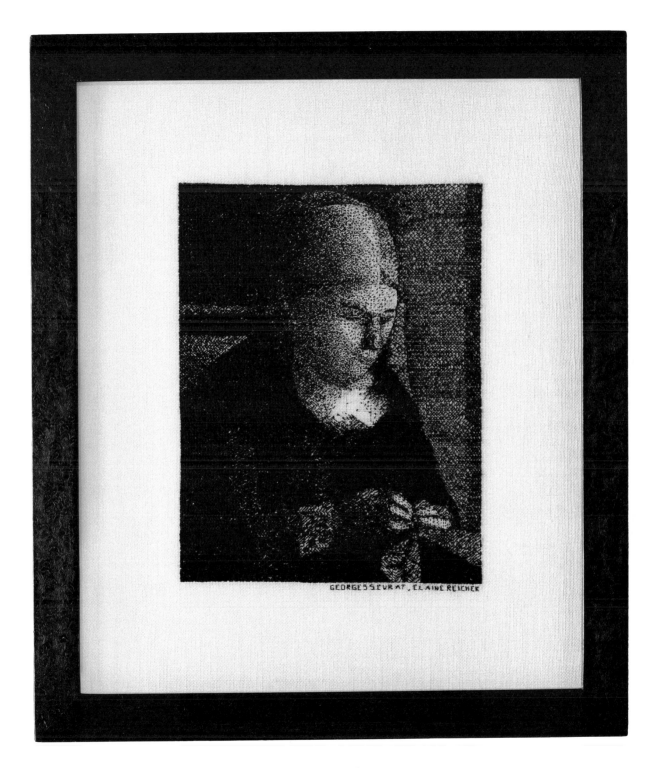
GEORGES SEURAT, ELAINE REICHEK

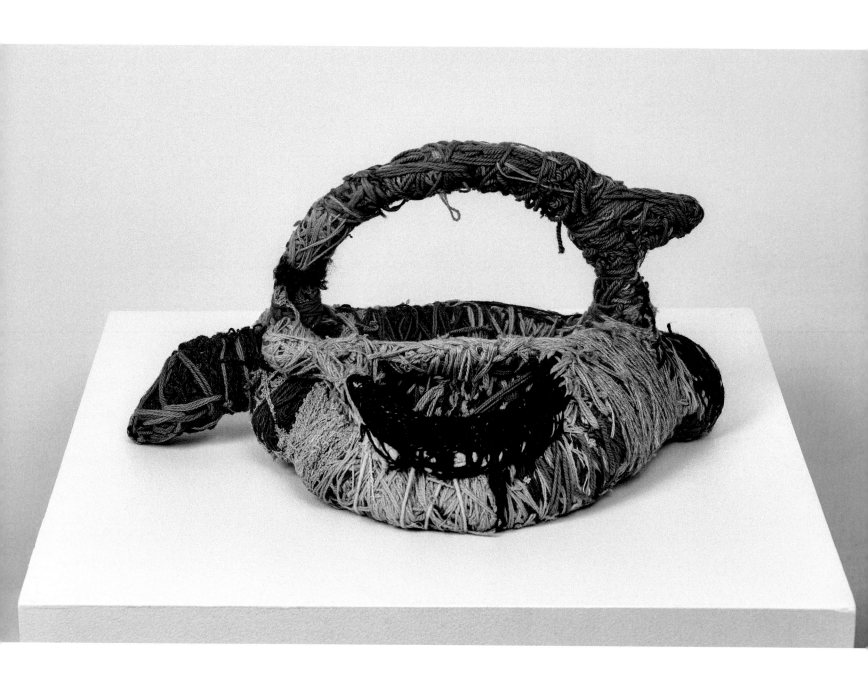

Judith Scott

Columbus, Ohio, 1943–2005 Dutch Flat, California

The idiosyncratic sculptural assemblages of Judith Scott consist of found objects bound with yarn and other materials. Having begun her career at the age of forty-five—after decades of confinement and limited opportunity—the artist had an exceptional aptitude for color, texture, and form. Largely since her death, her works have garnered critical acclaim, been acquired by major museums, and appeared in important international exhibitions, including, in 2017, the 57th Venice Biennale.

Scott and her fraternal twin sister, Joyce, were born in Columbus, Ohio, in 1943. While Judith's Down syndrome was diagnosed soon after birth, her deafness—likely a result of scarlet fever in infancy and masked by her inability to speak—remained undiagnosed until she was in her thirties. Mainly on account of this misunderstanding, Scott was deemed "ineducable" by medical practitioners and placed, at the age of seven, in the Columbus State Institution (originally known as the Ohio Institution for Feeble-Minded Youth, and now the Columbus Developmental Center).[1] She remained institutionalized for thirty-five years, until 1986, when her sister secured legal guardianship and arranged for her to move to California.

In 1987, Scott enrolled at the Creative Growth Art Center in Oakland, California. Founded in 1974 by the artist Florence Ludins-Katz (1912–1990) and her husband, the psychologist Elias Katz (1913–2008), Creative Growth is a not-for-profit organization that provides a studio and gallery program for artists with developmental disabilities, fostering a sense of autonomy in its participants. Guided by the principle that art is an essential and universal means of expression, Creative Growth is staffed by practicing artists who facilitate introductions to new materials and processes. While Scott showed little interest in the environment during her first few months—making just a small number of drawings and paintings—she was encouraged to join a class in late 1987 led by the sculptor and fiber artist Sylvia Seventy (born 1947). This introduction to textile-based techniques, including weaving and embroidery, facilitated the beginnings of Scott's remarkable career.

During a session with Seventy in 1988, Scott produced her first sculptural object: a bundle of wood sticks bound with woolen yarn and twine and wrapped in fabric that the artist painted blue. Similar sculptural assemblages followed. Beginning with a found object—a length of plastic tubing, an empty spool, a compact disc—Scott would bind it densely with innumerable layers of knotted and wrapped yarn, twine, and fabric, much of it industrial cutoffs gifted to the center. Additional objects were frequently attached to the original structure with further lengths of textile. While some of the largest scavenged objects—such as a desk fan, a child's chair, a shopping cart, and a walking crutch—are partly visible in the final works, smaller items are totally obscured by Scott's process of mummification. X-rays conducted on the works have revealed an astonishing variety of concealed items.

As her visual language developed, Scott was given "free rein," as Joyce Scott recalls, in her selection of materials from the center's inventory.[2] Her assemblages are wildly imaginative, demonstrating clear preferences for particular materials and recurring compositional forms. Works such as *Untitled* reveal her sensitivity to color, as described by her sister: "Judy had a tremendous sense of color, a love of color. If you look at her pieces, she used color in subtle and amazing ways."[3] After working on one piece at a time for weeks and even months, Scott would indicate to Creative Growth's artist-instructors that it was complete. Then, she would immediately gather new materials and begin work on the next.

Her voice curbed by her complex circumstances, Scott could not express the artistic decisions that shaped her practice. She did not title or sign her works, or even indicate the vantage points from which they should be viewed. While we cannot know her intentions, Scott's assemblages remain extraordinary exercises in form, color, and texture, fabricated by an individual for whom the senses of sight and touch held particular meaning. She remained with Creative Growth until her death in 2005, producing more than 150 artworks during her tenure there. Recalling her sister's determined spirit, Joyce Scott has said, "She was kind of the queen of the place. She had such a sense of her own core of strength and confidence in herself and her work. That's what she was about."[4] HJ

1. John M. MacGregor, *Metamorphosis: The Fiber Art of Judith Scott; The Outsider Artist and the Experience of Down's [sic] Syndrome* (Oakland, CA: Creative Growth Art Center, 1999), 48.
2. Joyce Scott, interview by Kevin Killian, in *Judith Scott: Bound and Unbound*, ed. Catherine Morris and Matthew Higgs, exh. cat. (Brooklyn, NY: Brooklyn Museum; Munich: DelMonico Books/Prestel, 2014), 44.
3. Ibid., 43.
4. Ibid., 46.

48. *Untitled*, 1992
Wool, acrylic, and cotton yarn, with rattan and wood
13 × 26 × 13½ in. (33 × 66 × 34.3 cm)

Phyllida Barlow

Born Newcastle upon Tyne, UK, 1944

The British artist Phyllida Barlow is best known for her unwieldy-looking sculptural installations, which she typically produces on a monumental scale but from deliberately antimonumental, everyday materials. Over a career spanning more than half a century, she has also been an influential teacher, counting Rachel Whiteread and Tacita Dean among her former students.

Barlow studied at Chelsea College of Art in London from 1960 to 1963. While she found the conservative, patriarchal environment stifling, she was invigorated by the appointment of George Fullard (1923–1973) to the sculpture department in 1961. Abolishing the tradition of working from life, Fullard encouraged his students to move beyond orthodox studio practices and instead to engage with the possibilities of the world around them. As Barlow has recalled, "George instilled a confidence that proclaimed contradiction as the propagator of creativity."[1] Barlow's initial efforts were in clay, but she began to experiment with plaster and fiberglass during her time at the Slade School of Fine Art in London, from 1963 to 1966.

During the 1970s, Barlow expanded her repertoire. She adopted building materials such as concrete and timber, which were inexpensive and readily available, for her use, as well as low-grade household supplies such as cardboard, plastic sheeting, fabric, and tape. In opposition to traditional sculpting methods, Barlow transformed these materials through juxtaposition and accumulation, working intuitively and improvisationally with repetitive actions of cutting, binding, and folding. The artist has referenced the formative influence of clay: "It gave me this ability to change things very quickly and accumulate, add and add and add and then take away: a constant ebb and flow between adding and removing."[2] Her expressive application of often lurid color to her mature sculptures relates to Fullard's early encouragement that she paint directly onto the clay. Barlow's works are characterized by a rough, uneven appearance that reveals their fabrication process. She has always ranked notions of "beauty" below her more pressing interest in "abstract qualities of time, weight, balance, rhythm."[3]

Driven by her use of cheap and plentiful materials, Barlow's work grew in scale during the 1980s. Because of the impermanent nature of many of those materials, however, and the cost and impracticality of storage for her at that time, the artist mostly dismantled and recycled her earlier sculptures and installations into new objects. This cycle of destruction and reconstruction has long informed the artist's thinking—a remnant, perhaps, of her experience driving around London's East End with her father in the 1950s, seeing both extensive war-related damage and frenetic reconstruction on an immense scale. Speaking of this dichotomy in relation to her work, Barlow has said, "Destruction and construction, or damage and repair, do meet in some way, however uncomfortably, and that's exactly what the sculptural process is about."[4] While her works are largely abstract, they evoke the urban environment through recurrent forms suggestive of functional objects such as columns, bollards, and signposts. Despite their familiarity, however, these references—and others to items in the domestic sphere, such as the putative shelf in the Shah Garg Collection work—almost always convey a state of disrepair. Barlow's materials are deceptive—what appears from a distance to be heavy concrete is, more often than not, polystyrene thinly coated in cement—and her structures seem to teeter precariously on the edge of collapse, brazenly and inexplicably defying gravity.

While Barlow has received widespread international acclaim for her large-scale sculpture in recent years, she has produced works on a more intimate scale, such as *untitled: brokenshelf2015*, throughout her career. The title of this example, by combining the name of a previously functional object with its new and abstract reimagining—the artist's signature titling formula—reinforces the work's visual ambiguity. Barlow has often maintained that her creations have no conventional meaning. Viewed instead as explorations of medium and process, they are launched from a starting point that is "very raw," fluid, and experimental: "It's often just the urge to begin a work, and to use my experience in a very direct way: pouring, spilling, piling up, all those kinds of ways of filling that empty space in front of me."[5]

HJ

1. Phyllida Barlow, "My Teacher: Phyllida Barlow on George Fullard," *Tate Etc*, no. 38 (Autumn 2016), https://www.tate.org.uk/tate-etc/issue-38-autumn-2016/my-teacher-phyllida-barlow-on-george-fullard.
2. Phyllida Barlow, interview by Edith Devaney, in *Phyllida Barlow: cul-de-sac*, exh. cat. (London: Royal Academy of Arts, 2019), 42.
3. Phyllida Barlow, quoted in Mark Brown, "Phyllida Barlow: An Artistic Outsider Who Has Finally Come Inside," *The Guardian*, April 28, 2016, https://www.theguardian.com/artanddesign/2016/apr/28/phyllida-barlow-artist-success-2017-venice-biennale.
4. Phyllida Barlow, "Simple Actions: A Conversation with Phyllida Barlow," by Ina Cole, *Sculpture*, May 6, 2016, https://sculpturemagazine.art/simple-actions-a-conversation-with-phyllida-barlow/.
5. Barlow, interview by Devaney.

49. *untitled: brokenshelf2015*, 2015
Timber, plywood, steel, fabric, PVA, cement, tape, and plaster
3 ft. 11¼ in. × 9 ft. 10⅛ in. × 3 ft. 7¼ in. (120 × 300 × 109.9 cm)

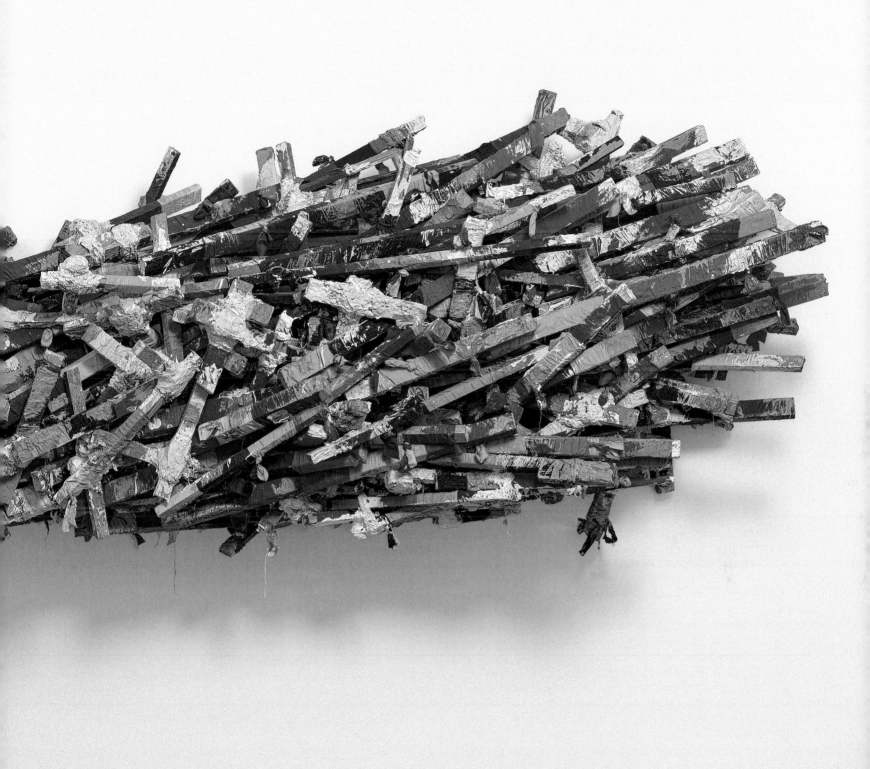

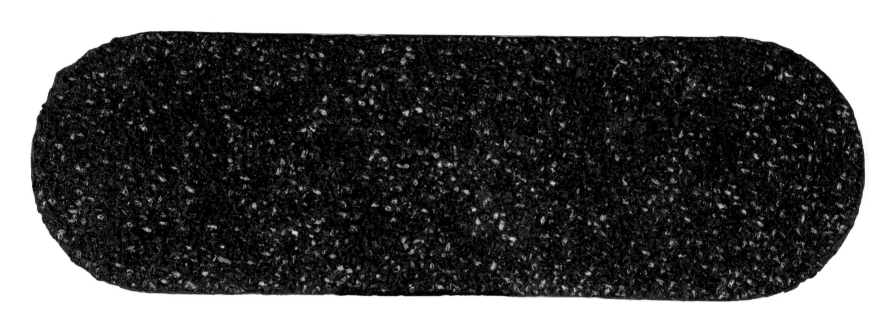

Harmony Hammond

Born Chicago 1944

In the early 1970s, Harmony Hammond was a leading figure in New York's feminist art movement. Following her studies at the University of Minnesota, she moved to the city shortly after the Stonewall Uprising in 1969, at a time characterized by intense political activism and the fight for sexual liberation. She cofounded A.I.R.—the first women's cooperative art gallery in New York—in 1972 and the Heresies Collective, publisher of the quarterly feminist magazine *Heresies*, in 1976. Two years later, she curated the groundbreaking *A Lesbian Show* at the artist-run exhibition space 112 Workshop (also known as 112 Greene Street), and in 2000, she published the seminal book *Lesbian Art in America: A Contemporary History*. As she later recalled, "The women's movement changed my life—and my art."[1] Since 1984, Hammond has lived and worked in northern New Mexico.

Like many of her feminist peers, Hammond moved away from what she called the "male-dominated site of painting" in the early 1970s, turning instead toward materials and techniques associated with craft and the arts of non-Western cultures and experimenting with a Postminimalist approach.[2] Her early work—exemplified by the wall-bound or -leaning "wrapped sculptures" for which she is perhaps best known—occupies a space somewhere between painting and sculpture. More recent work takes the form of almost monochromatic canvases disrupted by grommets and bindings. While Hammond deliberately engages with modernist histories of abstraction, she does so subversively, with gender politics in mind. Focusing on what she terms the "materiality of paint as a carrier of meaning," she "welcome[s] the world outside the painting edge into the painting field."[3]

Letting the Weather Get In belongs to Hammond's series of "weave paintings" of 1974–77 and represents the beginnings of her interest in the monochrome. She created these works by applying layers of oil paint mixed with Dorland's Wax Medium—a mixture of resin and wax that allows the paint to be more easily manipulated—to a shaped canvas. While the thick, impasto surface was still wet, Hammond then used the hard end of a paintbrush to dig into it in different directions, creating a textured, braided pattern. As the designation "weave painting" suggests, the result is reminiscent of weaving, evoking precedents ranging from Native American basketry to Anni Albers's experimentation at the Bauhaus.

Through this process of scarification, color from the first-applied layers of paint is revealed. While *Letting the Weather Get In* appears from afar to be an expanse of dark green paint—resembling the eerie color of the sky before a severe thunderstorm, perhaps, as suggested by the title—on closer inspection, flecks of blue, lighter green, ochre, and white emerge through cracks and holes in the surface. In the artist's words, "It's about what's hidden, what's revealed, pushing up from underneath, the painting surface under stress."[4] The deliberately agitated paint surface is intended to reflect the complexity of human skin and the memories and experience it holds, and the lozenge-shaped canvas appealed to Hammond for its curved ends, an extension of an earlier practice of stuffing rags and newspaper under a canvas at the edges to make it "lumpy and bumpy, irregular—presencing the body."[5] For Hammond and her work, "the body is always near."[6]

HJ

1. Harmony Hammond, quoted in Clarity Haynes, "Going beneath the Surface: For 50 Years, Harmony Hammond's Art and Activism Has [sic] Championed Queer Women," *ARTnews*, June 27, 2019, https://www.artnews.com/art-news/artists/harmony-hammond-12855/.
2. Harmony Hammond, *Harmony Hammond*, exh. cat. (New York: Alexander Gray Associates, 2016), 3.
3. Ibid.
4. Ibid., 4.
5. Harmony Hammond, interview by Julia Bryan-Wilson, Archives of American Art, Smithsonian Institution, Washington, DC (website), September 14, 2008, https://www.aaa.si.edu/collections/interviews/oral-history-interview-harmony-hammond-15635.
6. Hammond, *Hammond*, 3.

50. *Letting the Weather Get In*, 1977
Oil and wax-resin compound on canvas
14 × 45½ × 1¾ in. (35.6 × 115.6 × 4.4 cm)

Suzanne Jackson

Born Saint Louis 1944

Over the past fifty-plus years, Suzanne Jackson has worked as a painter, dancer, teacher, curator, and theater designer. While her diverse career defies easy categorization, she is renowned as the force behind Los Angeles's short-lived but highly influential Gallery 32.

Born in the Midwest, Jackson moved as a child to San Francisco and later to Fairbanks, in pre-statehood Alaska. She grew up in that remote environment, drawing inspiration from the natural world. As she later recalled, "Growing up in Alaska is why I learned to paint. I taught myself. I painted birds, mountains, and the things around me."[1] Jackson returned to the Bay Area to study painting at San Francisco State University, graduating in 1966; while in school, she also danced with Alan Howard's Pacific Ballet. In 1967, the artist moved to Los Angeles, where she attended drawing classes at the Otis Art Institute led by Charles White (1918–1979).

Encouraged by the artist David Hammons, whom she met in White's class, Jackson opened Gallery 32 in the studio below her living quarters in 1968. Sharing White's conviction that art should be a medium for social change, she envisaged the gallery as a community space that hosted discussions and exhibitions and raised funds for organizations such as the Black Arts Council, the Black Panther Party, and children's programs at the Watts Towers Arts Center. While Gallery 32 quickly became an important venue for African American artists—showing the work of Betye Saar, Senga Nengudi (see pl. 44), Emory Douglas, and Hammons, among others—it was fundamentally inclusive. As Jackson has said, "I showed everybody, people of all different colours. It was just a matter of any good work that was not being exhibited elsewhere."[2] Through Gallery 32, Jackson was particularly supportive to artists of her own gender, and the legendary *Sapphire Show*, on view for less than a week in July 1970, was the first exhibition in the United States devoted exclusively to the work of African American women. Having underwritten the gallery's operations herself, through her teaching income, Jackson had to close its doors in 1970.

Throughout the 1970s, Jackson drew on dreams and mysticism in her own work, creating compositions showing Black figures against a white ground, surrounded by symbols such as hands, flowers, hearts, leaves, and birds. Using acrylic paint like watercolor, she applied thin layers in "blooms and washes," as she described them, to achieve the desired shades.[3] Jackson's work of the 1990s was shaped by her employment as a theater designer, which she began after receiving an MFA from the Yale School of Drama. Noticing the abundance of discarded "bogus paper"—used to protect a stage while sets are painted—she began to integrate it into her works. *Sapphire & Tunis* is one example, incorporating layers of the paper to form a richly textured support for drips, stains, and flourishes of paint. With a title that alludes to Gallery 32's iconic 1970 project, it was displayed in *You've Come a Long Way, Baby: The Sapphire Show* at New York's Ortuzar Projects in 2021, staged in homage to the original show.

Jackson's recent work is more abstract and materials-driven, as she has sought to "[break] away from the structure of stretched canvas or paper."[4] In the early 2010s, she discovered that she could create a flexible surface on which to paint by applying acrylic gel medium, a thickening agent, to a flat surface and allowing it to dry. Later experimentation revealed that acrylic paint on its own—applied directly to a plastic-covered surface and then peeled off—could yield the same result. Jackson augments these translucent supports with multiple layers of paint and often shapes them with mesh or plastic netting from produce bags, as seen in another work in the Shah Garg Collection, *Cut/Slip for Flowers* (see fig. 10 on p. 53). Repurposing is crucial to the artist's practice, and she assimilates into her compositions found textural elements such as loquat seeds, beads, peanut shells, and even flakes of dried paint peeled off her own hands. Blurring the boundaries between media, these works are to be displayed, in her words, "suspended in space as sculpted paintings."[5]

HJ

1. Suzanne Jackson, quoted in Mae Tate, "The Art of Suzanne Jackson," *Black Art Quarterly* 4, no. 3 (1982): 3.
2. Suzanne Jackson, quoted in Chase Quinn, "The Paradoxes of Gallerist and Artist Suzanne Jackson," *frieze*, September 27, 2019, https://www.frieze.com/article/paradoxes-gallerist-and-artist-suzanne-jackson.
3. Suzanne Jackson, quoted in Aberjhani, "Suzannian Algorithm Finger-Painted on an Abstract Wall," in *Suzanne Jackson: Five Decades*, ed. Rachel Reese, exh. cat. (Savannah, GA: Telfair Museums, 2019), 14.
4. Suzanne Jackson, interview by Barbara McCullough, *BOMB*, no. 157 (Fall 2021): 36, https://bombmagazine.org/articles/suzanne-jackson/.
5. Ibid.

51. *Sapphire & Tunis*, 2010–11
Acrylic, bogus paper, and linen (2 parts)
Overall 92 × 92 × 6 in. (233.7 × 33.7 × 15.2 cm)

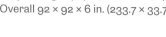

Mary Corse

Born Berkeley, California, 1945

In Mary Corse's large, monochromatic paintings, light is the primary medium. Often associated with the Light and Space artists of Southern California, who, beginning in the early 1960s, explored how the physical qualities of light could affect the viewer's environment, Corse was one of the first to incorporate electric light into her work. Since the mid-1960s—even before she graduated from Los Angeles's Chouinard Art Institute, in 1968, with a BFA—the artist has experimented with materials such as neon tubing and retroreflective beads, or microspheres. She is interested in the relationship between materiality and perception, and her techniques capture and project light in order to create an ethereal and shifting presence, which exists beyond the surface of the painting. "For me, art is about connecting with your inward self—your true self, your soul, a place inside. My work comes out of that," she has said. "Once I found my own language, it all became about that internal focus."[1] Resisting linear perspective, Corse's works embody movement: the surface of the canvas changes depending on the viewer's position.

Untitled (White Grid, Horizontal Strokes) forms part of the artist's ongoing *White Light* series, begun in 1968. First exhibited in 1970 in the group exhibition *Permutations: Light and Color* at the Museum of Contemporary Art Chicago, this seminal body of work has dominated Corse's practice over the past five decades and represents the majority of her output to date.[2] Marking an important transitional moment in her career, the first iterations of *White Light* immediately followed her plexiglass-box sculptures, made between 1966 and 1968, which incorporated fluorescent lightbulbs. "After the light boxes, I wanted to put subjectivity back in. That's what led me to keeping the brushstroke," Corse has explained. "I also still wanted the light in the work—light being part of our human state—so I had to find a material that would achieve that. I found glass microspheres, which are prism-like. It's not a reflection—it's a refractive material and actually brings the viewer into the painting. The surface of the painting, the viewer, and the light all work together."[3]

In these works, Corse applies multiple layers of white acrylic paint, sanding down the surface between each layer, and then, having mixed the glass microspheres—an industrial material typically used to demarcate car lanes on the highway—into an acrylic medium, she brushes them across the canvas in various directions. Offering tonal variation across the white surface, the glass beads instill each work with a subtly yet distinctly different texture. Soon, Corse introduced a visible grid format into the *White Light* compositions to provide them with structure, which also enabled her to work on one square at a time. She initially divided each canvas into a four-by-four grid, as seen in the Shah Garg Collection example, and later enlarged the frame to five-by-five. In the earliest exhibitions of the *White Light* works, the artist showed the paintings in pairs, highlighting these compositional differences.

In the late 1970s, Corse established her *Black Light* series, in which she spread glimmering squares of black plastic, about a quarter-inch wide, over black acrylic paint to achieve a similar light-scattering effect. Additionally, over the past twenty years, Corse has introduced primary colors into her practice, recognizing that they are the hues that emerge when white light is broken down into its component colors. By layering fields of red, yellow, and blue paint with glass microspheres, light and color become interchangeable. In the artist's own words, "Once I could make color a function of light, finally then I could use color."[4] AB

1. Mary Corse, quoted in Allie Biswas, "Lights On," *Glass*, no. 43 (Autumn 2020): 111.
2. Kim Conaty, "Light + Space + Time," in *Mary Corse: A Survey in Light* (New York: Whitney Museum of American Art, 2018), 9.
3. Corse, quoted in Biswas, "Lights On," 110.
4. Mary Corse, interview by Alex Bacon, *Brooklyn Rail*, June 2015, https://brooklynrail.org/2015/06/art/mary-corse -with-alex-bacon.

52. *Untitled (White Grid, Horizontal Strokes)*, 1969
Glass microspheres and acrylic on canvas
9 × 9 ft. (274.3 × 274.3 cm)

Pacita Abad

Batanes, Philippines, 1946–2004 Singapore

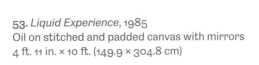

The Filipino American artist Pacita Abad was born into a family of politicians on the remote island of Batanes, the northernmost province in the Philippines. Of like-minded ambition, she studied political science and law at the University of the Philippines in Quezon City. When her father's 1969 congressional reelection campaign fell victim to election fraud financed by the country's authoritarian president Ferdinand Marcos, however, Abad turned to political activism. The family home was targeted, and Abad was urged, over concerns for her safety, to finish her studies elsewhere.

Abad settled in San Francisco in 1970 and studied Asian history at the University of San Francisco while supporting herself as a seamstress. Through the painter George Kleiman (to whom she was briefly married), she was introduced to the city's counterculture, and when she was offered a scholarship to study law at the University of California, Berkeley, in 1973, she demurred. Instead, she spent twelve months hitchhiking from Turkey to the Philippines with her new partner, Jack Garrity, passing through Iran, Afghanistan, Pakistan, India, Sri Lanka, Myanmar, Thailand, Laos, Taiwan, and Hong Kong. This exposure to diverse peoples and cultural traditions had a transformational impact, and Abad resolved to pursue painting instead of law. She began her first formal training at the Corcoran School of Art in Washington, DC, in 1976 and attended classes at the Art Students League of New York in the following year.

Thanks to Garrity's work as a development economist, the couple lived in multiple countries across six continents. In each new environment, Abad—desirous to learn from everyone she encountered—painted, researched traditional art-making techniques, and collected local manufactures, such as textiles, masks, and beads. She explored vernacular practices ranging from Indonesian batik and Papuan fiber work to West African tie-dye and Korean ink painting, incorporating aspects of the forms, materials, and techniques of each into her own unique creations. As she explained, "My works are like inspirations [from] the many places that I visited and the many cultures that I see."[1]

With encouragement from a doll-making friend around 1981, Abad began to explore the possibilities of painting in three dimensions. She developed a signature technique that she called "trapunto" in reference to a five-hundred-year-old quilting style of Italian origin in which designs are "stuffed" from underneath to create relief effects. To make her "trapunto" paintings, Abad stitched and padded large pieces of canvas by hand. She then painted and embellished them with colorful materials amassed from her travels, including beads, buttons, rickrack, fabric, and seashells. The works were left unstretched and hung directly on the wall, a decision inspired by a Tibetan Buddhist scroll painting, or *thangka*, Abad had admired in a refugee camp in Nepal. Its portability undoubtedly resonated with her peripatetic lifestyle.

While many of these compositions explored masklike forms, *Liquid Experience* is one of the artist's earliest abstractions. Its vivid surface—glimmering with tiny reflective disks that imply a familiarity with *shishah*, or mirror embroidery, from India—demonstrates Abad's fearlessness as a colorist. "I l-o-v-e colors," she explained in 1985, "and I will use anything that has them, the wilder, the brighter, the better."[2] Drawing inspiration from the peeling walls of downtown Manila, the painting, and its title, also suggest the underwater experiences in which Abad reveled, as an accomplished scuba diver.

Abad's exposure to diverse cultures provided formal inspiration, but her proximity to the international aid community also refined her subject matter. "I am a painter who paints from the gut, but has a strong social conscience," she once revealed. "As an artist, I have a social responsibility for my painting, to try to make our world a little better."[3] In the early 1990s, she produced her *Immigrant Experience* series, combining the "trapunto" technique with Social Realism to highlight the everyday struggles of immigrant communities living on the margins of society. In her final years, she returned to abstraction, prompted by public turmoil, such as that surrounding the September 11, 2001, terror attacks, and by her own lung cancer diagnosis. She continued to work and travel until her untimely death. HJ

1. Pacita Abad, quoted in "Look Closer: Understanding Pacita Abad's *European Mask*," Tate (website), accessed April 29, 2022, https://www.tate.org.uk/art/artworks/abad-european-mask-t15297/understanding-pacita-abads-european-mask.
2. Pacita Abad, quoted in Odette Alcantara, "The Color and Controversy That Is Pacita Abad," *Veritas* (Quezon City, Philippines), July 1, 1985.
3. Pacita Abad, "Feminist Art Statement," Feminist Art Base, Elizabeth A. Sackler Center for Feminist Art, Brooklyn Museum (website), accessed April 29, 2022, https://www.brooklynmuseum.org/eascfa/about/feminist_art_base/pacita-abad.

53. *Liquid Experience*, 1985
Oil on stitched and padded canvas with mirrors
4 ft. 11 in. × 10 ft. (149.9 × 304.8 cm)

Sherrie Levine

Born Hazleton, Pennsylvania, 1947

The photographer, painter, and sculptor Sherrie Levine rose to prominence in the 1970s as a member of the Pictures Generation, a group of artists named for the landmark 1977 exhibition at the SoHo gallery Artists Space—*Pictures*—in which she made her New York debut. Celebrated for her serial appropriations of artworks by male artists in the Western canon, Levine, through her postmodern conceptual practice, examines and interrogates the structures of signification underlying the production, circulation, and interpretation of all images.

After graduating from the University of Wisconsin, Levine moved to New York in 1975. There, she explored the possibilities of various modes of reproduction in contemporary art, drawing on her training as a printmaker and her experience of working at commercial art studios in Madison. Speaking at the time of the influence of commercial artists, Levine said, "I was really interested in how they dealt with the idea of originality. If they wanted an image, they'd just take it. . . . As an artist I found that very liberating."[1] Levine initially experimented with the medium of collage. In one body of work, she cut pages out of a book by the American photographer Andreas Feininger and mounted the images, unedited, in mats. In another, she produced silhouettes of American presidents from glossy images of women ripped out of magazines. Her shoe sale at 3 Mercer Street in 1977, in which she resold seventy-five pairs of thrift-store-purchased children's shoes for two dollars a pair, represented a variation on the Duchampian readymade.

By 1979, Levine had begun rephotographing images made by iconic modernist photographers, including Edward Weston and Walker Evans. In her first solo exhibition, at Metro Pictures in 1981, she presented *After Walker Evans 1–22*, photographic reproductions of photographs taken by Evans (1903–1975) during his Farm Security Administration–sponsored documentation of the rural South. By selecting, reproducing, and offering up images by another photographer as her own work—"They are pictures on top of pictures and the gap between the original and my image is the subject matter," she explained—Levine presented a philosophical challenge to notions of originality, authenticity, and authorship.[2] Her choice of male sources was a deliberately feminist attempt to "get some of the power."[3]

By the mid-1980s, Levine was painting monochromes and geometric compositions consisting of stripes, chevrons, or grids that recall the work of modernist painters such as Kazimir Malevich and Minimalists such as Frank Stella. With regard to this body of work, the artist has said, "What [my abstract paintings] appropriate are concerns of other artists rather than a specific image. This confuses the notion of originality even more, which I find amusing."[4] In 1986, Levine produced a series of twelve *Chair Seats*, including the example in the Shah Garg Collection, which she first exhibited that year at Jay Gorney Modern Art in New York's East Village. Using store-bought chairs with their legs and backs removed, Levine transposed the eponymous motif from her multiple *Stripe* series (*Broad Stripe*, *Thin Stripe*, *Two Inch Stripe*, etc.) onto the carved wood surfaces in two- and three-color combinations. By way of this awkward juxtaposition of the abstract and the functional, the two-dimensional and the three-dimensional, the artist undermined the deliberately flattened language of modernist painting. On the importance of the bodily reference in her work, Levine has said, "I enjoy painting because of its physicality. The surface becomes a record of the artist's bodily relationship to the painting. I always want my work to have a physical presence."[5]

Over the past two decades, Levine has continued to draw on her fascination with modernist art. She has made drawings after Willem de Kooning, paintings after Henri Matisse and Piet Mondrian, and sculptural appropriations indebted to the work of Man Ray and Constantin Brâncuși. Far from claiming ownership of the images she borrows, Levine views her translations as acts of collaboration. "What I think about in terms of my work," she explains, "is broadening the definitions of the word 'original.' I think of originality as a trope."[6] She continues: "What does it mean to own something and, stranger still, what does it mean to own an image?"[7]

HJ

1. Sherrie Levine, "After Sherrie Levine," interview by Jeanne Siegel, *Arts Magazine* 59, no. 10 (Summer 1985), reprinted in *Sherrie Levine: Hong Kong Dominoes*, ed. Elizabeth Gordon, exh. cat. (New York: David Zwirner, 2021), 36.
2. Sherrie Levine, interview by Peter Mahr, *Wolkenkratzer Art Journal*, Spring 1988, English translation courtesy of the artist and David Zwirner, New York.
3. Sherrie Levine, interview by Noemi Smolik, *Kunstforum International*, no. 125 (1994): 286–91.
4. Sherrie Levine, quoted in Lilly Wei, "Talking Abstract: Part Two," *Art in America* 75, no. 12 (December 1987): 114.
5. Ibid.
6. Levine, "After Levine," 38.
7. Ibid., 41.

54. *Chair Seat: 6*, 1986
Casein and wax on wood
18 × 18⅜ × 2¼ in. (45.7 × 46.7 × 5.7 cm)

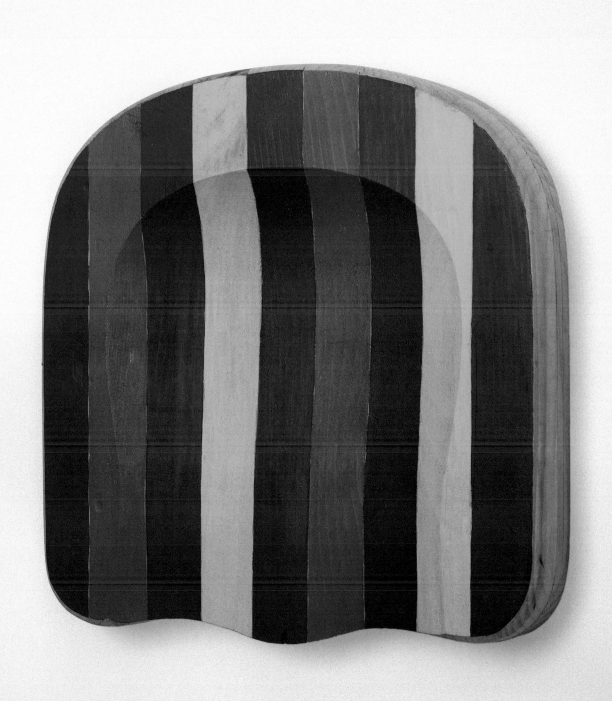

Dona Nelson

Born Grand Island, Nebraska, 1947

In the spring of 1968, while still pursuing her BFA at the Ohio State University in Columbus, the American painter Dona Nelson attended the Whitney Museum of American Art's Independent Study Program in New York. In the fall, after graduating from Ohio State, she moved permanently to the city. The artist worked abstractly until 1980, when she adopted a figurative style inspired by the depiction of space in Early Renaissance paintings; the resulting portraits, street scenes, and interiors arose from both observation and imagination. Toward the end of the decade, finding herself dissatisfied with the "continuousness" of representation, she began to cut up her own paintings and reassemble fragments into new works.[1] Eventually, as she later recalled, she "started to discard the flat pieces of canvas and to build up images with little wads of muslin and gel medium. They're like islands that interrupt the picture plane."[2]

Crow's Quarters was first displayed in the exhibition *Painting the Magic Mountain*, held at the Los Angeles gallery Michael Benevento in 2019. The eighteen paintings featured in the show are typical of the highly gestural abstractions Nelson has been producing since 2003, when she started to explore certain techniques and materials that

further altered the surfaces of her works. Most prominently, she began to conceive her paintings as freestanding, double-sided structures, with each side of the canvas distinct from the other. Now, she typically sets her paintings within custom metal frames that raise them a few inches off the ground. This mounting technique offers a more complex and participatory viewing experience—one that is akin to looking at sculpture.

The only work in *Painting the Magic Mountain* to be exhibited in a room on its own, *Crow's Quarters* illustrates numerous processes that inform Nelson's largely improvisational practice. On both sides of the painting—ultimately, the "front" is the side on which the stretcher is fully covered by canvas, not partially exposed, as it is on the back—an underlying grid can be seen. Nelson often begins her paintings with such a grid, made by laying down lengths of gel-saturated cheesecloth "rope" on one side of the canvas. Once that is dry, she pours a tar-like gel (pigmented with fluid acrylic paint) into the grid's interstices, which she describes as "dams." As she intends, the colors soak through to the other side of the canvas, which she then flips over to continue working on the image initially produced by seeping and staining (sometimes, as

55. *Crow's Quarters*, 2019
Acrylic, graphite, and remnants of cheesecloth on canvas, with steel stand
78 × 84 in. (198 × 213.4 cm), overall including stand 84¾ × 89 × 10¼ in. (215.3 × 226 × 26 cm)

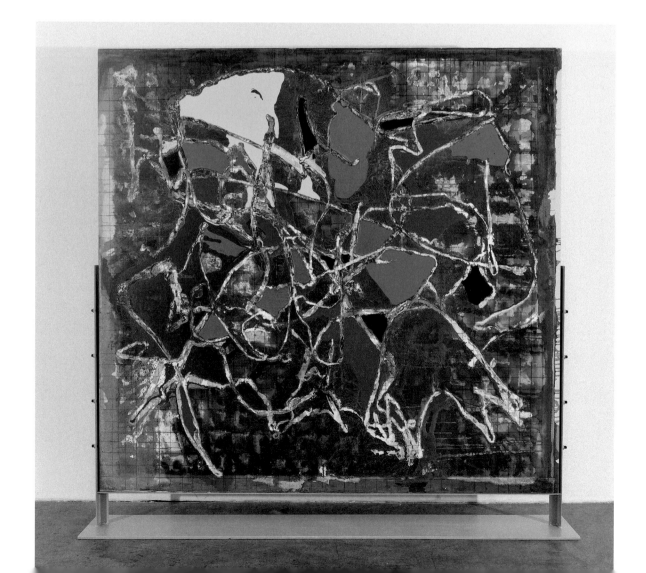

in *Crow's Quarters*, she applies an additional cheese-cloth framework, a loose tangle rather than a grid; often, though by no means always, she removes the cheesecloth from both sides before consider-ing the work complete). In an interview published in 2020, Nelson commented that "the backs of my paintings, which are inseparable, but often very different from the fronts of the paintings, determine that my two-sided paintings will keep producing themselves in time and space."[3]

The materiality of the canvas itself is an impor-tant part of the artist's process. In another series of works, Nelson begins by punching holes through the material, and then she and an assistant collabo-ratively ply the surface with many colors of paint-dripped string to create densely embroidered images. In all her formats and procedures, unpre-dictability informs Nelson's approach: she manipu-lates paint and textile in such a way that she does not necessarily see a composition coming into existence but is instead led by the physical, intuitive act of making. The artist attributes a major shift in her practice to her relocation from New York to Lansdale, Pennsylvania, in the 1990s: "Since mov-ing, I'm much freer and my art has taken off."[4] The two-sided paintings emerged during a period when she was "working in a field in New Jersey" because "an Italian countess bought the property where I had my studio. . . . I probably wouldn't have discov-ered this had I stayed in my studio."[5] While it is evident that Nelson's life experiences inform her paintings, albeit in a very unconscious way, the continuous disruption and development of mark-making methods are at the forefront of her project. As she says, "The whole idea of deconstructing and then reconstructing the image or redoing the image is the central idea in my work."[6] AB

1. Dona Nelson, interview by Richard Whelan, *BOMB*, no. 46 (Winter 1994), https://bombmagazine.org/articles/dona -nelson/.
2. Ibid.
3. Dona Nelson, "Two-Sided Paintings," in *Dona Nelson: Stand Alone Paintings*, ed. Ian Berry and Molly Channon, exh. cat. (Saratoga Springs, NY: Frances Young Tang Teaching Museum and Art Gallery at Skidmore College, 2020), 141.
4. Dona Nelson, "Dona Nelson's Talk at VSC in 2019, with a Personal 2020 Intro," Vermont Studio Center, Johnson, May 13, 2020, YouTube video, 24:56, https://www.youtube .com/watch?v=ORJxHTrVkzA&t=1308s.
5. Dona Nelson, "Some Steam: Dialogues with Dona Nelson," interview by Ian Berry, in Berry and Channon, *Nelson: Stand Alone Paintings*, 152.
6. Ibid., 146.

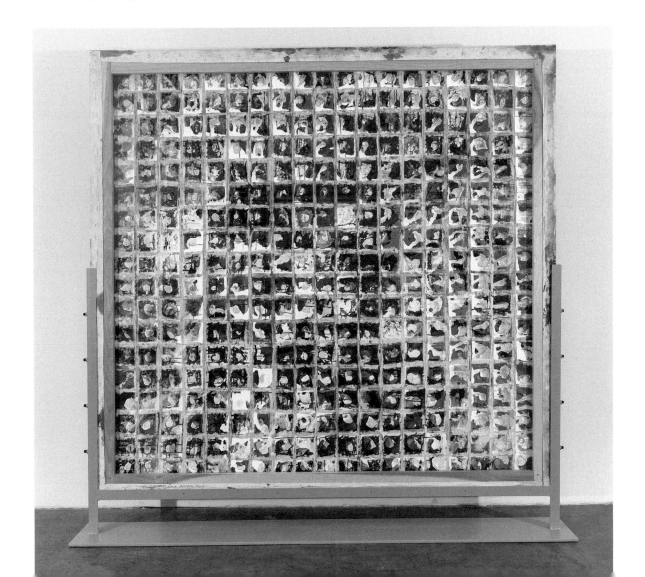

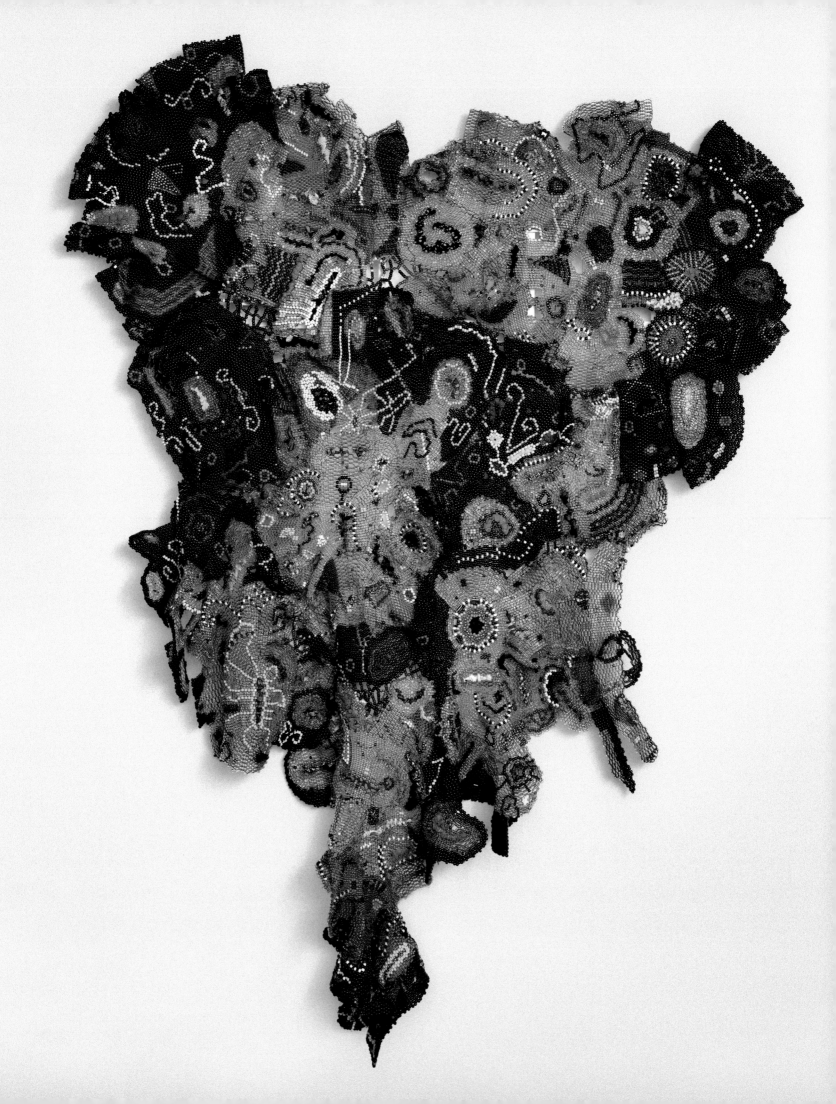

Joyce J. Scott

Born Baltimore 1948

The celebrated sculptor, jeweler, performance artist, printmaker, and educator Joyce J. Scott remains ensconced in the city of her birth: describing herself as "a true Baltimore babe and Sandtown girl," she has lived in a row house in the Sandtown-Winchester neighborhood of West Baltimore for over four decades.[1] Scott was named a MacArthur Fellow in 2016, won the Smithsonian Visionary Award in 2019, and received an honorary doctorate from Johns Hopkins University in 2022. She is perhaps best known for her eclectic figurative sculptures and for her beaded jewelry—often also partly figural—made through free-form, off-loom weaving techniques.

Harriet Tubman and Other Truths, Scott's largest exhibition to date, opened in October 2017 at Grounds for Sculpture, a sculpture park and museum in Hamilton, New Jersey. This homage to Tubman (ca. 1820–1913), the formerly enslaved abolitionist who, at great risk, led dozens of people to freedom, was curated by Patterson Sims, former director of New Jersey's Montclair Art Museum, with a separate installation, titled *Harriet's Closet*, curated by Lowery Stokes Sims, former director of the Studio Museum in Harlem and curator emerita at New York's Museum of Arts and Design. The installation was intended as a "dream boudoir" for Tubman: the "inner sanctum of a great lady," complete with a glass rifle.[2] A standout work there, spilling out of a found wooden trunk, was *Harriet's Quilt*, an organically shaped assemblage of glass beads, found plastic beads, and yarn incorporating fabric knotted by Elizabeth Talford Scott (see pl. 4), the artist's late mother, and left unused at the time of her death. The elder Scott was a renowned artist in her own right, known for her intricate, mixed-media quilts, and had always encouraged her daughter's creativity. Scott began drawing in elementary school and, in 1970, earned a BFA from the Maryland Institute College of Art. In 1971, she received an MFA from the Instituto Allende in Mexico (now officially part of the Universidad de Guanajuato).

In the mid-1970s, after working primarily with textiles, Joyce J. Scott began exploring glass beading, a labor- and time-intensive technique. As she gained experience in the medium, she began to incorporate into her beaded sculptural assemblages elements of blown and cast glass, which interested her as a natural material that exhibits a full spectrum of color and luminosity. In 1992, Scott was a visiting artist at the Pilchuck Glass School in Stanwood, Washington, and she has made repeated trips to a glass studio on the island of Murano, in the Venetian Lagoon, to further her practice. She has never stopped beading, however, and her use of the craft-store staple is innovative, technically dazzling, often grimly humorous, and thematically incisive. In many cultures, beading is an activity performed mostly by women, and Scott's art is her way of "prodding the viewer" to think specifically about the work of women. As she puts it:

I am very interested in raising issues. My work is not meant to be openly offensive, but that does happen. I skirt the borders between comedy, pathos, delight, and horror. I believe in messing with stereotypes, prodding the viewer to reassess, inciting people to look and then carry something home—even if it's subliminal—that might make a change in them. . . . I seek opportunities to talk about how women—the very people who make human life—are considered expendable and disposed of. On the other hand, my beadwork might inspire mathematically or musically.[3]

Balancing autobiographical allusions with broader political and social content—among her works are *Rodney King's Head Was Squashed Like a Watermelon* (1991; Philadelphia Museum of Art) and *Lynching Necklace* (1998)—Scott's visual vocabulary has long amalgamated a wide range of cultural references, including to Mexican Muralism, Yoruba weaving, Native American beadwork, and Buddhist iconography. Above all, traditions of quilting, weaving, and beadwork from the American South are integral to the artist's oeuvre. Scott's work is at once splendidly multicultural and deeply rooted in her community and family history. LOB

1. Joyce J. Scott, quoted in Tim Smith, "Baltimore Artist Joyce Scott Named MacArthur Fellow," *Baltimore Sun*, September 22, 2016, https://www.baltimoresun.com/features/bs-ae-joyce-scott-profile-20160921-story.html.
2. Joyce J. Scott, quoted in Ilene Dube, "'I Was an Artist in Vitro': Joyce J. Scott and Her Darkly Beautiful Art," *Hyperallergic*, January 30, 2018, https://hyperallergic.com/423894/i-was-an-artist-in-vitro-joyce-j-scott-and-her-darkly-beautiful-art/.
3. Joyce J. Scott, quoted in Patterson Sims, "Joyce J. Scott: Art/Life," in *Joyce J. Scott: Harriet Tubman and Other Truths*, by Lowery Stokes Sims, Seph Rodney, and Patterson Sims (Hamilton, NJ: Grounds for Sculpture, 2018), 24.

56. *Harriet's Quilt*, 2016–22
Plastic and glass beads, yarn, and knotted fabric
8 ft. 7½ in. × 6 ft. 7 in. × 6 in. (262.9 × 201.9 × 15.2 cm)

Contributors to the making of the work: Elizabeth Talford Scott (1916–2011), Lowery Stokes Sims (born 1949), Amy Eva Raehse (born 1974), Paul Daniel (born 1950), Leslie King Hammond (born 1944), Oletha DeVane (born 1950), Coby Green-Rifkin (born 1971), Grayce Johnson (born 1948), Karen Fitchett (born 1945)

Jenny Holzer

Born Gallipolis, Ohio, 1950

Words are the primary medium employed by the American artist Jenny Holzer. As a pioneer of text-based art, she has written and collected innumerable concise statements that are both poetic and polemical and that draw attention to the politics of everyday life. Working in many formats, Holzer has then projected her aphorisms onto public buildings, emitted them as LED signs, carved them into stone benches, displayed them on vehicles, and distributed them as posters. Accessibility has always been critical to the artist, and her works have occupied numerous civic spaces. In her first substantial body of work, *Truisms* (1977–79), Holzer printed hundreds of one-line slogans on sheets of paper, which she then pasted onto walls, telephone booths, and other such fixtures around New York City. Reflecting on the conflicting viewpoints at play in society, they included declarations such as "AN ELITE IS INEVITABLE" and "AMBIVALENCE CAN RUIN YOUR LIFE" in bold capital lettering, inviting viewers to question their own beliefs and values. "I wanted to offer content that people—not necessarily art people—could understand," she has explained. "I was concentrating almost exclusively on how to present artwork to a general public."[1]

Although Holzer explores various aspects of contemporary life, confronting matters of injustice is of paramount importance to her. "We don't need to work on joy—that is something that takes care of itself and is sustaining," she has commented, "but one must argue with cruelty, homicide—abuse of any sort."[2] Since 2005, Holzer has created paintings based on declassified government documents as part of her ongoing *Redaction* series (these are the first works on canvas she has ever exhibited). Dating to the beginning of the Iraq War in 2003, the heavily censored statements by United States officials, soldiers, and detainees sourced by the artist relate to matters such as military torture, terrorist threats, and data collection. In the documents, heavy black lines strike through information deemed too sensitive for public consumption, which is referred to as "redacted text"—yet, as Holzer has pointed out, "Even if hundreds of words are missing, if you read 500 of them, you'll come to some sort of accuracy."[3] The artist began to search for these materials following an interview with *WIRED* magazine in 2004, during which she was asked to imagine a new home page for Google's search engine. "I wanted to see secrets—a different secret every time I logged on," she has said, adding elsewhere that "like many people, I was confused about the 2003 invasion of Iraq. I showed the documents because I wasn't seeing much of their content in the press."[4]

The *Redaction* paintings are meticulous reproductions of the original documents. Holzer silkscreens or traces the typed, printed, or handwritten text, as well as any notations that were made in editing the paper for public release, onto canvas or linen, then paints over the censored sections. Other than that application of paint, and necessary adjustments in scale, no other alterations are made. In contrast to Holzer's other works, words are hidden, rather than highlighted, in these compositions. As she has remarked, "Sometimes the word should be there almost lonely—absolutely by itself, unadorned. Other times, the word wants to hide and be cloaked in something flashing or dark or dire."[5]

In early works in the series, Holzer replaced the censored components with distorted stripes in vivid colors, alluding to Constructivism and color-field painting. Since 2010, she has shifted to a muted palette that evokes Minimalist painters such as Ad Reinhardt and Robert Ryman. *TOP SECRET ENDGAME* is a recent installment in the series and marks a material transition. The textured background consists of gold leaf over oil paint, and each censored paragraph has been coated with a rectangle of pale, silvery metal. Although the work is otherwise abstract, the words "TOP SECRET" in the bottom left-hand corner reveal the painting's origins and emphasize how much the viewer has not been allowed to see. — AB

1. Jenny Holzer, interview by Kiki Smith, *Interview*, March 26, 2012, https://www.interviewmagazine.com/art/jenny-holzer.
2. Jenny Holzer, "Jenny Holzer: Interview," Fondation Beyeler, Basel, November 30, 2017, YouTube video, 6:55, https://www.youtube.com/watch?v=oaY8VmHmiB4.
3. Jenny Holzer, quoted in Caroline Roux, "Battle Lines: In Two New Shows, Artist Jenny Holzer Proves That Words Are Weapons," *Wallpaper*, June 12, 2017, https://www.wallpaper.com/art/battle-lines-in-two-new-shows-artist-jenny-holzer-proves-that-words-are-weapons.
4. Jenny Holzer, quoted in catalogue entry for *DODDOACID* (2007), National Gallery of Art, Washington, DC (website), accessed August 1, 2022, https://www.nga.gov/collection/art-object-page.152280.html. Howard Halle, "Jenny Holzer Discusses Her Process," posted by Karina Munoz, *Sunday Arts Blog*, Thirteen/WNET (website), April 3, 2009, https://www.thirteen.org/sundayarts/blog/museums/jenny-holzer-discusses-her-process/691/.
5. Holzer, "Holzer: Interview," Fondation Beyeler.

57. *TOP SECRET ENDGAME*, 2019
Oil, moon gold leaf, and palladium leaf on linen
80 × 62¼ in. (203.2 × 158.1 cm)

Magdalene Odundo

Born Nairobi, Kenya, 1950

Untitled Vessel, Symmetrical Series is representative of the gleaming, minimalistic forms that have come to define Magdalene Odundo's output. Over the past fifty years, the ceramic artist has created an oeuvre that revolves around vessels made almost invariably of English red clay and always by hand. Bypassing traditional throwing techniques and the mechanical pottery wheel, these voluptuous, streamlined objects, which often possess anthropomorphic features reminiscent of vertebrae, noses, and other body parts—"I do not see the difference between a figurative sculpture and a figurative vessel," Odundo has remarked[1]—are generated through laborious hand-coiling methods before the artist levels and smooths them with a shell and burnishes them by hand both before and after firing. The primary color palette of her works, dark amber and ebony, reflects her firing technique: a first firing in an oxidizing atmosphere turns the clay orange, while a second firing, in an oxygen-poor atmosphere, causes the clay to become black, sometimes all over and sometimes in select places. Left unglazed but treated with colloidal slip in a technique called *terra sigillata*, the works highlight the natural hues of the material, which Odundo manipulates to produce a sense of great depth.

The artist's processes relate to the pottery traditions of sub-Saharan Africa, especially of Kenya, Uganda, and Nigeria. After moving in 1971 from Kenya, where she was born, to England to study at the Cambridge School of Art (now Anglia Ruskin University), Odundo was taught by the influential potter Zoë Ellison (1916–1987), born in Rhodesia (now Zimbabwe), who introduced her to the work of contemporary British potters such as Lucie Rie and Robin Welch as well as to the ceramic achievements of ancient civilizations in Africa, Greece, and South America. Later, at West Surrey College of Art and Design (now University for the Creative Arts) in Farnham, Odundo studied with Michael Cardew (1901–1983), who had spent two decades teaching ceramics in West Africa. At his suggestion, Odundo, while still an undergraduate, took up residency at the Abuja Pottery in Suleja, Nigeria, in 1974, and was tutored in hand building by a renowned group of women potters, including Ladi Kwali (1925–1984) and Lami Toto. "That is

when I really fell in love with clay," Odundo says. "I realized what an amazing material it was—expansive, seemingly without boundaries. Put in the hands of a willing person, it spoke for itself as a material."[2] After her time in Nigeria, as part of her continuing thesis research, Odundo returned to East Africa to train with local potters in traditional firing techniques. A trip to New Mexico to observe the production of blackware vessels by Tewa potters followed her graduation from Farnham in 1976. By the end of the decade, she had begun to hone her skills at London's Royal College of Art, establishing forms that functioned as containers—a central motif of Odundo's project. She earned her MFA in 1982.

For the artist, notions of containment speak to the innate connection humans have with clay: objects made of it that hold substances and materials, such as teapots, are central to the formation of community. She has related ceramics to "a built structure, like a nest or a house that contains what will sustain you as a person."[3] While exposure to numerous cultures has shaped the artist's approach, her early childhood in Delhi, India, where her father worked as a journalist for three years, was especially important in establishing such ideas. "The internal space is part and parcel of my personality, informed by all that diasporic travel," she has remarked. "Imagine a woman wrapping herself in a sari; the gestures that bring a person into this container, this fabric. When she is walking, there is a certain balance that she has to maintain. It has all got meaning."[4]

In her quest to make pared-down vessels that are as symmetrical as they are precarious, where the interior void is equal to the external surface, Odundo evokes the spirit of human presence. AB

1. Magdalene Odundo, quoted in Isabella Smith, "Magdalene Odundo: Figuration and Abstraction," *Ceramic Review*, no. 296 (March–April 2019), https://www.ceramicreview.com/articles/magdalene-odundo-figuration-and-abstraction/.
2. Magdalene Odundo, "How Travel Transformed Magdalene Odundo's Ceramics Practice," *frieze*, no. 223 (November–December 2021), https://www.frieze.com/article/how-travel-transformed-magdalene-odundos-ceramics-practice.
3. Ibid.
4. Magdalene Odundo, telephone interview by the author, May 2022.

58. *Untitled Vessel, Symmetrical Series*, 2020
Ceramic
22½ × 13 × 13 in. (57.2 × 33 × 33 cm)

Rosemarie Trockel

Born Schwerte, Germany, 1952

Widely regarded as one of the most influential conceptual artists of her generation, Rosemarie Trockel emerged in the male-dominated art scene of 1980s Cologne. From 1974 to 1978, she studied painting at the Fachhochschule Köln, an institution heavily influenced by the art, theories, and values of Joseph Beuys, who had been dismissed from his post at the Kunstakademie Düsseldorf in 1972 but still retained great authority in German artistic circles. In seeking her own path, Trockel made important early allies in the women gallerists Monika Sprüth and Philomene Magers (mother of Sprüth's current business partner). It was at their galleries in Cologne and Bonn, respectively, that Trockel received her first solo exhibitions in 1983.

Trockel has worked in sculpture, collage, photography, installation, video, and paint, always taking a profoundly fluid approach to her materials. In the early 1980s, however, she explored mostly textiles, producing the *Strickbilder* (knitting pictures) for which she received swift international acclaim. These consisted of pieces of knitted wool—computer-designed and machine-knitted—that the artist stretched over wood frames to replicate the format of a painting on canvas. The earliest examples, which are either monochrome or fashioned into high-contrast patterns such as stripes and checkerboards, imitate the aesthetics of modernist abstraction. Later, the works incorporated commercial and political motifs, including the Woolmark logo (see fig. 3 on p. 84), the Playboy Bunny, and the hammer and sickle, as well as trademarks such as "Made in Western Germany."

Speaking of her choice of medium, Trockel has explained, "In the 70s there were a lot of questionable women's exhibitions, mostly on the theme of house and home. I tried to take wool, which was viewed as a woman's material, out of this context and to rework it in a neutral process of production."[1] Conceived to elevate a material and process traditionally confined to craft and the domestic sphere, Trockel's "knitting pictures" challenge gender politics, notions of labor, and patriarchal dominance of the art world. Their mechanical fabrication also deliberately highlights the belittled status of the decorative arts in conventional hierarchies. While Trockel has remained committed to feminism across her career, she has also refused to be co-opted by any single agenda. As she once asserted, with her trademark humor, "Art about women's art is just as tedious as the art of men about men's art."[2]

Since the late 1990s, Trockel has worked in ceramics, producing pots, figures, and abstract forms that are evocative of marine life and reflect her ongoing fascination with biology, born out of an early, unrealized, ambition to study the subject. She has also imitated and appropriated everyday objects—such as sofas by Knoll and burners purloined from electric stoves—to form "readymades," demonstrating her wit, irony, and capacity for visual and verbal punning. Trockel has a long-standing interest in divergent modes of creativity and has exhibited her works alongside those of self-taught artists and even animals, including Tilda, an orangutan at Cologne's zoo. She has said, "I think of work often as the invisible made visible, and it doesn't matter so much to me whether I made it or not."[3]

The fundamental role of paper in Trockel's practice is evidenced by the *Buchentwürfe* (book drafts) she has created since the 1970s. Taking the form of book covers—with or without internal pages—these works incorporate a title graphic alongside a drawing, collage, or found photograph. Not destined for publication, the hypothetical books are instead envisaged as sketches and a sounding board for ideas and motifs that emerge later in other media. Trockel's aptitude for collecting and reconfiguring imagery is also demonstrated in her photography, both analogue and digital.

Most recently, the artist has returned to wool to produce works such as *Chamade* and its study. While their monochromatic surfaces evoke the language of abstract painting in the same way her "knitting pictures" of the 1980s did, Trockel's long-time collaborator, Helga Szentpétery, produces these works by hand. This approach emphasizes the variations and subtle irregularities in the knit, aligning the object with the handcrafted quality of a painted canvas. On closer inspection, however, it becomes apparent that Trockel has deliberately stretched the knitted fabric over the frame with its *reverse* side presented. It is a characteristically playful reminder of the artist's challenge to the revered status of painting. HJ

1. Rosemarie Trockel, "'80s Then: Rosemarie Trockel Talks to Isabelle Graw," *Artforum* 41, no. 8 (March 2003), https://www.artforum.com/print/200303/rosemarie-trockel-4290.
2. Rosemarie Trockel, interview by Jutta Koether, *Flash Art*, no. 134 (May 1987): 42.
3. Rosemarie Trockel, quoted in Randy Kennedy, "An Artist's Solo Show Contains Multitudes," *New York Times*, October 24, 2012, https://www.nytimes.com/2012/10/24/arts/design/rosemarie-trockel-a-cosmos-to-open-at-the-new-museum.html.

59.

Chamade, 2021
Wool on canvas with wood
9 ft. 8½ in. × 9 ft. 8½ in. × 2¾ in.
(296 × 296 × 7 cm)

Study for Chamade, 2021
Wool on canvas with wood
39⅜ × 39⅜ × 2¾ in.
(100 × 100 × 7 cm)

Dawn Williams Boyd

Born Neptune, New Jersey, 1952

Based in Atlanta, Dawn Williams Boyd is recognized for the mixed-media works she calls "cloth paintings," which often intertwine social-justice themes with aspects of African American history and are deeply inspired by the art of Faith Ringgold (see pl. 14). As Boyd recently said of her current practice, "Six decades after clothing my dolls with the scraps from my mother's sewing room floor, I create 'cloth paintings' with scraps of fabric, garnered from myriad sources, to tell the stories of my people, my country and my times."[1]

The artist earned her BFA at Stephens College in Columbia, Missouri, in 1974. Her first job thereafter involved coloring maps to track race, income, and other statistics for the Atlanta Regional Commission. Marriage to her first husband took her to Denver, where she spent the next twenty-nine years working for United Airlines, raising her children, and painting during her off-hours, primarily acrylics on plywood or corrugated cardboard. "When I was a painter, I was spending so much time poring over paints in the art supply store, now I spend my time fingering fabrics and finding interesting patterns," Boyd notes.[2] Also during that time, she helped to found two Black arts organizations that regularly sponsored festivals and public installations by Black and Latinx artists.

While living in the Colorado capital, Boyd gave a talk at a local college about Ringgold's art. In the course of her preparatory research, she pondered Ringgold's practice of combining paint and fabric in her "story quilts," a genre the artist had pioneered in the early 1980s. "That was a eureka moment for me," Boyd recalls. "Why not just make the entire image out of fabric?"[3] She taught herself to sew and embroider from library books. It wasn't until she took early retirement and moved back to Atlanta in 2010 with her second husband that she was able to devote herself more fully to working with textiles.

Boyd's "cloth paintings," of which *Africa Rising* is an example, are often large-scale, vividly colored, and richly textured. "I use both the appliqué and piecing methods to sew scraps of fabric together.

Machine stitches, hand embroidery, beads, sequins, cowrie shells, laces, silk ribbons and, occasionally, acrylic paints are added to embellish the surface," she explains, adding, "Each piece is drawn repeatedly over a seven to eight step process with implements ranging from a #2 pencil to a steel needle holding six strands of cotton embroidery floss."[4]

In an artist's statement, Boyd claims, "My work is occasionally humorous and warm hearted—it brings back memories of more peaceful, happier times. More often the work is controversial, forceful, and sometimes bitter and heart wrenching as I retell the history and culture of this country from the perspective of the 'other'—the oppressed, the abused and the disenfranchised."[5] Among the topics of her "cloth paintings" have been the assassination of Medgar Evers (1925–1963), the unethical syphilis experiments conducted on Black men in Tuskeegee, Alabama, from 1932 to 1972, and—in *Sankofa* (2010), which the Metropolitan Museum of Art acquired in 2021—her own family and autobiography. As aptly summarized by Rosalind Bentley of the *Atlanta Journal-Constitution*, "It is hard to find softness in the quilts of Dawn Williams Boyd. There is flannel and silk. There are whispers of organza and jaunty grids of gingham. There is also a river of blood, hoods of Klansmen, and moonlight glinting off the hood of an assassin's car."[6] LOB

1. Dawn Williams Boyd, artist's statement for *Dawn Williams Boyd: Death Is Swallowed Up by Victory*, Atlanta Contemporary (website), exh. on view November 12, 2020–January 31, 2021, accessed February 14, 2022, https://atlantacontemporary.org/exhibitions/dawn-williams-boyd.
2. Dawn Williams Boyd, quoted in Rosalind Bentley, "Dawn Williams Boyd's Quilts Document Racial Justice Struggle," *Atlanta Journal-Constitution*, November 2, 2020, https://www.ajc.com/life/atlanta-quilt-artists-work-focus-of-nyc-gallery-show-on-racial-justice/EFLXUP5MD5GYJEIZVGS3FYKZOQ/.
3. Ibid.
4. Boyd, artist's statement for *Boyd: Death Is Swallowed Up by Victory*.
5. Ibid.
6. Bentley, "Boyd's Quilts Document Racial Justice Struggle."

60. *Africa Rising*, 2008
Kente cloth, cotton, and cowrie shells
43 × 62½ in. (109.2 × 161.3 cm)

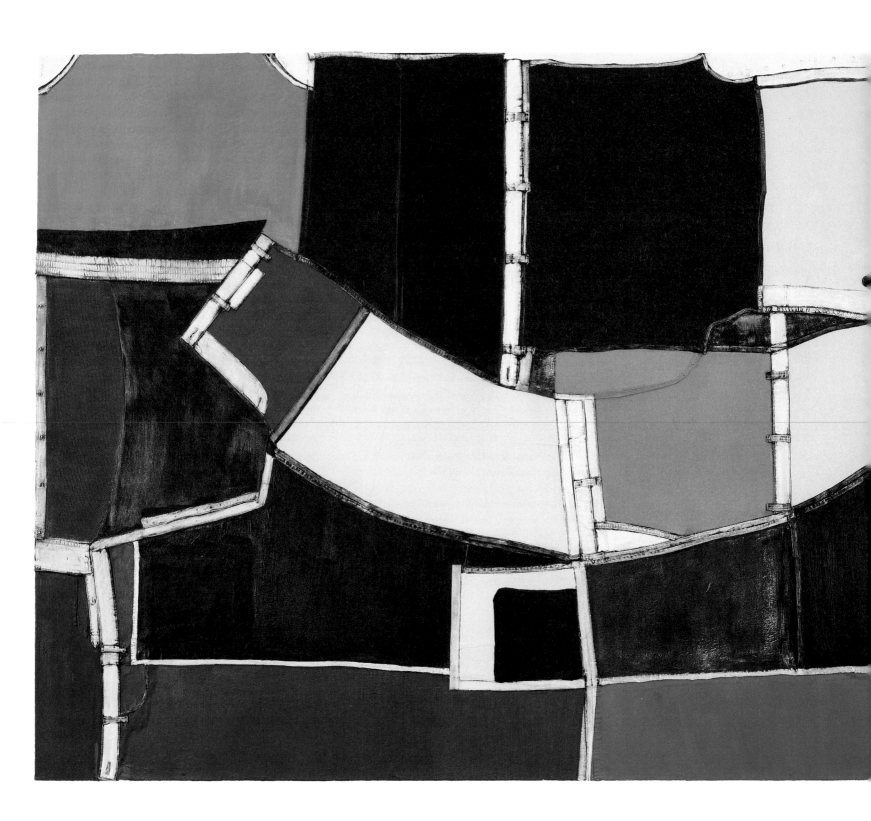

Medrie MacPhee

Born Edmonton, Canada, 1953

Favela is one of four paintings by the Canadian-born artist Medrie MacPhee that were first exhibited in *Words Fail Me*, a solo show held at the New York gallery Tibor de Nagy in 2021. Consisting of irregular blocks of color that appear slotted together like stained glass, the works are a significant departure from those of the first twenty-five years of MacPhee's career, which were figurative in style and based around the "gestures of the characters and the way that the background color snaps or sighs in relation to them."[1] The brightly colored forms resembling buildings and architectural remains that made up earlier series such as *The Floating World* and *Future Species* have been abandoned so that MacPhee can produce paintings in which "the content [is] inherent. . . . I've been able to reverse things, so rather than taking you into a space, the painting actually puts you up close to the surface."[2]

Indeed, the surfaces of *Favela* and its companions are completely idiosyncratic. In a process MacPhee terms "scaffolding," she creates a base layer for the works by cutting up secondhand and discounted clothing she has sourced at local retailers in her home of New York City, then randomly arranging the fragments—including buttons, zippers, and, as seen in *Favela*, belt-looped waistbands—on the surface of a stretched canvas. The result is a collaged network of shapes and textures to which MacPhee then applies a coat of white gesso to generate an "erasure" from which she can start painting in earnest. She builds her loose grids of color intuitively, applying oil paint in an improvisational process; as the painter Nicole Eisenman writes in the catalogue for *Words Fail Me*, "The interior shapes often have two aspects: the flatter middle and the raised, lumpy edge. Paint floats above, occasionally ignoring the boundaries suggested by the seams and creating a gestaltist or cloudlike shape, like a shadow on sunlit fields."[3] Revolving around a vibrant palette of red and blue, *Favela* is based on the artist's memories of Rio de Janeiro, where she found herself in awe of communal responses to the challenges of living in

what are commonly regarded as slums, noting the "incredible colors and details. And what they did with the pathways connecting them all together, I just loved it. I thought it was a triumph."[4]

The artist's incorporation of salvaged textiles into her paintings originated from an interest in deconstructing and reassembling articles of clothing. Initially sharing designs for clothes with friends as part of a "gift economy," the artist established a conceptual, though unofficial, fashion line called RELAX in 2012, making functional, one-off garments from leisurewear she found in thrift stores. The collage-like construction processes that informed these designs soon stimulated the artist to reassess her painting practice. Another admirer of MacPhee's, the painter Amy Sillman (see pl. 64), pointed out in a recent interview that making these works "takes incredible trust and rigor. It makes me think of those Gee's Bend quilts." To which MacPhee replied: "So fantastic. They embody everything that matters—improvisation, resourcefulness, gorgeous materiality, community, history!"[5]

Reminiscent of an existing architectural terrain, *Favela* is grounded in reality—specifically, material remnants—thereby achieving a purity that opposes what MacPhee describes as the "perverseness" of abstraction, in which a real-world source is absorbed and then deliberately altered.[6] The acute physicality of the painting only underlines MacPhee's enduring formalist concerns, as well as her overall interest in evoking a "psychic space"—one that is guided by an element of surprise. AB

1. Medrie MacPhee, quoted in *Double Vision: Medrie MacPhee, Landon Mackenzie*, ed. Lisa Baldissera, exh. cat. (Victoria, BC: Art Gallery of Greater Victoria, 2002), n.p.
2. Medrie MacPhee, "Excerpts from a Conversation between Amy Sillman and Medrie MacPhee," in *Medrie MacPhee: Words Fail Me*, exh. cat. (New York: Tibor de Nagy, 2021), 20–21.
3. Nicole Eisenman, "Med School," in *MacPhee: Words Fail Me*, 7.
4. MacPhee, "Excerpts from a Conversation between Sillman and MacPhee," 23.
5. Ibid., 22.
6. Ibid.

61. *Favela*, 2020
Oil and mixed media on canvas
62 × 98 in. (157.5 × 248.9 cm)

Sue Williams

Born Chicago Heights, Illinois, 1954

Sue Williams's artistic career began in the early 1980s, concurrently with the formative period of postmodern feminist discourse. Her painting practice, always permeated by her personal experience, investigates themes of sexual violence, gender inequality, and wider disempowerment while tenaciously engaging with the possibilities of abstraction.

Williams was raised in a city whose artistic culture was dominated by the distinctive irreverence of the Chicago Imagists. She received her BFA in 1976 from California Institute of the Arts (CalArts), where she had existed somewhat on the margins, her desire to paint being fundamentally at odds with the institution's overwhelmingly conceptualist ideology. Over the next decade or so, she moved back and forth between New York and Chicago, and while her artistic production of that time did not match her ambitions, a studio visit from an older artist in the late 1980s highlighted her aptitude as a draftsman. "I met Elizabeth Murray [see pl. 34]," Williams recalls, "and she gave me confidence because she said I should just draw straight on canvas, that I could do it."[1] Taking Murray's advice, Williams began to draw directly onto canvas, using an overhead projector to transfer her sketches.

The artist exhibited the resulting body of work in a solo exhibition at New York's 303 Gallery in 1992. Executed mostly in black and white and in a cartoonish style, the canvases were filled with graphic depictions of abuse, sexual objectification, and violent subordination of women by men. Based on source material gathered from newspapers and magazines, the works emphasized the misogynistic values and pornographic tendencies present in even the most innocuous-seeming corners of consumer culture. In an illustration of the artist's dark sense of humor, the pictorial narratives were accompanied by bitterly sarcastic textual commentary. Most shocking about these early canvases, however—and what distinguished them from much other feminist practice of the time—was their autobiographical nature: the themes of violence, humiliation, and cruelty drew directly on Williams's own harrowing experiences of domestic abuse. In a candid interview with the artist Nancy Spero in 1993, Williams presented her ongoing sense of trepidation and repression as one universally familiar to women: "I used to not want to talk about it as being autobiographical. . . . But I've gotten more nerve because it wasn't just me, it's also a reflection of the status quo."[2]

Critics dismissed much of Williams's work of the early 1990s as overly polemical and melodramatic.

"I felt misunderstood," the artist recalls. "I thought of my art as funny and as social statements. I didn't see it as cathartic. I wasn't making up anything grosser than what had really happened to me."[3] Faced with this reception, however, she attempted a different tactic: "After a while I got tired of the politics and the in-fighting. I wanted to play around with paint. I got interested in just doodling."[4] These "doodles" developed into works that juxtaposed discrete representational imagery with looser brushstrokes. By the middle of the decade, Williams had also begun to incorporate painted redactions into her compositions, often obscuring the most explicit imagery. As the artist became more interested in facilitating "what the brush wants to do," as she has explained it, her canvases filled up with flowing, meandering lines.[5] Lurid, near-neon color is often combined with gestural strokes and an allover treatment of the surface, evoking Abstract Expressionist precedents.

While from a distance these paintings may read as lyrical abstractions, close looking reveals references to digestive and respiratory organs, genitalia, and breast-like forms. *Fluorescent and Flooby*, whose humorous title references a slang term for sagging breasts and sexual organs, is a classic example, both for the presence of those motifs and for its incandescent palette. Speaking of the way in which her work is always inescapably tied to the body, Williams has said, "My images will probably always start with a line that's part of a body. That's the compulsion behind the line."[6] As she has demonstrated, a focus on formal concerns of line and color can be every bit as feminist as a more literal approach. HJ

1. Sue Williams, quoted in Michael Kimmelman, "In the Studio with: Sue Williams; In a Cheerful Groove, with a Plan and Serendipity," *New York Times*, December 28, 2001, https://www.nytimes.com/2001/12/28/arts/in-the-studio-with-sue-williams-in-a-cheerful-groove-with-a-plan-and-serendipity.html.
2. Sue Williams, interview by Nancy Spero, *BOMB*, no. 42 (Winter 1993), https://bombmagazine.org/articles/sue-williams/.
3. Williams, quoted in Kimmelman, "In the Studio with Williams."
4. Ibid.
5. Sue Williams, quoted in Ruth Erickson, "For the First Time," in *Sue Williams*, ed. Lionel Bovier (Zurich: JRP Ringier, 2015), 27.
6. Sue Williams, quoted in Brian Boucher, "Sue Williams," *Art in America* 96, no. 10 (November 2008): 180.

62. *Fluorescent and Flooby*, 2003
Oil and acrylic on canvas
7 ft. ⅛ in. × 8 ft. 8 in. (213.4 × 264.8 cm)

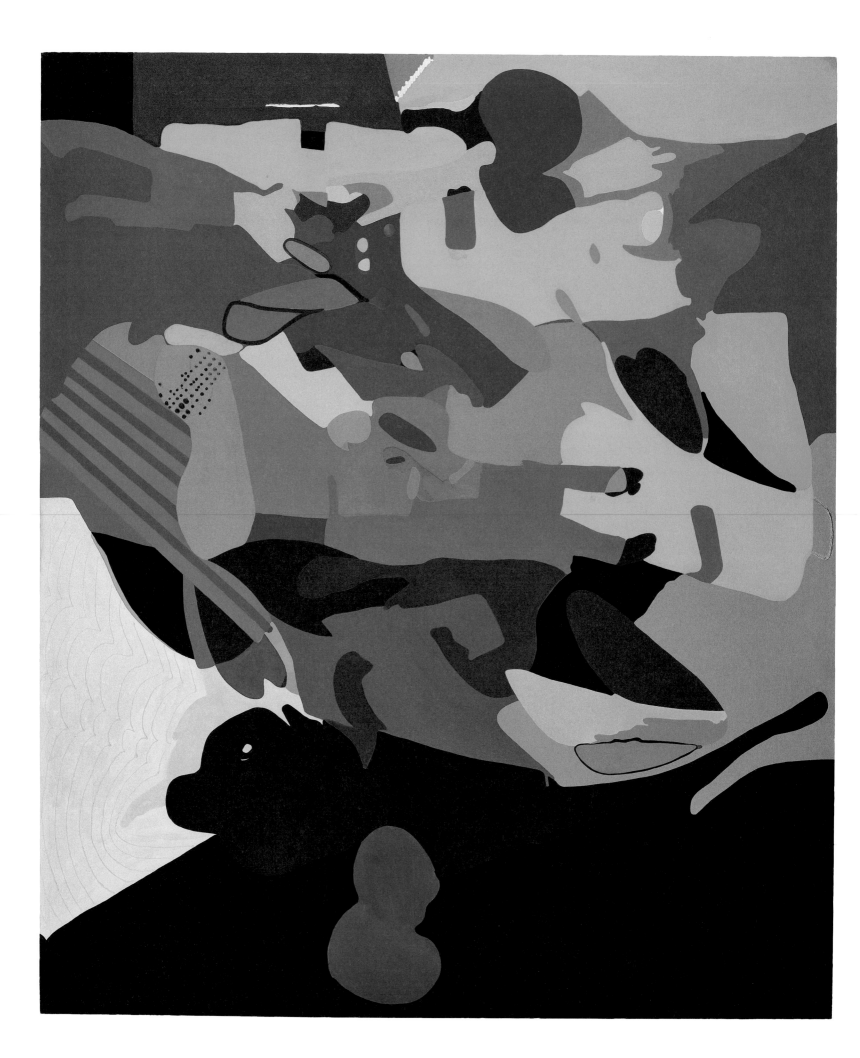

Candida Alvarez

Born Brooklyn, New York, 1955

The American painter Candida Alvarez was born in Brooklyn two years after her parents emigrated from Puerto Rico to New York. She grew up in the Farragut Houses, a public housing project in the borough's downtown area, and benefited as a child from the Fresh Air Fund program to experience summer life in the countryside; one activity she enjoyed during those visits to Upstate New York, she states unapologetically, was painting by numbers.[1] Alvarez earned a BA from Fordham University in 1977 and, in 1981, attended the Skowhegan School of Painting and Sculpture in Maine. Twenty years after graduating from college, in 1997, she earned her MFA from the Yale School of Art. "The reason was simple: the stock market had crashed, and it seemed like a reasonable thing to do at the moment," she recalls.[2] Still later in life, from 2010 to 2012, she studied philosophy at the European Graduate School in Saas-Fee, Switzerland. She is a tenured professor of painting and drawing at the School of the Art Institute of Chicago, where she has taught since 1998.

Alvarez's intricate and dazzlingly layered canvases merge abstract and figurative forms deriving from Pop art and other strains of modernism. She also makes reference to contemporary global events and her own personal memories. Many of her paintings employ silhouettes and bold colors and display a fascination with the aesthetics of cartoons, kitsch, and craft. In an interview published on the occasion of her 2012–13 exhibition at the Hyde Park Art Center in Chicago, Alvarez noted, "I always start with a frame, like a viewfinder. When I'm working, I'm taking pictures with my iPhone, for instance, I am hunting for relationships that might be formed in light, pattern, or color. That's just the beginning."[3]

Alvarez's materials include fabric, acrylic paint, enamel paint, and Galkyd gel medium, which she has used on various supports, ranging from canvas to cotton napkins to vellum paper. A large work such as *Black Cherry Pit* may take the artist as long as three years to complete. Here, the harmonious pinks, oranges, yellows, greens, and blues impart a lush, beachy vibe—likely influenced by Alvarez's many visits to her parents' native Puerto Rico. The hybrid territory constructed in her work is never an allusion to a single place or region, however, but is instead the result of a melding of multiple references, to people and reported events as well as to sites and landscapes. The orientation of the painting is the last decision Alvarez makes, and she typically does so with the desire of upending any recognizable figuration in the composition.

Collage lies at the heart of all of Alvarez's output, and she is drawn to images and material that hold a certain splendor, sway, and sparkle. For her, painting is never emotional. Rather, it represents a layering—a palimpsest of disparate images that hold together visually and vibrate with color. According to Alvarez, "The work is always comprised of multiple entry points that create a scaffold or collision of marks, gestures, or colors as it aims for a kind of system or methodology that is alive with adventure and the ability to fail."[4] LOB

1. Candida Alvarez, interview by Phong H. Bui, *Brooklyn Rail*, March 2020, https://brooklynrail.org/2020/03/art/candida-alvarez-with-Phong-H-Bui.
2. Ibid.
3. Candida Alvarez, "We Love to Work on Tables: A Discussion with Candida Alvarez and Kay Rosen Moderated by Terry R. Myers," in *Candida Alvarez: Here; A Visual Reader*, ed. Fulla Abdul-Jabbar and Caroline Picard (Chicago: Green Lantern, 2020), 145–46.
4. Ibid., 146.

63. *Black Cherry Pit*, 2009
Acrylic and enamel paint on canvas
84 × 72 in. (213.4 × 182.9 cm)

Amy Sillman

Born Detroit 1955

Arriving at painting by a circuitous route, Amy Sillman first worked as a canner in Alaska and studied Japanese at New York University, envisioning a career as an interpreter for the United Nations, before her exposure to Japanese brushwork fueled an interest in art. She received a BFA from the School of Visual Arts, New York, and an MFA from Bard College, where she was taught by Pat Steir (see pl. 37), among others. Today, she is best known for her oil paintings that oscillate between abstraction and figuration. Sillman draws inspiration from a diverse range of sources—from comics, Beat poetry, and jazz to Internet memes—and also produces drawings, zines, and iPad animations.

Following her arrival in New York in 1975, Sillman immersed herself in the downtown counterculture and was active in feminist and queer circles. Like many of her peers, she was educated under the waning star of Abstract Expressionism. Painting abstractly was not, she recalls, "the expectation for a female art student in the 1970s. . . . At that time it was basically like trespassing."[1] Despite this, her interest in the movement's legacy has remained a constant, teaching her important lessons about erasure, process, and chance: "what it means to make work that forces you to improvise," as Sillman conceives it. For her, to reclaim and transform AbEx's (heroically masculine) methodologies is also an act of feminist subversion.[2]

The artist begins by applying a layer of paint in different directions across a canvas. To this, she adds many subsequent layers, repeatedly reconfiguring the colors, shapes, and positions of compositional elements in a painstaking process of continual application and erasure. Speaking of her approach, Sillman has said, "Making paintings for me is liminal: not-quite-known, coming-into-being, not-yet-seen, being-remembered. It is a material process as much about destruction as construction, about going backwards and forwards."[3] Her palette—chosen analytically as well as intuitively—is idiosyncratic and atmospheric. The artist revels in the "murk" of gray and brown pigment, which she scrapes off her canvases as she works to sully the brightness of store-bought paint: "I really love working with those two kinds of registers because it's another of those double situations that I'm drawn to—two different formats that are meeting in the middle."[4]

In Sillman's work, the body is an important subject, albeit an often invisible one. Rarely representing the figure in its entirety, the artist instead presents detached limbs or fragmented features, which emerge from clusters of abstract lines and passages of color. Tapping into her fascination with the sensuality of paint and the prevalence of sex in contemporary culture—as the title of another work in the Shah Garg Collection, *Untitled (Little Threesome)* (see fig. 4 on p. 77), suggests—Sillman also eroticizes the human body. In that painting, the proliferation of rounded breast and elongated penile forms subtly suggests an intimate act under way. In recent works such as *Radiator*—produced during COVID-19-induced periods of isolation and homeboundedness—Sillman has seized on the everyday world of the studio for inspiration.

While the artist is best known for her canvases, drawing remains fundamental to her practice, both in preparation for paintings and as a mode of expression in its own right. In contrast to her protracted painterly technique, working on paper offers a different speed of mark making and a chance to explore ideas more fluidly. An example in the Shah Garg Collection, *Untitled April Drawing 2, Version 3* (2014)—the second version is in the collection of the Whitney Museum of American Art, New York—makes clear that drawing is also a means of exploring shape and color in all its permutations. HJ

1. Amy Sillman, "Parts and Labour: Amy Sillman in Conversation with Matt Saunders," *frieze*, no. 133 (September 2010), https://www.frieze.com/article /parts-labour.
2. Amy Sillman, "I'm Working with and against Painting: An Interview with Amy Sillman," by Imelda Barnard, *Apollo*, September 26, 2018, https://www.apollo-magazine.com /amy-sillman-interview-camden-arts-centre/.
3. Amy Sillman, "Process," in *Painting: The Implicit Horizon*, ed. Avigail Moss and Kerstin Stakemeier (Maastricht, Netherlands: Jan van Eyck Academie, 2012), 102.
4. Amy Sillman, interview by Toby Kamps, *Brooklyn Rail*, December 2018–January 2019, https://brooklynrail.org /2018/12/art/amy-sillman-with-Toby-Kamps.

64. *Radiator*, 2021
Oil and acrylic on canvas
75 × 66 in. (190.5 × 167.6 cm)

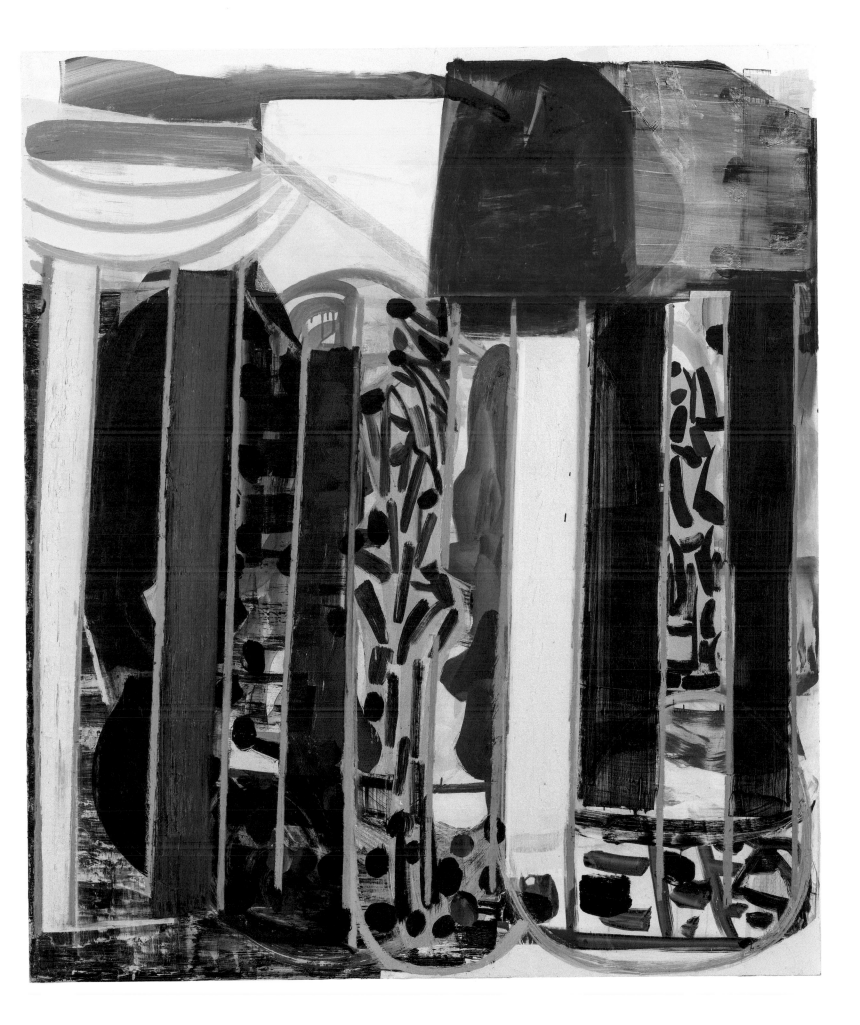

Moira Dryer

Toronto 1959–1992 New York City

Moira Dryer painted *Captain Courageous* toward the end of her life, in the later stages of an artistic practice that spanned barely a decade. Born in Toronto, Dryer moved to New York in the late 1970s and earned a BFA from the School of Visual Arts in 1981. After assisting the painter Elizabeth Murray (see pl. 34), who had taught her as an undergraduate, she worked for several years for the experimental theater company Mabou Mines, among other playhouses in downtown Manhattan, before fully committing herself to painting in 1985. This transitional moment resulted in a significant shift in the artist's work: her small, somber compositions evolved into the playful, illusionistic abstractions for which she became known. Following this breakthrough, in 1987, Dryer received her first museum show at the Institute of Contemporary Art, Boston. Her premature death, in 1992, was caused by cancer.

Keen to play on notions of perception, Dryer often accentuated the sculptural potential of paint in her handling of it. She invariably used wood panels as her supports, onto which she applied translucent layers of acrylic or casein to create undulating patterns that trick the eye. In *Captain Courageous*, a series of dark green streaks appears to swell and dissipate against a lighter green background that is saturated, in places, with white stains. The vibrant composition is grounded by a small, indented rectangle near the bottom of the picture plane, which acts as an invitation, of sorts, to look further into the painting. Dryer frequently employed such formal devices, combining them with traditional modernist tropes to construct an unusual, hybrid aesthetic.

Receptive to the physical qualities of paintings—namely, their status as objects—Dryer, as early as 1986, had begun to embellish her panels with fixtures she found or manipulated. She initially placed a smaller shelf or box beneath the main panel, as in *The Signature Painting* (1987), which consists of two physically disconnected components; Dryer derived the idea from standard display techniques in museums, where an explanatory text is positioned beneath or beside an artwork. Later, she perforated some of her panels and/or integrated small accessories into their surfaces, most commonly pieces of hardware such as grommets, locks, and rubber stoppers. The panels that Dryer herself designed and built sometimes took an unconventional form, with the frontal plane curving in one direction or another. In *Not Titled* (1989), the top edge of the panel bends slightly away from the wall, creating a looming shape like a modest tidal wave. Several of Dryer's works are painted on both sides, so that a white wall reflects the color on the back of the panel, thereby creating an augmented spatial dimension.

Dryer's engagement with found objects, which she termed "props," underlines the pivotal role played by her experience of working in theater. The artist suggested that these additional elements imbued her works not with artifice but with a "theatrical situation. . . . They are becoming, just by the nature of their physicality, figurative. It's almost a criterion for me to feel a painting is somehow alive and animate."[1] This "helter-skelter" quality that Dryer felt defined her practice ultimately led to the creation of paintings that, for her, and for many of her viewers, convey considerable emotion. Discussing her work in 1991, she reflected, "I cannot find 'unrecognizable' imagery in these paintings. The various styles in painting have been digested into the language and have become familiar. The minute the brush hits there is a fertile association to be made with other paintings elsewhere. It is the reassimilation and reorganizing of how we perceive the imagery that is the new frontier; where the excitement lies."[2]

AB

1. Moira Dryer, quoted in Robert Storr, "Projects 42: Moira Dryer," exh. brochure, The Museum of Modern Art, New York (website), exh. on view September 30–November 16, 1993, accessed August 1, 2022, https://assets.moma.org/documents/moma_catalogue_406_300063099.pdf?_ga=2.181345248.677873402.1635634109-622149750.1634645098.
2. Moira Dryer, "An Emotive Identity," *Tema Celeste*, no. 32–33 (Autumn 1991), quoted in "Moira Dryer's Playful and Poetic Art," *Experiment Station* (blog), April 6, 2020, https://blog.phillipscollection.org/2020/04/06/moira-dryer-business/.

65. *Captain Courageous*, 1990
Acrylic on wood panel
78 × 86 in. (198.1 × 218.4 cm)

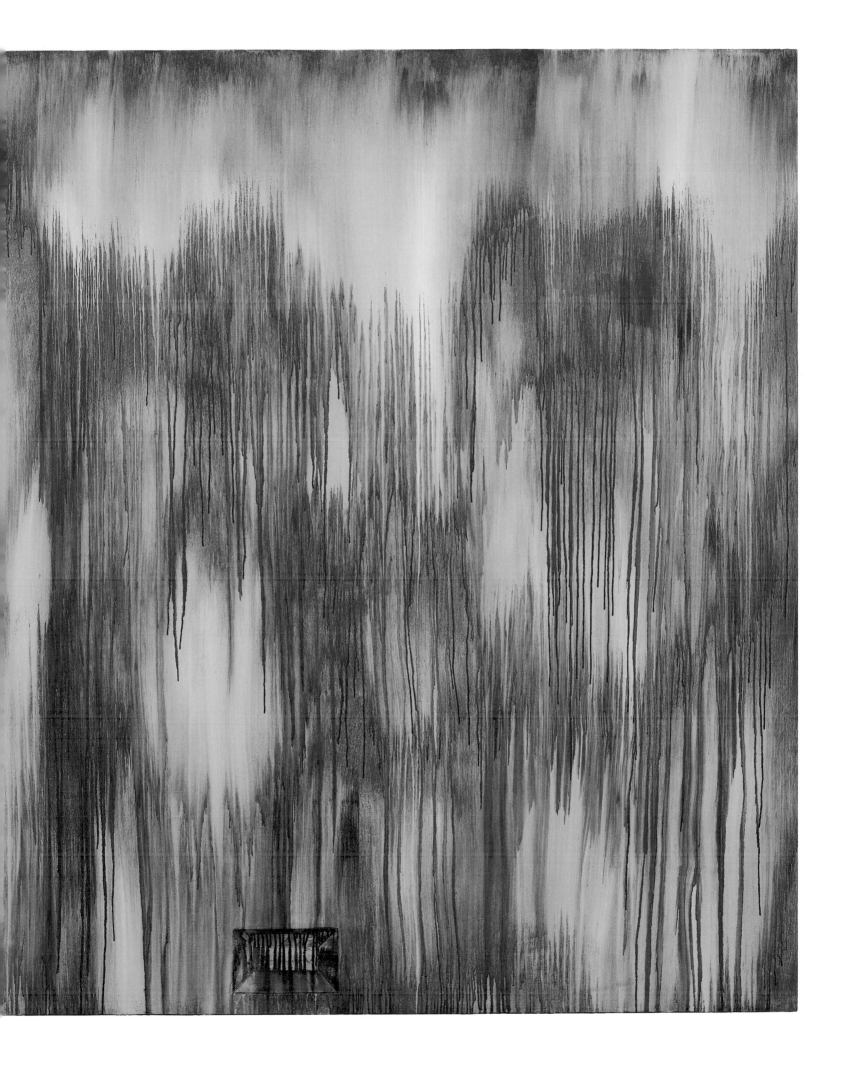

Jutta Koether

Born Cologne 1958

Although the German artist Jutta Koether is best known as a painter, she has referred to her work as "experimental expressionism": an interdisciplinary practice that incorporates music, writing, and performance as well as visual art.[1] The artist's countercultural ethos was formed during her teenaged immersion in Cologne's punk subculture, which taught her to "stretch and flex," "wander and improvise," and "become an artist outside the academic system."[2] This approach was furthered through her training in art and philosophy at the Universität zu Köln as well as her contribution of theoretical essays on art and music to the culture magazine *Spex*, among other publications. The artistic circle into which she graduated, however, was less congenial, dominated by the overwhelmingly masculine Neue Wilden, or Neo-Expressionist school. In defiant response, Koether turned to art history, seeking to "reconfigure the old canon as a counter-canon."[3] She adopted an irreverently feminist strategy of appropriation, repurposing subjects and compositions from classical and modernist painting. Her predominantly male sources spanned from Piero della Francesca, Nicolas Poussin, and Paul Cézanne to Lucian Freud.

Shortly after relocating to New York in 1991, Koether enrolled in the Whitney Museum of American Art's theory-driven Independent Study Program. The figure remained at the heart of her work, as did a preference for the color red, which would become her signature. Koether had already articulated her understanding of the color as a conceptual lens or symbolic filter in her 1987 novella, *f*. As she recently explained, red also functions as a means of intensification, "a decision made in favor of systematic, conceptual painting that pushes color into a state of extreme charge."[4]

Through her painting practice, Koether has always pushed boundaries. For her, the medium is multifaceted; in different contexts, she has noted, "painting [can] become flyer, theatrical prop, site for theoretical detritus, music/painterly scores, a door, an amplifier for an emotion, a site for word play . . . or just a carrier for thought and emotion and bodily matter."[5] Her love of music has endured, and a number of projects feature collaborations with rock musicians, including Kim Gordon, Thurston Moore, and Tom Verlaine. In 2002, Koether, on synthesizer, joined the artist and guitarist Steven Parrino (1958–2005) in the band Electrophilia. This partnership led to a body of paintings incorporating objects from punk culture, such as chains, buckles, and metal studs, beneath a layer of transparent, hardened resin.

Seriality is a recurrent theme in Koether's practice, articulated primarily through the grid. This motif first appeared in her work in December 2000, when she embarked on a project to create a drawing every day for a year. Using sheets of graph paper and colored pencils, Koether filled each square to create checkerboard compositions. Through variations in the direction of strokes and intensity of hues, the drawings reflect the artist's changing mood and the passage of time.

After this exercise, Koether began a new body of multipanel works—of which *Berlin Boogie #11* is an example—characterized by gridded patterns in her signature color. Each panel, she has explained, is "covered in grids painted in various tones of red, coming together in an expansive triangular form, like wings, like cleaning the palette [*sic*]."[6] Although these works were initially conceived as an "abstract counterpoint to a very strongly figurative oeuvre," the artist has continued to make them in a diaristic way.[7] Their titles specify the location of the studio in which they were created while also alluding to the painting *Broadway Boogie Woogie* (1942–43; The Museum of Modern Art, New York), by Piet Mondrian (1872–1944), and its visual representation of the syncopated rhythms of boogie-woogie music. Koether has described these works as "*bruised* grids," an acknowledgment of the fact that the interior squares are deliberately unevenly filled.[8] Visibly hand-painted and intentionally pixelated, they are characterized by disruptions that undermine minimalistic strategies and reaffirm the artist's touch. HJ

1. Jutta Koether, "Platform: Jutta Koether," lecture, Bergen Kunsthall, Bergen, Norway (website), February 23, 2008, video, 43:20, https://www.kunsthall.no/en/media/platform-jutta-koether/.
2. Jutta Koether, "A Conversation with Jutta Koether," by Benjamin Buchloh, *October*, no. 157 (Summer 2016): 18.
3. Jutta Koether, "Figure of Paint: Am Unwiderlegbaren!," *Texte zur Kunst*, no. 100 (December 2015): 135–37.
4. Jutta Koether, "Figuring," *Texte zur Kunst*, no. 122 (June 2021): 92.
5. Jutta Koether, interview by Sam Lewitt and Eileen Quinlan, in *Jutta Koether*, ed. Philippe Pirotte and Kathrin Rhomberg, trans. Aileen Derieg, exh. cat. (Cologne: DuMont, 2006).
6. Koether, "Figuring," 96.
7. Jutta Koether, live interview by Nicholas Cullinan, Lévy Gorvy, London (website), December 14, 2021, video, 3:58, https://www.levygorvy.com/works/conversation-jutta-koether-and-dr-nicholas-cullinan/.
8. Ibid.

66. *Berlin Boogie #11*, 2021
Acrylic on canvas (34 parts) and acrylic on wood panel (2 parts)
Each 11⅞ × 11⅞ in. (30 × 30 cm)

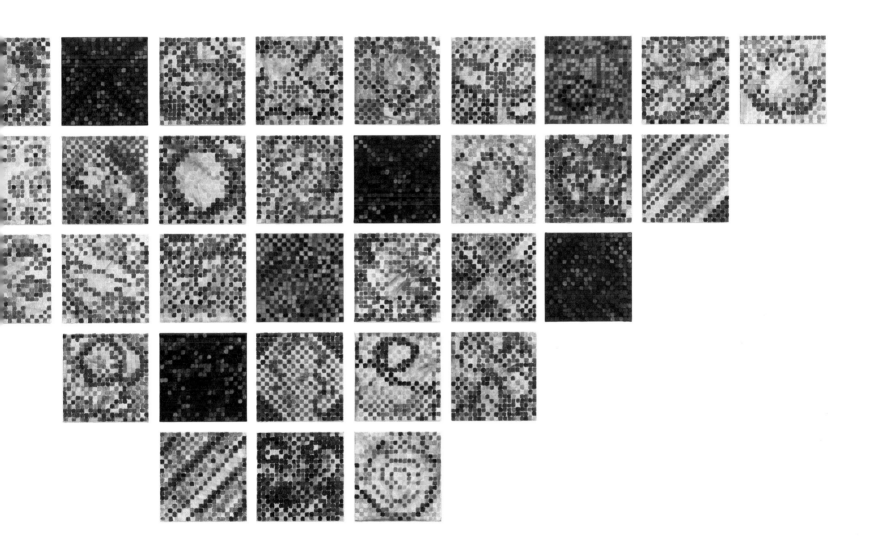

Jacqueline Humphries

Born New Orleans 1960

When Jacqueline Humphries was attending the Whitney Museum of American Art's theory-driven Independent Study Program in 1986—a time when the so-called death of painting dominated the critical discourse—her early efforts in abstraction were greeted with indifference. It was this sense of transgression, however, that fueled her ambitions. "To paint at all denoted artistic failure," she recalls. "Painting's status as the disavowed underside of artmaking gave it fresh meaning—it was almost a kind of rogue practice."[1] Since then, over the past four decades, Humphries has reinvigorated the language of abstraction as an influential member of an increasingly celebrated generation of painters. She is best known for works that engage with the challenges and potentials of new technologies, connecting abstraction to the realm of contemporary digital culture.

Using a wide variety of mark-making techniques, both instinctive and carefully considered, Humphries covers her canvases with brushstrokes, drips and pours of paint, and stenciled passages; she also removes paint by smudging, scratching, and sponging.[2] However, her surfaces are never as they seem. Drips that we assume to be the result of unintentional material excess are, in fact, painstakingly constructed. By tracing around marks to produce stencils, the artist can also repeat the same exact shape in a different location on a canvas—or indeed, on a different one—as well as digitally enlarge, manipulate, or rotate it to produce multiple effects from the same gesture. The outcome can be further influenced through accidental or deliberate misalignment of the stencil, or by moving it through paint of varying degrees of wetness. As the artist explains, "A drip, formerly a symbol of feckless artistic abandon, becomes for me a primary structuring agent."[3]

While Humphries's earliest compositions, in their limited palettes and ever-shrinking sizes, gave form to her experiences as a painter "under duress," later works confront questions about the relationship of abstract painting to a visual culture irrevocably altered by digital technology.[4] She recalls, "My identity as an abstract painter began to dovetail with this new reality of proliferating screens, and I had to ask myself what kind of image I should commit to a painting in a world full of moving images that are constantly replacing each other."[5] Thinking about the glow of computer monitors, she started working with hand-mixed silver paint around 2003. In 2014, laser-cut stencils, which she produced to her specifications, became an additional means by which she structured her paintings.

Created at that moment, *[///]* was first exhibited in the artist's 2015 solo exhibition at Greene Naftali, New York. The work is related to Humphries's interest in the conventions of looking. As she has said, "Typically a person would stand in front of a painting to look at it, but I began to think, what if the viewer were the painting? If a painting looks out at the world, what does the painting see?"[6] Wondering how to express this theoretical proposition in visual terms, Humphries decided to "make a painting and then stencil the canvas over top, as if the whole surface of the painting were inverted or flipped in on itself."[7] To achieve this effect, Humphries used a stencil depicting the texture of woven canvas: she started by making a pencil rubbing of a section of unprimed canvas, then she scanned it, enlarged the image with the help of Adobe Photoshop and Illustrator software, and programmed the resulting file into the laser cutter. Other than the black marks applied with the stencil, *[///]* is executed in a limited palette, characteristic of Humphries's practice. Color appears sporadically, in opposite corners, generating a push-pull effect.

In more recent work, Humphries has explored technological vocabularies including emoticons, logos, and CAPTCHA codes, as well as the possibilities of the ASCII (American Standard Code for Information Interchange) system. Working simultaneously on a number of canvases, she builds up her surfaces with a continual, looping process of application and removal. "I start a painting by finishing it," she says, "then may proceed to unfinish it, make holes in it or undo it in various ways, as a kind of escape from that finitude."[8]　　　HJ

1. Jacqueline Humphries, quoted in Mark Godfrey, "Statements of Intent," *Artforum* 52, no. 9 (April 2014): 296.
2. For Mark Godfrey's exploration of "immediate" versus "mediated" gestures in Humphries's work, see Jacqueline Humphries and Mark Godfrey, "A Guided Walkthrough of *jHΩ1:)*," in "Jacqueline Humphries: jHΩ1:)," exh. brochure, Wexner Center for the Arts, Columbus, OH (website), exh. on view September 18, 2021–January 2, 2022, accessed August 25, 2022, https://wexarts.org/sites/default/files/2021-09/EX_Humphries_GG_REL_WebsiteV3.pdf.
3. Humphries, quoted in Godfrey, "Statements of Intent," 297.
4. Jacqueline Humphries, "Romantic and Sublime Threshold State: Jacqueline Humphries in Conversation with Felix Bernstein," *Mousse*, May 30, 2019, https://www.mousse magazine.it/magazine/jacqueline-humphries-felix-bernstein-2019/.
5. Humphries and Godfrey, "A Guided Walkthrough of *jHΩ1:)*," 6.
6. Ibid., 9.
7. Ibid.
8. Humphries, quoted in Godfrey, "Statements of Intent," 300.

67. *[///]*, 2014
Oil on linen
8 ft. 4 in. × 9 ft. 3 in. (254 × 281.9 cm)

Beatriz Milhazes

Born Rio de Janeiro 1960

Born in Rio de Janeiro, where she continues to live and work, Beatriz Milhazes first came to prominence in the 1980s. Known for her optically dazzling, ornate abstractions, Milhazes established herself as a leading figure of Geração 80 ("the '80s Generation"), which also included the artists Leda Catunda, Cristina Canale, Ester Grinspum, Jac Leirner, and Ana Maria Tavares, among others. The group, which advocated for a return to painting following the dominance of conceptual-art practices in Brazil throughout the 1970s, set out its objectives in 1984 in the seminal exhibition *Como vai você geração 80?* (How Are You, '80s Generation?). Featuring nearly 130 artists, the survey, mounted at Rio's Escola de Artes Visuais do Parque Lage, was a major breakthrough for Geração 80 in its attempt to reposition painting at the forefront of Brazilian art.

In 1989, Milhazes began using a technique that she herself developed and that still distinguishes her work today. A cross between painting and print-making, the artist's "monotransfer" procedure consists of painting with acrylics on an extremely thin sheet of transparent plastic, letting the paint fully dry, brushing a specific adhesive onto the sheet, pressing it against the canvas, and then peeling off the plastic, leaving the painted motif behind on the painting, like a decal.[1] Milhazes is thereby able to create layered collages that are made entirely of paint; she is partial to the "soft" effect produced when the paint is "filtered" by the plastic and there are no visible brushstrokes.[2] Constructing a surface with multiple layers in this manner is analogous, one might say, to a broader hallmark of Brazilian painting in this period: the tendency to exploit an amalgam of influences. *O Egoísta*, in which concentric circles of colored dots, resembling beads, intertwine with spiraling forms, floral motifs, and ornate emblems—symbolic of the artist's fascination with Brazil's Carnival traditions as well as the country's architecture and flora—is characteristic of the rich variety of phenomena that have guided Milhazes's efforts. She has spoken of the impact the Brazilian painter Tarsila do Amaral (1886–1973) and the Carnival designers Rosa Magalhães and Joãosinho Trinta have had on her work, in addition to European precedents such as Henri Matisse, Piet Mondrian, and Bridget Riley.

Mixing the "high" with the "low," the artist brings modernist geometries and vernacular forms together to create elaborate and complex images. Despite the numerous sources that inform her project, however, Milhazes has underlined the significance of endemic references in her work, reflecting that "my interest is in things and behaviors that can only be found in Brazil."[3]

Milhazes painted *O Egoísta*, first shown at Galerie Nathalie Obadia, Paris, in the 1999 exhibition *Beatriz Milhazes: Paintings*, at a significant moment in the trajectory of her practice. As she has noted, "In the last years of the '90s, arriving at the end of 20th century, the evolution of my painting had already chosen the path to abstraction. Abstract art has the potential of freedom. It is inclusive and open to well-developed charms that explain themselves visually. Symbols and signs, such as the heart, daisies and stars, from the pop representation universe, build a more strident palette. The canvas surface starts another vibration."[4]

While the qualities of excess and intensity that ground Milhazes's aesthetic may lead to a critical detachment from reality,[5] or to the freedom of which the artist speaks, she nevertheless insists on injecting real life into her work—on including "elements that don't really come from the painting world," as she puts it.[6] Like the complex layering system from which each work is built, such a synthesis establishes a sense of tension and unpredictability, not unlike the fluctuating energy of lived experiences that are at the center of Milhazes's work. AB

1. "Beatriz Milhazes: Avenida Paulista," in *Beatriz Milhazes: Avenida Paulista*, ed. Adriano Pedrosa, Amanda Carneiro, and Ivo Mesquite, exh. cat. (New York: DelMonico Books/ D.A.P.; São Paulo: Museu de Arte de São Paulo, 2021), 30.
2. Philip Dolin and Molly Bernstein (producers), "Beatriz Milhazes," James Cohan, New York, October 10, 2008, YouTube video, 7:56, youtube.com/watch?v=WZ2lsc3yZH8.
3. Beatriz Milhazes, quoted in Achim Drucks, "No Fear of Beauty: Beatriz Milhazes," *ArtMag by Deutsche Bank*, no. 59 (2012): n.p.
4. Beatriz Milhazes, email message to the author, November 2021.
5. Luiza Interlenghi, "A Private Infinite," in Pedrosa, Carneiro, and Mesquite, *Milhazes: Avenida Paulista*, 61.
6. Beatriz Milhazes, "Interview with Beatriz Milhazes," *RES Art World/World Art*, no. 2 (May 2008): 12.

68. *O Egoísta*, 1999
Acrylic on canvas
78¾ × 35⅝ in. (200 × 90.5 cm)

Carrie Moyer

Born Detroit 1960

The artist and writer Carrie Moyer is known for two distinct but related practices: painting abstractly in bright colors, and making and distributing queer political propaganda. Having earned a BFA from Brooklyn's Pratt Institute in 1985, she began her career with an internship at the pioneering feminist magazine *Heresies*. Despite her early ambitions, she became disillusioned with painting as the AIDS crisis escalated in the late 1980s and involved herself deeply in gay rights activism. Recalling the political urgency of the time, she says, "Painting talked of history and everything I wanted to say was about the moment I was living in, the NOW."[1] She gave up her studio, earned an MA in computer graphics from the New York Institute of Technology, and began working in advertising agencies as a graphic designer. Alongside her day job, she served as the unofficial "Minister of Propaganda" for a number of activist organizations—Queer Nation, Lesbian Avengers, and the Irish Lesbian and Gay Organization among them—producing agitprop to support their efforts. In 1991, she cofounded Dyke Action Machine! (DAM!), one of the first lesbian public-art projects, with the photographer Sue Schaffner (born 1964).

In the mid-1990s, Moyer returned to painting. Wary of the legacy of abstraction—"the romance of painting still felt very suspect," she recalls— she began to produce works that combined the graphic aspects of her agitprop with art-historical influences, drawing on Pop art, 1970s feminism, Constructivism, and color-field painting.[2] Wanting to "set up a dialogue" between "historically loaded images" and "painterly gestures," she also referenced the work of artists central to her feminist art education, including Georgia O'Keeffe, Helen Frankenthaler, and Elizabeth Murray (see pl. 34).[3] In 2000, she received an MFA from Bard College, where Amy Sillman (see pl. 64) was among her teachers.

Fundamental to Moyer's renegotiation of painterly tradition is her rejection of the specific medium in which she was trained. Renouncing the historical baggage of oil paint, she instead uses acrylic for its ubiquitous commercial associations. Her working process begins with cutout paper shapes, which she uses to determine the spatial relationships in her compositions. As in *Four Dreams in an Open Room*, the shapes are often biomorphic. She then transfers her ideas from the collages to a larger scale on canvas. Planar shapes of solid color, reminiscent of hard-edge painting, coexist alongside transparent veils that evoke color-field technique. Glitter, a reference to 1970s disco culture, embellishes and adds light, while drop shadows undermine the pictorial flatness of historical abstraction.

To create textural variation, Moyer thins her paint with differing quantities of water; she also uses spray bottles to saturate paint that she has already applied. As seen here, this results in bubbles, channels, and modulations across the surface. Speaking of the joys of her dynamic production process, Moyer has said, "There is so much maneuvering of these big canvases, tipping them at odd angles. . . . Using gravity and the tension of the stretcher to mix color and move the paint around is where all the pleasure is."[4] However, control is also central to her work: "Every time I do the pour, I go back in and 'manicure' it. I want things to overlap in different ways."[5] Despite her rigorous strategies—and as suggested by the ethereal quality of this work's title—painting remains a fundamentally pleasurable endeavor for Moyer. "I'm going for beauty, seduction, and play," she explains. "A physical experience, an optical experience."[6] HJ

1. Carrie Moyer, quoted in Katy Siegel, "How to Have a Relationship," in *Carrie Moyer*, by Carrie Moyer, Lauren O'Neill-Butler, Katy Siegel, and Johanna Fateman (New York: Rizzoli, 2022), 7.
2. Carrie Moyer, "Beer with a Painter: Carrie Moyer," interview by Jennifer Samet, *Hyperallergic*, February 20, 2016, https://hyperallergic.com/276823/beer-with-a-painter-carrie-moyer/.
3. Ibid.
4. Carrie Moyer, quoted in Katy Siegel, *Carrie Moyer: Sirens*, exh. cat. (New York: DC Moore Gallery, 2016), 13.
5. Carrie Moyer, "Setting the Right Conditions: Carrie Moyer in Conversation with Johanna Fateman," in Moyer, O'Neill-Butler, Siegel, and Fateman, *Moyer*, 232.
6. Moyer, "Beer with a Painter."

69. *Four Dreams in an Open Room*, 2013
Acrylic and glitter on canvas
66 × 56 in. (167.6 × 142.2 cm)

Lorna Simpson

Born Brooklyn, New York, 1960

Lorna Simpson emerged during the 1980s as a prominent member of a generation of artists and photographers developing postconceptual practices. While her earliest work features striking juxtapositions of found (or staged) images and text, her practice has since expanded to incorporate drawing, painting, video, and sculpture. Despite its varying media, it is united by a common thematic: the exploration of identity politics, race, and gender from an African American woman's perspective.

Photography and mass media have long played a foundational role in Simpson's work. Tracing her fascination back to the discovery of her grandmother's magazine collection—specifically, a trove of *Ebony*, the monthly magazine dedicated to African American culture, first published in November 1945—the artist has since amassed a vast archive of material from *Ebony*; its sister publication, *Jet*; and the Associated Press. For the artist, the two magazines in particular have personal, social, and cultural significance: she recounts that they "informed my sense of thinking about being black in America and are both a reminder of my childhood and a lens through which to see the past fifty years of history."[1] After selecting the source material for a given work, Simpson then highlights the complexity of its narrative, using a process of fragmentation, montage, and superimposition to draw attention to "the cracks and the seams where things are put together or re-constructed."[2]

Ice 11, made comparatively recently, depicts a monumental glacial structure seemingly adrift in a dark, oceanic expanse. To construct it, the artist silkscreened enlarged fragments of text from magazines and found imagery of ice and smoke caused by volcanic eruptions onto fiberglass, then overpainted the ensemble with ink. While the selection and arrangement of imagery necessitated a methodical approach, the addition of ink introduced a freer way of working. Simpson has explained that this last element "requires you to make split-second decisions in the way you handle ink or the way ink flows on any given surface—that's always surprising to me."[3] To mask and obscure the text and images beneath, the artist applied hazy washes of color, which streaked and dripped with varying levels of intensity. The reduced palette of black, gray, and white—punctuated by a striking electric blue—imbues the work with an eerie sense of discomfort and foreboding.

Produced on such a scale as to elicit a sense of awe, *Ice 11* implies many kinds of unease: environmental peril (the hulk of drifting ice alluding to the climate crisis); wider societal unrest (the billows of smoke suggestive of the protests and police brutality on which Simpson has reflected elsewhere); and historical oppression (the words "dark," "black," "slave," and "sorry" all decipherable among the snippets from *Ebony* and *Jet*). Ice itself also has a special significance for the artist, referencing the expression "on ice"—used to refer to a person's incarcerated status—as well as the seminal text *Soul on Ice*, written by the Black Panther Party activist Eldridge Cleaver in 1968 in Folsom State Prison, near Sacramento, California.[4] Acting as a metaphor for what the artist views as the United States' current state of political despair, the work illustrates the psychological impact of life in these turbulent times: life against, in the artist's words, the "backdrop of foreboding doom."[5] Despite these pessimistic overtones, Simpson hints at resilience, too. As she says, "There's something about ice that has come into the work that indicates either freezing or endurance."[6] HJ

1. Lorna Simpson, quoted in press release for *Lorna Simpson: Unanswerable*, Hauser & Wirth, London (website), exh. on view March 1–April 28, 2018, accessed August 1, 2022, https://www.hauserwirth.com/hauser-wirth-exhibitions/6238-lorna-simpson-unanswerable.
2. Lorna Simpson, "Conversation with the Artist," interview by Isaac Julien and Thelma Golden, in *Lorna Simpson*, ed. Helaine Posner, exh. cat. (New York: Abrams; American Federation of Arts, 2006), 139.
3. Lorna Simpson, quoted in Joseph Akel, "The Photographic Memory: In the Studio with Lorna Simpson," *Paris Review*, October 15, 2015, http://www.theparisreview.org/blog/2015/10/15/a-photographic-memory-in-the-studio-with-lorna-simpson/.
4. Press release for *Simpson: Unanswerable*.
5. Lorna Simpson, "In Conversation: Lorna Simpson and Thelma Golden," live interview, Hauser & Wirth, London (website), March 1, 2018, video, 1:05:44, https://www.hauserwirth.com/hauser-wirth-exhibitions/6238-lorna-simpson-unanswerable/?modal=media-player&mediaType=film&mediaId=11959#films.
6. Simpson, quoted in press release for *Simpson: Unanswerable*.

70. *Ice 11*, 2018
Ink and screenprint on gessoed fiberglass
9 × 8 ft. (274.3 × 243.8 cm)

Charline von Heyl

Born Mainz, Germany, 1960

Trained at the Hochschule für Bildende Künste Hamburg and the Kunstakademie Düsseldorf, the German-born artist Charline von Heyl has lived in the United States since the mid-1990s, dividing her time between studios in New York and Marfa, Texas. Known for her eclectic and idiosyncratic approach to painting, she defiantly resists a signature style. Her emergence in the early 1980s was shaped by her proximity to the art scene of Cologne, where painters such as Sigmar Polke, Jörg Immendorff, Martin Kippenberger, and Albert Oehlen were dominant figures. While her work is undoubtedly indebted to that context, her move to New York—away from what she terms a "heavily male," "ironic," and "anarchistic" environment—prompted a wider engagement with art history, material culture, and everyday life.[1] In her canvases, she amalgamates references to French postwar painters such as Bernard Buffet (1928–1999) with quotations from Art Deco and Art Nouveau, Jugendstil illustration, comic books, and more. All this disparate source material she weaves into a complex patchwork, rather than citing it in directly recognizable form.

As von Heyl has explained, her process starts intuitively, with a line: "At the root of my painting is the line. As an outline, line defines a shape. In repetition, line creates pattern. Sometimes color just comes from filling in between the lines."[2] Working on an anthropomorphic scale—with canvases sized to her reach, without need of a ladder—she ensures that her paintings emerge organically and are never predetermined by preliminary sketches. "I don't want to make the painting," she has said. "I want the painting to invent itself and surprise me."[3] Despite the fact that she does not use computers in conceiving or fabricating her works, the processes of layering, masking, duplication, and deletion that are involved evoke digital manipulation. "It is a constant juggling of different layers, speeds, and materials," she remarks. "A constant interaction of shapes, lines, ghost images, and effects."[4] Von Heyl sometimes mixes her acrylic paint with charcoal powder to alter its consistency and tone, and she wipes and scratches away paint as she applies it. She uses pattern as a structuring agent; zigzag lines, stripes, and checkerboards all recur in her oeuvre.

Von Heyl also uses collage as a flattening device, but the reality of her surfaces is never as it seems. Rather than physically affixing cutout elements to the canvas, she uses them to explore composition, moving them swiftly over the picture plane, before rendering them painstakingly in paint. First exhibited in spring 2017 in the artist's second solo exhibition at Capitain Petzel, Berlin, *Plato's Pharmacy* and *Dunesday*—with their intriguingly alliterative titles—illustrate her sophisticated collage fakery. Both paintings depict the same row of bowling pins (the second of which is actually a long-necked bottle) against a background filled with abstract patterning, envisaged by the artist as a "stage design."[5] Describing the works as a "goofy take on still life and metaphysical surrealism," von Heyl likens the bowling pins to "Giorgio de Chirico's tailor dolls—silent stand-ins for people—and here they are standing on the edge of the canvas in the exact same stupid way in both paintings, waiting for the ball."[6]

Another work in the Shah Garg Collection, *Vel* (see p. 119), produced in the artist's studio in Marfa during the anxious first year of the COVID-19 pandemic, displays an equal level of deception. Von Heyl painted the seemingly gestural brushstrokes meticulously, to appear spontaneous, and the overlapping layers conceal the order in which they were applied. As the artist summarizes, "My paintings usually hide their traces and their own history. They have weird shifts where you don't expect them. . . . It's not about mystifying anything; it's about lengthening the time of pleasure. Or torture."[7]

HJ

1. Charline von Heyl, interview by Shirley Kaneda, *BOMB*, no. 113 (Fall 2010), https://bombmagazine.org/articles/charline-von-heyl/.
2. Charline von Heyl, interview by Raphael Rubinstein, *Brooklyn Rail*, November 2018, https://brooklynrail.org/2018/11/art/charline-von-heyl-with-Raphael-Rubinstein.
3. Von Heyl, interview by Kaneda.
4. Charline von Heyl, "The Eye Is Always Game: A Conversation with Charline von Heyl," by Evelyn C. Hankins, in *Charline von Heyl: Snake Eyes*, ed. Dirk Luckow, 2 vols., exh. cat. (London: Koenig, 2018), 1:64.
5. Ibid., 1:63.
6. Ibid.
7. Von Heyl, interview by Kaneda.

71.

Plato's Pharmacy, 2015
Acrylic on linen
62 × 60 in. (157.5 × 152.4 cm)

Dunesday, 2016
Acrylic on linen
62 × 60 in. (157.5 × 152.4 cm)

Katharina Grosse

Born Freiburg im Breisgau, Germany, 1961

Katharina Grosse discovered the spray gun in 1998 while living in Marseille, a city with a thriving graffiti culture. Fascinated by the way the sprayed paint sat on the surface "like many little dots," she purchased equipment of her own on her return to her native Germany.[1] At first, she attempted to spray oil paint without understanding the proper process: "I wasn't wearing a mask or suit, and after I sprayed there was a film of oil everywhere."[2] This experiment, however, cemented her enthusiasm for the technique: "It impressed me, how it could expand. It wasn't just taking place on the wall, it was also in front of you and everywhere, in all its multidimensionality."[3]

Grosse produced her first work with a spray gun, a commission for the Kunsthalle Bern, later that year and abandoned the paintbrush—in which she had been dutifully trained in the 1980s at the Kunstakademie Münster and the Kunstakademie Düsseldorf—thereafter. Providing an uninterrupted flow of paint and a vast reach, the spray gun offered seemingly limitless creative possibilities. Technical freedom resulted in a dramatic escalation of scale, leading to the large, site-specific installations for which she is best known, in which she inundates interiors, architecture, and landscapes with explosive color. Despite this predisposition of Grosse's, painting in the studio has also remained a constant. While she produces her installations intensively over a short period, she repeatedly revisits and reworks the studio canvases. As she has remarked, "The in-situ work allows me to expand the painting, to slow it down and magnify aspects of the movement. In my studio practice, I compress the space of activity. I overcharge the surface."[4]

Untitled is one such work. To produce it, the artist placed stencils over the canvas before spraying multiple hues of paint onto it (some of the colors in broad fields, some in distinct lines) to create one layer; then, she rearranged the stencils to create another layer; and so on. The result is a bold, graphic composition in which intertwining shapes and white areas of negative space suggest perspectival depth. Each canvas by Grosse bears the marks of its production: drips evince the velocity with which the paint emerged from the

gun, and smudges reveal where the stencils were removed before the paint was dry. The artist creates the stencils from materials such as cardboard and foam, which she is able, in her own words, to "tear or rip apart in order to create different shapes at will."[5] Ultimately, these devices mediate her creative energies. "The stencils are filters that define my input," she says. "They block it or let it through."[6]

Grosse works on many canvases simultaneously, articulating her changing response to each composition over time. As she explains, "I start compressing disruptive layers together. Sometimes I take one or two paintings out of that process so as to halt them at different moments of time, while others remain in the flow."[7] Her colors are vivid, the paint applied straight from the container and mixed only through the layering on the canvas. Access to this vibrant palette is central to the production of the work, allowing her to respond to her moods as well as her "sense of absurdity and lushness and exuberance."[8]

While Grosse has acknowledged the impact of many modern and contemporary artists on her practice, she also cites influences ranging from Renaissance frescoes to professional soccer. Offering a fundamental alternative to the homogeneous imagery of our technologically obsessed culture, Grosse's process is one of reinvigoration. In summary, she notes, "I actualise painting for the time I live in."[9]

HJ

1. Katharina Grosse, interview by Phong Bui, *Brooklyn Rail*, March 2017, https://brooklynrail.org/2017/03/art/Katharina-Grosse-with-Phong-Bui.
2. Ibid.
3. Ibid.
4. Katharina Grosse, "Katharina Grosse—Interview: 'My Eyes Are My Most Important Tools,'" by Anna McNay, *Studio International*, December 21, 2020, https://www.studiointernational.com/index.php/katharina-grosse-interview-my-eyes-my-most-important-tools-push-the-limits-fondazione-merz-turin.
5. Grosse, interview by Bui.
6. Katharina Grosse, interview by Louise Neri, *Gagosian Quarterly*, Spring 2017, 75.
7. Ibid.
8. Grosse, interview by Bui.
9. Grosse, "Grosse—Interview: 'My Eyes.'"

72. *Untitled*, 2015
Acrylic on canvas
9 ft. ¾ in. × 6 ft. 7¼ in. (276.2 × 201.3 cm)

Rina Banerjee

Born Calcutta (now Kolkata) 1963

Born into a Bengali family in the Indian state of West Bengal, Rina Banerjee grew up in London and New York. She completed an MFA in painting and printmaking at the Yale School of Art in 1995 after graduating in 1993 from Case Western Reserve University with a BS in polymer engineering. Of this unusual path, she has noted:

> After finishing at Case Western, I took a job at a lab based at Penn State University in 1988. My boss wanted me to enroll in the PhD program at the university, so I started taking coursework in engineering. But I also took a painting class with Santa Barraza [born 1951]. She is a Chicana woman, and her art was concerned with border politics. I ended up spending a lot of time with her, and this is what allowed me to learn what an artist does. It was Santa who told me that I was good enough to apply to Yale.[1]

Banerjee's work has long tackled fraught political issues—colonialism, imperialism, capitalism—without coming across as moralizing or heavy-handed. Instead, the artist identifies historical problems and opens them up through material investigations. In a 2011 interview, Banerjee described the foundations of her work: "I dream of this willingness to close the gaps between cultures, communities, and places. I think of identity as inherently foreign; of heritage as something that leaks away from the concept of home—as happens when one first migrates."[2] In her paintings and delicate works on paper, figures of women float in enigmatic landscapes, often in states of transformation, with hybrid features of birds and beasts. Take, for example, *It Rained so she Rained*, in which a furry, green, four-armed figure perched

on a blue-and-gold umbrella cries golden tears while scarlet droplets fall all around her. Part drawing, part collage (the umbrella), the work speaks to the artist's interdisciplinary approach.

Banerjee's sophisticated understanding of the micro and the macro also reverberates in another aspect of her practice: her sculptures. Often incorporating commodities made or harvested for the tourist trade, thus caught within transnational flows of capital—such as horn, bone, feathers, shells, textiles, glass bottles, and furniture—her seductively lush, frequently large-scale assemblages brim with nuance. These works reject hierarchies of material, culture, and value. *Take me, take me, take me . . . to the Palace of love* (2003) was a standout piece in the artist's first U.S. museum show, *Make Me a Summary of the World* (2019–21; organized by the Pennsylvania Academy of the Fine Arts and San José Museum of Art). It consisted of a replica of the Taj Mahal—the mausoleum of Mumtaz Mahal (ca. 1593–1631), wife of the Mughal emperor Shah Jahān—with an embellished antique wood chair and a globe in the center. Built in Agra, Uttar Pradesh, in an Indo-Muslim style, the original multi-domed structure was reconstituted by Banerjee at a scale of about 1:13 in layers of pink-hued plastic wrap. Supported by a metal frame suspended from the ceiling, the eighteen-foot-tall work hung one foot off the ground and was large enough for visitors to walk inside. LOB

1. Rina Banerjee, interview by Allie Biswas, in *Rina Banerjee: Make Me a Summary of the World*, ed. Jodi Throckmorton (Philadelphia: Pennsylvania Academy of the Fine Arts; San José, CA: San José Museum of Art, 2018), 113.
2. Rina Banerjee, "Rina Banerjee Discusses Her Exhibition at Musée Guimet," as told to Zehra Jumabhoy, *Artforum*, June 22, 2011, https://www.artforum.com/interviews/rina-banerjee -discusses-her-exhibition-at-musee-guimet-28485.

73. *It Rained so she Rained*, 2009
Ink, acrylic, and mixed media on handmade paper
29½ × 21½ in. (74.9 × 54.6 cm)

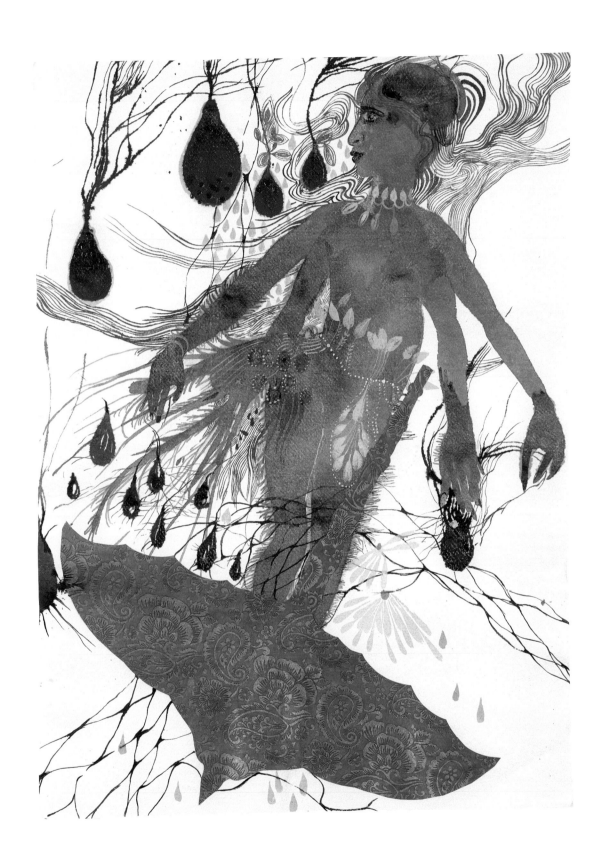

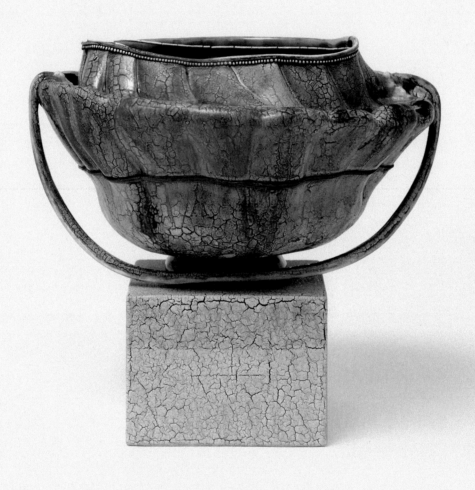

Kathy Butterly

Born Amityville, New York, 1963

Since the mid-1990s, Kathy Butterly has been producing an enigmatic oeuvre dedicated almost entirely to ceramics. Each of her sculptures is detailed and inimitable, yet the whole retains a unity. The works are generally small, ranging in height from six to nine inches: the artist prefers succinct, pithy statements to grand declarations. Through her meticulous handling of her chosen medium, she has fashioned a wide array of masses and surfaces, which together have allowed her to express a broad variety of moods. With each piece, Butterly achieves a careful equilibrium between humor and anxiety, seduction and disgust. While abstract in the main, her works—from the early, fragmentary self-portrait *Like Butter* (1997), which combines illusionistic pats of butter with squat, flesh-toned legs and a clitoris, to *Compromise* (2020), with its marbled, light green glaze and folds that pucker in the way a frowning mouth would—take pleasure in making strange certain aspects of figuration, whether in reference to the human body or to conventional still life. The uncanny feeling her works elicit in the viewer is alluringly unsettling.

Now based in New York City, Butterly attended art school when the so-called decorative arts, including ceramics, were still considered less vital than the fine arts of painting and sculpture. She studied at Philadelphia's Moore College of Art (now Moore College of Art and Design)—the first and only women's college historically devoted to the visual arts—for her BFA, then moved west for graduate school at the University of California, Davis, receiving her MFA in 1990. At Moore, she took classes with the ceramists Jack Thompson (born 1946) and Ken Vavrek (born 1939) and learned the foundational skills for working with clay. "I first saw the work of Ken Price, Ron Nagle, Viola Frey, and Bob Arneson when I was at Moore College of Art. I had thought clay had no meaning—it was pottery—and they proved me wrong," the artist has remarked.[1] At Davis, she studied with Arneson (1930–1992) as well as with the sculptor Manuel Neri and the painters Squeak Carnwath, Mike Henderson, David Hollowell, and Wayne Thiebaud.

Butterly's initial training in both ceramics and painting remains crucial to her work, as is evident in *Luminous Flow*, a deceptively simple, "classical" vase sitting on a cubic base. Starting from a basic, slip-cast ceramic form, which she considers a "readymade," Butterly typically contorts that form while the clay is still malleable, crumpling and twisting it in ways that are often compared to the works of the Biloxi, Mississippi, potter George Ohr (1857–1918) but that veer toward the subversive on the artist's own, unique terms. She then attaches additional elements, such as delicate "handles" of porcelain or carefully carved rows of beads—her "power pearls," as she calls them—and carves the

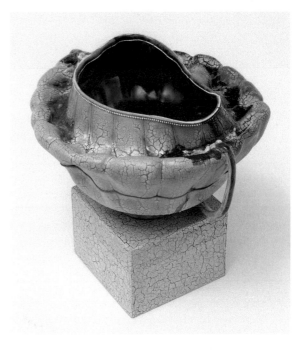

piece smooth until it "feels alive and becomes like a three-dimensional line drawing."[2] She then adds layer upon layer of glaze—Butterly is a master colorist—sometimes to the point of creating additional volume. To do so, she fires her works repeatedly, sometimes as many as forty times. As she says, "I need to have a long-term relationship with each piece."[3]

In Butterly's 2019 retrospective catalogue, the art historian Jenelle Porter wrote, "Butterly often includes pearls as a finishing flourish (though it must be noted they are not always added at the end), as a means to establish scale, to point to the feminine and empowerment, and to imbue tenderness. It can take weeks to carve one strand. They've been a constant throughout her work, her still point."[4] In *Luminous Flow*, these cling to the vessel's elegantly draped lip, striking a lyrical note that is, however, open to interpretation. As the curator Dan Nadel noted in the same volume, "A Butterly sculpture can be an object of contemplation, a voice in an art historical dialogue, a uniquely personal vision, a political statement"—or sometimes all at once.[5] LOB

1. Kathy Butterly, "'Going on Being': Kathy Butterly in Conversation with Elena Sisto," *artcritical*, October 12, 2018, https://artcritical.com/2018/10/12/elena-sisto-with-kathy-butterly/.
2. Ibid.
3. Kathy Butterly, "Kathy Butterly: *Color In Forming*," James Cohan, New York (website), exh. on view February 24–March 26, 2022, accessed August 20, 2022, video, 6:04, https://www.jamescohan.com/features-items/kathy-butterly-color-in-forming.
4. Jenelle Porter, "Color Safe," in *Kathy Butterly: ColorForm*, ed. Dan Nadel, exh. cat. (Davis: Jan Shrem and Maria Manetti Shrem Museum of Art, University of California, Davis, 2019), 31.
5. Dan Nadel, "King Sized," in Nadel, *Butterly: ColorForm*, 20.

74. *Luminous Flow*, 2021
Glazed porcelain and glazed earthenware
6¼ × 7 × 6 in. (15.9 × 17.78 × 15.2 cm)

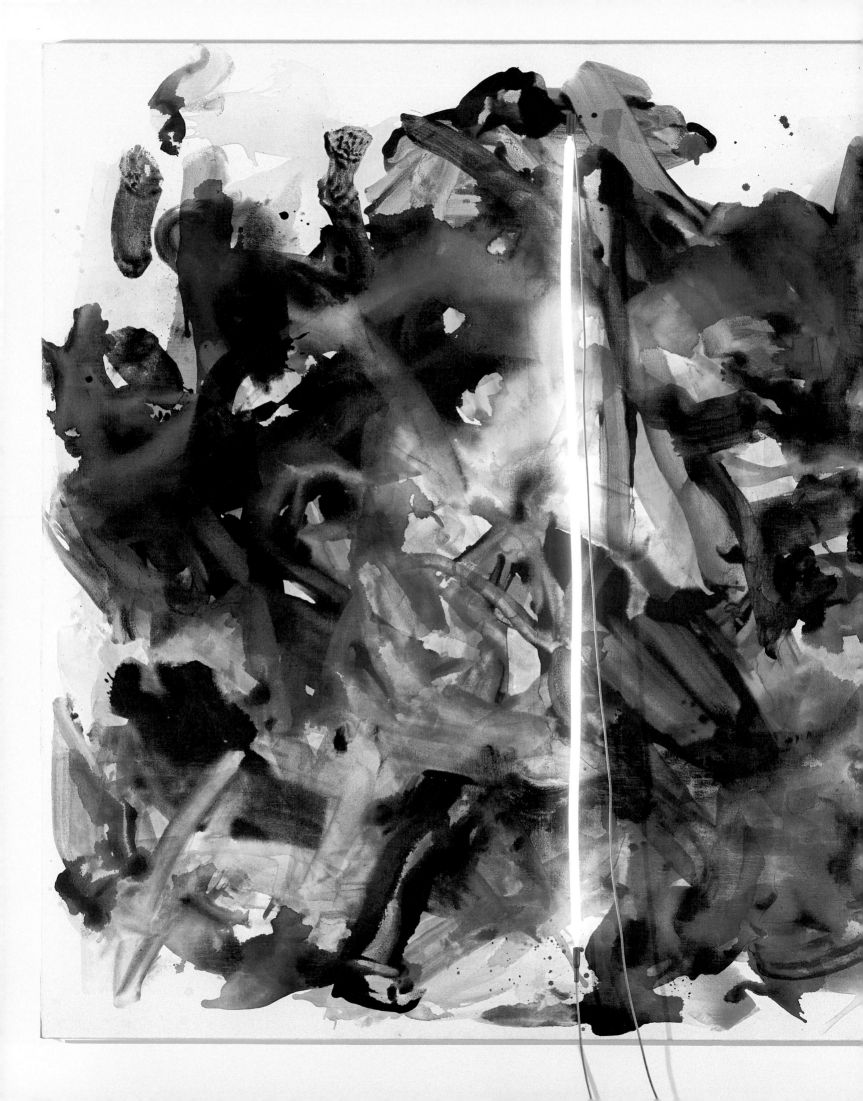

Mary Weatherford

Born Ojai, California, 1963

Having initially planned to pursue theater, the Californian Mary Weatherford studied both studio art and art history at Princeton University, graduating with a BA in 1984. Among her earliest works are those she developed in the following year while participating in the Independent Study Program at New York's Whitney Museum of American Art—large, colorful paintings resembling targets, inspired by tree rings—before embarking on a body of canvases incorporating actual seashells, starfish, and sea sponges. Shaped by her knowledge of Abstract Expressionism and color-field painting as well as her early association with a noteworthy roster of artists at Paula Cooper Gallery, where she helped to organize the archives as one of many sideline employments, Weatherford's oeuvre, to this day, explores the expressive potential of the painted gesture.

Following her move back to California from New York in 1999, Weatherford turned her attention to the landscape, using paint and light to explore the power and grandeur of her surroundings. Working on a deliberately monumental scale—a decision she aligns with her feminist sensibilities—the artist uses heavy linen canvases, custom-made at a Belgian mill, and primes them with gesso mixed with powdered chalk and marble dust, which "gives a bit of sparkle."[1] Instead of oil paint, which she considers to have too much historical precedent, she instead uses Flashe, a brand of matte-textured vinyl paint that offers intense color even when thinly spread. "I didn't want to go head-to-head with the history of oil painting," she says. "Even the scent of an oil painting signifies a historical continuum. I wanted to jump the track."[2] Weatherford staples her canvases to a low platform to keep them level, then pours water all over them before adding paint, which she manipulates with grouting sponges. The water remains on the surface and dries in situ, rather than running off, which results in a creative unpredictability. As she explains, "Because the water reflects, I can't really see what's going to happen. It's quite a mystery. As the water dries overnight and the pigment sinks into the painting, it's like watching a photograph develop. I come in the next morning and the image is there."[3]

While Weatherford has been exhibiting since the late 1980s, widespread critical acclaim arrived after she began to incorporate neon tubing into her work in 2012. This expansion of her practice coincided with an artist's residency at California State University, Bakersfield. Fascinated by the colorful neon signs adorning old restaurants, shops, and factories that she saw on her drives around the city—some illuminated, some burned out—she decided to integrate neon into her painted canvases. Fabricated from glass sourced in Murano, the glassmaking center in the Venetian Lagoon, the tubes are subtly bent by a San Diego sign-making company into forms reminiscent of hand-drawn lines. Then, they are screwed to the canvases and attached via wires to large magnetic transformers that sit on the floor. The tubes cast a stark and dazzling industrial light onto the surfaces, illuminating the layers of Flashe and creating lasting afterimages that blur the boundaries between paint and shadow. Deliberately given prominence as an integral part of the paintings, the neon tubes and their wires function together as drawings in three dimensions.

One such work, *the Tempest*, evokes the experience of a violent windstorm at sea; the confusion of crashing blue waves and white foam seems to engulf a few small objects in red and green, and it is difficult to decipher where the water ends and the sky begins. In her latest paintings, Weatherford has drawn inspiration from recent visits to Hawai'i. In *Light Falling Like a Broken Chain; Paradise*, also in the Shah Garg Collection (see pp. 136–37), sweeping brushstrokes of vivid color evoke lush foliage, exotic flowers, and the dramatic meteorological conditions of the tropical islands. While the canvas does not feature the artist's signature neon tubing—a noteworthy development in some of her newest works—its surface is nonetheless illuminated by a radiant, chain-like column of dazzling white. HJ

1. Mary Weatherford, "Mary Weatherford: Train Yards," interview by Laura Hoptman, *Gagosian Quarterly*, June 11, 2020, https://gagosian.com/quarterly/2020/06/11/interview-mary-weatherford-laura-hoptman-train-yards/.
2. Ibid.
3. Mary Weatherford, quoted in Sarah Cascone, "New York Has Always Been about Light to Me," *artnet news*, October 2, 2018, https://news.artnet.com/art-world/mary-weatherford-gagosian-1346399.

75. *the Tempest*, 2015
Vinyl paint on linen, with wired neon tube
8 ft. 8 in. × 9 ft. 9 in. (264.2 × 297.2 cm)

Monika Baer

Born Freiburg im Breisgau, Germany, 1964

Monika Baer is a German painter who lives and works in Berlin. She is best known for canvases that combine abstract and illusionistic techniques to explore the possibilities of painting as a visual language. Baer rejects narrow, literal readings of her works and has been driven throughout her career by what she calls "the principal problem of painting."[1]

Baer studied at the Kunstakademie Düsseldorf from 1985 to 1992. While she had early ambitions to be a painter, her arrival at the academy—after the establishment of Bernd and Hilla Becher's department of photography there in 1976—coincided with an overwhelming focus on that medium as the dominant field of study. The legacy of 1970s conceptual art and Minimalism was profound, and the teaching of painting was heavily male-dominated, characterized by what Baer has called the "ironic chauvinism" of artists such as Martin Kippenberger and Albert Oehlen.[2] As she recalls, "For me, right at the beginning, Conceptual Art struck me as: 'This is what art really is.' That shattered my notion of painting. How could painting even be possible?"[3] Rather than direct her energies elsewhere, however, Baer spent her academy years grappling with this problem, questioning how to deal with painting's "historical baggage" and attempting to find a way in which it might meaningfully form part of contemporary artistic discourse.[4]

Following her graduation, Baer felt compelled to paint, but without knowing what form her works should take or how they might circumvent the masculine traditions in which she had been trained. In 1997, turning to her long-standing interest in the theatrical, she produced a series of canvases based on images of productions of Mozart's operas at the Salzburger Marionettentheater in Salzburg (see fig. 4 on p. 84). Each painting depicts the front portion of the stage in trompe-l'oeil detail, above which a moment in the marionettes' performance is captured against a background of vividly colored, gestural strokes. Later works combine more monochromatic surfaces with physical manipulations of the canvas support, such as keyholes and cutout spider webs.

Baer's subject matter is both ubiquitous and disarming. Body parts, playing cards, lengths of chain, brick walls, bottles of vodka, and more commingle in seemingly surreal combinations. While her motifs differ from one painting to the next, the structuring devices remain constant, as the same fundamental shapes are repeatedly reused to different ends. As she has explained, "Money, sausage slices, faces, road markings, breasts, are all painted onto a basic form, a rectangle, circle or oval that has been stencilled, primed white and sanded. The motif is laid onto this *carrier*, like a layer or a mask."[5] The simultaneous use of conflicting styles also defines much of the artist's oeuvre. Gestural washes of painterly abstraction appear alongside motifs rendered in intricate detail, which she uses as a "method of seduction, a way of drawing the gaze into the painting."[6] Through an intuitive process, Baer develops strange compositions that are as disarming to her as they are to the viewer: "Allowing myself to wander off, while watching myself do so, brings me to places where I exceed the confines of my own taste—which I find a valuable and interesting aspect."[7]

Yet to be titled continues the artist's exploration of the theatricality of pictorial space. She conceived the painting during her appointment as Regents' Lecturer at UCLA in 2018–19, during which time the eucalyptus trees visible from her studio window acted as a prompt for a body of work that continued to explore the nature of painting. Against a low stone or concrete wall that evokes the edge of a stage rests a hyperrealistic matchstick—a protagonist, perhaps, in an unknown performance—while above it, a tilted tree trunk sheds its bark against a dreamlike sky. The painting was first exhibited in a solo exhibition at the Neuer Berliner Kunstverein in 2020 following Baer's receipt of the Hannah Höch Prize for lifetime achievement in 2019. While the title is deliberately suspenseful, it is the three-dimensional, bicolor foam teardrop affixed at the lower right-hand corner of the canvas that is most surprising. As Baer has asserted, "I don't accept the surface of the painting as something taken for granted."[8]

HJ

1. Monika Baer, "The Artist's Materials and Their Use in Painting" [July 9, 2013], reprinted in *Städelschule Lectures 2019–1999*, ed. Arielle Bier (London: König, 2019), 247.
2. Ibid., 246.
3. Ibid., 245.
4. Ibid., 246.
5. Monika Baer, "Surfacing," interview by Mark Prince, *frieze*, no. 6 (Autumn 2012), https://www.frieze.com/article/wo-die-bilder-aufhören.
6. Baer, "The Artist's Materials," 267.
7. Ibid., 251.
8. Baer, "Surfacing."

76. *Yet to be titled*, 2020
Oil and rigid foam on canvas
90½ × 60 in. (229.9 × 152.4 cm)

Ellen Gallagher

Born Providence, Rhode Island, 1965

After a diverse education—at progressively minded Oberlin College in Ohio, a carpenters' union in Seattle, Studio 70 in Kentucky, and Skowhegan School of Painting and Sculpture in Maine, among other places—the American artist Ellen Gallagher emerged to critical acclaim in the mid-1990s. Her practice incorporates painting, drawing, sculpture, collage, photography, and film. Today, she works between Rotterdam, in the Netherlands, and New York.

Gallagher's interest in art began under unlikely circumstances in 1986, when she spent a semester studying pteropods (microscopic "wing-footed" snails) as part of an oceanography course at Woods Hole Oceanographic Institution on Cape Cod. Perhaps most instrumental, however, was the time she spent in Boston (she graduated from the School of the Museum of Fine Arts in 1992). There, she met the poets Sharan Strange and Thomas Sayers Ellis, founders of the Darkroom Collective, an African American poetry cooperative. Appointed the group's official art coordinator, Gallagher began curating exhibitions to appeal to its diverse membership and public. An important counterbalance to the School of the MFA, this experience helped to develop her critical thinking. As she recalls, "The Darkroom Collective *was* school. . . . This complex audience was crucial to me developing a level of confidence with the ambivalence in my work."[1]

Gallagher's New York debut—at the Whitney Biennial in 1995, followed by a solo exhibition at Mary Boone Gallery in 1996—was a resounding critical success. In the two presentations, she showed a series of paintings crafted from yellowish penmanship paper—the kind ruled with solid and dashed blue lines, designed for children to practice their handwriting. The artist had glued variously sized squares and rectangles of the paper to canvases in uneven, overlapping grids—"from top to bottom, left to right"—before overpainting them in subdued tones to form what she has called "a skin."[2] Interested in paper as a neutral substance ripe for critical disruption, Gallagher is also drawn to the material's instability: "It will yellow and darken with time, so no matter what, it resists me in that way."[3]

Viewed from afar, the reduced formal vocabulary of these early paintings alludes to the work of Agnes Martin (1912–2004), in which the artist has acknowledged an interest, and to 1960s Minimalism. Upon close inspection, however, they reveal a subtle and complex political stance. Using the structure provided by the paper as a scaffold for her own iconographic lexicon, Gallagher drew and painted over the ruled lines with what she calls

"the disembodied ephemera of minstrelsy."[4] Often, these are exaggerated lips and wide-open eyes—repeated in intricate miniature across the canvas—that evoke the caricatured physiognomies of the nineteenth-century minstrel show, in which White actors in blackface farcically imitated Black people. The artist's repetition of motifs is key to her fabrication of what she terms a "cosmology of signs" and has been likened to the structuring principles of jazz music.[5] As she explains, you "start off with a limited class of signs" and then "revisit and repeat" to "build structure."[6]

With its title conjuring negative colonial stereotypes of the African continent, *Wild Kingdom* was first exhibited at the 1996 Mary Boone show. While the tiny coffee-bean-shaped forms in the painting allude subtly to mouths, Gallagher's minstrel iconography soon became much more definitive. In later paintings, complex patterns run riot across the canvas, seamlessly combining the monumental and the minute. Each painting is characterized by a visual tension—a "push and pull," as the artist has described it—between "the watery blue of the penmanship paper lines" and "the gestural marks made inside and around them."[7]

Gallagher's later work has drawn upon mythology, science fiction, oceanography, and the novels of Herman Melville. She also frequently references music, especially that of Sun Ra, George Clinton, and other jazz and funk musicians. Since the early 2000s, she has made collages incorporating advertisements for hair and beauty products aimed at Black women, which she sources from archival issues of Black lifestyle magazines such as *Ebony*, *Sepia*, and *Our World*. First manipulating them with a variety of printing processes, the artist then arranges pieces of predominantly yellow Plasticine, intricately molded into masks and extravagant wigs, over the figures. This act of transformation satirizes the advertisements' lofty—and deeply problematic—claims of beautification and explores complex questions of race and gender identity. HJ

1. Ellen Gallagher, interview by Jessica Morgan, in *Ellen Gallagher*, ed. Jessica Morgan, exh. cat. (Boston: Institute of Contemporary Art, 2001), 18.
2. Ellen Gallagher, "'eXelento' and 'DeLuxe,'" interview, Art21 (website), November 2011, accessed August 1, 2022, https://art21.org/read/ellen-gallagher-exelento-and-deluxe/.
3. Ibid.
4. Ellen Gallagher, quoted in Robin D. G. Kelley, "Confounding Myths," in *Ellen Gallagher: AxME*, by Carol Armstrong et al., exh. cat. (London: Tate Publishing, 2013), 10.
5. Gallagher, interview by Morgan, 22.
6. Ibid.
7. Gallagher, "'eXelento and DeLuxe.'"

77. *Wild Kingdom*, 1995
Oil and paper on canvas over wood panel
84 × 72 in. (213.4 × 182.9 cm)

Rachel Harrison

Born New York City 1966

The works of Rachel Harrison—in the artist's own words, "shapes that can't be described"—counter traditional notions of taste and the historical boundaries between creation and appropriation.[1] Although she is best known as a sculptor, Harrison also works in drawing and photography. Her conceptual sculptural assemblages juxtapose eclectic materials, formal experimentation, and references to popular culture and art history.

Harrison received a BA in fine art in 1989 from Connecticut's Wesleyan University, where her studies were shaped by the legacies of conceptualism. As she developed her artistic voice in the early 1990s, she began to experiment with an unorthodox sculptural language that combined abstract forms with mundane objects from everyday life. Her first solo exhibition—the extraordinarily titled *Should home windows or shutters be required to withstand a direct hit from an eight-foot-long two-by-four shot from a cannon at 34 miles an hour, without creating a hole big enough to let through a three-inch sphere?*—was held at ARENA, a gallery in the parlor of a curator's apartment in Cobble Hill, Brooklyn, in 1996. In it, Harrison created an immersive environment comprising fake-wood paneling, photographs of garbage bags piled on curbs, brightly colored papier-mâché forms, and cans of peas. While she has been compared to artists such as the late Mike Kelley (1954–2012)—who also engaged with the crass and the everyday, and whom she counts as an important influence—Harrison operates in a way that is uniquely hers. She conflates strategies from Surrealism, Pop, Minimalism, and Neo-Dada in a practice that confounds all expectations.

The artist has an ongoing interest in modes of display and, in her work of the past twenty years, has tended to create sculptures that serve as a means of physical support for found objects and photographs. In *Fendi*, an integrated shelf in a rectilinear hunk of colorful matter acts as a display mechanism for a bottle of discontinued Fendi eau de toilette (the fragrance was launched in 1985). Other works reference display precedents from museological history and consumer culture, such as the plinth, the pedestal, and the mannequin, offering up Harrison's carefully edited montages at optimal height for the viewer. To create these sculptural forms, Harrison first produces a support structure from wood before augmenting it with pieces of polystyrene. Once she is satisfied with the shape, she roughens it with cement and brushes on swaths of bright acrylic paint. Her palette is lurid, jarring, and always unexpected. Then, she transforms the sculpted form into a complex assemblage with an array of seemingly incongruous additions. These may include consumer goods and quotidian items purchased from 99¢ stores, supermarkets, and online merchants as well as taxidermied animals, clippings from tabloid newspapers, and photographs, both original and found. High and low art, the handcrafted and the readymade, and celebrity and the commonplace coexist uncomfortably in constructions that are ambiguous and often difficult to comprehend. Speaking of her fabrication process, the artist has said, "I combine and layer things to make sure I'm inconsistent. I've gotten it down to a certain way of making forms, but then I'm going to be constantly responding to what I'm working on. I really don't know what I want it to be when I start."[2]

Harrison's works have a deliberately banal and irreverent appearance and emanate a profound sense of antimonumentality. Demonstrating the way in which art is inextricably linked to the world around us, they offer a humorous rejoinder to the increasingly complex social and political circumstances in which we live. Viewing the physical presence of her works as an antidote, of sorts, to the "instantaneous distribution and circulation of images" that characterize contemporary culture, Harrison has remarked, "I want people to be real with art, to be conscious and present with the object in order to experience it."[3] HJ

1. Rachel Harrison, quoted in Peter Schjeldahl, "The Shape We're In: The Timely Sculpture of Rachel Harrison," *New Yorker*, December 15, 2014, https://www.newyorker.com/magazine/2014/12/22/shape.
2. Rachel Harrison, "Artist Rachel Harrison and Actor Matt Dillon Confront Their Own Worst Critics," joint interview, *Interview*, October 22, 2019, https://www.interviewmagazine.com/art/artist-rachel-harrison-and-actor-matt-dillon-confront-their-own-worst-critics.
3. Rachel Harrison, interview by Nayland Blake, *BOMB*, no. 105 (Fall 2008), https://bombmagazine.org/articles/rachel-harrison-and-nayland-blake/.

78. *Fendi*, 2016
Wood, polystyrene, acrylic, cement, and bottle of Fendi perfume
19½ × 14½ × 11½ in. (49.5 × 36.8 × 29.2 cm)

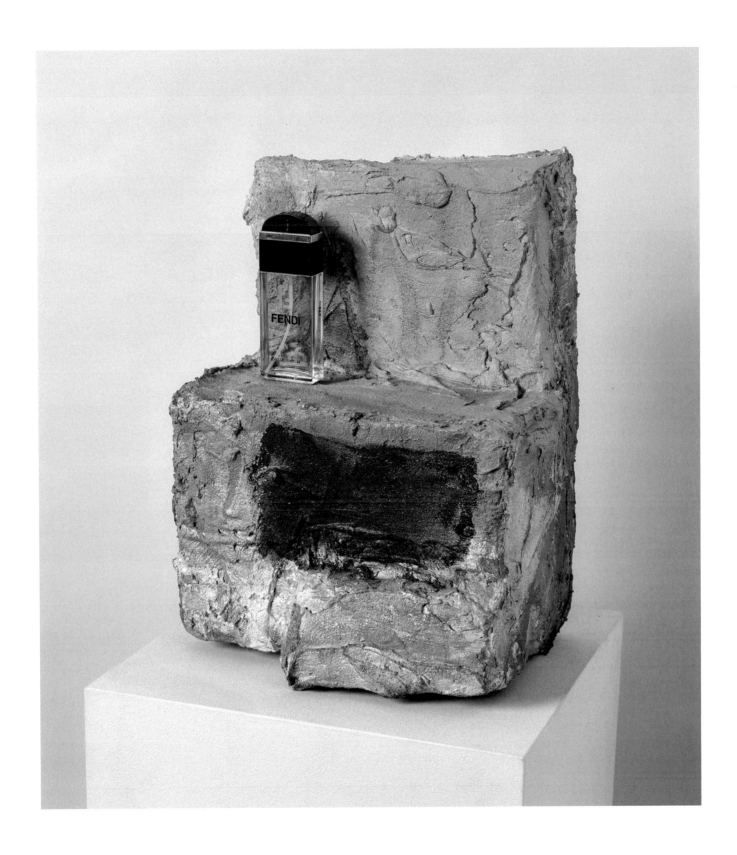

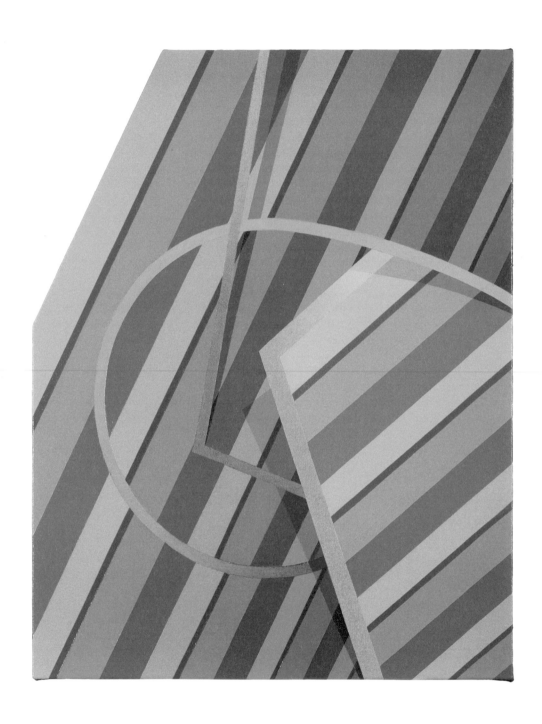

Tomma Abts

Born Kiel, Germany, 1967

Tomma Abts is best known for abstract paintings whose diminutive scale belies their dynamic complexity. She has also produced a small number of reliefs cast in metal from painted canvases. Despite being recognized as a painter, she did not train as one, instead studying mixed media at the Hochschule der Künste Berlin from 1988 to 1995. As part of the curriculum, she made experimental films, which led to the series of grid-based paintings with which she began her career. She has lived and worked in London since 1995 and received Tate's prestigious Turner Prize in 2006.

Abts begins her rigorous working process by covering a canvas with thin washes of acrylic, after which she switches to oil paint and commences a methodical process of revision: existing forms are painted over, contours are continually refined, areas of negative space are heightened, and colors are shifted over a period of time that can stretch from days and weeks into months and even years. The artist does not use preparatory sketches and begins each work with no preconceived idea of what the final result might be. She works freehand, without tape or stencils, habitually on several canvases simultaneously. Speaking of the ways in which her practice juxtaposes intuition and rationality, she has said, "Making a painting is a long-winded process of finding a form for something intuited . . . and making whatever shape and form it takes as clear and precise as possible."[1]

This labor-intensive editorial process manifests itself physically on the surface of the canvas. "When I pull the brush along the outline of a shape," Abts explains, "it makes a little ridge, which grows when I go over the same shape many times, i.e., to change the color."[2] Ridges and crackled paint are accompanied by gradated shading to create the impression of varying depths of pictorial space, in which forms both recede and project. Trompe-l'oeil drop shadows—such as those visible in *Leko*—complete the optical illusion, making it difficult to decipher which layers of paint lie on top and which underneath. As in many of Abts's works, the dynamic placement of stripes and curves in *Leko* creates a sense of movement. Despite the formal resemblance of her work to historical geometric abstraction, however, the artist does not refer to source material. As she explained in 2004, "The forms don't stand for anything else, they don't symbolize anything or describe anything outside of the painting. They represent themselves."[3] While Abts has worked predominantly in a uniform format since the beginning of her career—each painting measures roughly 19 by 15 inches—she began producing "shaped" canvases late in the first decade of the 2000s as a means of emphasizing their sculptural quality. In *Leko*, she sliced off one corner of the rectangle, while in other works, she rounds off corners or divides the canvas into two sections. Masquerading as part of the composition, the angle of the cut edge here informs and imitates the geometric shapes that emerge within it.

Abts continues to work on a painting until it becomes, in her own words, "congruent with itself."[4] To explain the shift that occurs with this resolution, she has said, "Before that the paintings just seem to be an arbitrary composition of geometric shapes, but then suddenly the relationships between all the elements on the canvas start to work: it all connects and becomes alive and suddenly it has a mood or an atmosphere. . . . It makes you feel something."[5] Once a composition is resolved, the artist chooses a title to mark its formal completion. Each comes from a dictionary of first names specific to Ostfriesland (East Frisia), a region in northwestern Germany, and claims a kind of personality for the work. The process, she explains, is finely tailored to the specific qualities of the composition: "I select a particular name for a particular painting and I choose it by the mood, sound or by shapes in the painting—it's definitely not random."[6]

HJ

1. Tomma Abts and Vincent Fecteau, "Some Similarities," *Parkett*, no. 84 (December 2008): 35.
2. Tomma Abts, quoted in Kate Nesin, "Degrees of Relief," in *Tomma Abts*, ed. James Rondeau and Lekha Hileman Waitoller, exh. cat. (Chicago: The Art Institute of Chicago, 2018), 19–20.
3. Tomma Abts, interview by Peter Doig, in *Tomma Abts*, ed. Daniel Buchholz and Christopher Müller, exh. cat. (Cologne: Galerie Daniel Buchholz: London: greengrassi, 2004), 14.
4. Tomma Abts, interview by Emma Brockes, *The Guardian*, December 6, 2006, https://www.theguardian.com/artand design/2006/dec/06/art.turnerprize2006.
5. Tomma Abts, "Interview with Tomma Abts, Champion of Abstraction," by Louisa Buck, *Art Newspaper*, December 31, 2005, https://www.theartnewspaper.com/2006/01/01 /interview-with-tomma-abts-champion-of-abstraction.
6. Ibid.

79. *Leko*, 2018
Acrylic and oil on canvas
18⅞ × 15 in. (47.9 × 38.1 cm)

Michaela Eichwald

Born Gummersbach, Germany, 1967

The Berlin-based artist Michaela Eichwald enrolled at the Universität zu Köln—located in the same state, Nordrhein-Westfalen (North Rhine–Westphalia), as her birthplace—in 1987 and studied philosophy, history, art history, and German literature. At the same time, she undertook a more informal education in the Rhineland's art scene, which was both notorious and celebrated for the self-critical antics of certain of its painters (such as Martin Kippenberger [1953–1997]). She later observed, "From my perspective, it was a very good polymorphously perverse school with many original teachers where I could learn and experience what I wanted to know. In a direct, physical way. When it all got too much for me, I could switch to my other school, the university."[1]

Eichwald's art is marked by a fruitful indifference to the boundaries between creative disciplines such as writing, sculpture, painting, and photography. She shares this quality with many of her women contemporaries: in 1991, she and her fellow artists Jutta Koether (see pl. 66), Cosima von Bonin (born 1962), and Charline von Heyl (see pl. 71), along with Isabelle Graw, cofounder of the influential German art quarterly *Texte zur Kunst*, posed for a black-and-white photograph by Hansjörg Mayer as "gun-toting militants," perhaps waging war on the mostly male-dominated art scene.[2] Filled with humor, Eichwald's works draw from theology, philosophy, and art history, with references ranging from medieval mysticism to contemporary lyric poetry, governmental blunders to Dadaist word strings. Through her practice, she questions the vast, seemingly limitless interactions that can occur between medium and form. While enthusiastically committed to pushing the material, formal, and conceptual possibilities of painting, the artist typically pokes fun at modernist conceits of purity—hence her engagement with synthetic supports, such as PVC and faux leather. She has aptly described the latter as "repulsive, inelegant, something that cannot be easily classified. And it doesn't suck."[3]

Bridging abstraction and figuration, Eichwald's thickly layered paintings are the outcome of alchemical amalgamations of acrylic, oil, tempera, spray paint, mordant, graphite, varnish, and lacquer, in various combinations and permutations. Whether in a large or a small format, her works combine suave paint strokes with hasty smudges, at times revealing figurative forms and snippets of text. One senses throughout her oeuvre a clear penchant for combing and roiling through art history via diverse painterly styles and techniques. Eichwald's nonrepresentational tactics—readily apparent in *CityHome 2000 Titelgenerator*—are partly a way to ensure that her work offers no singular declaration, even when it is finished. Her paintings are not subject to elaborate planning, nor are they made with the help of studio assistants. Summing up her approach in a 2016 interview, she stated her overarching desire: "Less hedging, more trial balloons. More life, more expression, more unintelligibility."[4] This anything-goes strategy also comes across clearly in Eichwald's sculptures, for which she pours resin into plastic bags, rubber gloves, and bottles already containing surprising and often jarring materials, such as chicken bones, erasers, jewelry, fishing tackle, candy, small drawings, and hard-boiled eggs. At once repellent and captivating, strange and seductive, these pieces are utterly surreal.

LOB

1. Michaela Eichwald, "Trust Communicator: Paint, Blog, Ask Questions; Michaela Eichwald Speaks with Pablo Larios," *frieze*, no. 25 (Autumn 2016), https://www.frieze.com/article/trust-communicator.
2. Michaela Eichwald, quoted in Bennett Simpson, *Make Your Own Life: Artists in and out of Cologne* (Philadelphia: Institute of Contemporary Art, University of Pennsylvania, 2006), 21.
3. Michaela Eichwald, quoted in Pavel Pys, "On Pleather: Michaela Eichwald's Inelegant Surfaces," *Sightlines* (blog), Walker Art Museum, Minneapolis, February 19, 2021, https://walkerart.org/magazine/on-pleather-michaela-eichwalds-inelegant-surfaces.
4. Eichwald, "Trust Communicator."

80. *CityHome 2000 Titelgenerator*, 2020
Acrylic, shellac-based ink, lacquer, and graphite on pleather
55¾ × 35⅝ in. (141.6 × 90.5 cm)

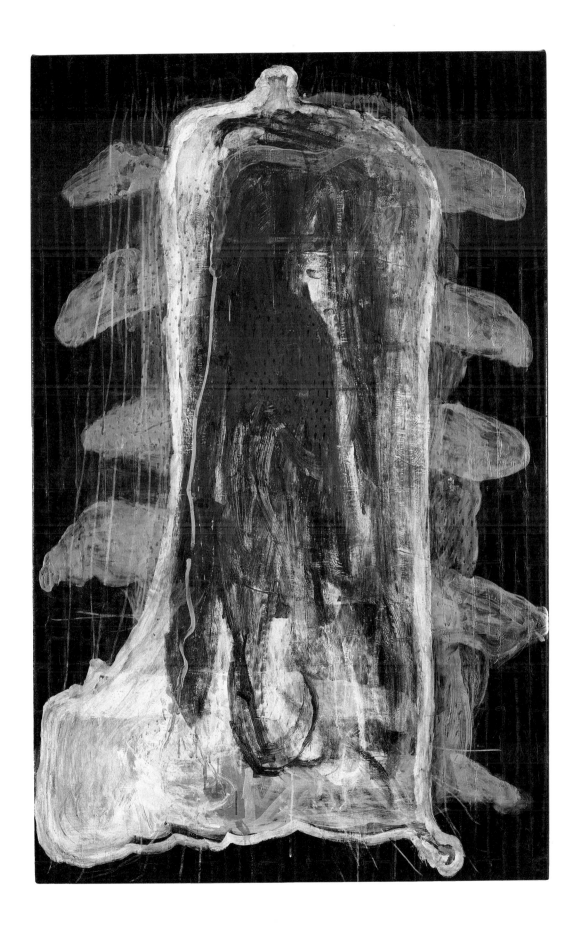

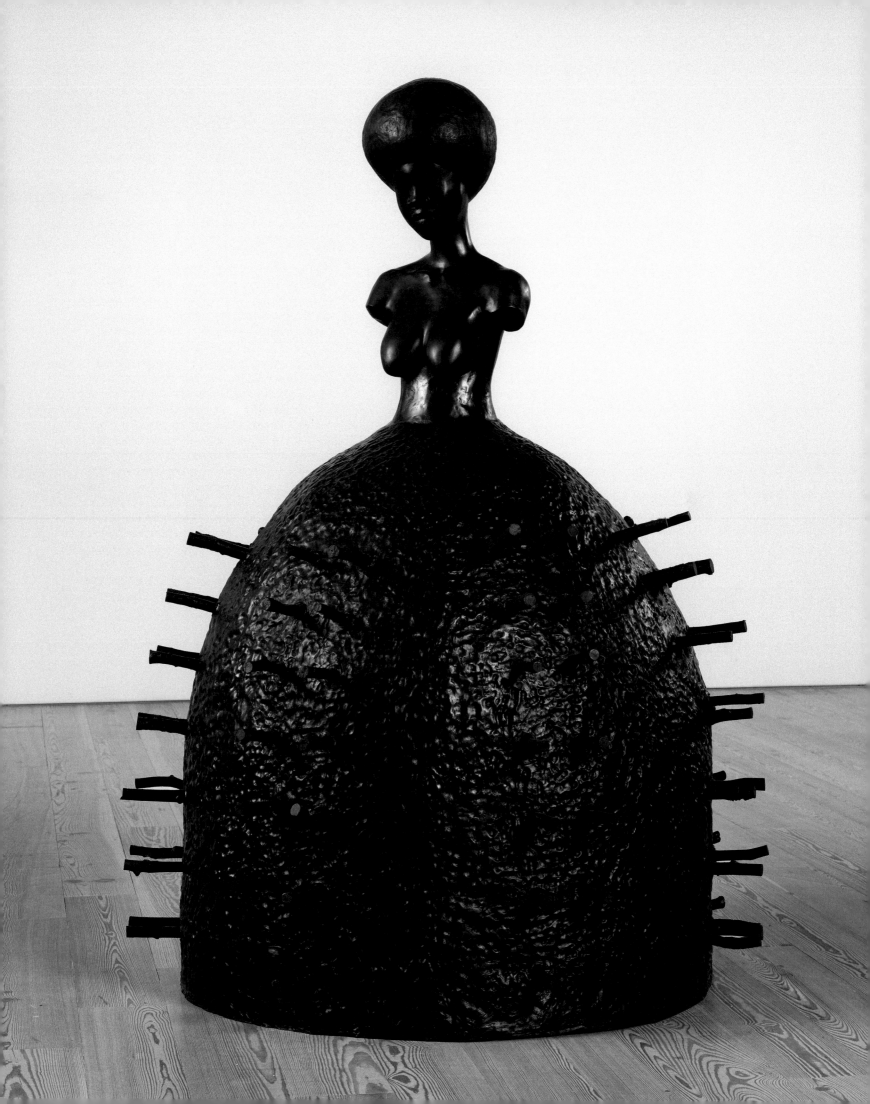

Simone Leigh

Born Chicago 1967

Stick is one of three sculptures created by Simone Leigh for the Whitney Biennial in 2019. Over seven feet tall, the bronze portrays a woman whose torso merges with a large, dome-shaped structure bristling with dozens of cylindrical rods. The figure is devoid of arms and ears, and her eyes are suggested only by subtle indentations—details that emphasize the importance of abstraction in the artist's work. "I'm not doing portraiture or representing anyone in particular," she has said, "but maybe many people, maybe a state of being."[1] Indeed, the lives of Black women in the United States, and across the African diaspora, constitute Leigh's primary intended subject matter. For several years, she was known to begin any talk she was invited to give by stating two points: that her work centers Black women, and that Black women are its primary intended audience.[2] Whether creating a small-scale ceramic, a towering bronze, a video, or an installation, or engaging in a form of social practice, Leigh seeks to elevate the status of women who have faced denial—"who, for whatever reason, have been left out of history."[3]

Stick belongs to a series the artist began in 2016 called *Anatomy of Architecture*. In these works, Leigh conflates the human body with motifs from various African building traditions, especially those relating to the domestic realm. The series grew out of Leigh's first outdoor public sculpture (*A particularly elaborate imba yokubikira, or kitchen house, stands locked up while its owners live in diaspora*, installed in Harlem's Marcus Garvey Park in 2016), which mimicked the clay-and-thatch "kitchen houses" of Zimbabwe but eliminated their doors. Another architectural source has been the homes of the Batammaliba people of Togo, whose name translates as "those who are the real architects of earth." The rods extending from *Stick* make reference to the horn-shaped clay projections at the entrance of Batammaliba properties, which have multiple, elaborate meanings and functions. The sculpture also cites the clay "beehive" houses of the Musgum people of Cameroon. Featuring raised geometric patterns, such buildings are the main feature of the village and are traditionally maintained by women. Leigh's quoting of these architectural types in combination with anatomical elements allows for a reappraisal of women's identities, in which she plays on the reductive notion of their bodies as reproductive receptacles or refuges. Moreover, her celebration of the sophisticated African domestic structures counters readings of primitivism that have been "used to humiliate us for years and years."[4]

Most recently, at the 59th Venice Biennale in 2022, the artist presented a monumental bronze sculpture in the forecourt of the United States Pavilion. Forming the centerpiece of an exhibition titled *Sovereignty*, the work, based on the D'mba ritual masks associated with the Baga people of Guinea, is one of several bodily sculptures that extend Leigh's inquiry into the recurring theme of self-governance.[5] As in *Stick*, women's agency is conveyed through a visual language that the artist has defined as solid and enduring. The dense sheen that permeates her sculptures is a particular hallmark, made possible by a salt-glazing process that requires twenty-four-hour stoking of the kiln.[6]

The clay jug is another traditional format frequently referenced by the artist. In her ongoing *Face Jug* series, ceramic vessels fuse with the heads of women, alluding to the face jugs made by enslaved people in Edgefield, South Carolina, in the early 1860s, which are stylistically related to sacred objects found throughout the Congo Basin. As with Leigh's other hybrid objects, these works acknowledge the persistence of African culture in the diaspora while pointing to the dignity of anonymous women.　　　　　AB

1. Simone Leigh, "I Want to Explore the Wonder of What It Is to Be a Black American," interview by Jenna Wortham, *T: The New York Times Style Magazine*, October 8, 2019, https://www.nytimes.com/interactive/2019/10/08/magazine/black-women-artists-conversation.html.
2. Christina Sharpe, "What Could a Vessel Be?," *The Milk of Dreams*, ed. Cecilia Alemani, exh. cat. (Milan: Silvana, 2022), 370.
3. Simone Leigh, quoted in Robin Pogrebin and Hilarie M. Sheets, "An Artist Ascendant: Simone Leigh Moves into the Mainstream," *New York Times*, August 29, 2018, https://www.nytimes.com/2018/08/29/arts/design/simone-leigh-sculpture-high-line.html.
4. Ibid.
5. "Simone Leigh: Sovereignty," in Alemani, *Milk of Dreams*, 162.
6. Sharifa Rhodes-Pitts, "Artist Unknown, Vessel Possibly for Water," in *Simone Leigh*, exh. cat. (New York: Luhring Augustine, 2018), 24.

81. *Stick*, 2019
Bronze (ed. 1/3; 1 AP)
85 × 63 × 63 in. (215.9 × 160 × 160 cm)

Sarah Morris

Born Sevenoaks, Kent, UK, 1967

The British American artist Sarah Morris attended Brown University in Providence, Rhode Island, from 1985 to 1989 and the Independent Study Program of New York's Whitney Museum of American Art from 1989 to 1990. She has a long-standing fascination with urban environments and is particularly interested in social space, power, economics, national identity, and city politics. Her work is located at the intersection of Pop art, conceptualism, and geometric abstraction. She incorporates an eclectic array of references into it, ranging from perfume distillation, airports, crowd control, advertising, and prostitution to the Olympic Games, the Eiffel Tower, and the Austrian French actress Romy Schneider.

Morris is known for her large-scale graphic canvases, which play with tropes found in various urban environments. The paintings, typically rendered in flat planes of glossy house paint, break apart and distill the architectural styles, color palettes, and impalpable psychologies of the cities that inspire them. For example, an uneven, asymmetrical grid filled in with purple, blue, black, and lime green suggests the glass façade of a Las Vegas hotel illuminated by neon signs. Elsewhere, a field of interlocking polygons in yellow, burnt orange, lavender, navy blue, white, and black evokes Abu Dhabi. It is important to note that the works are not *about* architecture per se. In the artist's words:

> It's always been sort of a misunderstanding that the paintings are about architecture. They're not really. They *use* architecture. They use the strategies of architecture—distraction and scale. And I title them after existing or past places that have been institutions of authority, whether for the good or for the bad. The paintings themselves are almost like virtual places.[1]

Alongside her often hard-edge abstract paintings, which she began making in the late 1990s, Morris creates films to investigate what she describes as "urban, social, and bureaucratic typologies."[2] These works are also based on cities and derive from close inspection of their architectural components, which Morris combines with a critical sensitivity to the nonphysical attributes of a given place. Her films include *Strange Magic* (2014), commissioned for the opening of the Fondation Louis Vuitton, Paris; *1972* (2008), about a "peripheral character" (a favorite trope of the artist's) in the hostage drama at the Munich Olympics; and *Capital* (2000), made during the final days of the Clinton administration. Long shots from unusual angles and electronic music are recurrent motifs in these works. "No matter what I capture, there is a sense of déjà vu to it, like you might have come across this visual before," Morris notes. "That's probably because images are always circulating at very fast speeds anyhow. Nevertheless, you make them again. So there's an automated element to it no matter how specific the coordinates are on the map. . . . The films are in some way fantasy. I don't view them at all as documentary, although probably some people see them that way."[3]

The painting *Sambodromo [Rio]* alludes to Morris's eleventh film, *Rio* (2012). The title references the Sambódromo da Marquês de Sapucaí, a permanent parade ground commissioned in 1983 from the Brazilian modernist architect Oscar Niemeyer (1907–2012) for the city's annual Carnival; completed in 1984, it represents his first major work after returning from exile toward the end of the Brazilian military dictatorship of 1964–85. The Sambódromo is the site where numerous samba clubs compete in dancing and drumming each year during Carnival. As is well known, these exhibitions attract thousands of Brazilians and foreign tourists each year, although fewer and fewer of the former can afford to attend, especially residents of the favelas, or slums, with which most of the samba clubs are associated. For the film, Morris captured scenes of Carnival from Niemeyer's building, which she combined with shots of glittering Guanabara Bay, surfers at the beach in Ipanema, a favela street party, a plastic surgeon in the midst of surgery, and a mist-shrouded Christ the Redeemer.

LOB

1. Sarah Morris, interview by Philippe Parreno, *Interview*, March 9, 2017, https://www.interviewmagazine.com/art/sarah-morris.
2. Sarah Morris, quoted in "Sarah Morris," White Cube (website), accessed February 7, 2022, https://whitecube.com/artists/artist/sarah_morris.
3. Morris, interview by Parreno.

82. *Sambodromo [Rio]*, 2014
Household gloss (paint) on canvas
60 × 60 in. (152.4 × 152.4 cm)

Ruth Root

Born Chicago 1967

Untitled 10 belongs to a group of paintings made by the American artist Ruth Root for a self-titled exhibition held at Pittsburgh's Carnegie Museum of Art in 2019. It consists of a fabric-covered semicircle that has been attached to a large, ziggurat-shaped panel through two wide apertures at the top of the panel. All the works in the series rely on this structural framework, in which one component of the painting is suspended from another. Similarly, the mechanisms that enable the works to be hung on the wall, such as nails and grommets, are visible on the surfaces. Root has described the origin of the works as "this experiment in almost something that was hard to accept as painting. I wanted to show what the hanging mechanism was and have everything be exposed, nothing hidden behind a stretcher. All the materials of a painting were there, but rearranged in a different way."[1]

Through such experiments in color, form, material, and pattern—which are, at the same time, reflections on the history of abstraction, especially color-field painting and Minimalism—Root has used her practice to expand the boundaries of her medium. The artist's development of devices such as her "Feminist Color Wheel," which prioritizes turquoise, pink, and other colors that have traditionally been disregarded in mainstream painting, underlines her mixed feelings about these art-historical precedents, in which men almost always dominated. In Root's words, "There needs to be a way of making sense of being a painter and acknowledging all that has come before you, and trying to make something that adds to that dialogue but is also something you experience visually, not through language."[2]

Since 2015, Root has been making paintings that, like *Untitled 10*, are twofold, consisting of a fabric designed by the artist with Adobe Photoshop software and digitally printed, plus an asymmetrical panel on which she has brushed or sprayed paint in various patterns. These evolved from a series of works on ultrathin aluminum sheeting, which Root likened to "flattened sculptures."[3] The artist's transition to her most recent compositions, based on a distinct compositional and material pairing, resulted from her interest in developing a practice that was "free" and "spontaneous"—to establish something that "functioned differently from a painting, but could still be termed a painting, because that's what it still was."[4]

The introduction of cloth, in particular, has allowed Root to broaden her ideas around what might be construed as "odd"—a term she has used in relation to her current works, which she recognizes are "hard to describe. . . . Often, a goal of mine in the studio is to surprise myself, and make something work that I didn't think would work. The result is frequently a quality that I like."[5] Incorporating images taken from a variety of media and news outlets, the textiles instill her otherwise abstract paintings with specific references to the real world. For the fabrics used in the pieces shown at the Carnegie, Root roamed the museum taking photographs of works by artists such as Lee Bontecou, Joan Brown, Eva Hesse, and Sol LeWitt and created patterns interspersing them with images of the artists Lorraine O'Grady and Ana Mendieta and the scholars (and famous U.S. congressional witnesses) Anita Hill and Christine Blasey Ford as well as other, more personal references, such as monster characters from a favorite television show of her son's. The cloth component of the Shah Garg Collection work features reproductions of eyes (taken from various artworks) alongside a headshot of Ruth Bader Ginsburg and a photograph of Hill being sworn in as a witness in Clarence Thomas's 1991 Supreme Court confirmation hearing.

The eye motif in *Untitled 10* makes reference to Root's earliest works, created shortly after she graduated from the School of the Art Institute of Chicago in 1993, which parodied the self-referential, inward-looking nature of much Abstract Expressionism. Her engagement with the external world is equally playful and intimate, and the artist's works, taken together, provide an index of her life: "Making connections between everyday things, and art things, and things happening in the world is essential for paintings," she has said, "and for looking at paintings."[6]

AB

1. Ruth Root, "Meet Ruth Root," Carnegie Museum of Art, Pittsburgh (website), video, 1:00, April 1, 2020, https://cmoa.org/artist/meet-ruth-root/.
2. Ruth Root, quoted in Hannah Turpin, "Patterns of Looking," *Carnegie*, Spring 2019, https://carnegiemuseums.org/carnegie-magazine/spring-2019/patterns-of-looking/.
3. Ruth Root, "Ruth Root: 'I Love to See How Artists Create Such a Joy from Colour,'" interview by Allie Biswas, *Studio International*, December 21, 2015, https://www.studiointernational.com/index.php/ruth-root-interview-old-odd-and-oval-aldrich-contemporary-museum-of-art-us.
4. Ibid.
5. Ibid.
6. Root, quoted in Turpin, "Patterns of Looking."

83. *Untitled 10*, 2019
Fabric, PVC panel, enamel paint, and spray paint
60 × 96 in. (152.4 × 243.8 cm)

Marie Watt

Born Seattle 1967

Working primarily in textiles, the Portland, Oregon–based artist and citizen of the Seneca Nation Marie Watt employs a wide range of motifs that crisscross time and cultures and unite disparate histories. Blankets are the most plentiful material in Watt's art; she has worked with them for more than twenty-five years. She has stacked blankets high, arranged them into arches, cut them apart and sewed them back together again, and cast them in clear resin and even in iron. For her ongoing *Blanket Story* series, she repurposes examples that have been donated by members of the public and thus are embedded with their own histories before becoming part of her project. In a 2013 installation at the Denver Art Museum, Watt stacked 157 blankets, each tagged by the donor with its story, to a height of twenty feet. The tower of blankets created, in the artist's words, "a bridge between sky and ground. As a Seneca person, our creation story is about Sky Woman, and Sky Woman lives in the sky and falls through this hole, and as she's falling she's helped—assisted—by a motley crew of animals, who are our first teachers, and they help her survive on what we now refer to as Turtle Island."[1] The blanket tower was installed in the museum's Northwest Coast gallery, framed by two nineteenth-century Haida totem poles.

In recent years, Watt has focused on tapestries, often producing them in collaboration with sewing circles around North America. She is interested in the type of social-practice art in which an engagement with multigenerational and cross-disciplinary storytelling, oral histories, and interviews can be crucial to the resulting work. "In our community," Watt notes, "there is no Indigenous word for *art*, but works that we would now refer to as 'artworks' have been made for a very long time. I think I'm really interested in how we can have more cross-disciplinary conversations, and conversations where art isn't institutionalized or segregated from our experience in the world."[2]

Watt holds an AFA degree from Santa Fe's Institute of American Indian Arts, a BS in speech communications and art from Willamette University in Salem, Oregon, and an MFA in painting and printmaking from the Yale School of Art. She describes herself as "half Cowboy and half Indian":[3] her mother is a member of the Turtle Clan of the Seneca Nation, and her father's family were ranchers of German-Scot descent in Wyoming.

Iroquois protofeminism and other Indigenous teachings have strongly influenced Watt's oeuvre. Her inclusive approach is also a knowing rejoinder to twentieth-century modernism, which many

84. *Companion Species (A Distant Song)*, 2021
Reclaimed satin bindings, industrial wool felt, and thread
2 ft. 9½ in. × 14 ft. (85.1 × 426.7 cm)

claimed to be a universal language despite its obvious Eurocentrism and often sexist and racist disregard for decorative, ornamental, and craft precedents—frequently branded "women's work." In her art, Watt counters such narratives. *Companion Species (A Distant Song)*, for instance, features reclaimed satin bindings—the strips of satin that run along the edges of a blanket—in various states of wear. Arranged horizontally in a spectrum running from pink to gold to blue, the composition recalls a sunset. The work suggests postwar American paintings by the likes of Mark Rothko, Barnett Newman, and Josef Albers, yet Watt "domesticates the idiom of these canonical artists without retreating an inch from their ambition to capture the sublime," the curator Glenn Adamson has written.[4] When a viewer stands close to the center of the work, it is impossible to see where it ends on either side. "It envelops you," Watt says of the piece, "just like an actual sunset does."[5]

Ultimately, Watt's work puts forward a different spin on the sublime, one that acknowledges an advanced form of interconnection—to plants, animals, and all living things on Earth. The very words "companion species," which anchor many of the artist's titles, suggest a deep relationality that extends beyond humans. As she reminds us, "When one is raised to think of animals as teachers and also as extensions of us—our relatives or relations— you're less likely to be able to separate how our actions affect the environment, animals, and the natural world."[6]

LOB

1. Marie Watt, "Marie Watt: Blanket Story," Denver Art Museum (website), accessed August 1, 2022, video, 5:10, https://www.denverartmuseum.org/en/edu/object /blanket-story-confluence-heirloom-and-tenth -mountain-division.
2. Marie Watt, artist's statement, in *Each/Other: Marie Watt and Cannupa Hanska Luger*, ed. John P. Lukavic, exh. cat. (Denver: Denver Art Museum, 2021), 15.
3. Marie Watt, quoted in Colette Lemmon, "Marie Watt," in *Oh, So Iroquois*, ed. Ryan Rice, exh. cat. (Ottawa: Ottawa Art Gallery/Galerie d'Art d'Ottawa, 2008), 124.
4. Glenn Adamson, "Native Song: Marie Watt's Communal Incantations in Fabric," *Art in America*, November 3, 2021, https://www.artnews.com/art-in-america/features/marie -watts-native-american-fabric-sculpture-1234608583/.
5. Ibid.
6. Marie Watt, "In Conversation with Marie Watt: A New Coyote Tale," *Art Journal* 76, no. 2 (Summer 2017), http://artjournal.collegeart.org/?p=9492.

Cecily Brown

Born London 1969

Like many of her peers, Cecily Brown—celebrated today for her gestural technique, vivid color, and imaginative imagery in works that exist somewhere on the fluctuating boundary between figuration and abstraction—came of age at a time when painting was not encouraged. After she graduated from London's Slade School of Fine Art in 1993, her emergence coincided with the rise of the Young British Artists (YBAs), against whose conceptually driven practice she consistently felt forced to defend her commitment to paint. In search of the creative freedom she had experienced on an exchange program at the New York Studio School in Greenwich Village in 1992, Brown relocated to the city in 1994. In early 1997, the artist presented her first mature body of work in *Spectacle*, a solo exhibition at Deitch Projects. Depicting rabbits engaged in graphic acts of sexuality and violence, the canvases seemed to critique the history of men's objectification of women while simultaneously reveling, tongue in cheek, in their lustful deeds. In subsequent years, the bunnies were replaced by free-floating penises and overlapping limbs—in paintings reminiscent of those of Sue Williams (see pl. 62), whom Brown had admired as a student—as well as recumbent female nudes and the orgiastic scenes for which she is best known.

In the creation of her work, Brown uses a vast range of source material. References from popular culture—newspaper photographs, magazine clippings, cartoon characters, children's book illustrations, album covers (such as that of the Jimi Hendrix Experience's *Electric Ladyland*), and so on—are given equal weight alongside motifs from psychology manuals and pornography. These then enter into a dialogue with the history of painting. Profoundly influenced by Francis Bacon (1909–1992) in her early years, Brown draws on the work of other postwar artists as well, including Arshile Gorky, Willem de Kooning, and Joan Mitchell (see pl. 10). In pursuit of what she has called "a natural conversation with the old masters," she also responds to artists ranging from Veronese and Delacroix to Rubens and Hogarth.[1]

Working intuitively, without preparatory drawings, Brown builds her compositions with energetic brushstrokes and a deliberately flattened pictorial space. Her color palettes are vivid and often jarring—she has noted the influence of the intense vermilion in Edgar Degas's painting *La Coiffure* (ca. 1896), which captivated her at London's National Gallery during her student days—and she works on a number of canvases simultaneously, often leaving one in progress for several weeks before returning to it.[2] A fundamental aim of Brown's is to encourage concentrated looking. As she has explained, "One of the main things I would like my work to do is to reveal itself slowly, continuously, and for you never to feel that you're really finished looking at something."[3] While she has always considered herself to be a figurative painter, she is particularly interested in the moment at which a figure breaks down into something less recognizable. This state of flux characterizes her work: in her words, "the whole figurative/abstract thing is about not wanting to name something, not pin it down. I've never wanted to let go of the figure, but it keeps wanting to disappear. It's always a fight to hold on."[4]

Alongside the body—the core of Brown's practice—nature is another recurring theme, as seen in *The Demon Menagerie*. The work references the motif known as the "concert of birds"—popularized by Frans Snyders (1579–1657) and other Flemish artists in the early seventeenth century—in which numerous species are depicted perched on top of one or more trees. In contrast to examples by Snyders, the jagged brushstrokes, sickly green hues, and skull-like form at the center of *Menagerie* create an atmosphere of violent unease. Speaking of her evocative titles in the context of her long-standing interest in the foreboding quality of old master paintings, Brown has said, "I like them to be troubling. They depend on what the viewer brings to them."[5] HJ

1. Cecily Brown, quoted in Alessandro Rabottini, "Cecily Brown: The Body Is Here," in *Cecily Brown*, ed. Danilo Eccher, exh. cat. (Cinisello Balsamo [Milan]: Silvana, 2015), 58.
2. Cecily Brown, "Cecily Brown Interview: Take No Prisoners," Louisiana Museum of Modern Art, Humlebæk, Denmark, November 3, 2015, YouTube video, 16:04, https://www.youtube.com/watch?v=c3ZPcC1p6pM.
3. Ibid.
4. Cecily Brown, "Conversation with Jackie Wullschlager (Extract), 2016," in *Cecily Brown*, by Courtney J. Martin, Jason Rosenfeld, and Francine Prose (London: Phaidon, 2021), 129.
5. Cecily Brown, "Paint Whisperer: A Conversation with Robert Enright (Extract), 2005," in Martin, Rosenfeld, and Prose, *Brown*, 118.

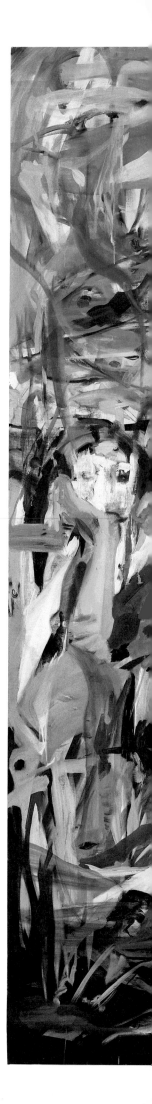

85. *The Demon Menagerie*, 2019–20
Oil on linen
8 ft. 9½ in. × 8 ft. 9½ in. (268 × 268 cm)

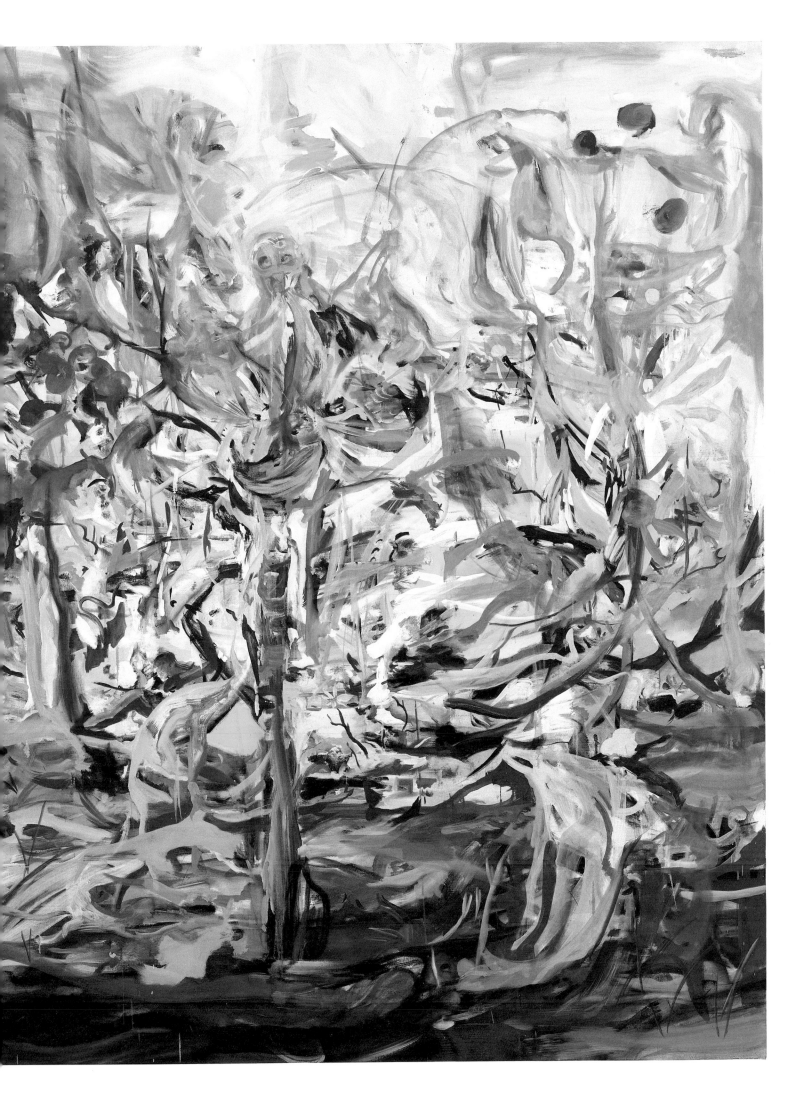

Shahzia Sikander

Born Lahore, Pakistan, 1969

Issues of gender and identity have occupied Shahzia Sikander since the earliest stages of her career. She made her first major work, *The Scroll* (1989–90), as her undergraduate thesis at the National College of Arts in Lahore, Pakistan, where she was studying miniature painting. The artist has described this semiautobiographical watercolor on tea-stained paper as "inspired by women all around me, Pakistani women activists, artists, poets, all my female friends."[1] Measuring over five feet in length, the composition depicts a spectral young woman traversing various settings within a house, each with a threshold that she overcomes to reach new territory. In the concluding scene, the protagonist is shown painting a self-portrait, marking the first time in the narrative sequence that the viewer sees her face. Grappling with the contentious subject of agency in the domestic realm as well as the quest for a sense of self, Sikander, in *The Scroll*, took the tradition of premodern Indo-Persian manuscript painting and transformed it into a format with contemporary relevance. Since this important transitional work, the artist has used ink and gouache on paper as her primary medium, taking the miniaturist tradition as her point of departure.

Sikander's interest in miniature painting, which historically illustrated episodes related to religion or courtly life, developed at a time when it was considered completely anachronistic. The genre was compelling to Sikander precisely because of this "largely dismissive attitude, as well as [the] collective lack of deep cultural knowledge in both Pakistan and the United States.... My peers and I had no real connections to our own region's historical art traditions."[2] She made it her objective to revive the genre by incorporating imagery that was deeply personal and characteristic of present-day life, thereby "reconstructing it from within its canon of historical representation."[3]

Infinite Woman was first presented as part of an exhibition held at the London gallery Pilar Corrias in October 2021. In the large-scale painting, which lent the exhibition its name, a circular form reminiscent of a planet is bordered by dozens of identically shaped streaks representing women's bodies, heads resting on the central form and feet extended outward. These multicolored figures, many of which are duplicated in fictive shadows, are as prominent as the imposing sphere from which they emerge and offer a dynamic counterpart. Evoking the powerful force of a sun's rays, the repeated forms underline the importance of women's identities in Sikander's practice, which "literally radiates and revolves around women's bodies."[4]

Whether relatively abstract, as in *Infinite Woman*, or more literally rendered, Sikander's images of women are consistently emblematic of resistance and regeneration. Some recurring motifs in her work, such as a roaming ghostly character and the disembodied, topknotted hair of a *gopi* (female worshiper of the Hindu god Krishna), are indicative of autonomy and free will, affording a reassessment of the roles women have typically been assigned throughout history. "The beheaded feminine forms were about my observing as a young artist the lack of female representation in the art world," she has commented, "and the misogyny present toward women in almost all spheres of work and life."[5] Similarly, Sikander's own perspective as a Muslim Pakistani American woman (she has lived and worked in New York since 1997)—and the "fetishization" of this position, as she has termed it—has influenced her visual lexicon. She acknowledges that "some of the iconography I created was a direct result to counter narrow definitions of the 'other.'"[6]

In 2020, Sikander created her first sculpture, *Promiscuous Intimacies*. In the warmly patinated bronze, the Roman goddess Venus, seated with legs bent to the side, supports an armless Indian *devata* on her right shoulder, intimately fingering her fellow goddess's necklace, and both bearing the weight of "communal identities from across multiple temporal and geographical terrains."[7] As with her reinvention of manuscript painting, Sikander's initial three-dimensional examination of women's bodies is an exercise in disrupting prevailing ways of looking at history while proposing alternative visions for the future.　　　　AB

1. Shahzia Sikander, "The Scroll," The Morgan Library and Museum, New York (website), exh. on view June 18–September 26, 2021, accessed August 1, 2022, audio, 1:58, https://www.themorgan.org/exhibitions/online/shahzia-sikander/scroll.
2. Shahzia Sikander, "Shahzia Sikander: What We Believe about Culture," May 25, 2021, https://www.nytimes.com/2021/05/25/special-series/shahzia-sikander-what-we-believe-about-culture.html.
3. Shahzia Sikander, quoted in Amishi Parekh, "Shahzia Sikander on Defying Conventions through Her Work," *Verve*, September 8, 2016, https://www.vervemagazine.in/people/shahzia-sikander-pakistani-artist.
4. Dorothy Price, "On Shahzia Sikander's 'World-Forming,'" Pilar Corrias, London (website), exh. on view October 12–November 13, 2021, accessed August 1, 2022, https://www.pilarcorrias.com/exhibitions/208-shahzia-sikander-infinite-woman/.
5. Shahzia Sikander, "Reclaiming Indo-Persian Miniature Painting, Reclaiming History: A Feminist Story; Shahzia Sikander in Conversation with Rafia Zakaria," in *Islamic Art: Past, Present, Future*, ed. Jonathan Bloom and Sheila Blair (New Haven, CT: Yale University Press; Ar-Rayyan, Qatar: Qatar Foundation; Richmond: Virginia Commonwealth University and VCUarts Qatar, 2019), 141.
6. Ibid.
7. Shahzia Sikander, "A Conversation with Shahzia Sikander," *Sculpture*, November 4, 2020, https://sculpturemagazine.art/a-conversation-with-shahzia-sikander/.

86. *Infinite Woman*, 2021
Watercolor, ink, gouache, and gold leaf on paper
69¼ × 60¼ in (175.9 × 153.03 cm)

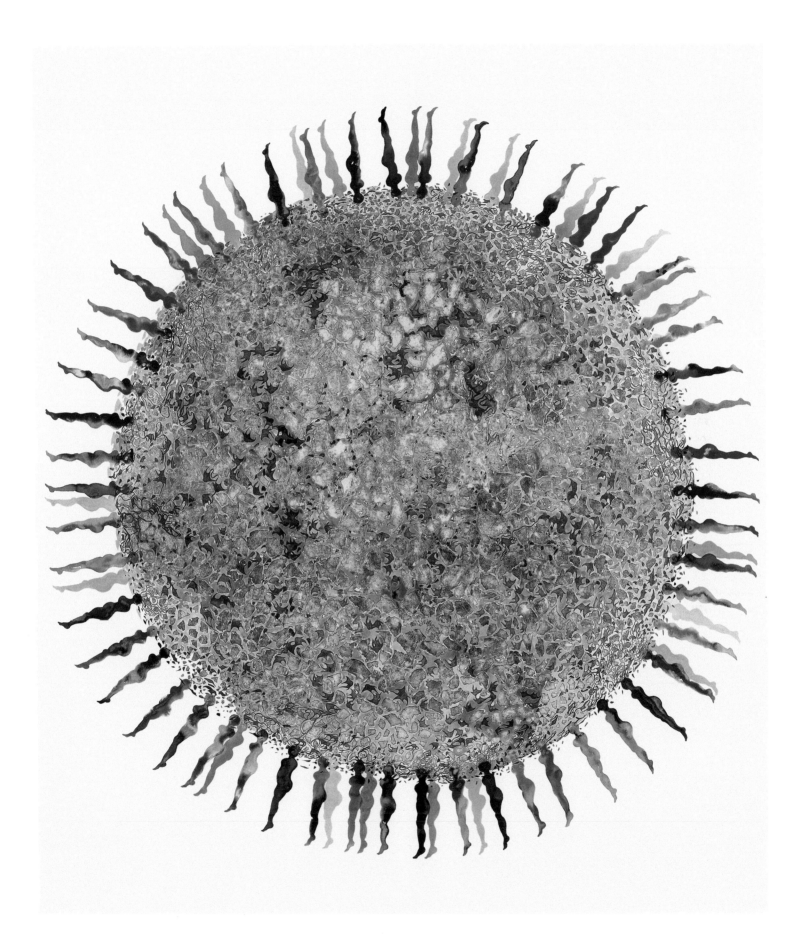

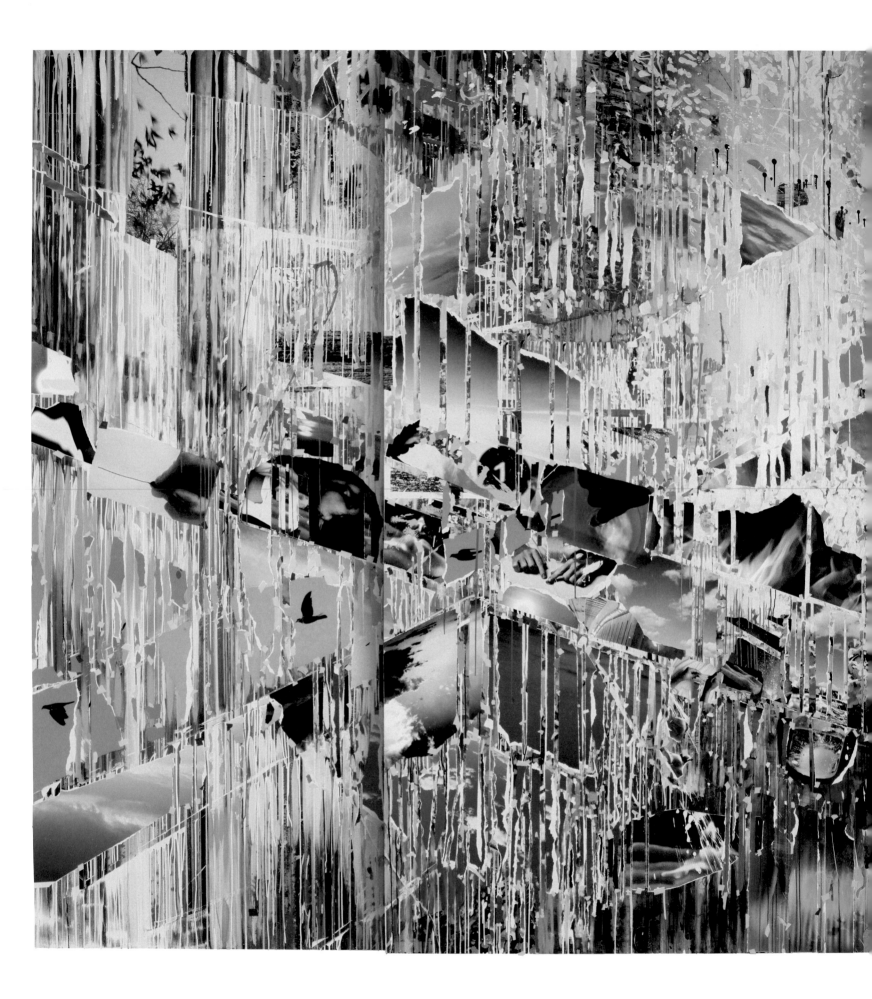

Sarah Sze

Born Boston 1969

The American artist Sarah Sze, who received a BA in architecture and painting from Yale College in 1991 and an MFA from New York's School of Visual Arts in 1997, is acclaimed for her complex multi-media installations, paintings, drawings, and videos that address temporality, entropy, and materiality. In a 2016 interview with the late curator Okwui Enwezor, Sze explained that in conceptualizing a work, her aim is to "choreograph the experience to create an ebb and flow of information," adding, "I'm thinking about how people approach, slow down, stop, perceive. I try and create alternating experiences of location and dislocation."[1] In 2003, the artist was named a MacArthur Fellow (for sculpture), and in 2013, she represented the United States at the 55th Venice Biennale with her exhibition *Triple Point* in the United States Pavilion, which she approached as a site of observation and experimentation. The sculptures and installations therein incorporated elements she had foraged from the urban landscape of Venice: piles of pebbles, leaves, espresso cups (and the napkins that come with them), tickets from vaporetto rides, and so on.

In recent years, Sze has returned to painting, the medium in which she first trained. For her 2021 solo exhibition at Victoria Miro in London, she presented six new paintings, all scaled to the gallery's high-ceilinged space. The artist integrated an abundance of painted elements into the works, laying bare how a piece progresses in an artist's studio as well as the catalysts that occur in the development of a series. She also extended her decades-long exploration of the myriad ways in which the non-stop production and proliferation of images—whether printed in the mass media, gleaned from the Internet or television, or captured in outer space—fundamentally change our conscious and unconscious relationships to our environment, memories, and time.

Sze conceived of the paintings on view at Miro in pairs, revealing two versions of a related image. For example, *Crisscross*, now in the Shah Garg Collection, was paired with *Crisscross Apparition* (2021; Marciano Art Collection), and the works were installed directly across the gallery from each other, registering as different stages in the life of a single painting (see fig. 2 on p. 100). Across the surfaces, images appeared to repeat, mirror, and flip back and forth, impressing upon the viewer a sense of

continual cross-pollination, rather than the more traditional idea of the original and its copy, or of one work's preceding another sequentially. The exhibition also included three floor-based stainless-steel sculptures in Sze's *Fallen Sky* series, related to her permanent outdoor installation at Storm King Art Center in Upstate New York. There, "the ratio of artwork to landscape [has] this really beautiful rhythm to it, how scale shifts in this kind of magnificent way. . . . I wanted to create a piece that would sort of flip the sky into the Earth itself."[2] One of Sze's sculptures at Miro was also installed outdoors, and it, too, reflected the sky and held within it an ever-changing play of light and shadow.

A primary theme in Sze's art is the question of what differentiates today's era from past epochs. In a 2017 conversation with Enwezor and the artist Julie Mehretu (see pl. 88) on the occasion of Sze's exhibition at Munich's Haus der Kunst, Sze reflected on the topic, arriving at what might be read as a call to action:

> Without undermining the importance of the current state of politics, two answers that immediately come to mind are: advances in artificial intelligence and genetic engineering. We have the instructions to self. We are beginning to have the scientific knowledge and tools to create and curate a living human being—as well as a computer that can potentially destroy it. Never before has this been the case in the history of the world. And yet, the problems these new developments present ultimately lead us back to the humanities, to the re-examination of basic definitions of suffering, difference, empathy, and creativity. All critical definitions that somehow connect us back to the arts. To me, agency is deeply rooted in the arts.[3]

LOB

1. Sarah Sze, "Okwui Enwezor in Conversation with Sarah Sze," in *Sarah Sze*, by Okwui Enwezor, Benjamin H. D. Buchloh, and Laura Hoptman (London: Phaidon, 2016), 26.
2. Sarah Sze, "Sarah Sze Commission: 'Fallen Sky,'" Storm King Art Center, New Windsor, NY, February 20, 2020, Vimeo video, 1:40, https://vimeo.com/392714792.
3. Sarah Sze, "A Conversation between Sarah Sze, Okwui Enwezor, and Julie Mehretu," in *Sarah Sze: Centrifuge*, ed. Okwui Enwezor (Cologne: Walther König, 2018), 114.

87. *Crisscross*, 2021
Oil, acrylic, acrylic polymer, and ink on composite aluminum panel, with wood support
9 ft. 6 in. × 11 ft. 10½ in. × 3⅛ in. (289.6 × 362 × 7.9 cm)

Julie Mehretu

Born Addis Ababa, Ethiopia, 1970

Drawing on diverse references—literature, architecture, activism, music, calligraphy, and art history, from prehistoric to contemporary times—Julie Mehretu's work across canvas, paper, and print addresses pressing social and political concerns. Raised in Michigan, the artist graduated from Kalamazoo College in 1992 and the Rhode Island School of Design in 1997, with an MFA in painting and printmaking. Her spectacular rise to fame began in the early 2000s, following her arrival in New York. Seeking to explore her interest in mapping—a nod, perhaps, to the work of her father, the geographer Assefa Mehretu—she began a series of paintings based on cartographic source material, conceived as an attempt to "make sense of who I was in my time and space and political environment."[1]

To produce what she termed her "story maps of no location," Mehretu collated found architectural diagrams, infrastructure blueprints, and archival images of public buildings and urban landmarks.[2] Next, she transferred elements of these documents to canvas—typically, by projecting them onto the surface, atop a background of faintly visible lines resembling wireframe drawings, and then tracing them—before applying and sanding down a clear silica-and-acrylic solution to create a smooth new exterior. She repeated this process several times, infusing each layer with fragmented geometric shapes and gestural marks made in ink and acrylic. Despite their debt to cartography, the works in this series refuse easy decoding and reject the notion of a magisterial aerial position or a consistent scale. Instead, they offer a multiplicity of fractured viewpoints that shift with the viewer's movement.

Over the intervening years, Mehretu's work has expanded in scale. Her source material has also been increasingly shaped by politics. Time spent in Berlin on an artist's residency in 2007 partly inspired a body of gray-toned paintings that explore the psychogeography of place, while the Arab Spring uprisings of the early 2010s provoked works that grapple with notions of geopolitical tension, social unrest, and military power. Mehretu has also made use of photographs from the mass media that document subjects including the 2017 fire at Grenfell Tower, part of a public housing complex in North Kensington, London; Black Lives Matter protests; and climate-change-induced California wildfires. As she remarks, "I work with images that haunt me, they nag at my core."[3]

Recent work has also seen an increasing investment in digital manipulation. Mehretu begins this process by using Adobe Photoshop software to crop, scale, and blur the media images she selects. Speaking of the importance of this technique, she has said, "In these blurs, I felt apparitions; ghosts

of the moment represented in the photograph. . . . I am fascinated with the blur, with the loss of focus, with how much of these images still comes through."[4] Once she is satisfied with her editing, Mehretu projects the imagery onto a canvas and traces it, or airbrushes it on with the guidance of a grid, square by square. This serves as a ground that she builds up with further airbrushing, screen printing, and brushstrokes of acrylic paint and ink in a labor-intensive process of layering and erasure: "I'll do a whole bunch of marks, and then I'll take away all the ones that I feel are too self-conscious or just don't feel right. So there's selection, and dismissal or erasure, and then conjuring again."[5] *Among the Multitude VI*—the sixth in a suite of works under the same title—was made in this way. Executed with jagged black marks over a blood-red and sea-blue airbrushed ground, it continues Mehretu's engagement with contemporary political crisis, drawing on images documenting migrant detention centers at U.S. borders and the violence of far-right anti-immigration protests.

While some painters use drawing as a preparatory tool, for Mehretu it remains what she has called "the most fundamental and primary element of my work."[6] Its importance as a forum for creative exploration can be seen in another work in the Shah Garg Collection, *Mind-Wind Fusion Drawings #1* (see p. 109), in which gestural, calligraphic strokes of black ink evoke swirling air currents and the cathartic release of doodling. Here and elsewhere, Mehretu has made a fundamental commitment to the possibilities of abstraction, which she views as "a place for radical thinking and for radical imagining."[7]

HJ

1. Julie Mehretu, quoted in Christine Y. Kim, "Julie Mehretu (A Chronology in Four Parts): On the Mark, 1996–2000," in *Julie Mehretu*, ed. Christine Y. Kim and Rujeko Hockley, exh. cat. (New York: Whitney Museum of American Art; Munich: DelMonico Books/Prestel, 2019), 57.
2. Julie Mehretu, quoted in Catherine de Zegher, *Julie Mehretu: Drawings* (New York: Rizzoli, 2007), 13.
3. Julie Mehretu, "Julie Mehretu: The Mark of an Artist," interview by Mark Benjamin, *Rain*, no. 7 (Winter/Spring 2020): 28.
4. Julie Mehretu, quoted in Christine Y. Kim, "Julie Mehretu (A Chronology in Four Parts): Disaster and Disembodiment, 2016 to the Present," in Kim and Hockley, *Mehretu*, 73.
5. Julie Mehretu, quoted in Ted Loos, "Legend of the Wall," *WSJ.: The Wall Street Journal Magazine*, October 2019, 62.
6. Mehretu, quoted in Kim, "Mehretu (A Chronology in Four Parts): On the Mark," 56.
7. Julie Mehretu, quoted in Maximilíano Durón, "How Julie Mehretu Creates Her Deeply Layered Abstractions Referencing Today's Most Pressing Issues," *ARTnews*, June 1, 2021, https://www.artnews.com/art-news/artists/julie-mehretu-artist-studio-visit-1234594422/.

88. *Among the Multitude VI*, 2020–22
Ink and acrylic on canvas
48 × 60 in. (121.9 × 152.4 cm)
Promised Gift to the Studio Museum in Harlem, New York

Laura Owens

Born Euclid, Ohio, 1970

Born in the Midwest and based in Los Angeles, Laura Owens trained at the Rhode Island School of Design and California Institute of the Arts (CalArts). Despite emerging at a time when abstract painting was largely discouraged, the artist remained dedicated to exploring its possibilities as she rose to prominence during the 1990s. Her celebrated paintings pose a defiant challenge to traditional distinctions between figuration and abstraction, "fine" and "decorative" art, and "high" and "low" culture.

Owens's work has long been characterized by an idiosyncratic and inclusive approach to source material. Art-historical references to Henri Matisse, color-field painting, and Japanese folding screens appear alongside visual quotations from folk art, children's coloring books, tapestries, wallpaper, clip art, and her grandmother Eileen Owens's embroidery. Other influences include the work of role models such as the abstract artist Mary Heilmann (see pl. 33) as well as materials found in her own daily life. While Owens's allusions to the everyday are often subtle, at times she physically affixes an actual object to the surface of the canvas, as with the bicycle wheel in *Untitled*. The artist's deliberate conflation of the elevated and the quotidian counters the heroism of the Abstract Expressionist legacy, challenging conventional notions of taste and reinforcing painting's contemporary relevance.

Owens's practice incorporates a variety of media and techniques, usually simultaneously, and her paintings possess multilayered surfaces whose coolness conceals a complex fabrication process. Sometimes, she begins a work with painted abstract marks or a freehand drawing, but often, she makes use of source material—in this case, a piece of her grandmother's embroidery—which she scans and then manipulates on the computer. The imagery finds its way to canvas by any number of methods, including screen-printing, stenciling, and tracing a projection. While the artist began using painting software in the early 1990s to, as she describes it, "get through choices that I'd have to make in the painting with color," she has come to see the process of layering that it facilitates as "an extension of printmaking."[1]

In *Untitled*, the curves of the bulbous shapes that sweep across the canvas are recognizable as those generated by an image-editing program, which allows the user to select a brush shape and alter its thickness to create marks and erasures.

Here, some of the shapes are packed with colored "pixels" of Flashe-brand vinyl paint that the artist screen-printed directly onto the dyed linen support; others are traversed by an enlarged lattice pattern created by a stencil, which she first filled with several coats of gesso and then with a CMYK (four-color) halftone image, in screen-printing ink. In some works, all this trickery is heightened by trompe-l'oeil drop shadows added by the artist, which mimic the real shadows cast by collaged objects—such as the bicycle wheel here, with its actual shadow. "I really want paintings to be problems," Owens has said. "What interests me in painting is that it comes out into the room, almost punches you in the face."[2]

Untitled was first exhibited at Sadie Coles HQ, London, as part of the artist's solo exhibition there in the fall of 2016. To accompany the exhibition, Owens produced a website, why11.com, which featured a drop-down menu from which viewers could select individually numbered paintings. Each time they selected a painting, an audio clip was played, either in the artist's or in a computerized voice. Multiple clips were assigned to each piece. In one of the clips for the Shah Garg Collection work, Owens described the complexity of the pattern and the labor involved in "unmasking all the vinyl." In another, a computerized voice listed some of the "unique colors" fabricated for the painting, including "moldy green," "muddy baby blue," and "pea soup." Further clips explained that the work incorporates imagery from a painting by the Spanish artist Juan Gris (1887–1927) and took seventy-two hours to complete.[3] Just as the website juxtaposed varying audio clips for the same painting, Owens layers her canvases in often jarring ways. Equal weight is given to each mark on the canvas, regardless of its source and method of production, offering up, in the artist's words, "more chances to level these hierarchies and talk about heterogeneity".[4] HJ

1. Laura Owens, "Laura Owens: A Mid-Career Interview," by Paul Laster, *CFArts*, March 14, 2020, https://www.conceptualfinearts.com/cfa/2017/11/21/laura-owens/.
2. Laura Owens, "Still Lifing: Conversation with Laura Owens," by Stephen Berens and Jan Tumlir, *X-Tra* 16, no. 2 (Winter 2014), https://www.x-traonline.org/article/still-li%EF%AC%81ng-conversation-with-laura-owens.
3. The website was still accessible at the time of this writing at http://why11.com/. *Untitled*, in the Shah Garg Collection, is "Painting 127."
4. Owens, "Still Lifing."

89. *Untitled*, 2016
Vinyl paint, screen-printing ink, and bicycle wheel on dyed linen
9 × 7 ft. (274.3 × 213.4 cm)

Carol Bove

Born Geneva, Switzerland, 1971

Raised in Berkeley, California, and trained at New York University, the Swiss-born American artist Carol Bove first gained public attention in the middle of the first decade of the 2000s with a body of work that explored her interest in the social, cultural, and political contexts of the 1960s and 1970s. Carefully selected books and magazines from the period were arranged alongside photographic elements and found objects, such as peacock feathers and stones, to make intimate assemblages. The artist's use of wall-mounted shelves and modernist furniture, including tables by the celebrated American design firm Knoll, as supports for these compositions demonstrated her interest in strategies of framing and display.

Over the next few years, Bove expanded her material repertoire, continuing to explore modes of display, excavate cultural history, and challenge the possibilities of formal abstraction. Works incorporating driftwood, seashells, and other items that she scavenged from the waterfront near her studio in Red Hook, Brooklyn, and elegantly suspended from wire armatures sat alongside pieces made from petrified wood or rusted I-beams, sourced from local junkyards. A shiny, cylindrically looping metal form that the artist calls a "glyph" also appeared around this time. By the mid-2010s, however, Bove was exploring industrial materials on a greater scale. Evoking the language of public sculpture by artists such as Anthony Caro, John Chamberlain, and Mark di Suvero, she embarked upon a body of large, often outdoor works that she refers to as "collage sculptures."

To create these works, Bove combines different types of steel. First, she bends six-inch-square tubing with a custom-made hydraulic press—subjecting the metal to several tons of force—before pulling it into configuration with a chain-hoist system. Other tools are used to dent and crush the steel, and in some works, the tubing is welded or bolted to pieces of found metal. Bove does not use preparatory drawings or models, instead working intuitively in space. Speaking of her process, she has explained, "It's very improvisational, and I respond to what the sculpture wants to do. Sometimes I have more of a preconceived idea of where I want it to go, but I try to be playful and spontaneous and not too attached to my ideas."[1] Despite their allusive titles, most of the works are abstract.

Once her compositions are finalized, Bove paints them in a matte finish. Her colors often reference outdated print technologies, ideas of digital distortion, and the work of other artists, such as Willem de Kooning (1904–1997), from whose painting *Woman and Bicycle* (1952–53; Whitney Museum of American Art, New York) she draws many of her hues. Other colors allude to the corporeal: the pink she has used in a number of works—*The Chevaliers* included—emphasizes their limb-like contortions. "That pink makes me think of [the British artist] Sarah Lucas [born 1962]," she has said. "It's fleshy, like pantyhose."[2] A number of Bove's recent "collage sculptures" are punctuated by glossy, black-lacquered disks—as also seen here—which the artist refers to as "polka dots."

In spite of the rigidity of steel, Bove's process of manipulation and the matte finishes she applies to her "collage sculptures" give them a delicate quality, strangely evocative of the softness and pliability of clay or fabric. As the artist has reflected, "We think stainless steel is hard and strong, and I'm wondering if this is really the case. Is there a gentle and persistent way to act on it so that it will behave differently? Can it be tricked into showing a different side?"[3] Despite its force, Bove's method is a sensitive one, balancing her will to "act on the material" with her deep understanding of its physical limitations.[4] "I never force the material to do something it doesn't want to do," she says. "I let it lead me as much as I lead it."[5] Fundamentally, her work is an exploration of the physical and aesthetic potential of a substance: "a story," as the artist has described it, "of movement and pressure, force and softness."[6]

HJ

1. Carol Bove, "Dimensions: Carol Bove in Conversation with Johanna Burton," in *Carol Bove: Ten Hours*, exh. cat. (New York: David Zwirner Books, 2019), 44.
2. Carol Bove, quoted in Caroline Roux, "Carol Bove on Crushing, Crashing and Twisting Heavy Metal into Better Shape," *Wallpaper*, May 31, 2018, https://www.wallpaper.com/art/carol-bove-profile-brooklyn-artist-studio.
3. Bove, "Dimensions," 42.
4. Ibid., 41.
5. Ibid., 42.
6. Bove, quoted in Roux, "Bove on Crushing."

90. *The Chevaliers*, 2021
Urethane paint on stainless steel
59 × 55 × 45 in. (149.9 × 139.7 × 114.3 cm)

Ulrike Müller

Born Brixlegg, Austria, 1971

From writing to video, performance to publishing, and through a spectrum of media—drawing, jewelry, enameling, rug making, and more—all of which stem from her long-term painting practice, Ulrike Müller makes art that speaks fluidly to different audiences and, at times, incorporates collaboration and exchange. After studying in Vienna at the Akademie der Bildenden Künste Wien, Müller moved to New York and took part in the Whitney Museum of American Art's Independent Study Program in 2003 and P.S.1's International Studio Program in 2004. From 2005 to 2008, along with her fellow artists K8 Hardy, Ginger Brooks Takahashi, and Every Ocean Hughes (formerly Emily Roysdon), Müller coedited the queer, feminist journal *LTTR*, which strove to update 1970s-era feminism through an explosion of forms of expression. In another collaborative rethinking of the archive, Müller invited one hundred artists to translate individual image descriptions from an inventory of feminist T-shirts she found in the Lesbian Herstory Archives in the Park Slope neighborhood of Brooklyn into drawings. The result, *Herstory Inventory: 100 Feminist Drawings by 100 Artists*, debuted in 2012 at Austria's Kunsthaus Bregenz and then traveled to New York for a reconfiguration at the Brooklyn Museum. Originally from the Tyrol region of Austria, Müller represented that country at the 12th Cairo Biennial in 2010 with an exhibition of enamel paintings and quilts.

In much of her work, Müller critically examines form, exploring relationships between abstraction and the body. The geometries in her compositions are never entirely abstract, nor can they be deemed properly figurative. In a catalogue published in 2016 on the occasion of two exhibitions at the Museum Moderner Kunst (mumok) in Vienna, one of her own works and one in which she and her co-curator, Manuela Ammer, rehung modernist works from mumok's collection in revelatory new ways (highlighting, among other Austrian artists, the renegade Surrealist Wolfgang Paalen [1905–1959]), Ammer noted Müller's desire to create a "matrix-like vocabulary whose employment is intended to decouple corporeality from what is posited as natural."[1] This is perhaps most evident in her enamel-on-steel paintings, a body of work begun in 2010; these precise arrangements of flat, suggestive shapes are subtly revisionist, allowing the artist to reconsider the histories of both art and feminism. Indeed, Müller's conception of painting is one that moves beyond the brush and the canvas: the works, intentionally intimate in scale, are refined slowly by hand through a meticulous, step-by-step process that culminates in a red-hot kiln.

In her ongoing *Sequitur* series, begun in 2020, Müller explores the possibilities offered by the limited palette of industrially made, commercially available glass frit and the ways in which color and shape can express ideas of representation. As she told an interviewer in 2019, "Picking colors from a preformulated palette introduces a culturally shared element—a language with built-in ideas and assumptions, like the six or eight colors that kids are given in a box of crayons. They're supposed to be enough to depict the world."[2] She typically works on several of these pieces at a time—the forms and hues arrive to her via colored-pencil drawings on paper, which she then translates into compositions of opaque, vitreous enamel fused at high temperature on steel backings. In this series, as in others, shapes and silhouettes negotiate a central vertical axis.

These works often carry erotic associations—forms touch, rub up against, and meld with one another—but they never portray a sense of hierarchy or binary logic. Müller's repetitious forms on hard, reflective surfaces create a sense of continuity. As she has said, "I always try to repurpose my motifs, by mirroring them, inverting their color, changing their scale, or cutting them up. When I am working on a new group of enamels, I often return to earlier groups and see if I can carry something over in a meaningful way."[3] — LOB

1. Manuela Ammer, "Go, Figure," in *Always, Always, Others*, by Ulrike Müller and Manuela Ammer, exh. cat. (Brooklyn, NY: Dancing Foxes; Vienna: Museum Moderner Kunst (mumok), 2016), 69.
2. Ulrike Müller, "In the Studio: Ulrike Müller," interview by Steel Stillman, *Art in America*, November 2019, 91, https://www.artnews.com/art-in-america/interviews/ulrike-muller-interview-enamel-painting-humiliation-63667/.
3. Ibid.

91. *Sequitur*, 2020
Vitreous enamel on steel
15½ × 12 in. (39.4 × 30.5 cm)

Shinique Smith

Born Baltimore 1971

Following her undergraduate studies at Baltimore's Maryland Institute College of Art, Shinique Smith founded an African American film festival in Seattle, earned a master's degree in teaching, and taught high school in Boston before returning to MICA's interdisciplinary Mount Royal School of Art for an MFA, which she completed in 2003. Toward the end of this period, she began to gravitate away from the figurative style in which she had been trained. Today, Smith works across painting, sculpture, collage, and installation and is best known for her gestural abstract paintings and her assemblages of densely packed fabric, both of which dramatize what she terms "the graceful and spiritual qualities of the written word and the everyday."[1]

Influenced by the unsanctioned murals that surrounded her while she was growing up in Baltimore, Smith spent some time in the mid-1980s as a member of the graffiti group TWC (The Welfare Crew). While this early practice as a tagger undoubtedly fostered her enthusiasm for spontaneous visual expression, it was her study of Japanese language and calligraphy—which she found similarly fluid—during graduate school that would prove most foundational. As the artist has explained, her painterly practice begins with the written word: "There has to be a confidence and a letting go that takes place to make the mark, and it starts with words. It starts with phrases and bits of song lyrics, and it's like your signature."[2] Once she is ready to commit pen to paper, so to speak, she builds her compositions through a process of layering. Partial words, letterforms, and purely gestural marks in ink and acrylic are laid over and against fabric swatches, patterned paper, and collaged fragments of calligraphy. In *Always and Everywhere*, these affixed elements form the core of a centrifugal composition of swirling, gestural brushstrokes rooted to the canvas with strands of yarn.

In 2002, an article by George Packer in the *New York Times Magazine* propelled Smith toward a new sculptural language.[3] As the artist recalls, "The article described the journey of a single T-shirt from a woman on the Upper East Side to the African man who bought it. The idea of the transference of the shirt across the Atlantic was really attractive to me."[4] Intrigued by this global trade in used clothing, Smith began to crumple and stack fabric and bind it together into tight bales with colored lengths of cord and ribbon. In addition to materials gathered from the backs of friends' closets, giveaway bins, and Goodwill stores, she also began to integrate personal items, such as her grandmother's linens, and found items, including plastic toys and flattened metal cans, into the works, which comment on consumption, excess, and waste. In her selection of materials, Smith is drawn to those with a prior purpose: "I first collect and employ items people once consumed and cherished as *belongings*, for the aesthetic and social references they express. The values society places on the garments especially—such as striving for success and a sense of belonging—are intriguingly human and endear them to me."[5] Rather than using tools or machine processes, Smith knots her sculptures together by hand. Her artful process of fabric manipulation—which she has characterized as "meditative and ritualistic"—reflects her familiarity with ancient, sacred traditions of wrapping and bundling as well as the influence of her mother, Vkara Phifer-Smith, a fashion editor and clothing designer.[6]

By the mid-2000s, Smith's bales were transforming into increasingly organic and bodily forms. Some works combine fabric assemblages with calligraphic paper cutouts cascading from walls, while others conjure immersive environments. Most recently, Smith has transformed herself into a sculptural object, enacting performances that combine the binding of her own body in fabric, head to toe, with rhythmic breathing, executed by herself and companions. Drawing parallels between her painting and sculpture practices, and continuing to champion the written word, Smith has described her work as an act of binding: "Calligraphy—that line, the linear nature of it—binds together things on the surface of a painting the way ribbon binds together the fabrics and objects in a sculpture."[7] HJ

1. Shinique Smith, "About," *Shinique Smith: Artworks and Projects* (artist's website), accessed February 28, 2022, https://www.shiniquesmith.com/about.
2. Shinique Smith, "Shinique Smith on Japanese Calligraphy and Street Art," UBS Art, December 8, 2019, Facebook video, 1:00, https://www.facebook.com/UBSart/videos/artist-shinique-smith-on-japanese-calligraphy-and-street-art/1746668348803665/.
3. George Packer, "How Susie Bayer's T-Shirt Ended Up on Yusuf Mama's Back," *New York Times Magazine*, March 31, 2002, https://www.nytimes.com/2002/03/31/magazine/how-susie-bayer-s-t-shirt-ended-up-on-yusuf-mama-s-back.html.
4. Shinique Smith, quoted in Barbara Pollack, "Clothes Connections," *ARTnews* 109, no. 1 (January 2010): 78.
5. Shinique Smith, quoted in "On Skins," *Metropolis Magazine*, September 2020, 128.
6. Shinique Smith, quoted in Paul D. Miller, "Shinique Smith: Body Mind Ballet and the Legible City," in *Shinique Smith: Menagerie*, by Bonnie Clearwater, Paul D. Miller, and Jane Simon, exh. cat. (North Miami, FL: Museum of Contemporary Art North Miami; Madison, WI: Madison Museum of Contemporary Art, 2010), 10.
7. Shinique Smith, quoted in Deborah Vankin, "Shinique Smith's 'Refuge' Explores Shelter, Homelessness and the Excess of Our Stuff," *Los Angeles Times*, June 13, 2018, https://www.latimes.com/entertainment/arts/la-ca-cm-shinique-smith-caam-20180613-story.html.

92. *Always and Everywhere*, 2013
Ink, acrylic, fabric, yarn, and paper on canvas over wood panel
60⅛ × 60⅛ in. (152.7 × 152.7 cm)

Haegue Yang

Born Seoul 1971

The Berlin- and Seoul-based artist Haegue Yang is currently a professor of fine arts at the Hochschule für Bildende Künste–Städelschule in Frankfurt, from which she received her MFA in 1999 (her BFA, from Seoul National University, had come five years before, in 1994). In 2018, Yang received the Wolfgang Hahn Prize, awarded every year by the Gesellschaft für Moderne Kunst/Museum Ludwig in Cologne. A breakthrough moment in her career occurred in 2009, when she represented South Korea at the 53rd Venice Biennale; she was the first woman ever to show in the country's pavilion.

By that time, the artist had become well known for the creative use of venetian blinds in her work, playing on the fact that in everyday life, these window treatments have multiple, inherently contradictory functions: they impede unwanted views in, but also allow for discrete peeks out; they let in light, but they also block it. Yang's large-scale sculpture *Sol LeWitt Upside Down—Structure with Three Towers, Expanded 23 Times, Split in Three* (2015; Tate, London), based on a 1986 work (*Structure with Three Towers*) by the prominent male conceptual artist Sol LeWitt (1928–2007), is made from more than five hundred blinds hanging from an apparatus near the ceiling; the blinds constitute the faces of cubic forms akin to LeWitt's stacked, outlined volumes. "With each new exploration of the blinds as a material the artist reveals their ability to serve as permeable boundaries between inside and outside, light and darkness, visibility and invisibility, revelation and concealment, individual and community, public and private," the curator Adelina Vlas recently noted. "At the same time, their porousness as architectural partitions allows these installations to become sites of sensorial emergence."[1]

As an international artist who has spent much of her life away from her homeland, Yang has a specific interest in migration and diaspora and draws inspiration from a range of cultures. Instead of considering one at a time, however, she incorporates multiple cultural references into a single work. *Quasi-Pagan Minimal*, Yang's second solo exhibition at the New York gallery Greene Naftali, held in 2016, consisted of sculptures and works on paper that merged industrial fabrication and traditional craft to examine intersections between the modern and the folkloric. In a side room with bright blue walls, Yang installed several pieces from her *Trustworthy* series, which she initiated in 2010. In these exacting geometric assemblages, the artist creates collages from graph paper, origami paper, and the insides of security envelopes—culled from friends and associates around the world—and hangs them in a manner that interacts with patterns she has cut from vinyl film and adhered directly to the gallery walls. *Masked Eyes—Trustworthy #277*, a mural featuring golden concentric circles and a single wavy line as well as five framed collages, recalls the work of visionary artists such as Hilma af Klint (1862–1944). Yang's intriguing installation at Greene Naftali transformed the space, which was galvanized by the mystical compositions and a dynamic sense of movement invoked through the artist's fluid forms and vivid colors.

Over the past few years, Yang's work has developed a more performative dimension, incorporating complicated arrays of movable objects (of course, the theme of mobility has long been explicit in her oeuvre). The bell-covered sculptures on casters in *Handles*, the artist's 2019 commission for the atrium of New York's Museum of Modern Art, appeared saturated with potential vitality even when still; that potential was activated when trained performers, at scheduled times, set them in motion by wheeling them around in ever-shifting choreographies.

As Yang has emphasized, art should "resist the conventional idea of possessing a common thread or summary in the sense of an understandable message."[2] Abstraction is the primary way she expresses this core idea. In the artist's estimation, this approach empowers viewers: first, they are drawn to her work, be it an installation of venetian blinds or a collection of sculptures; and then, this curiosity grants them the autonomy to freely navigate around the elements she has provided and appreciate abstraction's endless potential. LOB

1. Adelina Vlas, "From One to Many: Emergence in the Work of Haegue Yang," in *Haegue Yang: Emergence*, ed. Adelina Vlas and Haegue Yang, exh. cat. (Toronto: Art Gallery of Ontario; Munich: DelMonico Books/Prestel, 2021), 18.
2. Haegue Yang, "Haegue Yang Interview, Part Two," by Anna Dickie, *Ocula Magazine*, September 3, 2014, https://ocula .com/magazine/conversations/haegue-yang-part-ii/.

93. *Masked Eyes—Trustworthy #277*, 2016
Vinyl film and 5 framed collages consisting of security envelopes, graph paper, and origami paper on cardboard
Overall dimensions variable, each small framed collage 14¼ × 14¼ in. (36.2 × 36.2 cm), medium framed collage 28⅜ × 28⅜ in. (72.2 × 72.2 cm), each large framed collage 40½ × 40½ in. (102.2 × 102.2 cm)

Jennifer Guidi

Born Redondo Beach, California, 1972

The painter Jennifer Guidi, who lives and works in Los Angeles, received her BFA from Boston University in 1994 and her MFA from the School of the Art Institute of Chicago in 1998. In 2005, the LA gallery ACME staged her first solo exhibition, wherein she presented eleven small-scale oil paintings on linen depicting landscapes, plants, and insects. More recently, she has become known for her brilliantly colored, tactile abstract paintings as well as for the unique blend of sand and paint she has used from 2013 onward, beginning with the works that debuted in her solo show that year at the nonprofit cultural space LAXART, titled *Field Paintings*.

Guidi's compositions correspond directly to her personal experiences and insights. Regarding her move to working with sand, she has noted, "In the summer of 2013, as soon as I returned from my annual family vacation in Hanalei, Kauai, I began making solid sand paintings with marks from sticks that I had found on the beach. Those were my first abstract sand paintings."[1] The Shah Garg Collection's pink-orange-red example was originally presented at Art Basel in June 2018 and is one of her earliest triangular canvases. Its title likely references the artist's decisive 2012 trip to Marrakech, in which she became fascinated by the rich patterning of Moroccan rugs, specifically the intricate stitching found on their rarely seen undersides.

The organizing principle of each of Guidi's sand paintings is a central focal point, with dash-like marks expanding out toward the edges of the picture plane. Of this approach, she has observed, "I was facing a canvas as though it was a mirror and thought, 'What if I start where I feel my heart would be reflected?' I followed my intuition and made the first mark up and a little to the left. That was my center. This is when I felt that the work had a definite energy source, where it created a vibration moving in and out."[2] From that moment on, the repetition and movement of mark making have taken on a meditative aspect for the artist. In many cases, she builds up layers of sand, paint, and acrylic medium to achieve varying depths and then uses a wood dowel to carve out the radiating pattern of marks, each about the size of a large thumbprint. Elsewhere, as in *Marrakech Dreams (Painted Universe Mandala Triangle, SF #1T, Pink to Orange Gradient, Natural Ground)*, she creates the dashes in impasto, by additive rather than subtractive means.

While Guidi has been compared to 1930s painters of the American Southwest such as Georgia O'Keeffe and Marsden Hartley and to the Light and Space practitioners of 1960s California, her work finds more precise affinities with that of the twentieth-century colorists who embraced pattern and symbol to great effect, many of whom, like Guidi, maintained practices of both painting and drawing. For a brief six years, after Vasily Kandinsky (1866–1944) moved to France from Germany in 1933, he mixed his paint with sand, as did other Paris-based artists in the 1930s, including André Masson and Georges Braque. Another key precursor for Guidi is the visionary Swedish artist Hilma af Klint (1862–1944). Kandinsky is typically regarded as the pioneer of abstraction, yet af Klint predated him (as well as Kazimir Malevich and Piet Mondrian). Indeed, Guidi's works embrace both the divinely charged subject matter of af Klint's work and its stylistic diversity, employing maximalist and reductivist modalities in unison.[3] LOB

1. Jennifer Guidi, interview by Haley Mellin, *Garage Magazine*, no. 18 (February 29, 2020), https://garage.vice.com/en_us/article/g5xwaw/in-conversation-with-jennifer-guidi.
2. Guidi, interview by Mellin.
3. Lauren O'Neill-Butler, "Blood Moon," in *Jennifer Guidi: 11:11* (Los Angeles: David Kordansky Gallery, 2020), 6–11.

94. *Marrakech Dreams (Painted Universe Mandala Triangle, SF #1T, Pink to Orange Gradient, Natural Ground)*, 2018
Sand, acrylic, and oil on linen
65⅞ × 76 in. (167.3 × 193 cm)

Torkwase Dyson

Born Chicago 1973

I Am Everything That Will Save Me is a vast tondo consisting of a wood substrate covered in sheer washes and densely packed strokes of graphite. A black triangular form, truncated at the top and bordered by string, establishes a rigid outline in what might be considered the foreground of the composition. Beneath the triangle is a black semicircle, also cut off slightly at the ends in a manner that creates two much smaller gray triangles. A thin steel strip has been used to bisect the entire circle down the center, adding to the number of geometric elements that are manifested in the painting as a whole. An initial iteration of this work was included by the American artist Torkwase Dyson in her *Bird and Lava* series (a group of drawings and animations begun in 2020 during a residency at the Wexner Center for the Arts in Columbus, Ohio), which embodied her ongoing pursuit of geometric abstraction as a device for examining the politics of space and embodied experiences. Specifically, Dyson, who describes herself as a painter working across multiple media, engages long-standing strategies of Black spatial freedom, thinking about solutions for livable futures within our built and natural environments.

The curvilinear, rectangular, and trapezoidal forms that govern the artist's output are a unique geometric language she calls "hyper shapes." The forms are inspired by built environments used as hideouts by enslaved people, including Henry "Box" Brown (ca. 1815–1897), Anthony Burns (1834–1862), and Harriet Jacobs (1813–1897), on their paths to liberation. "Each human here manipulated and moved through infrastructures of state-sanctioned domination by converting enslavement into a system of structural confinement and clandestine geographic movement," Dyson says. "I've culled a geometric shape language from histories of Black liberation strategies to develop a system/structure/scaffolding of self-expression."[1] Although the artist's practice is diverse, ranging from layered acrylic paintings and glass sculptures to graphite-and-pen drawings, her works are closely related through their sleek angularity and reliance on an intensely black coloration.

Ideas of the corporeal also inform Dyson's practice. As a painting that moves toward a "direct sensorial experience," as Dyson puts it, *I Am Everything That Will Save Me* amalgamates her Zen Buddhist practice with African ancestral prayers.[2] Sensations felt by the body, particularly in relation to elements of water, architecture, and infrastructure, have long occupied the artist, who was born in Chicago and resides in Upstate New York. In 2013, she became certified as an open-water diver to have a relational experience with all three: "Through diving, I have been able to have an embodied experience with water. I don't think I could have gotten to where I am—to think about space and scale the way I think about them now—without such an intimate connection with water."[3] The monumentally scaled, semicircular works featured in the exhibition *Liquid A Place*, at London's Pace Gallery in 2021, were informed by the notion that water can retain an imprint or "memory" of substances with which it has come into contact, which Dyson has related to oil extraction zones, capitalism's superhighway, and the Middle Passage—the route taken by enslaved Africans across the Atlantic Ocean.

Similarly, water and infrastructure were central themes of the artist's 2019 exhibition at Columbia University's Arthur Ross Architecture Gallery, *1919: Black Water*, which examined how Black people use space creatively for liberation. The artist was inspired by the story of Eugene Williams (1902–1919), a Chicago teenager who, one summer day in 1919, built a raft out of driftwood and rope with some friends and took it onto Lake Michigan. Thinking of the raft as ephemeral urban architecture on water, Dyson produced a series of circular paintings exploring ideas of scale, weight, liquidity, and materiality. Unfortunately, while the boys were playing, the raft floated past the Black-only beach toward a segregated White beach. In this liminal space, a lone older White man threw a rock at Williams, which led to his death. The violent act sparked a weeklong riot, but Dyson's focus was on the skill and improvisation of the young men in constructing the raft, which spoke to her working theory of "Black compositional thought."[4] The resulting impenetrable compositions, like *I Am Everything That Will Save Me*, invited a haptic response, gesturing to the depth and breadth of natural elements. AB

1. Torkwase Dyson, artist's statement for the exhibition *Studies for Bird and Lava*, Pace Gallery, East Hampton, NY, exh. on view August 1–9, 2020, accessed August 15, 2020, https://www.pacegallery.com/exhibitions/torkwase -dyson-studies-for-bird-and-lava/.
2. Torkwase Dyson, email message to the author, May 2022.
3. Torkwase Dyson, quoted in Angela M. H. Schuster, "Torkwase Dyson Got Certified as an Open-Water Diver to Get Closer to Her Subject," *Avenue*, October 6, 2020, https://avenuemagazine.com/torkwase-dyson-studio-visit -artist-profile/.
4. Torkwase Dyson, quoted in press release for *Torkwase Dyson: Black Compositional Thought (15 Paintings for the Plantationocene)*, New Orleans Museum of Art (website), January 27, 2020, https://noma.org/torkwase-dyson -black-compositional-thought-15-paintings-for-the -plantationocene/.

95. *I Am Everything That Will Save Me*, 2021
Graphite on wood, with steel and string
Diameter 96 in. (243.8 cm), depth 7 in. (17.9 cm)

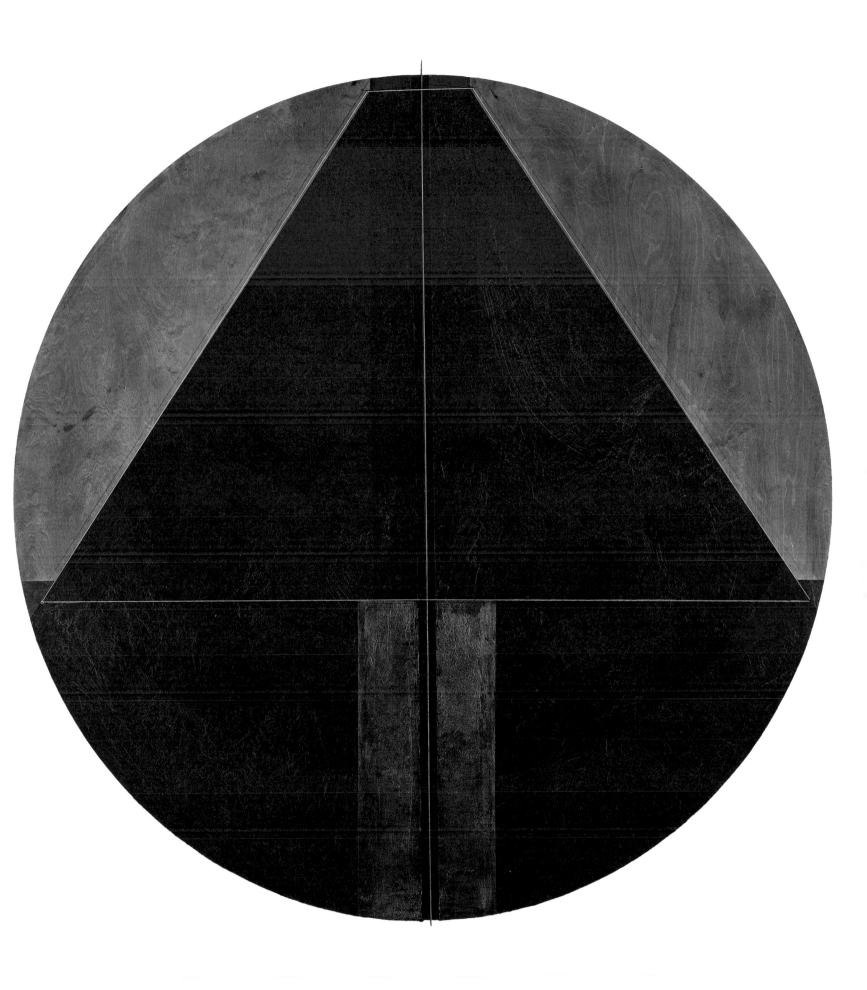

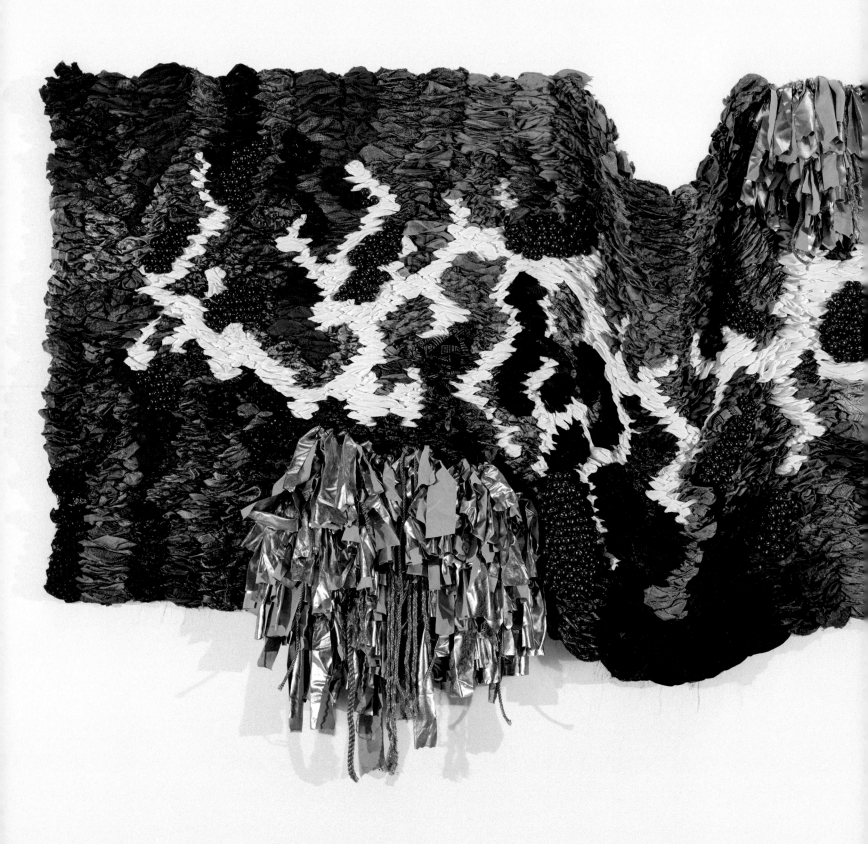

Suchitra Mattai

Born Georgetown, Guyana, 1973

Based in Denver, Suchitra Mattai is a multi-disciplinary artist who has lived in Canada, the United States, India, and Europe. Her studio practice often addresses a personal sense of disorientation and rootlessness—a feeling that informs much of her thinking about identity and representation. "I believe that we all are global citizens," she says. "And as a global citizen, it's important to be aware of what's happening outside of our comfort zones and communities. The more informed I am politically and socially, the more complex and rich my own practice can be."[1] Mattai primarily creates abstract, multimedia sculptures and installations into which she incorporates diverse found and handmade objects. Sometimes, figurative elements appear in her work via painting. For the artist, the cohabitation of various materials and techniques represents an ideal democratic plurality of culture and community.

Mattai received an MA in South Asian art and an MFA in painting and drawing from the University of Pennsylvania in 2001 and 2003, respectively. Blending traditional art media with the rigor of craft, derisively called "women's work"—she learned sewing, embroidery, and crocheting from her grandmother—Mattai's art probes resonant intersections between colonialism, labor, and gender in the past and the present. When an interviewer asked if her work is feminist, she responded:

> Yes, my work is feminist. I grew up crocheting, sewing, etc. I bring those practices into my work to honor them as "art-making." In many of the works in my show, "Calypso Queen" and "Caribbean Queen" in particular, I integrate these practices. The women in the works control what is revealed and what is concealed from the viewer. They return the gaze through traditionally domestic practices like embroidery and fight the invisibility that so many people of color feel.[2]

Regarding this historical marginalization, Mattai has stated, "My primary pursuit is to give voice to people whose voices were once quieted. Using both my own family's ocean migrations and research on the period of colonial indentured labor during the nineteenth century, I seek to expand our sense of 'history.'"[3] The artist achieves this goal by employing found components in her pieces that are rich with entrenched meanings, such as vintage saris and the *ghungroo* bells that are worn in classical Indian dance. She uses such items to empower women of the South Asian diaspora, including herself, and to connect them to one another: "Combining, recontextualizing, and reconfiguring disparate materials is a way of making sense of the world around me and of reconciling multiple cultural spheres that I inhabit as an Indo-Caribbean woman."[4]

Through her mixed-media approach, Mattai demonstrates how artists (and perhaps their audiences) can attempt to disentangle the encumbrances of the past and work toward reimagining long-established schemas. Often, there is a sense of displacement in her art, between reality and what feels more like a dream. The uncanny feeling prompted by *A mended heart, a lightened soul*, for example, is that of a utopian yet fragmentary world. Saris in a rainbow of hues are compressed into tight bunches and organized by color, while clusters of *ghungroo* bells punctuate the composition, which is rectangular but with a substantial dip or sag just right of center. Emitting a warm positivity and hopefulness, the work underscores Mattai's unraveling and reweaving of both historical narratives and the physical materials associated with her ancestry. Moreover, throughout her art, she embraces the skills of editing and revision, even comparing her vocation to that of a writer. As the artist has pointed out, "Rewriting this colonial history contributes to contemporary dialogue by making visible the struggles and perseverance of those who lived it."[5]

LOB

1. Suchitra Mattai, quoted in Joshua Ware, "Studio Visit: Suchitra Mattai," *Southwest Contemporary*, no. 4 (Winter 2021), https://southwestcontemporary.com/studio-visit-suchitra-mattai/.
2. Suchitra Mattai, "Artist Suchitra Mattai's Latest Exhibit Takes a Hard Look at a Difficult Year, and Envisions a Path Forward," interview by Ray Mark Rinaldi, *Denver Post*, July 28, 2020, https://www.denverpost.com/2020/07/28/artist-suchitra-mattais-latest-exhibit-takes-a-hard-look-at-a-difficult-year-and-envisions-a-path-forward/.
3. Suchitra Mattai, "Statement," artist's website, accessed February 7, 2022, https://suchitramattaiart.com/biostatement.
4. Ibid.
5. Ibid.

96. *A mended heart, a lightened soul*, 2021
Vintage saris, gold polyester lamé and cord, fabric, and metal bells
60 × 100 × 3½ in. (152.4 × 254 × 8.9 cm)

Billie Zangewa

Born Blantyre, Malawi, 1973

The Johannesburg-based artist Billie Zangewa creates intricate textile collages that document her everyday experiences. Fragments of raw silk are her primary material, which she hand-stitches together to depict habitual scenes of life at home, often related to her role as a parent, whether she is helping her son with his schoolwork at the kitchen table (*Heart of the Home*, 2020) or hosting a celebratory gathering (*Birthday Party*, 2020). Zangewa relates such narratives to duties that have historically been the responsibility of women, which she defines as "daily feminism"[1]: by placing herself at the center of what are deeply personal visual accounts, she seeks to dispel stereotypes related to the status of so-called women's work—emotional and physical labor that generates stability yet is invariably overlooked and undervalued. In tandem, the artist draws attention to the ways Black women are typically represented. "I realised at some point that black women are, and have always been, the most marginalised sector of our society," she says. "I realised that I had chosen to embody the most disempowered human form. . . . I had access to my body and understood the power [there] is in sharing the personal and revealing one's vulnerability."[2]

Following her graduation from Rhodes University in Makhanda (formerly Grahamstown), South Africa, where she studied graphics and printmaking and received a BFA in 1995, Zangewa began constructing embroideries on found fabrics that depicted verdant landscapes in Botswana, where she grew up. She then transitioned to making cityscapes of Johannesburg before turning to "things happening to me *in* the city, like failed relationships and being disappointed by lovers," and then, after the birth of her son, to themes of motherhood and home.[3] In 2020, for her debut solo exhibition at Lehmann Maupin, also her first in New York, Zangewa showed silk collages that reflected on the experience of living and working in isolation during the COVID-19 pandemic. Addressing the monotony of day-to-day routines as well as fluctuations in personal relationships, these compositions considered "what was lost, what was rediscovered, what was released, the resilience that was developed and the lessons learnt during this deeply emotional time."[4]

Zangewa's second presentation for the gallery, in 2021–22, took the form of two concurrent exhibitions: *Flesh and Blood*, at Lehmann Maupin, Seoul, and *Running Water*, at Lehmann Maupin, London. These new bodies of work continued to explore life as navigated amid the pandemic yet pointed to a new appreciation of ritual as well as the critical support offered by a close-knit community of friends and family. *Body and Soul*, which featured in the London display, portrays a solitary practice that provides structure to Zangewa's life—the daily act of meditating. As she explains, "It helps me to shut out the noise in my thinking mind, which can get overwhelming at times. Working towards an exhibition can be very stressful, on top of my other responsibilities, so I really have to cultivate a strong mind and solid ground. It is also a moment of prayer. I ask that I can put aside my ego and fears, and allow creativity to flow through me unimpeded. I ask to create from a pure place and to allow the process to guide me."[5]

With its jagged lower right-hand corner, *Body and Soul* conveys the artist's interest in asymmetrical forms. Nearly all of her works feature sections of cutout fabric, resulting in compositions that are irregular in shape. Zangewa has related this formal technique to "the potential ravages of time. I also love that it allows the viewer to finish the story."[6] The correlations that exist between the artist's narratives are also present in the making process itself: Zangewa often cuts segments from in-progress collages and uses them to construct other works that she is producing simultaneously, thereby generating a system based on interdependence. In the artist's words, "It is as if all my works are connected and in conversation, as they all carry pieces of each other."[7] AB

1. Billie Zangewa, "Artist Billie Zangewa—the Ultimate Act of Resistance Is Self-Love," Tate, February 21, 2020, YouTube video, 9:34, https://www.youtube.com/watch?v=ClSkiELcT6I&t=317s.
2. Billie Zangewa, interview by Allie Biswas, *Studio International*, October 27, 2020, https://www.studio international.com/index.php/billie-zangewa-wings-of -change-lehmann-maupin-new-york-i-had-chosen-to -embody-the-most-disempowered-human-form.
3. Zangewa, "Artist Zangewa—the Ultimate Act."
4. Billie Zangewa, quoted in Oluremi C. Onabanjo, "A Manual for Things Unseen," in *Billie Zangewa: Wings of Change*, exh. cat. (New York: Lehmann Maupin, 2020), 15.
5. Billie Zangewa, email message to the author, January 2022.
6. Ibid.
7. Ibid.

97. *Body and Soul*, 2021
Hand-stitched silk
44⅛ × 49⅝ in. (112.1 × 126.1 cm)

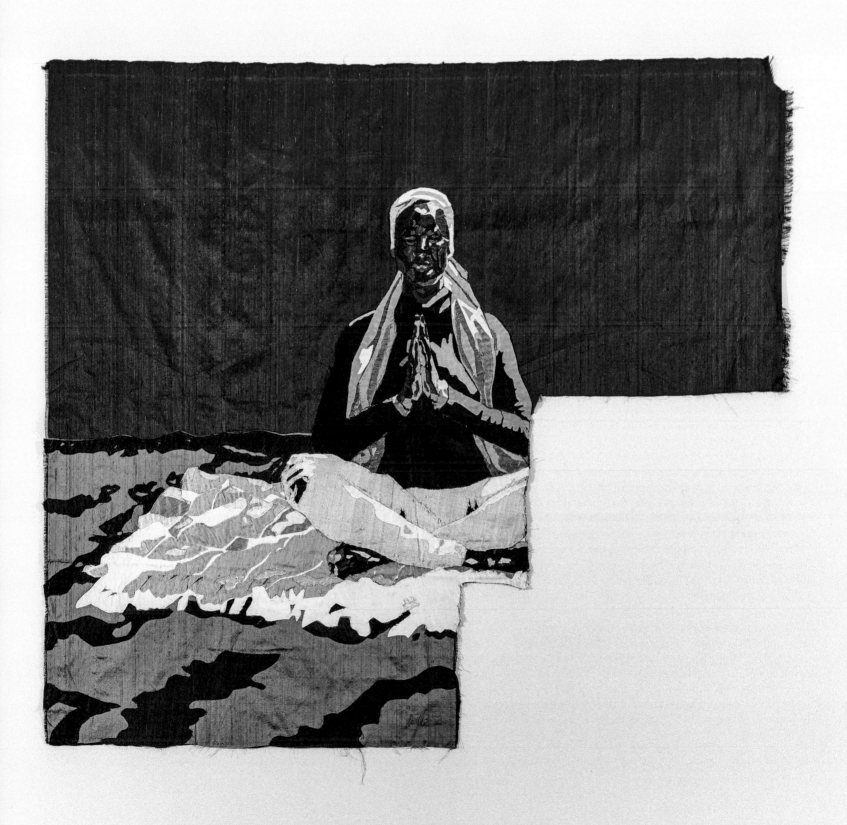

Caroline Kent

Born Sterling, Illinois, 1975

Through paintings, drawings, sculptures, installations, performances, and handmade books, the American artist Caroline Kent uses abstraction to explore how a visual language can act in the space of communication. Even the titles of some of her works allude to this focus—for instance, *The way she would write out her name as if it were a ballad* and, also in the Shah Garg Collection, *She had this way about her words* (2021). Recently, the artist has drawn on her experience growing up as an identical twin to create installations such as *Victoria/Veronica: Making Room* (Museum of Contemporary Art Chicago, August 3, 2021–June 12, 2022), which combined paintings with potted plants, carpeting, and domestic furniture to conjure a fictional world inhabited by telepathic twin sisters—a world where language "refuses to behave in the ways we might expect."[1]

Now based in Chicago, Kent received a BS in art from Illinois State University in 1998 and an MFA from the University of Minnesota in 2008. Her pastel palette and whimsical visual vocabulary were inspired, in part, by the two years she spent working as a United States Peace Corps volunteer in Transylvania, Romania, after graduating from college. While there, she was entranced by the local houses painted in various chalky and muted hues—colors, including canary, tangerine, eggshell blue, and cobalt, that recur in her paintings. Such cultural references and personal experiences combine in her work to generate an invented language of abstraction, which often defies easy interpretation.

Kent uses an improvisational methodology to produce her works. First, she makes mock-ups of her paintings by moving and rotating pieces of paper cut into abstract shapes before finalizing the image in paint on canvas. Her sometimes eight- to nine-foot-tall paintings typically feature choreographies of bold geometric shapes floating into, out of, and over expanses of black. On the occasion of a 2021 solo exhibition at her undergraduate alma mater, she observed, "I think of these new paintings as formulas or equations situated inside the cosmos; the cosmos here being metaphorical for a kind of space that invites one to comprehend in new ways."[2]

In *The way she would write out her name as if it were a ballad*, angular pastel shapes seem to float above the surface of the painting, hovering over traces—perhaps ghosts—of wavy fringes that emerge from an imaginary space behind the canvas that appears to be illuminated. The rich interplay among these enigmatic ciphers underscores Kent's penchant for breaking apart categories as well as her conception of much of her work as a challenge to the "preciousness of the canvas."[3] What is more, the painting—an example of the body of work she calls her "midnight canvases"—brings to our attention things that, in the artist's words, "might have at one time been covered in darkness, but have now been illuminated."[4] LOB

1. Jadine Collingwood, "In Darkness, a Language Forms," digital exh. brochure (Chicago: Museum of Contemporary Art Chicago, 2021), https://mcachicago.org/publications/essay/in-darkness-a-language-forms.
2. Caroline Kent, quoted in "Caroline Kent: What the Stars Can't Tell Us," University Galleries of Illinois State University (website), exh. on view August 11–December 16, 2021, accessed July 25, 2022, https://galleries.illinoisstate.edu/exhibitions/2021/caroline-kent.
3. Caroline Kent, "Speaking in Painted Symbols," interview by Jenn Pelly, *T: The New York Times Style Magazine*, November 22, 2020, https://www.nytimes.com/2020/11/16/t-magazine/caroline-kent.html.
4. Ibid.

98. *The way she would write out her name as if it were a ballad*, 2021
Acrylic on canvas
8 ft. 6¼ in. × 6 ft. 8½ in. (259.7 × 204.5 cm)

Calida Rawles

Born Wilmington, Delaware, 1976

Water is a central motif in Calida Rawles's photo-realistic paintings. The American artist typically depicts solitary figures—invariably, no more than one or two—submerged or floating in aquatic settings resembling swimming pools or the sea. The environments are expansive: water fills the frame entirely, with no indication of a shore, sky, or lip of a pool. The adolescent and adult bodies that appear in the works' foregrounds interact with the water in varying ways. Sometimes bare-skinned but usually wearing simple clothing, such as white sundresses, rather than swimsuits, the artist's protagonists float on their backs, their poised faces bathed in sunlight. In other examples, they are submerged deep below the water's surface, positioned laterally and partially distorted. These contrasting narratives speak to Rawles's view of water as a complex, often contradictory, element—one that enables renewal and restoration while also evoking histories of the slave trade and racial segregation. Drawing on her African American heritage, Rawles has characterized water as "a place of trauma and racial exclusion for Black bodies," referring to Jim Crow–era laws that prevented Black Americans from accessing certain swimming pools and beaches, adding, "I wanted to reclaim water."[1] In exploring the duality of water, Rawles's paintings seek to envision new possibilities for Black subjecthood through scenes that are ultimately celebratory. As the artist has commented, "In my culture, seeing black bodies in water is special."[2]

Rawles started to make her water-focused paintings in 2014, after learning how to swim—an activity that profoundly affected the artist, encouraging her to consider the metaphorical scope of water. She had previously worked as a graphic designer, after graduating from New York University with an MFA in painting in 2000. Her composition of a man floating facedown amid rippling waves, one of her earliest works to use water as a device to navigate Black trauma, was commissioned by the author Ta-Nehisi Coates and reproduced on the cover of his 2019 novel, *The Water Dancer*. For these initial paintings, as for those that have followed, Rawles has photographed friends and family members posing in pools. She takes up to four hundred digital photographs in a session, then merges selected images digitally to create a single one that serves as a reference for the final painting.

The works featured in Rawles's first solo exhibition, held at Various Small Fires (VSF), Los Angeles, in 2020, established the hyperrealistic painting style for which she has become known. The dazzling, sunlit pools that frame these portraits emphasize the importance of light to the artist, which she has called "one of the most important elements in the water—it's just magic."[3] For her debut show at Lehmann Maupin, New York, in the following year, Rawles took inspiration from Ralph Ellison's 1952 novel *Invisible Man*, enthralled by "the concept of light, and how he needed so much of it to be seen as a Black man."[4] The paintings on view in that exhibition, *On the Other Side of Everything*, present male figures suspended underwater in postures that leave them detached and obscured—traits that underline Rawles's recent transition to painting more abstractly. "With the added distortion, it creates a whole new image that's not a true portrait of the person. Our vision is as though we are all underwater looking at abstract versions of [other people's] world and their existence," she says.[5] *Requiem for My Navigator* is part of this series and depicts the artist's husband. "I wanted to explore what it means to both see and know a person, which is why I chose my husband, Gerald, the man who's been by my side for over 20 years," Rawles explains. "After all of the experiences we've shared, there are moments when it seems as though we only know a fraction of each other. I look forward to discovering the different sides of who we are and who we are becoming."[6] AB

1. Calida Rawles, quoted in Enuma Okoro, "How Three Artists Are Exploring Mythology and Race," *New York Times*, September 10, 2020, https://www.nytimes.com/2020/09/10/arts/design/black-female-art-mythology.html.
2. Calida Rawles, quoted in Jonathan Griffin, "Into the Deep End with Calida Rawles," *Cultured*, February 10, 2020, https://www.culturedmag.com/article/2020/02/10/calida-rawles.
3. Calida Rawles, quoted in Nicole Rudick, "Nearly 70 Years Later, 'Invisible Man' Is Still Inspiring Visual Artists," *T: The New York Times Style Magazine*, June 11, 2021, https://www.nytimes.com/2021/06/11/t-magazine/invisible-man-ellison-art.html.
4. Calida Rawles, quoted in Noor Brara, "'We're Coming Out from Under': Rising-Star Artist Calida Rawles on How Her Transfixing Water Paintings Address a Year of Mourning," *artnet news*, November 25, 2020, https://news.artnet.com/art-world/calida-rawles-profile-1922186.
5. Calida Rawles, quoted in Enuma Okoro, "Calida Rawles: 'I Use Soft Colours People Wouldn't Associate with Black Men," *Financial Times*, September 3, 2021, https://www.ft.com/content/da478062-d92e-4b47-9de5-1f4da0b06ca1.
6. Calida Rawles, email message to the author, January 2021.

99. *Requiem for My Navigator*, 2021
Acrylic on canvas
96 × 72 in. (234.8 × 182.9 cm)

Dana Schutz

Born Livonia, Michigan, 1976

The expressive canvases of Dana Schutz construct complex visual narratives that are simultaneously witty and disturbing. After her work was included in an exhibition at P.S.1 Contemporary Art Center in Queens, New York, in 2001, while she was still a graduate student at Columbia University, critical acclaim quickly followed. Although her practice draws on the legacies of both figurative and abstract painting, taking in influence from artists such as George Grosz and Philip Guston, among others, she is radically committed to her specific project of "painting an impossible subject."[1]

Gleaning ideas from a wide range of sources—popular culture, mythology, science fiction, current events, and more—Schutz produces large-scale paintings that depict imaginary, often dystopian or macabre, scenarios. Mixing fantasy and reality, she presents apocalyptic landscapes, bestial individuals, and unsettling customs as well as seemingly impossible combinations of activities, such as swimming while simultaneously smoking and crying. In her work, a sneeze, and other such mundane bodily functions, are treated in the same way as the wildest flights of imagination. Speaking of her process, Schutz has said, "I often use hypothetical situations to generate information and imagery for paintings and to create a fictional space where a subject can be put into play. . . . I don't paint from photographs or from life."[2]

Once Schutz has settled on her scenario, she begins to develop its characters. These figures are a fundamental component of what she terms her "invented narrative space" and are used to structure the specific situation she has conceived.[3] Examples of her protagonists include Frank, the Last Man on Earth, whom she depicts in a variety of island pursuits, as well as a population of subhuman "self-eaters," who feast on their own flesh and possess the capacity for limitless reincarnation. Known for her loose, gestural application of paint, Schutz covers the canvas with heavy layers of vibrant color, using coarse brushstrokes. As she prefers to work wet-on-wet, the art of painting is necessarily a rapid one. Despite the physicality of her technique, however, she views it as a means to an end. She explains, "I don't think of myself as putting down paint, but as bringing to life whatever it is that I'm painting."[4]

The body—specifically, the fragmented body—is at the center of Schutz's oeuvre. Rather than representing the human form with faithful anatomical correctness, she is interested in the ways in which it can be manipulated to give rise to an uncomfortable tableau. Addressing the notion of confinement in her work, the artist has said, "I was looking at a lot of Max Beckmann [1884–1950] and becoming really interested in his way of structuring narrative information into these really awkward spaces."[5] *Umbrella Man*, first exhibited by Friedrich Petzel Gallery at Art Basel in 2017, is one such tightly compressed composition. In it, an individual with deep-set, harrowing eyes and a disjointed, back-to-front lower half seems to be in the process of being consumed by an apparatus he is wielding. A fundamental ambiguity is at the core of each of Schutz's works: as she puts it, "I embrace the area between which the subject is composed and decomposed, formed and formless, inanimate and alive."[6]

With their claustrophobic compositions and disquieting subjects, Schutz's canvases engender an emotional response. The deliberately absurd situations into which she places her figures evoke pathos and, more broadly, the struggle of the human condition. And yet her dark sense of humor and deadpan approach force us to laugh as much as we empathize. Above all, her works remain strongly rooted in the world at large. "It is really important that the paintings do not hole up in their own realm of fantasy," she says.[7] Instead, she devises her characters to "act as surrogates or narratives for phenomena that I feel are happening in culture."[8]

HJ

1. Dana Schutz, "Dana Schutz: 'I Think of the Viewer as the Painter,'" interview by RK Lynn, *Studio International*, August 21, 2016, https://www.studiointernational.com/index.php/dana-schutz-interview-i-think-of-the-viewer-as-the-painter.
2. Dana Schutz, "If the Face Had Wheels: An Interview with Dana Schutz," by Helaine Posner, in *Dana Schutz: If the Face Had Wheels*, by Cary Levine and Helaine Posner, exh. cat. (Munich: Prestel, 2011), 84.
3. Schutz, "Schutz: 'I Think of the Viewer.'"
4. Dana Schutz, quoted in Barry Schwabsky, "Autopoiesis in Action," in *Dana Schutz*, by Jonathan Safran Foer and Barry Schwabsky (New York: Rizzoli, 2010), 14.
5. Schutz, "Schutz: 'I Think of the Viewer.'"
6. Dana Schutz, quoted in Eleanor Heartney, "Mutation and Regeneration: Dana Schutz Does Lightly Gruesome," *Art Press*, no. 328 (November 2006): 51.
7. Dana Schutz, interview by Mei Chin, *BOMB*, no. 95 (Spring 2006), https://bombmagazine.org/articles/dana-schutz/.
8. Ibid.

100. *Umbrella Man*, 2017
Oil on canvas
84 × 74 in. (213.4 × 188 cm)

Merikokeb Berhanu

Born Addis Ababa, Ethiopia, 1977

For Merikokeb Berhanu,[1] painting reflects the cycles of life. "Every creation on earth, natural and inanimate, changes over time," she says. "I have always used my art as an attempt to capture the feelings and emotions that have accompanied me throughout the different stages of my life."[2] Rather than documenting distinct moments in time or drawing on specific experiences, the Ethiopian artist situates her work in the space between the conscious and the unconscious. She navigates this liminal position through richly colored, abstract forms that are often predicated on real-world sources. While recurring motifs, from flowers and fruit to the human body, have populated the artist's large-scale paintings for the past two decades, a sense of ambiguity is nonetheless vital to her process, underlined by her proclivity to number her paintings but otherwise leave them untitled.

Certain types of imagery have played an especially critical role in Merikokeb's exploration of the human condition. Symbols that communicate the essence of existence—the building blocks of life—have become a focal point. As the artist says, "The embryo forms that I often incorporate into my paintings represent conception and reproduction. I like the idea of people conceiving, embracing, and 'giving birth' to their own thoughts, opinions, and questions."[3] *Untitled LXXIII* belongs to a group of works that explore the biological systems shared by numerous species. The series was first displayed in the exhibition *Cellular Universe* at Addis Fine Art, a gallery in the Ethiopian capital, in 2020 (following the artist's 2019 exhibition at the same gallery, *Beneath the Surface: The Mysteries of Living and Dying*). In these works, representations of fallopian tubes and cell-like forms appear amid streamlined geometric shapes, depicted in dazzling hues. Arranged into visually unified structures, the individual elements appear oversized, as though viewed under a microscope. Having trained at Addis Ababa University's School of Fine Arts and Design (now Alle School of Fine Arts and Design), which has been at the forefront of the country's modern art movement since the school's founding in 1958, Merikokeb draws on hallmarks of Ethiopian modernism, such as depthless perspective, elongated figures, and overlapping compositional elements—characteristics that are themselves related to the centuries-long tradition of Ethiopian Christian painting. Merikokeb, for her part, has contributed directly to the development of the art scene in Addis Ababa, cofounding the artist-run gallery and atelier Nubia Studio in 2002, the year of her graduation.

Recently, Merikokeb has integrated technological imagery into her works, including allusions to circuit boards and microchips. In the Shah Garg Collection canvas, such devices are indicated by the narrow, rectangular forms that occupy the bottom right-hand corner of the canvas. The artist's initial referencing of human-made objects coincided with her move to the United States in 2017 (she now lives and works in Maryland). Exposed to a context quite different from that of her upbringing, Merikokeb became alert to the role played by technology and mass consumerism and developed a particular concern for the environmental impact of those phenomena. In her paintings, through the juxtaposition of the digital and the biological, she alludes to natural processes that have been "confused and transformed," as she puts it.[4] For Merikokeb, this amalgamation is representative of the spectrum of existence that she seeks to address: "The thick fog and smoke, happiness and hope, misery and bliss—all elements push me to think and paint."[5]

AB

1. The artist may be referred to as either "Merikokeb Berhanu" or "Merikokeb." The concept of a family name does not exist in Ethiopian culture; Berhanu is the artist's father's first name.
2. Merikokeb Berhanu, email message to the author, May 2022.
3. Ibid.
4. Ibid.
5. Merikokeb Berhanu, artist's statement for the exhibition *Latest Artworks: Merikokeb Berhanu—Ethiopia*, Red Hill Art Gallery, Nairobi (website), exhibition on view September 27–November 1, 2015, accessed August 15, 2022, http://www.redhillartgallery.com/merikokeb-berhanu-latest-artworks.html.

101. *Untitled LXXIII*, 2021
Acrylic on canvas
72 × 36 in. (182.9 × 91.4 cm)

Aliza Nisenbaum

Born Mexico City 1977

This painting depicts Amelia Beniquez and Omar Muñoz, the owners of a salsa dance company in Los Angeles, seated together in their home. The couple's connection to dance is highlighted in their distinctive clothing and elegant postures as well as the framed pictures and posters hanging on the wall behind them, many of which reference renowned Latin American musicians, such as Celia Cruz and Bobby Valentín. Aliza Nisenbaum painted the couple during an extended stay in Los Angeles in 2020, having met them through members of a dance troupe in New York, where she is based. The dancers from downtown Manhattan had been the subject of a series of paintings Nisenbaum included in *Coreografías*, her first solo show in New York, held at Anton Kern Gallery in 2019. "I was thinking of the word 'choreography' as a term used to position dancers and orchestrate a sense of unity," Nisenbaum has said.[1] (Her remark echoes the text on a label for what looks like a platinum record mounted on the wall behind the couple: "Creating Unity through Salsa.") Indeed, the artist has practiced salsa throughout her life, and for her, the dance form represents liberation, making her aware of "how Latino communities come together in salsa clubs; it really is a very democratizing space."[2] After the *Coreografías* series, Nisenbaum created portraits of individuals associated with the salsa and music scenes in Kansas City, Missouri, commissioned by the Kemper Museum of Contemporary Art and exhibited there in 2022 in *Aliza Nisenbaum: Aquí Se Puede (Here You Can)*.

In addition to dancers, Nisenbaum has placed other specific communities at the forefront of her work. Her brightly colored group portraits feature members of grassroots organizations, subway workers, museum security guards, and health-care staff, among others. "I engage with these groups on various levels through pedagogy, the sharing of resources, skills and, ultimately, social representation," she explains.[3] The artist's working methods, together with the subjects she chooses to paint, correspond with her focus on making art with a social purpose. From 2012 to 2016, she taught English at Immigrant Movement International (IMI), a community center in Queens, New York, founded by the Cuban artist Tania Bruguera (born 1968),

which also acts as a platform for artists to engage with immigrant rights and neighborhood concerns. "I had never considered how my work might relate to Social Practice, or Performance art really, but I was so moved by her project and it made me rethink a lot of things," Nisenbaum says.[4] She developed close friendships with the women she taught—mainly Mexican and Central American immigrants—which eventually led to her painting their portraits.

Migrant communities remain integral to Nisenbaum's practice, part of her exploration of collective spaces and their capacity to nurture a sense of belonging. This preoccupation may be attributed to the artist's own experience of migration. Born in Mexico City to a Russian Mexican father and Norwegian American mother, Nisenbaum moved to the United States in the early 2000s to study painting at the School of the Art Institute of Chicago. "My life and work have been deeply influenced by my trans-border upbringing," she says.[5] Although her compositions give prominence to those who may not be commonly depicted in mainstream genres, Nisenbaum has asserted that "it's not really about visibility. At the heart of my project is sitting with people and going through the slow process of painting from life. Inevitably, a kind of ethics comes from that."[6] Drawing on the intimate connection she develops with her subjects over a period of time, Nisenbaum's portraits are a manifestation of this collaboration—one in which all participants are equal. AB

1. Aliza Nisenbaum, interview by Yasi Alipour, *Brooklyn Rail*, September 2019, https://brooklynrail.org/2019/09/art/aliza-nisenbaum-with-Yasi-Alipour.
2. Aliza Nisenbaum, email message to the author, January 2022.
3. Ibid.
4. Nisenbaum, interview by Alipour.
5. Aliza Nisenbaum, "Aliza Nisenbaum: Why I Paint," Phaidon (website), October 26, 2016, https://www.phaidon.com/agenda/art/articles/2016/october/26/aliza-nisenbaum-why-i-paint/.
6. Aliza Nisenbaum, "Aliza Nisenbaum—Interview: 'I Was Torn between Wanting to Be a Social Worker or a Painter,'" by Allie Biswas, *Studio International*, May 1, 2019, https://www.studiointernational.com/index.php/aliza-nisenbaum-interview-art-on-the-underground-mural-brixton-tube-station-london.

102. *Sin Salsa no hay Paraíso*, 2020
Oil on canvas
57 × 63 in. (144.8 × 160 cm)

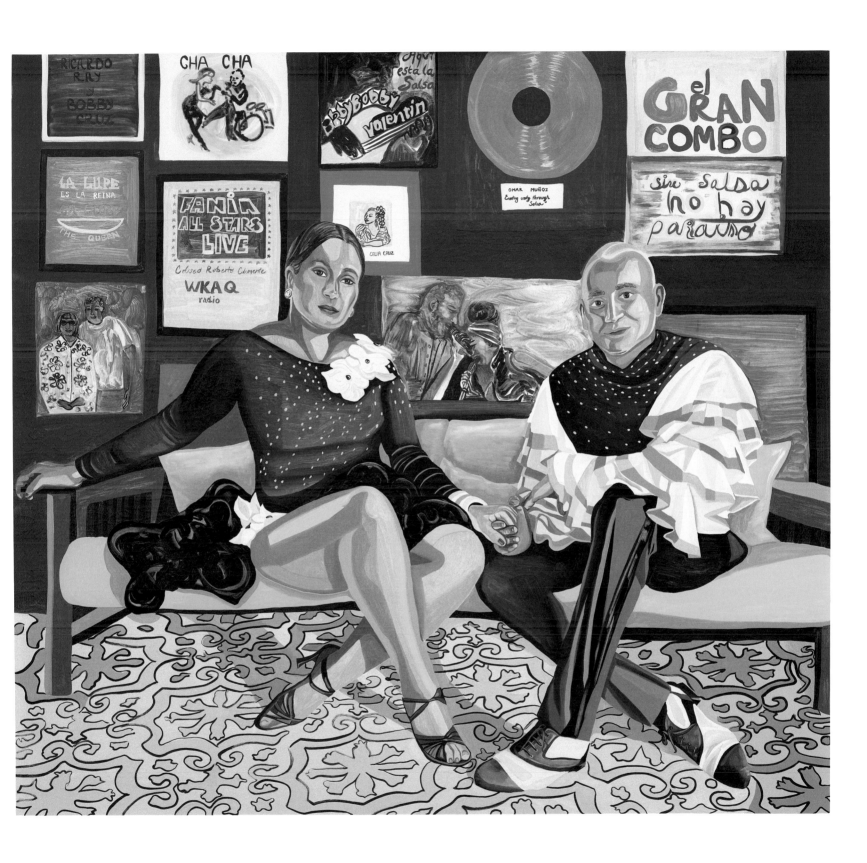

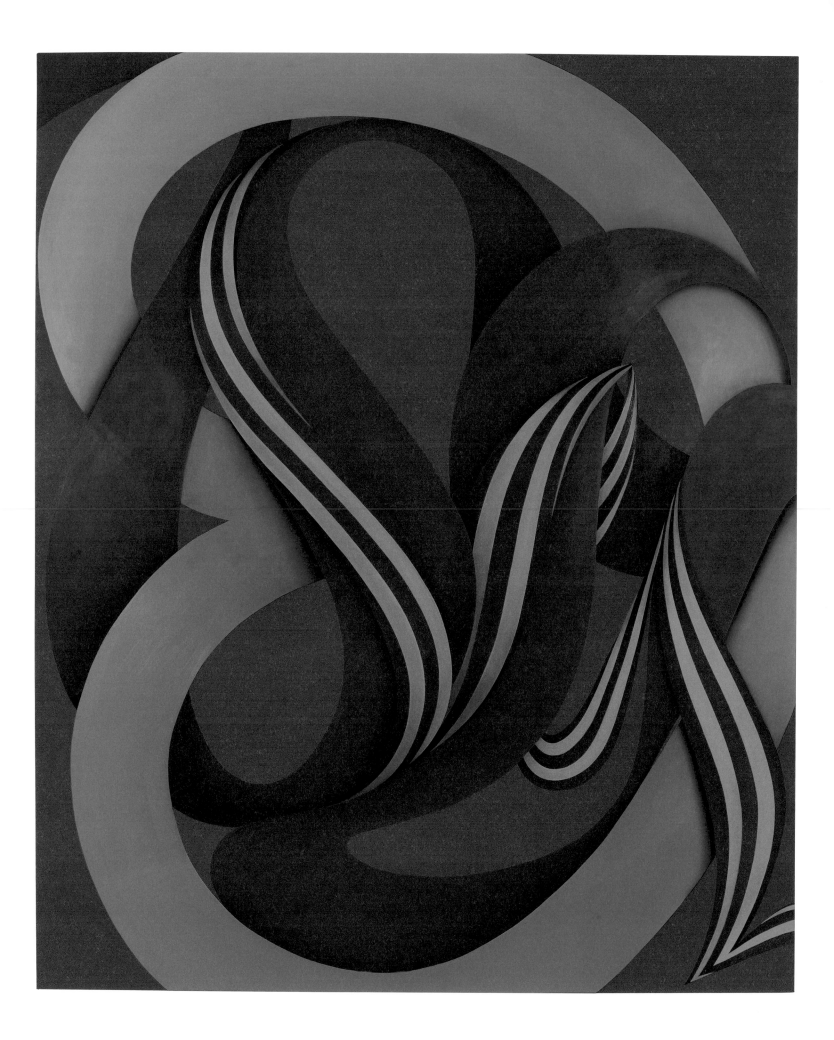

Lesley Vance

Born Milwaukee 1977

Since 2014, Lesley Vance has been creating paintings that consist of entirely invented and indeterminate forms. In her vivid, abstract compositions, networks of interlocking shapes overlap and recede, producing optical illusions that are heightened by her distinctive use of light and shadow. While the precise, curvilinear forms (mainly tubes and ribbons) that dominate the works are not directly derived from source materials, the American artist has spoken of her interest in citing from art history. Long-standing references include sixteenth- and seventeenth-century still lifes by Francisco de Zurbarán and Juan Sánchez Cotán, landscapes by Georgia O'Keeffe (1887–1986), and the process-driven paintings of Carla Accardi (1924–2014). Vance has also reflected on the importance of ceramics: "I love looking at paintings, but my work is pretty sculptural; I am interested in sculptural space."[1]

Earlier in her career, in the decade after she received her MFA from California Institute of the Arts (CalArts) in 2003, Vance painted diminutive still lifes based on photographs of leaves, seashells, and tree branches that she arranged in her studio. While the photos served as a starting point in her process, they became "little more than a memory" once a painting was under way.[2] This method undergirded the artist's 2009 painting shown at the 2010 Whitney Biennial, *Untitled (12)*, which emphasized her affinity with still-life traditions in the proportions and relationships of its forms. Early abstractions such as this were significantly muted in comparison to the luminous colors that now characterize her work. Moreover, in abandoning still-life setups for her recent paintings, Vance has developed imagery that no longer acknowledges any divide between the abstract and the figurative.[3]

Vance's 2012 exhibition at the Brussels gallery Xavier Hufkens instigated the major transition outlined above. For the artist, the show was "a culmination of a few years of making a certain type of painting. I had the feeling that I had taken it as far as I wanted it to go at that time. Two or three paintings [in the show] were performing in a different way—the ones that had more gesture in them and a lighter touch. They had more air in them."[4] Since this shift in her practice, Vance has continued to evolve the three-dimensional quality of her imagery, amplifying the dynamism of her looped forms. Although her principal motifs have become increasingly graphic, and her brushstrokes even flatter, a relatively impromptu process continues to guide her—one "that feels out of control ninety per cent of the time."[5]

Untitled and another work in the Shah Garg Collection, also titled *Untitled* (see p. 418), exemplify the variations in Vance's approach. She has commented that "it's almost like the two paintings are the inverse of each other."[6] The 2017 painting is more modestly scaled and conveys, in the artist's own words, "an intimacy . . . a swampy nocturnal atmosphere."[7] In contrast to this interiority, the later—and significantly larger—composition evokes what Vance terms an "expansive energy that pushes out into the world."[8] The paintings are united through the implied circular motion of the coiled shapes that convene in their foregrounds. The sense of momentum increases in certain areas through Vance's use of pattern (in the 2020 work) and bright highlights (in the 2017 example). Rather than enabling the viewer to decipher the origin and end point of each configuration, the artist instead induces the sensation of an endless loop. "I always want to not only get my viewer's attention," she says, "but hold onto it and keep them there looking at the painting."[9]

AB

1. Lesley Vance, "Beer with a Painter, LA Edition: Lesley Vance," interview by Jennifer Samet, *Hyperallergic*, September 26, 2015, https://hyperallergic.com/239657/beer-with-a-painter-la-edition-lesley-vance/.
2. Lesley Vance, quoted in Barry Schwabsky, "Abolished Still Life," in *Lesley Vance* (Los Angeles: David Kordansky Gallery, 2013), 4.
3. Douglas Fogle, "Medusa's Hair," in *Lesley Vance: Paintings, 2013–2019* (New York: Gregory R. Miller, 2019), 52.
4. Lesley Vance, "CalArts Visiting Artist Lecture Series Presents Lesley Vance," lecture, California Institute of the Arts, Valencia, March 7, 2013, Vimeo video, 1:35:07, https://vimeo.com/64824225.
5. Vance, "Beer with a Painter."
6. Lesley Vance, email message to the author via David Kordansky Gallery, New York, December 2021.
7. Ibid.
8. Ibid.
9. Ibid.

103. *Untitled*, 2020
Oil on linen
80 × 67 in. (203.2 × 170.2 cm)

Lynette Yiadom-Boakye

Born London 1977

Of Ghanaian heritage, the London-born painter Lynette Yiadom-Boakye attended Central Saint Martins College of Art and Design, Falmouth College of Arts, and the Royal Academy Schools and emerged to critical acclaim shortly after her MFA exhibition in 2003. Fifteen years later, in 2018, she received the prestigious Carnegie Prize at the 57th Carnegie International in Pittsburgh.

While Yiadom-Boakye was trained in drawing and painting from life, she realized early on that the pursuit of mere naturalistic likeness did not suit her ambitions. Instead, she begins her process by perusing her collection of found images—mostly magazine clippings and reproductions of paintings by artists including Edgar Degas, Édouard Manet, John Singer Sargent, and Walter Sickert, among many others—until she finds something that piques her interest: a pose, a color, an expression, or a scenario. Using this as a springboard, she then conjures a composition from her imagination. All of Yiadom-Boakye's enigmatic paintings share one fundamental characteristic: the people represented in them are fictitious constructions rather than depictions of specific individuals, living or dead.

Inhabiting a world of their own, Yiadom-Boakye's figures are deliberately undefined by their surroundings and are difficult to locate in time or place. The artist rarely includes details that might suggest the fashions of a particular culture or period, and the dark, ambiguous backgrounds are largely devoid of material or architectural references. Her characters appear content and at ease in settings imbued with a calm sense of inaction. Yiadom-Boakye has revealed that she sees them as unburdened by the modern world: "They don't share our concerns or anxieties. They are somewhere else altogether."[1] Yet despite this degree of separation, they remain familiar. "Although they are not real, I think of them as people known to me," the artist says.[2] "They seem to have souls—that ultimate retrogressive term!," wrote the novelist Zadie Smith in the *New Yorker* around the time of Yiadom-Boakye's 2017 solo show at New York's New Museum. "Though by 'soul' we need imply nothing more metaphysical here than the sum total of one person's affect in the mind of another."[3] Indeed, *Afterword*, featuring a lone, contemplative figure seated at a table bearing a fruit bowl evocative of Paul Cézanne's iconic still lifes, projects a profound sense of timelessness and ambiguity.

Yiadom-Boakye's use of primarily Black subjects often garners critical attention, but she remains insistent on her own priorities: "For me the political is as much in the making of [the work], in the painting of it, in the fact of doing it, rather than anything very specific about race or even about celebration. . . . Also, they're all black because, in my view, if I was painting white people that would be very strange, because I'm not white. This seems to make more sense in terms of a sense of normality."[4] As she recalled on another occasion, "I was always more interested in the painting than I was the people."[5] Fundamentally preoccupied with formal concerns of color, light, and composition, Yiadom-Boakye works wet-on-wet, rapidly and instinctively. Her muted, earthy palette of brown, green, and black has expanded in recent works to incorporate flecks of vibrancy, such as the orange, pink, and purple seen here. While the artist has acknowledged the laboriousness of her process—admitting that the paint "doesn't always do what you want it to do, it's alive"—her surfaces clearly demonstrate her mastery of the paintbrush.[6]

Although the evocative titles Yiadom-Boakye chooses for her paintings and exhibitions might suggest particular interpretations, she views them as just "another brush mark" rather than any attempt at definitive, descriptive explanation.[7] Alongside her visual practice, she also writes prose and poetry. For the artist, the two forms of creative expression are distinct but always intertwined: "The things I can't paint, I write, and the things I can't write, I paint."[8]

HJ

1. Lynette Yiadom-Boakye, quoted in Nadine Rubin Nathan, "Lynette Yiadom-Boakye's Fashionable Eye," *T: The New York Times Style Magazine*, November 15, 2010, https://archive.nytimes.com/tmagazine.blogs.nytimes.com/2010/11/15/lynette-yiadom-boakeyes-fashionable-eye/.
2. Lynette Yiadom-Boakye, quoted in Sarah Kent, "Lynette Yiadom-Boakye," in *Flow*, ed. Christine Y. Kim, exh. cat. (New York: The Studio Museum in Harlem, 2008), 103.
3. Zadie Smith, "Lynette Yiadom-Boakye's Imaginary Portraits," *New Yorker*, June 19, 2017, https://www.newyorker.com/magazine/2017/06/19/lynette-yiadom-boakyes-imaginary-portraits.
4. Lynette Yiadom-Boakye, "Futura: Hans Ulrich Obrist Interviews Afropolitan Artist Lynette Yiadom-Boakye," *Kaleidoscope*, no. 15 (Summer 2012): 102.
5. Lynette Yiadom-Boakye, "Lynette Yiadom-Boakye's Fictive Figures," interview by Antwaun Sargent, *Interview*, May 15, 2017, https://www.interviewmagazine.com/art/lynette-yiadom-boakye-new-museum.
6. Lynette Yiadom-Boakye, quoted in Jason Parham, "Considering Lynette Yiadom-Boakye's Borderless Bodies," *Fader*, May 10, 2017, https://www.thefader.com/2017/05/10/lynette-yiadom-boakye-solo-show-review.
7. Lynette Yiadom-Boakye, quoted in Antwaun Sargent, "Lynette Yiadom-Boakye: Speaking through Painting," *Tate Etc*, no. 50 (Autumn 2020), https://www.tate.org.uk/tate-etc/issue-50-autumn-2020/lynette-yiadom-boakye-antwaun-sargent-interview.
8. Yiadom-Boakye, "Yiadom-Boakye's Fictive Figures."

104. *Afterword*, 2019
Oil on linen
55⅛ × 59⅛ in. (140 × 150.2 cm)

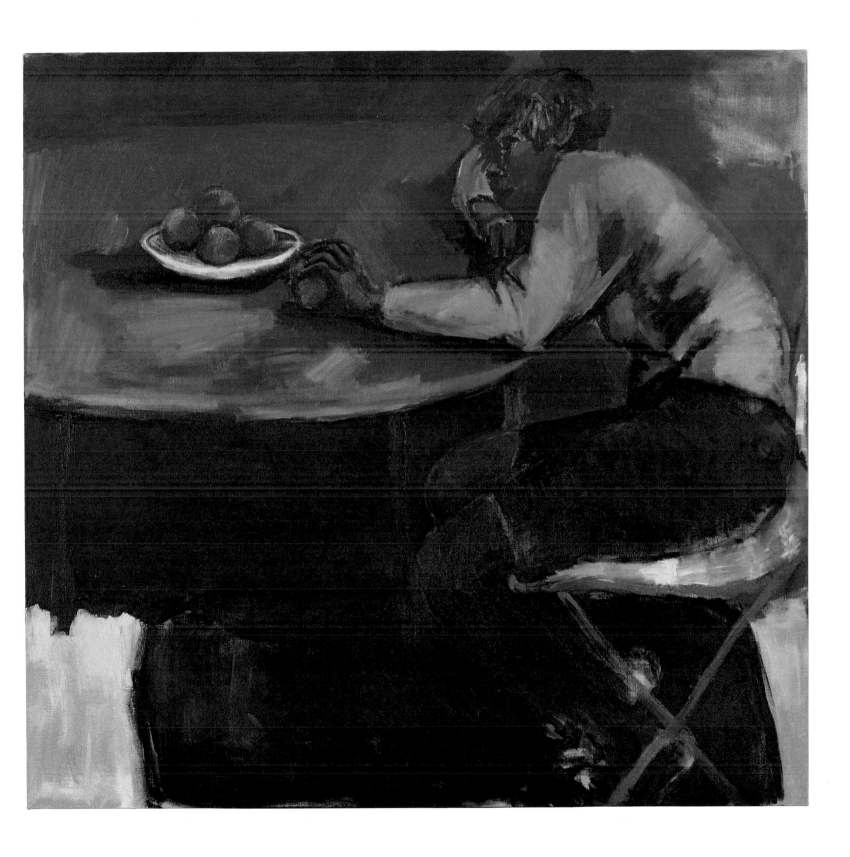

Vibha Galhotra

Born Chandigarh, India, 1978

Born in the planned, modernist city of Chandigarh, Vibha Galhotra is a Delhi-based conceptual artist whose works address globalization, climate change, and land and water use. Her practice crosses the disciplines of art, ecology, economics, science, religion, and activism. Galhotra earned a BFA in graphics from Chandigarh's Government College of Art in 1999 and an MFA from Visva-Bharati, the public university in Santiniketan, West Bengal, in 2001. After moving to Delhi, she observed the rapid urbanization of her new home—as is well known, the city experienced brisk growth in the five years leading up to the 2010 Commonwealth Games, when money poured into the city and hundreds of thousands of impoverished people were displaced to accommodate the building of new venues and the athletes' village. "There was an omnipresent smell of cement in the air accompanied by the sight of endless unplanned construction," the artist has noted, adding, "The result was unimaginable inflation, an exploding economy, and a beehive of construction on the one hand, and the contamination of the environment and the deterioration of health on the other."[1]

Galhotra often addresses urbanization's jumbles of steel and concrete through intricately sewn tapestries covered in *ghungroo* (small bells, typically of brass or bronze, worn around dancers' ankles), as in the two-panel work *Untitled 3*. *Ghungroo*, the artist has stated, were "originally inspired from a seed used by people in traditional cultures as a form of ornamentation, the sound produced to make their presence felt in the atmosphere."[2] The seed- or spore-like form of the *ghungroo* is also a metaphor for constant change. As Galhotra explains, "I started using the material to replace something tangible like a seed with a metal bead, since the latter deceives the viewer from the seriousness underlying the work, while at the same time also evokes interest in learning more about the work by drawing the viewer in." To create the tapestries, the artist first makes a drawing, which is then deconstructed in a "somewhat controlled-uncontrolled" manner by the local women she hires to sew the *ghungroo* onto fabric panels.[3]

An example of one such work is the large-scale *Acceleration* (2017; Kiran Nadar Museum of Art,

New Delhi), based on the American chemist Will Steffen's "Great Acceleration" graphs, first published in 2004, which chart changes in Earth's ecosystem and atmosphere owing to varying economic patterns of production and consumption since the 1950s.[4] While Steffen offered twenty-four separate graphs highlighting the effects of human activity and rapid growth on the environment, Galhotra overlapped all the graphs to produce one comprehensive, befuddling diagram. The shiny material threaded throughout the beautiful piece conceals the unpleasant facts and echoes how climate change denialism is severely worsening our ecology.

The artist also uses found and performative objects—from tree branches to horse manure to sludge from the Yamuna River—to create multisensory installations, staged photographic works, and films. Regarding her overall practice, she observes, "For me, all the different modes of work are interrelated, in a continuous dialogue with the subject I am working on at any specific time. The site specificity, however, helps me maneuver a performance."[5] Her underlying belief in the Buddhist mantra *yat pinde tat brahmande*—literally, "that which is in the microcosm is also in the macrocosm"—is important to note. Essentially, it means that whatever exists in the universe also exists in each human being, as they are inseparable. Consequently, the degradation of nature through climate change will inevitably impact and possibly destroy all living beings. Through her art, Galhotra is "doing her bit" to mitigate—or at least draw further attention to—our planet's looming collapse.[6] LOB

1. Vibha Galhotra, "Straight Talk with Vibha Galhotra," interview by Marnie Benney, *SciArt Magazine*, June 2018, https://www.sciartmagazine.com/straight-talk-vibha -galhotra.html.
2. Ibid.
3. Ibid.
4. Will Steffen et al., "The Anthropocene Era: How Humans Are Changing the Earth System," chapter 3 in *Global Change and the Earth System: A Planet under Pressure*, Global Change—The IGBP Series (Berlin: Springer, 2004), 132–33, figs. 3.66, 3.67.
5. Galhotra, "Straight Talk."
6. Vibha Galhotra, "The Artist's Studio: Vibha Galhotra," Kiran Nadar Museum of Art, New Delhi, February 28, 2021, YouTube video, 2:51, https://youtu.be/s5Dr3OPcaOs.

105. *Untitled 3*, 2014
Metal bells, thread, and fabric on wood panel (2 parts)
Overall 84 × 96 × 3¾ in. (213.4 × 243.8 × 9.5 cm), each panel 84 × 48 × 3¾ in. (213.4 × 121.9 × 9.5 cm)

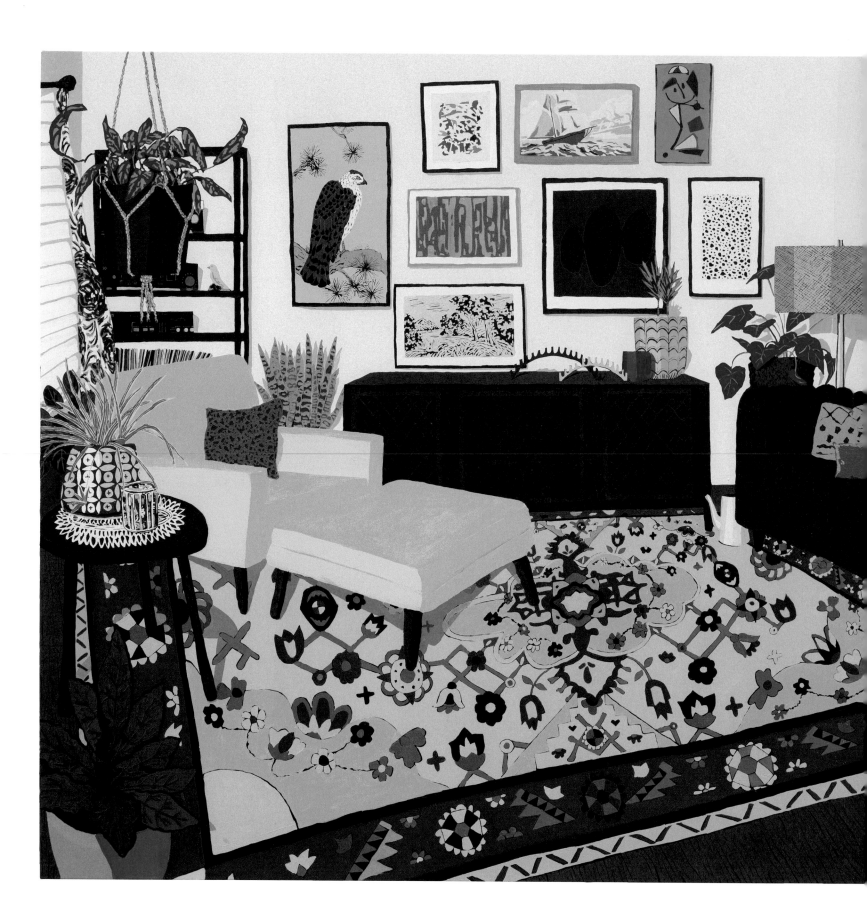

Hilary Pecis

Born Fullerton, California, 1979

The Los Angeles–based artist Hilary Pecis paints colorful interior scenes of friends' homes and tranquil, equally colorful exterior scenes of her native state of California. The former, which may be better described as domestic still lifes, present light-infused dwellings jam-packed with books, plants, art, furniture, and the occasional pet. The works (which richly evoke the fact that we all saw too much of our living rooms during the COVID-19 pandemic) convey how the objects in one's home can signify one's identity—or, to be truthful, one's aspirational identity. Within her vibrant interiors, Pecis often depicts salon-style hangings of paintings and posters alongside bookshelves and coffee tables filled with artists' monographs. (As a *New York Times* writer observed, "These objects are presented with a slight wink, perhaps, but ultimately Pecis isn't judgmental about them. . . . Instead, her canvases are infused with joy.")[1] *Jen's House*, which was featured in the artist's 2022 solo exhibition, *Warmly*, at Rachel Uffner Gallery in New York, shows a funky living room replete with a raspberry-red couch, a yellow armchair and matching ottoman, a midcentury-modern wood credenza, and a meticulously rendered Persian carpet. Among the pictures hanging on the walls are one of a hawk on a pine branch (reminiscent of a Chinese or Japanese ink or screen painting—or reproduction thereof), another of a sailboat on choppy waters, and various abstractions recalling different twentieth-century artists' approaches to modernism.

Pecis received her BFA and MFA (in 2006 and 2009, respectively) from San Francisco's California College of the Arts. In 2017, she cofounded the Binder of Women, an "independent platform for contemporary artists to empower female artists, expand their reach, broach the topic of equality and consent in the art world, and take action to grow the number of works by female-identifying artists in contemporary art collections."[2] Among the organization's activities has been the publication of two portfolios of signed works by ten women artists, ranging from "traditional forms of print to unique paintings" (Pecis's own contribution to the second portfolio features several raptors looking not unlike the hawk in the Shah Garg Collection work).

Pecis's paintings are generally marked by saturated colors and unconventional perspectives. It is perhaps no wonder that she begins each work with a photograph, from which she then devises a composition that she sketches directly onto canvas and then builds out with precise geometric patterning and line work. She fills in the negative spaces last, resulting in somewhat flattened configurations that recall the interiors of her contemporary Jonas Wood and the outdoor scenes of David Hockney as well as the work of California Funk artists such as Jim Nutt and Peter Saul. For the 2022 show at Rachel Uffner, Pecis scaled up her work from its previous proportions, creating a vaster pictorial space and allowing for more visual and textural variety. "With more space there are opportunities to loosen up and become a bit more painterly, as well as the logistics of the larger support allowing for more information to be covered, more paint to be applied," she notes.[3]

Pecis's scrupulous landscapes capture the sun-drenched vistas of Southern California, often highlighting its mountainous topography and lush foliage. Regarding these works, she has said:

> The landscape paintings feel a bit more personal to me, as they are typically from the trails that I run or street scenes from road runs. As a runner I spend many hours running the same paths, looking at the same markers day after day. There are many signifiers of the LA landscape that I enjoy, which never seem to lose their magic: the palm trees lining streets and towering over the homes below, the liquor stores peppered with hand-painted signage. Additionally, we have such amazing sunlit hills that never quite photograph the way they are seen in real life. I try my hardest to represent our beautiful landscapes as I see them, and not as how they are reproduced in a photograph. They truly are breathtaking.[4]

To be sure, Pecis succeeds in providing her audiences with a greater sense of that LA "magic" than a photograph or digital image could ever convey.

LOB

1. Adriane Quinlan, "Still Lifes and Landscapes That Capture Sunny California," *T: The New York Times Style Magazine*, March 10, 2022, updated March 11, 2022, https://www.nytimes.com/2022/03/10/t-magazine/terrestre-oaxaca-hilary-pecis.html.
2. "About," The Binder of Women (website), accessed May 6, 2022, https://www.thebinderofwomen.com/about.
3. Hilary Pecis, "Hilary Pecis Captures the Layers of Los Angeles's Landscapes," interview by Nancy Gamboa, *Cultured*, June 23, 2021, https://www.culturedmag.com/article/2021/06/23/hilary-pecis.
4. Ibid.

106. *Jen's House*, 2021
Acrylic on linen
74 × 100 in. (188 × 254 cm)

Emily Mae Smith

Born Austin, Texas, 1979

A sharp feminist undercurrent runs through all of Emily Mae Smith's paintings. Their typically humble scale and ominous, sometimes sexual imagery recall the work of several previous women artists, including the underappreciated Chicago Imagist Christina Ramberg (1946–1995) and the Belgian Pop painter Evelyne Axell (1935–1972). Like those precursors, Smith compresses the distinction between fine art and the practice of illustration or cartooning. "She's as likely to ransack the studio of Walt Disney (the Sorcerer's Apprentice's broom is a recurring muse) as she is to lift from the patriarchy of Pop (a Lichtenstein Benday-dot mirror has a cameo)," a reviewer observed in the *New Yorker* in 2015.[1]

Smith received a BFA in studio art from the University of Texas at Austin in 2002 and an MFA in visual art from Columbia University in 2006. She landed on the recurring "character" of the broomstick because it allowed her to paint a domestic tool associated with women's labor, another associated with the artist's profession (the paintbrush), and a phallic symbol all at once. In dozens of paintings, she has turned the smooth, rounded rod into a (mostly) faceless personage and placed it in a number of familiar art-historical contexts. Many of these works question what it means to be both a woman and a painter. *The Drawing Room* (2018), for example, directly references an 1801 painting in the collection of the Metropolitan Museum of Art, New York. That canvas, misattributed to Jacques-Louis David until the mid-1960s, is now considered to be the work of Marie Denise Villers (1774–1821). Smith's version shows the broomstick, elegantly wrapped in a sheer yellow curtain extending from the window, seated on a sleek chaise longue and interrupted at her drawing, exactly like the young woman in Villers's picture. The 2018 work is a sly occupational self-portrait and a meditation on Smith's labor as a painter.

The figure of the broomstick has evolved in the artist's oeuvre and taken on a wide variety of forms. Some involve the other end of the broom—the sheaf of straw—which sometimes morphs into a pair of legs. Smith has remarked:

> As I explore my relationship to the story of painting, the body of the broom becomes that story. As it unfolds, I find new unexamined dimensions. When I started to paint the legs as straw, I wondered about that. Then I found myself examining the historical paintings of peasant life working with fields of grain, thinking about what those paintings mean in patriarchal society, and how that has set up models resulting in conditions like invisible labor. It is an effective model.[2]

In *Daphne of the West*, a partial figure in this lineage—a woman wearing high heels, seen only from the waist down—lounges in a wheat field. The real star of the painting, however, is the fine detail with which Smith has imbued each stalk of wheat making up the figure's body, contrasting with the thicker, coarser fibers that make up the larger field around her. This work, while superficially peaceful, somehow still expresses the threatened danger that loiters in so much of Smith's imagery: gaping mouths, tongues being sliced on buzz saws, and snakes wrapped around empty hourglasses, all of which elicit visceral responses in the viewer, often simultaneous discomfort and attraction. Throughout, Smith's ongoing examination of sexuality, capitalism, and power gestures toward the themes that have come to define much of our era.　　　　LOB

1. "Emily Mae Smith at Laurel Gitlin," *New Yorker*, Goings On About Town section, review of exh. on view September 10–October 25, 2015, accessed February 11, 2022, https://www.newyorker.com/goings-on-about-town/art/emily-mae-smith.
2. Emily Mae Smith, "Emily Mae Smith Is Reexamining the Script of Art History," interview by Katy Donoghue, *Whitewall*, October 14, 2021, https://whitewall.art/art/emily-mae-smith-is-reexamining-the-script-of-art-history.

107. *Daphne of the West*, 2020
Oil on linen
48 × 37 in. (121.9 × 94 cm)

Andra Ursuţa

Born Salonta, Romania, 1979

Andra Ursuţa was born in northwestern Romania, on the Hungarian border, in the middle of Nicolae Ceaușescu's twenty-four-year totalitarian regime. Although she immigrated to New York in 1999, her work often mines Balkan history, culture, and economics, making reference to figures ranging from Vlad the Impaler to Constantin Brâncuși and acknowledging some of the trauma and misery of growing up in a Communist society under tragic conditions. In 2002, she received a BA in art history and visual arts from Columbia University, and today she is known for her darkly humorous sculptures that merge aspects of her cultural and religious inheritance with her own personal history and allusions to popular culture.

The uncanny and sexually suggestive *Canopic Demijohn* was featured, along with other works by Ursuţa, at the 59th Venice Biennale in 2022 and belongs to the artist's ongoing series of cast-glass sculptures whose imagery combines bodies and body parts—typically, her own face, limbs, and torso—with inanimate objects such as Halloween masks, fetish wear, shredded cardboard (the packing material known as "void fill"), plastic tubing, bottles, and other mundane materials. Ursuţa debuted this direction in her work three years earlier, also at the Venice Biennale, with clear vessels that held fingers of liquor and whose forms recalled cyborgs and other sci-fi experiments gone awry. "The throwaway, cheap props that the culture uses to express its fear—I love to use those kinds of things," the artist notes. "I love that they are disposable, that they're kind of like trash, but then, through these very elaborate processes, I can turn them into something that's going to last. That's the idea, to take something very low culture and treat it with reverence."[1]

To fabricate these works, the artist amalgamates traditional sculptural techniques with cutting-edge technologies, such as 3D scanning. After digitally transplanting corporeal forms onto scans of other objects, Ursuţa prints the resulting hybrids in plastic to create molds. From these, she makes wax models, which she then casts in clear or colored glass by the time-honored lost-wax method. The glass must be slowly melted under high heat, which adds another element of chance to an inherently unstable medium. When the artist uses colored glass, this stage in the process sometimes produces a whirling, marbled effect or a vibrant shock of molten color from within the work. The writer Zoë Lescaze aptly described the sculptures presented in *Nobodies*, the artist's 2019 solo exhibition at Ramiken in Brooklyn: "The hollow statues, with their crystal flesh stained glacial blue and absinthe green, seemed to emit their own icy light, as though Ursuţa had bottled the aurora borealis."[2]

Each of Ursuţa's works is a study in unexpected formal contrasts, especially between rock-hard glass and malleable flesh or other materials. Her attention to detailed surface textures, such as the ribbed "neck" of *Canopic Demijohn*, enhances the dialectic created in these works between interior and exterior, rigid and soft. The title here refers to two specific types of vessels: the ancient Egyptian canopic jar, where mummified organs were stored for safekeeping for the afterlife, and the European demijohn, a long, narrow-necked bottle typically used to hold water or alcohol. As the curator Ali Subotnick has written of Ursuţa, "Memory, death, the human condition, and the absurdity and irony of life are all inspirations for the artist. Her work is ripe with emotion and contradictions—pathos and humor, melancholy and hope, raw and refined, hard and soft, aggressive and tender. It's at times vulgar and political, poignant and wry, exotic and familiar."[3]

LOB

1. Andra Ursuţa, "Peer Inside the Otherworldly Studio of Andra Ursuţa, a Sculptor Who Transforms Horror-Movie Props into Eerie Totems," interview by Taylor Dafoe, *artnet news*, November 18, 2019, https://news.artnet.com/art-world/andra-ursuta-studio-visit-1706277.
2. Zoë Lescaze, "Andra Ursuţa at Ramiken #7," *Artforum* 58, no. 6 (February 2020), https://www.artforum.com/print/reviews/202002/andra-ursuta-81984.
3. Ali Subotnick, "Essay," Hammer Museum, UCLA (website), exh. (*Hammer Projects: Andra Ursuţa*) on view March 7–May 25, 2014, accessed August 20, 2022, https://hammer.ucla.edu/exhibitions/2014/hammer-projects-andra-ursuta.

108. *Canopic Demijohn*, 2021
Lead crystal
30½ × 15⅞ × 16 in. (77.5 × 40.3 × 40.6 cm)

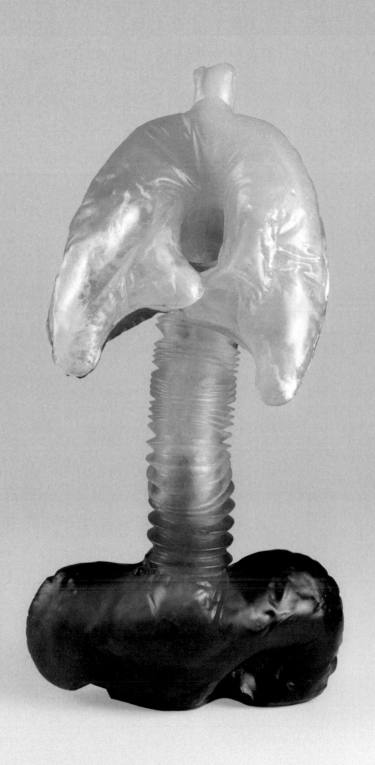

Tomashi Jackson

Born Houston 1980

Based in New York, the painter and printmaker Tomashi Jackson is known for breaking archival and contemporary photographs down into linear half-tones, printing them on canvas in layers, and then painting over them with vivid hues and bold, abstract geometry, often introducing additional elements of collage. She is also noted for excavating histories related to the dispossession, disenfranchisement, and displacement of Black and Brown communities. Still, as Holland Cotter observed in his *New York Times* review of the 2019 Whitney Biennial, Jackson's art is "as much about abstraction as it is about racial politics."[1] Perhaps a more precise way to put it is that Jackson mines the slippery relationship between abstract painting and identity—a topic well explored by the art historian Darby English with regard to an earlier cohort of Black artists, including Peter Bradley, Frederick Eversley, Alvin Loving, Raymond Saunders, and Alma W. Thomas.[2] For Jackson's body of work presented at the Biennial, she researched the razing of Seneca Village—the once-thriving Black middle-class community whose land the city seized through eminent domain during the creation of New York's Central Park—as well as echoes of similar policies in current municipal practices.

The artist received a BFA from the Cooper Union for the Advancement of Science and Art in 2010, an MS from the Massachusetts Institute of Technology's School of Architecture and Planning in 2012, and an MFA in painting and printmaking from the Yale School of Art in 2016. She began her career as a mural painter, working for several years as an apprentice to the Chicano muralist Juana Alicia (born 1953) in San Francisco. When she decided to embark on her solo practice, she returned to an interest she had had as an under-graduate in merging printmaking with painting: "At Cooper I learned very practical ways of making an image that reminded me of things I learned

following my mother around fixing things and in her work as an operating engineer. A lot of the practical concerns that govern printmaking are engineering concerns. They're wet-dry concerns, they're viscosity concerns, they're concerns around cleanliness. They're processes that are not up for any sort of conceptual or artistic debate. They are facts about how machinery and materials work and how images are made."[3] For her master's thesis at MIT, Jackson interviewed her mother about their family's suppressed history as domestic laborers. This established her approach of gathering oral histories to ground her work.

In her breakthrough solo exhibition *Forever My Lady*, held at Los Angeles's Night Gallery in 2020, Jackson engaged with archival images revolving around voting rights (she had recently been an artist-in-residence with ARCAthens in Greece, the birthplace of democracy) and, more specifically, around the suppression of Black voters' rights in the United States. *Girls Time (Heartbreak Hotel)* was a standout in the show. The painting consists of layers of printed and painted paper, vinyl, and fabric, all draped delicately atop an awning-like wood support that extends at a slight angle from the wall. The imagery presented in the work, drawn from political campaign materials and signage from the U.S. and Greece as well as archival and family photographs, is exceedingly compressed. Here, histories appear to collapse onto one another, literally and figuratively. LOB

1. Holland Cotter, "The Whitney Biennial: Young Art Cross-Stitched with Politics," *New York Times,* May 16 2019, https://www.nytimes.com/2019/05/16/arts/design/whitney-biennial-review.html.
2. Darby English, *1971: A Year in the Life of Color* (Chicago: University of Chicago Press, 2016).
3. Tomashi Jackson, interview by Maddie Klett, *Brooklyn Rail*, October 2021, https://brooklynrail.org/2021/10/art/Tomashi-Jackson-with-Maddie-Klett.

109. *Girls Time (Heartbreak Hotel)*, 2020
Archival flatbed print on PVC marine vinyl, with acrylic paint, paper bags, Pentelic marble dust, Greek canvas, fabric from Walmart, and American linen, mounted on handcrafted pine awning structure with brass hooks and grommets
8 ft. 11 in. × 6 ft. 9 in. × 1 ft. (271.8 × 205.7 × 30.5 cm)

Allison Katz

Born Montreal 1980

Allison Katz was trained at Montreal's Concordia University and at Columbia University in New York, where she studied under Amy Sillman, Jutta Koether, and Charline von Heyl (see pls. 64, 66, 71). Since receiving her MFA in 2008, the London-based artist has refused the umbrella of a single signature style. In addition to her painting practice, she makes ceramics and designs exhibition signage; for each of her shows, she creates a poster that functions as an artwork in its own right.

"Because I work in a representational mode there is an assumption about narrative, that the work is 'about' something, but that's not what motivates me," Katz has explained.[1] In her notebook, the artist keeps a record of her thoughts and experiences: biographical anecdotes, literary and art-historical references, and encounters, both mundane and noteworthy, from everyday life. She uses these as inspiration for her canvases—not to be illustrated, in any literal sense, but as a means of exploring the limitless associative possibilities of images. By presenting viewers with a stream of discordant elements—an assortment that refuses logical clarity, despite the fact that each individual image is recognizable in itself—she forces us to seek connections and ask questions, rather than offering any answers. As she notes, "I am attracted to images insofar as they can communicate a surplus of meaning."[2]

Over the past decade, Katz has developed an eccentric, curiously incongruent visual language comprising a number of recurrent motifs, including eggs and monkeys as well as cabbages; the green, leafy heads are typically rendered next to a man's shadowy profile, an image that began as a surrogate for her husband, the chef Philip Coulter, who was reluctant to pose for a portrait. Since 2011, Katz has been making paintings of roosters that she refers to as "cock paintings," relishing the discomfort of the term. As she has acknowledged, these works reference the male ego: "The paintings are about masculinity, and about trying to work out the iconography of power, and the attraction to it."[3] *The Other Side* depicts a rooster in motion through a series of overlapping silhouettes, speeding from left to right in a way that recalls Eadweard Muybridge's nineteenth-century photographic studies of moving forms. In each of the "cock paintings," Katz sprinkles grains of rice onto the canvas and paints over them, creating an impasto texture that reinforces the works' materiality in the face of painterly illusion.

The title and imagery of *The Other Side* draw on the timeless antihumor of the road-crossing chicken. Indeed, when installed at London's Camden Arts Centre in the artist's solo exhibition there in early 2020, the painting was hung so that it spanned a gap between two freestanding walls, enabling the bird to physically—and comically—cross from one to another. Much of Katz's work revels in this lack of a punchline, using humor, double entendres, riddles, and word association to compel viewers into drawing their own conclusions. Her focus on the ways language and naming conventions impact our understanding of images is fundamental to her conceptual strategy: "I don't think of jokes or wit or puns as frivolous—and I really believe in frivolity—because they're ways of defeating morality and your expectations. You also know your mind is on if you don't take a definition at face value."[4]

Katz involves herself in this wordplay and appears in her own works in both subtle and overt ways. Some paintings feature her likeness or the repeated profile of her nose as a signifier of self. Elsewhere, her signature, or an acronym or variation on the letters in her name—including "All Is On," "AKA," and "MASK" (Ms. Allison Sarah Katz)—forms one or more facial features in a graphic portrait. Another recurring motif is the wide-open mouth, borrowed from a woodcut by André Derain in an illustrated 1943 edition of Rabelais; in Katz's interpretations, the viewer occupies a position looking outward from behind the teeth. As she has explained, this allows her to "emphasize the non-order of things, from inside to out, as much as from outside to in."[5] For the artist, the act of painting—and the innovative strategies through which it is displayed—are a means of challenging perceptions and preconceived ideas, and of elevating the unexpected.　　HJ

1. Allison Katz, interview by Frances Loeffler, *White Review*, September 2015, https://www.thewhitereview.org/feature/interview-with-allison-katz/.
2. Allison Katz, "Confessions of a MASK: A Conversation with Camilla Wills," in *Allison Katz*, ed. Clément Dirié, exh. cat. (Geneva: JRP), 170.
3. Allison Katz, quoted in Francesca Gavin, "Beast in Show: Why Animals Rule the Art World," *Financial Times*, April 27, 2022, https://www.ft.com/content/2e9cf650-f934-425c-9bea-3bbaecb344b9.
4. Allison Katz, "Allison Katz: The Pleasure of Doubt," interview, *Border Crossings* 34, no. 3 (August 2015): 58.
5. Katz, "Confessions of a MASK," 173.

110. *The Other Side*, 2021
Oil on canvas, with grains of rice
4 ft. 7⅛ in. × 10 ft. 9⅞ in. (140 × 329.9 cm)

Firelei Báez

Born Santiago de los Caballeros, Dominican Republic, 1981

Born in the Dominican Republic to a Dominican mother and a father of Haitian descent, Firelei Báez spent her early childhood in the city of Dajabón. These formative years on the Dominican side of the deeply contested border between the island of Hispaniola's two neighboring countries fostered her enduring interest in the politics of place. Báez moved to the United States at the age of eight, then relocated from Miami to New York in 2002. Drawing upon diverse diasporic narratives, her paintings, works on paper, and installations conjure fantastical worlds, foregrounding stories of Black resistance through references to colonial history, Dominican folklore, and science fiction. Hers is fundamentally an art of layered storytelling. As the artist has said, "I like the idea of the palimpsest as revealing of time; these are a-temporal sagas, epic tales that you choose to time-travel within."[1]

Foregrounding Black women's bodies, which have been eclipsed in Western art history, and celebrating her own matriarchal upbringing, Báez frequently features strong women as protagonists in her projects. Among those who have inspired her are Marie-Louise Coidavid (1778–1851), the first queen of the independent Kingdom of Haiti, and Coidavid's daughters, Améthyste and Athénaïre, who were forced into exile in Pisa, Italy, after the death of the king, Henri Christophe, in 1820. Both daughters are depicted in *For Améthyste and Athénaïre (Exiled Muses Beyond Jean Luc Nancy's Canon), Anacaonas*, a site-specific installation first exhibited in a street-facing window of the Museum of Modern Art, New York, in 2018–19. The imaginary portraits are presented in decorative, colonial-style frames, but the background of canvas material painted and torn to resemble peeling wallpaper suggests the decline of colonial powers. The complex title seems to combat Western dominance (in the person of the French philosopher Jean-Luc Nancy [1940–2021]) while elevating a lesser-known Caribbean history (that of the defiant fifteenth-century Taíno cacique Anacaona). As in many of her works, the artist chose to represent her figures without noses or mouths—the features most often subject to racial stereotyping.

A recurring motif in Báez's work, seen here on Améthyste and Athénaïre, is the tignon, a knotted fabric headdress that all women of Black ancestry were forced to wear following the passage of sumptuary laws in Louisiana in 1786. To undermine this legislation, Black women conceived elaborate interpretations of the covering, transforming it into a mode of resistance and asserting their own agency.

Referencing the ongoing repercussions of their defiance, Báez has said, "The subversive beauty of these women's actions intrigued me. This outlawing of black women's hair inherently informs current policing and silencing of black women's bodies, and provides a potential pattern for resistance."[2]

Other depictions of women in Báez's oeuvre are more elusive. Typically portrayed in female form, with lustrous brown hair and backward-facing feet, the *ciguapa* is a mythical trickster in Dominican folklore that Báez uses to disrupt social and racial categorization. While the *ciguapa* emerges in many different guises in the artist's work, reflecting its transformative character, it is only the creature's legs and stylized locks of hair that appear from behind an explosion of vivid paint in another painting by Báez in the Shah Garg Collection, *Adjusting the Moon (The right to non-imperative clarities): Waning* (see fig. 1 on p. 90). The work's dazzling color—which the artist uses "as a way of opening up worlds"—draws on her memories of the intensity of Caribbean light.[3]

Báez also has a long-standing interest in maps, understanding them as historical documents intertwined with colonial power. By magnifying and printing old examples onto large canvases, then painting over them, she is able to disrupt the systems they depict and transgress the borders they outline. She is intrigued by their discolored and marred physical surfaces, and a number of her map paintings feature gestural applications of paint suggestive of fires, tsunamis, or explosions, evoking environmental catastrophes as well as the scenes of civil and political unrest that have dominated news reports in recent years. In a third work in the Shah Garg Collection, *temporally palimpsestive (just adjacent to air)* (see pp. 24–25) of 2019, Báez has laid calligraphic brushstrokes and splattered paint over a Works Progress Administration–commissioned architectural plan of Charity Hospital in New Orleans. Severely flooded by Hurricane Katrina in 2005, the decimated building remains abandoned to this day.　HJ

1. Firelei Báez, quoted in Rachel Kent, "Subversive Beauty," in *Artes Mundi 9: Firelei Báez*, exh. cat. (London: Black Dog, 2021), n.p.
2. Firelei Báez, "Firelei Báez: In Conversation with Naima J. Keith," in *Firelei Báez: Bloodlines*, ed. María Elena Ortiz, exh. cat. (Miami: Pérez Art Museum Miami, 2015), 21.
3. Firelei Báez, quoted in Siddhartha Mitter, "In Boston, Art That Rises from the Deep," *New York Times*, July 2, 2021, https://www.nytimes.com/2021/07/02/arts/design/28firelei-baez-ica-boston.html.

111. *For Améthyste and Athénaïre (Exiled Muses Beyond Jean Luc Nancy's Canon), Anacaonas*, 2018
Oil on canvas over wood panel, with hand-painted wood frames
Overall 10 × 21 ft. (304.8 × 640.1 cm)

Nathlie Provosty

Born Cincinnati 1981

Nathlie Provosty is an American artist based in Brooklyn. She earned a BFA at the Maryland Institute College of Art in 2004 and spent the following year painting in India on a Fulbright fellowship. In 2007, she received an MFA from the University of Pennsylvania. Of her work, the artist Shirin Neshat has said, "Nathlie Provosty represents a new generation of painters with a fresh relationship and engagement with abstract and minimal art. Her work carries strong emotional force and resonates mysticism of an unknown nature."[1] In 2018–19, for Provosty's first solo exhibition in Europe, she presented three canvases in the richly decorated seventeenth-century palazzo that houses the Museo Nazionale del Risorgimento in Turin, Italy, in conjunction with a sound installation by Andrea Costa of the pioneering Torinese synth band Monuments. She has also collaborated with writers such as the acclaimed Beat and post-Beat poet Anne Waldman (born 1945).

Provosty's art is primarily engaged with materiality and perception. She uses the subtle, highly tactile qualities of oil paint to create canvases that physically interact with light and the environment, resulting in compelling visual oscillations. An excellent example of this is *Photopia*. The entirely white painting was included in a group exhibition at the Brussels gallery Maruani Mercier in 2018. While many of Provosty's paintings of that period consist of a single color—black, white, or a mild, tinted green—the artist would likely remind us that "white" is never really white, just as black is never just black, and green is similarly composed of sundry and surprising hues.

The canvas appears to have been divided into a grid of four quadrants, across which a thick, curving swath, a bit like a sine wave, glides uneasily. "The interactions of the quadrants was a visual/intuitive process," Provosty has said of an earlier but similar body of work. "Once I decided where they would go, the movement became decided by color/space needs (what goes forward or back, warm or cool, range and harmonies)."[2] Importantly, the artist breaks out of the inflexibility of the grid and all the art-historical weight grids carry with them (see, for instance, Rosalind E. Krauss's famed essay "Grids" in her 1985 collection *The Originality of the Avant-Garde and Other Modernist Myths*). Here, instead of adhering to a rigid structure, Provosty shifted each of the quadrants ever so slightly, so that the symmetry of swooshing line that runs across the painting is not perfect but rather just a bit off. Perhaps her intention was to underscore what it means to have just a little bit of space between the quadrants. The painting recalls a text the artist wrote in 2019 for the *Brooklyn Rail*:

> Recently a friend said, "You know we never really touch each other." Yes, I remember reading that article in the Times, about how on the atomic level there is always space between us, between fingers and flesh. The comment had a note of cynicism, and implied "we never can touch each other." The absurdity is, we feel each other all of the time without touching, someone's presence in the room, their pleasure, their pain, our love.
>
> "To feel" and "to touch" handle massive vistas of meaning: the words traverse matter and emotion simultaneously and paradoxically. With such sweeping responsibility—the multitudes of expression they're required to transmit—comes the necessity for explanation and qualification. As singularities, or when generically articulated, touch can feel numb.[3]

"Numb" is not a word this work evokes, however, despite its seemingly clinical approach and appearance. *Photopia* emits an open warmness, thanks to a process that delicately balances the universality of geometric abstraction with the specificity of subjective perception. Reviewing the artist's 2018 solo exhibition at New York's Nathalie Karg Gallery, titled *My Pupil Is an Anvil*, for the *Brooklyn Rail*, the critic Will Fenstermaker remarked, "Provosty's paintings are designed to be looked at, experienced before being contemplated."[4]

LOB

1. Shirin Neshat, quoted in "The Women Artists Who Deserve Our Attention, According to 9 Leading Artists," *Artsy Editorial*, March 1, 2020, https://www.artsy.net/article/artsy-editorial -women-artists-deserve-attention-9-leading-artists.
2. Nathlie Provosty, quoted in Laila Pedro, "Paintings That Sensuously Shift in Tone and Texture," *Hyperallergic*, April 29, 2016, https://hyperallergic.com/294712/paintings-that -sensuously-shift-in-tone-and-texture/.
3. Nathlie Provosty, "Critics Page," *Brooklyn Rail*, December 2019–January 2020, https://brooklynrail.org/2019/12 /criticspage/Nathlie-Provosty.
4. Will Fenstermaker, "ArtSeen: Nathlie Provosty; *My Pupil Is an Anvil*," *Brooklyn Rail*, April 2018, https://brooklynrail .org/2018/04/artseen/nathlie-provostyMy-Pupil-is -an-Anvil.

112. *Photopia*, 2018
Oil on linen
92⅛ × 83⅞ in. (234 × 213 cm)

Melissa Cody

Born No Water Mesa, Arizona (Navajo Nation), 1983

Melissa Cody was raised largely in Leupp, Arizona, in one of the 110 chapters that constitute the Navajo Nation; she also lived in Southern California and Texas, as her father's work as a carpenter caused the family to move frequently. In 2007, she graduated from the Institute of American Indian Arts in Santa Fe, New Mexico, with a BA in studio art and museum studies. After college, she interned at the Museum of International Folk Art in Santa Fe and the National Museum of the American Indian in Washington, DC, before turning to art full-time. She is currently based in Long Beach, California.

Cody is a fourth-generation textile artist who began weaving at the age of five. As a child, she watched her mother, Lola Cody, and her grandmother Martha Schultz, along with other family members, work at the loom, and the women encouraged her to experiment and explore her own abilities as a weaver. Cody specializes in the Germantown Revival style, based on a traditional Diné (Navajo) manner of weaving that dates to the period of the so-called Long Walk—the United States government's attempted ethnic cleansing of the Diné people between 1864 and 1866, in which the Diné were deported from their land in present-day Arizona to an internment camp in Bosque Redondo, New Mexico. Supplied with worsted (medium-weight) yarn that had been commercially milled in Germantown, Pennsylvania—significantly, in a range of colors previously not available to them through natural dyeing processes—Diné weavers created brightly colored textiles in their own styles. "Characterized by vibrant hues, diamond patterning, stacked geometric forms, and overlapping jagged lines, these designs suggest the illusion of movement. At the end of the nineteenth century, Navajo weavers began to make rugs in this vein for domestic trade, tourists, and export," the art historian and curator Manuela Well-Off-Man noted in a biography of Cody in the catalogue for an exhibition of Native American art since 1950 mounted at Crystal Bridges Museum of American Art in Bentonville, Arkansas, in 2018–19.[1] Cody weaves on a traditional Diné loom with Germantown-style wool yarn. Her works are recognized for merging the blocky, pixelated look of 1980s-era video games (think Atari, NES, and Sega) with long-standing Diné symbols (such as the "whirling log" motif that resembles a swastika and is a Diné sign for good fortune) and Germantown designs as well as personal references; together, these disparate elements accelerate the sense of movement described above. Moreover, Cody's tapestries often incorporate patterns suggestive of television static, or "snow." Indeed, there are parallels between pre-digital television's interlaced signal, the loom's methodical encoding of yarn into patterned or image-bearing cloth, and the way in which text is printed: all happen line by line.

In *The Three Rivers*, Cody reinterprets established Germantown styles with geometric overlays and plays with scale, asymmetry, and curvature to enhance the dimensionality of the design. Her juxtaposition of patterns in a panoply of secondary and tertiary colors achieves a magnificent depth here, breaking from a conventionally flat plane into something much more intoxicating. While Cody initially worried that her elders would not appreciate her refreshing of the medium, she believes that younger generations must engage with and adapt this ancient craft. As she has remarked:

> Art isn't stagnant. Cultures aren't stagnant. . . . The work that is considered traditional now wasn't considered traditional when it was first made. The weavers were influenced by what was around them—by traders, by the railroad, by current events. We need to go back to that mentality and have work on the loom that is reflective of our personal stories of today and of this current generation.[2]

LOB

1. Manuela Well-Off-Man, "Melissa Cody," in *Art for a New Understanding: Native Voices, 1950s to Now*, by Candice Hopkins, Mindy N. Besaw, and Manuela Well-Off-Man, exh. cat. (Fayetteville: University of Arkansas Press, 2018), 150.
2. Melissa Cody, quoted in Jennifer Levin, "Weaving the Modern Stories: Melissa Cody," *Santa Fe New Mexican*, August 3, 2018, https://www.santafenewmexican.com/pasatiempo/art/weaving-the-modern-stories-melissa-cody/article_3b04107e-9cf5-57e8-8978-cf583e25d1fe.html.

113. *The Three Rivers*, 2021
Wool and aniline dye
10 ft. 7 in. × 3 ft. 6 in. (322.6 × 106.7 cm), not including tassels

Maja Ruznic

Born Brčko, Yugoslavia (now Bosnia and Herzegovina), 1983

With the outbreak of the Bosnian War in 1992, Maja Ruznic and her mother fled their home in present-day Bosnia and Herzegovina, living in refugee camps in Austria and elsewhere before immigrating to San Francisco in 1995. The artist's work is deeply informed by this childhood trauma and the experiences of loss, poverty, and linguistic alienation that characterized her early years in Europe and the United States.

After training at the University of California, Berkeley, and California College of the Arts, where she received her MFA in 2009, Ruznic began her career in her San Francisco bedroom, painting watercolors. The fluidity of the medium, as well as the formative influence of the color fields of Helen Frankenthaler (1928–2011) and Mark Rothko (1903–1970), facilitated the development of a loose and spontaneous approach—one that Ruznic has retained since switching to oil paint in the mid-2010s. The artist does not use preliminary sketches or references. Instead, she likens the process of creating a composition to evoking a memory or remembering a dream. "I never approach a painting with an idea," she has explained. "I check in with my gut, feet, thumbs, throat, which allows for shapes and colors to emerge in my mind's eye. It's like activating pressure points in my body, which in turn gives me imagery that appears abstract at first and through the process of painting, becomes more recognizable."[1] Working with what she has referred to as the "drunken hand," she first stains the canvas with translucent layers of oil paint, thinned with Gamsol-brand solvent.[2] From this starting point, she then allows the composition to emerge. As she layers and scumbles paint, rudimentary outlines suggestive of bodies and landscapes appear. Ruznic often works with soft-bristled makeup brushes, which keep the weave of the canvas visible through the paint.

In 2017, Ruznic began making fabric sculptures, which she titles *Phantoms*, by stitching together and stuffing scraps of old clothing. While she initially conceived these as a way of keeping her hands away from her paintings-in-progress so that they might "breathe," the sculptures evolved into unsettling works that embody the psychological anguish of the artist's early years. Speaking of the impact of those experiences, Ruznic has said, "Surviving a war has taught me that sharpness, emotional as well as physical, creates division and perpetuates violence."[3] Instead, she strives for "softness" in her work, using her interest in mythology, Slavic paganism, and healing practices such as shamanism to explore human suffering in a compassionate way. As she has explained, "I see myths and stories as having more welcoming shapes—soft and round like stuffed animals."[4]

Much of Ruznic's work of the late 2010s is characterized by soft, nebulous forms and muted, sandy tones—a reflection, perhaps, of her relocation to the dusty landscape of Roswell, New Mexico. Her most recent paintings, however—made after the birth of her first child in July 2020—are dark and somber. Depicting figures clustered into various family units, they suggest the panic of becoming a mother in the forced isolation of a global pandemic and articulate the artist's struggles with postpartum depression, anxiety, and insomnia. Over time, Ruznic grew to see a possibility in her predicament and turned to painting during sleepless nights. Works produced during this time conjure shadowy worlds that consider the ways in which color is perceived in darkness: "I am trying to create a sense of otherworldliness through color. I am really playing with color relationships and provoke that half-in-sleep, half-awake state."[5]

Part of this body of work, *Father (Consulting Shadows I)* depicts a mysterious, possibly ritualistic scene in which a crying father cradles a child. The light of a glowing full moon falls upon both figures through a series of interconnected geometric shapes. Fathers are a frequent reference point in Ruznic's work, channeling the specter of her own absent and unknown parent. "Painting has become a way for me to touch what I couldn't reach," she has said.[6] This sense of melancholy remains at the heart of her practice. HJ

1. Maja Ruznic, "Myths Full of Darkness and Suffering Beautifyly [sic] Told by Maja Ruznic," interview by Christina Nafziger, *ArtMaze Magazine*, September 13, 2018, https://artmazemag.com/myths-full-of-darkness-and-suffering-beautifyly-told-by-maja-ruznic/.
2. Maja Ruznic, "Texas Studio: Maja Ruznic," interview by Ashley Jones, *Arts and Culture Texas*, October 8, 2019, http://artsandculturetx.com/texas-studio-maja-ruznic/.
3. Ruznic, "Myths Full of Darkness and Suffering."
4. Ibid.
5. Maja Ruznic, quoted in Christina Stock, "Art: *In the Sliver of the Sun*—Maja Ruznic," *Roswell Daily Record*, March 14, 2021, https://www.rdrnews.com/arts_and_entertainment/vision/art-in-the-sliver-of-the-sun-maja-ruznic/article_60932bdd-1526-54de-a251-c6878e529858.html.
6. Maja Ruznic, quoted in Annie Godfrey Larmon, "Who Speaks Shadows," in *Maja Ruznic: In the Sliver of the Sun*, ed. Nicole Dial-Kay and Hariz Halilovich, exh. cat. (New York: Karma, 2021), 15.

114. *Father (Consulting Shadows I)*, 2021
Oil on linen
94 × 76 in. (238.8 × 193 cm)

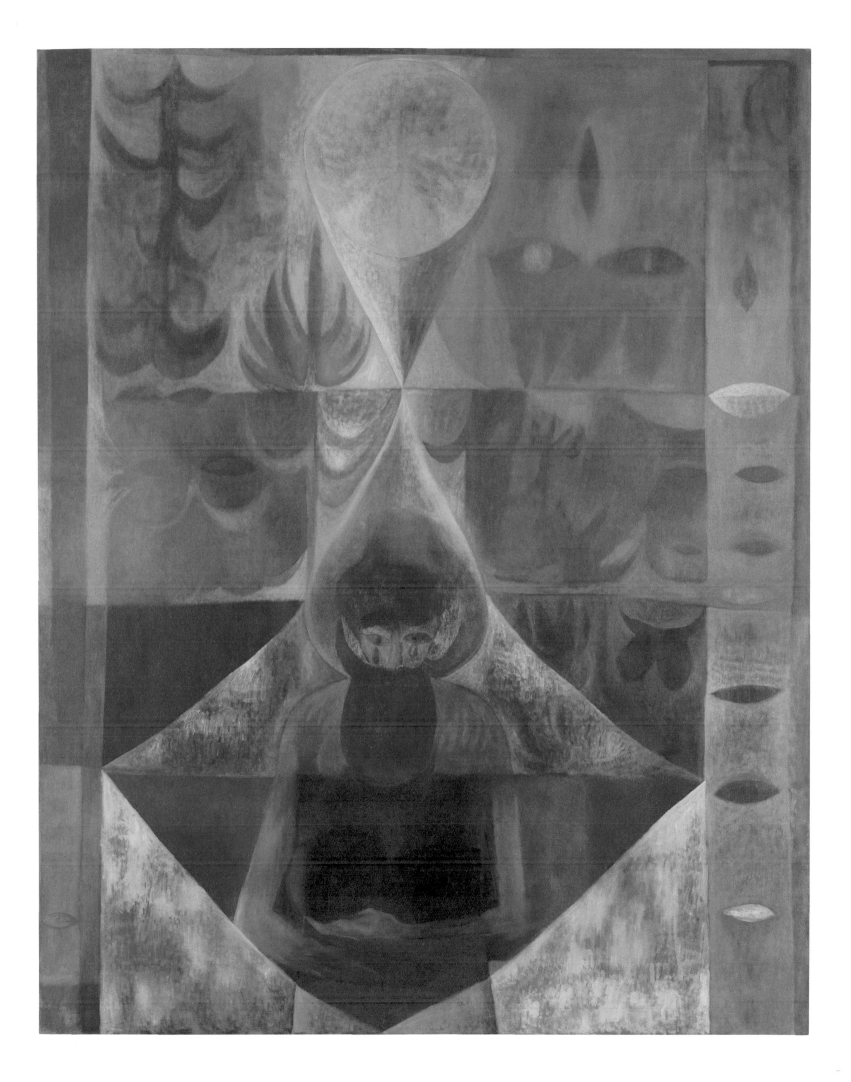

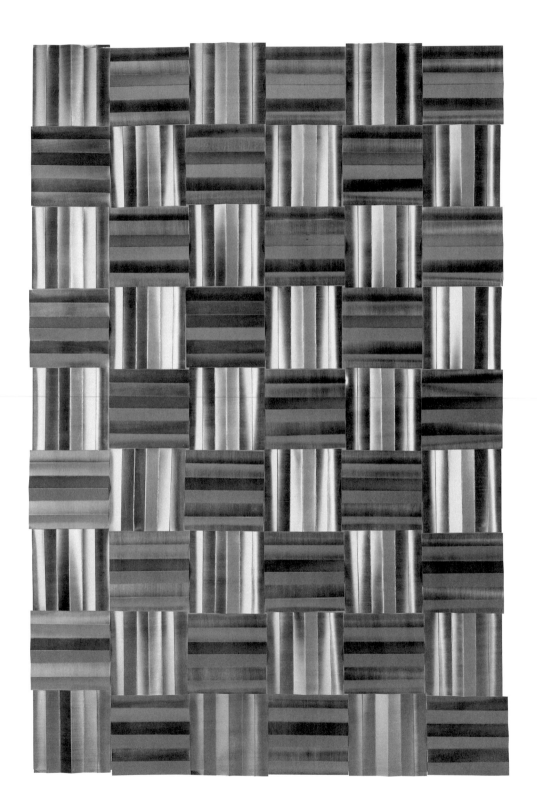

Ayesha Sultana

Born Jessore, Bangladesh, 1984

Ayesha Sultana's unmistakable, extraordinary drawings are inspired by the landscape and architecture of Dhaka, the capital of her native Bangladesh. Engrossed by the shapes and geometric patterns she discovers in windows, gates, and other elements of the built environment throughout the city, she reproduces these motifs in shimmering, graphite-dusted low reliefs made of paper that she cuts and reassembles into grids or amorphous, angular forms. In 2014, the artist's first solo exhibition with the gallery Experimenter in Kolkata, India, brought together a series of these works, including *Outside the Field of View IX* (2014), which references the corrugated tin roofs of Dhaka. Sultana replicated the unique pattern of their grooves in the work, reassembling the darkened paper at angles to create a fascinating play of light. "This body of work is quite ambiguous to me," she has said, "even though I've been working on it for a while now. From a material point of view, the fact that it's just paper and graphite is interesting because it's just two very basic drawing materials."[1]

Sultana received a BFA in 2007 and a postgraduate diploma in art education in 2008, both from the Beaconhouse National University in Lahore, Pakistan. She is a member of the Dhaka-based, artist-run nonprofit organization Britto Arts Trust, which "provides a platform for the development of professional artists, a place where they can meet, discuss and upgrade their skills on their own terms."[2] While she employs various techniques in her practice—including photography, sculpture, and painting—she is best known for her works on paper made through fastidious acts of folding, cutting, layering, and scratching. In their glinting, faceted surfaces, Sultana makes evident what is ordinarily ignored.

Driven by her interest in abstraction and Minimalism, Sultana's art goes against the grain of much South Asian art, which, if anything, is defined by a maximalist tendency. "When I started the series, I had this interest in painting—in how to create perspective and depth, so this relationship between the two-dimensional and the three-dimensional

was kind of intriguing to me. At first, I started making these small paper constructions," she explains, adding:

> It started off as folded paper. Simultaneously, I was doing other things, where I was filling up large sheets of paper with different types of pens, which created their own surface quality or sheen, and their own reflective quality. The folding came first, and then the other aspect of how I treat the paper. It has multiple layers of graphite powder, rubbings, and then sometimes I use graphite sticks for the final coats, and of course I fix it in between with spray. I've also worked with different types of paper over the years. I think each has its own gradations of grey and density and richness, so that's also quite playful to me.[3]

For *Shift 4*, Sultana covered acid-free paper with layers of graphite, allowing the movements and touch of her hand to remain visible. She then cut and folded the paper into the three-dimensional forms that we see. As a result of gaining spatial depth, the piece appears almost like a slab of corrugated iron, or a sheet of brushed steel. While Sultana continues to engage with diverse materials and techniques, in recent years she has turned her attention to painting. In *Over the Edge* (2019), a suite of four blue canvases, for example, she experimented with space and depth through variations in the density of the acrylic paint. And in *Miasms*, of the same year, she stained tissue paper with ink in various jewel tones and massaged it into a rippled, organic take on color-field painting. LOB

1. Ayesha Sultana, "Ayesha Sultana's Intentional Geometries: In Conversation with Murtaza Vali," *Ocula Magazine*, October 7, 2020, https://ocula.com/magazine/conversations/ayesha-sultana/.
2. "About Britto," Britto Arts Trust (website), accessed February 12, 2022, http://brittoartstrust.org/home/about-britto.
3. Sultana, "Sultana's Intentional Geometries."

115. *Shift 4*, 2016
Graphite on folded paper, mounted on aluminum composite panel
36¼ × 24 in. (92.2 × 61 cm)

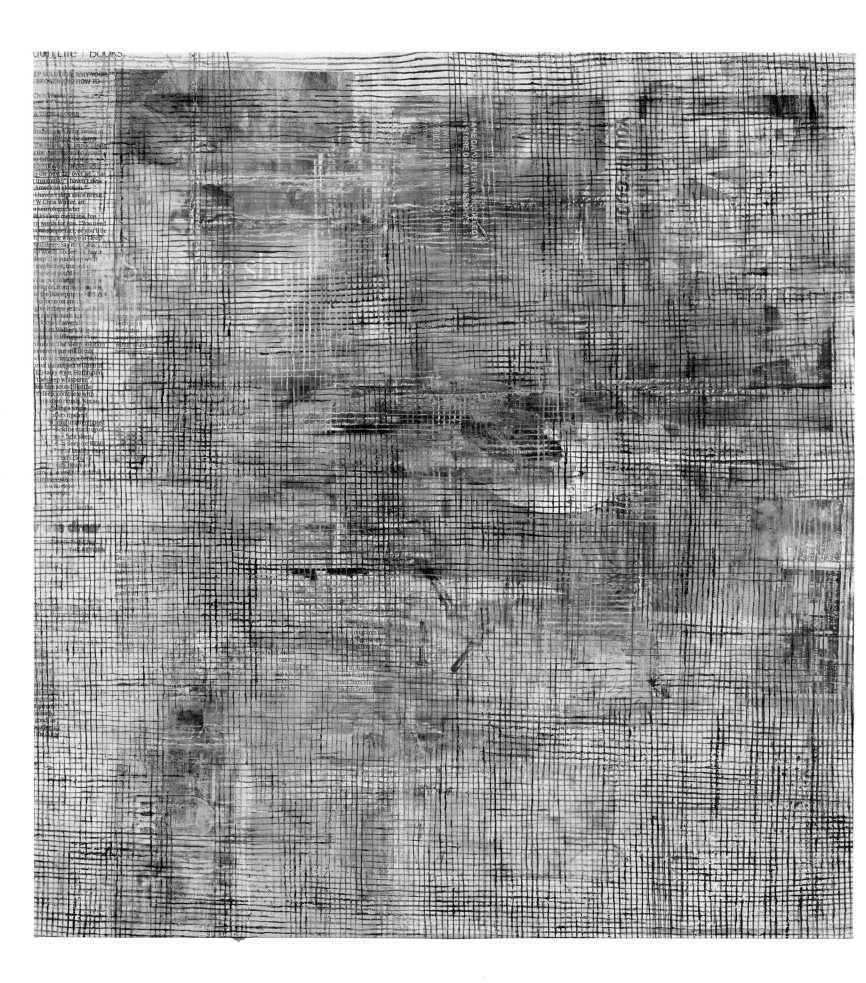

Mandy El-Sayegh

Born Selangor, Malaysia, 1985

The London-based artist Mandy El-Sayegh takes an interdisciplinary approach to her vocation, working in painting, sculpture, drawing, printmaking, installation, performance, video, and sound. Her art revels in the breakdown of systems of order, whether bodily, linguistic, or political. She received a BFA in 2007 from the University of Westminster, London, followed by an MFA in painting in 2011 from the Royal College of Art. The artist began her ongoing *Net-Grid* series of paintings in 2010, while still in graduate school. Then, she took a five-year hiatus from the art world, working as a caregiver for autistic young adults, before finding a foothold in 2017 with a group exhibition curated by the Canadian artist Marcel Dzama for the Independent art fair in Brussels and another group show organized by the Lebanese curator Christine Tohmé for the thirteenth edition of the Sharjah Biennial.

The *Net-Grid* paintings often start with newspaper clippings, fragments of her father's Arabic calligraphy, and other found elements. El-Sayegh silkscreens this imagery directly onto canvas to create a substrate for her dense, layered painting process. Over the serigraphy she applies layers of emulsion and additional mixed-media materials, varying the opacity across the series to obscure or reveal in different degrees. On top, she paints by hand the simple, repetitive pattern of a grid. This framework acts as a schematic that attempts to contain the fractured words, images, and materials that circulate through the work. The referent for El-Sayegh's original grid was "a tailor or seamstress grid, a 1cm squared red grid on white paper used to cut parts for garments.... The resulting *Net-Grid* paintings are a grill or vent—with a porosity, a transparency, and a barrier function, which frustrates reading."[1]

Despite often being read within lineages such as Abstract Expressionism, collage, and Matterism, El-Sayegh's works are oriented less toward art history than toward the structures that govern contemporary life. Often implying a latent violence within these structures, El-Sayegh's works evoke the highly chaotic and often disturbing ways social and political events unfold. Explanations and justifications, devised to impose some semblance of order—like the grid—appear only after the fact. Despite the tenuous containment offered by the grid, her paintings often feel flabbergasted by the onslaught of images and references in them. Amid the handwritten texts and journalistic excerpts,

mostly obscured by paint, there are also slashes and bruise-like passages of color suggestive of injuries. Bodies appear as disconnected forms, having been reproduced from sources ranging from advertisements and pornography to anatomy textbooks. Through this corporeal imagery, El-Sayegh explores the construction of the self as fragmentary and incomplete. As she has noted, "It's a forensic thing, I'm laying it all out. I want everything in there, the political, the sexual . . . there is a terror in excess."[2]

El-Sayegh believes that through close observation and reflection—the study of the self, for example—one can better understand the constant state of flux in which our world exists. "I think a problem is a practice, and how you apprehend that problem is the work," the artist said in an interview published in the brochure that accompanied her 2019 solo exhibition at London's Chisenhale Gallery.[3] She has further likened her method—dealing with a problem by repeating it against a blank, formal space to see what rises to the surface—to psychoanalysis. Like therapy, her work reminds us how something that is significant yet unpremeditated can come into being through a series of micro-interactions and repetitions. For the artist, the fragments of collage in her work are the "parts" that possess the power to disrupt the "whole" of such overarching structures and assumed truths.

"I imagine [them] like a family," El-Sayegh has said of her canvases to date. "The groupings and colors, my father's writings—which I often don't understand myself. It's about how I turn these personal things into a universal thing. It starts on such a base level—latex, paper, this stuff I've collected—then I have to raise it. So, it ends up not being about me, but I'm in there."[4] LOB

1. Mandy El-Sayegh, "In the Studio with Mandy El-Sayegh," interview by James Ambrose, *émergent magazine*, no. 6 (April 2021), https://www.emergentmag.com/interviews/mandy-el-sayegh.
2. Mandy El-Sayegh, quoted in Darren Flook, "Mandy El-Sayegh: 'I Want Everything in There, the Political, the Sexual . . . There Is a Terror in Excess,'" *The Guardian*, April 11, 2019, https://www.theguardian.com/lifeandstyle/2019/apr/11/mandy-el-sayegh-up-and-coming-artist-east-london-exhibition.
3. Mandy El-Sayegh, quoted in "Mandy El-Sayegh at Chisenhale," exh. brochure, Chisenhale Gallery, London (website), exh. on view April 12–June 9, 2019, accessed July 25, 2022, https://chisenhale.org.uk/wp-content/uploads/Mandy-El-Sayegh_Exhibition-Handout_website.pdf.
4. El-Sayegh, quoted in Flook, "El-Sayegh: 'I Want Everything.'"

116. *Net-Grid (red event 2)*, 2020
Oil, silkscreen, and mixed media on linen
92½ × 88⅝ in. (235 × 225 cm)

Helen Marten

Born Macclesfield, Cheshire, UK, 1985

Helen Marten is an English artist who lives in London and works in sculpture, installation art, and video. She studied at London's Central Saint Martins College of Arts and Design in 2004 and at the Ruskin School of Drawing and Fine Art at the University of Oxford from 2005 to 2008. After winning the inaugural Hepworth Prize for Sculpture in November 2016, Marten announced that she would share the prize money with the three other nominated artists, saying, "In the light of the world's ever lengthening political shadow, the art world has a responsibility to show how democracy should work. I was flattered to be on the shortlist and even more so if my fellow nominees would share the Prize with me." The artist added, "Here's to a furthering of communality and a platform for everyone."[1] The following month, she won the Turner Prize.

Marten's works examine language, logic, and embodiment through a dizzying cacophony of materials and with an objective that might be construed as "question[ing] the stability of the material world and our place within it."[2] *A Starling Orbit (real facts, real fiction)* was included in *Sparrows On the Stone*, the artist's 2021 exhibition at Sadie Coles HQ in London. Of the show, the *Guardian*'s art critic Adrian Searle noted:

> Marten's new show "Sparrows On the Stone" spells out an SOS in its title. Little wonder; the prolixity and diversions and endless details of this vast agglomeration of paintings, sculptures, and objects threaten to drown you or cast you gasping on the beach. Too much to look at, too many things to account for, too many signs and images, too much detail, too many things all at once, and too many words. Excess is central to what [Marten] does. She wants you to lose yourself.[3]

The layout of the exhibition sketched a stick figure lying on the ground—a human body reduced to head, trunk, and limbs. "A stick figure is not grotesque or contorted, it is an economical shorthand—a sanitizing of the overwhelming physicality of all bodies, but also a skeleton format upon which to hang the filth: it is the 'raw bones' in many analogical terms," Marten said in an interview.[4] "It is more than an armature," Searle argued. "Open-armed, the legs splayed symmetrically, the head nearest the entrance, the whole thing mapped out in black steel rebar, with a number of free-standing walls, following the same schematic outline, on which hang a series of very large paintings, each of which took months of work."[5]

A Starling Orbit dominated the front right arm of the stick figure (each limb had a front and a back). The painted component of the work, made through an exacting screen-printing process, displays a complex array of layered floral abstractions. Next to the picture sits a faceless, padded dummy on a slatted wood chair, with three small dioramas placed on the floor at its feet (one is labeled "Real Fiction," and another, "Real Facts"). The journalist Amah-Rose Abrams posited that the painting "appears to show the thoughts" of the dummy below it. Certainly, here and in Marten's other works, the process of thinking—possibly her own, possibly that of some animal or alien intelligence—is made visible and tangible.

Marten also imbues her wild installations with found imagery, everyday objects in states of decay, and snippets of text from fiction or poetry—all sculptural materials to her. As the critic Brian Dillon aptly put it, "What are [Marten's] sculptural chains of obscure relation if not actually sentences of a kind, structured and polished but somehow also botched and obscure?"[6]

LOB

1. Helen Marten, quoted in Clarisse Loughrey, "Hepworth Sculpture Prize Winner Vows to Share £30,000 Winnings with Other Nominees," *Independent* (UK), November 18, 2016, https://www.independent.co.uk/arts-entertainment /art/news/barbara-hepworth-prize-helen-marten-30000 -winnings-split-nominees-a7424291.html.
2. "Helen Marten," Sadie Coles HQ (website), accessed August 2, 2022, https://www.sadiecoles.com/artists/28 -helen-marten/.
3. Adrian Searle, "Helen Marten Review—Turner Winner's New Show Leaves You Gasping," *The Guardian,* September 3, 2021, https://www.theguardian.com/artanddesign/2021 /sep/03/helen-marten-review-sadie-coles-london.
4. Helen Marten, "Bodies That Matter: An Interview with Helen Marten," by Amah-Rose Abrams, *The Quietus*, October 9, 2021, https://thequietus.com/articles/30652 -helen-marten-sparrows-on-the-stone-sadie-coles-interview.
5. Searle, "Marten Review."
6. Brian Dillon, "Helen Marten at Sadie Coles," *London Review of Books* 43, no. 20 (October 21, 2021), https://www .lrb.co.uk/the-paper/v43/n20/brian-dillon/at-sadie-coles.

117. A Starling Orbit (real facts, real fiction), 2021
Nylon-based ink on fabric, aluminum, ash frame, steel, maple, fabric, zippers, cross-stitch embroidery, cast Jesmonite, painted balsa wood, cast pewter, marbles, cotton, bitumen paper, ballpoint pen, beads, paper bag, chamois leather, milk-bottle tops, black sand, and steel rebar
Overall dimensions variable, frame of painting 10 ft. 2⅛ in. × 8 ft. 2⅜ in. × 3⅜ in. (310.2 × 249.9 × 8.6 cm), bench 48⅛ × 78¾ × 26 in. (122.2 × 200 × 66 cm), stuffed figure 67½ × 21¼ × 7⅞ in. (171.5 × 56.5 × 20 cm)

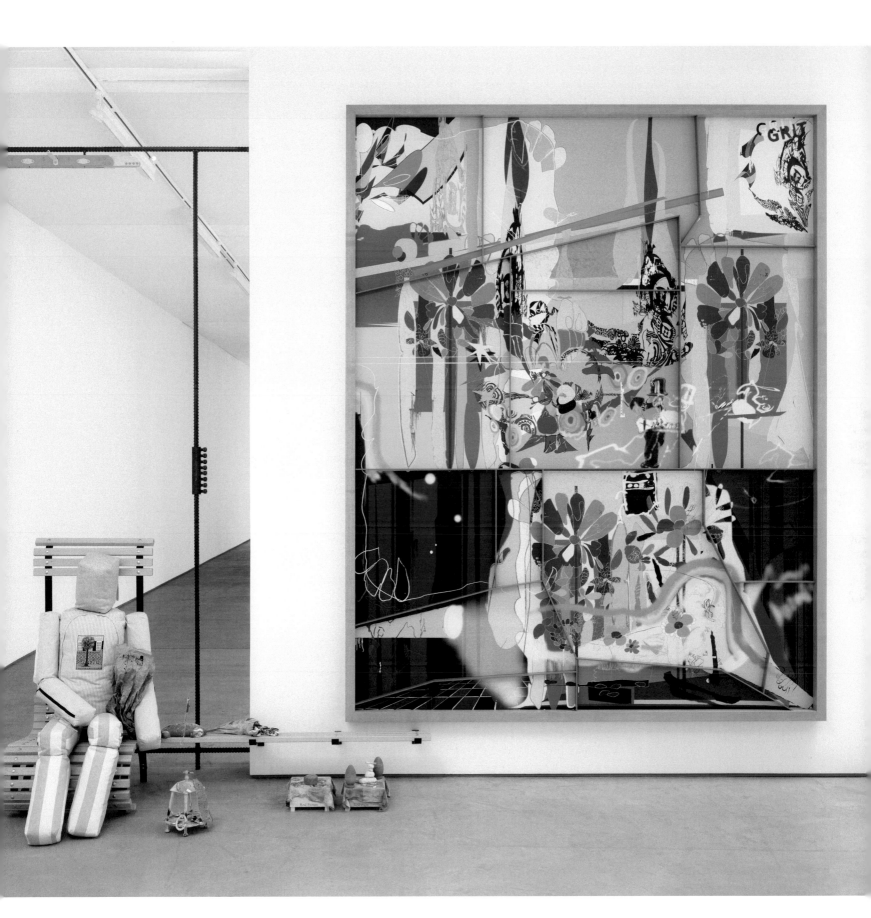

Toyin Ojih Odutola

Born Ilé-Ifẹ̀, Nigeria, 1985

The New York–based artist Toyin Ojih Odutola received her BA from the University of Alabama in Huntsville in 2008 and her MFA from San Francisco's California College of the Arts in 2012. She has earned popular and critical acclaim for her large-scale, often life-sized, multimedia drawings made with ballpoint pen, pencil, charcoal, and/or pastel, which she typically presents in series, or "chapters." Since 2011, themes in her work have included the pliability of value, memory, and power, expressed through portraiture and compelling visual storytelling. Her diverse representations of Black women and men are distinguished by an unmistakable hatching technique, sometimes as sharp and linear as a woodcut, elsewhere more fluid and blended. She uses a variety of textures and colors in her mark making to convey the depth and tonal variety of Black skin: "multilayered, mobile, full of depth and character, earthy, imperfect, but beautiful," as the novelist Zadie Smith has described it.[1] In so doing, the artist defies any and all ideas of a monolithic Blackness.

The scenes Ojih Odutola portrays range from bourgeois and banal to understatedly luxurious; at either end of that spectrum, her focus is on everyday but often unnoticed Black life. The artist's subjects, such as the seated woman in *This Side of Paradise*, tend to be contemplative and at ease. Here, the sitter gazes out a window over a cup of coffee. The work was featured in Ojih Odutola's exhibition *Testing the Name*, on view at the SCAD Museum of Art in Savannah, Georgia, in 2018. As the artist asserted in an introductory wall text, the show offered "rarely exhibited portraits of the Omodele family," an aristocratic Nigerian house whose "members have been instrumental in fields of trade, ambassadorship, and governance." The text went on to explain that the exhibition was intended to honor the family's legacy and arose from a collaboration between the museum, Lord Temitope Omodele, and his husband, Jideofor Emeka, 19th Marquess of the UmuEze Amara clan.

In truth, these families, united through same-sex marriage, are a richly conceived invention of the artist's and a response, on her part, to the severe infringement of rights currently being experienced by lesbian, gay, bisexual, and transgender people in Nigeria. The exhibition's entire conceit was underlined by the signature at the bottom of the wall text: "Toyin Ojih Odutola, Deputy Private Secretary, Udoka House, Lagos." When asked in 2020 what attracts her to such elaborate fictional worlds, the artist replied, "As I started working professionally, I realized that what I really like is telling stories. It freed me up from being beholden to my own story. My story's not that interesting. You can find out where I was born on Google. What I'm interested in is the 'could'—the possibility of something—not the 'should' or the 'would.'"[2] This echoes another of Zadie Smith's observations:

> "If only" is the sign under which Ojih Odutola works. If only slavery had never happened. If only African families had never been broken and serially traumatized. If only Africa's wealth had never dispersed to the four corners of the globe or her tribal differentiations been lost in the wanderings of her diaspora.[3]

In Ojih Odutola's work, so full of detail and texture, the possibilities of an "Afroternative" (Smith's coinage) to reality seem boundless and open. Her outstanding compositions rethink not only the genre of portraiture but, in broader philosophical terms, representation in general. LOB

1. Zadie Smith, "What Would It Be Like if Racism Never Existed?," *Vogue* (UK), June 4, 2018, reprinted in *The UmuEze Amara Clan and the House of Obafemi*, by Toyin Ojih Odutola et al. (New York: Rizzoli Electa, 2021), 16.
2. Toyin Ojih Odutola, "Artist Toyin Ojih Odutola: 'I'm Interested in How Power Dynamics Play Out,'" interview by Killian Fox, *The Guardian*, August 1, 2020, https://www.theguardian.com/artanddesign/2020/aug/01/artist-toyin-ojih-odutola-through-drawing-i-can-cope-with-racism-sexism-cultural-friction.
3. Smith, "What Would It Be Like," 14.

118. *This Side of Paradise*, 2017
Charcoal, pastel, and graphite on paper
56¼ × 50⅜ in. (142.88 × 127.95 cm)

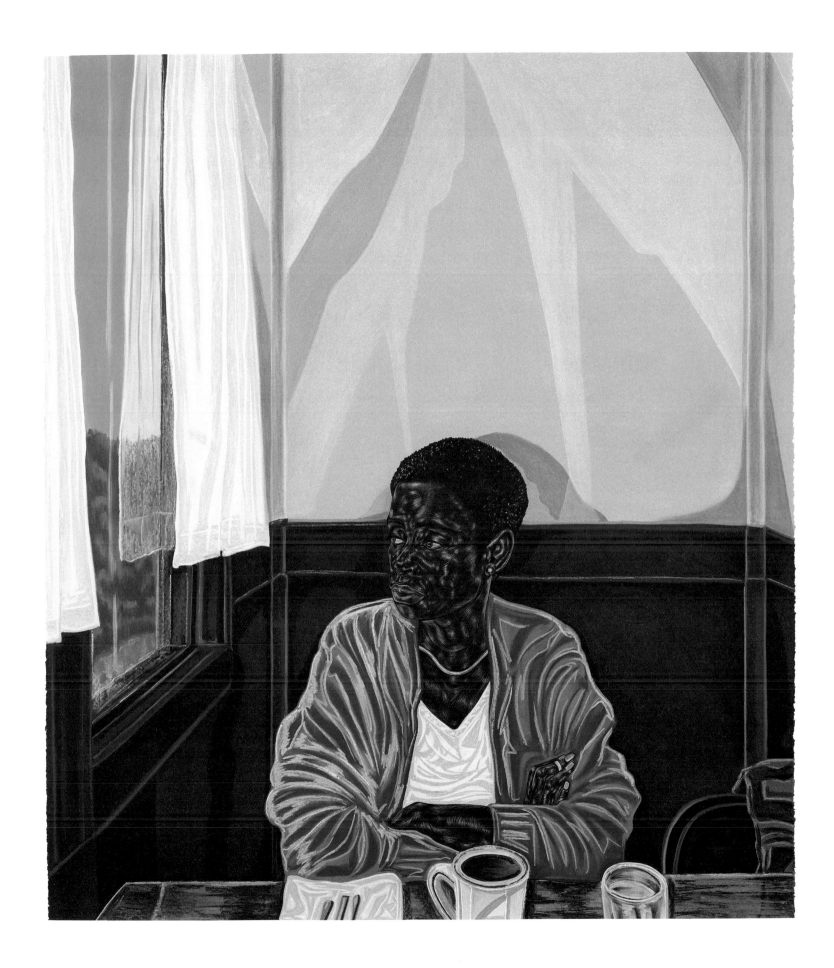

Christina Quarles

Born Chicago 1985

In *Meet in tha Middle*, a seated human figure appears in profile, the outline of the face duplicated by a colorful shadow. Possessing breasts, stomach folds, multiple limbs—long arms and legs extend in various directions across the canvas—and organs that dissolve into one another, the figure is in flux: it cannot be pinned down. Ambiguity is a prevailing characteristic of Christina Quarles's vibrant paintings, in which intersecting anatomies merge to create an "expansive, polymorphic sensuality."[1] These configurations speak to the intricacies of selfhood while laying bare the phenomena of inhabiting one's own body—themes that are at the center of Quarles's project. Rather than conveying the experience of looking at someone, the artist is instead interested in communicating the experience of being alive. Similarly, the figures that appear in her paintings are not portraits of any one individual but "portraits of being an individual," as she has described it.[2]

Various aspects of the artist's own identity have been central to the development of her practice, especially as they relate to race and gender. Quarles, who has a Black father and a White mother, has explored the notion of hybrid identity in her paintings and drawings since her graduate studies at the Yale School of Art, where she earned her MFA in 2016 (she received a BA in studio art and philosophy from Hampshire College in Amherst, Massachusetts, in 2007). Born in Chicago and raised in Los Angeles, where she continues to live, the artist has discussed the nuances attached to her parentage, which created a sense of displacement when she was growing up: "I felt like 'mixed race' was this vague position that glosses over all the different variables of having a multiply situated racial identity."[3] Quarles's definition of herself as a queer, cisgender woman has been equally significant. "Legibility, the way we understand things, is through this either/or mentality, but the reality is we have a both/and situation," she says, "and that's where a lot of my work comes from."[4]

The methods Quarles uses to construct her paintings mirror the ways in which she approaches her subject matter, combining spontaneous, meditative brushstrokes with more deliberate manipulations made with Adobe Illustrator software. She begins each work intuitively, painting without reference to any external sources, and photographs the canvas as soon as she establishes the outlines of a figure. She then transitions to working with a digital image. "I'll bring it onto the computer to actually finish the composition," she explains. "It's a way for me to add a mark that's not so physical."[5]

Drawing also plays an integral role in Quarles's work. Her attachment to the medium can be attributed to her early interest in the human body, which stemmed from the life-drawing classes she first took as an adolescent. Unlike many of her peers, she continues to practice figure drawing. "There was a teacher who really gave me a lot of time to think about the kind of figure that has gone on to influence my practice," the artist recalls. "A lot of that physicality in drawing, that physical connection to looking, is one that has carried through my entire life of making art."[6]

Most recently, in 2022, a suite of six new paintings by Quarles was unveiled in the exhibition *The Milk of Dreams* at the 59th Venice Biennale, prior to the artist's inclusion a few months later in the 16th Biennale de Lyon. AB

1. Suzanne Hudson, "The Body," in *Contemporary Painting* (London: Thames and Hudson, 2021), 192.
2. Christina Quarles, quoted in Lucy Biddle, "Christina Quarles," in *Kiss My Genders*, ed. Vincent Honoré and Tarini Malik, exh. cat. (London: Hayward Gallery, 2019), 194.
3. "Christina Quarles Paints the Complicated, Intimate Moments When We Feel like Ourselves," *Artsy Editorial*, April 15, 2020, https://www.artsy.net/article/artsy-editorial-christina-quarles-paints-complicated-intimate-moments-feel.
4. "Christina Quarles Wants You to Question Everything," *W Magazine*, March 25, 2021, https://www.wmagazine.com/culture/christina-quarles-painter-museum-of-contemporary-art-chicago-interview-2021.
5. Christina Quarles, "Hidden Figures," interview by Allie Biswas, *Glass*, no. 46 (Summer 2021): 134.
6. Ibid.

119. *Meet in tha Middle*, 2018
Acrylic on canvas
60 × 48 in. (152.4 × 121.9 cm)

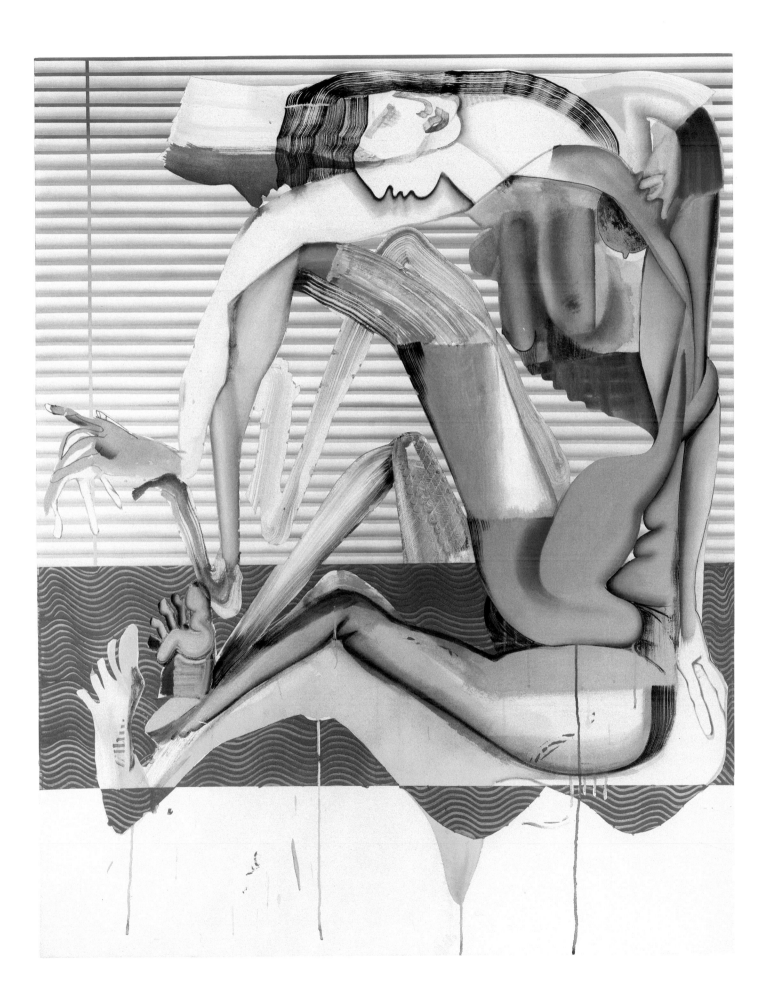

Kandis Williams

Born Baltimore 1985

The Los Angeles– and Berlin-based artist Kandis Williams is the founder of the nonprofit publishing and educational platform Cassandra, which is known for its photocopied "readers," compilations of critical theory and other previously published texts on topics such as "porn and and power in California," "Whiteness, dissonance, and horror," "performativity," and "misogynoir." The artist describes this ongoing project as a "site for my historical fantasies," asking, "What would abolition look like if Anna Murray Douglass was where she should be? What would concert music sound like if Nina Simone were positioned where she should be? What would the world look like if Black women were believed?"[1] Cassandra also organizes lectures and online courses, such as "Transatlantic Black Music Concepts" (taught by Khalif Diouf), with a sliding scale for tuition and scholarships earmarked for Black participants.

After graduating from New York's Cooper Union for the Advancement of Science and Art with a BFA in 2009, Williams moved to Berlin, began to apply for artists' grants, and started to produce the readers. "I received a grant to do dance documentation, so I started making readers on dance," she explains. "That's how I was able to maintain access to a lot of archives throughout Europe while I was living there."[2] This unique labor, because it was funded and "a fresh curiosity,"[3] sustained her art practice in this period, during which she continued to produce collages and works on paper: collage, especially through the lens of architecture, had been a mainstay of her work in college. As the artist recalls, "The last three paintings I made at Cooper were these collage portraits of white Western guilt set onto architectural schematics. Cain, Oedipus, and Lady Macbeth collaged onto African figures and images of African genocides and production stills from English theater renditions. The self-portrait of Artemisia Gentileschi set atop the architectural plan of the Pentagon."[4]

A Garden, Williams's breakthrough solo presentation with Los Angeles's Night Gallery in the "Positions" section of Art Basel Miami Beach in 2020, featured a collage of Black dancers from various eras surrounding a Monstera plant; a video slideshow with a voiceover by the Israeli feminist theorist and artist Bracha L. Ettinger (born 1948); three reliefs of spray-painted plastic foliage; and eight sculptures in vases (including After birth . . .). For these last, the artist "tattooed" images of Black bodies, both intact and disjointed, onto paper shaped as leaves, which she supplemented with additional plastic foliage and presented in "tasteful" arrangements. "I'm interested in how plants act as signifiers of our desires and as we lay the groundwork of our penal and corporeal systems, and for the genocidal conquests of lands and peoples," Williams observes. "At the same time, plants—because they act as ciphers and easily arouse a fascinating kind of neutrality—are pretty. Pretty things puzzle me."[5]

Williams's 2020–21 solo exhibition, A Field, mounted at the Institute for Contemporary Art at Virginia Commonwealth University, Richmond, furthered her consideration of the transatlantic slave trade, prison labor, horticulture, and patterns of migration. In 2021, Williams received the prestigious Mohn Award from UCLA's Hammer Museum for her standout works in the exhibition Made in L.A. 2020: A Version, which likewise investigated issues of race, nationalism, authority, and eroticism.

LOB

1. Kandis Williams, "Interview: Artist Kandis Williams Is Giving History a Hard Read," interview by Mahfuz Sultan and Chloe Wayne, Pin-Up, no. 29 (Fall/Winter 2020–21), https://pinupmagazine.org/articles/interview-kandis-williams-cassandra-press#14.
2. Ibid.
3. Ibid.
4. Ibid.
5. Kandis Williams, "Kandis Williams: 'Pretty Things Puzzle Me,'" as told to Osman Can Yerebakan, Art Basel (website), exh. (A Garden) on view December 2–4, 2021, accessed July 25, 2022, https://artbasel.com/stories/kandis-williams-on-plants-and-the-black-body-night-gallery.

120. *After birth all diligence is transferred to the calves; then the farmers brand them with their mark and the name of their breed And set aside those to rear to perpetuate their kind, to keep as sacred for the altar, or to cultivate earth and turn over the uneven field breaking it's clods. the rest of the cattle pasture on green grasses, but train those that you'll prepare for work and service on the farm when they are still calves and set them on the path to dociling while their youthful spirits are willing, while their lives are tractable. some few women are born free, and some amid insult and scarlet letter achieve freedom [sic] with that freedom they are buying an untrammeled independence and dear as is the price they pay for it, it will in the end be worth every taunt and groan.*, 2020
Sublimation prints on cotton paper, with copper wire and plastic, in painted glass vase
62¾ × 30 × 12 in. (162.6 × 81.3 × 63.5 cm)

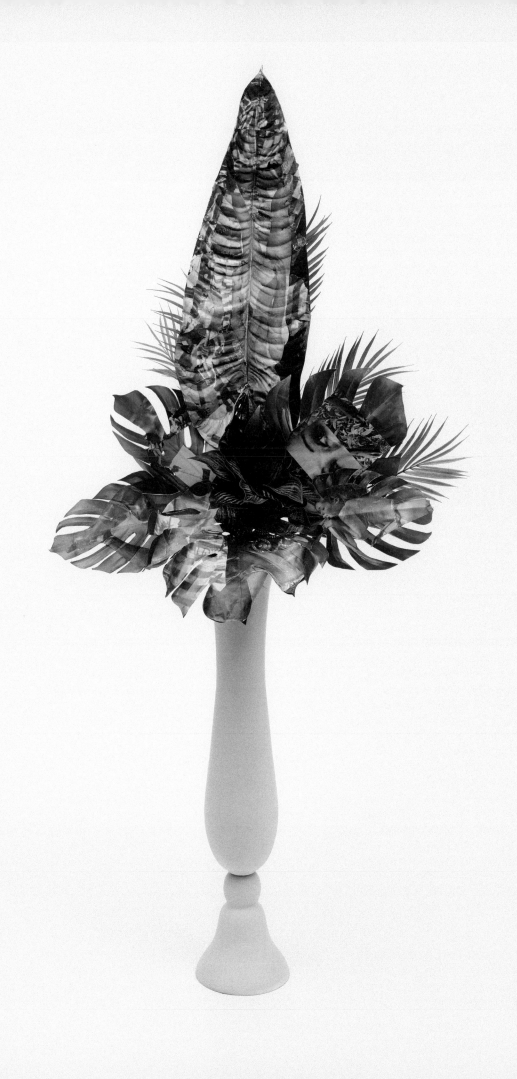

Portia Zvavahera

Born Harare, Zimbabwe, 1985

The unconscious realm is a guiding force for Portia Zvavahera: the Zimbabwean artist uses her dreams as a source for the vivid imagery that inhabits her monumentally scaled, expressionistic compositions. In her works, which integrate gestural painting with intricate printmaking techniques, primal, ghostlike figures merge with patterned fields of vibrant color that expand across the canvas. Densely layered brushstrokes form the backdrop to enigmatic narratives in which figures with female attributes, stand-ins for Zvavahera herself, appear alongside symbolic creatures such as owls and bulls, which become mediums for interpreting the artist's visions. Operating between the fantastical and the allegorical, these complex scenes are nonetheless grounded in an earthly plane.[1]

Dreams have been critical to the artist since she was a child. Zvavahera was raised by her family, especially her grandmother, to acknowledge phenomena beyond the corporeal world. On waking every day, all would recount what they had witnessed the night before while sleeping. Zvavahera's Pentecostal Christian upbringing also placed importance on the unconscious, which some devotees, the artist among them, view as a portal for communicating with God. As she explains, "I believe that I have a connection with the Master through sleeping and dreaming. I'm being told my future."[2]

Zvavahera first explored what is now her primary subject matter as an undergraduate at Harare Polytechnic, where she became aware of the European figurative painters Francis Bacon, Gustav Klimt, and Edvard Munch as well as the Zimbabwean artists Chikonzero Chazunguza (born 1967), Charles Kamangwana (1972–2015), Helen Lieros (1940–2021), and Luis Meque (1966–1998), whose work she encountered at the capital city's influential Gallery Delta.[3] Her belief in the prophetic nature of her visions led her to attempt to manipulate their content through the act of painting, altering anything that seemed harmful into a less daunting form. This approach has allowed her to navigate the upsetting subjects, related to moments of loss or trepidation, that dominate her work. Steered by her memory, the artist carefully charts her dreams and visions in written notes, which she then uses to generate preliminary sketches. Replicating a narrative is not the artist's intent, however; instead, her portrayals are reactive, guided by her emotional responses. A single dream can potentially inform an entire body of work, because, as Zvavahera says, "There's a story that I want to tell."[4]

Crying Belly belongs to a group of paintings that were displayed in 2021 in *Portia Zvavahera: Ndakaoneswa murima*, the artist's first solo exhibition in New York, at David Zwirner. The exhibition's subtitle, expressed in Shona, the artist's mother tongue, translates as "I was made to see the dark side." The Shah Garg Collection work depicts an encounter between two beings who appear unequal in stature, one physically dominating the other. The blue hand of the figure at the top of the frame hovers menacingly above the head of the lower figure, whose wide-open mouth denotes fear, or anger, and protest. Like other works in the series, *Crying Belly* has a heavily patterned section that dominates the center of the composition. Intricately detailed, looped shapes reminiscent of feathers or reptilian scales extend across both of the painting's figures, veiling their bodies like a garment. Cloaking her protagonists in this way helps the artist to establish a sense of ambiguity—a quality that inhabits each of her scenes. Also an important formal device, Zvavahera's tessellated motifs interrelate with the printing processes she deploys in many of her paintings, such as stenciling and a wax-resist technique similar to batik.

At the time of the Zwirner exhibition, Zvavahera articulated what kind of declaration the temporarily ensnared figure in *Crying Belly* might be making to the troubling spirit that governs the composition: "Wherever you're putting me, I'm going to get my victory—no matter what."[5] The moment speaks to the catharsis that is at the core of Zvavahera's working method. In transferring the spirit of her dreams into her work, the artist not only finds a resolution but undergoes a process of healing, in which the act of making a painting becomes a prayer. AB

1. Madeline Weisburg, "Portia Zvavahera," in *The Milk of Dreams*, ed. Cecilia Alemani, exh. cat. (Milan: Silvana, 2022), 346.
2. Portia Zvavahera, "Portia Zvavahera: The Path of the Heart," interview by Sinazo Chiya, in *9 More Weeks* (Cape Town: Stevenson, 2018), 132.
3. Nomaduma Rosa Masilela, "Ekphrasis for a Veiled Dream," in *Portia Zvavahera: I'm with You* (Cape Town: Stevenson, 2017), 23.
4. Zvavahera, "Zvavahera: Path of the Heart," 130.
5. Portia Zvavahera, quoted in fact sheet for the exhibition *Portia Zvavahera: Ndakaoneswa murima*, David Zwirner, New York, on view November 4–December 17, 2021.

121. *Crying Belly*, 2021
Oil-based ink and oil stick on linen
72⅛ × 79⅞ in. (183.2 × 202.9 cm)

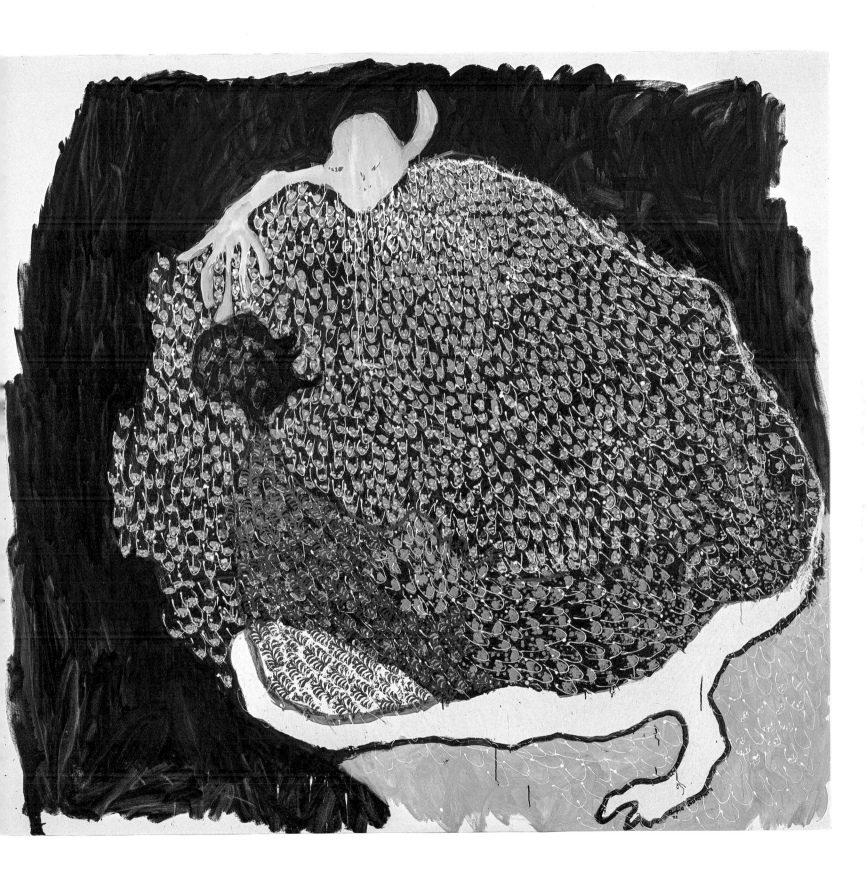

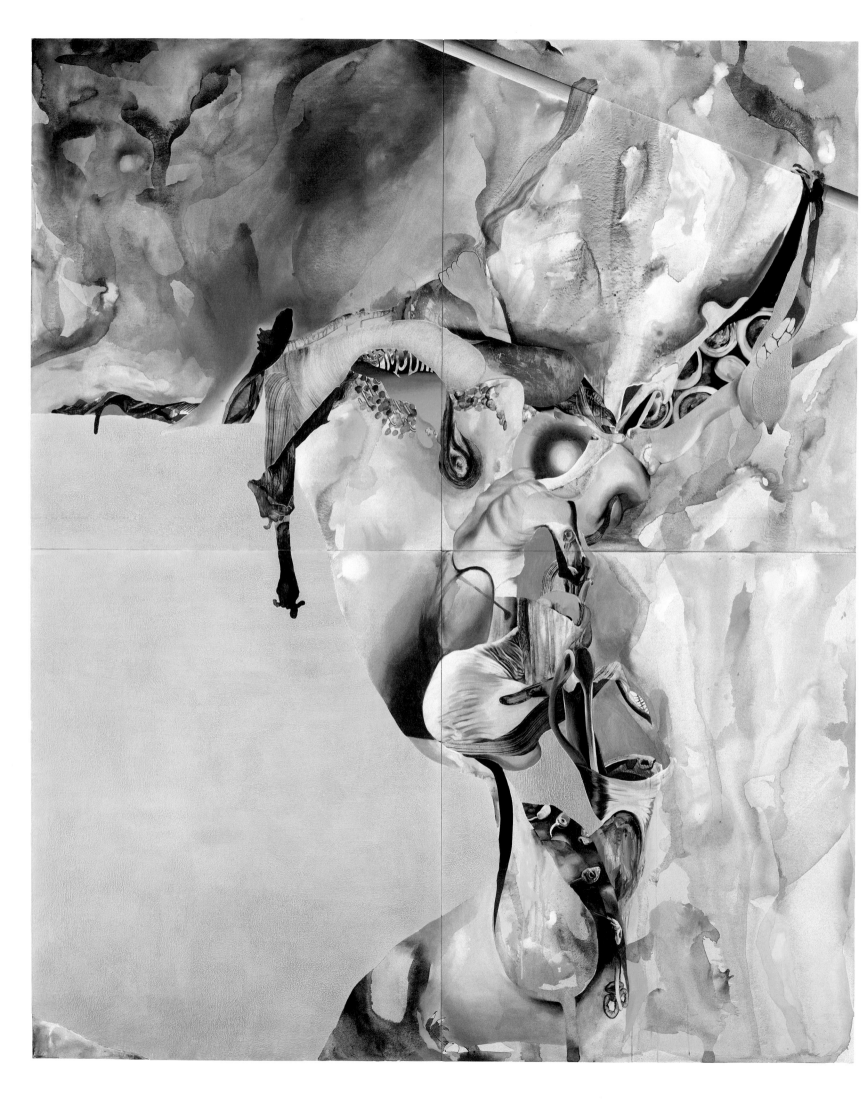

Ilana Savdie

Born Miami 1986

Ilana Savdie was born in Miami and raised in Barranquilla, Colombia, in the far north of the country, on the Caribbean Sea; today, she is based in Brooklyn. The artist received a BFA from the Rhode Island School of Design in 2008 and an MFA from the Yale School of Art in 2018. Before gaining her MFA, she was employed as a graphic designer at Calvin Klein Fragrances and as the creative and editorial director of the tech start-up Bib + Tuck, a member's-only women's clothing marketplace founded in 2012. Performing these jobs gave the artist a sense of structure: "I've always been a believer that while you live like an artist, you definitely also have to give yourself deadlines and responsibilities."[1]

Savdie's vivid, large-scale paintings are inspired in part by her upbringing, particularly by the Carnival celebrations that take place in her hometown every year (Barranquilla hosts the second-largest Carnival in the world, after Rio de Janeiro). "Color has been this way to work from a place of instinct, rather than thinking too much about the 'why,'" she told the curator, educator, and activist Jasmine Wahi in 2021. "I root it back to growing up surrounded by the Colombian *Carnaval*. Queer spaces tend to be extremely colorful. There's just something about the excess of color that feels like seductive subversion. I think about color as this way of getting to seduce."[2]

Barranquilla's weeklong explosion of dancing, music, and parades leading up to Lent revels in the surreal, the extravagant, and the capricious and is thus a fitting lens through which to view the works shown in Savdie's solo exhibition *Entrañadas* (literally, "innards"), which opened in 2021 at Kohn Gallery in Los Angeles. There, the artist presented eight paintings of otherworldly figures—some relatively intact and recognizable as human, others dismembered or seemingly assembled from multiple donor bodies—against colorful, atmospheric dreamscapes. In the center of *The Enablers (an adaptation)*, for example, is what looks like a bare torso, with pronounced ribs grotesquely emerging from the back; above and to the right is a pair of pendulous breasts, at a much larger scale. Sometimes, the artist makes reference to Marimonda, a Carnival character invented in Barranquilla that is a cross between an elephant and a monkey but whose mask, worn by many revelers, is formidably phallic. Overall, Savdie's fluid body parts defy prescribed shapes, and the result is a brash merging of figuration and abstraction, often, as in *The Enablers*, in a cacophony of textures and fluorescent hues.

The artist begins each painting with ink drawings that she scans and manipulates with Adobe Photoshop software to create new compositions. The original analogue drawings are essentially black-and-white doodles (though typically "fairly figurative . . . I look at a lot of religious Baroque paintings"), and the altered digital designs (where "bodies start to dissolve and undo themselves") provide a point of departure for further handwork on the canvas.[3] "I play with different applications of line and paint and mark-making in different ways. That's when bodies start to dissolve and undo themselves," she says of her process.[4] After laying down a ground of vibrant pours and brushstrokes, Savdie builds a composition by layering intricately painted body parts, bright fields of wash, and corpulent sections of brushed beeswax on the canvas. "All these paintings have large sections that have wax-like paint, so there's this combination of these rigid boundaries and different ways in which I can infiltrate those boundaries," she observes. "It all becomes leaking, spilling, sagging, or transgressing. All these different terms start to dictate actions of how I apply paint and then respond to how that's happening. Sometimes even images of my work will go into the collage."[5]

The results are ecstatic and outlandish and recall the visceral, twisted bodies of the twentieth-century painters Francis Bacon and Kay Sage. "I use violent language and the language of horror because it feels like the grotesque caricature of something," the artist has remarked, adding, "There's a mockery within that. It's this thing about access that feels like a way to end the abundance of something, to allow these subjects to take up as much space as possible and then leak into their environment."[6]

LOB

1. Ilana Savdie, "Exploring Depth of Self," interview by Inny Taylor, *Metal*, February 24, 2015, https://metalmagazine.eu/en/post/interview/ilana-savdie-exploring-depth-of-self-inny-taylor.
2. Ilana Savdie, "'Euphoric and Grotesque': Ilana Savdie on Painting Parasites," interview by Jasmine Wahi, *Interview*, December 17, 2021, https://www.interviewmagazine.com/art/euphoric-and-grotesque-ilana-savdie-on-painting-parasites.
3. Ibid.
4. Ibid.
5. Ibid.
6. Ibid.

122. *The Enablers (an adaptation)*, 2021
Oil, acrylic, and beeswax on canvas over wood panel
10 ft. × 8 ft. 4 in. (304.8 × 254 cm)

Lauren Halsey

Born Los Angeles 1987

Lauren Halsey's monumentally scaled sculptures and installations illuminate the culture of South Central Los Angeles (now officially known as South Los Angeles), where the artist was raised and continues to reside and where her family have lived for four generations. Halsey's distinct visual language, consisting of fantastical imagery, architectural forms, and ample text and lettering in neon colors, takes its inspiration from the attributes and rituals of local environments with which she is intimately connected as well as the neighborhood ephemera that she accumulates and archives. Drawing on both the beauty and the trauma that inform this historically African American, now largely Latinx, community, which has long been misconceived and stereotyped, Halsey's works evoke the essence of a complex and rapidly changing landscape.

Luxury development initiatives that have recently overrun parts of the area, especially around Crenshaw Boulevard, have been a particular stimulus for Halsey in her commitment to honor and elevate the cultural legacy of South Central in the face of gentrification. Describing herself as a community organizer, she considers civic responsibility to be the basis of her practice. "Community building is a mission for the work, and if that's not happening, then the artwork shouldn't exist," she says. "That's the attitude of the project."[1] In 2020, initially in response to the COVID-19 pandemic, Halsey founded Summaeverythang, a self-directed community center that distributes fresh produce, at no cost, to residents of South Central.

Halsey's hair-extension compositions, initiated around 2018, reflect on the demographic shifts in her neighborhood that have disenfranchised and displaced Black beauty-store owners. The richly textured, wall-based works consist of brightly colored synthetic hair arranged in horizontal bands. The artist became suddenly aware of the depletion of Black-run businesses upon returning home from graduate school (Halsey received her MFA from the Yale School of Art in 2014). One iteration of this series, Slo But We Sho (Dedicated to the Black Owned Beauty Supply Association) (2019), features the colors of the Pan-African flag and celebrates a national organization whose logo enables consumers to identify beauty products from Black manufacturers. The works also allude to the musician George Clinton (born 1941), a seminal figure

for Halsey, whose stage costumes have long incorporated elaborate, colorful wigs. Clinton's Parliament-Funkadelic (P-Funk) collective established a singular form of music and style during the 1970s, aggregating utopian fantasies and other-worldly aesthetics and defining what later came to be known as "Afrofuturism." Halsey cites P-Funk's representations of Blackness as a profound influence, alongside the group's own mythology, which spurred her creativity early on.

In 2018, Halsey's Crenshaw District Hieroglyph Project (Prototype Architecture) "remixed," as she has termed it, mythological imagery from Afrofuturist contexts and used it to address contemporary life. The prototype for a community monument and gathering space—a freestanding structure, reminiscent of a mausoleum—was presented at the Hammer Museum's biennial showcase Made in L.A. 2018. The hand-carved surfaces, constructed from gypsum board (one form of a building material widely employed in ancient Egypt), revealed hieroglyphic markings alongside jubilant street scenes. Untitled (2020), in the Shah Garg Collection (see p. 111), is an example of the individual wall-based works that the artist has produced by the same method.

In 2019, as the recipient of the Frieze Artist Award, Halsey orchestrated another civic moment. Prototype Column for tha Shaw (RIP the Honorable Ermias Nipsey Hussle Asghedom) I & II memorialized her friend Nipsey Hussle (1985–2019), the murdered rapper, who had been an important figure in South Central. While such works are signifiers of community pride, they nonetheless grapple with issues of violence and injustice, often recording the names of Black Americans who have died at the hands of the police. The overall project is in keeping with the artist's belief that those from a particular place are best suited to create something meaningful for their community.[2] Consolidated through practical, real-world proposals, world building is the driving force of Halsey's artistic practice. AB

1. Lauren Halsey, quoted in Dalya Benor, "Lauren Halsey," Kaleidoscope, no. SS20, https://www.kaleidoscope.media/season/lauren-halsey.
2. Anne Ellegood, "Lauren Halsey's Holding Environment," in Lauren Halsey: Mohn Award 2018, by Anne Ellegood and Erin Christovale (Munich: Prestel; Los Angeles: Hammer Museum, UCLA, 2020), 116.

123. Untitled, 2020
Synthetic hair on wood
9 ft. 8 in. × 4 ft. 10½ in. × 8 in. (294.6 × 148.6 × 20.3 cm)

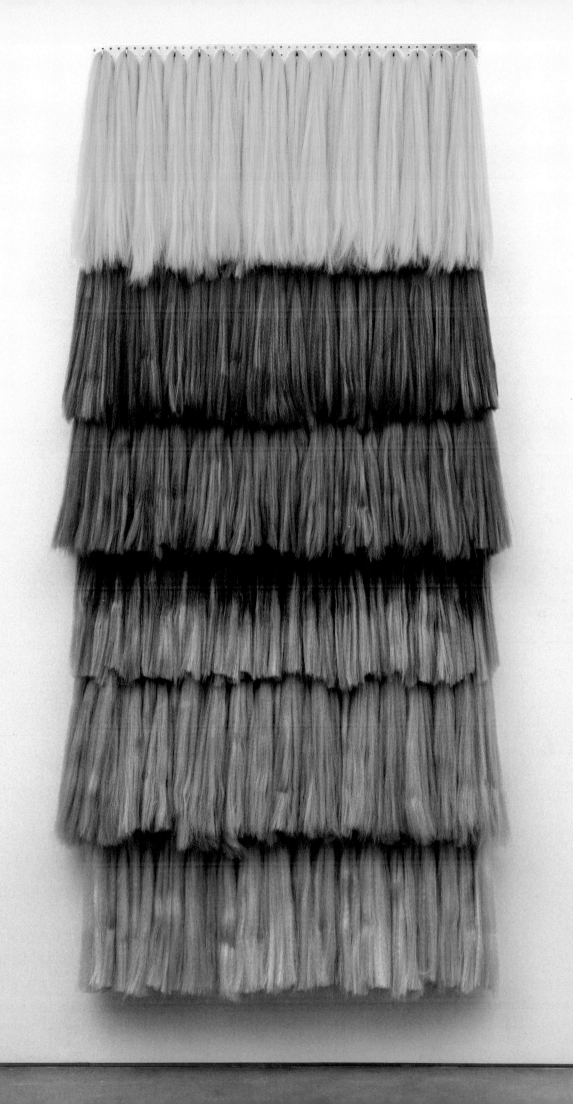

Kennedy Yanko

Born Saint Louis 1988

The American artist Kennedy Yanko creates hybrid objects from metal and paint. The backbones of her vast constructions are large pieces of copper and steel that she sources from scrapyards and contorts with industrial machinery, resulting in compressed and crumpled abstract forms. The artist subsequently expands these metal frameworks with seamless sheets of luminous material that she generates from paint. She makes these "skins" by hand; the process involves pouring large pools of industrial paint onto a surface and waiting for them to assume exactly the right texture before peeling them off. The artist often uses the paint skins as drapes that cascade from the metal or engulf it. First displayed at the Armory Show in New York in 2021, *Remnants of Rust on My Face* belongs to a small group of metal-and-"skin" works that also incorporate delicate steel cable. Here, Yanko has molded the cable into a precise rectangle that extends horizontally on either side of the primary metal component. Through her handling and assembling of materials, the artist seeks to challenge how such media are typically perceived, subverting expectations related to texture, mass, scale, and gender while encouraging viewers to abandon rigid, learned ways of seeing.

Yanko initially experimented with paint as a three-dimensional material in 2009, after having left the San Francisco Art Institute in the previous year, forgoing graduation. Eager to expand the spatial quality of the abstract paintings she was producing, the artist started to remove paint skins from her canvases and exhibit them as compositions in their own right. Metal became a critical addition to Yanko's repertoire in 2016, following an apprenticeship at an iron-and-steel factory near her studio in the Bushwick neighborhood of Brooklyn. "As soon as I removed paint from the canvas, a subconscious search for a skeletal system began," she says.[1] In addition to salvaged metal, the artist has paired paint skins with marble and other types of rock as well as found objects.

Although her works are considered sculptures, it is the artist's self-identification as a painter that guides her process: "I've always worked standing over the work, that's how I have to see everything. . . . Visceral is the only word for it. And when I'm painting large-scale, which has always been my preference, there's really no other way."[2] In 2021, the artist embarked on a residency at Miami's Rubell Museum with the intention of working monumentally. The three towering sculptures in the resulting installation, *White, Passing*, on view in 2021–22, were constructed from parts of a discarded shipping container that stood out to Yanko on account of its vivid blue-and-red coloring. Color is critical in her practice: she often uses it to unify a series of works, and it is a determining factor when she is selecting detritus. For the writhing, vertical structures at the Rubell (which were nearly ten feet tall), Yanko made paint skins from more than one hundred gallons of paint. Her work on this project coincided with the writing of an autobiographical graphic novel, *Indelible Fluidity*. Grappling with her identity as a mixed-race American woman who is often assumed to be White, Yanko sought to develop a sculptural language "for the incommunicable parts of my existence, in scale, form, and synchronicities within materials. The latter—where metal and paint skin both bend and twist and sing—articulate dualities occurring within one moment, one person, one spirit."[3]

Encouraged by the preexisting life cycles of the materials she chooses to work with, Yanko has made personal histories a prevailing theme in her work. For example, in her exhibition *HANNAH* at the Chicago gallery Kavi Gupta in 2019, the artist reflected on the role of individual agency, taking her rejection of her birth name as a starting point. The sculptures shown in *Salient Queens* at Vielmetter Los Angeles in 2020 drew inspiration from various women who have shaped Yanko's life to date. Indicative of present-day models of "hybrid social identity,"[4] the artist's work, she insists, "chooses how it wants to be seen."[5] AB

1. Kennedy Yanko, "Kennedy Yanko Isn't Afraid to Take Up Space," interview by Ryan Waddoups, *Surface*, October 20, 2020, https://www.surfacemag.com/articles/kennedy-yanko-artist-interview/.
2. Kennedy Yanko, "Angel Otero and Kennedy Yanko in Conversation," in *Kennedy Yanko: HANNAH* (Chicago: Kavi Gupta Gallery, 2019), n.p.
3. Kennedy Yanko, quoted in "Kennedy Yanko: *White, Passing*" (calendar entry for the Rubell Museum exhibition *White, Passing*), *Surface*, exh. on view November 29, 2021–October 31, 2022, accessed August 20, 2022, https://www.surfacemag.com/events/kennedy-yanko-white-passing/.
4. Christian Viveros-Fauné, "It's in Her Blood: Abstraction and Inclusiveness in Kennedy Yanko's Sculptures," in *Kennedy Yanko: Because It's in My Blood* (Florence: Galleria Poggiali, 2020), 78.
5. Kennedy Yanko, quoted in Viveros-Fauné, "It's in Her Blood," 78.

124. *Remnants of Rust on My Face*, 2021
Acrylic paint "skin," metal, and steel cable
8 ft. 5 in. × 5 ft. 10 in. × 5 ft. 1 in. (256.5 × 177.8 × 155 cm)

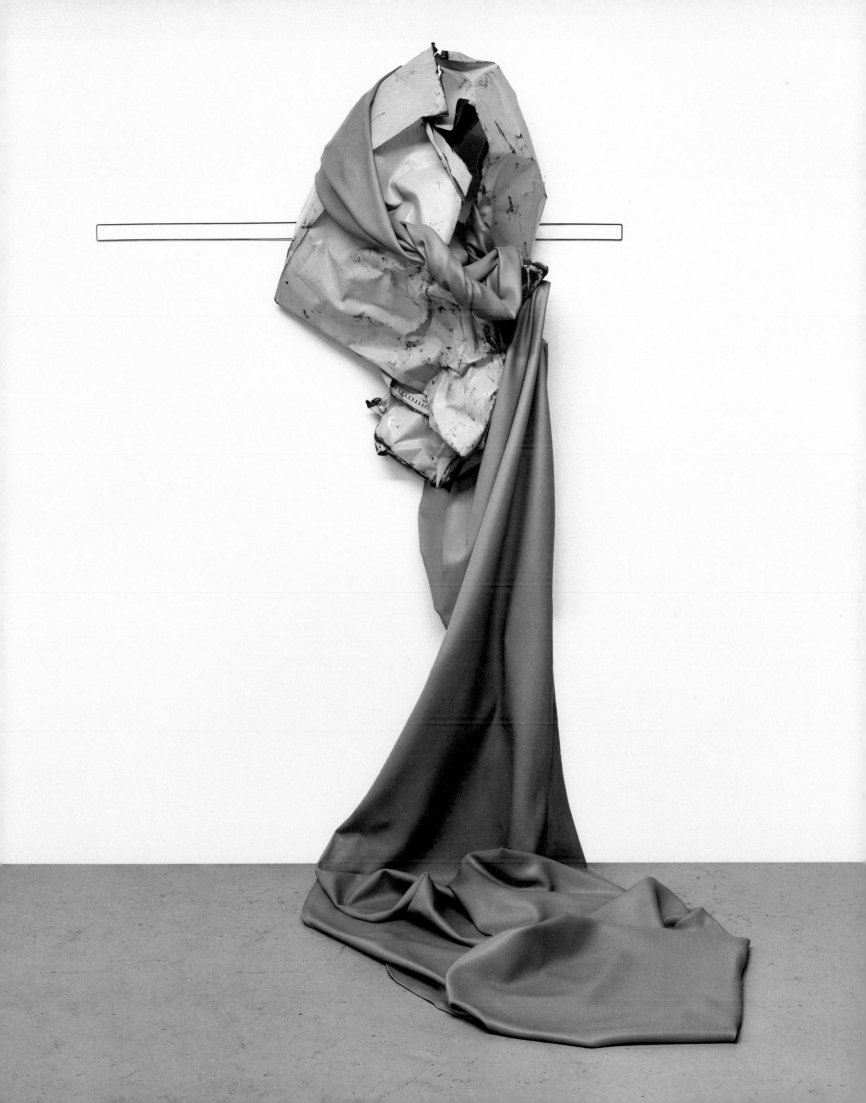

Jordan Casteel

Born Denver 1989

An Ethiopian restaurant in New York's Harlem neighborhood is the setting for *Benyam*. The painting depicts the chef and co-owner Helina Girma alongside her brothers, Miku Girma and Beniam Asfaw, also proprietors of the eponymous restaurant. Gazing directly at the viewer and posing informally, the siblings, leaning closely together on the bar, appear at ease in an environment that holds personal significance and shapes their daily lives. As in other paintings by the American artist Jordan Casteel, which are equally monumental (often six or more feet tall), *Benyam* captures a moment in time that is based on a social exchange—both between or among the subjects and between them and the artist herself. After taking dozens of photographs in situ, Casteel lets the images guide her to a single composition: as she explains, "I don't really care about the photos themselves. What I care about is capturing a moment in time with someone."[1]

The artist's relationship to those she chooses to paint is vital. Casteel actively seeks out the people highlighted in her vibrantly colored portraits: either she feels an immediate affinity with them after noticing them in public, or she has already developed a rapport with them in her own environment. Benyam is located near the artist's home, and its owners are her friends. "Representing the community has been integral to how my practice has evolved," she says. "Having come from a family driven by social justice, I knew that would be a part of my story."[2] (The artist's mother, Lauren Young Casteel, is an activist who works in philanthropy, and her maternal grandfather, the civil rights leader Whitney M. Young Jr., headed the National Urban League in the 1960s.)

Harlem, where Casteel moved after earning a BA from Georgia's Agnes Scott College in 2011 and an MFA from the Yale School of Art in 2014, is an important site for her. Notable for its rich history related to African American culture, the neighborhood is where she encounters many of the figures she represents in her paintings, who are often Black and exclusively non-White. In 2015, during her year as an artist-in-residence at the Studio Museum in Harlem, the artist approached people outdoors, mostly street vendors, as well as those working inside the museum, such as the security guards, and asked to paint their portraits. One of the resulting works, which depicts Fallou Wadje, a Senegal-born clothing designer, and her brother, Baaye Demba Sow, was later transposed into a 1,400-square-foot wall mural installed on New York's High Line in 2019. Following the Studio Museum residency, Casteel developed her *Nights in Harlem* series, which documented men in repose on the street or subway. In contrast to her previous works, these paintings were the result of fleeting encounters with her subjects and were more concerned with exploring the qualities that constitute a neighborhood than with specific personal relationships.

Most recently, the artist has returned to painting those who are well known to her. *Cansuela* (see fig. 3 on p. 92), also in the Shah Garg Collection, is part of a body of work that depicts the undergraduate students Casteel teaches at Rutgers University–Newark, many of whom are first-generation Americans or immigrants themselves. Asked by the artist to choose the settings for their portraits, several of her sitters selected their own homes. Like Cansuela, the young woman in the Shah Garg painting, they are ensconced in environments that illuminate who they are as individuals, drawing on their heritage, aptitudes, and aspirations.　　AB

1. Jordan Casteel, "Many Are Called: Jordan Casteel in Conversation with Massimiliano Gioni," in *Jordan Casteel: Within Reach*, ed. Massimiliano Gioni, exh. cat. (New York: New Museum, 2020), 19.
2. Jordan Casteel, "A Harlem Family: Thelma Golden in Conversation with Jordan Casteel," in Gioni, *Casteel: Within Reach*, 35.

125. *Benyam*, 2018
Oil on canvas
90 × 78 in. (228.6 × 198.1 cm)

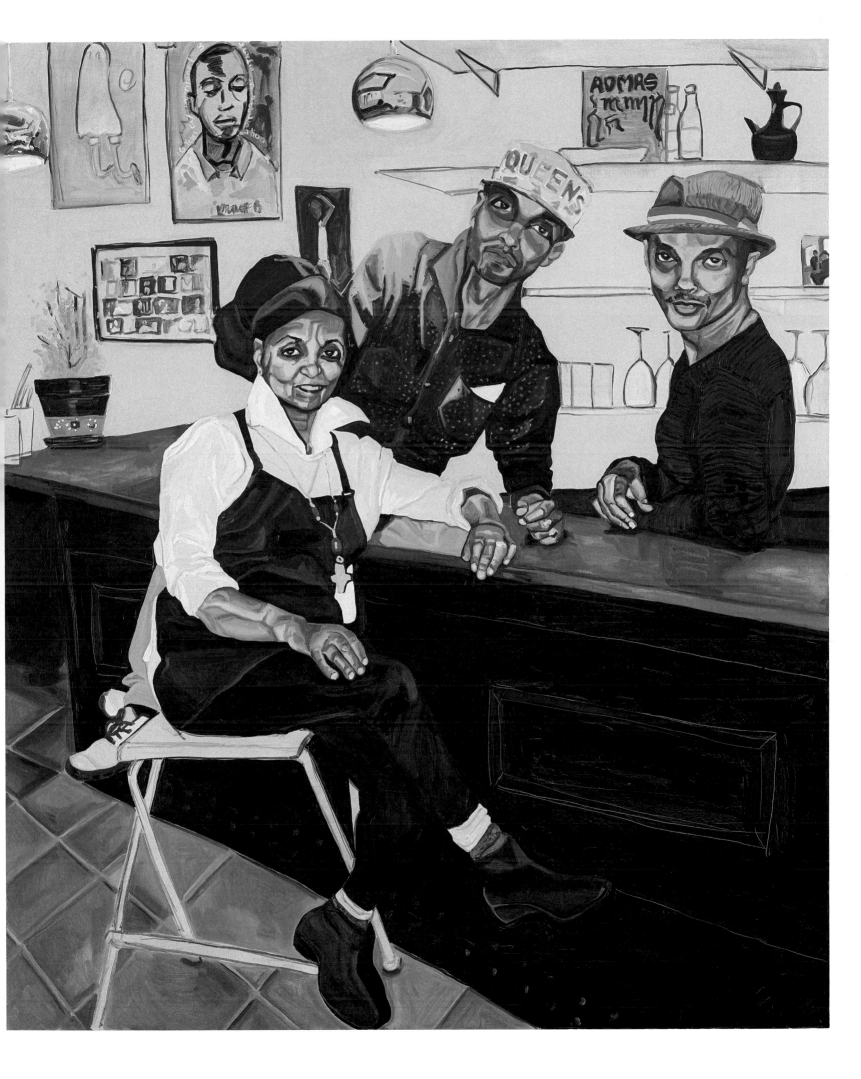

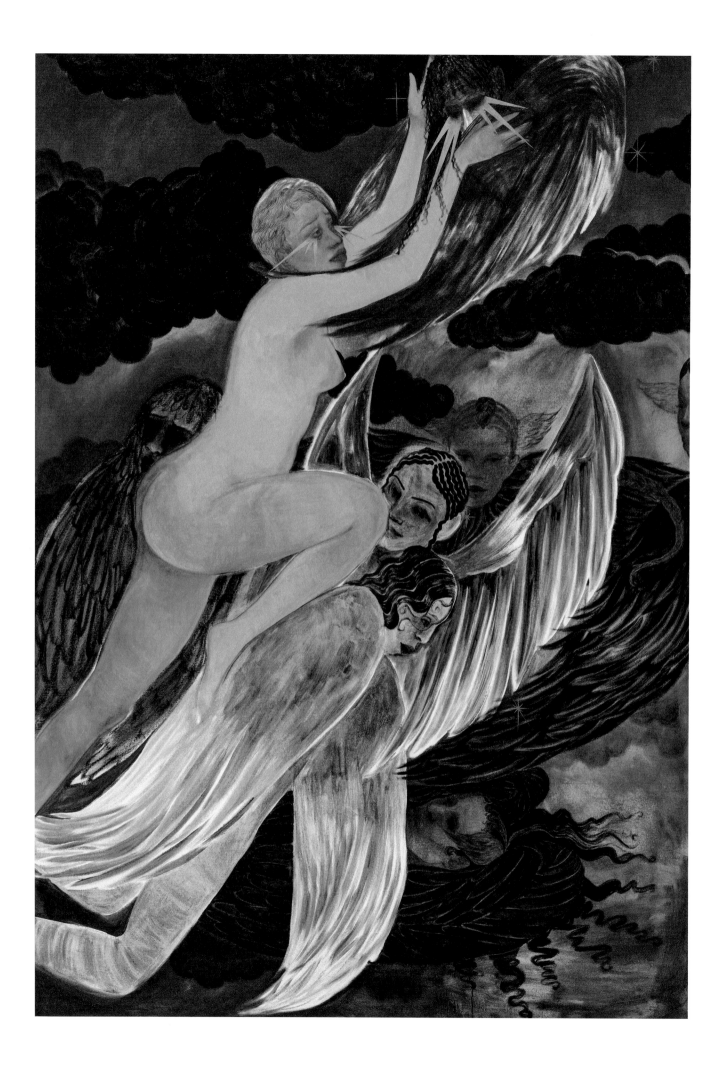

Naudline Pierre

Born Leominster, Massachusetts, 1989

Of Haitian extraction, the Brooklyn-based artist Naudline Pierre was raised in a spiritual household—her father is a pastor—and she attributes some of her visual language to her upbringing. "I grew up learning about the Biblical apocalypse, about visions, prophets, signs, and symbols," she explains. "The images around me were fantastical and even scary sometimes. Growing up in church, I saw really vivid events like my father and the church elders casting out demons. It was a colorful place for my imagination—full of fear, longing, and miracles—to take shape. I'm very grateful for my upbringing, experiences and influences."[1] Indeed, Pierre puts a positive spin on this rich personal background in canvases that center ecstasy, devotion, and tenderness in grand, sometimes sci-fi landscapes; specifically, in their customary conflation of a Black woman's nude body and recognizably Christian narratives, her works engender a rapturous space for liberation.

The artist received a BFA from Andrews University, a Seventh-day Adventist institution in southwestern Michigan, in 2012 and an MFA from the New York Academy of Art in 2017. The vibrant, otherworldly paintings she has been producing for the past several years, typically rendered in prismatic layers, unite passion, religion, sensuality, and, perhaps most of all, intimacy. "In the process of painting, I'm always searching for a way to get at the rawest depiction of intimacy," Pierre asserts. "Intimacy can exist in many places, it can be familial, romantic, or platonic. In the work, I'm creating my personal mythology and exploring these themes in this imagined world that I've put together, using religious iconography as a tool just like I use color and texture as tools."[2]

Consider, for example, *A Timely Rescue.* Here, several celestial beings, enveloped in a vast, horizonless pink sky with black clouds, perform what appears to be an act of salvation. Whirling with texture, the painting exudes a sense of protection and care but also a certain amount of precarity: the winged figures must arrange themselves to shoulder a heavy burden as they lift the orange-skinned nude woman in the center of the canvas up to the heavens (as the artist says of this work, "There's a bit of sacrifice that's happening with these other winged beings to get her to a place where she needs to be. And so that whole ascension, to me, just feels like a rescue"[3]). Moreover, the protagonist cries blue bolts of tears, matching those shed by the red being embracing her from above. Pierre deploys the figure of the woman here, and comparable ones elsewhere in her work who are clearly in the grip of emotion and transformation, as avatars to discover the infinite possibilities of self-knowledge that can be unlocked through sustained self-examination.

Often, Pierre's subjects appear to be inspired by, yet willfully out of step with, art history. "I'm in love with a time in art history that I find extremely beautiful, but that also raises conflicting feelings for me," she states. "I am a figurative painter who is interested in looking at a moment in Eurocentric art history, roughly the 1400s–1600s. I'm looking back in time and using aspects of paintings made by people who are dead and gone, people who definitely did not make those paintings for me to look at—much less consume, understand, and enjoy."[4] Indeed, the artist's ethereal and substantial bodies defy art-historical categories as well as traditional myths of sublimation, mercy, and resurrection.

Whether referencing the Renaissance format of the altar triptych or adopting forced perspective in a flattened space, Pierre does something new with tropes from the past: "I'm taking that figurative language and making it mine through color, texture, my own stories, and by inserting my own body. As a painter using oil paint, I feel very engaged in the rich legacy of that material, which is the start of my co-opting a classical language."[5] Ultimately, the personal mythology and heavenly performances of intimacy in Pierre's paintings offer novel narratives of devotion. Her works extend canonical traditions—of encounters between the human and the unhuman—by fully vaccinating the conventions of painting and imbuing them with an intriguing equivocality.　　　LOB

1. Naudline Pierre, "In Conversation with Naudline Pierre: Painting Her Personal History Phenomenally on the Canvas," interview by Jasmin Hernandez, *Gallery Gurls*, September 11, 2018, https://gallerygurls.net/art-convos/2018/9/11/in-conversation-with-naudline-pierre.
2. Ibid.
3. Naudline Pierre, "Naudline Pierre," James Cohan, New York (website), accessed August 2, 2022, video, 3:46, https://www.jamescohan.com/features-items/naudline-pierre.
4. Pierre, "In Conversation with Pierre."
5. Ibid.

126. *A Timely Rescue*, 2019–20
Oil on canvas
84 × 60 in. (213.4 × 152.4 cm)

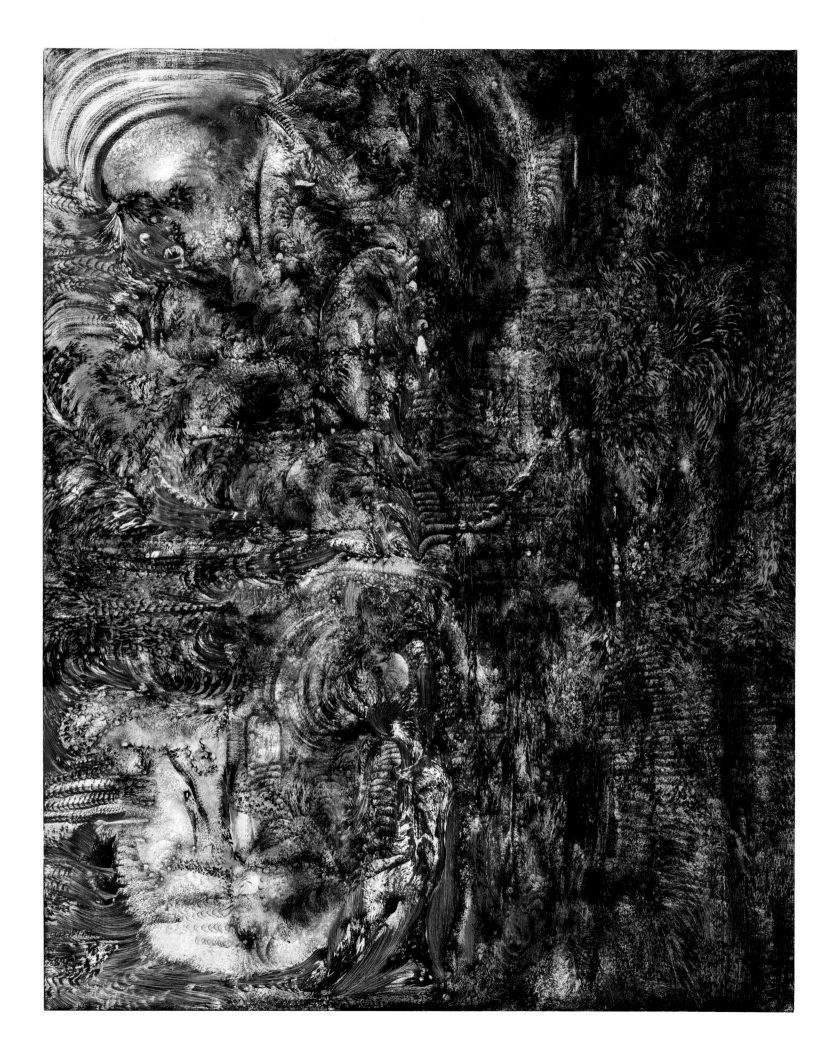

Lucy Bull

Born New York City 1990

"I think that the most interesting paintings are the ones that are disruptive, confusing, and show something of the psyche that you're not aware of," says the New York–born, Los Angeles–based painter Lucy Bull.[1] After receiving her BFA in 2012 from the School of the Art Institute of Chicago, Bull landed in Los Angeles in 2014 and began exhibiting her work at local galleries. Since 2018, under the heading "From the Desk of Lucy Bull," she has also staged a series of curatorial projects on a tabletop in her apartment.

Bull's large-scale, biomorphic abstractions evoke the unconscious mind: their trails and swirls are inexplicably both ghastly and assuasive, leading the mind to make numerous associations while the eye strives to disentangle snarls of spatial and optical effects. Her forms and colors are often categorized as "psychedelic" or "kaleidoscopic," and it is hard to argue with either description. It takes between four and twenty layers of paint for the artist to create a work, and she uses a wide range of tools to paint, both adding and subtracting liberally. "It's this combination of playing with the mark-making and stamping it with the imprint of my brush and twisting it in weird ways," she comments. "It's all about the speed and wrist gestures, the amount of paint on the brush. There's this build-up of the layers and then sort of reductive techniques like scratching away or making marks."[2]

The artist starts with a base layer of paint, transforms it with some of the "weird stuff" she obtains at hardware stores, and then paints another layer. "Basically, the tools just kind of let the work make itself," she says, "activating the older layers."[3] Regarding her intuitive process, the artist additionally notes:

> In the beginning it's like I'm just doing this dance where I'm getting lost in the different kinds of brushwork and marks that I can make and sort of getting to that point where there's this flow and I'm not thinking of anything and just kind of going with it and trusting that something will come of the layers. The more I go, the more disorienting it starts to get; but that's when things start to happen. I start to have associations and tease certain aspects out. But every impulsive layer of mark-making

is countered with a more calculated response. It goes in waves.[4]

1:00 was exhibited, along with three other works by Bull and two drawings by the late Guo Fengyi (1942–2010), at the Shanghai gallery Pond Society in 2022. From the predominantly hot-pink field, Rorschach-like patterns emerge in various other bright hues. Black paint seems to hover over some of these motifs, recalling the American artist Morris Louis's method, beginning in 1953, of pouring a final wash of diluted black and ochre paint across his canvases to create a staining effect. The title of Bull's work may be related to the fact that she recently moved into a studio that permits her to paint at night, after previously working outdoors, in an alley next to her apartment: "I've finished so many paintings between 3:00 a.m. and 4:00 a.m. . . . It's this magical period of time where you're completely alone, and it feels almost like time stolen from sleep. There's something really empowering about not being asleep."[5]

Bull takes her time with each canvas, trying not to rush, despite her tendency to work on deadline. "In order for the painting to move forward, I have to let whatever I'm seeing fall back," she observes. "I want to leave room for different associations. Sometimes the paintings that come together too quickly don't allow enough time for things to open up in a different way."[6] By lifting all restrictions, Bull creates space for both fastidiousness and uninhibitedness, welcoming viewers to partake in a means of production that she directs but never fully controls. — LOB

1. Lucy Bull, "Getting Lost in the Brushstrokes: Lucy Bull Interviewed by John Garcia," *BOMB*, April 26, 2021, https://bombmagazine.org/articles/getting-lost-in-the-brushstrokes-lucy-bull-interviewed/.
2. Lucy Bull, quoted in Stephanie Eckardt, "In the Studio with Lucy Bull, the Painter Bringing Back Abstraction," *W Magazine*, April 2, 2021, https://www.wmagazine.com/culture/lucy-bull-david-kordansky-studio-visit.
3. Ibid.
4. Bull, "Getting Lost."
5. Lucy Bull, quoted in Kat Herriman, "Artist Lucy Bull Brings Her Color Vision to David Kordansky," *L'Officiel*, October 18, 2021, https://www.lofficielusa.com/art/lucy-bull-contemporary-art-los-angeles-david-kordansky.
6. Bull, "Getting Lost."

127. *1:00*, 2021
Oil on linen
84 × 68⅛ in. (213.4 × 173 cm)

Tschabalala Self

Born New York City 1990

The large, multimedia composition *Sisters* was first displayed at New York's Agora Gallery in 2021 as part of the exhibition *A Force for Change*. Organized by UN Women, a United Nations organization dedicated to gender equality and women's empowerment, the show featured works by twenty-six women of African descent in acknowledgment of the important role art by Black women has played in social-justice movements around the world. Depicted in the Shah Garg Collection's painting are two sisters, a young woman and a child, standing side by side and embracing affectionately. The elder sibling looks down in a manner that is both adoring and protective, despite the fact that her young charge is stepping gently on her foot. As Self began to explore figuration—always her focus—while studying painting and printmaking at Bard College and the Yale School of Art (she earned a BA from the former in 2012 and an MFA from the latter in 2015), she decided that it would be "most sincere to start with a narrative with which I had a lived experience."[1] Black women have remained her most frequent protagonists, and Self, while granting that the works "are not about real people," insists that they "are about real ideas."[2]

The figures that occupy Self's compositions are treated less as literal subjects than as "avatars," as she terms them, enabling the artist, herself a Black woman, to reclaim "interpretative authority" over Black women's bodies.[3] The figures are usually placed against vivid, monochromatic backdrops, creating a stark contrast between foreground and background and highlighting the human body, which is invariably positioned in the center of the picture plane. Composed of a variety of materials, such as lace, silk, and velvet, the exaggerated forms—bulging muscles, generous hips and buttocks, elongated fingers with sharply pointed nails—emit a strong sense of three-dimensionality. "I'm trying to figure out how much information is needed for the body to read as gendered or for a body to be racialized," the artist has explained. "So the idea of simplifying forms through abstraction is an attempt to see what are the visual cues that allow for audiences to identify the subject as being feminine or as being black."[4] Moreover, in exploring issues of race and gender, the artist has become alert to the fact that "when you're constantly politicizing someone, only seeing their body within the context of a system, you're reverting to kind of a Colonial mindset. It leaves no space for anyone's humanity."[5] Thus, she has conceived her most recent paintings as "vignettes" rather than portraits, underlining the experiential component that guides her practice.

The artist's process in creating her compositions mirrors her conceptual approach. She sources materials from her day-to-day life and "builds" her images with collaged elements—a technique that parallels the multifaceted nature of the lived experiences she is evoking. Rather than using adhesive, Self sews each component onto the canvas base (she has related this technique to childhood memories of her late mother, Glenda M. Self, who was an ardent seamstress). The artist's affinity for repurposing existing materials brings to the fore her interest in mining real life, allowing her to construct, quite literally, her own narratives.

Similarly, Self's *Bodega Run* series of immersive installations, which incorporate sculptures, neon signage, and wallpaper alongside paintings, replicate aspects of New York's eponymous corner shops (the literal meaning of *bodega* in Spanish is "warehouse"), which emerged with the mass arrival in the city of Puerto Ricans in the first half of the twentieth century. Initially developed in 2017 as part of her inaugural show at the London gallery Pilar Corrias, the project has enabled the artist to provide a tangible environment for her figures in a space she believes is emblematic of Black and Brown metropolitan life. As she explains, "For so long, within my practice, my figures had existed within a liminal space defined by abstract color fields. My exploration of the bodega has allowed me to situate my figures in a real and socially relevant space."[6] AB

1. Tschabalala Self, "Artist Interview: Tschabalala Self," Institute of Contemporary Art, Boston, June 23, 2020, YouTube video, 9:21, https://www.youtube.com/watch?v=bMCRsAX8y3k.
2. Tschabalala Self, "Of This World and Not: A Conversation between Isabelle Graw and Tschabalala Self," in *Beyond the Black Atlantic: Sandra Mujinga, Paulo Nazareth, Tschabalala Self, Kemang Wa Lehulere*, ed. Sergey Harutoonian and Angela Lautenbach, exh. cat. (Vienna: Verlag für Moderne Kunst, 2021), 72.
3. "Tschabalala Self," in *"Journey through a Body" Reader: Kate Cooper, Luki von der Gracht, Christina Quarles, Nicole Ruggiero, Tschabalala Self, Cajsa von Zeipel*, ed. Gregor Jansen and Alicia Holthausern, exh. cat. (Berlin: Tabloid, 2021), 33.
4. Self, "Of This World and Not," 67.
5. Tschabalala Self, "Conversation: Tschabalala Self," interview by Brandon Stosuy, *Creative Independent*, June 30, 2017, https://thecreativeindependent.com/people/2017-06-30-tschabalala-self-on-not-being-afraid-of-hard-work/.
6. Tschabalala Self, "Tschabalala Self's 'Bodega Run' at the Hammer," interview by Katy Donoghue, *Whitewall*, February 13, 2019, https://whitewall.art/art/tschabalala-selfs-bodega-run-hammer.

128. *Sisters*, 2021
Velvet, felt, tulle, marbleized cotton, craft paper, fabric, and digitally printed, hand-printed, and painted canvas on canvas
84 × 80 in. (213.4 × 203.2 cm)

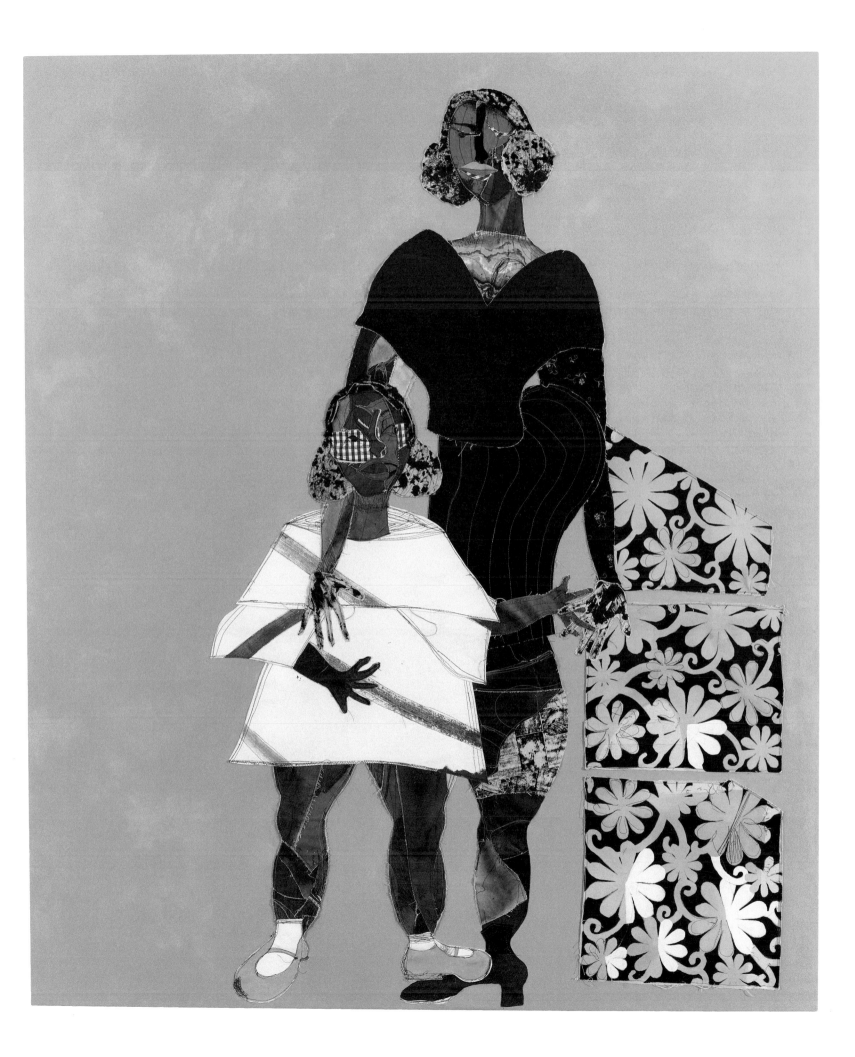

Rachel Jones

Born London 1991

This composition by the British artist Rachel Jones is one of a number of works, all titled *SMIIILLLLEEEE*, which debuted in an exhibition of the same name at Thaddaeus Ropac, London, in December 2021. Like the others in the group, it is monumental in size, measuring over eight feet tall, and was made without a brush. Committed to probing the possibilities of her medium ("it's a matter of being able to explore different ways of making paintings"[1]), the artist applies pigment in a way that is closer to drawing than to traditional painting methods. Her use of oil stick, a combination of paint and wax in the form of a cylindrical bar—a material that can be "picked up and used immediately"—accentuates her intuitive approach to creating her work.[2]

After earning her BFA at Glasgow School of Art in 2013, Jones first explored abstraction in earnest as a graduate student at London's Royal Academy Schools (from which she received an MA in fine art in 2019), using isolated parts of the body as vessels to navigate emotions and life experiences. A series of drawings made early in this period were intimately scaled and incorporated eyes, countering Jones's feeling of being observed and surveiled in society. As she once explained, "This stemmed from thinking about experiences I've had where people look at me and how that raises a sense of hyper-visibility and sensitivity to being looked at, and especially being a Black woman being stared at by people. And the idea that all these emotions—desire, inquisitiveness, hostility—can be communicated just through a stare."[3]

More recently—in works that remain principally abstract—Jones has turned her attention to mouths and teeth. Offering a literal point of access into the body, these corporeal features have become recurring motifs, allowing the artist to explore notions of interiority and self-expression, especially as they relate to her perspective as a Black woman. The paintings in *SMIIILLLLEEEE* follow the 2021 series *lick your teeth, they so clutch*, which was partly inspired by the culture of tooth adornment, particularly the gold grills worn by some Black men and women. Indeed, the circles that appear on a number of her canvases, including the Shah Garg Collection example—which almost look like stains made by a coffee mug or a can of house paint—may have emerged as an allusion to the practice of bonding diamonds and colored gemstones to teeth.

Flowers have become another prevailing motif in Jones's work. Initially an outgrowth of the aforementioned circles, they have persisted as a formal device, in the *SMIIILLLLEEEE* series and elsewhere. The artist explains, "The flowers became repeated as a form to emphasise the idea of having a pattern, or something stuck on the tooth. But now I'm using flowers in different ways and in various scales," amplifying them and making them increasingly abstract.[4] Color is also a critical tool for Jones, which she uses as a device for provoking and challenging viewers. She often considers her color combinations to be "ugly" and deliberately makes her hues "clash."[5] As the artist has remarked, "That's probably my main priority when I'm making an image. I don't want it to be a comfortable, easy thing to take in, so I try to create as much friction as possible. . . . It's important that the works are nuanced, they are difficult, because what I'm describing isn't a one-liner."[6]

AB

1. Rachel Jones, "A Focus on Painting: Rachel Jones," Thaddaeus Ropac, London (website), exh. on view September 12–October 21, 2020, accessed August 15, 2022, video, 2:10, https://ropac.viewingrooms.com/viewing-room/10/?_preview_uid=4b1cb3daec424566981db5e1c50efd35&version=96ec90.
2. Rachel Jones, "Teeth, Lips, Flowers: Rising Star Rachel Jones on Her Latest Works and How She Prioritises a Black Audience," interview by Louisa Buck, *The Art Newspaper*, December 7, 2021, https://www.theartnewspaper.com/2021/12/07/rising-star-rachel-jones-on-her-latest-works.
3. Ibid.
4. Ibid.
5. Rachel Jones, "Rachel Jones at Chisenhale" (exh. brochure), Chisenhale Gallery, London (website), exh. on view March 12–June 12, 2022, accessed August 15, 2022, https://chisenhale.org.uk/wp-content/uploads/rachel-jones-at-chisenhale-gallery_exhibition-handout.pdf.
6. Jones, "A Focus on Painting."

129. *SMIIILLLLEEEE*, 2021
Oil pastel and oil stick on canvas
98½ × 63 in. (250.2 × 160 cm)

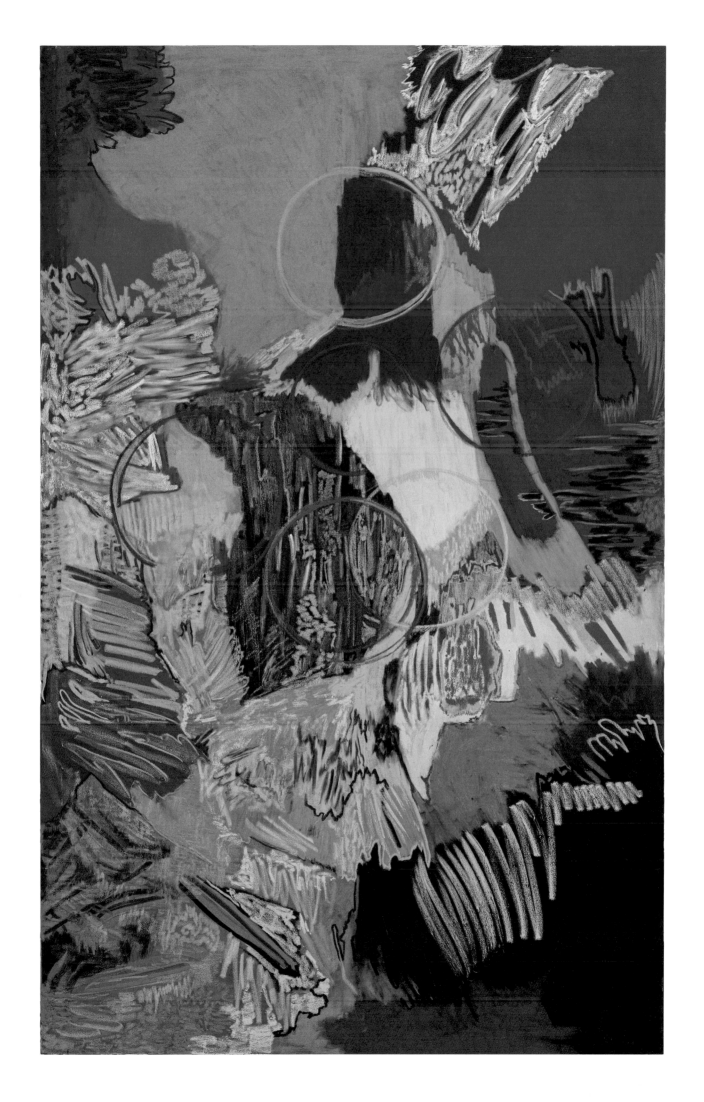

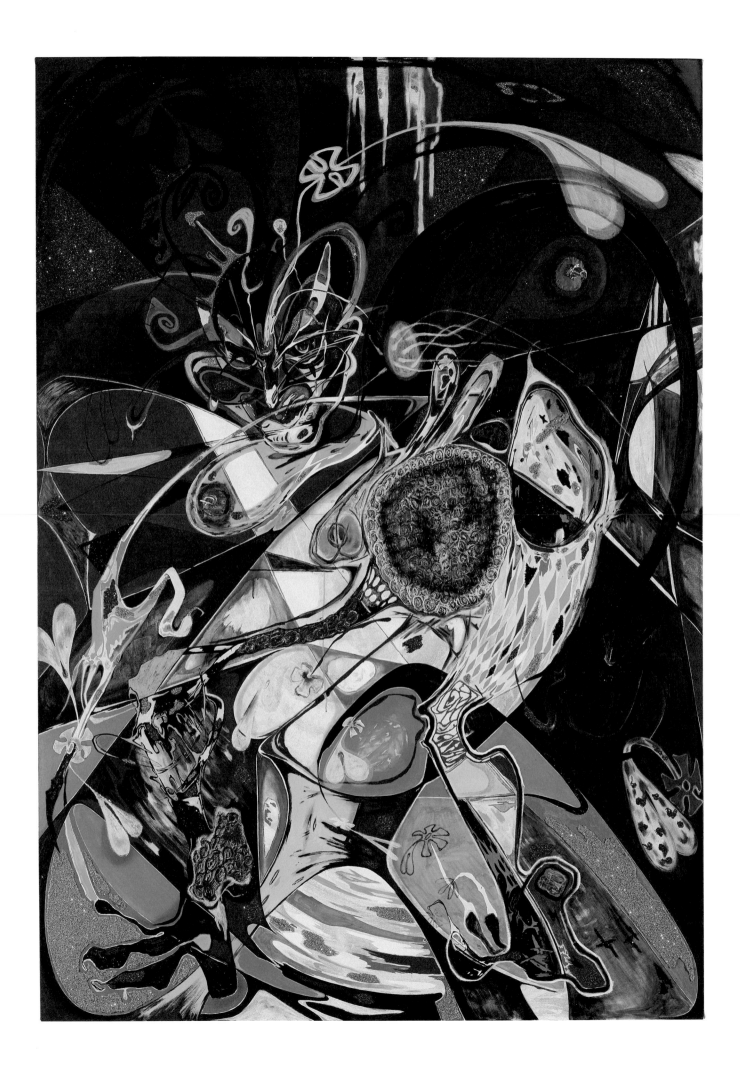

Theresa Chromati

Born Baltimore 1992

Theresa Chromati, a Guyanese American mixed-media artist, was raised in West Baltimore and spent her formative years living in a multigenerational home with her "DIY, off-the-grid type family": her mother, who was "always making things," her grandfather, and her grandmother.[1] She earned her BFA in graphic design at the Pratt Institute in 2014 and continues to live and work in Brooklyn.

Chromati's debut exhibition, *BBW* (an initialism used in popular culture for "big, beautiful women"), took place at Baltimore's Platform Gallery in 2016. The exhibition featured paintings of lithe nude figures dancing, resting, and braiding hair. To make these images, she began with digital sketches, which she then printed out onto paper or vinyl and elaborated with paint and collaged elements, including bandanna fabric and synthetic hair. In all the works, the figures' faces were covered by almond-shaped, often vibrantly hued masks with empty eyeholes and often pronounced lips.

To date, Chromati's oeuvre has been chiefly concerned with Black women, and one Black woman in particular—herself. She recently explained that it is important for her to "start and end my work from a place of intimacy. That's how I connect with the viewer. It's a very intimate experience that is based in me understanding myself as a woman and reflecting on the connection I have spiritually to other women before me."[2] In an act of deep self-exploration, the artist resists any attempt to project what she calls "clickbait" about generalized "trauma, identity, and the gaze" onto her work: "I think it takes more effort and more self-awareness from me to be like, 'I'm only making work about my feelings and emotions, versus making work about my identity, necessarily, or trauma or struggle,'" she observed to a *New York Times* reporter in 2019.[3]

In her latest paintings, Chromati has removed the masks from her figures' faces and shifted the focus to vortices of whirling bodies, which often, taken together, produce a likeness of the artist herself. "I want to pack a lot into the work, so you can always see something new in it. You can take whatever you want at whatever time," Chromati has said, adding, "Throughout my working practice, I started to realize that these faces are fragments of myself."[4] In the center of the dizzying, large-scale canvas *Tuned Extensions—Full Time Traveler (Woman Growing with Her Scrotum Flowers)* is what appears to be a mouth rimmed with teeth, above and to the left of which a face with a piercing gaze, evocative of the artist's earlier masks, can be discerned. Rendered in bright colors, the spermatozoic shapes and flowers growing out of scrota throughout the work are met with multiple areas of silver and red glitter, several patches of impasto, and two tentacular protrusions of stuffed red satin, emerging straight out of the canvas (one to the left of the large mouth and the other above it and slightly to the right). Other recent paintings depict a handful of intertwined faces and fragments thereof, smiling or grimacing, which the artist calls representations of her "energy and inner thought."[5] These pieces mark a radical departure from her earlier, graphic-design-inspired output. Regarding her artistic evolution, Chromati has stated, "Once you stop hiding, you find more ease in how you move and how you've given yourself permission to understand yourself, to love yourself and to demand love and understanding from others. At that point, there's no reason to have the mask."[6] LOB

1. Theresa Chromati, "Theresa Chromati's New Growth," interview by Ashley Tyner, *Garage*, June 25, 2019, https://garage.vice.com/en_us/article/ywy4vg/theresa-chromatis-new-growth.
2. Theresa Chromati, "Stepping Out to Step In: Theresa Chromati's Commission at the Delaware Contemporary," interview by Kristin Hileman, *Bmore Art*, https://bmoreart.com/2020/06/stepping-out-to-step-in-theresa-chromati.html.
3. Theresa Chromati, quoted in Wilbur L. Cooper, "An Artist Making a Powerful Statement—by Creating Work about Herself," *T: The New York Times Style Magazine*, August 7, 2019, http://www.nytimes.com/2019/08/07/t-magazine/theresa-chromati-artist.html.
4. Ibid.
5. Ibid.
6. Ibid.

130. *Tuned Extensions—Full Time Traveler (Woman Growing with Her Scrotum Flowers)*, 2021
Acrylic, glitter, fabric, thread, and leather cord on canvas
84 × 60 in. (213.4 × 152.4 cm)

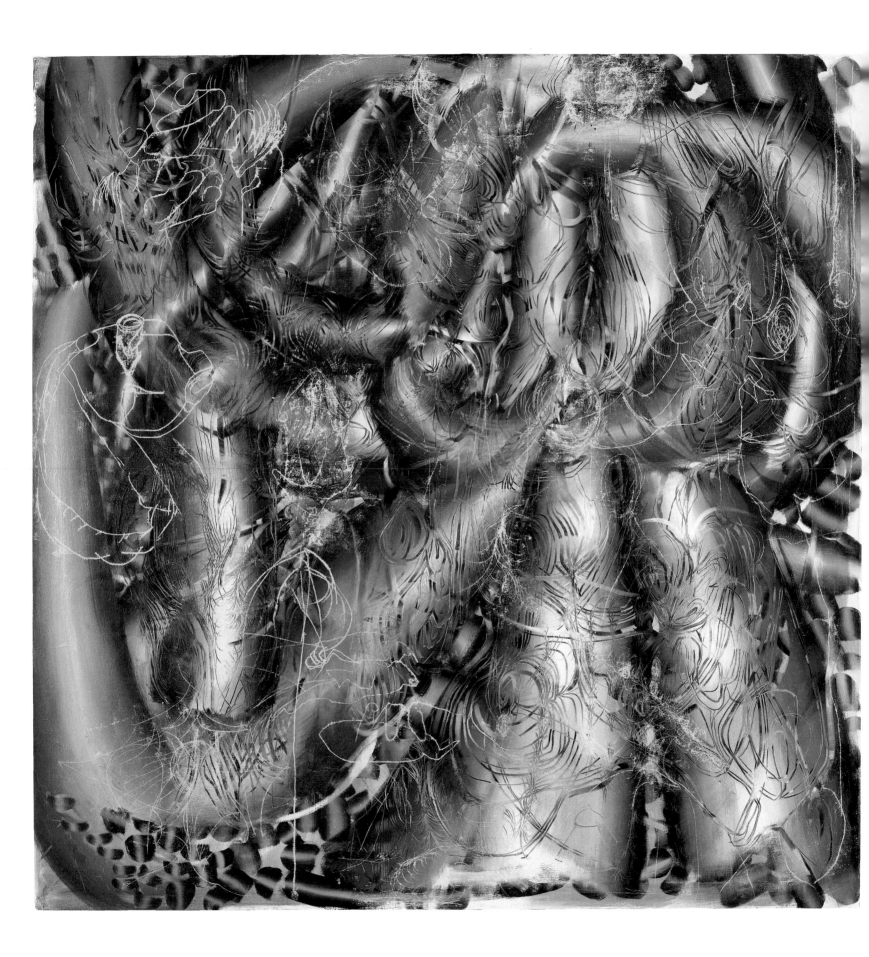

Lauren Quin

Born Los Angeles 1992

Lauren Quin was born in Los Angeles, raised in Atlanta, and now lives in Los Angeles and San Francisco. She earned a BFA from the School of the Art Institute of Chicago in 2015, attended the Skowhegan School of Painting and Sculpture, and received an MFA in painting from the Yale School of Art in 2019. However, Quin's most formative instruction came from her father, who had no artistic training but painted enthusiastically in his free time. "He just worked in the basement, alongside me," she recalls.[1] It was there that he passed on the basics of facture, such as how to hold a paintbrush.

Far from using a brush in any conventional manner, however, Quin creates her current paintings by dragging a dull knife or the tip of her fingernail through wet oil paint to refine the volumetric, tubelike forms that appear in the background of many of her works. This effect is a direct result of the time she spent at Skowhegan: "I had never experienced pitch black as I did walking at night through the deep woods of Maine during my residency there. Your sense of depth is completely removed. You have to turn your flashlight off, because the light attracts bugs, and just remember that you're on a path. I kept feeling like things were flying at me and I was being pushed through a tube." She continues:

> That feeling carries over to my work, even now. I'm constantly trying to change the range of depth in my paintings; it's like the painting falls off the edges, and I keep moving into the center. That's how I know that a painting is finished—when I reach that point where you feel everything is flying at you and you're just moving through it.[2]

Indeed, her delicate and sharp marks seem to move both forward and backward, as the viewer may notice in *Fly's Eye*, which references the large, compound eyes that allow the titular insect almost 360-degree vision. (Amazingly, each unit of the eye, of which there are thousands, captures a slightly different image, and these images come together in the brain in a kind of mosaic to create a broad field of vision for the fly.)

To create a composition, Quin usually begins by painting a base layer of smaller cylinder forms in a crosshatch pattern, then adds larger ones that resemble tunnels or intestines—the "tubelike" elements. Atop this background, she then copies a line drawing, often featuring hands, over and over, adding gradients and swelling it beyond identification. When enough layers build up, the artist repeats the drawing—this time, by carving it into the paint, using anything from a miniature medicine spoon to an X-Acto knife. After the paint dries, she flips the canvas over and presses it against a large sheet of glass on which she has rendered the same drawing in ink. This final step is akin to making a monoprint. The process is laborious and repetitive. In college, Quin initially considered becoming an art therapist, and in learning about the field, she was "fascinated by the rhythmic, repetitive elements of patients' work, which ultimately made their way into her own."[3]

As the marks on each of Quin's works proliferate, they begin to generate an undulating, wavelike effect, to the point that her painstaking oil paintings sometimes appear to be digitally printed. The artist likens this to a moiré pattern: a visual mirage created by the interference of two superimposed images. Like the hypnotic warping that appears in any digital photograph taken of a computer screen, her art is hard to ignore—and even harder to forget.

LOB

1. Lauren Quin, quoted in Stephanie Eckardt, "In the Studio with Lauren Quin, the Painter Doing Abstraction Her Own Way," *W Magazine*, July 8, 2021, https://www.wmagazine.com/culture/lauren-quin-artist-studio-visit.
2. Ibid.
3. Janelle Zara, "Painter Lauren Quin Explores a New, Electric Type of Mark," *Cultured*, December 7, 2021, culturedmag.com/article/2021/12/07/painter-lauren-quin-explores-a-new-electric-type-of-mark.

131. *Fly's Eye*, 2021
Oil on canvas
72 × 72 in. (182.9 × 182.9 cm)

Aria Dean

Born Los Angeles 1993

Since graduating from Ohio's Oberlin College with a BA in studio art in 2015, the artist Aria Dean has produced works that critically investigate the legacies of Minimalism, the effects of digital culture, and the relentless convergence and reinscription of race, gender, and power. She is particularly interested in what constitutes the difference today between reality and illusion. As she noted in a 2021 interview, "The driving question that I'm still constantly asking is: what are the things that make up our reality, and how do perception and an objective sense of the world collide? Film and art are places where that's constantly being negotiated."[1]

Dean's sculpture *Little Island/Gut Punch*, which was featured in the 2022 Whitney Biennial, is a case in point. The effervescent work is painted chroma-key green—the same color used for green-screening, the technique of filming a scene against a monochromatic green backdrop and then, in postproduction, using a filter to replace the green background with different footage. The sculpture is mounted on a cylindrical pedestal painted the same hue. Formally, it is a simple, erect rectangular solid, roughly the size of the artist's body—but one that appears to have been struck forcefully in its middle and is beginning to collapse in on itself (hence, the "gut punch").

Little Island/Gut Punch was created through several digital processes, including collision simulation and 3D modeling; ultimately, outsourced fabrication made it material. It is rigorously executed, exquisitely textured, and, indeed, anthropomorphic. "The work makes a joke about my own artistic practice—beating up a monolith," says Dean. "You can take this as beating up monumentality, beating up Minimalism . . . beating up the phallus or phallic gesture. None of these and all of these are right."[2]

The piece was inspired, in part, by Dean's fascination with Little Island, a park propped up on 132 tulip-shaped concrete columns that opened in the Hudson River just off the west side of Manhattan, near the Whitney Museum of American Art, on May 21, 2021. The park is a five-minute walk from the installation *Day's End* (2021), a ghostly architectural exoskeleton commissioned by the Whitney from David Hammons (born 1943) in tribute to a 1975 intervention by the artist Gordon Matta-Clark (1943–1978), also titled *Day's End*. For the original work, Matta-Clark made five incisions and one larger, semicircular cutout in Pier 52, a huge, roofed structure formerly on the spot where Hammons's shrewd installation now stands. In the Biennial's catalogue, Dean discusses how both Little Island and the latter-day *Day's End*—always overcrowded with people taking pictures and selfies—contributed to her thinking about our current moment as "all just a backdrop . . . an empty set."[3] During the Biennial, *Little Island/Gut Punch* was installed near a floor-to-ceiling window offering visitors a view of Hammons's *Day's End* and the Hudson River; it was, again, a popular place to take pictures.

It is important to note that Dean, in addition to her artistic practice, is an accomplished writer and critic. In perhaps her most acclaimed essay, "Notes on Blacceleration" (2017), she examined the constitution of the Black subject at the onset of capitalism alongside the extractive violence of slavery, arguing that "accelerationism always already exists in the territory of blackness, whether it knows it or not—and, conversely, that blackness is always already accelerationist."[4] She is also an editor of the nonprofit online magazine *November*, where she has written sharp revisionist texts on figures such as the French philosopher Georges Bataille (1897–1962).[5]

LOB

1. Aria Dean, quoted in Elleza Kelley, "Critic Aria Dean Is Untangling the Knots of Art, Design and Human Nature," *i-D*, no. 365 (Winter 2021), https://i-d.vice.com/en_uk/article/v7dmnb/aria-dean-in
2. Aria Dean, quoted in Nate Rynaski, "Aria Dean: Do You Hear That Static?," *Flaunt Magazine*, April 26, 2022, https://flaunt.com/content/aria-dean-phone-a-friend.
3. Aria Dean, artist's statement, in *Whitney Biennial 2022: Quiet as It's Kept*, by Adrienne Edwards and David Breslin, exh. cat. (New Haven, CT: Yale University Press, 2022), 92.
4. Aria Dean, "Notes on Blacceleration," *e-flux*, no. 87 (December 2017), https://www.e-flux.com/journal/87/169402/notes-on-blacceleration/.
5. Lauren O'Neill-Butler, author of this text, is a cofounder of *November*.

132. *Little Island/Gut Punch*, 2021
Urethane paint on high-density foam
68⅞ × 20⅝ × 19¾ in. (174.9 × 52.4 × 50.2 cm), overall including base 84⅞ × 56⅝ × 55⅝ in. (215.6 × 143.8 × 141.3 cm)

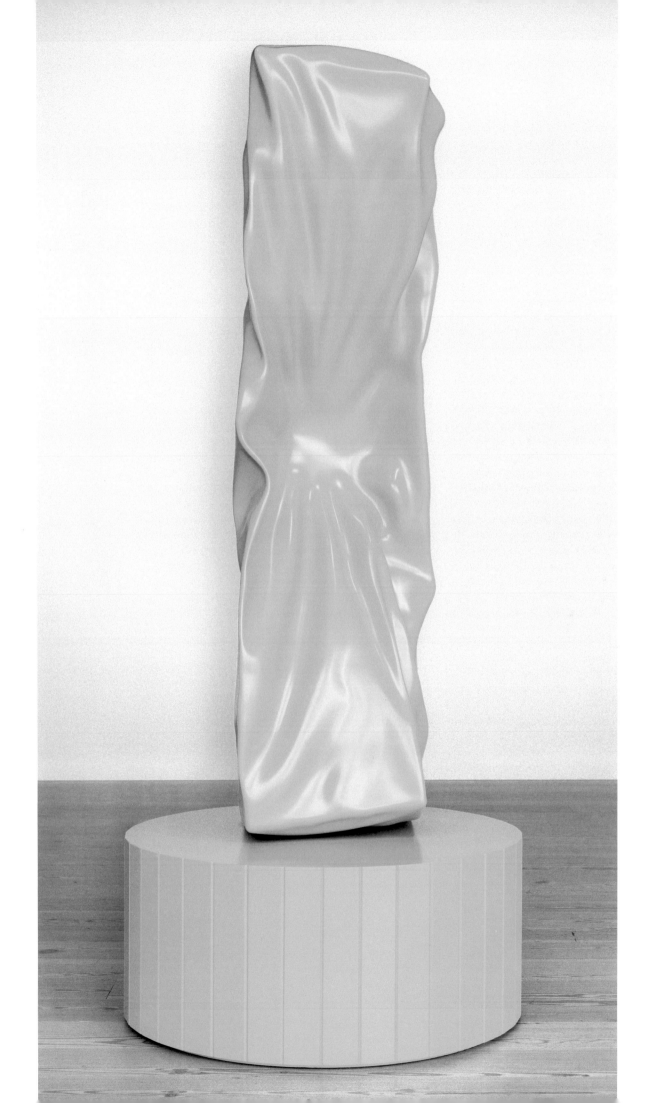

Jadé Fadojutimi

Born London 1993

The London-based artist Jadé Fadojutimi's large, phenomenally colorful paintings are inspired by a broad array of source material, ranging from Japanese anime and Victorian furniture to plants, fashion, and video games. For *The Milk of Dreams*, the international art exhibition curated by Cecilia Alemani for the 59th Venice Biennale in 2022, Fadojutimi produced three new canvases (*The Prolific Beauty of Our Panicked Landscape*; *And that day, she remembered how to purr*; and *Rebirth*), which showcased her ambitious approach to abstraction at a monumental scale. *The Prolific Beauty*, in particular, was a tour de force of illusionism in the guise of abstraction (or vice versa), featuring what looked like a huge white curtain behind a projection of free-floating, graffiti-like shapes and marks.

Fadojutimi graduated with a BA from London's Slade School of Fine Art and, in 2017, earned an MA from the Royal College of Art. Using her canvases as a sounding board, she grapples with memories and her everyday experiences, translating them into paintings that are charged with energy and emotion. The artist has said that her work stems primarily from daily occurrences and her interest in self-knowledge and growth: "I think of my work as a diary of my life, and my studio as a diary of my childhood."[1] Teeming with swift, haphazard brushstrokes that smolder through further skeins of oil paint, Fadojutimi's canvases typically appear drenched in rapturous hues, marks, and lines, spinning, swirling, and sprawling over the canvas. The artist cites the Argentinian Italian artist Varda Caivano (born 1971) and the British painter Phoebe Unwin (born 1979) as points of reference, but her strongest influence may be Japanese popular culture, with which she admits being somewhat "obsessed."

Fadojutimi is fascinated by the ways we adorn ourselves with clothing and accessories to construct a sense of self. The shapes of hair bows and patterns lifted from hosiery recur in her works. Some canvases, such as *Inside My Shell*, depict enigmatic landscapes that toe the line between figuration and abstraction in an attempt to create a form of reality that feels parallel to but separate from the real world. The composition recalls a lush and verdant tropical jungle, or perhaps an underwater kelp forest. Outlines of objects that resonate with the artist but often elude the viewer also feature surreptitiously in her art—here, the loose shape of a seashell seems to hover at the top of the picture plane.

Color is central to Fadojutimi's approach. "I think we can translate a lot of moods into color, and see it literally, too. I've been thinking about a lot of what it means to talk about identity, or question it," she observed in an interview with British *Vogue*. "We are all colors that are constantly fluctuating, we change every day, we change every minute, and it was a wonderful thing to think about in terms of why these paintings feel so different to me all the time, because I am constantly changing, and the colors I am experiencing are constantly changing. I don't want to use color literally, but it's more of a synesthesia of sorts."[2]

For Fadojutimi, the act of painting informs and is informed by her environment. "It's really important for [my studio] to feel like my bedroom, because that's where my journey with myself started, where my journey with my interests started," she observes.[3] Indeed, her paintings seem to emerge from a clear mind. "I try really hard not to contaminate the experience of painting with unnecessary, premature questions. When you're having a conversation with yourself through material, it's best to succumb to the experience. How can you really experience yourself if you're distracted by the noise of the world?"[4] LOB

1. Jadé Fadojutimi, quoted in Katy Hessel, "27-Year-Old Painter Jadé Fadojutimi Is in a League of Her Own," *Vogue* (UK), August, 31, 2020, https://www.vogue.co.uk/arts-and-lifestyle/article/jade-fadojutimi-interview.
2. Ibid.
3. Jadé Fadojutimi, "Jadé Fadojutimi—Studio Visit," Liverpool Biennial, March 12, 2021, YouTube video, 3:12, https://youtu.be/gOjtHikN8UQ.
4. Jadé Fadojutimi, "Jadé Fadojutimi: 'When I Change, the Work Changes,'" interview by Tessa Moldan, *Ocula Magazine*, December 2, 2021, https://ocula.com/magazine/conversations/jade-fadojutimi-ica-miami/.

133. *Inside My Shell*, 2018
Oil on canvas
78⅛ × 71 in. (198.4 × 180.3 cm)

Bronwyn Katz

Born Kimberley, South Africa, 1993

Salvaged materials, typically metals such as copper, iron ore, steel, and wire, form the basis of the minimalistic sculptures made by the South African artist Bronwyn Katz. ǁgane ǀʼamiros belongs to a series of wall- and floor-based works constructed from dismantled bed frames and bedsprings into which the artist inserts plastic pot scrubbers of various colors. Katz first exhibited these large-scale compositions in 2019 on the occasion of her third show at Blank Projects, a gallery in Cape Town. The most recent installment in the series, which included the Shah Garg Collection work, was presented at the Investec Cape Town Art Fair in February 2022.

Katz's use of found objects, specifically those involving beds—a central motif in her practice following her studies at the University of Cape Town, from which she graduated with a BFA in 2015—allows her to explore ideas of belonging, especially in relation to geographical terrains. For Katz, the earth acts as a repository for memory: "I am thinking through the land as a bed and the soil as a blanket. Drawing allegories, gathered from stories told by elders in my community about the earth."[1] The artist also seeks to address specific people. Although Katz was "born free"—that is, born and raised in post-apartheid South Africa—her work is largely informed by that long period of racial subjugation, as well as by the present-day economic inequality endured by large segments of the country's Black population. The artist, who is Indigenous Khoekhoe, grew up in Greenpoint, formerly a designated non-White area of the diamond-mining city of Kimberley—an outcome of apartheid policies that forcibly relocated Black people to the suburbs. For her 2017 exhibition at Blank Projects, Grondskryf, Katz collected wire bedsprings and mattresses abandoned on the street in Johannesburg, which she associates with the displacement of working-class communities caused by the city's rapid gentrification. "I am interested in the residue that lives in found objects," Katz says. "I think of this residue as a collaborator in my work. Contributing to the value and importance of forgotten or neglected objects is political."[2]

Language is another entity that Katz seeks to revive through her abstract constructions. The title ǁgane ǀʼamiros features a system of notation the artist has been developing to signify the phonetics of an imagined creolized language not dissimilar to !Ora, an ancestral, click-based language of southern Africa that is now on the verge of extinction. By devising linguistic codes and realizing them through her sculptures, the artist proposes to preserve ancient modes of communicating. In 2019, Katz produced a body of work titled Salvaged Letter in response to a statement made by the !Ora language activist Benjamin Kats in 1928: "Ta a-b kobab ada kāxu-da, ti khoe-du'e!" (Do not let our language be lost from us, you, my people!). The following year, for the 22nd Biennale of Sydney, Katz created a group of wall-mounted sculptures based on four click consonants sourced from endangered southern African languages, including Khoekhoe, and interspersed them between European oil paintings in the Art Gallery of New South Wales.

Recently, the artist has widened her references to incorporate mythology. Gōegōe (2021), exhibited at the 59th Venice Biennale in 2022, takes its title from the name of a fabled water snake that appears in the folklore of several southern African peoples. In the version of the tale shared with Katz by her grandparents, the creature awakes one day to find that a man has stolen its eye (a diamond), which leads the serpent to destroy itself in a rage.[3] The work, consisting of bedsprings and pot scrubbers configured into a rectangular form measuring nearly thirty square feet and rusted, over time, with hydrochloric acid, extends Katz's exploration of how to continue to exist in one's homeland amid the ongoing destructive processes of human consumption.　　AB

1. Bronwyn Katz, "Bronwyn Katz: 'Beauty Is the Magic That Life Shows Us When We Pay Attention,'" interview by Holly Black, Elephant, May 31, 2021, https://elephant.art/bronwyn-katz-beauty-is-the-magic-that-life-shows-us-when-we-pay-attention-31052021/.
2. Ibid.
3. Siddhartha Mitter, "Art That Finds Clarity in South Africa's Fraught Terrain," New York Times, April 28, 2022, updated May 3, 2022, https://www.nytimes.com/2022/04/28/arts/design/venice-biennale-south-africa-art.html.

134. ǁgane ǀʼamiros, 2022
Bedsprings, pot scrubbers, hydrochloric acid, and wire
72⅞ × 55⅛ × 10¼ in. (185 × 140 × 26 cm)

Tau Lewis

Born Toronto 1993

The mixed-media textile work *fetus ex angelus (Liberation of the planetary ovum)*, by the self-taught Canadian artist Tau Lewis, was first exhibited at Sadie Coles HQ, London, in the 2021–22 group show *WHAT DO YOU SEE, YOU PEOPLE, GAZING AT ME*. Taking the genre of figuration as its starting point, the exhibition, which also included pieces by Natalie Ball, Kevin Beasley, and Agata Słowak, among others, explored the expressive possibilities of the human body and its usefulness as a device for creating new perspectives in works of both two and three dimensions. Lewis's three-dimensional contribution to the show was *Mutasis Moon* (2021), a soft, humanoid sculpture in shades of aqua and peach with multiple faces and fringed, outspread arms. Her two-dimensional contribution, the work now in the Shah Garg Collection, consists of ten overlapping fabric panels stitched together into a roughly rectangular shape. The artist considers such works to be "quilts" and, in the catalogue accompanying the 59th Venice Biennale of 2022, in which Lewis participated, her compositions were likened to those of the Gee's Bend quilters of Alabama and to the story quilts of Faith Ringgold (see pl. 14).[1]

In *fetus ex angelus*, abstracted versions of women's bodies appear alongside depictions of solar systems. Toward the top of the work, two pregnant bodies in profile, with visible babies in utero, frame a circular configuration of contoured shapes reminiscent of developing embryos or amoebas, with a sort of checkerboard of planetary orbs in the center. Potentially understood as a celestial map portraying both the birth process and cosmic multiverses, *fetus ex angelus* encapsulates Lewis's ongoing fascination with the cyclical and regenerative nature of the human species. For her 2020 exhibition at the Toronto gallery Cooper Cole, she produced a series of immersive, pastel-hued figurative sculptures (or "soft portraits," as Lewis terms them) that, in conjunction with the strands of fabric flowers hanging all around them, were intended to resemble a light-filled womb.

The artist's interest in the notion of motherhood as a source of knowledge and triumph relates to another prevailing theme that guides her practice: physical labor as a generative tool. Lewis completely hand-stitches her intricate, wall-based textile works and freestanding stuffed sculptures in a method she describes as "tender," but she is also capable of carving denser materials, such as plaster, by hand. "I'm interested in how I can honour and continue diasporic practices of art making, which have been labour intensive,"[2] Lewis says, acknowledging the role played by her Jamaican heritage as well as the larger Black diasporic legacies that inform her work.

Lewis uses recycled materials—"the backbone of my art"—to engage with histories of Black cultural production, where repurposing has long been a recuperative activity.[3] "So many of our cultural tools, especially against oppression, have to do with physical or situational upcycling," Lewis has remarked, whether of "a circumstance or an idea or an object."[4] This resourcefulness has been mirrored by the artist in her accumulation of fabrics and objects: *fetus ex angelus* comprises materials collected by Lewis previously in Toronto as well as more recent finds obtained in Brooklyn, where the artist is now based, and Negril, Jamaica, where her family has a home. Because she is committed to what she has called the "material DNA" of her fabrics, familiarity is integral to the textiles she selects, to allow for the "emotive transference" of memories and histories. As Lewis explains, "I want to create places to go to. My artwork takes me out of this world, out of this realm."[5] AB

1. Madeline Weisburg, "Tau Lewis," La Biennale di Venezia (website), exh. (*The Milk of Dreams*) on view April 23–November 27, 2022, accessed August 15, 2022, https://www.labiennale.org/en/art/2022/milk-dreams/tau-lewis.
2. Tau Lewis, quoted in "Tau Lewis," Stephen Friedman Gallery, London (website), accessed August 15, 2022, https://www.stephenfriedman.com/artists/79-tau-lewis/.
3. Tau Lewis, quoted in Baya Simons and Rosanna Dodds, "Six Artists Reshaping Our Way of Seeing," *Financial Times*, April 25, 2021, https://www.ft.com/content/5b3ccf57-d715-45aa-9880-b89a27720465.
4. Tau Lewis, quoted in Sky Goodden, "With Stuffed Dolls and Hidden Talismans, Artist Tau Lewis Conjures a Space to Address the Black Diaspora's Legacy—and Its Future," Art Basel Miami Beach (website), exh. (Cooper Cole booth) on view December 5–8, 2019, accessed August 15, 2022, https://artbasel.com/news/studio-visit-tau-lewis-art-basel-miami-beach.
5. Lewis, quoted in Simons and Dodds, "Six Artists."

135. *fetus ex angelus (Liberation of the planetary ovum)*, 2021
Leather, wood, suede, fabric, and acrylic paint
9 ft. 11¾ in. × 3 ft. 11 in. (304.2 × 119.4)

Gisela McDaniel

Born Bellevue, Nebraska, 1995

Born on a naval base in Nebraska and raised in Cleveland, Gisela McDaniel is a diasporic, mixed-race Chamorro artist based in Detroit. The Chamorro are the Indigenous people of the Mariana Islands, an archipelago in the western Pacific Ocean that is divided between two United States territories: Guam, where McDaniel's grandfather served in the U.S. Navy, and the Commonwealth of the Northern Mariana Islands (the political distinction dates back to the Spanish-American War). "My Chamorro values are incredibly important to me, in the way I work and move," the artist has said. "Even the way I work with other people, the foundation of everything is respect. Respect is one of the biggest values in our culture, especially in regards to our elders, first and foremost, but it also applies to everybody."[1] The ancient concept of *inafa'maolek*—literally, in Chamorro, "doing good for each other" but often translated as "interdependence"—is a core value of the islands' traditional culture. This and other key Chamorro doctrines apply not only to human beings but to the land, the water, and the culture itself.

McDaniel received a BFA from the University of Michigan in 2019. Her intimate and affecting, opulent and triumphant paintings depict women and nonbinary people who identify as Black, Micronesian, Turtle Island Indigenous, Asian, Latinx, and/or mixed race. The artist sees her portraits as platforms for healing, specifically for survivors of sexual trauma. As she notes on her website, she "aims to heal those who have experienced gender-based sexual violence, giving a voice, space, as well as a confidential vehicle for survivors to not only share their experiences, but to also explore how those experiences have affected them long-term."[2]

Works by McDaniel such as *Build in My Soul* intertwine oil painting, audio, and motion-sensor technology. The visual portions of these ensembles tend to comprise layers of bright and earthy hues, in both smoothly blended gradients and thick, sculptural masses of paint. The artist pays careful attention to color and depth, bathing the figures in restful, inviting lighting. There are formal concerns here, but also ethical ones. McDaniel is interested in producing pieces that "come to life" and literally "talk back" to viewers.[3] When exhibited, the works are accompanied by recordings, triggered by viewers' movements, in which the paintings' subjects share their experiences, both positive and negative, thus making the artworks inseparable from the people they depict. "It's a survival, honestly" and "Take back my body" are just two of the spoken lines that reverberate in the Shah Garg Collection piece.[4] The artist says that she "intentionally incorporates survivors' voices to subvert traditional power relations and to enable both individual and collective healing."[5] Her models find her by word of mouth, and each sitter has complete control over their representation, from choosing the backdrop and the pose to permitting or disallowing the inclusion of their personal possessions. For McDaniel, the act of painting thus entails a transfer of power back to historically oppressed individuals.

McDaniel considers her portraits "consensual artifacts" because they convey oral histories that refuse to make trauma the center of the representation. Instead, she focuses on individuals and their intimate moments of becoming, being, and healing. As she has stated, "I have an agenda with this work. I love painting, I'm so grateful I get to paint every day, but this is so much more than that to me. A lot of the pressure I put on myself isn't necessarily to be 'successful,' but to make sure that I'm doing right by my people and the people I work with."[6] LOB

1. Gisela McDaniel, "'I Want to Replace Gauguin's Work': How Chamorro Painter Gisela McDaniel Gives Survivors of Trauma a Voice with Her Empowering Portraits," interview by Julie Baumgardner, *artnet news*, January 26, 2022, https://news.artnet.com/art-world/chamorro-painter -gisela-mcdaniel-interview-2064002.
2. Gisela McDaniel, "Bio," artist's website, accessed February 2, 2022, https://www.giselamcdaniel.com/biography.html.
3. Ibid.
4. At the time of this writing, the audio associated with *Build in My Soul* was available at https://vimeo.com/480354872.
5. McDaniel, "Bio."
6. McDaniel, "'I Want to Replace Gauguin's Work.'"

136. *Build in My Soul*, 2020
Oil on wood panel, with found objects, resin, and sound
45 × 60 × 5½ in. (114.3 × 152.4 × 14 cm)

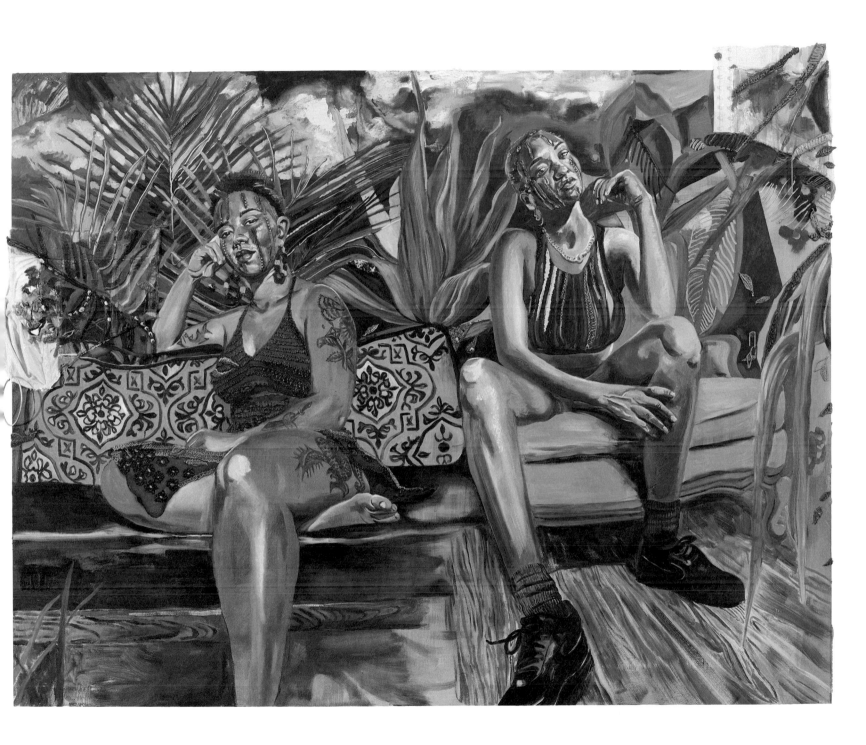

Acknowledgments

It has taken a village, with many special women and a few good men, to make this book a reality. My dream over the past decade has been to elevate art made by women, amplify their voices, and redress centuries of suppression—in some cases, sabotage—by society and by the high priests of art. This book and the scholarship herein are an important step forward in bringing into focus the strength and pervasive influence of work by women artists.

First and foremost, I must acknowledge my parents, Manju and Ratin, for instilling in me the confidence and chutzpah to follow my dreams, however farfetched those dreams may have seemed. They withstood ridicule from my extended family when they chose to support my education in the United States rather than save for a dowry for my marriage.

Gaurav, my husband and partner in this ambition and a true believer in the mission, has been by my side throughout the crazy work days and emotional lows and highs involved in creating a collection and this accompanying book.

Mark Godfrey has had a huge impact on my art journey. He introduced me to many of the artists in the collection and to their work. He drew countless maps outlining networks and influences among the artists in the book. I especially remember the first network he drew for me on a train to Zurich: it truly opened my eyes. Such maps inspired the artist-on-artist commentaries that appear in this volume, between the essays and the plates.

When Mark suggested that we work together on a book about women artists, we immediately thought of partnering with Katy Siegel. Katy is a visionary and a fearless fighter for gender parity and racial equity in the art world. She and I hit it off the first time we met many years ago, gushing over Carrie Moyer and Charline von Heyl. I have never felt so aligned with someone in a first meeting. From then on, Katy was always generous with her knowledge, and her passion was contagious. As we continued to check in over the years, my respect for her only deepened. I am so pleased that she agreed to work with Mark and me on our shared vision.

I will forever be indebted to Gary Garrels, former Chief Curator of Painting and Sculpture at SFMOMA, whose wealth of knowledge about painting and painters and belief in so many women artists enhanced the collection immeasurably. Gary knows instinctively what a good painting is, and I am so appreciative that he graciously shared his time, expertise, and support. He is one of my greatest teachers.

Chris Bedford, Director of SFMOMA since June 2022, has the vision and gumption to transform the art world, in part through his strong commitment to diversity and inclusion. His support and counsel on the collection and the book have been invaluable. Even at his busiest times, he was there to look at paintings with me or to give advice.

Our collection manager, Alex Polson, has been steadfast over the past nine years. I thank her for her unwavering support in managing the collection and shepherding this book project to completion.

I have had the privilege of meeting many of the artists whose works we have acquired: it is one of the premier joys of building a collection. I want to thank so many of them who have been thought partners in this endeavor and specifically Charline von Heyl, one of my favorite sparring partners. She has sharpened the focus of the collection's mission to showcase "excellence" in visual arts by artists who happen to be women.

I am overwhelmed that so many artists I admire agreed to contribute personal, poetic, and thoughtful texts to the book. Thank you to Kevin Beasley, Aria Dean, Charles Gaines, Lyle Ashton Harris, Jacqueline Humphries, Allison Katz, Helen Marten, Laura Owens, Christina Quarles, Joyce J. Scott and Cecilia Wichmann, Kay Sekimachi and Jenelle Porter, Tschabalala Self, Jaune Quick-to-See Smith, Kay WalkingStick, and Mary Weatherford for sharing such compelling memories and stories.

I am extremely grateful to the scholars, curators, and critics Glenn Adamson, Daniel Belasco, Kirsty Bell, Jessica Bell Brown, David Getsy, and Gloria Sutton, whose essays, commissioned for the book, challenge accepted art-historical narratives and highlight the breadth of achievement of women artists.

With patience and good humor, Allie Biswas, Hannah Johnston, and Lauren O'Neill-Butler accepted the challenge of writing more than 135 mini essays, each of which contextualizes one of the illustrated plates. Their entries are informative and deeply researched, and I thank them for their game spirit and diligence.

Greg Miller, the publisher of this volume and a longtime friend, responded so enthusiastically when I shared the idea for the book. His early support gave us the conviction to proceed. With his backing and his partners, I knew the book would have the best team ever.

I am grateful to Jennifer Bernstein for reviewing every word and comma in the book, not just for syntax and grammar but also to help us communicate our ideas and emotions effectively.

Miko McGinty and Rita Jules instilled the book with magic and visual beauty, sure to seduce generations of women and men to read it and come away inspired.

This volume is an invaluable resource because of the gorgeous photography of our collection seen throughout

the plates section and elsewhere. We were fortunate to pull Ian Reeves out of retirement to take on the project, and Dashiell Arkenstone coordinated and oversaw its success.

Gina Broze handled the monumental task of securing permission from all the artists to reproduce their works in the book. She helped to source hard-to-find images and was an invaluable resource to us.

I am very fortunate to count two collectors, Bob Rennie and Pamela Joyner, as personal friends for whom I have the utmost adoration. They have built two of the most important collections in the world and have been great sounding boards as I traverse a path not tread before.

Finally, I want to thank my kids, Bijoy and Elina Garg, for keeping me grounded—sometimes with eye rolls. Most importantly, they inspire me to make the art world a more equitable place, with an authentic respect for diversity, for the benefit of their and future generations.

—Komal Shah

Mary Grigoriadis (born 1942). *Untitled (White Painting 1)*, ca. 1968–71. Oil on linen, 66 × 66 in. (167.6 × 167.6 cm). Shah Garg Collection

Notes on Contributors

Mark Godfrey is an independent curator and art historian based in London. Recent projects include exhibitions of the work of Laura Owens (Fondation Vincent van Gogh, 2021) and Jacqueline Humphries (Wexner Center for the Arts, 2021–22), and recent publications include essays on Firelei Báez, Kevin Beasley, Petrit Halilaj, and Faith Ringgold. From 2007 to 2021, he was Senior Curator at Tate Modern, where he curated or co-curated several exhibitions, including *Alibis: Sigmar Polke, 1963–2010* (2014–15), *Soul of a Nation: Art in the Age of Black Power* (2017), and *Franz West* (2019). He has published two books with Yale University Press, *Alighiero e Boetti* (2013) and *Abstraction and the Holocaust* (2007).

Katy Siegel is Research Director at San Francisco Museum of Modern Art (SFMOMA) and Distinguished Professor and Eugene V. and Clare E. Thaw Endowed Chair in Modern American Art at Stony Brook University. Exhibitions she has curated or co-curated include *Joan Mitchell* (2021), *Generations: A History of Black Abstract Art* (2019), *Odyssey: Jack Whitten Sculpture, 1963–2017* (2018), Mark Bradford's presentation at the 57th Venice Biennale (2017), *Postwar: Art between the Pacific and the Atlantic, 1945–1965* (2016), *Pretty Raw: After and Around Helen Frankenthaler* (2015), and *High Times, Hard Times: New York Painting, 1967–1975* (2006–8). She edited the 2018 volume *Jack Whitten: Notes from the Woodshed, 1961–2015* and has published widely on modern and contemporary artists, including Lee Krasner, Sharon Lockhart, Carrie Moyer, Mary Lovelace O'Neal, Toshiko Takaezu, and Charline von Heyl.

Glenn Adamson is a curator, writer, and historian based in New York. He has previously been Director of the Museum of Arts and Design, New York; Head of Research at the Victoria and Albert Museum, London; and Curator at the Chipstone Foundation in Milwaukee. His publications include *Objects: USA 2020* (2020), *Fewer Better Things: The Hidden Wisdom of Objects* (2018), *Postmodernism: Style and Subversion* (2011, accompanying a V&A exhibition co-curated with Jane Pavitt), and *Thinking through Craft* (2007). His most recent book, *Craft: An American History*, was published by Bloomsbury in 2021.

Daniel Belasco is an art historian and Executive Director of the Al Held Foundation. His research on artists and critics including Louise Bourgeois, Helen Frankenthaler, Grace Hartigan, and Ti-Grace Atkinson has appeared in numerous journals and exhibition catalogues, and he is currently at work on a book about all-women exhibitions in the United States at midcentury. Belasco previously served as Henry J. Leir Associate Curator at the Jewish Museum, New York, and as Curator of Exhibitions and Programs at the Dorsky Museum, State University of New York at New Paltz.

Kirsty Bell is a writer and art critic living in Berlin. Her book *The Undercurrents: A Story of Berlin* was published in 2022 and has been translated into several languages. She was awarded an Andy Warhol Foundation Arts Writers Grant for her 2013 book *The Artist's House: From Workplace to Artwork*. A contributing editor at *frieze* from 2011 to 2021 and a regular contributor since 2001, she has also published widely in other magazines and journals and in more than seventy exhibition catalogues. Since 2015, she has been an Advisor at the Rijksakademie van Beeldende Kunsten, Amsterdam.

Allie Biswas is a writer and editor. She was born in Scarborough, England, and studied at King's College London and Birkbeck, University of London. In 2021, she coedited *The "Soul of a Nation" Reader: Writings by and about Black American Artists, 1960–1980*. Between 2015 and 2019, Biswas published long-form interviews in the *Brooklyn Rail* with artists including Rashid Johnson, Julie Mehretu, Meleko Mokgosi, Zanele Muholi, Adam Pendleton, and Wolfgang Tillmans. Most recently, she has written profiles on Garrett Bradley, Lubna Chowdhury, and Theaster Gates for *frieze* and contributed texts to *Portia Zvavahera* (David Zwirner), *Strange Clay: Ceramics in Contemporary Art* (Hayward Gallery), *Frank Bowling: Sculpture* (Ridinghouse), and *With the End in Mind: Reginald Sylvester II* (InOtherWords). Forthcoming publications include a catalogue of the United States Embassy's art collection in London.

Jessica Bell Brown is Curator and Department Head for Contemporary Art at the Baltimore Museum of Art. Among her recent exhibition projects are *How Do We Know the World?* (2021–23) and *A Movement in Every Direction: Legacies of the Great Migration* (2022), co-organized with the Mississippi Museum of Art, Jackson. Prior to the BMA, she was Consulting Curator at Gracie Mansion Conservancy in New York, where she co-curated *She Persists: A Century of Women Artists in New York, 1919–2019* with First Lady Chirlane McCray. Previously, she held roles at the Museum of Modern Art, New York; Brooklyn Academy of Music; and Creative Time. Her writing has been featured in monographs and catalogues devoted to Janiva Ellis, Matthew Angelo Harrison, Lubaina Himid, Baldwin Lee, and Thaddeus Mosley as well as in *Flash Art*, *Artforum*, *Art Papers*, *Hyperallergic*, and the *Brooklyn Rail*.

David J. Getsy is Eleanor Shea Professor of Art History at the University of Virginia. His books include *Queer Behavior: Scott Burton and Performance Art* (2022), *Queer* (2016), *Abstract Bodies: Sixties Sculpture in the Expanded Field of Gender* (2015), and *Rodin: Sex and the Making of Modern Sculpture* (2010). He is currently writing a book based on the retrospective exhibition *Rubbish and Dreams: The Genderqueer Performance Art of Stephen Varble*, which he curated for the Leslie-Lohman Museum of Art, New York, in 2018–19.

Lesley Vance (born 1977). *Untitled*, 2017. Oil on linen, 31 × 24 in. (78.7 × 61 cm). Shah Garg Collection

Hannah Johnston is a writer and researcher, trained at Durham University and University College London and based in Greater London. Between 2012 and 2020, she was Assistant Curator at Tate Modern, London, where she organized exhibitions and displays of the work of Helen Frankenthaler, Richard Hamilton, Georgia O'Keeffe, and Dorothea Tanning, among others. During her tenure at Tate, she produced copious scholarly texts on works in the collection by a vast range of artists, including Lynda Benglis, Sam Gilliam, Felix Gonzalez-Torres, the Guerrilla Girls, Julie Mehretu, Lorna Simpson, and Hannah Wilke. Her book *Tate Introductions: Georgia O'Keeffe* was published in 2016.

Lauren O'Neill-Butler is a New York–based writer whose book *Let's Have a Talk: Conversations with Women on Art and Culture* (Karma, 2021) brings together nearly ninety interviews. A cofounder of the nonprofit magazine *November* and a former senior editor of *Artforum*, she has also contributed to *Aperture*, *Art Journal*, *Bookforum*, and the *New York*

Times. Her essays have recently appeared in monographs devoted to Leilah Babirye, Peter Bradley, Maria Lassnig, and Carrie Moyer. In 2020, she received an Andy Warhol Foundation Arts Writers Grant.

Gloria Sutton is Associate Professor of Contemporary Art History and Women, Gender, and Sexuality Studies at Northeastern University. A research affiliate in the Art, Culture, and Technology (ACT) program at the Massachusetts Institute of Technology, Sutton also serves on the Advisory Committee of the MIT List Visual Arts Center and has published widely. In 2016–18, she collaborated with the artist Renée Green on a series of interlinked public programs and exhibitions at Harvard University's Carpenter Center for the Visual Arts, culminating in the volume *Renée Green: Pacing* (D.A.P., 2021), and her book *The Experience Machine: Stan VanDerBeek's Movie-Drome and Expanded Cinema* (MIT Press, 2015) will be published in a French translation by Éditions B2 in 2023, with a foreword by Olafur Eliasson.

Index

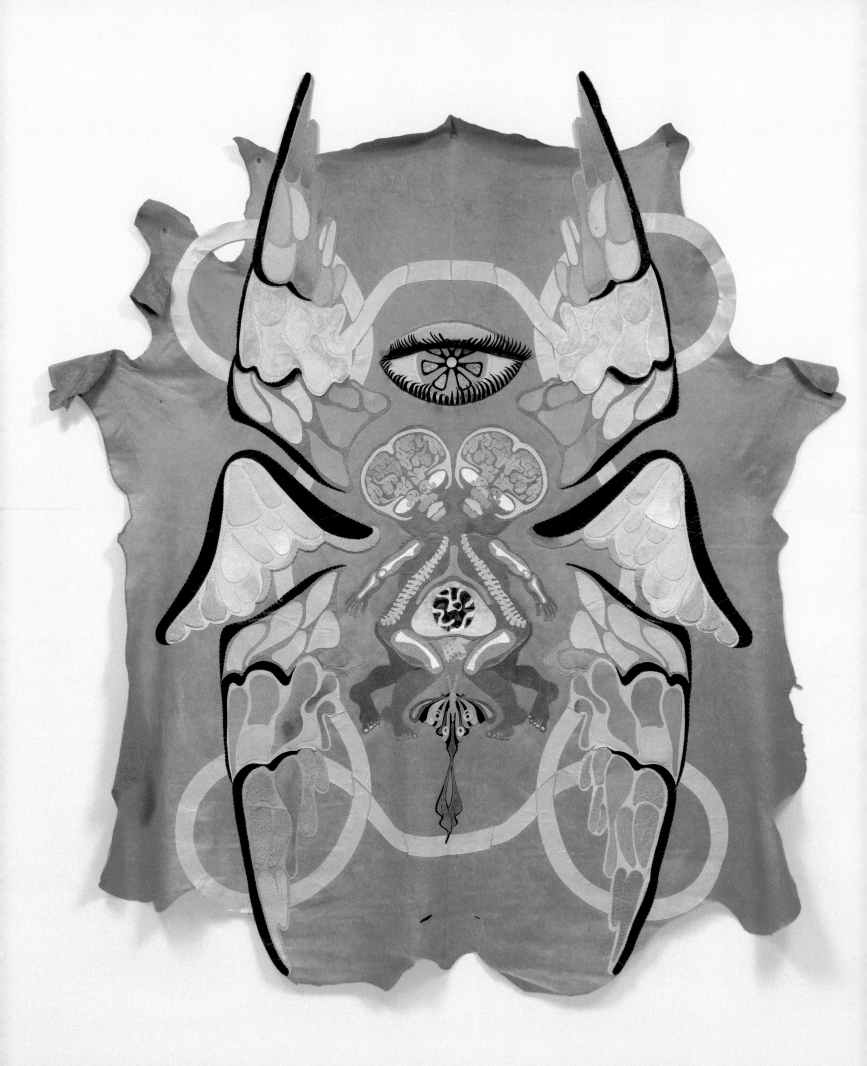

The Shah Garg Foundation

The Shah Garg Foundation supports new scholarship on and public engagement with the achievements, contributions, and innovations of women artists. Through a wide range of projects and partnerships with educational institutions, arts organizations, and arts leaders, the Foundation works to bring greater recognition to art by women and to rectify the underrepresentation of women in public collections, exhibitions, and art-historical narratives. The Foundation offers strategic financial and programmatic support in service to its vision to achieve parity for women artists within the arts ecosystem.

Tau Lewis (born 1993). *Knot of Pacification*, 2021. Leather, lambskin, goatskin, pigskin, stingray shagreen, python skin, ostrich skin, crocodile skin, and sand dollars, 9 ft. 4 in. × 8 ft. 3½ in. (284.5 × 252.7 cm). Shah Garg Collection

Photograph Credits and Copyrights

431

Making Their Mark: Art by Women in the Shah Garg Collection
is published in 2023 by Gregory R. Miller & Co.

 GREGORY R.
MILLER & CO.

Gregory R. Miller & Co.
62 Cooper Square
New York, NY 10003
grmandco.com

Distributed worldwide by:
ARTBOOK | D.A.P.
75 Broad Street, Suite 630
New York, NY 10013
artbook.com

ISBN 978-1-941366-50-9

Library of Congress Control Number: 2022947539

Production by Miko McGinty Inc.
Design by Rita Jules, Miko McGinty Inc.
Project management by Alex Polson
Copy editing by Jennifer Bernstein, Tenacious Editorial
Proofreading by Marian Appellof
Index by Kathleen Friello
Typesetting by Tina Henderson
Printed and bound in Verona, Italy, by Trifolio S.r.l.

Jacket illustrations (details): (front) Elizabeth Murray, *Joanne in the
Canyon*, 1990–91 (pl. 34); (back) Julie Mehretu, *Among the Multitude VI*,
2020–22 (pl. 88)

Full-page details: (pp. 2–3) Charline von Heyl, *Plato's Pharmacy*, 2015
(pl. 71); (pp. 4–5) Pat Steir, *For Philadelphia Three*, 2013 (pl. 37); (pp. 6–7)
Jaune Quick-to-See Smith, *Petroglyph Park: Escarpment*, 1987 (pl. 35);
(p. 10) Emma Amos, *Star*, 1982 (pl. 24); (p. 26) Maria Lassnig, *Die grüne
Malerin* (The Green Paintress), 2000 (pl. 5); (p. 41) Ellen Gallagher, *Wild
Kingdom*, 1995 (pl. 77); (p. 42) Mary Obering, *Window Series #4*, 1973
(pl. 25); (p. 56) Suzanne Jackson, *Migration*, 1998 (fig. 3 on p. 59); (p. 62)
Joyce J. Scott, *Harriet's Quilt*, 2016–22 (pl. 56); (p. 69) Françoise Grossen,
Contact III, 1977 (pl. 43); (p. 70) Joan Snyder, *Untitled*, 1974 (pl. 36); (p. 79)
Christina Quarles, *Meet in tha Middle*, 2018 (pl. 119); (p. 80) Amy Sillman,
Radiator, 2021 (pl. 64); (p. 88) Jadé Fadojutimi, *Inside My Shell*, 2018
(pl. 133); (p. 94) Sarah Sze, *Crisscross*, 2021 (pl. 87); (p. 99) Ilana Savdie,
The Enablers (an adaptation), 2021 (pl. 122); (pp. 104–5) Mary Weatherford,
Light Falling Like a Broken Chain; Paradise, 2021 (pp. 136–37); (pp. 140–41)
Miriam Schapiro, *Double Rose*, 1978 (pl. 9); (p. 414) Marie Watt, *Companion
Species (A Distant Song)*, 2021 (pl. 84); (p. 427) Howardena Pindell,
Untitled #21, 1978 (pl. 46)